DISCARD

Eighth Edition

ART FUNDAMENTALS

THEORY & PRACTICE

Otto G. Ocvirk
Robert E. Stinson
Philip R. Wigg
Robert O. Bone
David L. Cayton

Michelle 59/9 (4.2) 433-9551

School of Art / Bowling Green State University

This book is dedicated to the memory of Robert O. Bone, co-author, teacher, colleague, and friend.

McGraw-Hill

A Division of the McGraw-Hill Companies

ART FUNDAMENTALS: THEORY AND PRACTICE

Copyright 1998 by The McGraw-Hill Companies, Inc. All rights reserved. Printed in the United States of America. Except as permitted under the United States Copyright Act of 1976, no part of this publication may be reproduced or distributed in any form or by any means, or stored in a data base or retrieval system, without the prior written permission of the publisher.

This book is printed on recycled, acid-free paper containing 10% postconsumer waste.

1234567890 DOR/DOR 90987

ISBN 0-697-34033-3

Publisher: Phil Butcher

Sponsoring editor: Cynthia Ward Marketing manager: Margaret Metz Project manager: Marilyn Rothenberger Production supervisor: Mary Jess Cover Designer: Kristyn Kalnes Art editor: Joyce Watters Compositor: GTS Graphics, Inc.

Typeface: Bembo

Printer: R.R. Donnelley & Sons Company, Roanoke, Virginia.

Library of Congress Catalog Number: 96-78734

Front cover:

Joan Mitchell, *Quiet Please*, 1980. Oil on canvas, $94\frac{1}{2}$ in \times 142 in $(2.3 \times 3.61 \text{ m})$ Courtesy of Manny Silverman Gallery, Los Angeles, CA. © The Succession Joan Mitchell.

Back Cover:

Martin Puryear, *Thicket*, 1990. Basswood and cypress, $67 \times 62 \times 17$ in (170.18 \times 157.48 \times 43.18 cm).

The Seattle Art Museum, Gift of Agness Gund. (Photo: Paul Macapia)
© Martin Puryear.

8 8

INTERNATIONAL EDITION

Copyright © 1998. Exclusive rights by The McGraw-Hill Companies, Inc. for manufacture and export.

This book cannot be re-exported from the country to which it is consigned by McGraw-Hill.

The International Edition is not available in North America.

When ordering this title, use ISBN 0-07-115417-5

www.mhcollege.com

Contents

Preface	vi	Approximate symmetrical balance	55
Acknowledgements	Radial balance		55
		Asymmetrical (occult) balance	56
I. Introduction	2	Proportion (4)	58
	4	Dominance (5)	65
The Vocabulary of Introductory Terms	4	Movement (6)	67
The Need and Search for Art	6	Economy (7)	68
The Ingredients of Art	9	Space: Result of Elements/Principles	70
The Components of Art	10	Form Unity: A Summary	71
Subject	10		
Form	12	3. Line	72
Content	12		
Savoring the Ingredients	16	The Vocabulary of Line	74
The Ingredients Assembled	19	Line: The Elementary Means of Communication	74
Media and Techniques	21	The Physical Characteristics of Line	79
Picture Plane	23	Measure	79
Picture Frame	23	Туре	79
Positive and Negative Areas	25	Direction	80
The Art Elements	26	Location	80
		Character	81
2. Form	28	The Expressive Properties of Line	82
The Vocabulary of Form	30	Line and the Other Art Elements	83
Form and Visual Ordering	31	Line and Shape	83
The Seven Principles of Organization	32	Line and Value	85
·	33	Line and Texture	86
Harmony (1)	34	Line and Color	88
Repetition Pattern	35	The Spatial Characteristics of Line	88
Motif	36	Line and Representation	89
•	38		
Rhythm	40	4. Shape	92
Closure or Visual Grouping Visual Linking	43	The Vershulam of Share	0.4
Connections—Shared Edges	43	The Vocabulary of Shape	94
Overlapping	43 44	Introduction to Shape	95
		The Lies of Shape	95
Transparency	44	The Use of Shapes	98
Interpenetration Extensions	45 45	Shape Dimensions	99
	45	The Illusions of Two-dimensional Shapes	99
Variety (2)	49	The Illusions of Three-dimensional Shapes	100
Contrast	49	Shape and Principles of Design	103
Elaboration	49	Balance	104
Balance (3)	50	Direction	105
Symmetrical balance	54	Duration and Relative Dominance	106

Harmony and Variety	108	letrads	15
Shapes and the Space Concept	108	Analogous and Monochromatic Colors	157
Shape and Content	109	Warm and Cool Colors	157
		Plastic Colors	157
5. Value	114	Simultaneous Contrast	159
		Color and Emotion	162
The Vocabulary of Value	116	Psychological Application of Color	164
Introduction to Value Relationships	117	The Evolution of the Color Wheel	160
Descriptive Uses of Value	118	The Origins of Color Systems	160
Expressive Uses of Value	120		160
Chiaroscuro	121	The Discovery of Pigment Primaries The First Triadic Color Wheel	160
Tenebrism	123		160
Decorative Value	123	American Educators	
Compositional Functions of Value	125	The Ostwald Color System	160
Value Patterns	127	The Munsell Color System	16
	127	The Subtractive Color Mixing System	168
Open and Closed Compositions	127	The Discovery of Light Primaries	169
	120	The Role of Color in Composition	170
6. Texture	130	Color Balance	17
The Vocabulary of Texture	132	Color and Harmony	172
Introduction to Texture	133	Color and Variety	174
Texture and the Visual Arts	133		
	134	8. Space	178
The Nature of Texture			
Types of Texture	134	The Vocabulary of Space	180
Actual Texture	135	Introduction to Space	18
Simulated Texture	137	Spatial Perception	18
Abstract Texture	138	Major Types of Space	18
Invented Texture	139	Decorative Space	18
Texture and Pattern	140	Plastic Space	18
Texture and Composition	142	Divisions of Plastic Space	182
Relative Dominance and Movement	142	Shallow Space	182
Psychological Factors	142	Deep and Infinite Space	182
Texture and Space	142	Spatial Indicators	183
Texture and Art Media	142	Size	183
	**************************************	Position	184
7. Color	144	Overlapping	18
			18
The Vocabulary of Color	146	Transparency	180
The Characteristics of Color	147	Interpenetration	186
Light: The Source of Color	147	Fractional Representation	
Additive Color	148	Sharp and Diminishing Detail	18
Subtractive Color	148	Converging Parallels	188
Artist's Color Mixing	149	Linear Perspective	188
The Triadic Color System	151	Major Systems of Linear Perspective	190
Neutrals	151	One-point perspective	193
The Physical Properties of Color	151	Two-point perspective	193
	152	Three-point perspective	19
Hue	152	Perspective Concepts Applied	19
Value		The Disadvantages of Linear Perspective	20
Intensity	153	Other Projection Systems	20
Developing Aesthetic Color Relationships	155	Intuitive Space	20
Complements and Split-complements	156	The Spatial Properties of the Elements	20
Triads	157	s spatial 1. specifies of the Elements	

Shape and Space 206	Line and Space	204	Impressionism	253	
Texture and Space 208	Shape and Space	206	Post-Impressionism	257	
Color and Space 209	Value and Space	207	Photographic Trends		
Recent Concepts of Space 210	Texture and Space	208	Nineteenth-century Sculpture	260	
The Search for a New Spatial Dimension 210 Plastic Images 213 Plastic Images 214 Pictorial Representations of Movement in Time 214 Pictorial Representations of Movement in Time 214 Pictorial Representations of Movement in Time 218 Pictorial Representations of Movement in Time 214 Expressionism in the United States and Expressionist Sculpture 217 Post-Part Abstract Art in the United States 215 Abstract Caulpture 217 Abstract Art in the United States 215 Abstract Ar	Color and Space	209	Early Twentieth-Century Art	263	
Plastic Images Pictorial Representations of Movement in Time 214 Pictorial Representations of Movement in Time 214 Pictorial Representations of Movement in Time 214 Post-Impressionism in the United States and Mexico 268 Color Photography and Other New Trends 269 Cubism 270 Cubism 271 Abstract Art 272 Abstract Art 273 Abstract Art 274 Abstract Art 274 Abstract Art 275 Architecture 275 Abstract Art in the United States 275 Abstract and Realist Photography 277 Glass Design 276 Ceramics 276 Abstract Sculpture 277 Abstract and Realist Photography 278 Abstract and Realist Photography 279 Abstract and Realist Photography 270 Abstract Art in the United States 275 Abstract Art in the United States 275 Abstract and Realist Photography 277 Abstract and Realist Photography 278 Abstract and Realist Photography 279 Abstract Expressionist Sculpture 280 Surrealist Sculpture 281 Surrealist Sculpture 282 Surrealist Sculpture 283 Abstract-Expressionist Painting 284 Abstract-Expressionist Painting 287 Abstract-Expressionist Painting 287 Abstract-Expressionist Painting 287 Abstract-Expressionism and Photography 288 Abstract-Expressionism and Photography 289 Abstract-Expressionism and Photography 280 Abstract-Expressionism and Photography 280 Abstract-Expressionism and Photography 280 Abstract-Expressionism and Photography 281 Abstract-Expressionism and Photography 282 Abstract-Expressionism and Photography 284 Abstract-Expressionism and Photography 285 Abstract-Expressionism and Photography 286 Abstract-Expressionism	Recent Concepts of Space	210	Expressionism	263	
Pictorial Representations of Movement in Time 2.14 Expressionism in the United States and Mexico 2.68 Post-Impressionist and Expressionist Sculpture 2.60 Fort Photography and Other New Trends 2.60 Substance Are Color Photography and Other New Trends 2.60 Substance Are Color Photography and Other New Trends 2.60 Substance Are Color Photography and Other New Trends 2.60 Substance Are Color Photography and Other New Trends 2.60 Substance Are Color Photography and Other New Trends 2.60 Substance Are Color Photography and Other New Trends 2.61 Substance Are Color Photography and Other New Trends 2.62 Substance Are Color Photography and Other New Trends 2.73 Abstract Art in the United States 2.75 Abstract Art in the United States 2.75 Abstract Sculpture 2.77 Abstract Art in the United States 2.75 Abstract Sculpture 2.77 Abstract Are Realist Photography 2.77 Abstract Art in the United States 2.78 Abstract Art in the United States 2.79 Abstract Sculpture 2.70 Abstract Art in the United States 2.75 Abstract Art in the United	The Search for a New Spatial Dimension	210	French Expressionism: The Fauves	263	
Post-Impressionist and Expressionist Sulpture 268 Color Photography and Other New Trends 269 Cubism 270 Futurism 273 Abstract Art 274 Abstract Art 275 Abstract Art 275 Abstract Art 276 Abstract Art 276 Abstract Art 277 Abstract Art in the United States 275 Architecture 275 Abstract Art in the United States 275 Architecture 276 Abstract Art in the United States 275 Architecture 277 Abstract Art in the United States 275 Architecture 276 Abstract Art in the United States 275 Architecture 277 Abstract Sulpture 277 Abstract Sulpture 277 Abstract Art in the United States 275 Abstract Sulpture 277 Abstract Art in the United States 275 Architecture 276 Abstract Art in the United States 275 Abstract Sulpture 277 Abstract Art in the United States 275 Abstract Sulpture 277 Abstract Art in the United States 275 Abstract Sulpture 277 Abstract Sulpture 277 Abstract Art in the United States 275 Abstract Sulpture 277 Abstract Art in the United States 275 Abstract Art in the United St	Plastic Images	213	German Expressionism	264	
Post-Impressionist and Expressionist Sulpture 268 Color Photography and Other New Trends 269 Cubism 270 Futurism 273 Abstract Art 274 Abstract Art 275 Abstract Art 275 Abstract Art 276 Abstract Art 276 Abstract Art 277 Abstract Art in the United States 275 Architecture 275 Abstract Art in the United States 275 Architecture 276 Abstract Art in the United States 275 Architecture 277 Abstract Art in the United States 275 Architecture 276 Abstract Art in the United States 275 Architecture 277 Abstract Sulpture 277 Abstract Sulpture 277 Abstract Art in the United States 275 Abstract Sulpture 277 Abstract Art in the United States 275 Architecture 276 Abstract Art in the United States 275 Abstract Sulpture 277 Abstract Art in the United States 275 Abstract Sulpture 277 Abstract Art in the United States 275 Abstract Sulpture 277 Abstract Sulpture 277 Abstract Art in the United States 275 Abstract Sulpture 277 Abstract Art in the United States 275 Abstract Art in the United St	Pictorial Representations of Movement in Time	214	Expressionism in the United States and Mexico	268	
Cubism 270			Post-Impressionist and Expressionist Sculpture	268	
The Vocabulary of the Third Dimension 220 Futurism 273 Abstract Cart 274 Abstract Art 274 Abstract Art 275 Abstract Art 275 Abstract Art 276 Abstract Art 276 Abstract Art 277 Abstract Art 277 Abstract Art 278 Abstract Art 378 Abstra	9. The Art of the Third Dimension	218	- · ·		
Basic Concepts of Three-Dimensional Art 221 Abstract Art 274 Sculpture 222 Nonobjective Art 275 Other Areas of Three-dimensional Art 223 Abstract Art in the United States 275 Architecture 225 Abstract Cart In the United States 275 Metalwork 226 Abstract Caulpture 277 Glass Design 226 Fantostic Art 280 Ceramics 226 Fantostic Art 280 Fiberwork 228 Individual Fantasists 281 Froduct Design 228 Individual Fantasists 282 Froduct Design 228 Surrealist Sculpture 284 Materials and Techniques 228 Surrealist Sculpture 284 Subtraction 229 Late Twentieth-Century Art 287 Addition 230 Abstract-Expressionist Painting 287 Substitution 230 Abstract-Expressionist Sculpture 290 Shape 231 Abstract-Expressionist Sculpture 290 Shap	The Vocabulary of the Third Dimension	220			
Sculpture 222					
Other Areas of Three-dimensional Art Architecture Architecture Architecture Active Curamics Ceramics Fiberwork Product Design The Components of Three-Dimensional Art Addition Substitution Substitution Substitution Substitution Substitution Shape Value Space	•				
Architecture Metalwark Aclass Design Ceramics Fiberwork Product Design The Components of Three-Dimensional Art Materials and Techniques Subtraction Materials and Techniques Subtraction Materials and Techniques Subtraction Materials and Techniques Subtraction Manipulation Addition Substitution The Elements of Three-dimensional Form Shape Value Space Spa					
Metalwork 226 Abstract and Realist Photography 277 Glass Design 226 Fantastic Art 280 Ceramics 226 Dadaism 281 Fiberwork 228 Individual Fontasists 282 Product Design 228 Surrealist Painting 283 The Components of Three-Dimensional Art 228 Surrealist Painting 283 Materials and Techniques 228 Surrealist Sculpture 284 Subtraction 229 Surrealist Sculpture 284 Addition 229 Abstract-Expressionist Painting 286 Subtration 230 Abstract-Expressionist Painting 287 Addition 230 Abstract-Expressionist Painting 287 Abstract-Expressionism and Photography 294 Abstract-Expressionism and Photography 294 Abstract-Expressionism and Photography 294 Abstract-Expressionism and Photography 294 Value 233 Assemblage 298 Space 234 Kinetics and Light </td <td></td> <td></td> <td></td> <td></td>					
Glass Design Ceramics					
Ceramics 226 Dadaism 281 Fiberwork 228 Individual Fantasists 282 Product Design 228 Surrealist Painting 283 The Components of Three-Dimensional Art 228 Surrealist Sculpture 284 Materials and Techniques 228 Surrealism and Photography 286 Subtraction 229 Late Twentieth-Century Art 287 Manipulation 229 Abstract-Expressionist Painting 287 Addition 230 Abstract-Expressionist Sculpture 290 Substitution 230 Abstract-Expressionist Sculpture 290 Substitution 230 Abstract-Expressionist Sculpture 290 Shape 231 Post-Painterly Abstraction 296 Shape 231 Op Art 298 Value 233 Assemblage 298 Space 234 Kinetics and Light 301 Texture 236 Minimalism 302 Line 237 Hoppenings/Performance Art			0 . ,		
Fiberwork	•				
Product Design 228					
The Components of Three-Dimensional Art 228 Surrealists Cullpture 284					
Materials and Techniques228Surrealisms Scripture286Subtraction229Late Twentieth-Century Art287Manipulation230Abstract-Expressionist Painting287Addition230Abstract-Expressionist Sculpture290Substitution231Abstract-Expressionism and Photography294The Elements of Three-dimensional Form231Post-Painterly Abstraction296Shape231Op Art298Value233Assemblage298Space234Kinetics and Light301Texture236Minimalism302Line237Pop Art304Color237Happenings/Performance Art308Time (the Fourth Dimension)238Site and Earth Art310Principles of Three-dimensional Order238Sott and Earth Art310Balance239New Realism (Photorealism)313Proportion240Process and Conceptual Art314Economy240Process and Conceptual Art314Movement242Chronological Outline of Western Art312Introduction to Content and Style246Chronological Outline of Western Art322Neoclassicism246Glossary324Neoclassicism246Bibliography334Realism and Naturalism249Media Index344			Surrealist Painting	283	
Subtraction Manipulation Addition Substitution Shape Value Space Space Space Space Size Line Color Time (the Fourth Dimension) Time (the Fourt			Surrealist Sculpture	284	
Manipulation Addition 229 Abstract-Expressionist Sculpture 290 Substitution 230 Substitution 231 The Elements of Three-dimensional Form 231 Shape 231 Value 233 Space 234 Space 234 Color Line 237 Color 237 Time (the Fourth Dimension) 238 Balance 239 Broportion 240 Proportion 240 Proportion 240 Proportion 240 Proportion 240 Proportion 240 Process and Conceptual Art Movement 241 Novement 242 Nove-Abstraction 257 Neo-Abstraction 260 Space 278 Neoclassicism 246 Romanticism 287 Neoclassicism 248 Romanticism 249 Realism and Naturalism 250 Necelassics 240 Realism and Naturalism 250 Necelassics 246 Realism and Naturalism 250 National Style 250 Abstract-Expressionist Sculpture 290 Abstract-Expressionist and Photography 294 Abstract-Expressionist Sculpture 290 Abstract-Expressionist Sculpture 290 Abstract-Expressionist Sculpture 290 Abstract-Expressionist Aculpture 290 Abstract-Expressionist and Photography 294 Abstract-Expressionist Aculpture 290 Abstract-Expressionist Aculpture 298 Assemblage 298 Assem			Surrealism and Photography	286	
Addition 230 Abstract-Expressionist Sculpture 290 Substitution 230 Abstract-Expressionist Sculpture 290 Abstract-Expressionist Sculpture 294 Abstract-Expressionist Sculpture 294 Abstract-Expressionism and Photography 294 Abstract-Expressionist Sculpture 295 Abstract-Expressionist Sculpture 296 Abstract-Expressionism and Photography 294 Abstract-Expressionist Sculpture 296 Abstraction 296 Abstraction 296 Abstraction 296 Abstraction 296 Abstraction 296 Abstraction 297 Ab			Late Twentieth-Century Art	287	
Substitution 230 The Elements of Three-dimensional Form 231 Shape Value 233 Value 234 Space 234 Space 235 Space 236 Line Color Time (the Fourth Dimensional Order Balance Principles of Three-dimensional Order Balance Proportion Pro	·		Abstract-Expressionist Painting	287	
The Elements of Three-dimensional Form 231 Post-Painterly Abstraction 296			Abstract-Expressionist Sculpture	290	
The Elements of Three-dimensional Form 231 Post-Painterly Abstraction 296 Shape 231 Op Art 298 Value 233 Assemblage 298 Space 234 Kinetics and Light 301 Texture 236 Minimalism 302 Line 237 Pop Art 304 Color 237 Happenings/Performance Art 308 Time (the Fourth Dimension) 238 Site and Earth Art 310 Principles of Three-dimensional Order 238 Postmodernism 312 Balance 239 New Realism (Photorealism) 313 Proportion 240 Process and Conceptual Art 314 Economy 240 Neo-Expressionism 317 Movement 242 Neo-Abstraction 319 10. Content and Style 244 Chronological Outline of Western Art 322 Nineteenth-Century Art 246 Glossary 327 Neoclassicism 246 Bibliography 334 <td></td> <td></td> <td>·</td> <td>294</td>			·	294	
Shape 231				296	
Value 233 Assemblage 298 Space 234 Kinetics and Light 301 Texture 236 Minimalism 302 Line 237 Pop Art 304 Color 237 Happenings/Performance Art 308 Time (the Fourth Dimension) 238 Site and Earth Art 310 Principles of Three-dimensional Order 238 Postmodernism 312 Balance 239 New Realism (Photorealism) 313 Proportion 240 Process and Conceptual Art 314 Economy 240 Neo-Expressionism 317 Movement 242 Neo-Abstraction 319 10. Content and Style 244 Chronological Outline of Western Art 322 Neoclassicism 246 Glossary 327 Neoclassicism 246 Bibliography 334 Romanticism 248 Index 336 Beginning of Photography 249 Media Index 344	Shape				
Space Texture Texture Time Todo Time (the Fourth Dimension) Time (the Fourth Dimensional Order Texture Time (the Fourth Dimensional Order Time (the Fourth Dimension) The Appenings/Performance Art Today	Value	233			
Texture Line Line Color Color Time (the Fourth Dimension) Principles of Three-dimensional Order Balance Proportion Proportion Economy Movement 10. Content and Style Nineteenth-Century Art Neoclassicism Romanticism Reginning of Photography Realism and Naturalism A 302 Alappenings/Performance Art Site and Earth Art Postmodernism Site and Earth Art Proportion Proptmance Neo Author Ne	Space	234			
Line Color Time (the Fourth Dimension) 238 Principles of Three-dimensional Order Balance Proportion Proportion Economy Movement 10. Content and Style Nineteenth-Century Art Neoclassicism Romanticism Reginning of Photography Realism and Naturalism Pop Art Happenings/Performance Art Site and Earth Art Postmodernism Nee Realism (Photorealism) Propertion Process and Conceptual Art Neo-Expressionism Neo-Abstraction 110. Content and Style Rappenings/Performance Art Replace Site and Earth Art Neosentes and Earth Art Neosentes and Earth Art Neosentes and Earth Art Neosentes and Conceptual Art Neo-Expressionism Neo-Abstraction Neo-Abstraction 110. Content and Style Neoclassicism Neocl	Texture	236	•		
Color Time (the Fourth Dimension) 238 Principles of Three-dimensional Order Balance Proportion Economy Movement 10. Content and Style Nineteenth-Century Art Neoclassicism Romanticism Romanticism Reginning of Photography Realism and Naturalism Alaga Site and Earth Art Postmodernism New Realism (Photorealism) Process and Conceptual Art Neo-Expressionism Neo-Expressionism Neo-Abstraction 110. Content and Style Site and Earth Art Postmodernism New Realism (Photorealism) New Realism (Photorealism) Neo-Abstraction 110. Content and Style Site and Earth Art Postmodernism New Realism (Photorealism) Neo-Expressionism Neo-Abstraction 110. Content and Style Site and Earth Art Postmodernism Site and Earth Art New Realism (Photorealism) Neo-Expressionism Neo-Abstraction 110. Content and Style Site and Earth Art New Realism (Photorealism) New Realism (Photorealism) Neo-Abstraction 110. Content and Style Site and Earth Art Neo-Expressionism Neo-Expressionism Neo-Abstraction 110. Content and Style Site and Earth Art New Realism (Photorealism) New Realism (Photorealism) New Realism (Photorealism) Neo-Expressionism Neo-Expressionism Neo-Abstraction 110. Content and Style Neo-Abstraction 110. Content and Style Neo-Abstraction 110. Content and Style Neo-Abstraction 111 Neo-Abstraction 111 Neo-Abstraction 112 Neo-Expressionism Neo-Abstraction 112 Neo-Expressionism Neo-Abstraction 113 Neo-Expressionism Neo-Abstraction 114 Neo-Expressionism Neo-Abstraction 115 Neo-Abstraction 116 Neo-Expressionism Neo-Expressionism Neo-Abstraction 117 Neo-Abstraction 118 Neo-Abstraction 119 Neo-Abstraction 119 Neo-Abstraction 110 Neo-Ab	Line	237			
Time (the Fourth Dimension) Principles of Three-dimensional Order Balance Proportion Proportion Economy Movement 10. Content and Style Introduction to Content and Style Neoclassicism Neoclassicism Neoclassicism Romanticism Beginning of Photography Realism and Naturalism Site and Earth Art Postmodernism New Realism (Photorealism) Process and Conceptual Art Neo-Expressionism Neo-Abstraction 110. Content and Style Chronological Outline of Western Art Glossary Bibliography Index Media Index	Color	237			
Principles of Three-dimensional Order Balance Proportion Proportion Economy Movement 10. Content and Style Introduction to Content and Style Nineteenth-Century Art Neoclassicism Neoclassicism Romanticism Beginning of Photography Realism and Naturalism 238 Postmodernism New Realism New Realism (Photorealism) Process and Conceptual Art Neo-Expressionism Neo-Abstraction 312 New Realism (Photorealism) Process and Conceptual Art Neo-Expressionism Neo-Abstraction 313 Neo-Abstraction 314 Neo-Abstraction 315 Neo-Abstraction 317 Neo-Abstraction 318 Neo-Abstraction 318 Neo-Expressionism Neo-Abstraction 319 Chronological Outline of Western Art 322 Ribiliography Index Media Index Media Index Media Index 336	Time (the Fourth Dimension)	238			
Balance Proportion Proportion Proportion Proportion Proportion Process and Conceptual Art Process and Conceptual Art Neo-Expressionism Neo-Abstraction 10. Content and Style Process and Conceptual Art Neo-Abstraction 10. Content and Style Process and Conceptual Art Neo-Abstraction 10. Content and Style Process and Conceptual Art Neo-Abstraction 11. Content and Style Process and Conceptual Art Neo-Abstraction 11. Content and Style Process and Conceptual Art Neo-Abstraction 11. Content and Style Process and Conceptual Art Neo-Abstraction 11. Content and Style Process and Conceptual Art Neo-Abstraction 12. Content and Style Process and Conceptual Art Neo-Abstraction 13. Process and Conceptual Art Neo-Abstraction 14. Chronological Outline of Western Art Process and Conceptual Art Neo-Abstraction 14. Chronological Outline of Western Art Process and Conceptual Art Neo-Abstraction 14. Chronological Outline of Western Art Process and Conceptual Art Neo-Expressionism Neo-Abstraction 15. Chronological Outline of Process and Conceptual Art Neo-Expressionism Neo-Abstraction 16. Chronological Outline of Process and Conceptual Art Neo-Expressionism Neo-Abstraction 17. Content and Style Neo-Abstraction 18. Chronological Outline of Process and Conceptual Art Neo-Expressionism Neo-Abstraction 19. Content and Style Neo-Abstr	Principles of Three-dimensional Order	238			
Proportion Economy Movement 10. Content and Style Introduction to Content and Style Nineteenth-Century Art Neoclassicism Neoclassicism Romanticism Beginning of Photography Realism and Naturalism Process and Conceptual Art Neo-Expressionism Neo-Abstraction 11. Content and Style Chronological Outline of Western Art Glossary Bibliography Index Media Index Media Index Media Index 314 Neo-Expressionism 317 Neo-Abstraction 319 Chronological Outline of Western Art 322 Bibliography 334 Nedia Index 336 Media Index 344	· ·	239			
Economy And Movement 240 Neo-Expressionism Neo-Abstraction 317 Neo-Abstraction 317 Neo-Abstraction 319 10. Content and Style 244 Introduction to Content and Style 246 Nineteenth-Century Art 246 Neoclassicism 246 Romanticism 248 Beginning of Photography 249 Realism and Naturalism 250 Process and Conceptual Art Neo-Expressionism Neo-Abstraction 317 Neo-Abstraction 319 Chronological Outline of Western Art 322 Chronological Outline of Western Art 322 Index 334 Neoclassicism 334 Neoclassicism 248 Bibliography 1334 Nedia Index 334	Proportion	240			
Movement 242 Neo-Abstraction 319 10. Content and Style Introduction to Content and Style Nineteenth-Century Art Neoclassicism Neoclassicism Romanticism Beginning of Photography Realism and Naturalism 242 Neo-Abstraction 244 Chronological Outline of Western Art 322 Glossary Bibliography Index Media Index Media Index 336 Media Index 344			•		
Introduction to Content and Style Nineteenth-Century Art Neoclassicism Romanticism Beginning of Photography Realism and Naturalism 246 Chronological Outline of Western Art 322 Chronological Outline of Western Art 323 Glossary Bibliography Index Media Index 336 Media Index 344	•		•		
Nineteenth-Century Art Neoclassicism Romanticism Beginning of Photography Realism and Naturalism 246 Glossary Bibliography Index Media Index Media Index 327 Media Index 336	10. Content and Style	244			
Nineteenth-Century Art 246 Glossary 327 Neoclassicism 246 Bibliography 334 Romanticism 248 Index 336 Beginning of Photography 249 Realism and Naturalism 250	Introduction to Content and Style	246	Chronological Outline of Western Art	222	
Neoclassicism246Bibliography334Romanticism248Index336Beginning of Photography249Media Index344Realism and Naturalism250		246	•		
Romanticism 248 Index Beginning of Photography Realism and Naturalism 248 Index 336 Media Index 344		246			
Beginning of Photography 249 Realism and Naturalism Media Index 330 Media Index 344	Romanticism	248			
Realism and Naturalism 250					
			riedia ilidex	344	

Preface

It is the belief of your authors that with perseverance, considerable effort and the aid of our supporters we have produced a much improved edition of Art Fundamentals. Despite many changes in the recent art scene (changes reflected in the text) we retain our basic tenets regarding aspects of artistic creativity. We still see the design, composition or organization of an artwork as the binding force that makes it legible and compelling. And we think that the elements of art must work in concert under the guidance of certain principles. Therefore, the basic layout of the book remains the same, but we have tried to improve our presentation of 2-D and 3-D (and 4-D) art fundamentals.

This edition recognizes new directions in art and also aims to include a broader range of media and greater representation of works by women, multicultural, and nonwestern artists. Our publisher has achieved, we think, a

high level of reproduction quality of art works with which the book is profusely endowed. These works, which cover a vast span of art history, appear on the same page spread as the text discussion.

Each chapter begins with a detailed outline of topics followed by a boxed list of art terms and definitions; there is a combined glossary of terms in the appendix, all of this expanded for this new edition. The chapters focus on each of the basic art elements and their function in the total work. Our insistence on an understanding of the role of the art elements is intended to encourage creativity in apprentice artists of different media including sculptors, graphic designers, jewelers, workers in fiber and glass and, yes, architects.

Of collateral but valuable interest is the last chapter on Style and Content. This chapter provides a rich review of the last two centuries indicating the development of styles leading to and including the current art scene. This chapter is followed by a chronology of art and a bibliography for those seeking additional reading on the subject. We encourage our users to make great use of these chapters as they will find ideas and inspiration.

This edition strives for a better balance of practical applications and theoretical foundations. More attention has been given to color theory and pigment mixing. Also expanded is the section on perspective and traditional and more recent techniques of achieving the illusion of pictorial space. The Instructor's Resource Manual contains various art projects allied with the specific chapters of the text as well as teaching suggestions.

We appreciate the response given previous editions and hope and feel that this one will be even more warmly received!

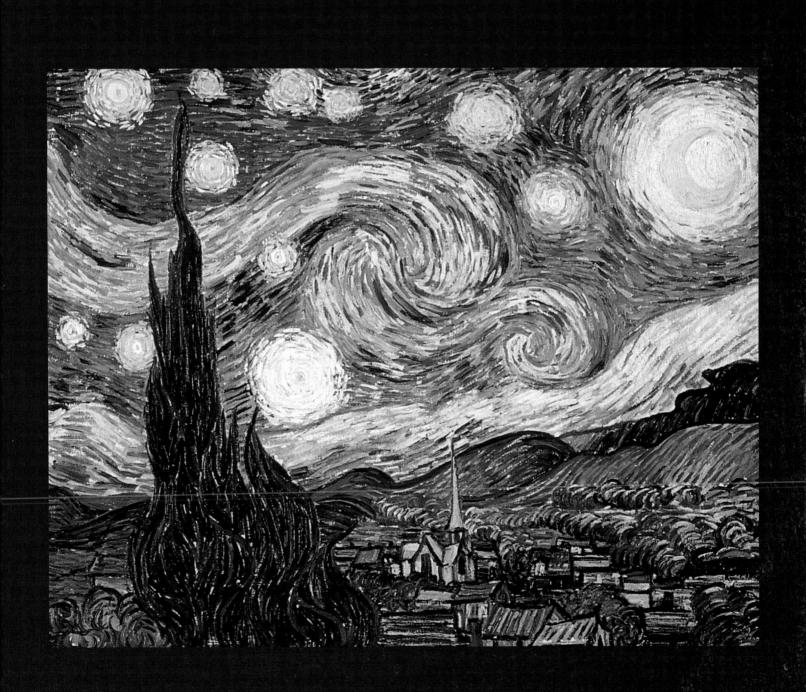

THE VOCABULARY OF INTRODUCTORY TERMS

Art The formal expression of a conceived image or imagined conception in terms of a given medium. (Sheldon Cheney)

abstraction

Abstraction is a relative term for it is present in varying degrees in all works of art from full representation to complete nonobjectivity (a term given to the visual effects derived by the simplification and/or rearrangement of the appearance of natural objects or nonrepresentational work arranged simply to satisfy artists' needs for organization or expression).

aesthetic, aesthetics

The theory of the artistic or the "beautiful"—traditionally a branch of philosophy, but now a compound of the philosophy, psychology, and sociology of art. As such, aesthetics is no longer solely confined to determining what is beautiful in art, but attempts to discover the origins of sensitivity to art forms and the relationships of art to other phases of culture (such as science, industry, morality, philosophy, and religion). Frequently, aesthetics is used in this book to mean concern with artistic qualities of form as opposed to descriptive form or the mere recording of facts in visual form (see objective).

conceptual perception

Creative vision derived from the imagination.

content

The expression, essential meaning, significance, or aesthetic value of a work of art. Content refers to the sensory, subjective, psychological, or emotional properties we feel in a work of art, as opposed to our perception of its descriptive aspects alone.

craftsmanship

Aptitude, skill, or quality workmanship in use of tools and materials.

decorative (art)

Ornamenting or enriching but, more importantly in art, emphasizing the two-dimensional nature of an artwork or any of its elements. Decorative art emphasizes the essential flatness of a surface.

descriptive (art)

A type of art that is based upon adherence to actual appearances.

design

The underlying plan on which artists base their total work. In a broader sense, design may be considered synonymous with the term **form.**

elements of art

Line, shape, value, texture, and color—the basic ingredients the artist uses separately or in combination to produce artistic imagery. Their use produces the visual language of art.

expression

1. The manifestation through artistic form of thought, emotion, or quality of meaning. 2. In art, expression is synonymous with the term **content.**

form

I. The organization or inventive arrangement of all the visual elements according to the principles that will develop unity in the artwork. 2. The total appearance or organization.

graphic art

 Two-dimensional art forms such as drawing, painting, making prints, etc.
 The two-dimensional use of the elements.
 May also refer to the techniques of printing as used in

newspapers, books, magazines, etc.

mass

In graphic art, a shape that appears to stand out three-dimensionally from the space surrounding it, or appears to create the illusion of a solid body of material.
 In the plastic arts, the physical bulk of a solid body of material (see plastic).

medium, media (pl.)

The material(s) and tool(s) used by the artist to create the visual elements perceived by the viewer.

naturalism

The approach to art that is essentially a description of things visually experienced. Pure naturalism would contain no personal interpretation introduced by the artist.

negative area(s)

The unoccupied or empty space left after the positive elements have been created by the artist. However, when these areas have boundaries, they also function as design shapes in the total structure.

nonobjective, nonrepresentational (art)

A type of art that is entirely imaginative and not derived from anything visually perceived by the artist. The elements, their organization, and their treatment by the artist are entirely personalized and, consequently, not associated by the observer with any previously experienced natural objects.

objective (art)

A type of art that is based, as near as possible, on physical actuality or optical perception. Such art tends to appear natural or real.

optical perception

A way of seeing in which the mind has no other function than the natural one of

providing the visual sensation of object recognition.

organic unity

A condition in which the components of art, that is, subject, form, and content, are so vital and interdependent that they may be likened to a living organism. A work having "organic unity" is not guaranteed to have "greatness" or unusual merit.

picture frame

The outermost limits or boundary of the picture plane.

picture plane

The actual flat surface on which the artist executes a pictorial image. In some cases, the picture plane acts merely as a transparent plane of reference to establish the illusion of forms existing in a three-dimensional space.

plane

I. An area that is essentially two-dimensional, having height and width. 2. A flat or level surface. 3. A two-dimensional surface having a positive extension and spatial direction or position.

plastic (art)

I. The use of the elements to create the illusion of the third dimension on a two-dimensional surface. 2. Three-dimensional art forms such as architecture, sculpture, ceramics, etc.

positive area(s)

The state in the artwork in which the art elements (shape, line, etc.), or their

combination, produce the subject—nonrepresentational or recognizable images. (See **negative area.**)

realism, Realism (art movement)

A style of art that retains the basic impression of visual actuality without going to extremes of detail. In addition, realism attempts to relate and interpret the universal meanings that lie beneath surface appearances. As a movement, it relates to painters like Honoré Daumier in nineteenth-century France and Winslow Homer in the United States in the 1850s.

representation(al) (art)

A type of art in which the subject is presented through the visual art elements so that the observer is reminded of actual objects (see **naturalism** and **realism**).

space

The interval, or measurable distance, between points or images.

style

The specific artistic character and dominant trends of form noted during periods of history and art movements. Style may also refer to artists' expressive use of media to give their works individual character.

subject

I. In a descriptive approach to art, subject refers to the persons or things represented, as well as the artists' experiences, that serve as inspiration. 2. In

abstract or nonobjective forms of art, subject refers merely to the visual signs employed by the artist. In this case, the subject has little to do with anything experienced in the natural environment.

subjective (art, shapes, color, etc.)

That which is derived from the mind reflecting a personal viewpoint, bias, or emotion.

technique

The manner and skill with which artists employ their tools and materials to achieve an expressive effect. The ways of using media can have a strong effect on the aesthetic quality of an artist's total concept.

three-dimensional

To possess, or to create the illusion of possessing, the dimension of depth, in addition to having the dimensions of height and width.

two-dimensional

To possess the dimensions of height and width, especially when considering the flat surface, or picture plane.

unity

The result of bringing the elements of art into the appropriate ratio between harmony and variety to give a sense of oneness.

volume

A measurable area of defined or occupied space.

W | • |

Piet Mondrian, Tree, c. 1912. Oil on canvas, $37 \times 27^{7/8}$ in (94 \times 70.8 cm).

In this work, we can see the beginnings of abstraction that marked Mondrian's progress toward the purity of his mature style (see fig. 1.3).

Museum of Art, Carnegie Institute, Pittsburgh, PA, Patron's Art Fund, 61.1. © Mondrian Estate/Holtzman Trust.

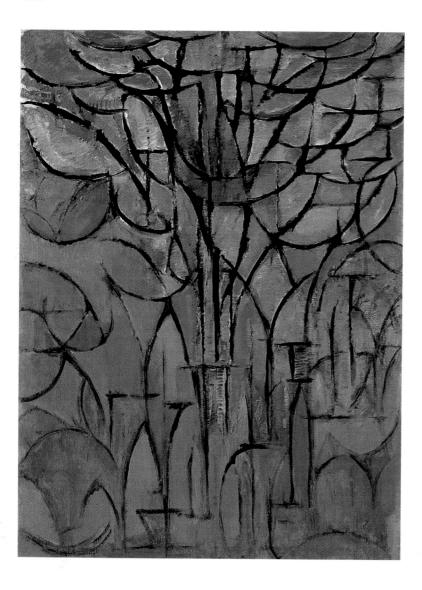

THE NEED AND SEARCH FOR ART

The study of the past proves that human beings have always had a need for art. From cave paintings to avant-garde works of the twentieth century, a great variety of styles have emerged. Many definitions and interpretations have been applied to these styles, but regardless of the time or place of its creation, art has always been produced because an artist has wanted to say something and chose a particular way of saying it. Over the years, artists have been variously praised, neglected, misunderstood, and criticized. The amount of art being created today is unrivalled by that of the past. In an attempt to give us some insight into the subject, many books have been written. Some have been intended for casual, enjoyable viewing, some for the general artistic enlightenment of the layperson, some for passive end table display, and some for an introduction to the practice of art. Apparently many people want to be actively engaged in art but find that much of what they see is not meaningful to them; this probably adds to the inhibitions of our potential creators. Some of the inability to understand much of the art being created may be due to the enormous diversity of our world. Sophisticated printing and distribution techniques have made most of the art of the past and present available to us. In addition, television, radio, and air travel have contributed to a great cultural mixing. This is a far cry from the insularity of the periods before our century; in those days, people often had a better understanding and greater acceptance of what they saw because they saw so little.

The fine arts of drawing, painting, printing, sculpture, and so forth, have been, throughout history, the fountainhead of significant artistic change and discovery, with a great potential for proliferation. One prime

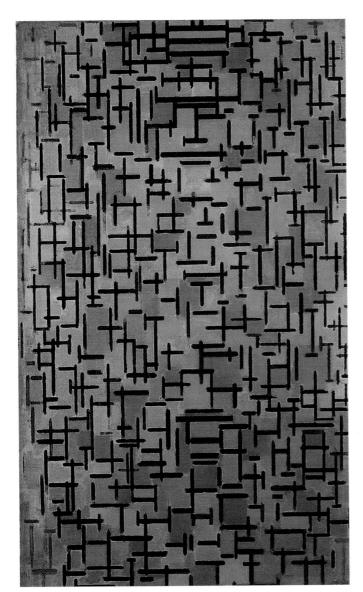

1 . 2

Piet Mondrian, Composition, 1916, c. 1916. Oil on canvas and wood strip, $47\frac{1}{4} \times 29\frac{1}{2}$ in (120 × 74.9 cm).

As a follow-up to figure 1.1, this later work can be seen to be even closer to the severity of Mondrian's final style.

Solomon R. Guggenheim Museum, New York. Photograph: David Heald.

© Solomon R. Guggenheim Foundation, New York (FN 49.1229). © Mondrian Estate/Holtzman Trust.

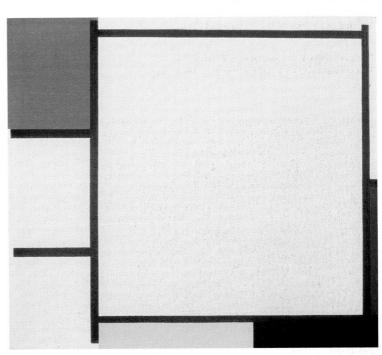

example of this can be found in the paintings of Piet Mondrian. The development of his distinctive mature style can be traced easily by an examination of his works (figs. 1.1, 1.2, and 1.3). The final style, the one best known, has been, and is, even today, extremely influential in a very wide variety of applications (figs. 1.4, 1.5, and 1.6). It has, in fact, seeped into the subconscious attitudes of us all—this is despite the fact that we may have little taste for the paintings themselves. In similar fashion, other significant artists, those whom we would deem "fine"

artists, have subtly and involuntarily altered our vision. Many of those included in this book could be counted among that number.

In order to gain some appreciation for the many forms of art to which we have access today, one must understand the basics of art from which they have grown. This book seeks to provide an understanding through illustrated writings. An explanation requires a rationale—a method for providing information. In this book the method is that of a general dissection of the nature and functions of the many factors

A 1 · 3

Piet Mondrian, Composition with Red, Blue, Yellow, Black, and Gray, 1922. Oil on canvas, $16\frac{1}{2} \times 19\frac{1}{8}$ in (41.9 \times 48.6 cm).

The primary colors divided by block lines, all in a two-dimensional grid, are typical of Mondrian's later work. This is the style that has generated so much influence through the years.

Toledo Museum of Art, Toledo, OH. Purchased with funds from the Libbey Endowment, Gift of Edward Drummond Libbey. (1978.44) © Mondrian Estate/Holtzman Trust.

1.4

Gerrit Rietveld and Truus Schröder, Rietveld-Schröder House, 1920–24.

Rietveld (architect and designer) and Schröder (client and co-designer) were members, along with Mondrian, of the de Stijl group in Holland—a fact that probably accounts for the similarities in style.

© Nathan Willock/Architectural Association Slide Library, London.

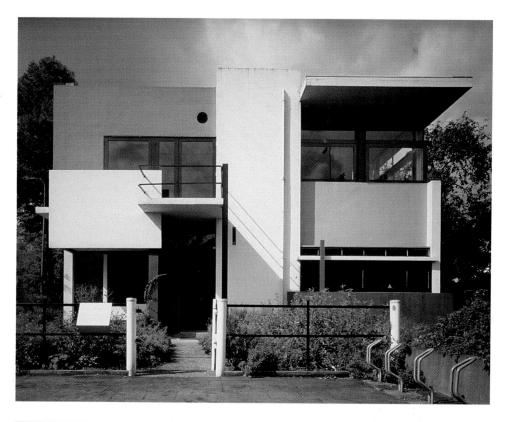

1.5

Gerrit Rietveld, Red/Blue Chair, designed 1918 (made c. 1950 by G. van de Groenekan). Pine, ebonized and painted, $34^{7}/_{8} \times 23^{5}/_{8} \times 29^{3}/_{4}$ in (88.4 × 60 × 75.5 cm).

The relationships between horizontals and verticals and the juxtapositions of color within an asymmetrical grid are features shared by this chair and the paintings of Piet Mondrian.

Toledo Museum of Art, Toledo, OH. Purchased with funds from the Florence Scott Libbey Bequest, in memory of her father, Maurice A. Scott. (1985.48) © 1998 Beeldricht, Amsterdam.

9

4 1.6

From Deerskin catalog, lightweight color block jacket.

The influence of Mondrian on commercial products is clearly evident in this design.

Courtesy of Deerskin Trading Post, North Bergen, NJ.

involved in producing artworks. This is accompanied by an introduction to the principles that normally govern those factors. The authors have tried to avoid the pitfalls of stylistic favoritism by presenting a system for evaluating the structure of art. Analyzing structure may seem a bit cold when applied to a creative field, but structure is necessary to all artistic areas, including music, dance, and literature. Without structure the expression would not come through and the work would lack interest.

THE INGREDIENTS OF ART

Subject, form, and content have always been the three basic parts of a work of art. Presumably this is still true today except that, in recent years, these parts are often more difficult to identify, differentiate, and define in some works.

Traditionally, subjects concerned persons, objects, and themes. They still do; but, with the advent of the abstract age, subject can refer to a particular configuration of the art elements. This, in turn, can collide with the understanding of form, which is commonly understood as the use of elements in constructing an artwork. Confusion indeed for someone who is trying to write about art!

Content, too, has been lost or altered from its original state. A conventional definition of content would define it as the total message of the work as developed by the artist and interpreted by the viewer. Today this seems to be true in some cases, but we find that the content derives from an artist's very private experiences. These experiences

Chapter I

are so personal that it is sometimes difficult for an observer to understand unless he or she has had the same kind of experiences as the artist.

The following definitions of subject, form, and content are traditional. Those who read this and see some of the illustrations in the book must recognize the contemporary blurring of these definitions; then it may be easier to cope with works that defy our usual understanding of art.

Beyond art's three basic parts, there may be certain principles—harmony, variety, balance, movement, proportion, dominance, and economy—that contemporary art may not always follow. Although there may be some quarrel with the observance of these principles in certain works, there can be no argument with their constituent basics: the elements of line, shape, value, texture and color. All artists must deal with these principles either singularly or in combination. These principles may be the guiding forces for organization and interpretation. As a consequence, content may have an opportunity to appear.

Thus, to summarize, in art we have the motivation (subject), the substantiation (development of the work), and communication (content).

THE COMPONENTS OF ART

Subject

A **subject** is a person, a thing, or an idea. The person or thing is, as expected, pretty clear to the average person, but the idea may not be. In abstract or semi-abstract works, the subject may be somewhat perceivable, but in nonobjective works, the subject is the idea behind the form of the work, and it communicates only with those who can read the language of form (fig. 1.7). Whether recognized or not, the subject is important only to the degree that the artist is motivated by it. Thus, subject is just a starting-point; the way it is presented or formed to give it **expression** is the important consideration.

Richard Hunt, *Untitled*, 1978. Print (lithograph), $15 \times 22\frac{1}{4}$ in (38.1 × 56.5 cm). Without the benefit of an obvious subject, Richard Hunt has expressed an excitement with organic shape, line, and spatial relationships. He does not limit himself to superficial appearances

but tries to reveal what lies deeper.

© Richard Hunt.

1.7

Music, like any area of art, deals with subjects, and it makes an interesting comparison with the visual arts. In the latter, the subject is frequently the particular thing(s) viewed and reproduced by the artist. But at other times art parallels music in presenting a "nonrecognizable" subject; the subject is, of course, an idea rather than a thing. Music sometimes deals with recognizable sounds—thunderstorms and bird songs in Beethoven's *Pastoral Symphony* or taxi horns in Gershwin's *An American in Paris*.

Although rather abstractly treated, these may be the musical equivalents of recognizable subjects in an artwork. By way of contrast, Beethoven's *Fifth Symphony* or Gershwin's *Concerto in F* are strictly collections of musical ideas. In the dance medium, choreography often has no specific subject, but dancing in Copland's ballet *Rodeo* is, to a degree, subject-oriented. All of the arts have subjects that obviously should not be judged alone, but by what is done with them (fig. 1.8).

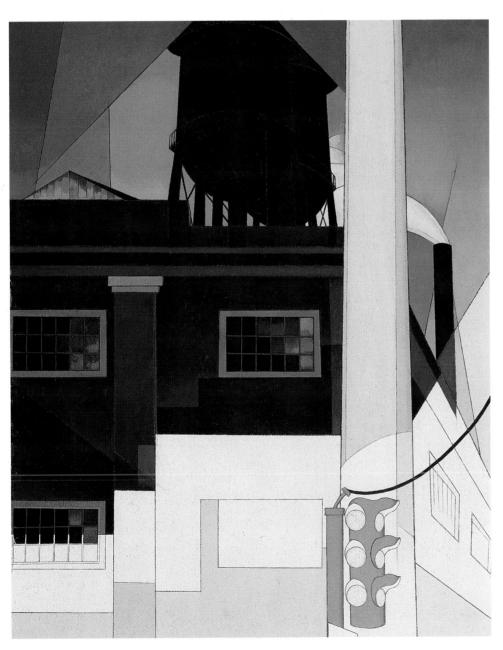

4 I · 8

Charles Demuth,... And the Home of the Brave, 1931. Oil on composition board, $29\frac{1}{2} \times 23\frac{5}{8}$ in (74.8 × 59.7 cm).

The subject—manmade structures—is clear enough; however, a work should not be judged by its subject alone, but by how that subject is treated.

Art Institute of Chicago. Gift of Georgia O'Keeffe, 1948.650. Photo © 1998 Art Institute of Chicago.

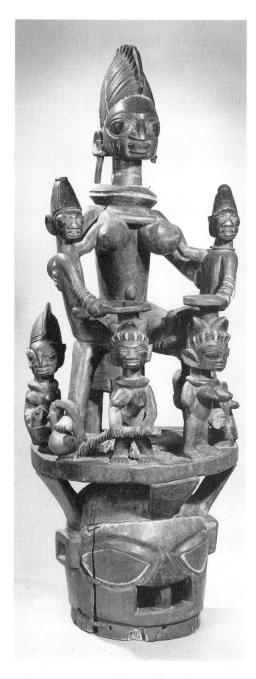

▲ 1 · 9 Areogun, Nigerian Epa Society Mask, Yoruba Tribe, Village of Osi, c. 1900–10. Wood with polychrome painted decoration, 4 ft 1½ in (1.26 m) high.

To illustrate the different meanings of the term "form," we can say that the forms in this piece of sculpture are its parts, largely individual figures—or that the form of the work consists of the total assembly of those parts.

Toledo Museum of Art, Toledo, OH. Gift of Edward Drummond Libbey.

Form

The term **form** is used in various ways when referring to art objects. Speaking of a piece of sculpture, one may refer to the individual forms that together make up the piece or one may speak of the sculpture's form, meaning its total appearance (fig. 1.9). As used in this book, form means the latter: the totality of the physical artwork. It involves all of the visual devices available to the artist in the material of his or her choice. Using these devices, artists must make their arrangement and manipulation most effective for what is being expressed. Some artists arrange more intuitively than others, some more logically; but, with experience, all of them develop an instinctive feeling for organization.

Form (including the principles of order) is so important to the creation and understanding of art that it is given a special, detailed chapter in this book. The principles of formal order are flexible, with no dogmatic rules; every work is different and has its own unique problems. Nevertheless, despite their flexibility the principles must be observed in order to give the work a meaningful construction.

Content

The emotional or intellectual message of an artwork is its content, a statement, expression, or mood read into the work by its observer —hopefully synchronized with the artist's intentions. For example, the artist W. Eugene Smith delivers meaning through the subject and associated symbols of death (fig. 1.10). In this work, form provides additional subconscious meaning through the use of blacks and somber grays, a reduced awareness of texture, and the emphasis of low diagonals. For many people content is confined to familiar associations, usually by feelings aroused by known objects or ideas. This is obviously selflimiting—limited to those observers

who have had similar experiences. A much broader and, ultimately, more meaningful content is not utterly reliant on the image but reinforced by the form created by the artist. This content is found in abstract as well as more **realistic** works.

Although all visual artworks require some degree of abstraction, a greater degree is often more difficult to understand and appreciate; sometimes this "appreciation" is, instead, revulsion and confusion! Abstraction is a term frequently misunderstood and sometimes incorrectly applied. It is often a process that imposes itself on the artist in reaching the desired effect in a work, although this effect is not always foreseen while the work is in progress. Abstraction usually involves re-ordering and emphasis—in short, the route taken to arrive at a certain result. It is a stripping-down to expressive and communicative essentials. The end result is not always appreciated by observers conditioned to expect a literal copying of a subject (fig. 1.11). Although simplification frequently results, changes in this direction do not mean a less profound outcome; instead, it is intended to make the profundity more easily experienced. When an observer's expectation is of literal work, the intended content of the artist is often misinterpreted. In the case of nonobjective or non-literal abstraction, the "objective" (yes, there is one!) is the content as in all art (see fig. 8.1). The content in such work is generally subjective and sometimes totally invented and a subject, if one exists (although normally it does not) is unseen. We often see the term abstract used comprehensively for all art that is both derivative and non-derivative. We think a distinction should be made. In truth, abstract is often more verb than noun.

The progress toward content in the development of an artwork generally follows a certain course. The artist is motivated by feelings about a subject

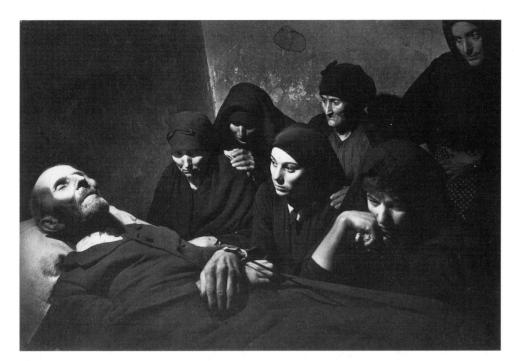

4 1.10

W. Eugene Smith, Spanish Wake, 1951. Photograph.

The emotional factor in the content of this photograph is quite evident (and with this particular subject would probably always be so), but the artist-photographer has enhanced the content by his handling of the situation.

© W. Eugene Smith/Black Star.

Development toward Abstraction

Object	Naturalism	Realism	Semi-Abstract	Abstra	action
from				(objective)	(nonobjective)
Nature	Fully representational. (very objective)	Representational but emphasizing the emotional. (more subjective)	Partly represen- tational but simplified and rearranged.	Based on a subject but visually appears nonobjective	Nonrepresentational, started without any reference to subject and assuming artistic value resides in form and content completely.

A 1.11

Development leading toward Abstraction:

Abstraction is a relative term because it is present in varying degrees in all works of art from full representation to complete nonobjectivity.

Object from Nature: Often the starting point for artists who seek to respond to it or interpret it in some manner. Even the most Naturalistic drawing imaginable will have abstracted or eliminated the three-dimensional nature of the object.

Naturalism: Impersonal depiction of the natural. Tends to imitate the effect of the camera, stressing specific details, objects, and particulars.

Realism: A fairly "natural" appearance modified by the artist's reaction to the subject. It may include the "unpleasant" and characteristic or grotesque while revealing universal meanings. Daumier's Washerwoman (see fig. 10.8) does not present a portrait of a specific individual easily recognized by the viewer, but a statement about a universal woman representing the conditions, the drudgery, and the hardships faced by all women of the period.

Semi-Abstract: A less "natural" appearance with further loss of recognizability. Changes in the subject are not carried to totally abstract extremes. The beginnings of simplification and rearrangement characterized by intentional "distortion."

Abstract: The term "abstract" applies to art that appears nonobjective but is either derived from natural objects through a process of

simplification (altering or distilling them to their essence) and rearrangement or is intentionally nonrepresentational. Historically abstraction has been thought of as a process of varying degrees of change. The term, however, is currently applied equally to non-recognizable imagery based on nature and nonobjective images with no basis in reality. The totally invented image assumes that artistic quality resides in the form (elements and principles), completely independent of subject matter—pure design. It should not be assumed that an image always starts from a recognizable position and builds toward abstraction because a work may have totally abstract beginnings—originating with aimless "doodlings" or playful experimentation with the medium. Suggestions resulting from this may eventually evolve into or materialize as recognizable imagery.

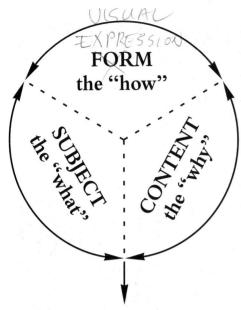

combining to produce ORGANIC UNITY

1.12

This diagram illustrates the interrelationsip of subject, form, and content. The artist is motivated by feelings about the subject (the "what"), which may or may not be given a descriptive likeness. The artistic elements—line, shape, and so on—are manipulated to create form ("the how") in the work, which will, in turn, produce content (the "why") that parallels the artist's feelings. In so doing the artist attempts to make all parts of the work mutually interactive and interrelated as they are in a living organism. This is referred to as "organic unity," the work contains nothing that is unnecessary or distracting (the relationships seem inevitable). Subject is not always the starting point. In some instances, artists start by exploring color or shape (the elements), and discover meaning as they work. The positions on the diagram and their degree of importance may be changed. And, though the content is revealed by the form, it might in some instances, be the motivating force. Whatever the evolution, progression, or emphasis of the components—subject, form, and content—organic unity is the desired end.

(which we shall call the "what"). That subject may or may not be a representational likeness. The artist then manipulates the artistic elements (line, shape, and so on) to create the kind of form (the "how") that will result in the desired content (the "why"). The content expresses the artist's feelings (fig. 1.12). In this process the artist attempts to make all parts of the work mutually interactive and interrelated—as they are in a living organism. If this is achieved we can call it organic unity, containing nothing that is unnecessary or distracting, with relationships that seem inevitable.

A television set might be used as an illustration of organic unity because it has a complex of parts intended to function as do the organs in a living body. A television set contains the minimum number of parts necessary to function, and these parts work only when properly assembled with respect to each other. When all the parts are activated, they become organically unified in the same way as the parts of the human body. Surely Dr. Frankenstein would appreciate this analogy! As in the case of sophisticated engineering, this sense of reciprocating "wholeness" is what is sought in art.

This "wholeness" is difficult to detect in the works of some contemporary artists who challenge tradition. In their works the distinctions between subject, form, and content are "muddied" because these components are sometimes treated as identical. This constitutes an obvious break with tradition and requires a shift of gears in our thinking. In Conceptual art (a style—most art is conceptual, to some degree), the concept is foremost; the product considered negligible; and the concept and subject seem to be one. In Process art (again, a style) the act of producing is the only significant aspect of art, thus reducing form and content to one entity (see the "Process and Conceptual Art" section in Chapter 10, page 316). Styles that embrace such goals can be quite puzzling if the aims of the artist are not understood by the viewer.

Even conventional art forms sometimes scramble the roles of the components. Although content results from form, content sometimes functions as the precipitating force, thereby placing it prior to the subject in the scheme of things. Also, in some cases, the developing form may mutate into a subject and/or content altogether different from that originally conceived.

Many people expect visual art to be recognizable, representing such familiar items as houses, flowers, people, trees, and so on. When the artist reproduces such things faithfully the vision may be thought of as the "real" world. The artist who works in this manner could be called a "perceptual" artist because he or she records only what is perceived. But in art the "real" can supersede mere optics; reality in art does often include things seen but, more importantly,

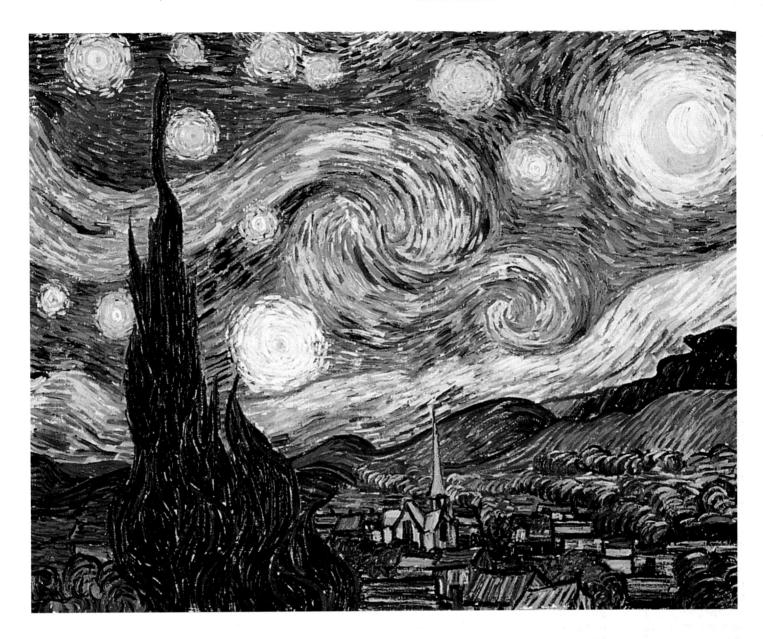

includes our reactions to those things (fig. 1.13). Artists who are more concerned with responses than with commonplace perceptions are legitimately called *conceptual* because they are idea-oriented and thus more creative.

Creativity emanates from ideas. Generally speaking an idea is something that is given birth in the mind. For the artist it may be an all-encompassing plan, a unique or particularly suitable set of relationships (however broad its scope), an attitude that could be conveyed or a way of conveying an attitude, a solution to a visual problem. In the artist's mind this occurs as mental imagery and may be a "bolt from the blue" (inspiration?) or the end product of much thoughtful searching, some of which may be reflected in numerous notes, sketches, or repeated overhauling of the artwork.

All such creative enterprises are occasionally plagued by idea blocks, but they seem to afflict the fledgling artist most often. For the beginner, the idea is conceived at a more pedestrian level,

A 1 · 13

Vincent van Gogh, The Starry Night, 1889. Oil on canvas, $29 \times 36\frac{1}{4}$ in (73.7 \times 92.1 cm).

Surveying the landscape is a fairly common experience, but few if any of us see landscapes with the perception and intensity of van Gogh.

The Museum of Modern Art, New York. Acquired through the Lillie P. Bliss Bequest. Photograph © 1998 the Museum of Modern Art, New York.

being equated with subject ("I don't know what to do!"). In such situations a familiar object or experience is the best bet as a starter, supplemented by the brainstorming of anything remotely related. In art, an idea is of value only when converted into visual reality; sometimes this is the more difficult problem, sometimes not, depending on the fertility of one's imagination.

All art is illusory to some extent and some art makes a greater effort to draw us out of our standard existence into a more meaningful state. Artists are aided in this by familiar devices such as frames, stages, exaggerated costumes and gestures, cosmetics, concert halls, and galleries. All of these emphasize the idea that in seeing and hearing the arts we are not in an everyday world but, rather, in a hypersensitized world of greater values. By strengthening this illusion, art enlarges our awareness.

SAVORING THE INGREDIENTS

When, in being subjective, the artist reaches below surface appearances and uses unfamiliar ways to find unexpected truths, the results can often be distressing for many of us. Such distress frequently follows changes in art styles. The artist is sometimes accused of being incompetent or a charlatan. Much of what we value in art today was once fought for, tooth and nail. General acceptance of the new comes about only when enough time has passed for it to be reevaluated. At this point, the new begins to lose its abrasiveness. Thus, there is no need for embarrassment at feeling confused or defiant about an artwork that seems "far out"; instead, we need to strive for continued exposure, thought, and study (fig 1.14). We all have the capacity to appreciate the beautiful or expressive, as evidenced by the aesthetic choices we make every day. But we must enlarge our

sensitivity and taste, making them more inclusive.

One way to extend our responses to art is by attempting to see the uniqueness in things. Gertrude Stein once said, "A rose is a rose is a rose." If we interpret this literally rather than poetically, we realize that every rose has a different character, even with identical breeding and grooming. Every object is ultimately unique, be it a chair, a tree, or a person. One characteristic that sets the artist apart is the ability to see (and experience) the subtle differences in things. By exposing those differences, the artist can make the ordinary seem distinctive, the humdrum exciting.

Perception is the key. When an artist views an object—a tree branch, say—and is inspired to try to reproduce the original as seen, he or she is using and drawing inspiration from **optical perception**. However, another artist seeing the same branch may find it evokes a crying child or a rearing horse. When the imagination triggers this creative vision and additional images are suggested, the artist is employing **conceptual perception**.

Leonardo da Vinci, writing in his *Treatise on Painting*, recorded an experience with conceptual perception while studying clouds. "On one occasion above Milan, over in the direction of Lake Maggiore, I saw a cloud shaped like a huge mountain made up of banks of fire" Elsewhere, he recommends staring at stains on walls as a source of inspiration. Following Leonardo, the nineteenth-century French author and painter Victor Hugo found many of his ideas for drawings by studying the blots made by coffee stains on tablecloths.

Another way to enlarge our sensitivity to the visual arts is by ridding ourselves of the expectation that all forms of art should follow the same rules. Photography might serve as an example. We know that many people judge a work of art by how closely it can

The Wrapping Up.

Here's what it takes to wrap the German Reichstag as Christo and Jeanne-Claude did:

The German Reichstag

Total perimeter: 1,520.3 feet Width (north-south): 314.9 feet Length (east-west): 445.2 feet Height of the four towers: 139.4 feet

Height at roof: 105.5 feet

The Materials

Yarn for weaving: 43,836 miles Silver polypropylene fabric: 119,603

square yards

Width of the original woven fabric: 5 feet

Number of fabric panels: 70 Length of thread: 807.8 miles Window anchors: 110 Roof anchors: 270

Visits to Germany by the Christos:

1976-95:54

Members of Parliament visited: 352 Number of presidents of the Bundestag involved: 6

The Workforce

Monitors: 1,200 in four 6-hour shifts

Professional climbers: 90

Professional helpers: 120 in two shifts

Office staff (Berlin): 17
Office staff (New York): 2

The Costs

Rope: \$72,000

Fabric metalization: \$72,000

Sewing: \$1,080,000

Structural engineering and construction: \$1,080,000

Documentation of building condition: \$72,000 Air cushions and covering of cages: \$216,000

Steel construction: \$2,160,000 Steel Weights: \$180,000

Insulation and dismantling: \$1,368,000 Monitors and security: \$1,296,000

Rents, further wages, transportation: \$324,000

Total cost to Christo and Jeanne-Claude:

\$13,000,000 of their own money. The work of art was entirely financed by the artists, as they have done for all their projects, through the sale of preparatory studies, drawings, collages, scale models as well as early works and original lithographs. The artists do not accept

sponsorship of any kind.

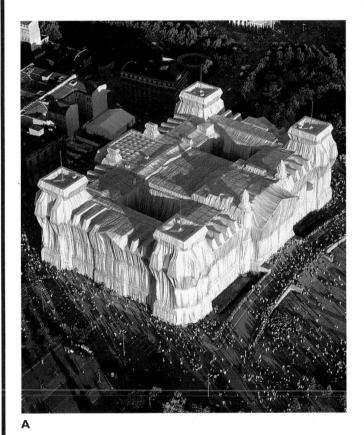

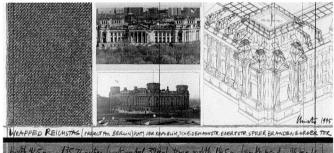

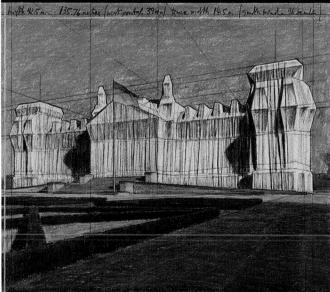

В

▲ ► I • I4 A (left) and B (right)

- A. The realized work: Christo and Jeanne-Claude, Wrapped Reichstag, Berlin, 1971-95.
- B. Preparation work (drawings) before the project was realized: Christo, Wrapped Reichstag, Project for Berlin.

As the culmination of Christo and Jeanne-Claude's long-held dream, they succeeded in wrapping the Reichstag in aluminum coate fabric and rope. © Christo and Jeanne-Claude, 1998. Photographs: Wolfgang Volz.

▶ 1 • 15

Minor White, Cobblestone House, Avon, New York, 1958. Gelatin silver print.

Photographers may have the edge on other visual artists when it comes to recording objective reality, but photographer-artists are not satisfied with obvious appearances and use complex technical strategies to achieve their goals.

The Art Museum, Princeton University, Princeton, NJ. The Minor White Archive. (© 1982 Trustees of Princeton University.)

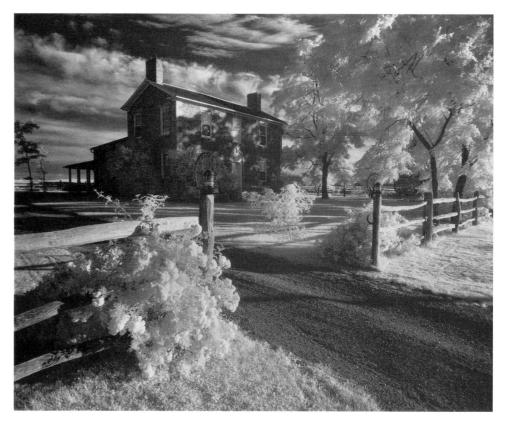

be made to look like something. It is true that skillful artists can create amazing resemblances, but the camera can win this game! The artist fights a losing battle with the camera if he or she plays by photography's rules. Artists are often proud of their ability to reproduce appearances, but most artists regard this skill as less important. If making lookalikes is the key to art, it is strange that the best photographers are not content simply to point and shoot. Instead, they look for the best view, blur focus, use filters, alter lighting, and make adjustments in developing (fig. 1.15). Photographers become artists when they are not satisfied with obvious appearances. So, too, do plastic and graphic artists.

People also tend to associate visual art with literature, hoping it will tell a story in a **descriptive** manner. Many fine works have contained elements of story-telling, but artists have no need or

obligation to narrate. "Picture-stories" succeed as art only when influenced by formal considerations (fig. 1.16). The visual arts and literature share certain elements. For the author, objects or things are nouns; for the visual artist, representational subjects are nouns. Nouns are informative, but provide nothing poetic for the author; there is always a need for verbs, adjectives, and so on to establish action, moods, and meanings. Similarly the visual artist's "subject-nouns" rarely inspire except, occasionally, by association. For the visual artist the "verbs" are the combined effect of the elements and their principles; by manipulating these, a poetic effect very like that found in literature can be achieved.

In adapting ourselves to the rules peculiar to art, one must also place one's own taste on trial. This means acceptance of the possibility that what is

unfamiliar or disliked may not necessarily be badly executed or devoid of meaning. Of course, one should not automatically accept what one is expected to like; instead, open-mindedness is required. Even artists and critics rarely agree unanimously about artists or their works. Fortunately, the authors of this book are generally of the same mind regarding art, but there are some disagreements! Even with training, people's tastes, like Stein's roses, do not turn out to be identical. The quality of art is always arguable and regrettably (?) unprovable. Perhaps the most reliable proof of quality comes only with time and the eventual consensus of sensitive people.

Aside from satisfaction, one of the dividends gained by a better understanding of the visual arts is that it puts us in touch with some remarkably sensitive and perceptive people. We always benefit from contact, however

indirect, with the creations of great geniuses. Einstein's perception exposed relationships that have reshaped our view of the universe. Mozart responded to sounds that, in an abstract way, summed up the experiences and feelings of the human race. Though not always of this same magnitude, artists too expand our frames of reference, revealing new ways of seeing and responding to our surroundings. When we view artworks knowledgeably, we are on the same wavelength as the artist's finely tuned emotions.

THE INGREDIENTS ASSEMBLED

In this chapter we have mentioned some of the means by which an artist's emotions are made to surface. You have been introduced to the components, elements, and principles involved in making visual art. You have been given an idea of how all these factors enter into the expression of the artist's feelings. You have been given some counsel on the attitudes to develop in order to share these feelings with the artist. Now, let us consider how these matters fit sequentially in developing a hypothetical work of art.

In any construction project structural elements are needed. Under the supervision of the contractor these are assembled and put together until an edifice of some kind results. The corresponding structural **elements of art** are **line**, **shape**, **value**, **texture**, and **color**. In art the artist is not only the contractor but also the architect; he or she has the vision, which is given shape by the way the elements are brought together. The contractor is limited by adherence to blueprints, but the artist has

the advantage of constant flexibility in the structuring. For example, the raw elements can be manipulated to produce either a **two-dimensional** (circle, triangle, or square) or **three-dimensional** effect (sphere, pyramid, or cube). When two-dimensional, the elements and whatever they produce seem to lie flat on the **picture plane**, but when the elements are three-dimensional, penetration of that **plane** is implied.

There are other terms used in art circles to describe the conditions found in any consideration of dimensionality. **Decorative** is a term that we usually associate with ornamentation, but it is also used to describe the effect produced when the elements of art cling rather closely to the artistic surface. We can say that line (which can decorate in the familiar sense) is decorative if it does not leap toward or away from us dramatically

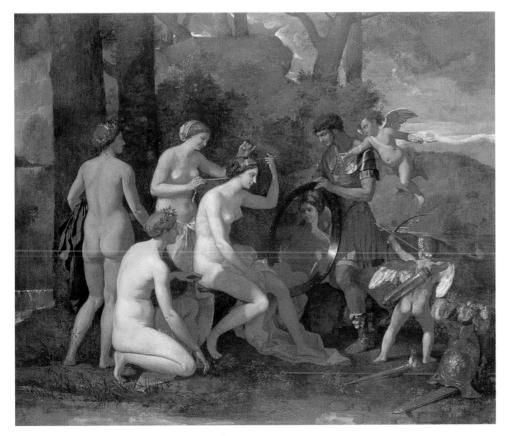

Nicolas Poussin, Mars and Venus, c. 1633-34. Oil on canvas, 5 ft 2 in \times 6 ft $2^{3}/_{4}$ in (1.57 \times 1.90 m).

This painting could be called a "picture story" because it derives from a classical literary legend. It could have been no more than a factual statement about a moment in that legend, but Poussin's concern for design enhanced the narrative.

Toledo Museum of Art, Toledo, OH. Purchased with funds from the Libby Endowment, Gift of Edward Drummond Libbey. (1954.87)

► I • 17A (right) and B (far right) Rembrandt Harmenszoon van Rijn, Christ Presented to the People, last state 1606–09, print (etching).

Rembrandt searched for the most interesting and communicative presentation of his idea. In doing so, he made dramatic deletions and changes, which in this case involved scraping out a portion of the copper plate. Figure 1.17A is the first version of the work, and figure 1.17B is the last.

Metropolitan Museum of Art, New York. Gift of Felix M. Warburg and his family, 1941.

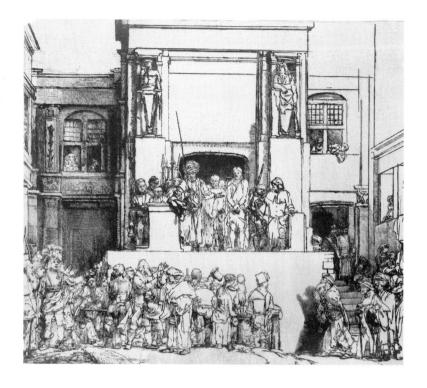

in the format. The same is true of the other art elements. When they are of this nature collectively we can say that the space created by them is decorative, or relatively flat. On the other hand, if the elements make us feel that we could dive into the picture and weave our way around and behind the art elements, the space is said to be **plastic**.

Thus defined, the term plastic has clear implications for **sculpture**, because we can (we must!) move about the piece. Any **mass**, whether actual (as in a statue) or implied (as portrayed in drawing or painting), can be called plastic. Mass is anything that has cohesive, homogeneous bulk, implying a degree of weightiness. **Volume**, on the other hand, is an area of defined containment. An empty living room has volume in its dimensions, but no mass. A brick has mass within its volume. Mass and volume indicate the presence of three-dimensionality in art.

A distinction must be made between plastic and graphic art. The graphic arts include drawing, painting, printmaking, and photography. These are arts generally existing on a flat surface that rely on the illusion of the third dimension. By contrast, the plastic arts (sculpture, ceramics, architecture, and so on) are tangible and palpable, occupying and encompassed by their own space. In summary, graphic art may have two-dimensional, decorative effects as defined by art elements of the same description, and plastic art has a three-dimensional plastic aura created by art elements that share these same properties.

An artist must begin with an idea, or germ, that will eventually develop into the concept of the finished artwork. The idea may be the result of aimless doodling, a thought that has suddenly struck the artist, or a notion that has been growing in his or her mind for a long time. If this idea is to become tangible, it must be developed in a **medium** selected by the artist (clay, oil paint, watercolor, and so on). The artist not only controls, but is controlled by, the medium. Through the medium the

elements of form emerge, with their intrinsic meanings. These meanings may be allied with a nonobjective or, to different degrees, objective image; in either case, the bulk of the meaning will lie in the form created by the elements.

While developing the artwork, the artist will be concerned with **composition**, or formal structure, as he or she explores the most interesting and communicative presentation of an idea. During this process, **abstraction** will inevitably occur, even if the work is broadly realistic—elements will be simplified, changed, added, eliminated, or generally edited (figs. 1.17A and B). The abstraction happens with an awareness, and within the parameters, of the principles.

As the creative procedure unfolds (not always directly, neatly, or without stress or anguish), the artist fervently hopes that its result will be organic unity. This is an all-inclusive term that refers to the culmination of everything that is being sought in the work. Put simply, it

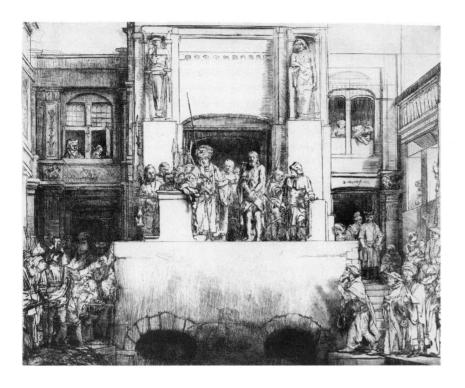

▼ 1 • 18Ansel Adams, Moonrise, 1941. Photograph (Hernandez, New Mexico).

The invention and development of photography added an important new medium to the repertoire of artists. Now the accomplishments of such photographers as Ansel Adams rank with those of well-known painters, sculptors, and architects.

Copyright © Trustees of the Ansel Adams Publishing Rights Trust/Corbis Media.

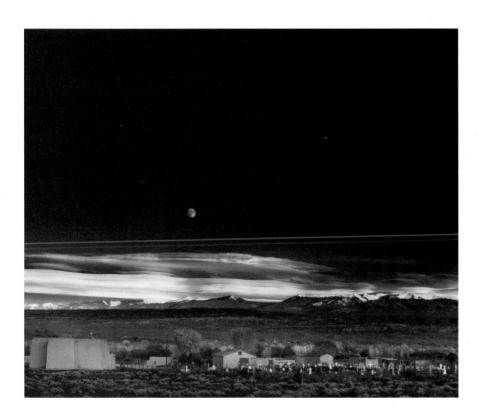

means that every part not only fits, but that each one contributes to the overall content, or meaning. At this point, however arduous or circuitous the artist's route, the work is finished—or is it? Having given the best of themselves, artists are never sure of this! Perhaps the perspective of a few days, months, or even years will give the answer.

And if the work is finished, and it has *organic unity*, does it guarantee a "great work of art"? The ingredients assembled—"organic unity"—do not guarantee "greatness" or immortality, but they do assist in giving a vital completeness.

MEDIA AND TECHNIQUES

The nineteenth and twentieth centuries have produced numerous advances in scientific technology. These have spun off into many areas, including art. Artistic people have made use of new media and techniques as aids to their creative expression. One of the great visual breakthroughs was the development of photography. The camera is not as flexible as the art tool, but photographic innovations have served to broaden our vision. The creative efforts of such photographic artists as Edward Steichen, Alfred Stieglitz, and Ansel Adams (fig. 1.18) are as well known today as the works of many of our important painters and sculptors. From the photographic experiments of such people have come creative film-making, xerography, and the artistic employment of other photographically related media.

Of late, there has been a deluge of new media and techniques. Some are extensions of traditional approaches, while others are without precedent. All have been absorbed into the artist's armory. Traditional painting media have been expanded by the addition of acrylics, enamels, lacquers, preliquefied

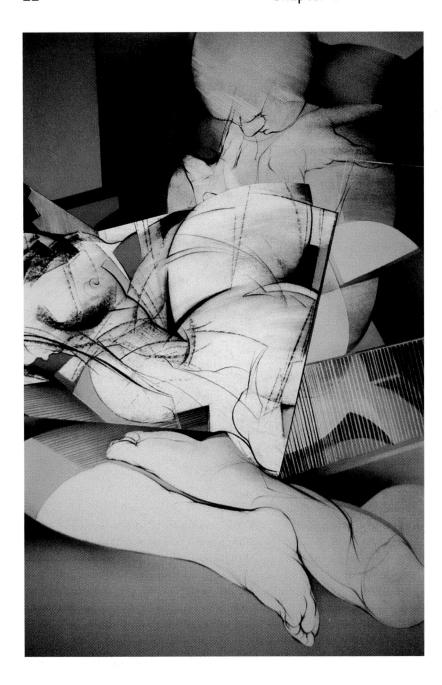

■ 1 · 19 Thomas Hilty, Meditation, 1996. Charcoal, pastel, and conté on museum board, 28 × 40 in (71.12 × 101.6 cm).

This drawing shows the artist's characteristic use of mixed media. He has skillfully blended and rubbed the materials to produce the effect of expressive and varied surfaces.

Courtesy of the artist.

watercolors, roplex, and other less well-known materials. Drawing media include new forms of chalk, pastels, crayons, and drawing pens. Sculptors now use welding, plastics, composition board, aluminum, stainless steel, and other materials and techniques. The unique, or nontraditional, media include video, holography, computer-generated

imagery, and performances that mix dance, drama, sound, light, even the audience. Very often the traditional and nontraditional media and techniques are mixed.

Although new and exotic techniques and media have found their way into artists' studios, they generally follow after the artist has already mastered the more traditional art forms. Nontraditional media usually require specialized knowledge (of a somewhat scientific nature) and specialized skill development. The pursuit of this skill and knowledge can become an end in itself unless one has the maturity required to reconcile it with one's artistic aims. For this reason this book is principally

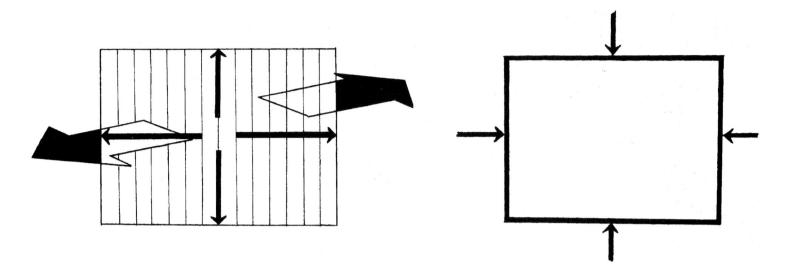

▲ I • 20A

Picture plane. Movement can take place on a flat surface, as indicated by the vertical and horizontal arrows. The vertical lines represent an imaginary plane through which a picture is seen. The artist can also give the illusion of advancing and receding movement in space, as shown by the two large arrows.

▲ I • 20B

Picture frame. The picture frame represents the outermost limits, or boundary, of the picture plane. These limits are represented by the edges of the canvas or paper on which the artist works or by the margin drawn within these edges.

concerned with helping to establish a foundation in the more traditional aspects of visual art.

Even the specialized skills required for the mastery of traditional media may take the artist beyond the content of this book. In studio practice, the artist must consider the effect of media and tools on imagery and how surfaces that carry this imagery affect its total form. The natural texture of a paper surface, for instance, may dictate a particular medium and certain tools. Charcoal and pastel will produce a different effect on smoothsurfaced paper than on rough-surfaced (or "toothed") paper (fig. 1.19). Different grades of graphite in the pencil can become a factor. In ink drawing, a felt-tip pen has a different expressive potential than a crow-quill pen. The softening effect of water in the ink or on the paper can drastically change the meaning of an image.

PICTURE PLANE

There are many ways to begin a work of art. It is generally accepted that artists who work with two dimensional art begin with a flat surface. To artists, the flat surface is the picture plane on which they execute their pictorial images. The need to somehow establish a relationship between the artists' actual environment and the reduced size of their working area, or picture plane, has had a long history. A piece of paper, a canvas, a board or a plate may be representative of the picture plane. This flat surface may also represent an imaginary plane of reference on which an artist can create spatial illusions. The artist may manipulate forms or elements so that they seem flat on the picture plane, or extend the forms/elements so that they appear to exist in front of or behind the picture plane (fig. 1.20A). In this way the picture plane is used as a basis for judging two- and three-dimensional space. In three-dimensional art the artist begins with the material—metal, clay, stone, glass, and so on—and works it as a total form against the surrounding space, with no limitations except for the outermost contour (see Chapter 9, "The Art of the Third Dimension").

PICTURE FRAME

We know that all cultures have used defined boundaries around the working area, or picture plane, generally called the **picture frame** (fig. 1.20B). The picture frame should be clearly established at the beginning of a pictorial organization. Once its shape and proportion are defined, all of the art elements and their employment will be influenced by it. The problem for the pictorial artist is to

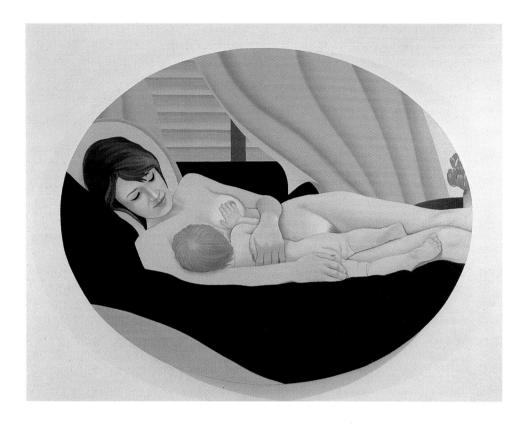

▲ $1 \cdot 21$ Tom Wesselmann, Barbara and Baby, 1979–81. Oil on canvas, 5 ft \times 6 ft $4\frac{1}{4}$ in $(1.52 \times 1.94 \text{ m})$.

Wesselmann has used an unusual frame shape for a timeless subject. The organic shape evokes a feeling of birth and motherhood.

© 1998 Tom Wesselmann/Licensed by VAGA, New York, NY.

El Greco, Madonna and Child with Saint Martina and Saint Agnes, c. 1597–99. Oil on canvas, 6 ft $4^{1}/_{8}$ in \times 3 ft $4^{1}/_{2}$ in (1.94 \times 1.03 m).

The rectangular frame shape, by its proportions, offers the artist a pleasing and interesting spatial arrangement. Here, El Greco has elongated his main shapes to repeat and harmonize with the vertical character of the picture frame.

Widener Collection. © 1997 Board of Trustees, National Gallery of Art, Washington.

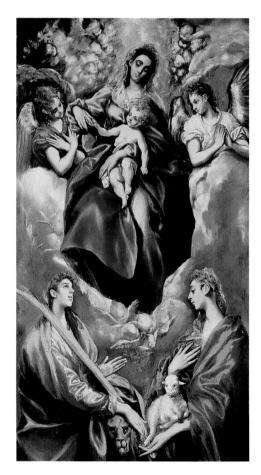

organize the elements of art within the picture frame on the picture plane.

The proportions and shapes of frames used by artists are varied. Squares, triangles, circles, and ovals have been used as frame shapes, but the most popular is the rectangular frame, which in its varying proportions offers the artist an interesting variety within the twodimensional space (figs. 1.21, 1.22, 1.23; see fig. 2.23). Many artists select the outside proportions of their pictures on the basis of geometric ratios (see the "Proportions," section in Chapter 2, p. 58). These rules suggest dividing surface areas into odd proportions of two-to-three or three-to-five rather than into equal relationships. The results are visually pleasing spatial arrangements. Most artists, however, rely on their instincts rather than on a mechanical

formula. After the picture plane has been established, the direction and movement of the *elements of art* should be in harmonious relation to this shape. Otherwise, they will tend to disrupt the objective of pictorial unity.

POSITIVE AND NEGATIVE AREAS

All of the surface areas in a picture should contribute to unity. Those areas that represent the artist's initial selection of element(s) are called **positive areas**. Positive areas may depict recognizable objects or nonrepresentational elements. Unoccupied spaces are termed **negative areas** (figs. 1.24A and B). The negative areas are just as important to total picture unity as the positive areas, which seem

tangible and more explicitly laid down. Negative areas might be considered as those portions of the picture plane that continue to show through after the positive areas have been placed in a framed space (fig. 1.25).

Traditionally, figure and/or foreground positions have been considered positive, and background areas have been considered negative. The term *figure* probably came from the human form, which was used as a major subject in artworks and implied a spatial relationship with the figure occupying the position in front of the remaining background (fig. 1.26; see figs. 1.24A and B). In recent times, abstract and nonobjective painters have adopted the terms *field* to mean positive and *ground* to mean negative. They speak of a color field on a white ground or of a field of

► 1 • 23

Fra Angelico and Fra Filippo Lippi, The Adoration of the Magi, c. 1445. Tempera on panel, diameter 4 ft 6 in (1.37 m).

The artists have used figures and architecture, and the direction of the movement of the art elements, in harmonious relation to a circular picture frame.

Samuel H. Kress Collection. © 1997 Board of Trustees, National Gallery of Art, Washington.

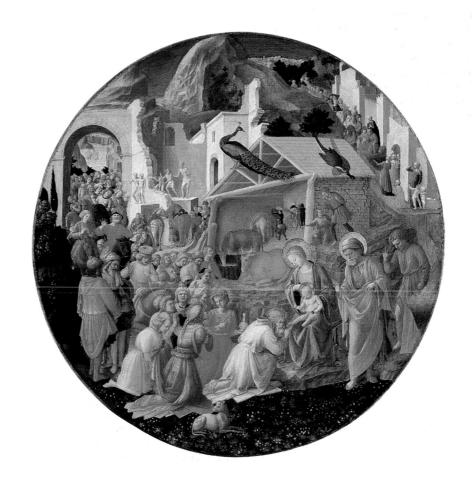

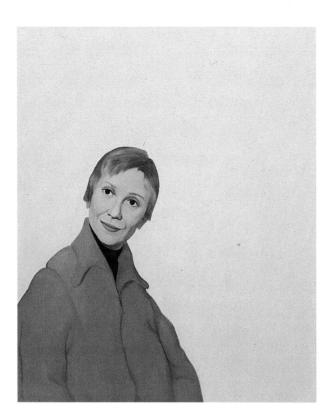

Andrea Rosen Gallery, New York. Photograph: Fred Scraton

I · 24 A & B

John Currin, The Moved Over Lady, 1991. Oil on canvas, 46 × 38 in (116.8 × 96.5 cm).

The subject in this painting represents a positive shape that has been enhanced by careful consideration of the negative areas, or the surrounding space. In figure 1.24B, the dark area indicates the negative shape and the white area the positive shape.

shapes against a ground of contrasting value.

The concept of positive and negative areas is important to beginners investigating art organization, because they usually direct their attention to positive forms and neglect the surrounding areas. As a result, pictures often seem overcrowded, busy, and confusing.

When the artist's tool touches the picture plane, leaving a mark, two things happen. First, the mark divides, to some extent, the picture plane. Generally the mark is seen as a positive image, leaving the remainder to be perceived as a negative area. Secondly, the mark

seemingly may take a position in front of, or at some distance behind, the picture plane. Each of these results will continue to be important to the artist as the work develops.

THE ART ELEMENTS

The artist employs the media to implement the art elements: line, shape, value, texture, and color. These elements are the fundamental, essential constituents of any artwork. In this textbook the basic elements are thought to be so indispensable to art fundamentals that each will be examined individually in the chapters that follow.

A 1 · 25

Ellsworth Kelly, Red and White, 1961. Oil on canvas, 5 ft $2^{3}/4$ in \times 7 ft $1^{1}/4$ in (1.59 \times 2.17 m).

In this nonfigurative (or nonobjective) work, some areas have been painted in, others not. It is very simple, perhaps deceptively so. To the viewer, the darks seem to be the negative shapes, although after some looking, the effect may be reversed.

Hirshhorn Museum and Sculpture Garden, Smithsonian Institution, Washington, D.C. Gift of Joseph H. Hirshhorn, 1972. Photograph: Ricardo Blanc. © 1998 Ellsworth Kelly.

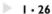

Paul Gaugin, Ancestors of Tehamana, 1893. Oil on canvas, $30^{1}/8 \times 21^{1}/8$ in (76.3 \times 54.3 cm).

Items in the foreground (generally toward the bottom of the picture plane) are traditionally considered positive areas, whereas unoccupied spaces in the background (upper) are negative areas. This traditional view does not always apply, however, as can be seen by looking at other illustrations in this book.

Art Institute of Chicago. Gift of Mr. and Mrs. Charles Deering McCormick, 1980.613. Photo © Art Institute of Chicago.

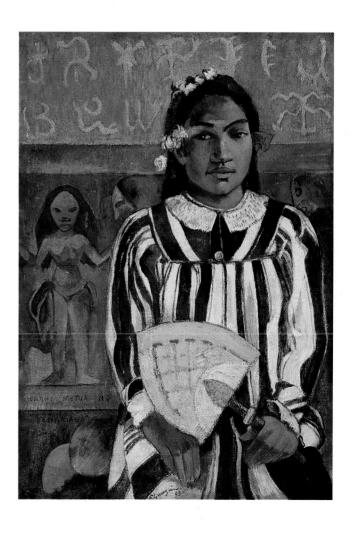

Form

THE VOCABULARY OF FORM

ORDERING THE ELEMENTS

THE SEVEN PRINCIPLES OF ORGANIZATION

Harmony (1)

Variety (2)

Balance (3)

Proportion (4)

Dominance (5)

Movement (6)

Economy (7)

Space: Result of Elements/Principles

FORM UNITY: A SUMMARY

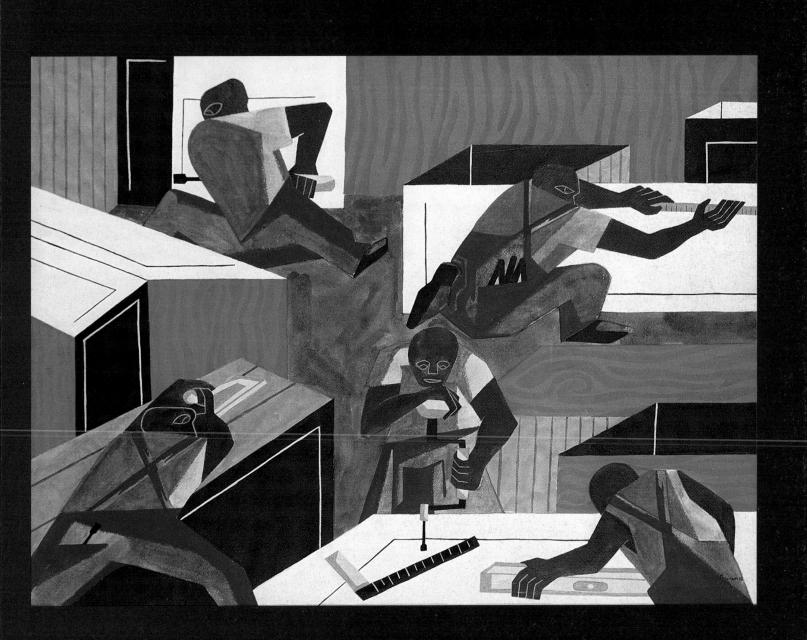

THE VOCABULARY OF FORM

Form I. The organization or inventive arrangement of all the visual elements according to the principles that will develop unity in the artwork. 2. The total appearance or organization.

academic

Art that conforms to established traditions and approved conventions as practiced in art academies. An art that stresses standards and set procedures and rules.

allover pattern

Refers to the repetition of designed units in a readily recognizable systematic organization covering the entire surface.

approximate symmetry

The use of similar imagery on either side of a central axis. The visual material on one side may resemble that on the other, but is varied to prevent visual monotony.

asymmetry

Having unlike, or noncorresponding, appearances—"without symmetry." An example: a two-dimensional artwork that, without any necessarily visible or implied axis, displays an uneven distribution of parts throughout.

balance

A sense of equilibrium achieved through implied weight, attention, or attraction, by manipulating the visual elements within an artwork.

closure

A Gestalt concept where the development of groupings or patterned—relationships occurs when incomplete information is seen as a complete-unified whole—the artist provides minimum visual clues and the observer brings them to final recognition.

composition

An arrangement and/or structure of all the elements, as organized by the principles, that seeks a unified whole.

Often used interchangeably with the term "design."

dominance

The principle of visual organization where certain elements assume more importance than others in the same composition or design. Some features are emphasized and others are subordinated.

economy

Distilling the image to the basic essentials for clarity of presentation.

Gestalt, Gestalt psychology

A German word for "form." Defined as an organized whole in experience. Around 1912, the Gestalt psychologists promoted the theory that explains psychological phenomena by their relationships to total forms, or Gestalten, rather than their parts.

golden mean/golden section

I. Golden mean—"perfect" harmonious proportions that avoid extremes; the moderation between extremes. 2. Golden section—a traditional proportional system for visual harmony expressed when a line or area is divided into two sections so that the smaller part is to the larger as the larger is to the whole. The ratio developed is 1:1.6180. . . . or, roughly, 8:13.

harmony

The quality of relating the visual elements of a composition. Harmony is achieved by repetition of characteristics that are the same or similar. These cohesive factors create pleasing interaction.

motif

A designed unit or pattern that is repeated often enough in the total composition to make it a significant or dominant feature. Motif is similar to "theme" or "melody" in a musical composition.

movement

Eye travel directed by visual pathways in a work of art.

pattern

- 1. Any artistic design (sometimes serving as a model for imitation).
- 2. Compositions with repeated elements and/or designs that are usually varied and produce interconnections and obvious directional movements.

principles of organization

There are seven principles that guide the employment of the elements in achieving unity. They are harmony, variety, balance, proportion, dominance, movement, and economy.

proportion

The comparative relationship between parts of a whole or units as to size. For example, the size of the Statue of Liberty's hand relates to the size of her head (see scale).

radial

Compositions that have the major images or design parts emanating from a central location.

repetition

The use of the same visual effect a number of times in the same composition. Repetition may produce the dominance of one visual idea, a feeling of harmonious relationship, an obviously planned pattern, or a rhythmic movement.

rhythm

A continuance, a flow, or a sense of movement achieved by repetition of regulated visual units; the use of measured accents.

31

scale

Scale is established when associations of size are created relative to some constant standard or specific unit of measure relative to human dimensions. For example, the Statue of Liberty's scale is apparent when she is seen next to an automobile (see **proportions**).

symmetry

The exact duplication of appearances in mirrorlike repetition on either side of a (usually imaginary) straight-lined central axis.

variety

Differences achieved by opposing, contrasting, changing, elaborating, or diversifying elements in a composition to add individualism and interest; the counterweight of **harmony** in art.

FORM AND VISUAL ORDERING

A completed work of art has three components: subject, form, and content. These components change only in the degree of emphasis put on them. Their interdependence is so great that none should be neglected or given exclusive attention. The whole work of art should be more important than any one of its components. In this chapter, we explore the component *form* in order to investigate the structural principles of visual order (fig. 2.1).

When we see images, we take part in visual forming (or ordering). An object is reduced to elements. A chair might be seen as a shape or a group of lines, a wall as a value, and a floor as a color. In this act, the eye and mind organize visual differences by integrating optical units into a unified whole. The mind instinctively tries to create order out of chaos. This ordering adds *harmony* to human visual experience, which would otherwise be confusing and garbled.

Artists are visual formers with a plan. With their materials they arrange the elements—lines, shapes, values, textures, and colors for their structure. The elements they use need to be controlled and integrated. Artists manage this through the unifying principles of organization: harmony, variety, balance, proportion, dominance, movement, and economy. These

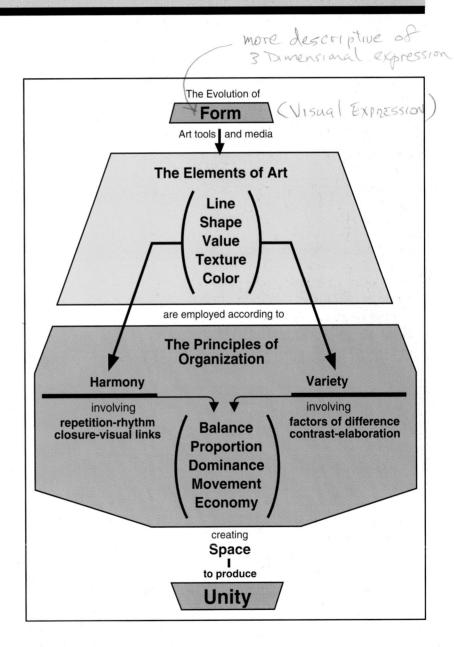

A 2 · I

Although this is a logical and common order of events in the creation of an artwork, artists often alter the sequence.

Courtesy Authors

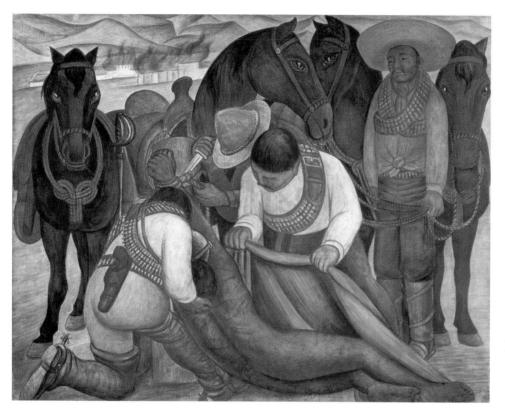

direction, etc. While an artist may use line to unify a work, in this chapter, we will discover that the resulting harmony will actually be created by the "relatedness" of one or all of those properties—length, width, character, etc. Thus, we see that the principles of organization may be applied to the "individual characteristics" of each element—or that the "individual characteristics" of each element may be subjected to the principles of organization in order to bring unity to a composition. In view of this, it is a necessity that these principles be reviewed after each of the following chapters to see how that element or any of its separate attributes could be used to produce space and to achieve harmony, variety, balance, movement, proportion, dominance and economy.

\triangle 2 · 2 Diego Rivera, The Liberation of the Peon, 1931. Fresco, 6 ft 2 in \times 7 ft 11 in (1.88 \times 2.41 m).

Here we see a political artist making use of appropriate and expected subject material. Without the effective use of form, however, the statement would be far less forceful.

Philadelphia Museum of Art, PA. Gift of Mr. and Mrs. Herbert Cameron Morris.

© Philadelphia Museum of Art/Corbis Media. Reproduction authorized by National Institute of Fine Art and Literature of Mexico.

principles create *space* and the sum total, assuming the artist's plan is successful, equals **unity.** Unity in this instance means oneness, an organization of parts that fit into the order of a whole and become vital to it.

Form is the complete state of the work. The artist produces this overall condition using the elements of art structure, subject to the principles of organization. The artist's plan is usually a mix of intuition and intellect. Ideally, the plan will effectively communicate the artist's feeling, even though it may change as the work progresses. The plan can be variously termed **composition** or **design** (fig. 2.2).

In this chapter, we will be dealing with "how" the elements are organized. The individual characteristics of each element are so important to this organizational process that they really can not be separated from it. But, for the sake of clarity, the elements will be discussed individually in the chapters which follow. If the act of organization is as important as what is being organized, which should be presented first? It is the problem of the chicken or the egg. One must know about the individual elements in order to use them to harmonize a work. In the line chapter, for example, the physical properties of line include length, width, character,

THE SEVEN PRINCIPLES OF ORGANIZATION

As explained earlier, the principles of organization—(1) harmony, (2) variety, (3) balance, (4) proportion, (5) dominance, (6) movement, and (7) economy—are only guides. They are not laws with only one interpretation or application. These principles are used to help organize the elements into some kind of action. The principles of organization may help in finding certain solutions for unity, but they are not ends in themselves, so following them will not always guarantee the best results. Artworks are a result of personal interpretation and should be judged as total visual expressions. In other words, the use of the principles is highly subjective or intuitive.

Organization in art consists of developing a unified whole out of diverse units. This is done by relating contrasts through similarities. For example, an artist might use two

33

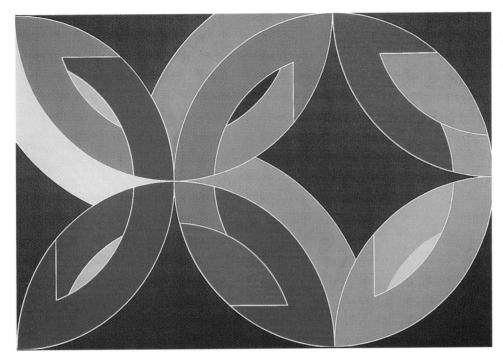

< 2·3

Frank Stella, Lac Laronge IV, 1969. Acrylic polymer on canvas, 9 ft $\frac{1}{8}$ in \times 13 ft 6 in (2.75 \times 4.11 m).

Stella has harmonized the painting through his insistent use of the curve; he has provided variety by using contrasting colors and shape sizes.

Toledo Museum of Art, Toledo, OH. Purchased with funds from the Libbey Endowment. Gift of Edward Drummond Libbey. © 1997 Frank Stella/Artists Rights Society (ARS), New York.

opposing kinds of lines, vertical and horizontal, in a composition. Because both the horizontal and vertical lines are already straight, this likeness would relate them. Unity and organization in art are dependent on a dualism of similarity and contrast—a balance between harmony and variety (fig. 2.3).

Harmony (1)

Harmony may be thought of as a factor of cohesion—relating various picture parts. This "pulling together" of opposing forces on a picture surface is accomplished by giving them all some common element(s): color, texture, value, and so forth. The repetition or continued introduction of the same device or element reconciles that opposition. **Rhythm** is also established when regulated visual units are repeated. Whether created by **repetition** or rhythm, harmony may create the feeling of boredom or monotony when its use is carried to extremes. But, properly

introduced, harmony is a necessary ingredient of unity.

We have often cited music in this book because its composition is quite similar to the construction of an artwork. Harmony in music is identifiable when the component notes "fit" in producing a sound. Of course, sometimes composers intentionally introduce discord (not normally a pleasant listening experience) and resolve it later in the composition. Discord in art can also result when unrelated parts are put together.

Musicmaking requires the efforts of at least two participants: the composer and the performer(s). The composer (the creator) provides the musical blueprint (the score), the "key" signature (what notes go together); the performer (the interpreter) follows these guidelines, with some latitude for individual interpretation. The score indicates the placement and movement (up or down) of the notes, the rests, and the degree of sound (the volume) to be produced. This is not

unlike a visual art product; the artist controls eye movements in both speed and direction, provides pauses (rests), and, in a sense, the volume (loud or soft colors and clashing or more gently related lines and shapes). In the visual arts, the artist/creator lays out the guidelines and the interpretation is in the eyes and minds of the viewers. The viewer thus shares with the artist the responsibility for the success of the artwork. Knowledgeable and sensitive viewers are a necessity.

Because relationships are essential to harmony, what would relate one part of the artwork to another or more parts? A common element or motif—a repeated color, texture, value or a common configuration of line or shape—would be the connecting force. Rhythm is also present when regulated units are repeated. However, properly handled, harmony is a necessary ingredient in the broader coalescence of unity. In art, as in music, if the parts "fit" harmony is achieved.

2 . 4

Eva Hesse, Repetition 19 III, 1968. Nineteen tubular fiberglass units, $19-20\frac{1}{4}$ in \times $11-12\frac{3}{4}$ in (48.3-51.4 cm \times 27.8-32.3 cm).

This work, as the title implies, exploits the repetitive dimensions of identical "can forms." These are then given variety by distorting the basic shapes.

The Museum of Modern Art, New York. Gift of Charles and Anita Blatt. Photo © Museum of Modern Art.

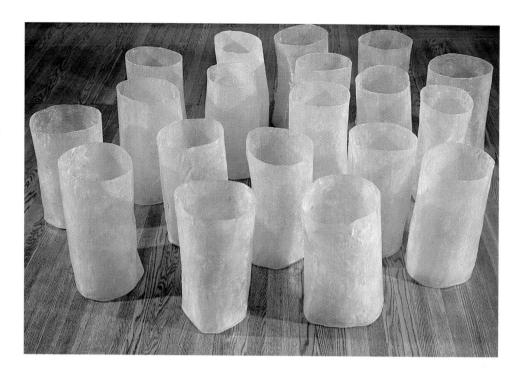

₩ 2 • 5

Copper Giloth, Bird in Hand, 1983. Computer.

Repetition is found in the pattern produced by the computer as well as in the repeating images. Nevertheless, the hands change position periodically, producing some variety.

Courtesy of the artist.

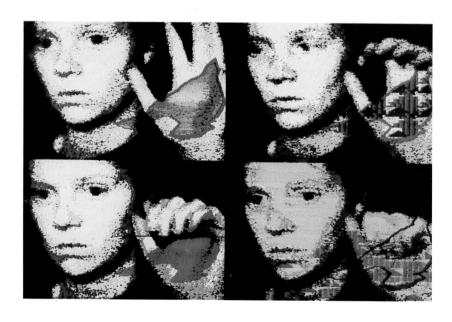

Repetition

Repetition, needless to say, means that certain things are repeated. In art these things will most likely be the elements of art, characteristics of those elements, or certain motifs produced by a combination of the elements. The relationships created by repetitive resemblances imbue the artwork with a degree of harmony. The repetition does not require exact duplication but, instead, similarity or near likeness. Such treatment will undoubtedly hammer home, through its emphasis, a condition desired by the artist. Also, carefully handled repetition can use the similarities as links for developing planned eye travel for the observer. When those similarities are somewhat reduced, the *least* related can also achieve emphasis, drawing attention to the dissimilarities. Emphases, of any kind, tend to hold our attention, if only briefly. Repetitive similarities are not unlike our genetic predisposition to resemble our parents, clarifying relationships. Harmonious relationships are similarly

35

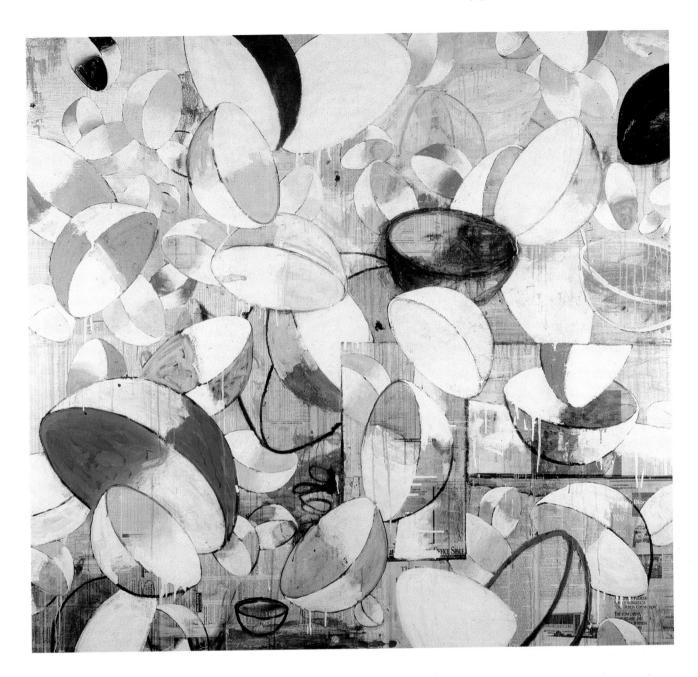

established in art through repetition (figs. 2.4, 2.5, and 2.6).

Pattern This is a concept that may be considered within the discussion of repetition. At the most elementary level, pattern may be seen as any arrangement or design and may function as the model for imitation or for making things (one or multiples). Examples are the pattern a dressmaker uses to make a skirt, the pattern a moldmaker uses for a piece of

machinery, or the pattern an artist uses to create artistic designs. On the next level, pattern is usually seen as a noticeable formation or set of characteristics that is created when the basic pattern (model) is repeated. The resulting pattern may be made of regular repetitions, as in an "allover" pattern, or of irregular repetitions. These repetitions may be composed of simple marks, of elements (line, shape, value, texture, or color pattern), or of a series of named complex

A 2.6

Paul Manes, Eiso, 1995. Oil on canvas, 60×66 in (152.4 \times 167.6 cm).

The visual units in Manes' painting are ovoid saucer shapes. The repetition of this shape creates harmony. Variety develops out of differences in the shape's size and color.

Marisa Del Re Gallery, New York, N.Y.

2 · 7A & B

In figure 2.7A, the basic pattern is the universally and immediately recognizable paisley shape (see fig. 2.9). Figure 2.7B is a detail (of fig. 2.8). Here the pattern is created by an arrangement of lines and shapes based on an abstraction of trees.

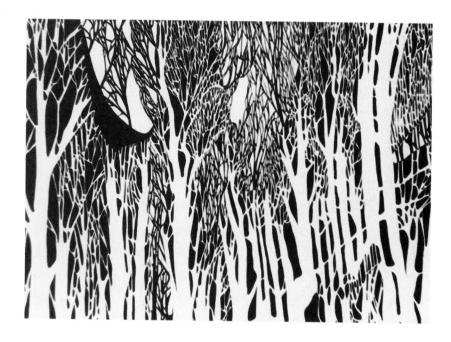

\triangle 2 · 8 Student work, Patterns: Trees, c. 1970. Brush, pen, and ink, 18×24 in (45.7 × 61 cm).

Although the subject is trees, the distinctive pictorial characteristic of this work is the pattern produced by the tree relationships—a pattern that is developed, though not identically, in all areas of the work, creating unity.

designs, such as a paisley or a geometric pattern (figs. 2.7A and B, see fig 2.9).

The generally repetitive nature of such patterns can be used to create harmony and rhythm with pauses and beats that cause flow and connections between parts. They serve to direct eye movement from one part to another. In a more sophisticated sense, pattern may be seen as a series of arranged elements that may be totally invented or suggested by objects—like tree branches and/or their spaces (fig. 2.8).

Motif is a concept closely related to pattern. The difference is that once the basic unit, cell, or original pattern (model) is repeated it is referred to as a *motif*. Once this unit becomes a motif, it serves to connect the larger repetitive formation—a conspicuous pattern due to its overall size. This larger pattern may be formed with regularly or irregularly repeated motifs. This new formation (pattern) may be called an

Paisley pattern, 1992. Wallcovering.

2.9

The paisley is repeated casually to achieve a pattern of more or less irregular design. Courtesy of Fashion Wallcoverings, Distributors, Cleveland, OH.

4 2 • 10

Log cabin quilt, c. 1860. Made from English printed dress cottons, 6 ft 8 in \times 6 ft 8 in (2.03 \times 2.03 m).

In this traditional quilt an unusual "allover pattern" (see "Asymmetrical Balance," p. 56) was created by changing color, value, and texture within the unit to accentuate and emphasize new shape relationships.

Reproduced by permission of the American Museum in Britain, Bath ©.

allover pattern when the motifs have been repeated in a regular manner over an entire surface. The repeated motifs found in wallpaper designs may be cited as an example. Further, the Pop artist Andy Warhol created "allover pattern" with his soupcan artworks (see fig. 10.93). When an artist doesn't want such a repetitive image, he or she might choose to create an irregular pattern design (fig. 2.9). Quiltmakers often rotate their motifs, changing their color, value, texture, and placement. This serves

to further accent the change and bring about an entirely new "allover pattern" (fig. 2.10).

Studio artists often find the obvious and continuous repetition of a motif in an "allover pattern" too monotonous. For them, a subtler use of motif would treat it more like a repeated idea, theme, or pattern of notes in music. For example, the "ta-ta-ta-TUM" in Beethoven's *Fifth Symphony* is repeated but constantly changes in terms of tempo, pitch, volume, and the voice of

₹ 2 • 11

Max Ernst, The Hat Makes the Man, Cologne, 1920. Cut-and-pasted paper, pencil, ink, and watercolor on paper, 14×18 in (35.6 \times 45.7 cm).

The hats in this picture represent strong motifs in a system of accents and pauses. Notice the variety of style, size, and shape contour within the repetitive order.

The Museum of Modern Art, New York. Purchase. Photo © 1998 Museum of Modern Art. © 1997 Artists Rights Society (ARS), New York/ADAGP, Paris. the instrument playing it. Max Ernst, in *The Hat Makes the Man*, uses the idea of a hat in much the same way (fig. 2.11). It is not repeated over and over exactly alike, but rather is introduced as a theme, constantly changing and accented in differing ways.

Sometimes the theme develops for an artist over a long series of work. Consider thirty paintings by an artist, each dealing with a cat in some different attitude or position. In each individual painting, the cat would be the subject. But, within a consideration of the total series, the cat may be seen as the artist's repeating theme, idea, or motif. Two examples from a larger series may be

seen in the Impressionist artist Claude Monet's *Rouen Cathedral* paintings (see figs. 7.23 and 7.24).

Rhythm

One attribute of repetition is its ability to produce rhythm. *Rhythm*, in art as in music, results from repeated beats, sometimes regular, sometimes more eccentric. Walking, running, dancing, woodchopping, and hammering are human activities with recurring measures. Rhythm in art derives from reiterating and measuring similar or equal parts. This reiteration is, of course, a synonym for repetition. Consequently

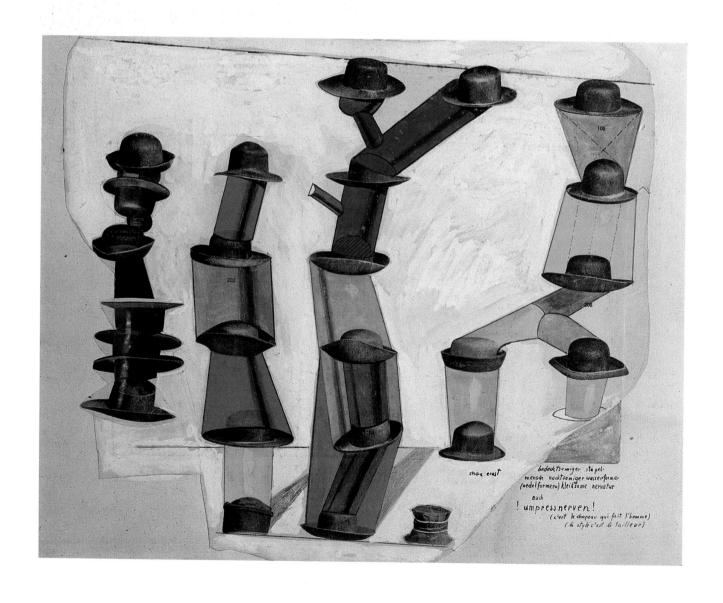

Form 39

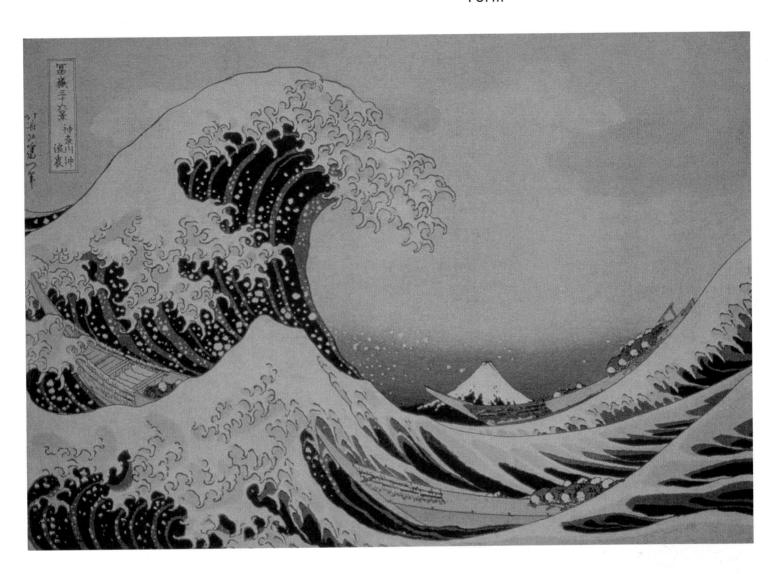

the repetition of elements and motifs strategically placed and, if necessary, suitably accented, will result in rhythm (fig. 2.12). The rhythm may be smoothly flowing or less regular and even jerky in the visual movements as dictated by the artist (much like a musical composition). Repetition and rhythm can bless an artwork with both excitement and harmony depending on how they are used. A gentle rhythm, as in a quiet landscape, suggests peace, while a very active rhythm, as in a stormy landscape, or riot, suggests violent action. The type of rhythm will depend on horizontal or vertical lines versus diagonal lines, regular or irregular shapes, smooth or fast transitions between optical units to

2.12

Katsushika Hokusai, Under the Wave off Kanagawa (from the series "The Thirty-Six Views of Fuji"), 1829–33. Colored woodblock print, $10\frac{1}{2} \times 15$ in (26.7 × 38.1 cm).

Hokusai has given us a dramatic sense of the rhythmic surging of the sea in this print.

Takahashi Collection. Sakamoto Photo Research Laboratory/Corbis Media.

where the eye is guided. Jose Clemente Orozco charges his pictures with obvious rhythmical order (figs. 2.13A and B). He uses several rhythmical measures simultaneously to create unity. He ties his pictures together by repeating shapes

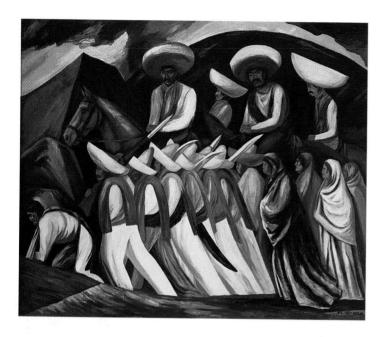

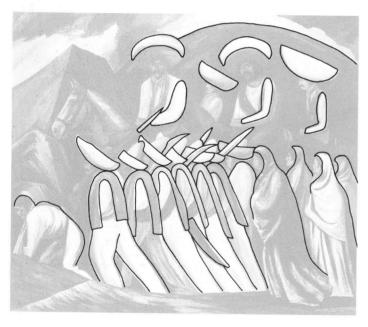

▲ 2 · 13A & B José Clemente Orozco, Zapatistas, 1931. Oil on canvas, 3 ft 9 in × 4 ft 7 in (1.14 × 1.39 cm).

A continuous movement is suggested as the zapatistas cross the picture surface from right to left. In passing, these figures form a repetitious beat as their shapes, leaning in the same direction, create a rhythmic order. The diagram in figure 2.13B illustrates the major shapes and their edges arranged in continuous, flowing, and harmonious directions.

The Museum of Modern Art, New York. Given anonymously. Photo © 1998 Museum of Modern Art.

of certain directions and edges, value differences, and color modifications.

In art, just as in music, variation in size (quarter or whole notes) or volume (loudness or softness) may create more interest, but there is another aspect of rhythm often overlooked by the visual artist—the intervals of silence between repeating units. This becomes apparent when a drummer taps out the old "shave and a haircut, two bits." When the relative size and accent of the drum beat is made as similar as possible, the recognizable rhythmic pattern must be attributed to the variation in the negative space or intervals of silence between the beats. When this concept is applied to the visual arts, the importance of this variation in spacing can be seen in the sculpture of Alexander Calder (see fig. 9.35) or in the placement and intervals between the heads in Andrew Stepovich's Carnival (see fig. 5.20).

Closure or visual grouping

In the early part of the 20th century. Max Wertheimer, a German Gestalt psychologist, and his colleagues began to investigate how the viewer sees form. pattern, shape, or total configuration in terms of group relationships rather than as individual items. They discovered several factors like nearness and size that help objects relate visually. The concept bringing most of these together to create pattern we will be referring to as closure. The principle of closure states that people tend to see incomplete pattern or information as complete or unified wholes. This "closure tendency" occurs when an artist provides a minimum of information or visual clues, and the observer brings the gestalt to closure or an understandable pattern with final recognition. For example, in the upper example in figure 2.14A, some viewers will see a diagonal "X" and others will see a horizontal and vertical "+." By application of this principle, the fragmented black borders of a circle

41

would be seen as a complete circle (bottom right illustration in fig. 2.14A). Cover up one unit or move them farther apart as in figure 2.14C and the "circle" is destroyed. Admittedly, with closure there are many principles at work like the "rule of proximity" (relative nearness may "visually join" objects) or the "rule of similarity" (visual elements may "join visually" if they resemble one another in size or shape; see lower left illustration in fig. 2.14A). For Wertheimer, this visual ordering helped explain how artists see and create structural organization or pattern in their work. For the Gestalt psychologists, the whole (the collective pattern) was greater than its individual parts.

How do images interact visually as they are moved or placed closer and closer together? In the diagram fig. 2.14B, when separate images are evenly spaced throughout the area, each must be experienced individually. But as we begin to pull some of those shapes nearer together as in figure 2.14C (before they physically touch), they begin to join together as visual units. As enough come together, there is a growing awareness of a circular form and a horizontal linear development. In the final image, all of the various shapes, by playing with or altering their spacing, have been given a harmonious relationship (fig. 2.14D). All of the individual shapes (circles, rectangles, and squares of many sizes) have become "related." Here, the cohesive or harmonizing factor is not restricted to color, related surface, or shape type—though for purposes of illustration here, they are all printed the same. The relationship is in fact a psychological relatedness where all the different individual images become part of something even greater. We see the larger group rather than the individual parts involved in its creation. By varying the negative interval between shapes, the new grouping can appear dense in one location or fade away in another. The same shapes that create a "circle" in one

₩ 2.14

(A) Examples in which the total configuration is more important than the individual items making them. (B) Individual shapes without any implied organization. (C) Individual shapes moving close enough to imply some visual grouping. (D) Closure suggesting patterns of an "oval," a "circle," and a horizontal "strand."

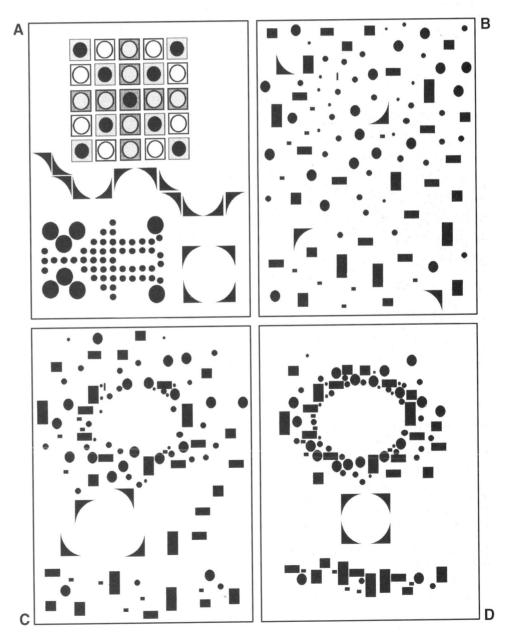

Chapter 2

location can be made to suggest a serpentine movement in another (center example fig. 2.14A). It is not always necessary to create recognizable shapes through closure. A group of value or color related shapes may appear to move across a composition as its controlling value pattern (see fig. 2.52). The areas or

shapes come together visually with the correct spacing or proximity to form a new grouping. Relatedness in color, value, texture, shape type, direction, linear quality, etc. can also help this happen.

In addition to positive images, *closure* can also make negative areas become specific identifiable forms. Notice, in the

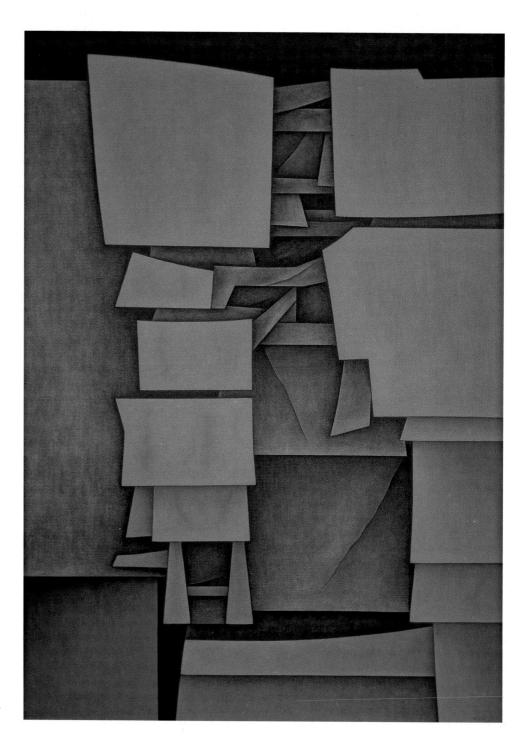

2 · 15

Gunther Gerzso, Personage in Red and Blue, 1964. Oil on fabric, $39\frac{3}{8} \times 28\frac{3}{4}$ in (100.33 \times 73 cm).

In this painting, shapes are united by shared edges as well as similar color and textural development. Though the sense of space is shallow, it is heightened by the contrast of value.

Collection Jacques and Natasha Gelman, courtesy of Centro Cultural/Arte Contemporáneo, A. C., Mexico. Photograph: Jorge Contreras Chacel. center image of figure 2.14D, how the four black "triangular" corner shapes cause the negative area to become important. It is difficult to see the white only as negative area surrounding the black shapes. Instead, the missing sections of the black shapes are "filled in" and we are forced to see the white as a very powerful circle in the center. As shapes are moved around, one should explore the relationship of their placement—the negative interval. Discover how the mind fills in missing information. Determine at what point they begin to "visually" join together. Can a third shape be made to join a grouping of two? Is more or less space needed between the units as the third joins the unit? Try to discover when the most tension is created between members. With the correct spacing, unrelated elements, shapes, or images may be given a harmonious relationship as they participate in an "implied" grouping.

Visual linking

Just as closure unifies by moving objects or shapes close enough that they share in a new implied relationship or shape system, other ways of unifying a composition bring the elements so close together that they physically touch. When this occurs, the cohesive device or commonly held and unifying factor is the *shared space* itself.

Connections—shared edges

Shapes *sharing a common edge* (contacting, touching, butting together), are often easier to unite, because it imposes other common relationships that help draw them together. For example, they tend to appear to be on the same limited space plane or share a similiar spatial or pictorial depth. The cubists and some contemporary artists like Gunther Gerzso (fig. 2.15) have used this idea very successfully.

A great way to unite compositions dealing with flat or more limited space

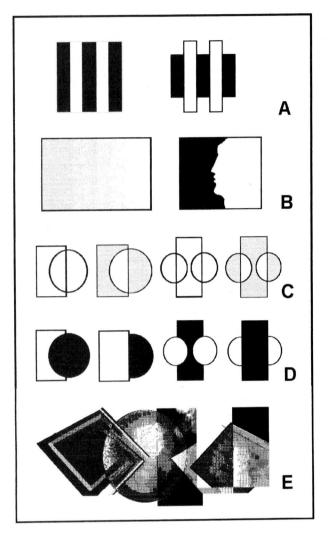

A 2 · 16

- (A) Shared edges relate shapes.
 (B) Dissolved and altered spatial references involving shared edges.
 (C) Shapes related by overlapping.
 (D) Overlapping to create spatial reference.
- (E) Shapes related by transparency.

Courtesy Authors

solutions is by using shapes of the same size and related color or value. This technique, however, may not always be the easiest way to develop an illusionistic or more three-dimensional space. It is difficult because even two shapes with a shared edge and contrasting values limit the ability to create a spatial reference (fig. 2.16A left). Changing the sizes of shared shapes will make it easier to see those shapes pass behind or in front of each other (fig. 2.16A right).

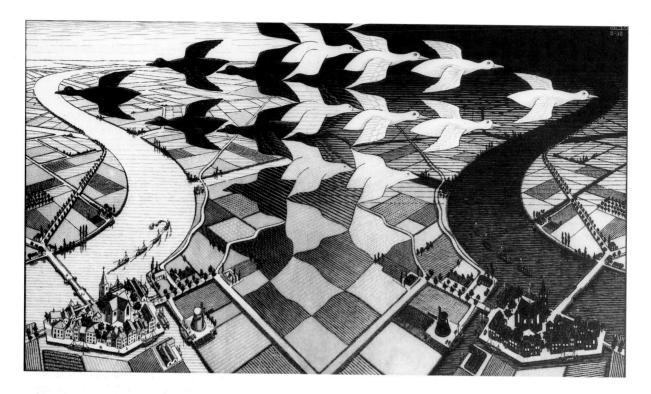

A 2 · 17

M.C. Escher, Day and Night, 1938. Woodcut in two colors, $15\frac{1}{2} \times 26\frac{3}{4}$ in (39.3 \times 67.9 cm).

This is an example of shapes sharing mutual edges with one image (light ducks) appearing to change into another (dark ducks).

The Gemeentemuseum, The Hague. © 1998 Cordon Art-Baarn-Holland. All rights reserved.

When shapes with a common border share a similar value level or color, the dividing edge between shapes is often obscured if not lost all together where they merge (visually become one new shape) (fig. 2.16B left). Further, even with decorative relationships, there is a danger with sharing edges. It works best when the common dividing edge is rather generic or nondescript. For when the edge begins to suggest something recognizable, it separates to which side the new "image" belongs, thus, making it into a positive shape, creating a specific spatial reference, and forcing the remaining shared shape to become a negative area (fig. 2.16B right). Changes in value or texture that create differences further exacerbate the situation. M.C. Escher explored this phenomenon, using it to his advantage when he made patterns

of dark ducks fly through patterns of light ducks (fig. 2.17). As the ducks flew farther away from the central part of the image, the elaboration of detail became more and more distinct. As that same shape system is tracked backwards, it looks less and less like ducks and takes on the imagery of the landscape.

Overlapping With *overlapping*, the areas involved are also drawn together by a common relationship and the shared item is a bit more involved than a simple edge; it becomes a shared area. As long as the color, value, texture, etc. are the same or related, the overlapping of the areas tends to unite the items involved (see fig. 2.16C). However, the space defined may be shallow and rather ambiguous—one time the circle is seen on top, the next time the square is seen on top. The

Futurists often achieved this by overlapping multiple views of the same object (see fig. 8.56). Vastly unrelated objects can be harmonized in this fashion. Overlapping does not always mean limited space or cohesive relationships, because a deeper space may be caused by visual separation or difference in treatment. The object overlapped can be seen as the receding object (see fig. 2.16D). Color and value choices can exaggerate or minimize the spatial effect of overlapped shapes. With a more figurative application, completely independent symbolic information occurring (overlapping) within any entirely different symbol or image area can even be brought into a plausible context. If we study the photo by Sam Haskins titled Apple Face, 1973, the face is quite believably contained within the shape of the apple (fig. 2.18).

Transparency Transparency is another way an artist can add harmony to images that occur in the same area. When a shape or image is seen through another, the relating visual devices that

create harmony and unite those areas include: the shared area itself, the layers of space they all pass through, and the surface treatment of all the images (highlights, shading, color, etc.). Like simple overlapping, this technique tends to limit the visual depth that may be introduced and is another relating harmonious device (see figs. 2.16E and 8.9).

Interpenetration When several images not only share the same area but appear to pass through each other, they are brought into a harmonious relationship not only by the common location, but also by the physical depth of the space in which they all appear (see fig. 8.10). Whether shallow or deep, or illusionistic or stylized, the space itself pulls the various images into a visual harmony. Notice how in the corner of figure 2.19, the objects from one wall

seem to plunge into the objects and space of the adjoining wall. Even though the two areas are treated in different colors, ochre and red-brown, the sharing of the internal space created by **interpenetrating shapes** helps unify this interesting work.

Extensions (Implied and subjective edges/lines/or shapes)

Like the invisible lines of a surveyor that map out and organize the cities, roads, and contour of the land, the *extended edges* in a composition help the artist organize and bring all parts of that structure into a harmonious relationship. While we have seen harmony achieved by concepts where there are jointly shared edges, shared areas by overlapping shapes, similar transparency of surface, or even the relating of forms by making them pass through each other, these often are used to relate items relatively

close to each other. However, the concept of extensions—implied edges, lines, or shapes—provides the artist with a visual alignment system. It is used to help locate new objects in a composition, relate, provide commonalities, bring together, or harmonize areas, images or shapes in different and distant locations. It may be used to integrate all areas within the composition and create space by tension between areas.

Extensions create hidden relationships. They harmonize by setting up related directional forces, creating movement, and providing a repetition of predictable spacing between units. The strong direction impulse suggested by these *subjective edges* (subconscious and invisible or implied extensions) provides the viewer with an "expectation" that something else will be discovered in a new area and helps "pull" or direct the eye to a new location. It can integrate a

2 . 18

Sam Haskins, Apple Face, from the book HASKINS POSTERS, 1973. Photograph.

In this image, two distinctly different naturalistic images convincingly share the same shape and space.

© Sam Haskins Partnership. (Website URL: www.haskins.com)

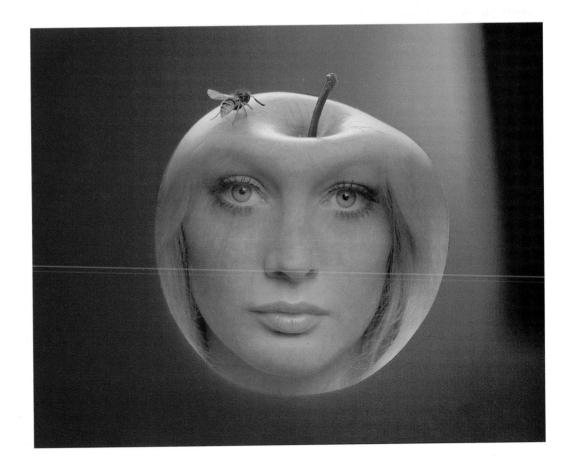

work as it winds through the composition along contours of information (figs. 2.20A and B).

As an element in its own right, line can draw all sectors of the arrangement together (see figs. 3.9 and 3.10). This line may be clear and dominate or be less emphasized and fade away to become a lost or dissolved contour (see fig. 5.20). As a strong directional indicator, new lines introduced or repeated anywhere along the extension of a first may relate both by implied direction. Invisible linear extensions (subjective lines) are such a strong device for relating compositional areas that designers also use them in the form of a grid system for the layout and organization of blocks of type, logos, and graphic information (fig. 2.21).

Like line, a shape may create a strong directional movement and as an organizational tool create cohesive (harmonious) relationships with other shapes. A shape has two ways of directing

the viewer toward objects or shapes creating this movement: (1) the volume of the shape points in a general direction (for example, a long triangle points straight ahead in the general direction of the narrow end) directing the viewer across the composition to another image or shape; and (2) the outside edges of that pointing shape may also be extended by subjective hidden lines that will direct the viewer in two new directions. These implied or subjective edge extensions may be used to locate new shapes or objects all across the composition that can be harmonized by the same directional force. Irregular shapes can also be brought into harmonious relationship and into group patterns (closure) much more quickly by moving them around until their subjective edges (invisible extended edges) intersect or align themselves. A grouping of shapes in one part of the composition can create tension or closure with another grouping

2 · 19

This is an example of interpenetration with lines, shapes, and planes passing through one another.

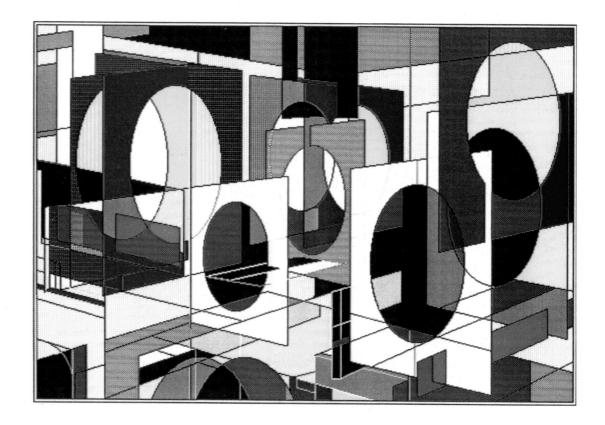

47

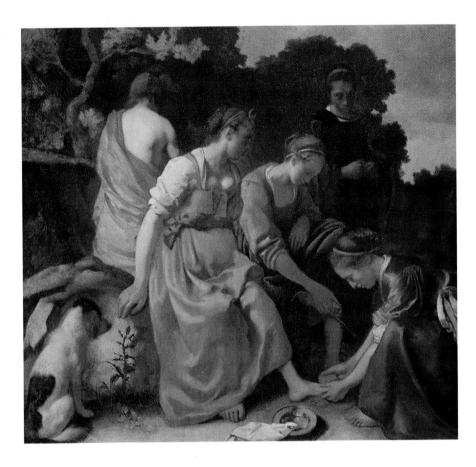

2 · 20A

Johannes Vermeer, Diana and the Nymphs, c. 1655–1656. Oil on canvas, $33\frac{1}{2} \times 41$ in (97.8 × 104.6 cm).

This painting by Vermeer uses extended edges to interlock the images, find the location for new forms, relate shapes, and create directional movement across the painting.

Royal Cabinet of Paintings, Mauritshuis. The Hague, Netherlands. Scala/Art Resource.

4 2⋅20B

This overlay shows some of the extended edges by solid lines of various strengths and their extensions by dots and dashes. Notice how the implied direction is often interrupted or disguised by subtle changes.

A 2 · 21

An excerpt from the book How to Understand and Use Grids, by Alan Swann.

Designers often use a grid system to help with the layout and organization of text and visual information. The system can be applied to one image or made to relate a whole corporate campaign. or individual shapes some distance away. By employing subjective edges, movement may be controlled and directed anywhere, rotating volumes in space, and returning the viewer to the picture plane (see the implied circle and serpentine movement in the center portion of figure 2.14A).

While many concepts used to create harmony tend to limit the spatial or pictorial depth, the unifying concepts of extension may be applied equally to plastic space, decorative space development, or any degree of abstraction. The implied lines may cross over areas enclosed by other images and shapes or across open areas of color and texture not restricted by other images. Because extensions are such an important tool of organization, great care must be taken that their use does not become too obvious. Therefore, artists take notable

Form 49

2 · 22

George Sugarman, Inscape, 1963–64. Polychromed wood, $28 \times 158 \times 97$ in $(71.12 \times 401.32 \times 246.38 \text{ cm})$.

The balance between harmony and variety can be tipped to favor either principle or order depending on the artist's intention. George Sugarman is an artist who pushes his balance strongly in the direction of variety. In this three-dimensional work, Sugarman varies the shape contours and colors of his assembled pieces with a personal vigor. He arouses an initial curiosity in his viewer that, after greater reflection, provides enduring vitality.

Whitney Museum. Courtesy of the artist.

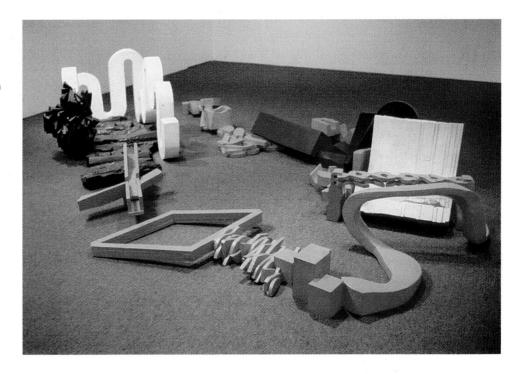

delight in "hiding" the directional forces by interrupting them with counter movements, accents, or subtle "misalignments."

Variety (2)

Variety is the counterweight of harmony. It is the other side of organization essential to unity. While an artist might bring a work together with harmony, it is with variety that the artist achieves individuality and interest. In this instance, "interest" refers to the ability to arouse curiosity and to hold a viewer's attention. If an artist achieves complete equality of visual forces, the work usually will be balanced, but it may also be static, lifeless, and unemotional. Visual boredom is an indication of an overly harmonious composition. By adding variation to the visual forces, the artist introduces essential ingredients (such as diversion or change) for enduring attention.

Visual interest, then, is a direct result of adding variety to the pictorial components. Variety is a factor of visual separation—a "pulling apart" of related

elements or images. This is done in a way that makes the components become different or disassociated. This separation (variety) is achieved by the use of contrast and elaboration.

Contrast

Contrast occurs when the elements are repeated in a way that makes them appear unrelated—a few wide lines in an area of narrow ones. These dissimilarities are more exaggerated by contrast when opposing elements and/or their parts are juxtaposed or placed in close proximity, such as red marks against green or extreme dark against extreme light. As these contrasts are heightened, the areas involved become less harmonious but increase proportionately in visual excitement (fig. 2.22). It is through the introduction of increasing contrasts that an area, image, or shape may be made to become dominant.

Elaboration

Elaboration is another way that variety or dissimilarity is introduced to areas that lack visual interest. It may be thought of as the addition of minute detail or

embellishment to certain areas. The enhancement of the surface with subtle or contradictory information heightens this attraction. Though elaboration and contrast may sound like repetition, the intent is not to heighten the relatedness but to gradually introduce visual difference or opposition. Notice how M.C. Escher added more and more elaboration or detail to the light and dark duck shapes as they moved away from the rather ambigious central area, making them stand apart from the oppositecolored duck area, which was slowly becoming background (see fig. 2.17). Artists will rework areas persistently to express themselves at greater length until an attractive solution is reached. The surfaces are enriched by the extensive changes, and the artist's concept usually develops dramatic strength and purposeful meaning.

Drab picture surfaces become more exciting as variations are introduced. In music, the higher the pitch the greater the number of vibrations. Similarly, in art, as contrasts are introduced the "pitch" or excitement is increased; reduction in contrast lowers the

▲ 2 · 23 Victor Vasarely, Orion, 1956–62. Paper on paper mounted on wood, 6 ft $10\frac{1}{2}$ in × 6 ft $6\frac{3}{4}$ in (2.09 × 2 m).

While harmony is provided through the recurring use of circles, the artist achieves interest through the variety of the same shapes: some are tipped; some are larger or smaller than the norm; and some are emphasized by contrast with their backgrounds. Hirshhorn Museum and Sculpture Garden, Smithsonian Institution, Washington D.C. Gift of Joseph H. Hirshhorn, 1966. (Photograph by Lee Stalsworth).

© 1997 Artists Rights Society (ARS), New York/
© ADAGP, Paris.

"vibration" experienced. The frequency of contrasts in a given artwork might also be compared to the composer's markings for dynamics—very loud (ff) or very soft (pp)—that emphasize certain passages by contrast of volume; in art, it is necessary to give some contrasts greater emphasis than the rest. However, when contrast is overused throughout the composition, the excessive variety will cause a feeling of visual chaos. But something just short of that point can be quite exciting!

One of the most difficult concepts to grasp is that of applying harmony and variety at the same time and to the same element. Consider the use of shape. Victor Vasarely in Orion uses circles as a unifying device to create a harmonious relationship (fig. 2.23). However, to avoid monotony, the artist seeks all the different ways that circles can be introduced by changing their size, point of view, and angle. Thus, he has introduced variety by way of the very element (circular shapes) used to create harmony. The same thing could be done with any of the elements. Red, for example, could be used to make a series of shapes relate, providing harmony. But changing the red's character could vary the design at the same time. Again, variety and harmony have been developed out of the same basic component.

Harmonious means seem necessary to hold contrasts together. However, the ratio of shared similarities to shared differences does not have to be of equal proportions; harmony might outweigh variety, or variety might outweigh harmony (fig. 2.24; see fig. 2.23). Whatever relationship of harmony to variety is chosen, it will become an instrument/concept that will help explore the other principles of organization. A sensitive use of harmony and variety will help to create space and will have a bearing on the development of balance, movement, proportions, dominance, and economy.

Balance (3)

We deal with balance daily as we know and/or expect it to function with gravitational forces. Gravity is a universally and an intuitively felt experience. Walking, standing on one leg, or tipping back in a chair reveal our intuitive need for balance. When off balance, there is the anticipation that gravity will resolve our dilemma (that is, we will fall over!). As upright animals we spend our lives resisting gravity's influence. Similarly, in art we deal with the expectation of counteracting gravitational forces. Most artworks are viewed in a vertical orientation—in terms of top, sides, and bottom. Visual compositional balance is achieved by counteracting the downward thrusts and gravitational weights of the components. For example, a ball placed high in the pictorial field produces a sense of tension, bringing with it the expectation that gravity will cause that ball to drop (fig. 2.25A). A ball placed low or on the baseline provides a sense of peace or resolution, gravity having acted on the ball (fig. 2.25B). Our understanding of the particular image or symbol used has an effect upon its psychological weight and the resulting balance in a composition. For example, if the ball in figure 2.25A becomes a helium-filled balloon, a large negative area under that shape will tend to support or balance it—we may even have the sensation of the balloon lifting up from that area (fig. 2.25C). If the image becomes a lower-positioned bowling ball, its symbolic weight seems to make the composition bottomheavy—gravity's force seems to be pulling the bowling ball down to a still position on the lane at the picture's bottom (fig. 2.25D). What we know of the weight of actual objects (here a ball, a balloon, and a bowling ball) influences how we judge balance on a picture surface. If we were to replace the objects with nonobjective entities their psychological weight would be created

Form 51

₹ 2 • 24

Nancy Graves, Perfect Syntax of Stone and Air, 1990. Watercolor, gouache and acrylic on paper, $48\frac{1}{2} \times 48\frac{3}{8}$ in (123.2 × 122.9 cm).

So many colored brush strokes and black linear symbols are used that some degree of harmony is sure to exist, but variety is by far the dominant theme because of the array of colors and patterns.

Gerald G. Peters Gallery. © 1998 Nancy Graves Foundation/licensed by VAGA, New York, NY.

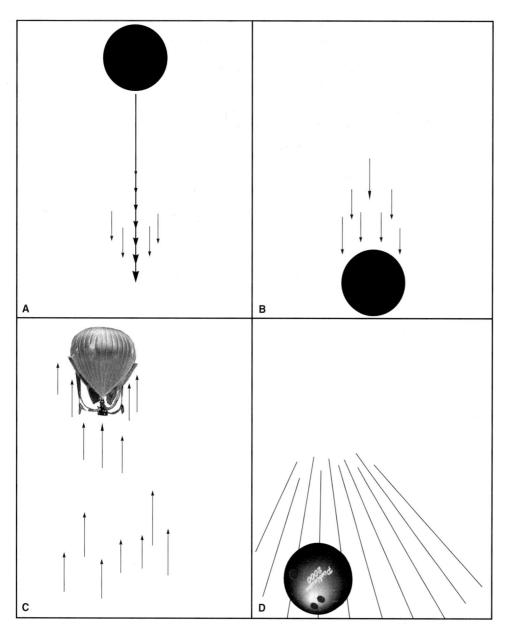

▲ 2 · 25

Balance: gravitational forces and the resulting pictorial tensions.

by their shape, value, and/or color, and our view of their balance again would change. Whether objective or non-objective components are used, the potential creation of psychological weight/balance and its compositional adjustment are endless.

Artists will often offset their pictorial works with a mat—an area between the picture's edge and an actual picture frame (structured of wood, metal, and so on). Even here, psychological factors can affect the visual weight and balance. If a mat with two-inch top, sides, and bottom were used, the bottom would have the illusion of being pinched or smaller than the other sides. The artwork would appear unstable on the wall. Gravity's downward pull creates this illusion. To compensate, the bottom measurements on mats are generally made deeper than the ones at the top, and they seem balanced.

Balance is so fundamental to unity that it is impossible to consider the principles of organization without it. At the simplest level, balance implies the gravitational equilibrium of a single mark on a picture plane. This is clear if one places a single positive unit (any color) on a white surface, putting it anywhere but in the center. Balance can also refer to the gravitational equilibrium of pairs or groups of units (such as lines or shapes) that are arranged on either side of a central axis. This balancing is best illustrated with several different representations of weighing devices or scales that have beams poised on centering points (fulcrums), or centering lines that can be moved freely (fig. 2.26). When we apply this concept to art, balance must be viewed not as actual physical weighing processes but as visual judgments of the observer, based on his or her past experiences and intuitive knowledge of certain principles of physics.

The illustrations in figure 2.26 provide examples of three basic types of balancing scales. These can be used as

preparatory experiences for creating pictorial and/or three-dimensional balance. In the first two rows of scales, the forces are balanced left and right or horizontally, with respect to the supporting balance beam or crossline. The horizontal balance scale shows a line of one physical dimension balancing or counterbalancing a line with the same (or equal) physical characteristics. These examples also point out the balance between lines, shapes, and values that have been modified. A second type of weighing scale, in which forces are balanced vertically, is also illustrated in figure 2.26. The third weighing device shown in the figure points out not only horizontal and vertical balance, but also balance of forces that are distributed around a center point. This is a radial weighing scale.

In picturemaking, balance refers to the "felt" optical equilibrium among all parts of the work. The artist balances forces horizontally, vertically, and radially in all directions and positions (figs. 2.27A and B). Several factors, when combined with the elements, contribute to balance in a work of art. These factors or variables are position or placement, size, proportion, character, and direction of the elements. Of these factors, position plays the lead role. If two shapes of equal physical qualities are placed near the left side of a picture frame, the work will appear out of balance with the right side. Such shapes should be positioned to contribute to the total balance of all the picture parts involved. Similarly, the other factors can put a pictorial arrangement in or out of balance according to their use.

As the eye travels over the picture surface, it pauses momentarily at the significant picture parts. These points of interest represent moving and directional forces that counterbalance one another and may be termed *moments of force*. In seeking balance, the artist should recognize that the varied elements create the moments of force, and their

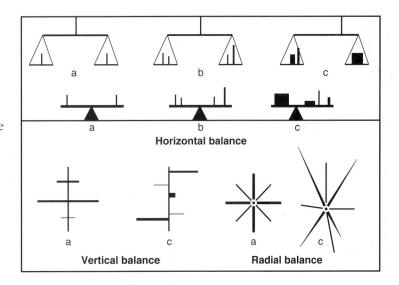

A 2 · 26

Using simple elements, these diagrams illustrate three types of balancing studies: horizontal, vertical, and radial. Also illustrated are the following:

- a. symmetry.
- b. approximate (near) symmetry.
- c. asymmetry (see pages 54-58).

7 2 · 27A & B

Here, all the chief forms of balance—horizontal, vertical, radial, and diagonal—are combined in two diagrams.

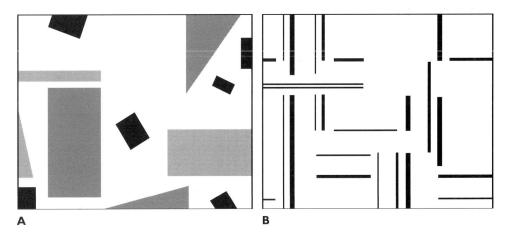

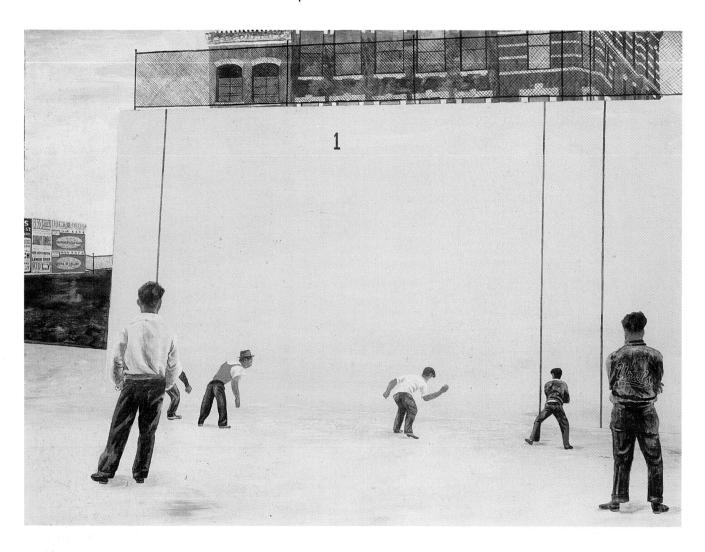

A 2 · 28

Ben Shahn, Handball, 1939. Tempera on paper over composition board, $22\frac{3}{4} \times 31\frac{1}{4}$ in (57.8 × 79.4 cm).

Collectively, the figures and buildings may be seen as representative forces that the artist sets in a supporting, controlled balance and tension.

The Museum of Modern Art, New York. Abby Aldrich Rockefeller Fund. Photo © 1998 Museum of Modern Art. © 1998 Estate of Ben Shahn/licensed by VAGA, New York.

discriminating placement will result in controlled tension. In the painting *Handball*, Ben Shahn creates tension between the two figures in the foreground and the number 1 at the top of the wall (fig. 2.28). These forces together support one another. The darker values of the building above the large wall are counterbalanced by those of the left-hand building and in the figures in the lower portion of the painting.

Symmetrical balance

A symmetrical image displays a portion on one side of the format that is repeated on the other side. It is a "mirror" view and the simplest form of artistic balance (fig. 2.29). If we have two people of equal weight on a centered teeter-totter equidistanced from each other, symmetrical balance is achieved. If those same persons had identical shapes PURE **symmetry** would be present. In art, of course the "teetering" persons would be replaced by different images.

Symmetrical works can be aggressively confrontational; they stare directly at us in a somewhat intimidating manner. This focus certainly captures our attention. Unfortunately this hold on us is usually rather short-lived because of the static quality of the composition. However, secondary features may tend to alleviate this somewhat. Because of the nature of symmetry, unity can be easily

Form 55

2 . 29

Erté, Twin Sisters, 1982. Print (serigraph), 34×49 in (86.36 \times 124.46 cm).

The repetitious nature of this symmetrical work is counterbalanced and relieved by the lively details. The composition is divided equally on either side of an imaginary vertical axis

 $\ensuremath{@}$ Sevenarts Ltd. 1998. Courtesy of Chalk & Vermilion Fine Arts.

achieved, but the artist is challenged to keep us looking by titillating our senses with various decorative details (fig. 2.30 and see fig. 4.29).

Approximate symmetrical balance

The potentially boring qualities of symmetry can be reduced by deviations from its repetitive nature. Balance is still the goal and the solution is similar, but the artistic components, instead of being identical, are different; they are, however, still positioned in the same manner. The apparent weights of the components must still be equal or balance out. The differences add variety thereby producing more interest, but at the loss of some harmony. It is still, though, a fairly static image. Approximate symmetry requires more sensitivity from the artist regarding the various weights for the components cited earlier. Nevertheless, the severe monotony of pure symmetry is given relief (figs. 2.31 and 2.32).

Radial balance

Another type of arrangement, called radial balance, can create true or approximate symmetry. In radial balance, forces are distributed around a central point. The rotation of these forces results in a visual circulation, adding a new dimension to what might otherwise be a static, symmetrical balance. Pure radial balance opposes identical forces, but interesting varieties can be achieved by modifying the spaces, numbers, and

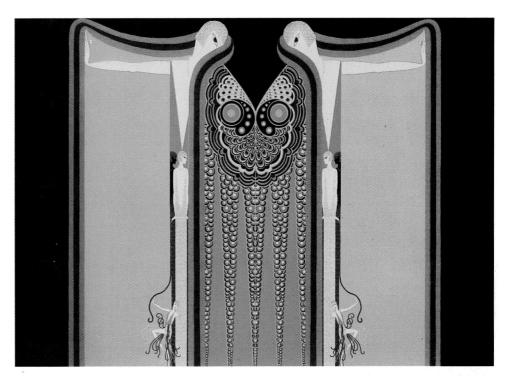

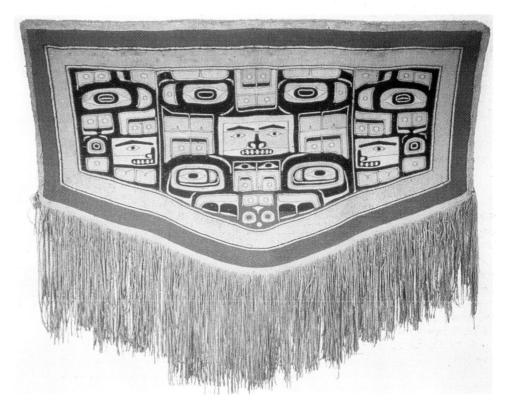

A 2 · 30

Chilkat Blanket, Tlingit, Northwest coast, Alaska. Dyed wool and cedar bark fibers, 69 in (175.2 cm).

A formal, symmetrical product that relies on shape, size and arresting imagery. The frontality of the center section draws the spectator into the composition.

Adolph Gottlieb Collection, Brooklyn Museum.

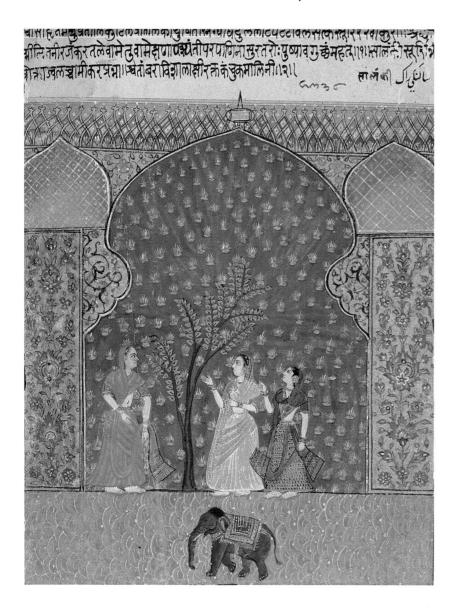

directions of the forces (fig. 2.33). Although modified, the principle of repetition must still be stressed so that its unifying effect is utilized. Radial balance has been widely used in the applied arts. Jewelers often use radial patterns for stone settings on rings, pins, necklaces, and brooches. Architects have featured this principle in quatrefoils and "rose" windows, where the petals of flowers are radially arranged. The potter's plates and vessels of all kinds evolve on the wheel in a radial manner and frequently give evidence of this genesis. In twodimensional work, the visual material producing the radial effect can be either nonobjective or figurative.

Asymmetrical (occult) balance

Asymmetrical balance means visual control of contrasts through felt equilibrium between parts of a picture.

2 . 32

Masoud Yasami, Balancing Act with Stone II, 1992. Edition of 50, Ilfochrome, 3 ft 4 in \times 5 ft (1.02 \times 1.52 m).

Approximate symmetry could be said to be the subject as well as the form of this composition.

Courtesy of Masoud Yasami (American, 1949-)

A 2.31

Ragamala, Salangi Raga (Three females under a tree), c. 1580–1590. Indian (Deccan, probably Ahmadnagar). Colors and gilt on paper, $10^{15}/16 \times 8^{3}/4$ in (27.79 \times 22.23 cm).

This is approximate symmetry. While the format is symmetrical, the central image is rendered asymmetrical by modifying the positions of the trees, figures, and elephant. The vertical axis is still retained.

The Metropolitan Museum of Art, New York, Rogers Fund, 1972. Photo © 1998 Metropolitan Museum of Art.

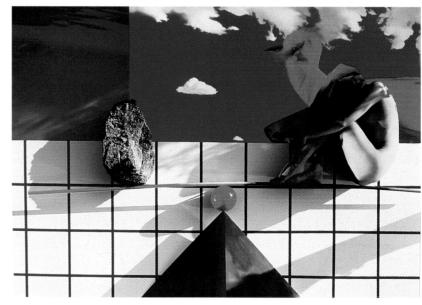

Form 57

2 · 33

Richard Anuszkiewicz, *Iridescence*, 1965. Oil on canvas, 5×5 ft (1.52 \times 1.52 m).

In radial balance, there is frequently a divergence from some (usually central) source. Note here, though, the different stresses placed on the rays as they move away from the square, creating an almost mystical energy. Albright-Knox Art Gallery, Buffalo, NY. Gift of Seymour H. Knox, 1966. © 1998 Richard Anuszkiewicz/licensed by VAGA, New York.

For example, felt balance might be achieved between a small area of strong color and a large empty space. Particular parts can be contrasting, provided that they contribute to the allover balance of the total picture. There are no rules for achieving asymmetrical balance; there is no center point and no dividing axis. If, however, the artist can feel, judge, or estimate the opposing forces and their tensions so that they balance each other within a total concept, the result will be a vital, dynamic, and expressive organization on the picture plane. A picture balanced by contradictory forces (for instance, black and white, blue and orange, shape and space) compels further

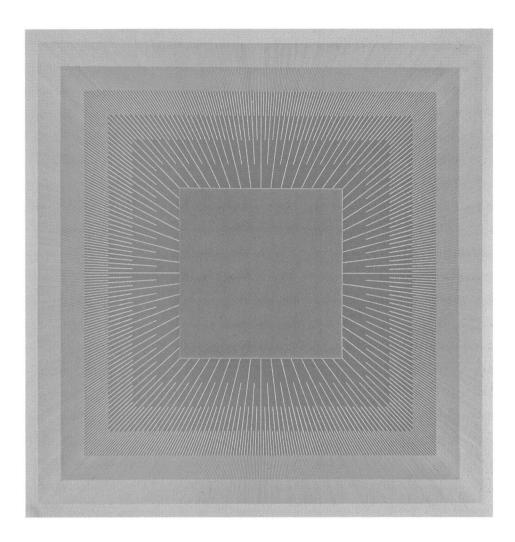

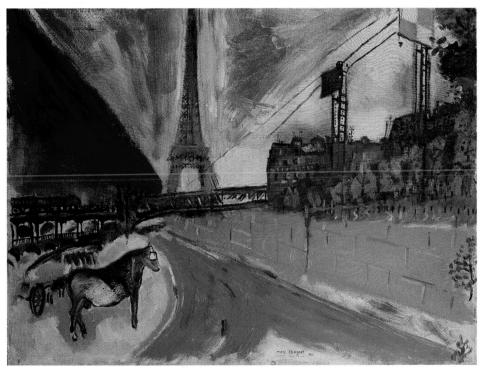

2 · 34

Marc Chagall, Le Pont de Passy et la Tour Eiffel, 1911. Oil on Canvas, $23\frac{3}{4} \times 32$ in. (60 × 80 cm).

The equilibrium in this painting is centered where the radiating diagonal edges and lines come together under the railroad bridge.

Metropolitan Museum of Art, Robert Lehman
Collection, 1975. (1975.1.161) Photo © 1994

Metropolitan Museum of Art. © 1997 Artists Rights

Society (ARS), New York/ADAGP, Paris.

investigation of these relationships and thus becomes an interesting visual experience (figs. 2.35 and 2.36).

Proportion (4)

Proportion deals with the ratio of individual parts to one another. In works of art, the relationships of parts are difficult to compare with any accuracy because proportion often becomes a matter of personal judgment. Proportional parts are considered in relation to the whole and, when related, the parts create harmony and balance. The term **scale** is used when proportion is related to size and refers to some gauge for relating parts to the whole. Often a "norm" or standard is established as a scale. For example, the human figure is most often considered the "norm" by architects for scaling buildings and often by artists for representations in their artworks.

₹ 2 • 35

Ronald Kitaj, Walter Lippmann, 1966. Oil on canvas, 6×7 ft (1.83 \times 2.13 m).

In concentration of subject matter, this painting is weighted toward the left; but the inverted pyramidal lines produce a degree of equilibrium, and there are eye-catching designs on the right, adding emphasis. The balance is achieved through dissimilar visual weights.

Albright-Knox Art Gallery, Buffalo, NY. Gift of Seymour H. Knox, 1967.

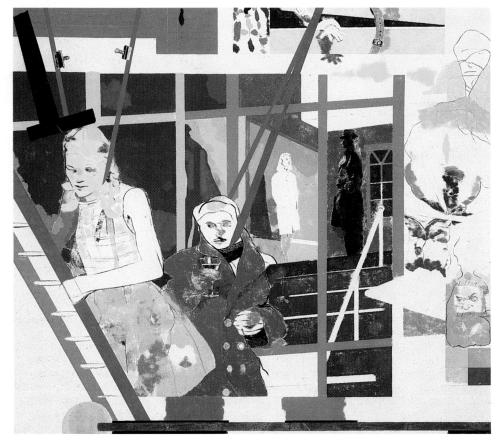

Artists have been seeking the "ideal" standard for proportional relationships since ancient times. Classical Greek philosophy expressed the view that mathematics was the controlling force of the universe and established the Golden Mean, sometimes called the Golden Section, to represent the ideal standard for proportion and balance in life and art. The Greek mathematician Euclid held that the Golden Mean was the "moderation of all things," a place between two extremes. The Golden Section, as it applied to works of art, stated that a small part relates to a larger part as the larger part relates to the whole. It may be seen in a geometric relationship when a line is divided into what is called the mean and extreme ratio (fig. 2.37). When a line AB is sectioned at point C, AC is the same ratio to AB as CB is to AC: AC:AB = CB:AC. This extreme and mean ratio has a numerical value of .6180. Any new unit will be this much smaller or larger than the original unit, making those units in a ratio of 1 to 1.6180. Applying this concept to geometry, the Greeks sought the most beautifully proportioned rectangle that could be created out of a square. They arrived at what is referred to as the Golden Rectangle (figs 2.38A and B and 2.39A and B).

Holding the human figure in highest esteem, the ancient Greeks devised special proportional standards for their figurative works. These standards are found in their sculpture. The scale was based on certain canons or mathematical rules that established ideal relations of human parts. A figure, for example, was determined to be seven and one-half heads tall, and the distance from the top of the head to the chest was said to be one-quarter of the total height. The Greek sculptor Polyclitus is thought to be the first to issue such a canon in the form of a written treatise (which has since been lost). His bronze sculpture of a spear bearer (the original also lost) is

Form 59

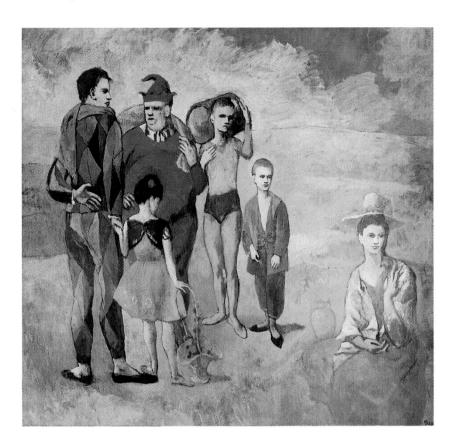

 \triangle 2 · 36 Pablo Picasso, Family of Saltimbanques, 1905. Oil on canvas, 6 ft 11 $\frac{3}{4}$ in \times 7 ft 6 $\frac{3}{8}$ in (2.13 \times 2.30 m).

An intuitive balance is achieved through the juxtaposition of varying shapes and the continuous distribution of similar values and colors.

Chester Dale Collection. © 1998 Board of Trustees, National Gallery of Art, Washington. Photo: B. Grove © 1997 Estate of Pablo Picasso/Artists Rights Society (ARS), New York.

A 2 · 37

A line is here divided into a geometric relationship known as the mean and extreme ratio. This is sometimes referred to as the Golden Mean or Golden Section.

A 2 · 38A

A Golden Rectangle may be found by extending the baseline of a perfect square in one direction. With a compass point fixed on the center of the square's baseline, draw an arc from the upper corner of the square down to the extended baseline. Having thus located the length of the new rectangle, draw a line upward to the line extended from the top of the square.

sometimes called the canon, because it best demonstrates his standard for figure proportions (fig. 2.40). The idea of affording keenly pleasing proportional relationships extended into all areas of daily Greek life.

Historically these ancient Greek ideals have had continuing effects, influencing generations of artists. Leonardo Fibonacci, a Medieval mathematician of the thirteenth century, discovered a series of related numbers. The sequence was created by adding together the two previous numbers to arrive at each new number: 0, 1, 1, 2, 3, 5, 8, 13, 21, 34, 56, and so on, Published in Liber Abaci (Book of the Abacus) in 1202, this sequence is called the Fibonacci Series and also demonstrates an increasing ratio of approximately 1:1.6180. Indeed, one may start with any number. Using 10 as an example, one can multiply by 1.6180 to get the number 16. From that point simply adding the previous two numbers will provide the next number (26, 42, 68, etc.) and the growing sequence will have the same ratio as the Golden Section.

Today, scientists recognize this relationship in nature. It is found in the

▲ 2·38B

A diagonal line drawn across the new rectangle will cross the original square where the Golden Mean should be drawn parallel to the baseline. Measuring the sides of the Golden Rectangle will expose some interesting mathematical relationships. Comparing the original length of the square (AC) to the length of the new rectangle (AB) will reveal the same ratio as the length of the new addition (CB) is to the original square (AC). That ratio will be I to I.6180 (See the Fibonacci Series).

expanding curve of the nautilus shell, the curve of a cat's claw, the spiral growth of a pine cone, the seed patterns in a sunflower's head, or the center of a daisy (fig. 2.41). Botanists study this spiral arrangement (called phyllotaxy) in leaves, scales, and flowers. This spiraling curve may be demonstrated in the continuing projection of the Golden Rectangle into

progressively larger and larger units (figs. 2.42A and B).

During the Renaissance, artists like Leonardo da Vinci demonstrated renewed interest in mathematically formulated proportional scaling. This can be found, for example, in Leonardo's drawing *Proportions of the Human Figure* (fig. 2.43).

Modern artists also have composed pictures that conform with the standard frame shape of the Golden Rectangle. Georges Seurat, the French painter, is known for his scientifically measured use of the Post-Impressionistic technique of Pointillism, and his use of light and simultaneously contrasted colors. He was also intrigued with the mathematical

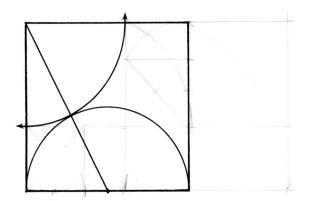

A 2 · 39A

A Golden Mean may be achieved by projecting into a square as well as projecting a square into a rectangle. From the center of the base of the square, draw a semicircle inside the square. Next draw a line from the center of the baseline to the square's upper corner. Where the diagonal crosses the first circle, establish a radius from the upper corner and draw an arch to the top and side of the square.

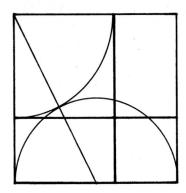

▲ 2·39B

Lines drawn parallel to the top and side of the square from the points of intersection by the second arc will subdivide the square into Golden Rectangles with the mathematical ratio of 1: 1.6180. This process may be done again from the opposite side or repeated in the new squares just created. This subdivision could continue on indefinitely revealing the same ratio of 1: 1.6180. (See the Fibonacci Series on page 59).

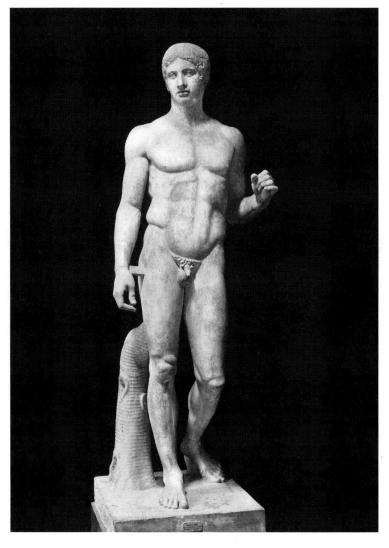

A 2 · 40

Polyclitus of Argos, Doryphoros (Roman copy), 450-440 B.C. Marble, 6 ft 11 in (2.12 m) high.

Polyclitus wrote a theoretical treatise and demonstrated a new system of ideal proportions in a sculpture, which took the form of a young man walking with a spear (the spear is no longer extant). The Greeks called the figure "Doryphoros" (spear carrier). The Polyclitus style was characterized by harmonious and rhythmical composition, and it influenced Roman culture.

National Museum, Naples, Italy. Art Resource, New York.

Form 61

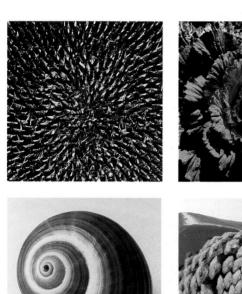

4 2 • 41

Examples of spiraling curves taken from nature.

(Top left and center, bottom right: © Bob Coyle/Red Diamond Stock Photos)

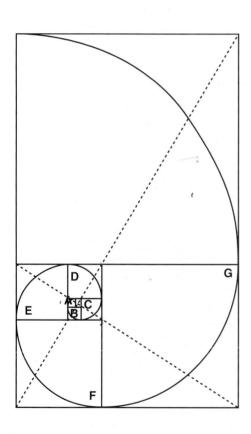

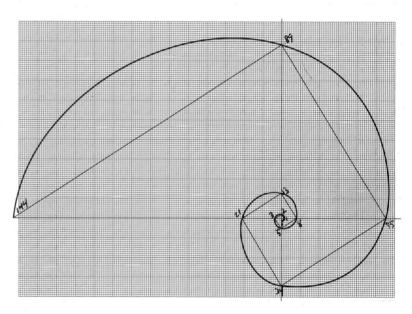

▲ 2 · 42B

This diagram illustrates the same spiral, created by plotting the numbers from the Fibonacci Series (1, 1, 2, 3, 5, 8, 13, 21, 34, 55, 89, 144) on a horizontal and vertical axis.

A 2 · 42A

The spiraling curve is created by the continuing projection of the Golden Section and may be drawn with the aid of a compass. The inside corner of the square locates the compass point, which scribes an arc from corner to corner. This line is continued into the next square with a new compass point located on the inside center corner of that square. The process continues from square to square until the spiral is completed.

2 · 43

Leonardo da Vinci, Proportions of the Human Figure (after Vitruvius), c. 1485–90. Pen and ink, $13\frac{1}{2} \times 9^{3}$ /4 in (34.3 × 24.8 cm).

Here, Leonardo demonstrates his interest in human anatomy. By positioning a male figure within a circle and a square, Leonardo was investigating the proportional relationships of the head, body, arms, and legs. Note that the figure's height is equal to its outstretched arms and that the square's center is located where the legs join while the circle's center is the navel.

Accademia, Venice, Italy. Corbis-Bettmann.

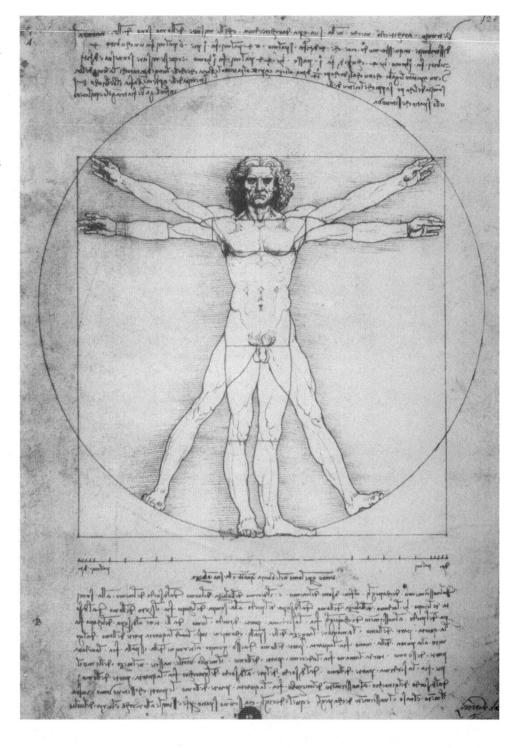

proportions of the Golden Rectangle. In the painting *Circus Sideshow (La Parade)*, Seurat used subtle variations of Golden Rectangles and squares (figs. 2.44A and B). Notice how he strategically placed the softly rounded figures, the tree, the geometric forms, and the various decorative motifs at Golden Section points.

Most artists seek balance and logical proportions. The dimensions of the images reproduced in this book would reinforce this claim. Some artists choose to disregard the essentials of proportions, that is, harmonious and balanced relationships, in order to emphasize the extremes of scale. When a very large

shape is placed alongside a much smaller one in an artwork, the effect is disproportionate. A spectator may register some dismay when confronted with extreme examples of disproportionate scale. Common objects are particularly unsettling when made monumental (fig. 2.45). Most artists who

63

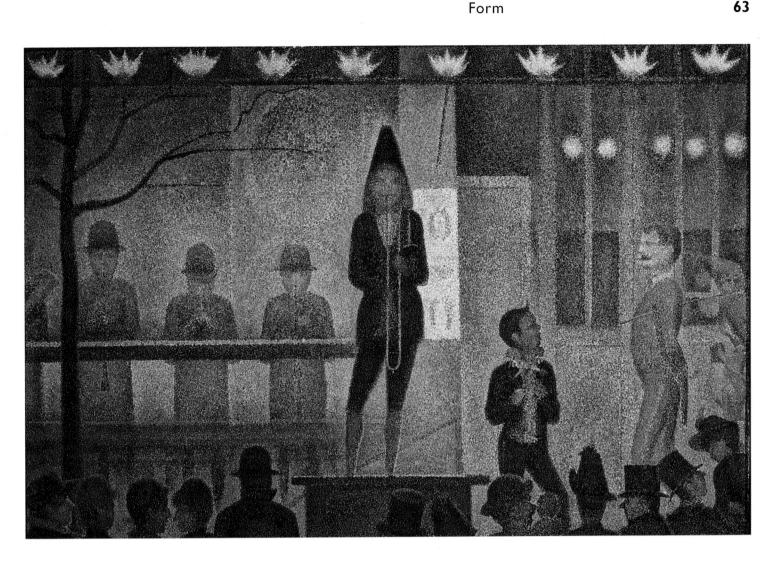

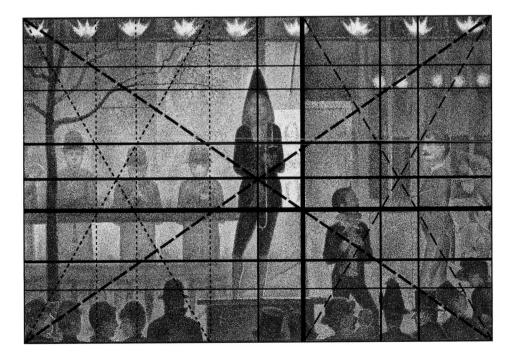

4 ▲ 2 · 44A & B

Georges Seurat, Circus Sideshow (La Parade), 1887-88. Oil on canvas, $39\frac{1}{4} \times 59$ in (99.7 × 149.9 cm).

When this Seurat painting is divided by a diagonal from upper left to lower right (large dashes), it crosses the large square where a Golden Rectangle would be subdivided by a heavy horizontal line. Smaller Golden Rectangles are created in the vertical rectangle on the right. These small rectangles may be further divided by intersecting diagonals. This could continue indefinitely. In addition, when the original square is established on the right side of the picture (small dotted lines) and a diagonal is drawn from lower left to upper right, the left side may be broken down into smaller Golden Rectangles that mirror those on the right side of the diagram. Notice how Seurat has used these lines and their intersections for the strategic placement of figures and imagery.

Metropolitan Museum of Art, New York. Bequest of Stephen C. Clark, 1960. Photo: Metropolitan Museum of Art/AKG, Berlin/SuperStock.

2 · 45

Claes Oldenburg and Coosje van Bruggen, Spoonbridge and Cherry (a fountain), 1985–88. Stainless steel, paint, and aluminum, $139 \times 243^{1/3} \times 63^{3/4}$ in (354 × 618 × 162 cm).

These clearly recognizable objects far surpass the scale expected of them.

Collection Walker Art Center. Minneapolis. Gift of Frederick R. Weisman in honor of his parents, William and Mary Weisman, 1988.

\checkmark 2 · 46 Jerome Paul Witkin, Jeff Davies, 1980. Oil on canvas, 6 × 4 ft (1.83 × 1.22 m).

If there was ever a painting in which one subject dominated the work, this must be it. Most artworks do not need this degree of dominance, but Witkin evidently wanted a forceful presence—and he got it.

Palmer Museum of Art, Pennsylvania State University. Gift of the American Academy and Institute of Arts and Letters (Hassam and Speicher Purchase Fund). make judgments in determining proportions will rely on an educated intuition and will adjust and readjust the sizes of their elements so that they seem to fill the whole work of art.

Still, many artists find a need for enlarging and/or diminishing the sizes of certain elements in order to aid the expression of an idea, or as a means of creating emphasis or dominance. When changes in scale are used for emphasis the artist will find that he or she can harness and sustain the observer's attention. In the Jerome Witkin painting (fig. 2.46), the artist uses enlargement as a means of emphasizing the presence of his figure. The subject, a large, physical man, is presented with a bulky torso in simple, light values, surrounded by the darker forms of the head, arms, jacket, and pants. The artist has positioned the white torso in the center of the composition for primary attention and has sized the figure's image so that it seems to burst the limits of the painting's format. Witkin's exaggerated

65

enlargement and relative scaling came from his perceptions of the actual figure he was to represent. The result is an overpowering portrait.

Another way artists have used inordinate proportion or scaling is to indicate rank, status, or importance of religious, political, military, and social personages. "Hierarchical scaling" is a term used to describe this system whereby figures of greatest importance are made larger in size according to their successive status. In the painting Madonna of Mercy, Piero della Francesca doubled the size of his Madonna figure in order to elevate her to a lofty object of reverence (fig. 2.47). The proportions in this painting, and others like it, are subjective in their intent rather than representational.

The physical size of the work in comparison to human scale can also be utilized for expressive purposes. As an example, Jan van Eyck's painting St. Francis Receiving the Stigmata seems to acquire an intimate, reverential quality because of its small size— $5 \times 5^{3/4}$ in $(12.7 \times 14.6 \text{ cm})$ (fig. 2.48). The artist Chuck Close, on the other hand, tends to overwhelm us with paintings of enormous human heads (fig. 2.49). Resulting from their overall size—the portraits range from five to eight feet in height—there is a proportional enlargement of facial details, such as hairs and skin pores. The view of the artist in his studio illustrates the overpowering scale of these enlargements (see fig. 2.49). The heads become heroic, intimidating, and, in some respects, sordid.

To summarize: scaling is used to create emphasis and expressive effects and to suggest spatial positions, as will be shown in later chapters.

Dominance (5)

Any work of art that strives for interest must exhibit differences that emphasize the degrees of importance of its various

2 · 47

Piero della Francesca, Madonna of Mercy (center panel of triptych), 1445–55. Oil and tempera on wood, height about 4 ft 9 in (1.44 m).

The figure of Mary extends her arms to make a shelter of her cape for the smaller figures at her feet. The positioning of the worshipful figures who surround the central columnar form helps to give a sense of depth to the scene. The artist's use of hierarchical scaling also strengthens the maternal and merciful power of the Madonna.

Italian Civic Museum, Sansepolcro, Italy/SuperStock.

A 2 · 48

Jan van Eyck (active 1422-d. 1441), St. Francis Receiving the Stigmata, no date. Oil on wood, $5 \times 5\frac{3}{4}$ in (12.7 × 14.6 cm).

As can be seen from the dimensions of this work, van Eyck has created an amazing microcosm. Despite its tiny size, everything is in near-perfect scale. The radical scaling-down creates a subdued, almost precious effect; there is no bombast or superficial heroism.

Philadelphia Museum of Art, PA. John G. Johnson Collection.

parts. These differences result from medium and compositional considerations. A musical piece, for example, can use crescendo; a dramatic production can use a spotlight. The means by which differences can be achieved, in fact, are many. If we substitute the term contrast for difference, we can see that the following, among others, can be used to achieve dominance: (1) isolation or separation of one part from others, (2) placement— "center stage" is most often used, but it can be used elsewhere, depending on the surroundings, (3) direction—a movement that contrasts with others draws attention, (4) scale—larger sizes normally dominate, and (5) character—a significant difference in general appearance is striking. Contrasts in color, value, and texture also produce attraction.

Obviously, the artist intends to use contrast to call attention to the significant parts of the work, thereby

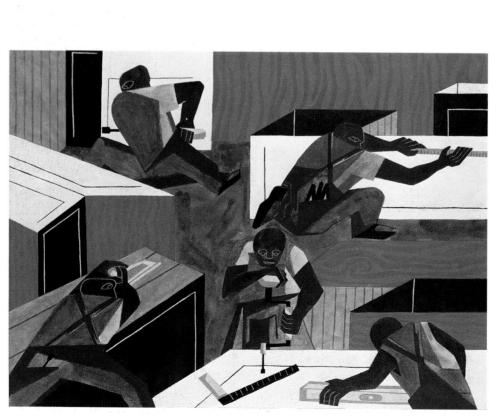

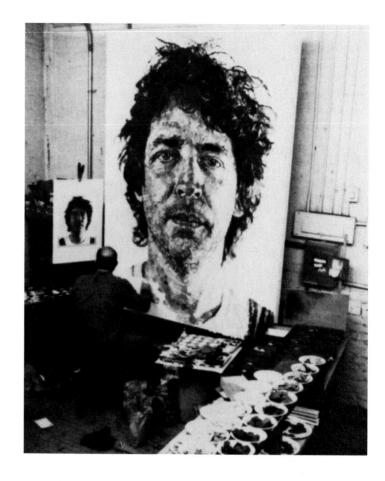

A 2 · 49

Chuck Close, Jud, 1982. Pulp paper collage on canvas, 8×6 ft (2.44 \times 1.83 m).

The enlargement of the heads in such paintings involves a scrupulous examination of every textural and "geographical" aspect of the sitter's face.

Courtesy of the Pace Gallery, New York. (Photograph by S. K. Yaeger.)

4 2⋅50

Jacob Lawrence, Cabinet Makers, 1946. Gouache with pencil underdrawing on paper, $21\frac{3}{4} \times 30$ in $(55.2 \times 76.2 \text{ cm})$.

The human figures here become the focal points, or "optical units" of greatest importance, because of their size and activity. The dominant area is where the two central figures merge. The other figures are lesser players, and the tables and tools less dominant still

Hirshhorn Museum and Sculpture Garden, Smithsonian Institution, Washington, D.C. Gift of Joseph H. Hirshhorn, 1966. (Photograph by John Tennant.)
Courtesy of the artist and Francine Seders Gallery, Seattle, WA.

67

making them dominant. Artists who neglect dominance in their work imply that everything is of equal importance; such art not only fails to communicate, but also creates a confusing visual image where the viewer is given no direction. In one sense, all parts are important, because even the secondary parts produce the norm against which the dominant parts are contrasted.

Regarding dominance, artists have two problems. First they must see that each part has the necessary degree of importance; and second, they must incorporate these parts, with their varying degrees of importance, into the rhythmic movement and balance of the work. In doing this, artists often find that they must use different methods to achieve dominance. One significant area might derive importance from its change in value, whereas another might rely on its busy or exciting shape (figs. 2.50, 2.51, and 2.52; see fig. 5.12).

The basic order created by variations in dominance (and in hierarchy, more generally) can be witnessed at every level of our lives—the celebrity pecking order in the entertainment field; the hierarchy of political, ecclesiastical, and civic organizations; the atomic system; the solar system—all in very different ways.

Movement (6)

Many observers do not realize that, in looking at an artwork, they are being "taken for a ride" or, more accurately, a tour. The tour director is, of course, the artist, who makes the eye travel comfortable and informative by providing roadways and rest stops. The roadways leading to the rest stops have certain speed limits established by the artist and the rest stops are of a predetermined duration.

The artist's roadways are, in fact, transitions between the rest stops, or optical units. The eye movements dictated by these transitions are produced by the direction of lines, shapes, shape

2.51

Agnes Pelton, The Voice, 1930. Oil on canvas, 26×21 in $(66.04 \times 53.34 \text{ cm})$.

"The Voice" illuminates this painting as the dominate, large, stark, and unforgettable image. Agnes Pelton speaks of "the abstract beauty of life—the voice." She further speaks of a delicate, plantlike flame that springs out of a smoldering root-source.

Collection of The Jonson Gallery of University of New Mexico Art Museum, Albuquerque.

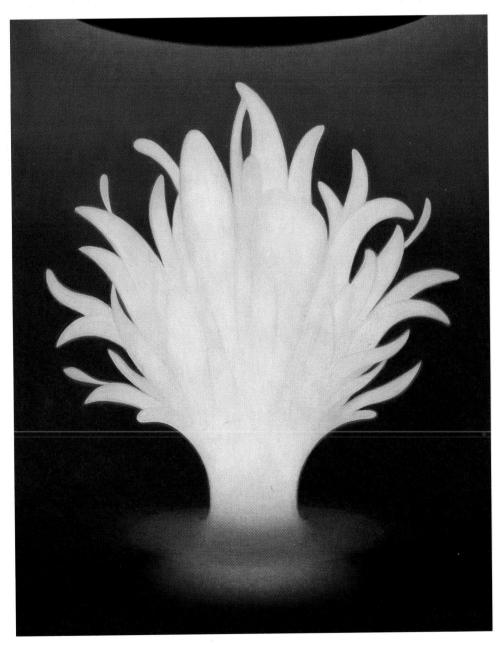

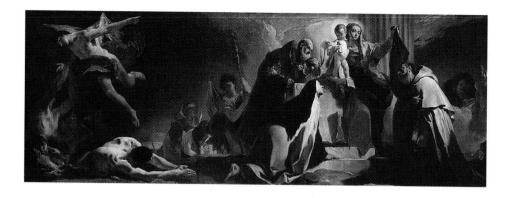

▲ 2.52

Giambattista Tiepolo, Madonna of Mt.

Carmel and the Souls in Purgatory, c. 1720. Oil on canvas, 82⅓ × 256 in. (210 × 650 cm).

The movement weaves its way through this work

because the lighting gives the figures dominance.

Scala/Art Resource, New York,

edges (or contours) and motifs that, in their similarity, cause us to relate them to each other. The lines and shapes (generally lengthy ones) and shape contours are generally pointed at each other in the same general direction. They may be touching but are normally interrupted by gaps over which the eyes skip as they move about. Sometimes "leaps" are necessary requiring strong directional thrusts and/or potent attractions.

The optical units that direct us contain vital visual information. In a work such as the *Mona Lisa* the figure is such a dominant unit that little eye movement is required (although there is secondary material of considerable interest). In other works, there may be several units of great interest that are widely separated and it thus becomes critical that the observer's vision be directed to them. There is usually some hierarchy in these units, some calling for more attention than others.

Kinetic, or moving, sculpture exists, but most sculpture and all picture

surfaces are static. Any animation in such works must come from an illusion of movement created by the artist through the configuration of their parts. The written word is read from side to side, but a visual image, whether twodimensional or three-dimensional can be read in a variety of directions. The movement of one's eyes as dictated by the artist must ensure that all areas are exploited with no static or uninteresting parts. The movement should be selfrenewing, constantly drawing attention back into the work (fig. 2.53 and see the "Pictorial Representations of Movement in Time" section in Chapter 8, p. 214).

Another movement in picturemaking is caused by the spatial positioning of the elements. Historically the illusion of spatial movement into the work has been produced by linear perspective. Although this is effective, it is not necessary. There is also "intuitive" space that often denies perspective by using certain artistic devices covered in the chapter on space. Some art, as in sculpture, and particularly kinetic

sculpture, even incorporates the element of time into its movement; more on this later, as well (see the "Movement" section in Chapter 9, p. 242).

Economy (7)

Very often, as a work develops, the artist will find that the solutions to various visual problems result in unnecessary complexity. The problem is frequently characterized by the broad and simple aspects of the work deteriorating into fragmentation. This process seems to be a necessary part of the developmental phase of the work, but the result may be that solutions to problems are outweighed by a lack of unity.

The artist can sometimes restore order by returning to significant essentials, eliminating elaborate details, and relating the particulars to the whole. This is a sacrifice not easily made or accepted because, in looking for solutions, interesting discoveries may have been made. But, interesting or not, these effects must often be surrendered for greater legibility and a more direct expression. Economy has no rules, but rather must be an outgrowth of the artist's instincts. If something works with respect to the whole, it is kept; if disruptive, it may be reworked or rejected.

Economy is often associated with the term "abstraction." Abstraction implies an active process of paring things down to the essentials necessary to the artist's style of expression. It strengthens both the conceptual and organizational aspects of the artwork. In a sense, the style dictates the degree of abstraction, though all artists abstract to some extent (fig. 2.54).

Economy is easily detected in many contemporary art styles. The early *modernists* Pablo Picasso and Henri Matisse were among those most influential in the trend toward economical abstraction (fig. 2.55; see fig. 4.7). The hard-edged works of Ellsworth

69

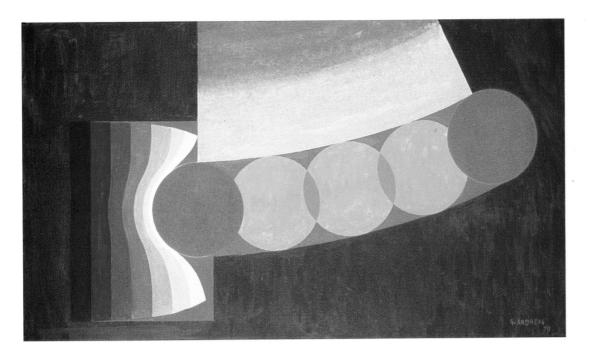

▲ 2.53
George Andreas, Energy, 1979. Oil on canvas, 31 × 54 in (78.7 × 137.2 cm).
The swing of the circles and their subsequent

The swing of the circles and their subsequent rebounding generates a sweeping pendulum-like movement.

Courtesy of the artist and Andreas Galleries.

Kelly, the "field" paintings of Barnett Newman and Morris Louis, and the analogous color canvases of Ad Reinhardt, all clearly feature economy (see figs. 1.25, 10.78, 10.81, and 10.90). Two sculptors of the Minimalist style (which itself bespeaks economy), Tony Smith and Donald Judd, make use of severely limited geometric forms (see figs. 9.41 and 9.42). They have renounced *illusionism*, preferring instead to create three-dimensional objects in actual space that excludes all excesses. The absence of elaboration results in a very direct statement.

In economizing, one flirts with monotony. Sometimes embellishments must be preserved or added to avoid this pitfall. But if the result is greater clarity, the risk (and the work!) are well worth it.

V 2.54

Tom Wesselmann, Study for First Illuminated Nude, 1965. Synthetic polymer on canvas, 3 ft 10 in × 3 ft 7 in (1.17 × 1.09 m).

Wesselmann has reduced the image to the few details he considers crucial, thereby practicing economy. Hirshhorn Museum and Sculpture Garden, Smithsonian Institution, Washington, D.C. Gift of Joseph H. Hirshhorn, 1966. (Photograph by John Tennant.) © 1998 Tom Wesselmann/licensed by VAGA, New York.

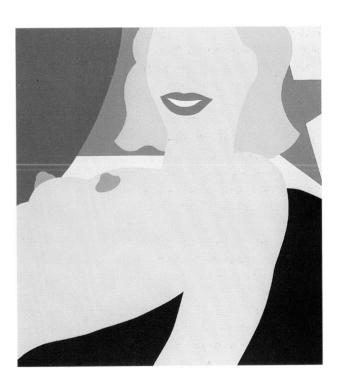

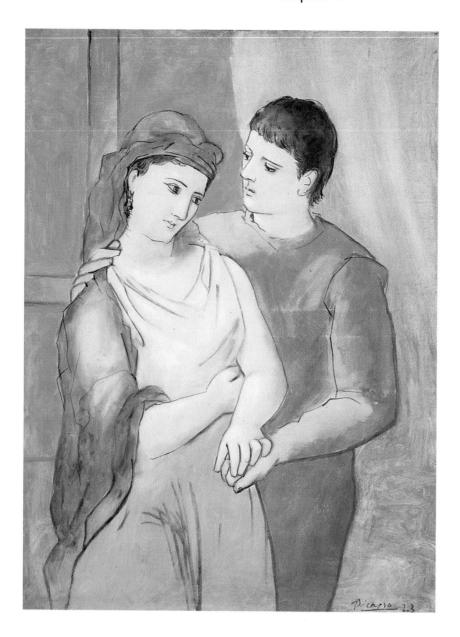

▲ 2 · 55 Pablo Picasso, *The Lovers*, 1923. Oil on linen, $51^{1/4} \times 38^{1/4}$ in (130.2 × 97.2 cm).

Picasso has simplified the complex qualities of the surface structures of his two figures, reducing them to contour lines and flat color renderings. Through the use of economy, the artist abstracted the two lovers to strengthen the expressive bond between them.

Chester Dale Collection. © 1998 Board of Trustees, National Gallery of Art, Washington. © 1997 Estate of Pablo Picasso/Artists Rights Society (ARS), New York.

SPACE: RESULT OF ELEMENTS/PRINCIPLES

The artist is always concerned about space as it evolves in artworks. The authors have taken the position that **space** is not an element, (that is, not one of the **principles of organization**) but a by-product of the elements as they are put into action and altered by the various principles of organization. Other people regard space as an element in its own right. However space is classified, the

concept of space is unquestionably of crucial importance—so much so, that many chapter sections in the text and the entire contents of Chapter 8 are devoted to the subject.

If we follow the order in our diagram (see fig. 2.1) we see that a medium is necessary for the creation of an element and that, once an element (a line for example) becomes visible, it automatically creates a spatial position in contrast with its background.

An artist, when considering space in a work, should look for consistency of relationships. There is nothing that can throw an artwork so "out of kilter" as a jumbled spatial order. If an artist begins with one kind of space, say, a flat two-dimensional representation of a figure, he or she should continue to develop two-dimensional concepts in the succeeding stages of the artwork. Consistency contributes immeasurably to unity.

Our familiarity with space comes, in part, from the exploration of outer space. Of course, we personally become acquainted with space, though on a less exalted level, as we move from point to point in the performance of our normal daily duties. As we do this we are unconsciously aware of the distance between these points and even of the limit of our vision, the horizon. In transferring nature's space to the drawing board or canvas, the artist has long been faced with problems—problems that have been dealt with in various ways in different historical periods. The artist must use the art elements to produce the illusion of the spatial phenomena he or she wants represented in the artwork. Quite often the effect sought is one that has the observer viewing the frame as a window into the space, terminating at some point or continuing to infinity. Such space, in an art setting, is called three-dimensional because all of this is condensed into a drawing or painting surface. These surfaces have their natural limits, but, additionally, there is a further

71

measurement, the illusion of depth, giving three-dimensional space.

FORM UNITY: A SUMMARY

Artists select a picture plane framed by certain dimensions. They have their tools and materials and with them begin to create elements on the surface. As they do so, spatial suggestions appear that may conform to their original conception; if not, the process of adjustment begins. The adjustment accelerates and continues as harmony and variety are applied to achieve balance, proportion, dominance, movement, and economy. As the development continues, artists depend on their intellect, emotions, and instincts. The ratio varies from artist to artist and from work to work. The result is an artwork that has its own distinctive form. If the work is successful, its form has unity—all parts belong and work together.

A unified artwork develops like symphonic orchestration in music. The musical composer generally begins with a theme that is taken through a number of variations. Notations direct the tempo and dynamics for the performers. The individual instruments, in following these notations, play their parts in contributing to the total musical effect. In addition, the thematic material is woven through the content of the work, harmonizing its sections. A successful musical composition speaks eloquently, with every measure seeming to be irreplaceable.

Every musical element just mentioned has its counterpart in art. In every creative medium, be it music, art, dance, poetry, prose, or theatre, the goal is unity. For the creator, unity results from the selection of appropriate devices peculiar to the medium and the use of certain principles to relate them. In art, an understanding of the principles of form-structure is indispensable. In the first chapters of this book, one can

begin to see the vast possibilities in the creative art realm. Through study of the principles of form organization, beginners develop an intellectual understanding that can, through persistent practice, become instinctive.

The art elements—line, shape, value, texture, and color—on which form is based rarely exist by themselves. They join forces in the total work. Their individual contributions can be studied separately, but in the development of a work, the ways in which they relate to each other must always be considered. Because each of the elements makes an individual contribution and has an intrinsic appeal, the elements are discussed separately in the following five chapters. It is necessary to do this for academic reasons. As an element is studied, please keep in mind those that preceded it. At the end, all the elements must be considered both individually and collectively. This is a big task, but necessary for that vital ingredient, unity.

CHAPTER THREE

Line

THE VOCABULARY OF LINE

LINE: THE ELEMENTARY MEANS OF COMMUNICATION

THE PHYSICAL CHARACTERISTICS OF LINE

Measure Type Direction Location Character

THE EXPRESSIVE PROPERTIES OF LINE

LINE AND THE OTHER ART ELEMENTS

Line and Shape Line and Value Line and Texture Line and Color

THE SPATIAL CHARACTERISTICS OF LINE

LINE AND REPRESENTATION

意名をなる人はそのからる

THE VOCABULARY OF LINE

Line The path of a moving point that is made by a tool, instrument, or medium as it moves across an area. A line is usually made visible because it contrasts in value with its surroundings. Three-dimensional lines may be made using string, wire, tubes, solid rods, etc.

calligraphy

Elegant, decorative writing. Lines used in artworks that possess the qualities found in this kind of writing may be called "calligraphic" and are generally flowing and rhythmical.

contour

In art, the line that defines the outermost limits of an object or a drawn or painted shape. It is sometimes considered to be synonymous with "outline"; as such, it indicates an edge that also may be defined by the extremities of darks, lights, textures, or colors.

cross-contour

A line that crosses and defines the surface undulations between, or up to, the outermost edges of shapes or objects.

expression

1. The manifestation through artistic form of a thought, emotion, or quality of meaning. 2. In art, expression is synonymous with the word *content*.

hatching

Repeated strokes of an art tool producing clustered lines (usually parallel) that create values. In "cross"-hatching similar lines pass over the hatched lines in a different direction, usually resulting in darker values.

implied line

Implied lines (subjective lines) are those that dim, fade, stop, and/or disappear. The missing portion of the line is implied to continue and is visually completed by the observer as the line reappears.

mass

1. In graphic art, a shape that appears to stand out three-dimensionally from the space surrounding it or appears to create the illusion of a solid body of material.

2. In the plastic arts, the physical bulk of a solid body of material.

nonrepresentational art

A term used to define work encompassing nonrecognizable imagery. This ranges from pure abstraction (nonrecognizable but derived from a recognizable object) to nonobjective art (not a product of the abstraction process, but derived from the artist's mind).

representation(al) art

A type of art when the subject is presented through the visual art elements so that the observer is reminded of actual objects.

LINE: THE ELEMENTARY MEANS OF COMMUNICATION

The lineup—"this guy's giving me a line"—the long gray line—"he plays tackle on the line"—the bus line—"the line forms here." These are some of the everyday expressions that share the word line with our first element. These common uses of the word imply that something is strung out or stretched a certain distance. You have undoubtedly stood in line for something and found your impatience turn to relief as you reached the front. Your line may have

been a single line (narrow) or two abreast (wider). Sometimes lines become straggly—but this had better not be the case in the military, where perfectly straight alignment is enforced. Standing lines often exhibit differences in width because of the different sizes of the people in the line or because people are bunched together.

Art lines and "people lines" have things in common. Theoretically a line is an extended dot; so, if only one person shows up, a dot is made. But, as other people are added, with their different dimensions and positions, the line's characteristics change. In art, these line variations are called "physical characteristics," and they can be used by

the artist to create meanings as well as to reproduce the appearance of the artist's subjects.

Different types of lines are everywhere: the easily seen lines the graphic artist makes with instruments such as crayons, pens, and pencils; the phenomena in nature that we can perceive as lines such as cracks in a sidewalk, rings in a tree, or a series of pebbles in alignment; and the linear masses such as spider webs, dental floss, and tree limbs that may be recognized as lines.

The artist uses line as a graphic device of visual instruction or as a symbol of something observed; these observances may prompt certain

Line **75**

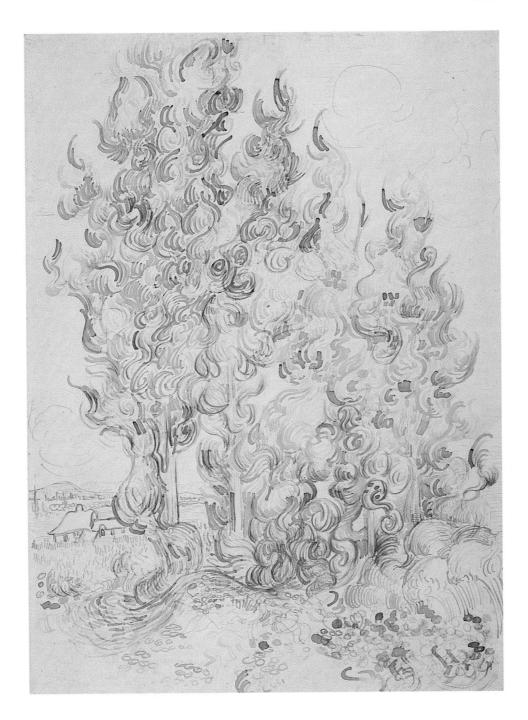

reactions in the artist that can be interpreted by line (fig. 3.1). Linear designs in the form of ideograms and alphabets are used by people as a basic means of communication, but the artist uses lines in a more broadly communicative manner. Line operates in different ways in the visual arts. For example, line can describe an edge, as on

A 3 · I

Vincent van Gogh, Grove of Cypresses, 1889. Reed pen and ink over pencil on paper, $24\frac{1}{2} \times 18\frac{1}{4}$ in (62.5 × 46.4 cm). By using broad-stroked lines and arranging them in a turmoil of flowing movement, van Gogh has subjectively interpreted his impression of a wind-blown landscape. Art Institute of Chicago. Gift of Robert Allerton, 1927.543. Photograph © Art Institute of Chicago. All rights reserved.

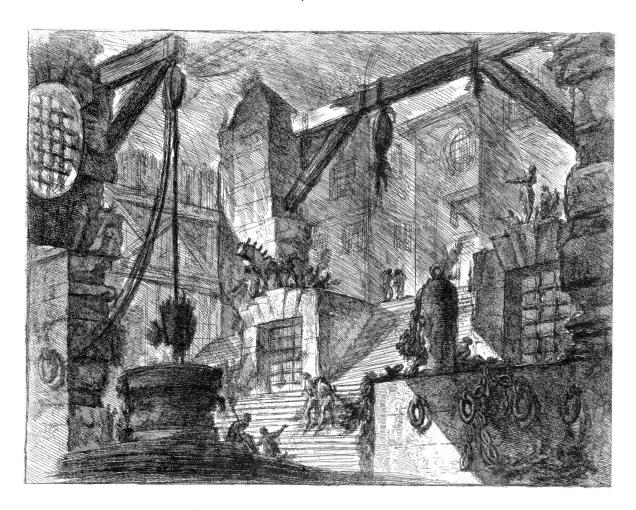

A 3 · 2

Giovanni Battista Piranesi, *The Well*, from *Carceri* (first edition, second issue), published 1750–58. Etching, engraving, scratching, burnishing, $16\frac{1}{4} \times 22$ in $(41.3 \times 55.9 \text{ cm})$.

Although this scene is the product of the artist's imagination, the objects are depicted objectively, with line used to define shapes, textures, and shadows.

Rosenwald Collection © Board of Trustees, National Gallery of Art, Washington.

₹ 3 ⋅ 3

Ellsworth Kelly, Apples, Paris, 1949. Charcoal pencil on paper, $17 \times 22^{1/8}$ in $(43.4 \times 56.4 \text{ cm})$.

Line becomes contour as it encircles an object, giving it a distinctive, and often recognizable, shape.

The Museum of Modern Art, New York. Gift of John S. Newberry (by exchange). Photograph © 1998 Museum of Modern Art.

Line 77

a piece of sculpture; it may be a meeting of areas where value, textural, or color differences do not blend in a drawing (fig. 3.2); or it may be a contour when defining the limits of a drawn shape (fig. 3.3).

Although clear and positively laid down graphic lines are often an artist's first choice, he or she may use an implied broken line for variation in application to suggest spatial change, movement, or animation. These lines seem to fade, stop, and/or disappear and then reappear as a continuation, or an extension of an edge or a direction. In the lithograph by Henri de Toulouse-Lautrec (fig. 3.4), the line of the dancer's skirt above her foot is implied to continue and the shapes in the highest portion of the print have implied lines that the spectator must complete (see the "Extensions" section in Chapter 2, page 45).

In three-dimensional art, actual lines that are created with fine floss, strings, wire, tubes, solid rods, etc., have added a new dimension to the repertoire of the plastic artist in the twentieth century. In addition complete works in such materials are unique to this time period. Artists like Richard Lippold, Alexander Calder, and Kenneth Snelson have devoted their entire careers to creating such works (see figs. 9.27, 9.35, and 9.37).

Linear-type materials used sculpturally as cited above add an extra dimension to lines as they literally move in space with measurable distances between them. They may seem passive or actually swoop and swirl in that space. Such linear explorations of space are a relatively new development.

Calligraphic lines in graphic art also seem to "swoop and swirl" sometimes suggesting, but never literally dipping into, space. A calligraphic line is highly personal in nature, similar to the individual qualities found in handwriting; it is flowing and rhythmical, and intriguing to the eye as it enriches an artwork. In comparing the

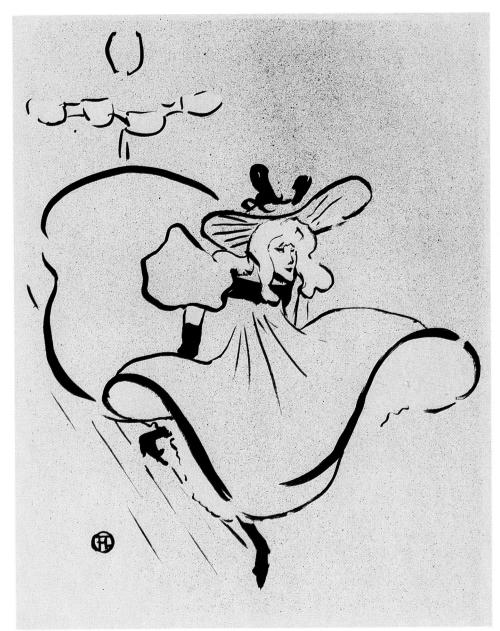

A 3·4

Henri de Toulouse-Lautrec, Jane Avril, first plate from Le Café Concert, 1893. Lithograph, printed in black, $10\frac{1}{2} \times 8\frac{7}{16}$ in (26.7 × 21.4 cm).

The lines in this image seem to have been drawn with great freedom, communicating the graceful action of the subject.

The Museum of Modern Art, New York. Purchase fund. Photograph © 1998 Museum of Modern Art.

3 • 5

Elmer Girten, exercise in calligraphy, 1992. Pen and ink on textured paper, 9×12 in $(22.9 \times 30.5 \text{ cm})$.

This is an example of the handwriting style developed by a professional calligrapher. It demonstrates the technique of flowing lines that has influenced so many graphic artists.

Courtesy of the artist.

₹ 3 . 6

Wang Hsi-chih: from Three Passages of Calligraphy: "Ping-an," "Ho-ju," and "Feng-chu," Eastern Ch'in dynasty, fourth century (321-379 A.D.), Calligraphy, Ink on paper.

Certain meanings intrinsic to line arise from their character. These character meanings are the product of the medium, the tools used, and the artist's method of application. The example of Chinese calligraphy shown here, which has historically been admired in China as an art form as valued as painting, is by a fourth century A.D. calligrapher. Always created with brush and ink on paper (the Chinese invented paper), the lively, abstract ideographs appear to leap upwards and outwards, "like a dragon leaping over heaven's gate," according to a later emperor. National Palace Museum, Taipei, Taiwan, Republic of China.

Line **79**

calligraphy of figure 3.5 with examples of drawn figures 3.6 and 3.7, one can see the shared qualities of grace and elegance. In addition, line can perform several functions at the same time. Its wide application includes the creation of value and texture, illustrating the impossibility of making a real distinction between the elements of art structure (see figs. 3.17 and 3.19).

When lines are used to reproduce the appearance of subjects in an artwork, this appearance can be reinforced by the artist's selection of lines that carry certain meanings. In this way, the subject may be altered or enhanced, and the work becomes an interpretation of that subject. Line meanings can also be used in conjunction with the other art elements.

THE PHYSICAL CHARACTERISTICS OF LINE

The physical characteristics of line are many. Lines may be straight or curved, direct or meandering, short or long, thin or thick, zigzag or serpentine. The value of these characteristics to the artist is that they have certain built-in associations. When we say that a person is a "straight arrow," we mean that the person is straightforward and reliable; a "crooked" person, on the other hand, is devious and untrustworthy. Most of us can find adjectives to fit various kinds of lines; those meanings, deriving in part from the associations cited above, make for the possibility of subtle psychological suggestions.

MEASURE

Measure refers to length and width of line. A line may be of any length and breadth. An infinite number of combinations of long and short, thick and thin lines can, according to their use,

▲ $3 \cdot 7$ Zhen Wu, (attributed to) Bamboo in the Wind, early 14th century hanging scroll, ink on paper, $29^{5/6} \times 21^{3/6}$ in (75.2 × 54.3 cm), China, Yuan dynasty.

Wu Zhen uses meticulous, controlled brushwork to describe the flowing linear (calligraphic) qualities of the bamboo tree.

Chinese and Japanese Special Fund. Courtesy of Museum of Fine Arts, Boston.

divide, balance, or unbalance a pictorial area.

TYPE

There are many different kinds of line. If the line continues in only one direction, it is straight; if changes of direction gradually occur, it is curved; if those changes are sudden and abrupt, an angular line is created. Taking into consideration the characteristic of type as well as measure, we find that long or short, thick or thin lines can be straight, angular, or curved. The straight line, in its continuity, ultimately becomes repetitious and, depending on its length, either rigid or brittle. The curved line may form an arc, reverse its curve to become wavy, or continue turning within itself to produce a spiral. Alterations of movement become visually entertaining and physically stimulating if they are rhythmical. A curved line is inherently graceful and, to a degree, unstable (see fig. 3.1). The abrupt changes of direction in an angular line create excitement and/or confusion

₩ 3.9

Mel Bochner, Vertigo, 1982. Charcoal, conté crayon, and pastel on canvas, 9 ft \times 6 ft 2 in (2.74 \times 1.88 m).

Line, the dominant element in this work, is almost wholly diagonal, imparting a feeling of intense activity and stress.

Albright-Knox Art Gallery, Buffalo, NY. Charles Clifton Fund, 1982. © Mel Bochner.

₫ 3 ⋅ 8

Student work, Cock Fight.

The abrupt changes of direction in the angular lines of this drawing create the excitement and tension of combat.

Courtesy of the authors

(fig. 3.8). Our eyes frequently have difficulty adapting to an angular line's unexpected deviations of direction. Hence, the angular line is full of challenging interest.

DIRECTION

A further complication of line is its basic direction; this direction can exist irrespective of the component movements within the line. That is, a line can be a zigzag type but take a generally curved direction. Thus, the line

type can be contradicted or flattered by its basic movement. A generally horizontal direction could indicate serenity and perfect stability, whereas a diagonal direction would probably imply agitation and motion (fig. 3.9). A vertical line generally suggests poise and aspiration. The direction of line is very important because in large measure it controls the movements of our eyes while we view a picture. Our eye movements can facilitate the continuity of relationships among the various properties of the element (fig. 3.10).

LOCATION

The control exercised over the measure, type, or direction of a line can be enhanced or diminished by its specific location. According to its placement, a line can serve to unify or divide, balance or unbalance a pictorial area. A diagonal

₩ 3 • 10

Dorothea Rockburne, Continuous Ship Curves, Yellow Ochre, 1991. Fresco pigment and watercolor stick, $10 \text{ ft} \times 15 \text{ ft} 7 \text{ in } (3.05 \times 4.75 \text{ m}).$

The ever-changing directions of the continuous lines in Dorothea Rockburne's painting control the movement of the eye as they loop about and traverse the pictorial composition.

Courtesy of André Emmerich Gallery, a Division of Sotheby's, on behalf of Dorothea Rockburne.

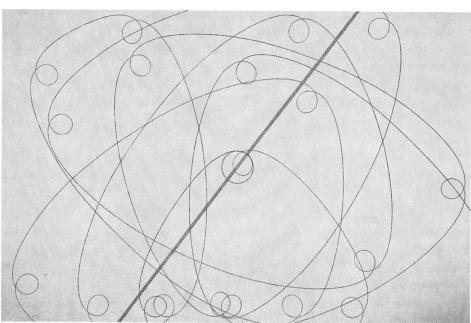

Line 81

line might be soaring or plunging, depending upon its high or low position relative to the frame. The various attributes of line can act in concert toward one goal or can serve separate roles of expression and design. A fully developed work, therefore, may recognize and use all physical properties, although it is also possible that fewer than the total number can be successfully used. This is true largely because of the dual role of these properties. For instance, unity in a work might be achieved by repetition of line length, at the same time that variety is being created through difference in the line's width, medium, or other properties.

CHARACTER

Along with measure, type, direction, and location, line possesses character, a term largely related to the medium with which the line is created. Different media can be used in the same work to create greater interest. Monotony could result from the consistent use of lines of the same character unless the unity so gained is balanced by the variation of other physical properties. Varied instruments, such as the brush, burin, stick, and fingers, have distinctive characteristics that can be exploited by the artist (fig. 3.11). The artist is the real master of the situation, and it is the artist's ability, experience, intention, and mental and physical condition that determine the effectiveness of line character. Whether the viewer sees lines of uniformity or accent, certainty or indecision, tension or relaxation, are decisions only the artist can make.

The personality or emotional quality of the line is greatly dependent on the nature of the medium chosen. In Rembrandt's sketch *Nathan Admonishing David*, the expressive qualities created by the soft brush lines of ink, juxtaposed with the precise and firm lines of pen and ink, can be clearly seen (fig. 3.12).

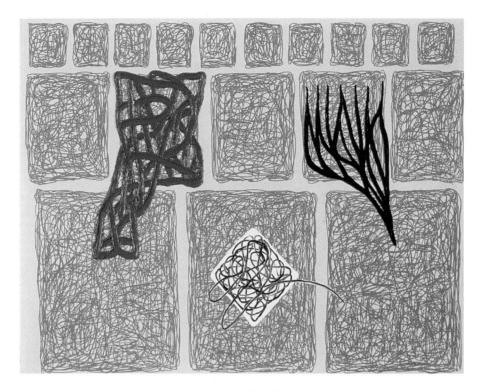

3 • 11

Jonathan Lasker, The Division of Happiness, 1991. Oil on linen, 5 ft 3 in \times 6 ft 9 in (1.60 \times 2.06 m).

The unique character of the line work in this piece is enhanced by the careful choice of instruments, color, and shape. Courtesy of the artist and Camille and Paul Oliver-Hoffmann.

₹ 3 • 12

Rembrandt Harmenszoon van Rijn, Nathan Admonishing David, no date. Pen and brush with bistre, $7^{5/16} \times 9^{5/16}$ in (18.6 \times 23.6 cm).

The crisp, biting lines of the pen contrast effectively with broader, softer lines of the brush.

© Metropolitan Museum of Art, New York. Bequest of Mrs. H. O. Havemeyer, 1929. The Havemeyer Collection.

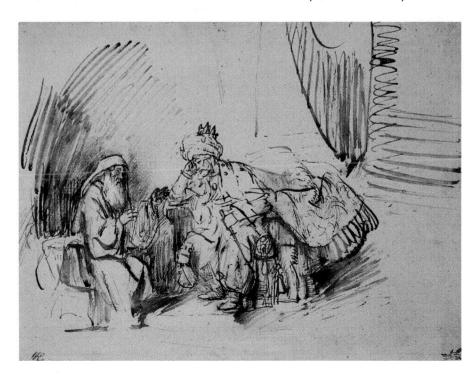

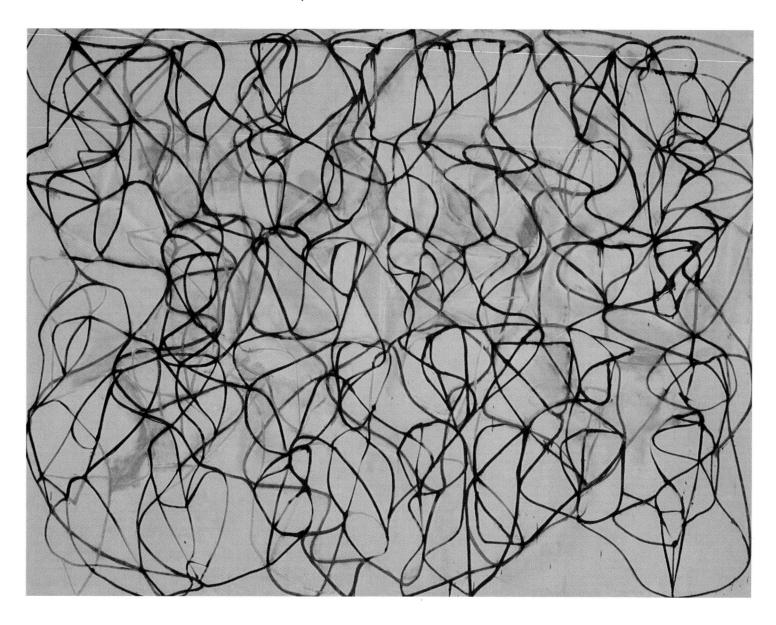

\blacktriangle 3·13 Brice Marden, Cold Mountain 3, 1989–91. Oil on linen, 9 × 12 ft (2.74 × 3.66 m).

In this painting—from a series he calls *Cold Mountain* (after a Chinese poem)—Brice Marden presents a weblike network of lines that seem to wander in space. This artist, however, works, reworks, and calculates the lines as he engages in spatial exploration. The pale blue lines interact like trails left behind. © 1997 Brice Marden/Artists Rights Society (ARS), New York.

THE EXPRESSIVE PROPERTIES OF LINE

The qualities of line can be described in terms of general states of feeling—somber, tired, energetic, brittle, alive, and the like. However, in a work of art, as in the human mind, such feelings are rarely so clearly defined. An infinite number of conditions of varying subtlety can be communicated by the artist. The spectator's recognition of these qualities is a matter of feeling, which means that the spectator must be receptive and

perceptive and have a reservoir of experiences to draw upon.

Through composition and expression, individual lines come to life as they play their various roles. Some lines are dominant and some subordinate, but all are of supreme importance in a work of art. Although lines may be admired separately, their real beauty lies in the relationships they establish in the form (fig. 3.13). This form can be representational or non-representational, but recognition and enjoyment of the work is more likely when the work is understood on the abstract level.

83

Preoccupation with subject can blind one to the work's expressive art qualities, and the lack of organizational soundness may well confuse the artist's message. Organization, however, brings the artist's message to the forefront. Planned composition also aids in organizing the thoughts and feelings of the viewer regarding the image depicted in the art, regardless of the subject matter that has been a part of the viewer's past experience.

LINE AND THE OTHER ART ELEMENTS

Line has additional physical characteristics that are very closely related to the other art elements. Line can possess color, value, and texture, and it can create shape. Some of these factors are essential to the very creation of line,

while others are introduced as needed. These properties might be thought of separately, but nevertheless they cooperate to give line an intrinsic appeal, meaning that line can be admired for its own sake. Artists often exploit this appeal by creating pictures where the linear effects are dominant, the others subordinate. On the other hand, there are some works that are line-free. depending entirely on other elements.

LINE AND SHAPE

In creating shape, line serves as a continuous edge of a figure, object, or mass. A line that describes an area in this manner is called a contour. Whereas contour lines generally describe the extremities of shapes or masses, crosscontours provide information about the nature of the surfaces contained within those edges, somewhat in the manner of a topographical map (fig. 3.14). If it is

4 3⋅14

Line

The lines on a topographical map indicate the various elevations of the earth's surface. In a similar way, the artist uses cross-contours to show the configuration of the subject.

3 · 15

Harold Tovish, Contour Drawing, 1972. Pencil, 19×25 in $(48.3 \times 63.5 \text{ cm})$.

The cross-contours illustrate the dips and swells of the features. This technique can be used to describe the surface of any subject being interpreted.

Courtesy of the artist.

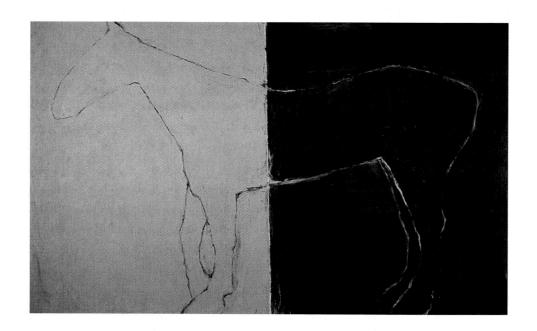

A 3 · 16

Susan Rothenberg, *United States*, 1975. Acrylic and tempera on canvas, 9 ft 6 in \times 15 ft 9 in (2.90 \times 4.80 m).

The line describing the horse in this painting is called a contour. Susan Rothenberg is a contemporary artist who is noted for her series of horses done in a manner that might be referred to as Minimalist-Abstract.

Collection Mr. and Mrs. Frank Rothman. Courtesy of Sperone Westwater, New York, on behalf of the artist.

85

< 3 ⋅ 17

Group lines produce value. The upper row of blocks appears to become darker from left to right because the lines increase in width. In

the second row of blocks, a similar effect is created as the lines on the right become closer together.

imagined that an ant, saturated with ink, crawls across one's face, leaving its trail, one can see that it has described the features of that face by cross-contour (fig. 3.15). One can use modulated lines, that is, thick and thin, irregular and curved, to enhance cross-contours; one can even vary the pressure when producing the line so that its darkest portion would seem to advance and the lightest to recede. Lines, massed together, can be varied in spacing from narrow to wide to produce a similar advancing and/or receding effect. Contour lines also have the capacity to separate shapes, values, textures, and colors (fig. 3.16).

A series of closely placed lines creates textures and toned areas. The relationships of the ends of these linear areas establish boundaries that transpose the areas into shapes.

LINE AND VALUE

The contrast in lightness and darkness that a line exhibits against its background is called value. Usually, every line will use a value different than its surroundings to be visible. Groups of lines create areas that can differ in value. Lines can be thick, thin, or any width in between. Wide, heavy lines appear dark in value, while narrow lines appear light in value. Value changes also can be controlled by varying the spaces between the lines. Widely spaced lines appear light, and closely spaced lines appear dark (see fig. 3.17). Value differences can also result from mixtures of media or amount of pressure exerted. Parallel lines and cross-hatching are examples of groups of single lines that create areas of differing value (fig. 3.18). Sometimes, when

3 . 18

Jacques Villon, Baudelaire, c. 1918? Etching, printed in black, plate, $16^{5/16} \times 11$ in (41.4 \times 28 cm).

This work gives evidence of the use of hatching and cross-hatching to create degrees of value.

The Museum of Modern Art, New York. Gift of Victor S. Riesenfeld. Photograph © Museum of Modern Art. © Artists Rights Society (ARS), New York/ADAGP, Paris.

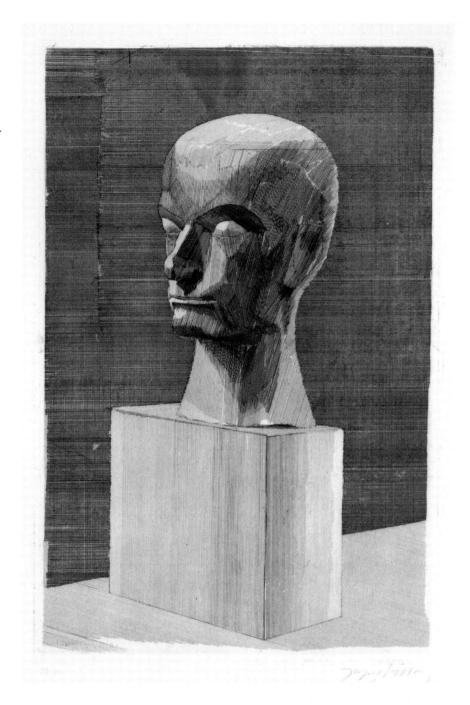

hatching is used to produce value, the strokes will be made to define the direction of a surface at any given point.

LINE AND TEXTURE

Groups of lines can combine to produce *textures* that suggest a visual feeling for the character of the surface (fig. 3.19). This apparent texture can result from the inherent characteristic of individual

media and tools, and their distinctive qualities can be enhanced or diminished by the manner of handling. Brushes with a hard bristle, for instance, can make either sharp or rough lines, depending on hand pressure, amount of medium carried, and quality of execution. Brushes with soft hairs can produce smooth lines if loaded with thin paint and can produce thick blotted lines if loaded with heavy paint. Other tools and

Line **87**

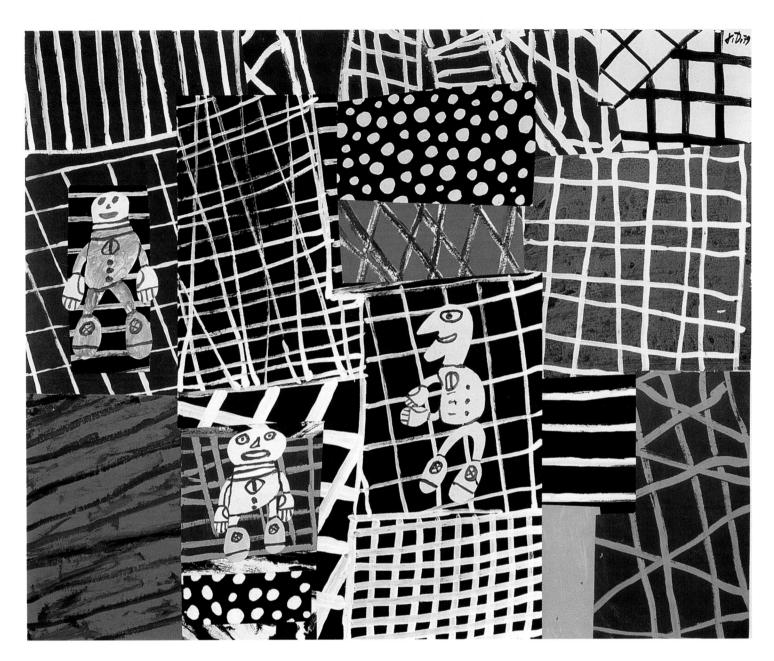

A 3·19

Jean Dubuffet, Urgence, 1979. Acrylic on canvas-backed paper with collage, $22^{1}/2 \times 27^{1}/2$ in (57.15 \times 69.85 cm).

In this painting/collage, Jean Dubuffet creates diverse textures by varying his many line combinations.

Collection Donald Rubin. Courtesy of Jonathan Novak Contemporary Art, Los Angeles. © 1997 Artists Rights Society (ARS), New York/ADAGP, Paris.

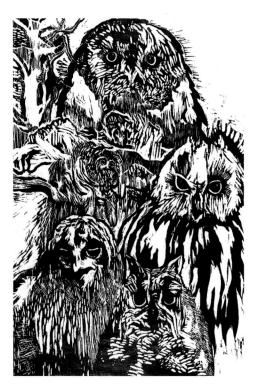

media can produce similar variations of line (fig. 3.20).

LINE AND COLOR

The introduction of color to a line adds an important expressive potential. Color can accentuate other line properties. A hard line combined with an intense color produces a forceful or even harsh effect. This effect would be considerably muted if the same line were created in a more neutralized color. Different colors have come to be identified with different emotional states. Thus, the artist might use red as a *symbol* of passion or anger, yellow to suggest cowardice or warmth, and so forth (see the "Color and Emotion" section in Chapter 7, p. 162).

THE SPATIAL CHARACTERISTICS OF LINE

All the physical characteristics of line contain spatial properties that are subject to control by the artist. Mere position within a prescribed area suggests space. Value contrast can cause lines to advance and recede (fig. 3.21). An individual line with varied values throughout its length may appear to writhe and twist in space. Because warm colors generally advance and cool colors generally recede, the spatial properties of colored lines are obvious. Every factor that produces line has something to say about line's location in space. The artist's job is to

▲ $3 \cdot 20$ Kathleen Ellen Gibson, Owls, 1971. Print (woodcut), $11\frac{1}{2} \times 17$ in (29.2 × 43.2 cm).

When knives and gouges are used to cut the wood, the lines and textures created are usually somewhat different from those produced by another medium.

3.21

Collection Dave Cayton

Daniel Christensen, GRUS, 1968. Synthetic polymer on canvas, 130×99 in $(3.3 \times 2.51 \text{ m})$.

Variations in the continuous curvilinear lines within this painting create illusions of open space. These variations include changes in the physical properties of the measure, direction, location, and character of the lines, as well as changes in value and color.

Hirshhorn Museum and Sculpture Garden, Smithsonian Institution, Washington, D.C. Gift of Joseph H. Hirshhorn, 1972. (Photograph by Lee Stalsworth.) © 1998 Daniel Christensen/licensed by VAGA, New York, NY.

89

use these factors to create spatial order (fig. 3.22).

LINE AND REPRESENTATION

Line creates representation on both abstract and realistic levels. In general, we have dealt primarily with abstract definitions, but it is easy to see that the application can be observed equally in a realistic context. For example, we have discussed the advancing and receding qualities of value in a line. If a particular line is drawn to represent the contours of a piece of drapery, the value contrast, as it changes in measure and direction, might describe the relative spatial position of the folds of the drapery (fig. 3.23). An

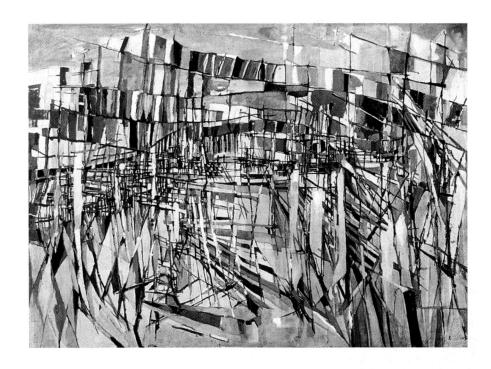

A 3 · 22

Maria Helena Viera da Silva, The City, 1951. Oil on canvas, $37\frac{1}{4} \times 32\frac{1}{4}$ in (94.6 \times 81.9 cm).

The spatial illusion, of such obvious importance in this example, is largely the product of the physical properties of the lines strengthened by contrasting areas of value and color. Toledo Museum of Art, Toledo, OH. Gift of Edward Drummond Libbey.

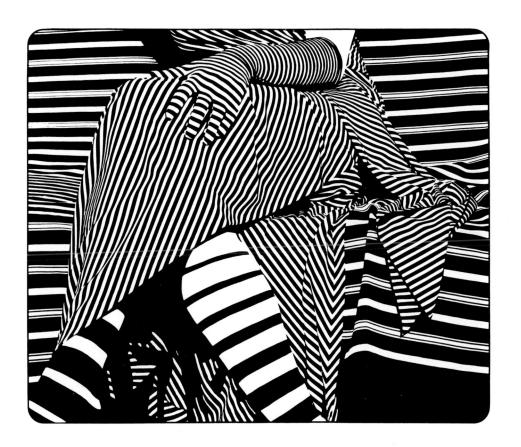

∢ 3 ⋅ 23

J. Seeley, Stripe Song, 1981. Print (photo silkscreen), 22 × 30 in (81.9 × 76.2 cm). Seeley is an acknowledged master of the high-contrast image. Combining the undeniable visual appeal of Op art with the implicit realism of the photographic image, the artist's black-and-white kinear abstractions are boldly decorative, highly complex, and a delightful treat for the eye.

© 1998 J. M. Seeley/licensed by VAGA, New York, NY.

3 . 24

Juan Gris (José Victoriano González), Portrait of Max Jacob, 1919. Pencil on sheet, $14\frac{3}{8} \times 10^{1/2}$ in (36.5 × 26.7 cm).

This drawing, done entirely in line, provides information on the physical presence as well as the psychological character of the sitter.

The Museum of Modern Art, New York. Gift of James Thrall Soby. Photograph © 1998 Museum of Modern Art.

A 3 · 25

Giovanni Battista Tiepolo, Study for Figure of Falsehood on the Ceiling of the Palazzo Trento-Valmarana, Vicenza, no date. Pen and brown ink, $6\frac{3}{8} \times 6$ in (16.2 × 15.4 cm).

This gestural drawing clearly illustrates the dramatic action of the activity. Artists often try to sustain this effect beyond the initial stage of a sketch.

The Art Museum, Princeton University, NJ. Bequest of Dan Fellows Platt. Photo: Bruce M. White

A 3 · 26

Honoré Daumier, Two Barristers, c. 1866. Pen and ink, 8 \times 113% in (20.5 \times 29.5 cm).

Gesture relieves the static immobility of a subject, giving it liveliness and excitement.

© Board of Trustees of the Victoria and Albert Museum, London.

artist drawing a linear portrait of a person might use line properties to suggest a physical presence (fig. 3.24). The artist might also be able to convey—either satirically or sympathetically—much information about the character of the sitter. Thus, line in *representation* has many objective and subjective implications. All are the direct result of the artist's manipulation of the physical properties.

In its role of signifying ideas and conveying feelings, line moves and lives, pulsating with significant emotions. In visual art, line becomes a means for transcribing the expressive language of

Line 91

ideas and emotions. It describes the edges or contours of shapes, it diagrams silhouettes, it encompasses spaces and areas—all in such a way as to convey meaning.

Line is not used exclusively to express deep emotion and experience in this manner. Often, it depicts facts alone: the lines drawn in an architect's plan for a building or an engineer's drawings of a bridge; the lines drawn on maps to represent rivers, roads, or contours; or the lines drawn on paper to represent words. Such use of line is primarily utilitarian, a convenient way of communicating ideas to another person. In addition to its ability to describe facts with precision, line can express action in a "gestural" sense. The gesture in graphic work

A 3 · 27

Steve Magada, *Trio*, c. 1966. Oil on canvas, size and present location unknown. The gestural lines in this work successfully evoke the movements of the performers. Photograph courtesy of Virginia Magada.

implies the past, present, and future motion of the drawn subject. Gestural drawing in any medium displays lines that are drawn freely, quickly, and seemingly without inhibition. Many paintings are preceded by and based on the artist's initial gestural response (fig. 3.25). If preserved in the work, this response captures the intrinsic spirit and animation seen in the subject. This spirit can pertain to both animate and inanimate subjects—a towel casually

thrown over a chair has a unique "gesture" resulting from the way it falls, its weight and texture, and the surface it contacts. Obviously this gestural concept applies even more conspicuously to those subjects that are capable of movement (fig. 3.26).

Whichever the emphasis— expression of human emotions, depiction of action, or communication of factual information—line is an important element for the artist to use (fig. 3.27).

Shape

THE VOCABULARY OF SHAPE

INTRODUCTION TO SHAPE

THE DEFINITION OF SHAPE

THE USE OF SHAPES

Shape Dimensions

The illusions of two-dimensional shapes
The illusions of three-dimensional shapes

Shape and Principles of Design

Balance

Direction

Duration and relative dominance

Harmony and variety

Shapes and the space concept

SHAPE AND CONTENT

THE VOCABULARY OF SHAPE

Shape An area that stands out from the space next to or around it because of a defined or implied boundary or because of differences of value, color, or texture.

actual shape

Clearly defined or positive areas (as opposed to an implied shape).

amorphous shape

A shape without clarity or definition: formless, indistinct, and of uncertain dimension.

biomorphic shape

Irregular shape that resembles the freely developed curves found in live organisms.

Cubism

The name given to the painting style invented by Pablo Picasso and Georges Braque between 1907 and 1912, which used multiple views of objects to create the effect of their three-dimensionality, while acknowledging the two-dimensional surface of the picture plane. Signaling the beginning of abstract art, it is a semi-abstract style that continued the strong trend away from representational art initiated by Cezanne in the late 1800s.

decorative (shape)

Ornamenting or enriching but, more importantly in art, stressing the two-dimensional nature of an artwork or any of its elements (shape). Decorative art emphasizes the essential flatness of a surface.

equivocal space

A condition, usually intentional on the artist's part, when the viewer may, at different times, see more than one set of relationships between art elements or depicted objects. This may be compared to the familiar "optical illusion."

geometric shape

A shape that appears related to geometry. Geometric shapes are usually simple, such as triangles, rectangles, and circles.

implied shape

A shape suggested or created by the psychological connection of dots, lines, areas, or their edges, creating the visual appearance of a shape that does not physically exist. (See Gestalt.)

kinetic art

A form of art named after a Greek word (Kinesis) meaning "motion." Art that involves an element of random or mechanical movement.

mass

1. In graphic art, a shape that appears to stand out three-dimensionally from the space surrounding it, or appears to create the illusion of a solid body of material.

2. In the plastic arts, the physical bulk of a solid body of material. (See plastic, three-dimensional, and volume.)

objective (shape)

That which is based, as near as possible, on physical actuality or optical perception. Such art tends to appear natural or real.

perspective

Any graphic system used to create the illusion of three-dimensional images and/or spatial relationships on a two-dimensional surface. There are several types of perspective: see atmospheric, linear, and projection systems in Chapter 8.

planar (shape)

Having to do with planes.

plane

I. An area that is essentially twodimensional, having height and width. 2. A flat or level surface. 3. A two-dimensional surface that may extend in a threedimensional spatial direction.

plastic (shape)

- I. The use of the elements (shape) to create the illusion of the third dimension on a two-dimensional surface.
- 2. Describing three-dimensional art forms such as architecture, sculpture, ceramics, etc. (See mass, three-dimensional, and volume.)

rectilinear shape

A shape whose boundaries usually consist entirely of straight lines.

subjective (shape)

1. That which is derived from the mind and reflects an individual viewpoint or bias. 2. Subjective tends to be inventive or creative.

Surrealism

A style of artistic expression, influenced by Freudian psychology, that emphasizes fantasy and whose subjects are usually experiences revealed by the subconscious mind through the use of automatic techniques (rubbings, doodles, blots, cloud patterns, etc.). Originally a literary movement and an outgrowth of Dadaism, Surrealism was established by a literary manifesto written in 1924.

three-dimensional (shape)

To possess, or to create the illusion of possessing, the dimension of depth, in addition to having the dimensions of height and width.

two-dimensional (shape)

To possess the dimensions of height and width, especially in regard to the flat surface or picture plane.

volume

A measurable area of defined or occupied space. (See mass, plastic, and three-dimensional.)

4 • 1

Rufino Tamayo, Dos Personajes Atacados por Perros, 1983. (Edition of 75) Mixografia on handmade paper, 60×90 in. (152.4 \times 228.6 cm).

Tamayo has created an air of fantasy by semiabstracting the people and dogs, creating an image of distance and ritualized terror.

Courtesy of Remba Gallery, Hollywood, CA.

INTRODUCTION TO SHAPE

Shapes are the building blocks of art structure. Edifices of brick, stone, and mortar are intended by the architect and mason to have beauty of design, skilled craftsmanship, and structural strength. The artist shares these same goals in creating a picture. Bricks and stones, however, are tangible objects, whereas pictorial shapes exist largely in terms of the illusions they create. The challenge facing the artist is to use the infinitely varied illusions of shape to make believable the fantasy inherent in all art. In other words, an artwork is never the real thing, and the shapes producing the image are never real animals, buildings, people; they are the artist's subjects, if indeed the artist uses subjects at all. The artist might be stimulated by such objects and, in many cases, might reproduce the objects' basic appearances fairly closely. The alterations of surface appearance required to achieve compositional unity may result in a semifantasy (fig. 4.1). On the other hand, the artist may use shapes that are not intended to represent anything at all, or that, even though representational at the outset, may eventually lead to a final work where

copied appearances are almost eliminated. This could be called pure fantasy, because the final image is entirely the product of the artist's imagination. Capable artists, whatever degree of fantasy they employ, are able to convince us that the fantasy is a possible reality. Any successful work of art, regardless of medium, leads the sensitive observer into a persuasive world of the imagination. In the visual arts, shapes play an important part in achieving this goal.

THE DEFINITION OF SHAPE

We can begin to define shape in art as a line enclosing an area. Such use of line is called outline or **contour.** However, even when we have only a few elements of form to go by, as illustrated in figure 4.2, our minds adjust to read a visible effect of shape. Apparently, we have an instinctive need for order that enables our minds to fill in the parts that have been left out. This is the principle first put forward by the German **Gestalt** psychologists, during their exploration into human perception in the early twentieth century. They stated that our minds tend to "see" organized wholes, or forms, as a totality (*Gestalt* is the German word for "form"), before they perceive

4 • 2

The spectator automatically infers fully drawn shapes from those suggested by the dots and lines.

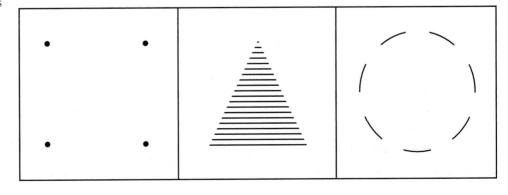

the individual parts applied to human visual perception. Our minds also tend to insist on creating shapes from approximately related elements such as the four dots perceived as a square. Thus we read the diagrams in figure 4.2 as shapes, even though no contours have been drawn to connect the dots, or around the tips of the lines forming the triangle. The last drawing, where gaps and dashes are mentally filled in to form a circle, comes closest to illustrating our first definition of a shape as being a line enclosing an area. But the Gestalt theory causes us to question our first definition, because closure is not always an

V 4 · 3 Claude Monet, Water Lilies, 1919–26. Oil on canvas, 6 ft $6\frac{3}{4}$ in × 13 ft $11\frac{3}{4}$ in (2 × 4.26 m).

Had he so chosen, Monet could have painted a more distinct version of the lilies in the water, but he was much more interested in the effect of shimmering light on color relationships—hence the misty, amorphous nature of the shapes.

Saint Louis Art Museum, St. Louis, MO. Gift of the Steinberg Charitable Fund.

absolutely necessary condition for forming a shape.

There are other definitions of what we call shape that may round out our understanding of this element. Among these are: any visually perceived area of value, texture, color, or line, or any combination of these elements. In pictorial forms of art, shapes are flat, or two-dimensional. In the threedimensional forms of art (sculpture, architecture, environmental design, and so on), shapes are more often described as solids, or masses. When threedimensional artists do their initial planning using graphic means, they must be aware of the shape of the picture plane. The picture plane conditions the use and characteristics of all shapes and other elements on it, as was already discussed at greater length in Chapter 2.

Shapes in pictorial art sometimes have exact limits, as in the case of geometric shapes, or they may be implied, as illustrated by the preceding diagrams. Or they may be amorphous—that is, so vague or delicate that their edges cannot be

determined with any degree of exactitude (fig. 4.3). Shapes in the **plastic** arts, however, are more defined, because of the very nature of the materials from which they are created. Their edges, or outer contours, are the determining factor, no matter what their degree of irregularity (fig. 4.4).

Shapes can vary endlessly, ranging in type from **objective**, **geometric**, and **implied** to amorphous. They may differ in size, position, balance, color, value, and texture according to the function they need to fulfill in the work of art. Shapes also can be static, stable, active, lively, and seem to contract or expand, depending on how they are used by the artist.

There are different names for categories or families of shape depending on whether they are imaginary (*subjective*) or derived from observable phenomena (*objective*). The configuration of a shape gives it a character that distinguishes it from others. When the shapes used by an artist imitate those formed by natural forces (stones, puddles, leaves, clouds) they are called by various terms, in addition to objective,

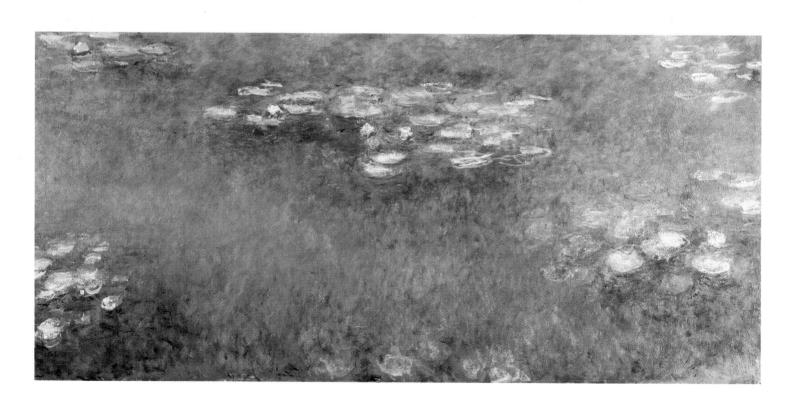

97

Anthony Caro, Odalisque, 1984. Steel, 6 ft 5 in \times 8 ft 1 in \times 5 ft 4 in (1.96 \times 2.46 \times 1.63 m).

Despite the irregularity and complexity of the contours, lighting, and color of these sculptural shapes, the edges of contours read more clearly than is often the case in the graphic arts.

© Metropolitan Museum of Art, New York. Gift of GFI/Knoll International Foundation, 1984. 328a–d.

depending on the context of their use. Some of these are naturalistic, representational, and/or realistic. When they seem to have been contrived by the artist, they are also given various names, in addition to subjective and abstract. Among these are the terms nonrepresentational and nonobjective. The distinction between these opposed shape families is not always easily made, because the variations of both are so vast. Hence, several specific terms have been evolved to attempt an explanation.

Natural objects generally seem rounded. We see this in the fundamental organisms encountered in biological studies (such as amoebas, viruses, and cells). Such shapes are normally referred to as organic, but, because organic shapes are often curved, the term **biomorphic** was coined in early twentieth-century art to describe the irregular rounded shapes in art that suggest life (fig. 4.5; see figs. 10.72 and 10.75).

4 • 5

Roberto Sebastian Antonio Matta Echaurren, Listen to Living {Écoutez vivre}, 1941. Oil on canvas, $29\frac{1}{2} \times 37\frac{3}{8}$ in $(74.9 \times 94.9 \text{ cm})$.

Within the limits of the human mind's ability to conceive such things, Matta Echaurren has given us a vision of a completely alien milieu. Though as far as imaginable from everyday reality, this environment seems possible, thanks to the facility of the artist. The blending of shapes gradually makes them indistinct and no longer measurable; their softened, flowing character means that separate components merge and interlock, becoming one.

The Museum of Modern Art, New York. Inter-American Fund. © 1998 Museum of Modern Art. © 1997 Artists Rights Society (ARS), New York/ADAGP, Paris.

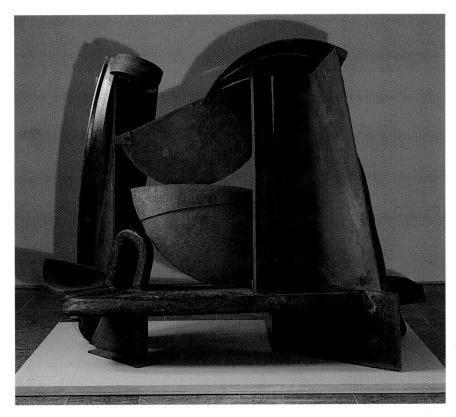

Shape

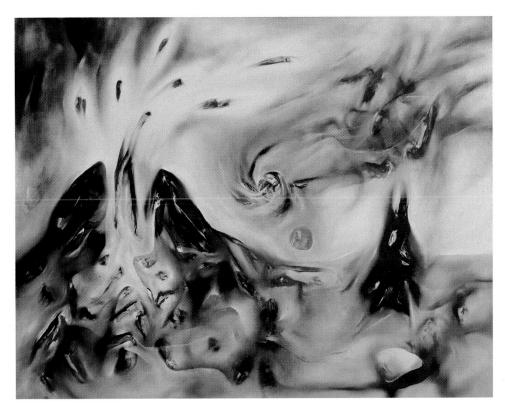

Chapter 4

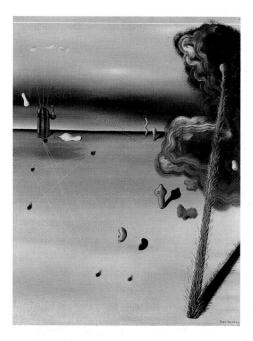

▲ 4 · 6 Yves Tanguy, Mama, Papa is Wounded {Maman, papa est blessé}, 1927. Oil on canvas, 36 ¹/₄ × 28 ³/₄ in (92.1 × 73 cm).

Surrealists such as Yves Tanguy have given considerable symbolic significance to biomorphic shapes. These remind us of basic organic matter or of flowing and changing shapes in dreams.

The Museum of Modern Art, New York. Purchase.
© 1998 Museum of Modern Art. © 1997 Estate of Yves Tanguy/Artists Rights Society (ARS), New York.

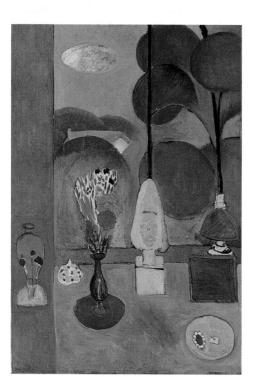

With the great interest aroused by abstract art (from around 1910 forward), the increasing awareness of the microscopic world through science, and the growth of Freudian psychology, the biomorphic shape became a key component in the paintings of Surrealist artists. Their interests in the mystic origins of being and in the exploration of subconscious revelations, such as in dreams, attracted them strongly to organic or biomorphic shapes (fig. 4.6). Other artists (Matisse and Braque are examples) abstracted organic forms in a less symbolic and primarily decorative manner (fig. 4.7; see fig. 4.17A).

Rectilinear (straight-lined) shapes, called geometric because they are based on the standardized shapes used in mathematics, contrast with biomorphic shapes. The precisionist, machinelike geometric shapes appealed to the *Cubists*, who used them in their analytical dissection and reformulation of the natural world (fig. 4.8).

From these examples, it is clear that, however shapes are classified, each shape or combination of shapes can display a particular personality according to their physical employment and our responses to them.

THE USE OF SHAPES

Shapes are used by artists for the two fundamental purposes mentioned in the preceding paragraphs: to suggest a

4 • 7

Henri Matisse, The Blue Window, Issy-les-Moulineaux (summer 1913). Oil on canvas, $51\frac{1}{2} \times 35\frac{5}{8}$ in (130.8 \times 90.5 cm).

Matisse has abstracted organic forms for the purpose of decorative organization.

The Museum of Modern Art, New York. Abby Aldrich Rockefeller Fund. © 1998 Museum of Modern Art. © 1997 Succession H. Matisse/Artists Rights Society (ARS), New York.

physical form they have seen or imagined, and to give certain visual qualities or content to a work of art.

Shapes in art can be used for some of the following purposes:

- 1. To achieve order, harmony, and variety—all related to the principles of design discussed in Chapter 2.
- 2. To create the illusion of mass, volume, and space on the surface of the picture plane.
- 3. To extend observer attention or interest span.

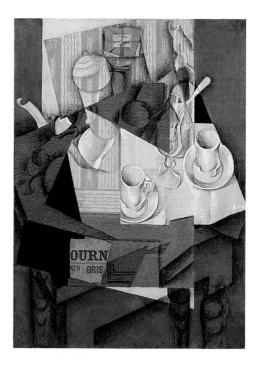

A 4 · 8

Juan Gris (José Victoriano González), Breakfast, 1914. Cut-and-pasted paper, crayon, and oil over canvas, $31\frac{7}{8} \times 23\frac{1}{2}$ in (80.9 × 59.7 cm).

Gris, an example of a Cubist, not only simplified shapes into larger, more dominant areas, but gave each shape a characteristic value, producing a carefully conceived light-dark pattern. He also made use of open-value composition, where the value moves from one shape into the adjoining shape, as can be seen in this example.

The Museum of Modern Art, New York. Acquired through the Lillie P. Bliss Bequest. © 1998 Museum of Modern Art.

The last usage listed requires further clarification. While the arts of music, theater, and dance evolve in time, the visual arts are usually chronologically fixed. This means that the time of an observer's concentration on or mental unity with most works of art is by comparison usually limited. This is particularly true in the pictorial or graphic arts. It is not quite so true with one type of plastic art, kinetic forms. Mobiles, for example, are a form of sculpture in motion; their constantly changing relationships of shapes usually hold the viewer's attention longer than immobile forms of sculpture or pictorial art.

SHAPE DIMENSIONS

In the preceding parts of this chapter we defined shapes as having either two- or three-dimensional identities. In order to use shape(s) successfully in works of art we must further consider these dimensional aspects. Some people, for example, make a distinction between shape that is two-dimensional and shape that is three-dimensional (referred to as mass and/or volume), and consider them to be two separate elements. However, the authors have always considered shape, whether two-dimensional or three-dimensional, to be one element of form. For increased familiarity with the way the term "shape" is used in this context, more information about shape dimension follows.

The illusions of twodimensional shapes

Foremost among shapes and probably the most useful is the two-dimensional *plane*. As was noted, in pictorial artworks the flat surface on which artists work is called the picture plane. In addition to being a working surface, a planar shape is often used as a device to simplify vastness and intricacies in nature. In sketching

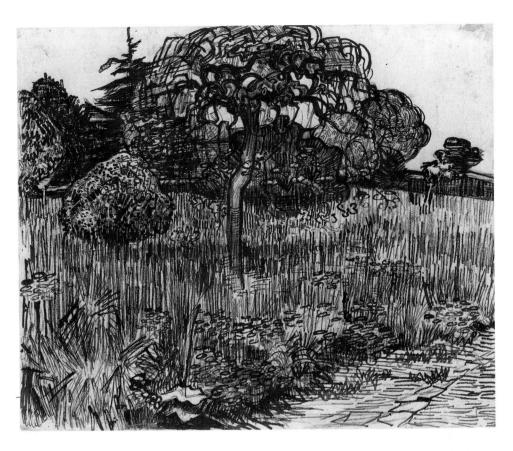

trees, for example, an artist will utilize a large, simple planar shape to represent the overall image of the tree. Further, individual clumps of foliage often are shown by a number of smaller varied shapes (fig. 4.9). This use of the plane creates more economical, stable, and readily ordered units that are useful to the artist not only for preliminary sketches but also for finalizing the organization of his or her work. Beyond this, planes are extremely useful in creating the illusion of threedimensionality on the two-dimensional picture plane, whether or not they have the appearance of objects or are abstract.

The use of the plane varies from a flat or **decorative** appearance on a picture plane, to one or more that appear to occupy space. Artists use all kinds of shapes, from geometric to organic, to achieve both these effects. A rectilinear shape—that is, a geometric shape whose boundaries consist of straight lines—might appear flat when lying on the

A 4.9

Vincent van Gogh, Corner of a Park at Arles (Tree in a Meadow), 1889. Red and black ink over charcoal, $19\frac{3}{8} \times 24$ in (49.3 × 61 cm).

Planar shapes are used to simplify the intricacies of the large centrally located tree. A large oval shape can be superimposed over the outer limits of the foliage, while the inner groups can be seen as smaller organic planes.

Art Institute of Chicago. Gift of Tiffany and Margaret Blake 1945.31. Photograph © Art Institute of Chicago. All rights reserved.

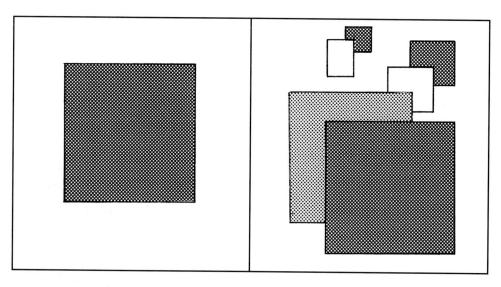

4 · 10Rectilinear planes can suggest the illusion of depth in a number of ways.

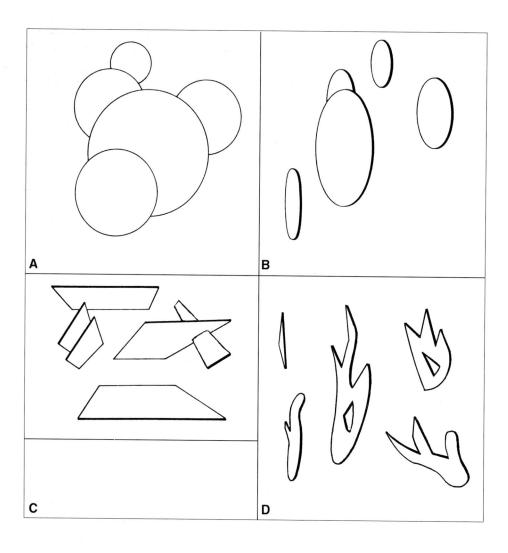

surface of the picture plane, but even a simple overlapping of two or more rectilinear shapes can give them a sense of depth. The addition of size, color, value, and texture contrasts to these planes can establish an impression of depth even more definitively (fig. 4.10).

Curvilinear planes, those planar shapes made up of circles, ovals, or irregular organic attributes, can also create shallow effects of space or, through their curving nature, suggest movements into depth. When either curvilinear, rectilinear, or other irregular planes are given a foreshortened appearance by tilting them and making the near end look larger than the distant one, we have a much stronger visual statement of depth than in the decorative use of planes (figs. 4.11A-D).

The illusions of threedimensional shapes

When the term mass is used to describe three-dimensional shapes in the picture plane, we mean that they have the appearance of solid bodies. If a three-dimensional shape is a void or an area of definable containment, it occupies a certain amount of measurable space, and is called a volume. Rocks and mountains are masses, while holes and valleys are volumes; cups are masses, while the areas they contain are volumes (figs. 4.12A and B). When beginning to develop

4 · IIA-D

The diagrams illustrate how differently shaped and positioned planes can create illusions of depth: (A) Curvilinear or circular planes overlapped to suggest shallow space; (B) Curvilinear planes placed on edge and tilted to suggest an effect of greater depth—note how the circles become elliptical in shape; (C) Straight-edged or rectilinear planes positioned so that they float in deep space (see fig. 4.10 for a shallower effect); (D) Irregular shapes creating a sense of depth. In diagrams B, C, and D, the illusion of depth is accentuated by thickening the nearest edges of the planes. Variations of value, size, texture, and color would further enhance or diminish the illusion of depth.

4 · 12A & B

Masses and volumes: Arches and Canyonlands National Parks, Utah.

In figure 4.12A, mountainous rock formations and their valleys represent mass and volumes. Figure 4.12B illustrates a close-up view of a gigantic rock formation (mass) with an enormous hole (volume).

three-dimensional shapes, we should select the kind(s) of shape(s) we wish to portray—geometric, organic, or irregular—just as we did in working with their two-dimensional counterparts. Because geometric shapes, such as the square/rectangle, are the most basic two-dimensional shapes, let us look at the development or transformation into their three-dimensional equivalents—the cube/rectangular solid.

The illusion of masses or volumes on the picture plane is produced by arranging two or more flat or curvilinear planes (flat or curved) in relation to one another to give them an appearance of solidity, as shown in figure 4.13. The planes that constitute the sides of these illusionary three-dimensional objects could be detached from the parent mass and tilted back at any angle. In fact, such planes do not have to be closed or joined at the corners in order to afford an appearance of solidity—the Gestalt effect again. As we can see in this diagram, there is no limit to the number of shapes that can be shown in three dimensions, but the rectangular solid is probably the simplest. Spheres, pyramids, hexagonal and ovoidal solids all have their counterparts in planar shapes, such as circles, triangles, hexagons, and ovoids.

The illusionary effect of juxtaposing the planes without connecting them makes the arrangement of planes seem less substantial than the mass, but it shows the development of the planes more clearly and is more flexible in the pictorial exploration of volume and space. Presenting the planes in this way highlights the importance of the edges'

Δ

В

functions as the planes combine to form the illusion of mass and its depth. In figure 4.14A, the diagram shows planes that have parallel-angled edges. They establish a directional movement (usually away from a central location—an edge/corner). This combination of planes seems to provide solidity, whereas any plane on its own would appear relatively flat.

In the next example of a mass, figure 4.14B, the planes appear to tilt or tip. The planes take on an added feeling of

dimension—depth illusion—as they appear to recede away from the spectator. These planes are the converging sides of the mass. When several converging planes are juxtaposed and touching, the spatial illusion of mass and depth is greater than that provided by the use of parallel-edged planes. This is because the illusion of the converging planes receding in depth more closely relates to our optical perception. Under normal conditions one may expect the size of the planes to appear to diminish

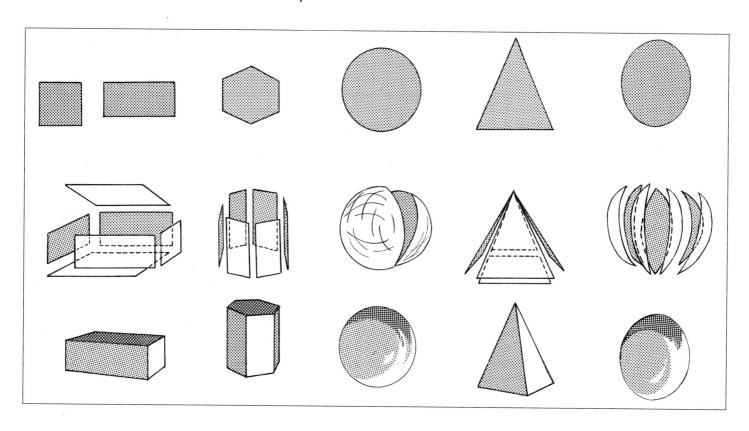

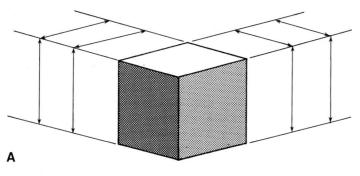

▲ 4 · I4A

A combination of planes that show parallel edges in depth creates the illusion of mass (shape).

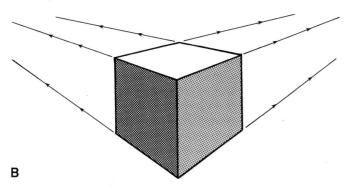

▲ 4 · I4B

A combination of planes that show converging edges in depth (moving away from the viewer) creates the illusion of mass (shape).

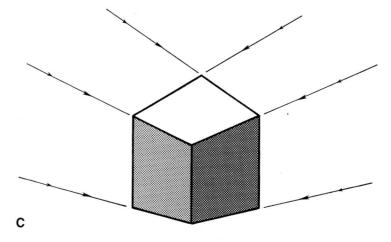

▲ 4・14C

A combination of planes that show edges converging toward the viewer creates the illusion of mass (shape). (This is the reverse effect of the shape in figure 4.14B.)

4 • 15

Ron Davis, Parallelepiped Vents #545, 1977. Acrylic on canvas, 9 ft 6 in \times 15 ft (2.90 \times 4.57 m).

While the strict order of linear perspective is not observed here, a sense of space is achieved by other means under the control of the artist's instincts.

Los Angeles County Museum of Art, CA. Gift of the Eli and Edythe Broad Fund.

as they move away from the viewer. The use of planes with converging sides is not limited to that concept and traits of depth; however, equivocal planes also occur when the traditional application is reversed as in figure 4.14C. Equivocation means ambiguity or uncertainty. This is certainly true of equivocal space in this example; it is a "now you see it and now you don't," or, more accurately, "now you see it and now you see it another way." This is typical of equivocal art situations. Initially figure 4.14C is seen as a solid block, though not in perspective. Following another inspection the white plane may be seen as an advancing "ceiling" and other planes as retreating to a corner. Such ambiguities can add challenge, spice, and interest to the viewing. This application of converging edges advancing may appear to exaggerate and distort shape definitions and impart some decorative qualities to the image; however, the individual planes in isolation remain relatively plastic.

Review figures 4.13 to 4.14C and you will find examples of three-dimensional shapes that have planes with parallel, advancing, and receding converging edges. Artists enjoy the freedom of creating imaginative shapes in three dimensions unencumbered by the restrictions of formulae and mechanical processes. Ron Davis in his painting *Parallelepiped Vents #545* employs flat planes, shapes with parallel edges, shapes with converging edges receding, and shapes with converging edges advancing (fig. 4.15). Al Held creatively employs the same types of shape-edge

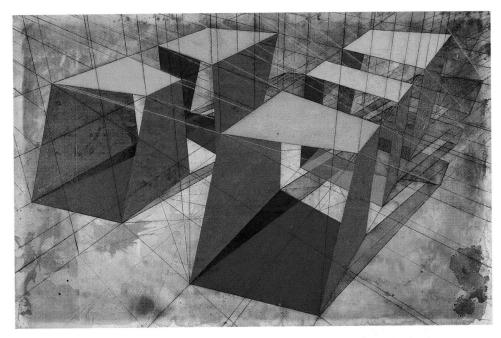

development in his painting B/WX (see fig. 8.45).

The creation of three-dimensional shapes and their depth through the use of converging edges (receding and/or advancing) preceded the development of linear perspective but is closely related to it. Because of linear perspective's importance to the creation of space it will be discussed further in Chapter 8, "Space." The parallel-edge shape concepts that have been presented are closely related to the system of perspective used in mechanical drawings. Within this chapter we are primarily concerned with the illusions of shape and depth created by graphic artists. Other artists employ actual threedimensional shapes in their art, but this is more appropriately discussed in Chapter 9, "The Art of the Third Dimension."

SHAPE AND PRINCIPLES OF DESIGN

If artists wish to create order or unity and increase attention span, they have to

conform to certain principles of order or design. In observing these principles, they are often forced to alter shapes from their natural appearance. It is in this respect that shapes can be called the building blocks of art structure. Just as in the case of line, our first element of artistic form, shapes have multiple purposes in terms of visual manipulation and psychological or emotional effects. These purposes, as suggested, vary depending on the artist and the viewer.

The principles determining the ordering of shapes are common to the other elements of form. In their search for significant order and expression, artists modify the elements until:

- 1. The desired degree and type of balance is achieved.
- 2. The observer's attention is controlled both in terms of direction and duration.
- 3. The appropriate ratio of harmony and variety results.
- 4. The space concept achieves consistency throughout.

While space is a result of the use of the elements, and harmony and variety

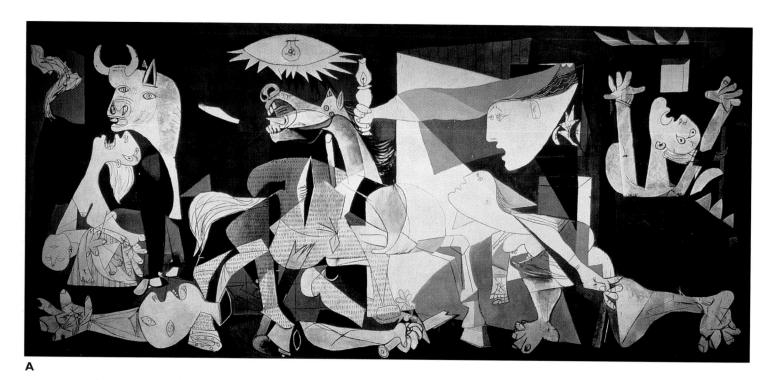

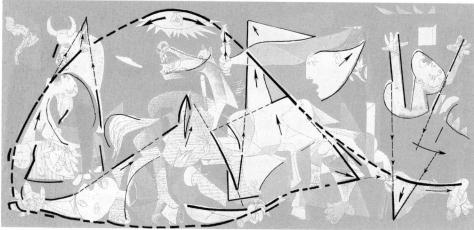

В

have already been discussed (pp. 35-50), the concepts of balance, direction, and duration, as they regard shape, are important enough to warrant additional investigation.

Balance

As artists seek compositional balance, they work with the knowledge that shapes have different visual weights depending on how they are used. Although this principle of form organization was treated at some length in Chapter 2, it may be helpful to reexamine balance in particular regard to shape by reusing the example of the seesaw, or weighing scale, as depicted in figure 2.26. We see that placing shapes of different sizes at varying distances from the fulcrum can be controlled to create a sense of balance or imbalance. Because

▲ 4 · I6A & B

Pablo Picasso, Guernica, 1937. Oil on canvas, 11 ft $5\frac{1}{2}$ in \times 25 ft $5\frac{1}{4}$ in (3.49 \times 7.75 m).

The linear diagram (B) overlaying Picasso's *Guernica* is one of several possible interpretations of the way shape is used as a directional device. The arrows in the middle of shapes indicate their major directional "thrust." The thick solid lines show the edges where a felt direction seems to line up with a corresponding shape edge across a space (indicated by broken lines). These create the major shape directions in the overall composition. Secondary shapes, related in a similar way, are shown by middleweight lines. The lighter lines show curving shape edges counteracting the straighter and more broadly arced edges of the design.

Museo del Prado, Madrid, Spain. Photo: Centro de Arte Reina Sofia, Madrid/Giraudon, Paris/SuperStock. © 1997 Estate of Pablo Picasso/Artists Rights Society (ARS), New York.

no actual weight is involved, we assume that the sensation is intuitive, or felt, as a result of the various properties composing the art elements. For example, a dark value adds weight to a shape, while substituting a narrow line for a wider line around it reduces the shape's apparent weight.

The seesaw is an example of how a few basic elements can operate along only one plane of action. Developed

▶ 4 · I7A & B

Georges Braque, Still Life: The Table, 1928. Oil on canvas, $32 \times 51 \frac{1}{2}$ in (81.3 \times 130.8 cm).

This painting by the French Cubist Georges Braque has many elements that contain direction of force. The simplified grouping of darks in figure 4.17A illustrates the controlled tension resulting from the placement, size, accent, and general character of the shapes used by the artist. In figure 4.17B the black arrows show the natural eye paths by which the artist intended to create visual transition and rhythmic movement. Chester Dale Collection. National Gallery of Art, Washington/Corbis Media. © 1997 Artists Rights Society (ARS), New York/ADAGP, Paris.

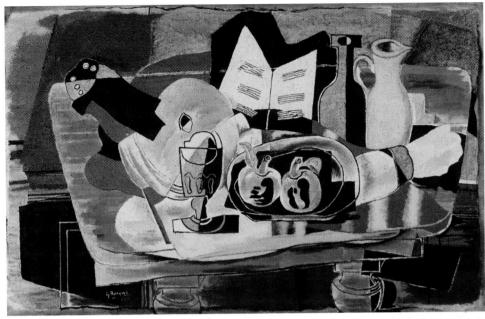

Δ

artworks, on the other hand, contain many diverse elements working in many directions. The factors that control the amounts of directional and tensional force generated by the various elements are: placement, size, accents or emphasis, and general shape character (including associative equivalents to be discussed under "Duration and Relative Dominance," (p. 106). The elements are manipulated by the artist until the energy of their relationships results in dynamic tension.

Direction

Artists can use the elements of form to generate visual forces that direct our eyes as we view the work. Pathways are devised to encourage transition from one pictorial area to another. There are several ways of facilitating this; one way is to make use of shapes pointing in specific directions (shorter shapes generally obstruct the visual pathways). Secondly, artists often extend or "aim" edges so that they imply a linkage with

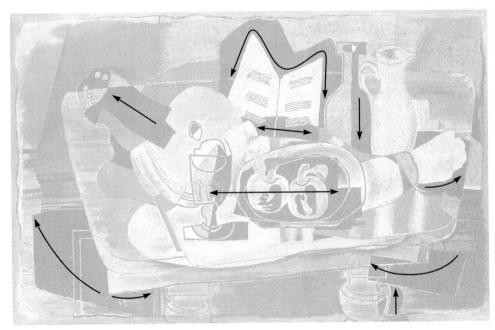

В

the edges of other shapes, or suggest by the direction of the edges a related movement in a certain direction (figs. 4.16A and B). A third solution is the use of *intuitive space* (see Chapter 8, p. 204), an implied perspective given to shapes that tip them into or "through" the picture plane and direct our eyes along three-dimensional routes; this can be observed in figures 4.11B, C, and D. The

direction of the eyes along these paths should be rhythmic, providing pleasurable viewing and unification of the work. The character of the rhythm produced depends on the artist's intentions—jerky, sinuous, swift, or slow (figs. 4.17A and B). The control of direction helps us to see things in the proper sequence and according to the degree of importance planned for them.

4 · 18

Sassetta, workshop of, The Meeting of Saint Anthony and Saint Paul, c. 1440. Tempera on panel, $18^{3}/_{4} \times 13^{5}/_{8}$ in (47.6 \times 34.6 cm).

In this painting by the Italian artist Sassetta, "station stops" of varied duration are indicated by contrasts of value. In addition, eye paths are provided by the edges of the natural forms that lead from figure to figure. This painting also illustrates how late-Gothic artists used shallow space in compositions prior to the full development of perspective.

Samuel H. Kress Collection. © Board of Trustees, National Gallery of Art, Washington.

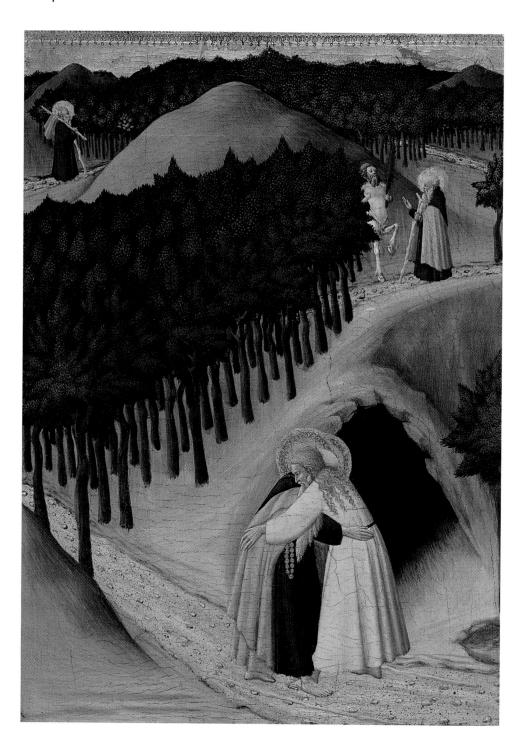

Duration and relative dominance

The unifying and rhythmic effects provided by eye paths are modified by the number and length of the pauses in the eye journey. If the planned pauses are of equal duration, the viewing experience is more monotonous. The

artist, therefore, attempts to organize pauses so that their lengths are related to the importance of the sights to be seen on the eye journey (fig. 4.18). The duration of a pause is determined by the pictorial importance of the area. Although shapes create transitions, they are very often focal points in a picture. In a work depicting the Crucifixion, for

example, we would expect an artist to make the figure of Christ particularly significant (fig. 4.19). In the case of the illustration shown, this dominance is achieved by the size of the shape created by Christ's body. The effect of a shape's size can be further modified by manipulations of value, location, color, or any combination of these elements.

107

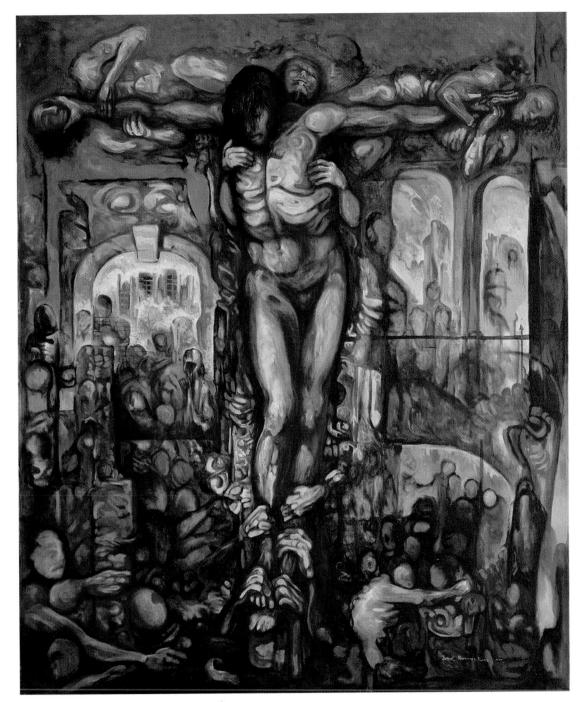

∢ 4⋅19

Ismael Rodríguez Rueda, El Sueño de Erasmo (The Dream of Erasmus), 1995. Oil on canvas, 39¹/₃ × 47¹/₂ in (100 × 120 cm).

The figure of Christ is made dominant by its size and centrality of location.

Courtesy of Ismael Rodríguez Rueda.

Artists develop dominance on the basis of their feelings, and they reconcile the various demands of the design principles with those of relative dominance. The degree of dominance is usually in direct proportion to the amount of visual contrast. This is true of both representational and abstract works (see figs. 4.19 and 4.20). The idea of relative

dominance is similar to the hierarchy in organizations that have a dominant figure and other members with diminishing responsibilities.

There is another aspect, association, or similarity, that tends to qualify the attention given to shapes or other elements. The contrasts between Christ's T-shape, the ovals in the right and left

foreground, the arch tops in the background, and the differences in value and color from His figure, all afford differences that increase the dominance of it in Ismael Rodríguez's painting *El Sueño de Erasmo*. Playing a diminished role, but adding to the organized coherence of the painting, is the repetition of the similar head shapes in

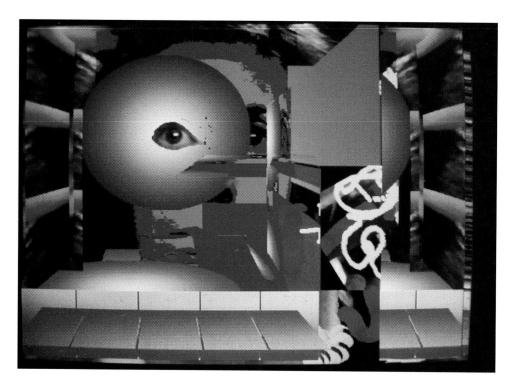

▲ 4 • 20 Ronald Coleman, Supervisory Wife II, 1992. Computer-aided art.

The principle of relative dominance is generated in this computer print by the large size, contrasting purple color, and the mysterious eye that peers out of the sphere. Further attention is drawn to this spherical shape by the converging front lines and side shapes that are directed to it. Courtesy of the artist.

the figures, and the touches of yellow, red, and green in parts of the painting (see fig. 4.19). In an abstract work of art, such as the Coleman computer-aided art (fig. 4.20), an oval shape may well receive more attention if for some reason it reminds us of a head. Artists usually would try to avoid such chance interpretations, although they cannot always be foreseen. Of course, size remains the principal device used for dominance. At other times, artists can use the innate appeal of associative factors to advantage, weighing them in the balance of relative dominance and forcing them to operate for the benefit of the total organization.

Harmony and variety

Harmony ensures that all things seem to belong together. Shapes and other elements achieve this by having a "likeness." With repetition those parts form a family, just as members of human families share certain characteristics. A family of shapes could be mostly rectilinear (composed of straight edges), curvilinear (curved edges), or another similar type. The shape likeness could be additionally enhanced by sharing common applications of value, texture, or color. There need not always be an identical likeness but, perhaps, merely enough to see their relationship. A stress on shape harmony can result in a relatively peaceful situation, but overstressing harmony may curtail our interest.

Variety is the other side of the coin. Enough differences must exist to make for challenging viewing. These differences are attractions that grasp and hold our attention for the period thought necessary by the artist. If the artwork consists of mostly gently flowing shapes, the introduction of angular shapes

will produce sharp accents and, of course, the reverse would be true. Although the presence of some differences is essential, excessive differences may be "out of tune" with the total concept; some reconciliation with harmony is necessary. If agitation and somewhat violent effects are sought, shape variety is the answer. Remember: repetitive shapes for harmony; contrasting shapes for variety.

Shapes and the space concept

Regarding space, the sculptor may have an advantage over the two-dimensional artist who is confronted with a flat working surface. This surface must be converted into a "window" where things appear to be advancing and retreating. Space has been dealt with in different ways in different cultures; sometimes it has been extended, sometimes compressed. In either case, shapes are an important factor.

Shapes are often seen as planes, independent of or part of objects, tilted or upright, and often, although not always, flat. They may be seen as ground surfaces, walls, tabletops and sides, and the like. Frequently, shapes are seen in perspective as they move away from us, resulting in different depths of space. Shapes may twist and bend in space or overlap and may be seen through and penetrate each other, causing new spatial relationships.

The artist must be consistent with his or her space; a mix does not ordinarily work well. One challenge is balancing the spatial forces. In two-dimensional art, one form of balance depends on the apparent weights of the elements. In seeking an apparent three-dimensional appearance, the thrusting and recession of the elements in "space" must balance; otherwise, the picture plane can appear "twisted." Equalization of the spatial forces depends on adjustments in size and position and variations of strong or weak values and

colors. When the artist makes these adjustments, he or she will help the shapes take their desired position in space.

SHAPE AND CONTENT

Whereas the physical effects created by artists are relatively easily defined, the qualities of expression, or character, provided by shapes in a work of art are so varied (because of individual responses) that only a few of the possibilities can be suggested. In some cases, our responses to shapes are quite commonplace; in others, our reactions are much more complex because our own personality traits can influence the shapes' character (for example, shyness, aggressiveness, awkwardness, poise, and so forth). These are just some of the meanings or content we can find in shapes. Artists, naturally, make use of such shape qualities in developing their works of art, although much of it is instinctive.

It is hardly conceivable that an architect would use shapes in buildings to suggest natural forms. It has been done during art history, but very rarely. On the other hand, sculptors and pictorial artists have almost always used natural forms in their respective media. Yet the evidence indicates that they were not always interested in using shapes to represent known objects. Artists more often tend to present what they conceive or imagine to be real, rather than what they perceive, or see objectively, to be real. This has been particularly evident in the twentieth century, when whole movements have been based on the nonrepresentational use of shapes-from the abstract movement of the early 1900s to the conceptual movement of the seventies and eighties.

Thus, conception and imagination have always been parts of artistic expression. It is usually a matter of

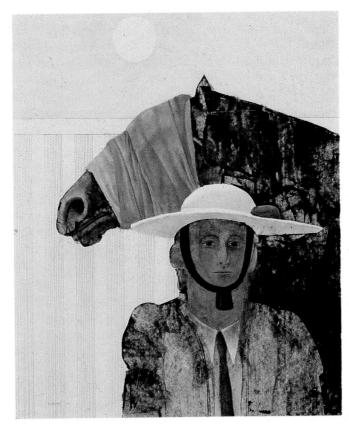

▲ 4·21 Morris Broderson, Picador with Horse, 1967. Mixed media, 33 × 26 in (83.8 × 66 cm).

While it is a straightforward exercise to recognize the subjects in this painting, this should only be a starting point for getting a grip on the uncertain meaning of this work.

degree as to how much artists use their imagination and how much they use their perceptual vision. By trying to say something through their use of subject and form, artists find that their points cannot be made without editing the elements (or "grammar") of form/ expression. So while the work of those artists who are more devoted to representing actual appearances might seem to be quite natural, comparison with the original subject in nature may still show considerable disparities (figs. 4.21 and 4.22). Artists, therefore, go beyond literal copying and transform object shapes into their personal style or

4 · 22

Conrad Marca-Relli, The Picador, 1956. Oil and fabric collage on canvas, $3 \text{ ft } 11\frac{1}{4} \text{ in } \times 4 \text{ ft 5 in } (1.20 \times 1.35 \text{ m}).$

Artists differ in their responses to subject matter. It is often a matter of degree as to how much artists use their imaginations and how much their visual perceptions vary. Such differences of response, and the concepts that result, are apparent if one contrasts the similar subjects of figures 4.21 and 4.22.

Hirshhorn Museum and Sculpture Garden, Smithsonian Institution, Washington, D.C. Gift of Joseph H. Hirshhorn, 1966. (Photograph by Lee Stalsworth.)

4 • 23

Ernest Trova, Three Men in a Circle, 1968. Oil on canvas, 5 ft 8 in \times 5 ft 8 in (1.72 \times 1.72 m).

The circular elements generate subconscious and generally indefinable reactions, which are in contrast to the cool rectilinear style.

Courtesy of Owens Corning Collection, Toledo, OH.

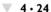

Charles Burchfield, The Night Wind, (Salem, Ohio, January) 1918. Watercolor and gouache on paper, $21\frac{1}{2} \times 21\frac{7}{8}$ in (54.4 × 55.5 cm).

The shapes used by Burchfield in this painting are partly psychological and partly symbolic. The approaching storm seems to evoke human qualities, such as the onset of depression or anger.

The Museum of Modern Art, New York. Gift of A. Conger Goodyear. Photograph © 1998 Museum of Modern Art.

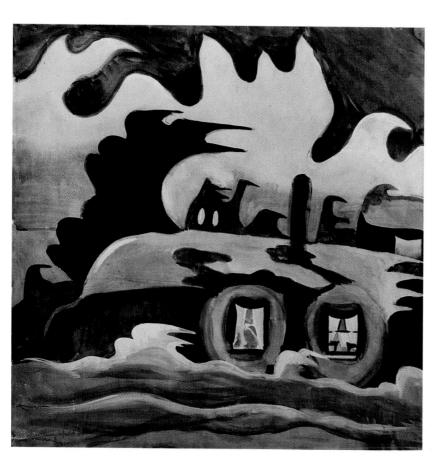

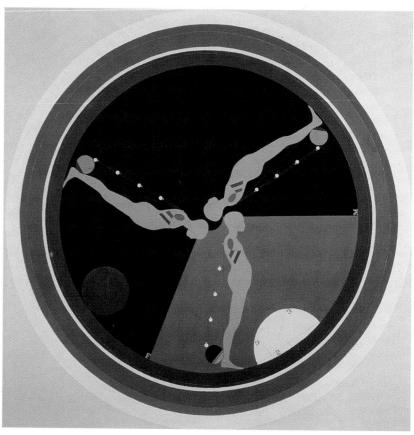

language of form (figs. 4.23, 4.24, and 4.25; see fig. 4.5).

Just as the configuration of a shape gives it the character that distinguishes it from other shapes, so configuration also changes a shape's content or expressive meaning. The abstract artists of the present century seem to have been influenced by the stylization of machinery, for example, to create pristine, clear-cut shape relationships (fig. 4.26). Our reactions to these, or the meanings we find in them, vary with our own psychological conditioning. While many people accept Charles Sheeler's artworks because of their recognizability, some react adversely to simple abstract shapes like those in Albers's paintings (see fig. 4.25). While both artists use similar shapes, visual differences in their relationships change the shapes' meanings. There are differences in color and treatment of value—one flat and the other blended. In other examples, shape extremities become important; thus, the

4 . 25

Josef Albers, Homage to the Square: Star Blue, 1957. Oil on board, $29\% \times 29\%$ in (75.9 \times 75.9 cm).

The meaning of the squares in this picture lies not in their resemblance to a real object, but in their relationship to one another.

Contemporary Collection of the Cleveland Museum of Art, 65.1, Cleveland, OH. © DACS 1994. © 1997 Josef and Anni Albers Foundation/Artists Rights Society (ARS), New York.

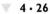

Charles Sheeler, Architectural Cadences, 1954. Oil on canvas, 25×35 in $(63.5 \times 88.9 \text{ cm})$.

The slightly abstract shape relationships of Sheeler's cityscape still have a strong resemblance to the "real world" and evoke the streamlined workings of machines. A more purely abstract approach, such as that of Josef Albers (see fig. 4.25), requires a different kind of understanding.

Collection of the Whitney Museum of American Art, New York. Purchase 54.35.

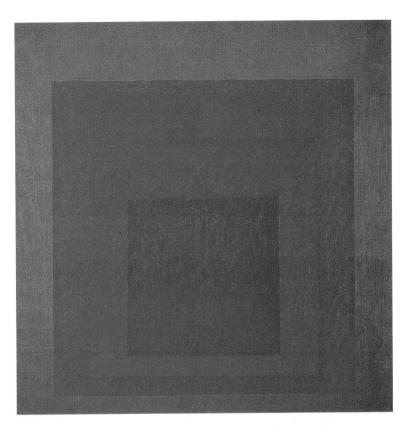

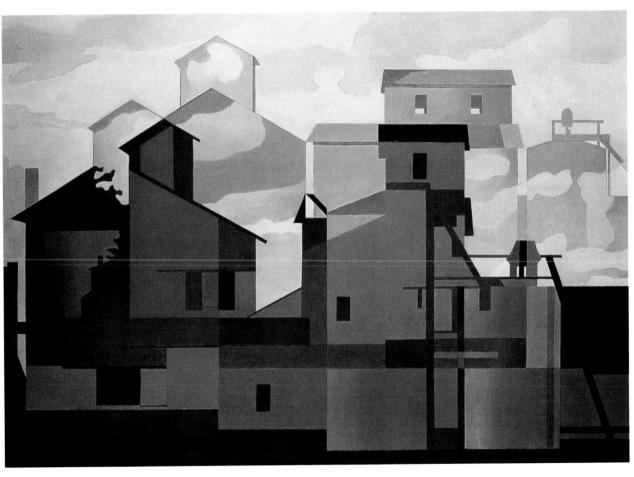

terms "soft edge" and "hard edge" are simply another way of defining shape edges as being fuzzy and indistinct as opposed to clear-cut and sharply defined (figs. 4.27, 4.28, and 4.29). In addition, colors, values, textures, and the application of particular media can affect whatever feeling or lack of it we intuit in such works of art. The student only has to glance around a class where all

members are working on a similar exercise to see the variety of personal ways that the work is done; it is amazing to see the differences in style and content that can result from the same assignment. How much more can be expected, in terms of endless expressive potential, in the case of trained artists?

All the principles involved in ordering shapes are of little value until

one becomes aware of the various meanings that can be revealed through relationships made possible by the language of art. Much of this awareness, of course, comes through practice, as in learning any language.

Artists usually select their shapes to express an idea, but they may initially be motivated by the psychological associations of shape, as in the Matta and Burchfield paintings (see figs. 4.5 and 4.24). Shapes suggest certain meanings, some readily recognizable, others more complex and less clear. Some common meanings conveyed by squares, for instance, are perfection, stability, stolidity, symmetry, self-reliance, and monotony. Although squares may have different meanings for different people, many common sensations are shared when viewing them (see fig. 4.25). Similarly, circles may suggest self-possession, independence, and/or confinement; ovals might suggest fruitfulness and creation; and stars could suggest reaching out. A vast array of other shapes possess distinctive meanings as well; however, all shapes' meaningfulness depends on their complexity, their application, and the sensitivity of those who observe them (see figs. 4.27 and 4.28). How different are our reactions to the biomorphic shapes favored by the Surrealists when compared to the hard-edged shapes of the geometric abstractionists (see figs. 4.5 and 4.29)? We know we are sensitive to shape meaning as proven by the psychologist's use of the familiar Rorschach (inkblot) test, which is designed to aid in evaluating emotional stability. The evidence from these tests indicates that shapes can provoke emotional responses on different levels. Thus the artist might use either abstract or representational shapes to create desired responses. By using the knowledge that some shapes are inevitably associated with certain objects and situations, the artist can set the stage for a pictorial or sculptural drama.

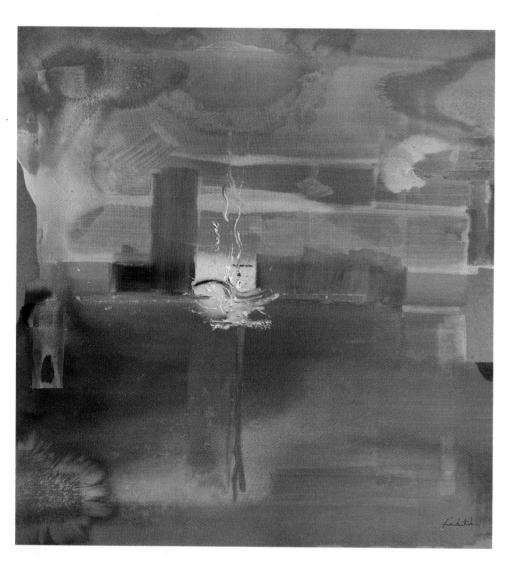

A 4 · 27

Helen Frankenthaler, Storm Center, 1989. Acrylic on canvas, 7 ft $9\frac{1}{4}$ in \times 7 ft $4\frac{1}{4}$ in (2.37 \times 2.24 m).

Many shapes are not meant to represent or even symbolize. Here, for example, the shape extremities, the softly changing values of the larger shapes, and the red ground act against the explicit verticality of the white and red lines. The artist provokes a momentary feeling of excitement within an otherwise quiet mood.

Kukje Gallery, Seoul, Korea. © Helen Frankenthaler. (Photograph by Steven Sloman, New York.)

4 • 28

Fernand Léger, Three Women {Le Grand déjeuner}, 1921. Oil on canvas, 6 ft $\frac{1}{4}$ in \times 8 ft 3 in (183.5 \times 251.5 cm).

The Cubist painter Léger commonly used varied combinations of geometric shapes in very complex patterns. Here, because of his sensitive design, he not only overcomes a dominant, hardedged feel, but imbues the painting with an air of femininity.

The Museum of Modern Art, New York. Mrs. Simon Guggenheim Fund. Photo © 1998 Museum of Modern Art. © 1997 Artists Rights Society (ARS), New York/ADAGP, Paris.

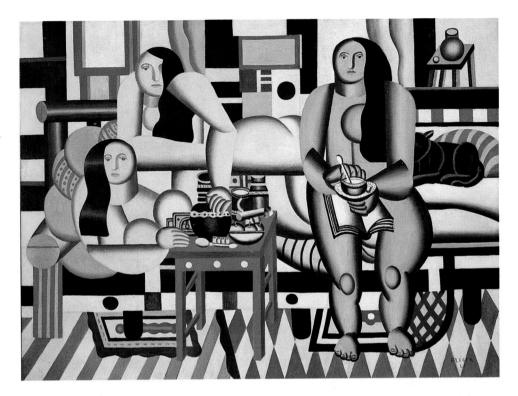

4 . 29

Dorothea Rockburne, Mozart and Mozart Upside Down and Backward, 1985–87. Oil on gessoed linen, hung on blue wall, 89 × 115 × 4 in (226.06 × 292.1 × 10.16 cm).

Dorothea Rockburne is representative of the new Postmodern artists who are reviving the hard-edged geometric abstraction of the fifties. Based on a seemingly simple scheme, on closer examination this piece reveals a labyrinth of interlocking rectilinear shapes.

Courtesy of André Emmerich Gallery, a Division of Sotheby's, on behalf of the artst.

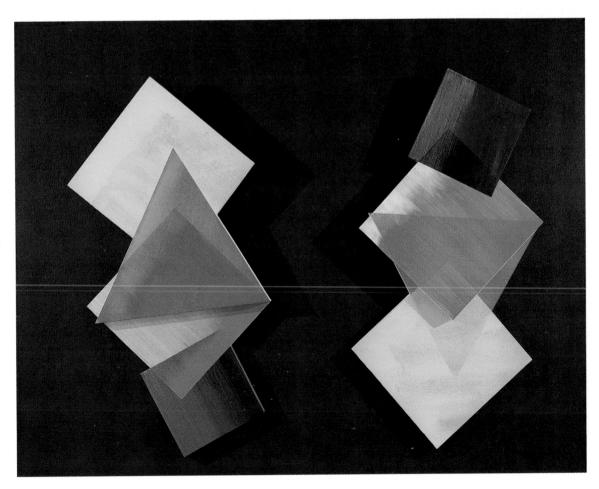

CHAPTER FIVE

Value

THE VOCABULARY OF VALUE

INTRODUCTION TO VALUE RELATIONSHIPS

DESCRIPTIVE USES OF VALUE

EXPRESSIVE USES OF VALUE

Chiaroscuro Tenebrism Decorative Value

COMPOSITIONAL FUNCTIONS OF VALUE

Value Patterns
Open and Closed Compositions

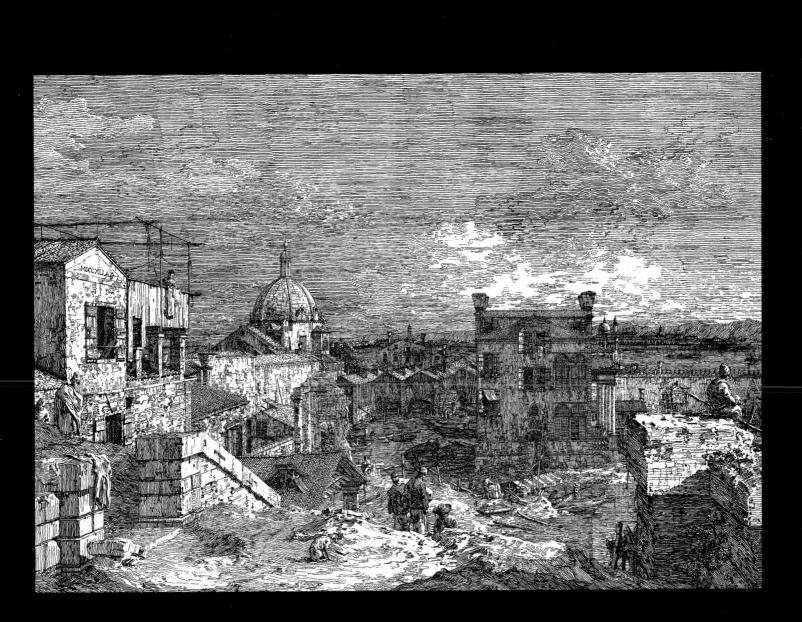

THE VOCABULARY OF VALUE

Value I. The relative degree of light or dark. 2. The characteristic of color determined by light or dark, or the quantity of light reflected by the color.

achromatic (value)

Relating to differences of light and dark; the absence of hue and its intensity.

cast shadow

The dark area that occurs on a surface as a result of something being placed between that surface and a light source.

chiaroscuro

1. Distribution of light and dark in a picture. 2. A technique of representation that blends light and shade gradually to create the illusion of three-dimensional objects in space or atmosphere.

chromatic (value)

The value (relative degree of lightness or darkness) demonstrated by a given color.

closed-value composition

Values are limited by the edges or boundaries of shapes (see also **decorative value**).

decorative (value)

Ornamenting or enriching but, more importantly in art, stressing the two-

dimensional nature of an artwork or any of its elements. Decorative art emphasizes the essential flatness of a surface.

highlight

The portion of an object that, from the observer's position, receives the greatest amount of direct light.

local value

The relative light and dark of a surface, seen in the objective world, that is independent of any effect created by the degree of light falling on it.

open-value composition

Values cross over shape boundaries into adjoining areas.

plastic (value)

1. The use of the elements to create the illusion of the third dimension on a two-dimensional surface. 2. Three-dimensional qualities of architecture, sculpture, ceramics, etc., are enhanced by value.

shadow, shade, shading

The darker value on the surface of an object that gives the illusion that a portion of it is turned away from or blocked from the source of light.

shallow space

The illusion of limited depth. In the case of shallow space, the imagery moves only a slight distance back from the picture plane.

tenebrism

A technique of painting that exaggerates or emphasizes the effects of chiaroscuro. Larger amounts of dark value are placed close to smaller areas of highly contrasting lights—which change suddenly—in order to concentrate attention on important features.

value pattern

The arrangement or organization of values that control compositional movement and create a unifying effect throughout a work of art.

Value II7

INTRODUCTION TO VALUE RELATIONSHIPS

A definition of *value* for the purpose of this book is found in the dictionary, which states that value in art is the relationship of one part or detail to another with respect to light or dark. That definition, insofar as its application to this chapter is concerned, will concentrate on **achromatic** value (white, black and the limitless degrees of gray). Value is also called tone, brightness, shade or even color, but these terms may throw us off the track.

Anyone who studies art must consider the relationship of value to the other elements of art form, all of which possess value. An examination of the value scale in figure 5.1 will indicate that there are low key values (middle value to black) and high key values (middle value to white). Many art works lean toward low key values (often with lighter accents) while others take the opposite path. The "key" selected usually sets the mood of the work. Traditionally, most printmakers (fig. 5.2) have worked entirely with achromatic values to produce eminently successful works. Many artists and photographers, even today, prefer this approach. Rich darks and sparkling lights can be a visual delight.

For the graphic artist, the particular value of a line could be the result of the medium used or the pressure exerted on the medium by the artist. For example, the degree of value of a pencil line would be determined by the hardness of the graphite or the force with which it is used (see fig. 1.19). Value can be created by placing lines of the same or different qualities alongside or across each other to produce generalized areas of value; this is sometimes called hatching or cross-hatching (fig. 5.2). Shapes are also created and distinguished by the use of value. In reproducing textures, the

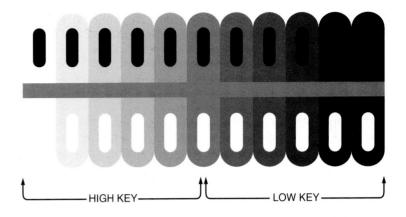

A 5 · I

This value scale shows a gradation from light to dark. The value is also seen against middle gray and black and white. Regardless of the media or technique used to create them, compositions that use values from white to middle gray are referred to as high key, while low key images would include dark values—middle grays to black. Small amounts of contrasting value are often necessary to make either low or high key exciting.

5 · 2

Canaletto (Giovanni Antonio Canal), Imaginary View of Venice, 1741. Print (etching), $11\frac{3}{4} \times 17\frac{1}{16}$ in (29.8 \times 43.3 cm).

A casual glance might make one think that these values were produced with a wash. In fact, they are all composed of hatched and cross-hatched lines scratched through a ground, etched into a metal plate, and printed. Toledo Museum of Art, Toledo, OH. Purchased with funds from the Libbey Endowment, Gift of Edward Drummond Libbey.

▲ 5·3 Henry Moore, Page 44 from Sheep sketchbook—Sheep Study, 1972. Blueblack ballpoint and felt pen, sketchbook measurements $9^{3}/4 \times 8$ in (24.77 × 20.32 cm).

The degree of line concentration indicates the value of the subject; where tightly bunched shadows are suggested, the forms of the animal are defined. Reproduced by permission of the Henry Moore Foundation.

shadows and **highlights** peculiar to particular surfaces are copied. The values in abstract textures depart to some degree from the values of the objects being represented.

The intoxicating effects of a particular color often blind people to the fact that color's very existence is entirely dependent upon the presence of chromatic value—the lightness or darkness of a color. A standard yellow, for example, is of far greater lightness than a standard violet, although both colors may be modified to a point that they become virtually equal in value. A common weakness in painting is the unfortunate disregard for the pattern created by the

value relationships of the colors. Blackand-white photographs of paintings often reveal this deficiency very clearly.

DESCRIPTIVE USES OF VALUE

One of the most useful applications of value is in describing objects, shapes, and space (fig. 5.3). Descriptive qualities can be broadened to include psychological, emotional, and dramatic expression. For centuries artists have been concerned with the problem of using value to translate the effect of light playing about the earth and its inhabitants. Objects are

usually perceived in terms of the characteristic patterns that occur when those objects are exposed to light rays. Objects, at least normally, cannot receive light from all directions at once. A solid object gets more light from one side than another because that side is closer to the light source and thus intercepts the light and casts shadows on the other side (fig. 5.4A).

Light patterns vary according to the surface of the object receiving the light. A spherical surface demonstrates an even flow from light to dark; a surface with intersecting planes shows sudden contrasts of light and dark values. Each basic form has a basic highlight and shadow pattern. Evenly flowing tone gradation invokes a sense of a gently curved surface. An abrupt change of tone indicates a sharp or angular surface (see fig. 5.4A).

Cast shadows are the dark areas that occur on an object or a surface when a shape is placed between it and the light source. The nature of the shadow created depends upon the size and location of the light source, the size and shape of the interposed body, and the character of the surfaces where the shadows fall. Although cast shadows offer very definite clues to the circumstances of a given situation, they only occasionally give an ideal indication of the true nature of the forms (fig. 5.4B). The artist normally uses or creates shadows that aid in descriptive character, enhance the effectiveness of the design pattern, and/or contribute to the mood or expression.

Many contemporary artists use value to create descriptive form. Some may employ chiaroscuro techniques that use light and shadow to reveal a representational image. In addition, artists like Anne Dykmans and other (New) Realists (for example, Richard Estes and Philip Pearlstein) draw inspiration from photography and cinema for their artworks (fig. 5.5: see figs. 10.103 and 10.104). Historically, most prints were

Value I19

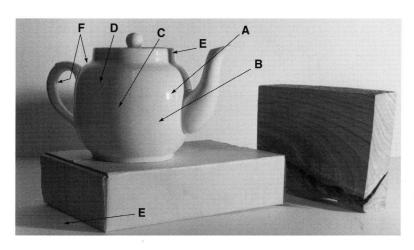

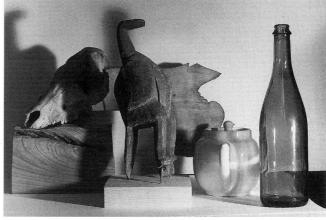

▲ 5 • 4A Russell F. McKnight, *Light and Dark*, 1984. Photograph.

A solid object receives more light on one side than the other because of its proximity to a light source. As the light is blocked out shadows occur. Curved surfaces exhibit a gradual change of value, whereas angular surfaces give sharp changes. (A) Highlight; (B) Light; (C) Shadow edge; (D) Shadow core; (E) Cast shadow; and (F) Reflected light.

Courtesy of the artist.

▲ 5 · 4B
Russell F. McKnight, Shadows, 1984.
Photograph.

Light can cast overlapping shadows that tend to break up and hide the true character of object forms. When the shapes of shadows are not factored into the composition, results are often disorganized, as in this experiment.

Courtesy of the artist.

■ 5 · 5 Anne Dykmans, Trois Fois, 1986. Etching, mezzotint and aquatint, 13³/4 × 19¹/2 in (34.9 × 49.53 cm).

This is a fairly straightforward portrayal of the benches including cast shadows of an undisclosed source. The background is made moody because of the shielding. One might initially expect this to be a photograph. Courtesy Stone and Press Galleries, New Orleans, LA.

5 . 6

Giorgio de Chirico, The Nostalgia of the Infinite, 1913–14? (date on painting is 1911). Oil on canvas, $53\frac{1}{4} \times 25\frac{1}{2}$ in (135.2 \times 64.8 cm).

Giorgio de Chirico often used shadow effects, strong contrasts of value, and stark shapes to enhance the lonely, timeless nostalgia that is so much a part of his poetic expression.

The Museum of Modern Art, New York. Purchase. Photo © 1998 Museum of Modern Art.

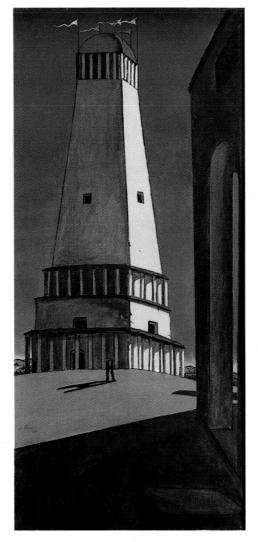

black and white; but, over the past one hundred years in particular, color has also flourished. The value component is self evident in black and white prints; however, it is something that must be used in conjunction with color prints as well.

There are four fundamental techniques of printmaking utilized by the artist: screen process (also known as silk screen, serigraphy), intaglio, relief, and lithography. In *screen printing*, ink is forced through a screen onto the printing paper by pressure applied to a squeegee. The preparation of the screen determines the ink pattern. *Intaglio printing* usually involves a metal plate that

the artist has cut into or etched using acid. Ink is rubbed into the crevices of the plate which is then wiped so that only those crevices contain the ink. Under the pressure of a press, the ink is then forced out of the plate onto the printing paper. Lithography makes use of stones or metal plates that are treated so that ink will be retained by certain areas. The printing is accomplished by using a press with a scraper bar. The pressure of the bar forces the ink to cling to the paper. Relief printing utilizes the concept of the venerable woodcut; wood (or linoleum or a commercial block) is cut away, the remaining surface rolled up with some form of ink, and the block pressed against the paper by a press or a smooth surfaced instrument. Many prints have used combinations of these techniques. With any of these techniques, when value is used to describe the illusion of volume and space, it can be called plastic value.

EXPRESSIVE USES OF VALUE

The type of expression sought by the artist ordinarily determines the balance between light and dark in a work of art. A preponderance of dark areas creates an atmosphere of gloom, mystery, drama, or menace, whereas a composition that is basically light will produce quite the opposite effect. Artists aren't bound to an exact duplication of cause and effect in light and shadow, because this practice may create a series of forms that are monotonously light or dark on the same side. The shapes of highlights and shadows are often revised to produce desired degrees of unity and contrast with adjacent areas in the composition. In summary, lights and shadows exist in nature as the by-products of strictly physical laws. Artists must adjust and take liberties with lights and shadows to create their own visual language (fig. 5.6).

Value 121

5 • 7

Giotto, The Kiss of Judas, Scrovegni Chapel, Padua, 1304–06. Fresco, 7 ft 7 in \times 6 ft $7\frac{1}{2}$ in (2.31 \times 2.02 m).

Although line and shape predominate in Giotto's works, some early attempts at modeling with chiaroscuro value can be seen.

Photo: Arena Chapel, Cappella Degli Scrovegni, Padua/SuperStock

V 5 · 8

Leonardo da Vinci, Madonna of the Rocks, c. 1483. Oil on panel, 6 ft 3 in \times 3 ft 6 in (1.9 \times 1.09 m).

Leonardo extended the range of values set by previous artists; he also developed a technique known as *sfumato*, which featured extremely subtle transitions from light to dark or dark to light. Louvre, Paris, France. Erich Lessing/Art Resource, NY.

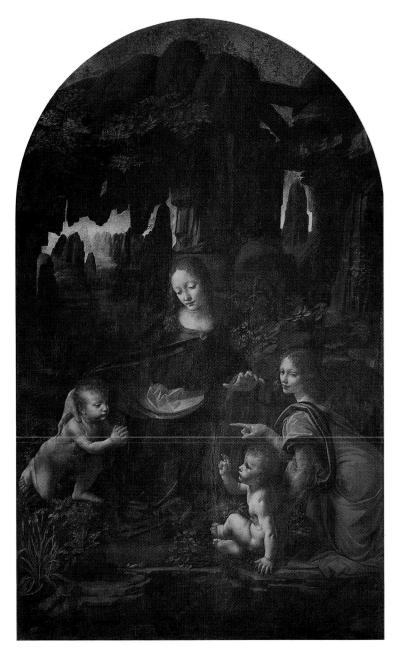

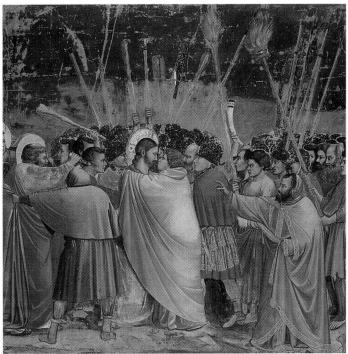

CHIAROSCURO

Chiaroscuro refers to the technique of representation that makes forceful use of contrasting lights and darks. The term also alludes to the way that artists handle those atmospheric effects to create the illusion that the objects are surrounded on all sides by space. Chiaroscuro developed mainly in painting, beginning with Giotto (1266-1337), who used darks and lights for modeling but expressed shape and space in terms of line (fig. 5.7). The early Florentine masters Masaccio, Fra Angelico, and Fra Filippo Lippi carried chiaroscuro a step further by expressing structure and volume in space with an even, graded tonality (see figs. 1.23 and 8.17A). Leonardo da Vinci employed a much bolder series of contrasts in light and dark but always with soft value transitions (fig. 5.8). The great Venetian painters, such as Giorgione and Titian, completely subordinated line and suggested compositional unity through an enveloping atmosphere of dominant tonality (figs. 5.9 and 5.10).

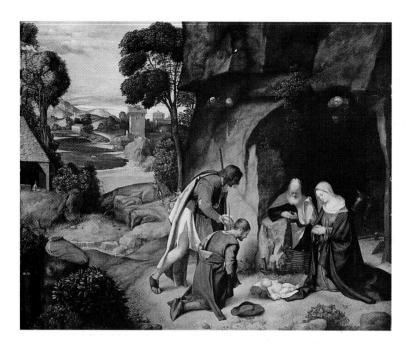

€ 5 • 9

Giorgione, The Adoration of the Shepherds, c. 1505–10. Oil on wood, $35\frac{3}{4} \times 43\frac{1}{2}$ in (90.8 × 110.5 cm).

In Giorgione's work, line was largely disregarded in favor of atmospheric definition.

Samuel H. Kress Collection. National Gallery of Art, Washington, D.C. Photo: SuperStock

₹ 5 • 10

Titian (Tiziano Vecellio), The Entombment of Christ, 1559. Oil on canvas, 4 ft 6 in \times 5 ft $8^{7/8}$ in (1.37 \times 1.75 m).

The Venetian master Titian subordinated line (contrasting edges with value) and enveloped his figures in a total atmosphere that approaches tenebrism.

Museo del Prado, Madrid, Spain. Photo: Scala/Art Resource, NY.

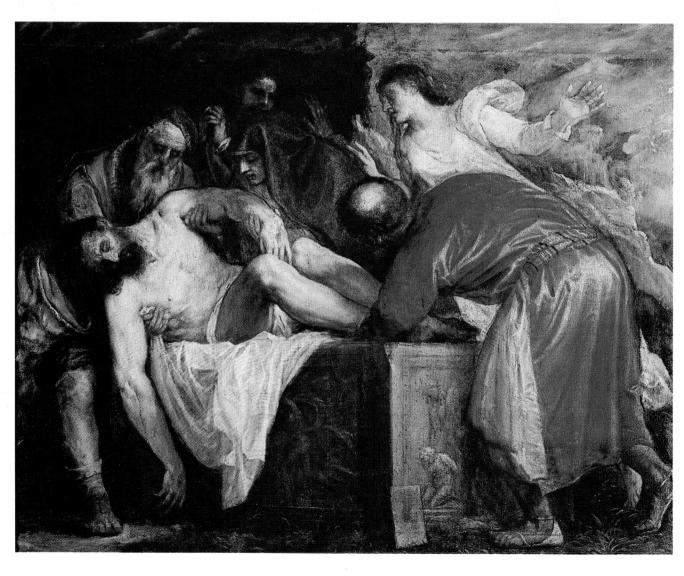

Value I23

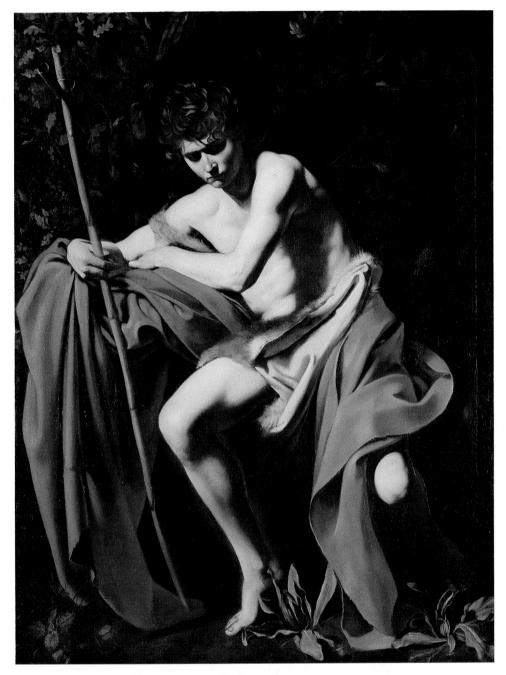

TENEBRISM

Painters who use violent chiaroscuro are called tenebrists. The first tenebrists were an international group of painters who, early in the seventeenth century, were inspired by the work of Michelangelo Merisi da Caravaggio (fig. 5.11). Caravaggio based his chiaroscuro on Correggio's work and instituted the so-called "dark manner" of painting in Western Europe. Rembrandt became the technical adapter and perfector of this dark manner, which he learned from migratory artists of Germany and southern Holland (fig. 5.12). The dark manner made value an instrument in the characteristic exaggeration of Baroque painting. The strong contrasts lent themselves well to highly dramatic, even theatrical, work of this type.

Later, the dark manner evolved into the pallid, muddy monotone that pervaded some nineteenth-century Western painting. The tenebrists and their followers were very much interested in peculiarities of lighting, particularly the way that lighting affected mood or emotional expression. They deviated from standard light conditions by placing the implied light sources in unexpected locations, creating unusual visual and spatial effects. In the hands of such superior artists as Rembrandt, these effects were creative tools; in lesser hands, they became captivating tricks or visual sleight-of-hand.

▲ 5・11

Michelangelo Merisi, called Caravaggio, St. John the Baptist, c. 1604–5. Oil on canvas, 5 ft 8 \times 4 ft 4 in (1.73 \times 1.32 m).

Caravaggio was essentially the leader in establishing the dark manner of painting in the sixteenth and seventeenth centuries. Several of the earlier northern Italian painters, however, such as Correggio, Titian, and Tintoretto, show a strong tendency toward compositions using darker values.

Nelson-Atkins Museum of Art, Kansas City, MO. (Purchase: Nelson Trust) 52–25.

DECORATIVE VALUE

Art styles that stress **decorative** effects usually ignore conventional light sources or neglect representation of light altogether. If light effects appear, they are often a selection of appearances based on their contribution to the total form of the work. This admixture is characteristic of the artworks of children and of primitive and prehistoric tribes, traditional East Asians, and certain

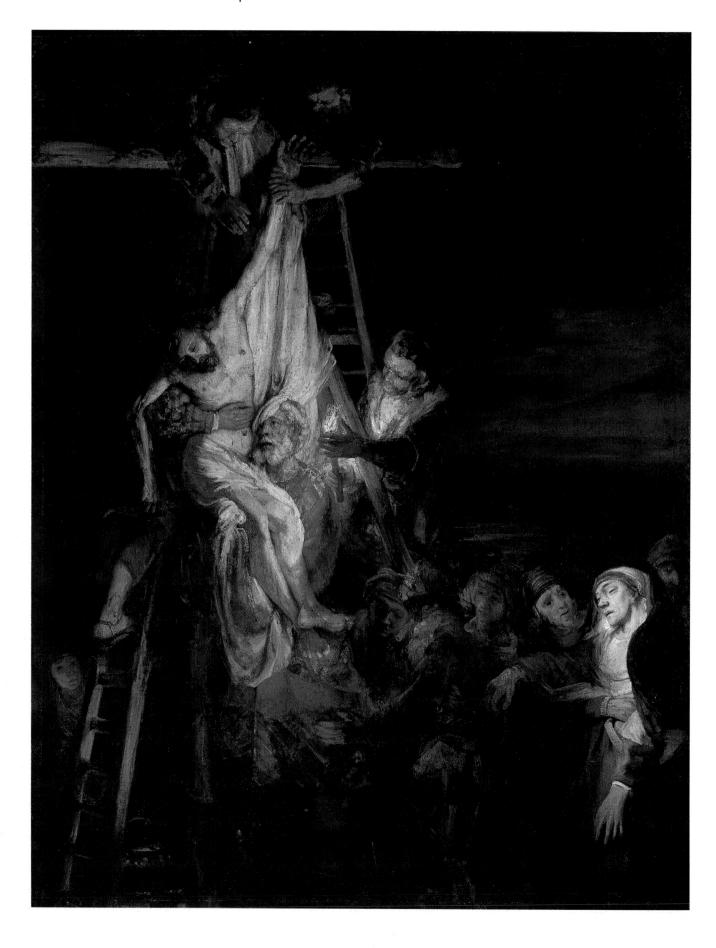

Value I25

4 5 ⋅ 12

Workshop of Rembrandt van Rijn, probably Constantijn van Renesse, Descent from the Cross, 1650/52. Oil on canvas, 4 ft 8½ in × 3 ft 7¾ in (1.43 × 1.11 m). Rembrandt often used inventive, hidden light sources that deviated from standard conditions to enhance the mood or emotional expression. Widener Collection. © 1998 Board of Trustees, National Gallery of Art, Washington, D.C.

5 • 13

Photo: R. Carafelli.

Signed: Khem Karan, Prince Riding an Elephant, Mughal, period of Akbar, c. 1600. Opaque watercolor and gold on paper, $12\frac{1}{4} \times 18\frac{1}{2}$ in $(31.2 \times 47 \text{ cm})$.

Historically, south Asian artists have often disregarded the use of light (illumination) in favor of decorative value compositions.

© 1998 Metropolitan Museum of Art, New York. Rogers Fund, 1925. (25.68.4)

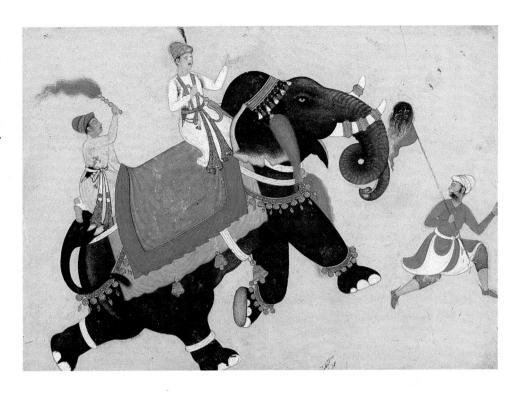

periods of Western art, notably the Middle Ages. Many contemporary artworks are completely free of illusionistic lighting. An artwork that thus divorces itself from natural law is obviously based on pictorial invention, imagination, and formal considerations. Emotional impact is not necessarily sacrificed (as witness Medieval art), but the emotion speaks primarily through the forms and is consequently less extroverted.

The trend away from illumination values gained strength in the nineteenth century, partly because of growing interest in Middle Eastern and east Asian art forms (fig. 5.13). It was given a scientific, Western interpretation when the naturalist Edouard Manet observed that multiple light sources tended to flatten object surfaces. He found that this light condition neutralized the plastic qualities of objects, thereby minimizing gradations of value (figs. 5.14A and B).

As a result, he laid his colors on canvas in flat areas, beginning with bright, light colors and generally neglecting shadow (fig. 5.15). Some critics have claimed this to be the basic technical advance of the nineteenth century, because it paved the way for nonrepresentational uses of value and helped revive interest in the *shallow-space* concept.

COMPOSITIONAL FUNCTIONS OF VALUE

The idea of carefully controlled shallow space is well illustrated in the works of the early Cubists and their followers. In those paintings, space is given its order by the arrangement of flat planes abstracted from the subject matter. In the initial stages of this trend, the planes were shaded individually and semi-

illusionistically, although giving no indication of any one light source. Later, each plane took on a characteristic value and, in combination with others, produced a carefully conceived twodimensional light-dark pattern. Eventually, the shallow spatial effect was developed through attention to the advancing and receding characteristics of value (see fig. 4.8). The explorations of these early twentieth-century artists helped focus attention on the intrinsic significance of each and every element. Value was no longer forced to serve primarily as a tool of superficial transcription, although it continued to be of descriptive usefulness. Most creative artists should think of value as a vital and lively participant in pictorial organization. An artist can strengthen underlying compositional structure by controlling contrast of value; it is instrumental in creating relative dominance and two-dimensional pattern,

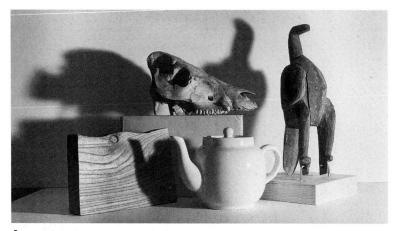

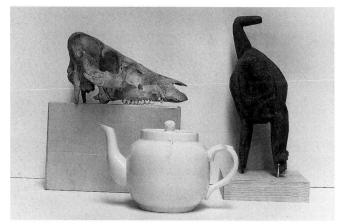

Α

В

▲ 5 · I4A & B

Russell F. McKnight, Effect of Light on Objects, 1984. Photograph.

Figure 5.14A demonstrates how light from one source emphasizes the three-dimensional qualities of an object and gives an indication of depth. The cast shadows also give definite clues to the descriptive and plastic qualities of the various objects. The photograph in figure 5.14B shows the group of objects under illumination from several light sources. This form of lighting tends to flatten object surfaces and produces a more decorative effect.

Courtesy of the artist.

₩ 5 • 15

Edouard Manet, The Dead Toreador, probably 1864. Oil on canvas, 297/8 × 603/8 in (75.9 × 153.4 cm).

Manet, a nineteenth-century naturalist, was one of the first artists to break with traditional chiaroscuro, making use, instead, of flat areas of value. These flat areas meet abruptly, unlike the blended edges used by artists previous to Manet. This was one of the great technical developments of nineteenth-century art.

Widener Collection © 1998 Board of Trustees, National Gallery of Art, Washington, D.C.

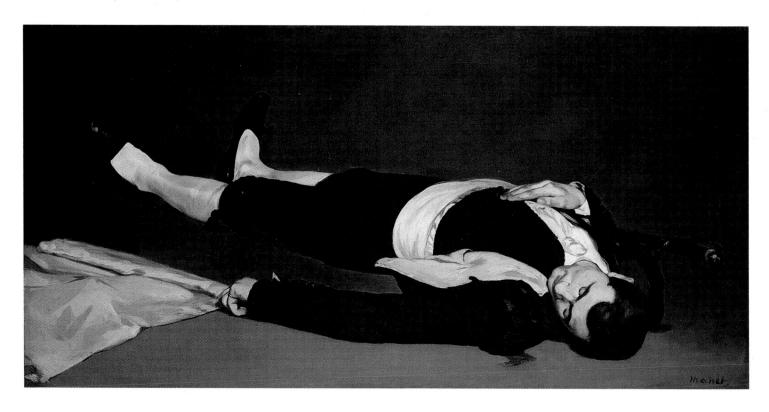

Value I27

₩ 5 • 16

Henri Matisse, Nuit de Noël. Paris, summer-autumn 1952. Stained-glass window commissioned by Life, 1952. Metal framework, $132^3/4 \times 54^3/4 \times 5^5/8$ in (337.19 \times 139.1 \times 1.6 cm).

Matisse chose to use a two-dimensional value pattern enhanced by stained glass.

The Museum of Modern Art, New York. Gift of Time, Inc. Photo © 1998 Museum of Modern Art. © Succession H. Matisse/Artists Rights Society (ARS), New York.

▲ 5 · 17

Nicolas Poussin, study for Rape of the Sabines, c. 1633. Pen and ink with wash, $6\frac{1}{2} \times 8\frac{7}{8}$ in (16.4 × 22.5 cm).

Preparatory or "thumbnail" sketches give the artist the opportunity to explore movement, ground systems, value structure and compositional variations. In the Poussin sketch, it seems likely that the artist was striving for rhythmical movement within the horizontal thrust of the composition. Devonshire Collection, Chatsworth, England. Reproduced by permission of the Trustees of the Chatsworth Settlement. (Photograph from Courtauld Institute of Art, London.)

establishing mood, and producing spatial unity (fig. 5.16).

VALUE PATTERNS

Artists have long explored possible variations for a composition's value pattern—its underlying movement and ground system—by making small studies of the value structure called thumbnail sketches. These **value patterns** may be thought of as the compositional skeleton that supports the image. When properly integrated into the final work, the movement, tension, and structure of the value pattern explored in the sketches

reinforces the subject. It does not distract from the image nor separate itself as an overpowering entity, or an isolated component. The advantage of small-scale preliminary value studies is that they allow an artist to quickly explore compositional variations before selecting a final solution. In figures 5.17, 5.18, and 5.19, for example, Nicolas Poussin and Barry Schactman develop large rhythmical dark shapes across the bottom, while intermingling smaller receding toned shapes in the middle areas.

Often it is difficult to relate such small studies to the final work because of scale. Small drawings may look exciting

₹ 5 • 18

Barry Schactman, Study after Poussin, 1959. Brush and ink with wash, $10 \times 7^{7}/8$ in $(25.4 \times 20 \text{ cm})$.

By using thumbnail sketches artists can quickly position subjects in several locations before arriving at the final composition.

Collection of Yale University, New Haven, CT. Transfer from Yale Art School

5 · 19

Barry Schactman, Study after Poussin, 1959. Brush and ink with wash, $10 \times 7^{7}/8$ in (25.4 \times 20 cm).

Loose, rapid sketches can also be used to explore value patterns, color structure, and movement.

Yale University Art Gallery, New Haven, CT. Transfer from Yale Art School.

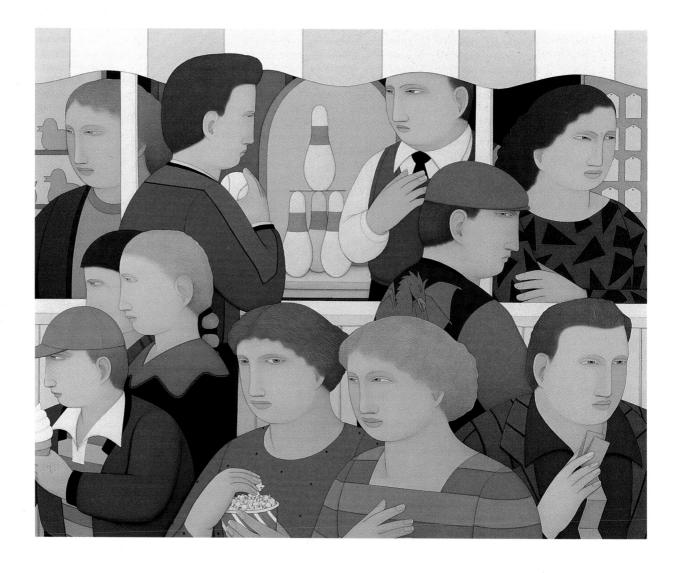

Value 129

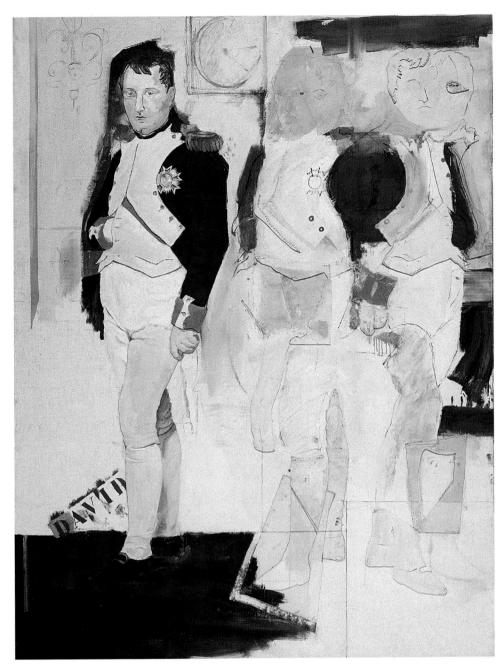

4 5 ⋅ 21

Larry Rivers, The Greatest Homosexual, 1964. Oil, collage, pencil, and colored pencil on canvas, 6 ft 8 in \times 5 ft 1 in (2.03 \times 1.55 m).

In this work, values pass freely through and beyond the contour lines that normally serve as boundaries of color separation. This is an example of an open-value composition.

Hirshhorn Museum and Sculpture Garden, Smithsonian Institution, Gift of Joseph H. Hirshhorn, 1966.

Hirshhorn Museum and Sculpture Garden, Smithsonia Institution. Gift of Joseph H. Hirshhorn, 1966. (Photograph by John Tennant.) © 1998 Larry Rivers/Licensed by VAGA, New York.

OPEN AND CLOSED COMPOSITIONS

While integrating the value structure and the image, the artist should be aware of two approaches for developing the value pattern—closed-value or open-value compositions. In closed-value compositions, values are limited by the edges or boundaries of shapes (fig. 5.20). This serves to clearly identify and, at times, even isolate the shapes (see fig. 5.16). In open-value compositions, values can cross over shape boundaries into adjoining areas. This helps to integrate the shapes and unify the composition (fig. 5.21; see fig. 4.8). With both open- and closed-value compositions, the emotive possibilities of value schemes are easy to see. The artist may employ closely related values for hazy, foglike effects (see fig. 4.5). Sharply crystallized shapes may be created by dramatically contrasting values (see figs. 4.21 and 5.6). Thus, value can run the gamut from decoration to violent expression. It is a multipurpose tool, and the success of the total work of art is in large measure based on the effectiveness with which the artist has made value serve these many functions.

₹ 5 • 20

Andrew Stevovich, Carnival, 1992. Oil on linen, 4×5 ft (1.22 \times 1.52 m).

In the Stepovich painting, a closed-value composition, the color values lie between prescribed and precise limits, usually object edges or contours.

Courtesy of Adelson Galleries, New York.

because of the way the areas of value are drawn—with rapid sketchy strokes. When enlarged many times, small strokes become large enough to be seen as bold flat shapes that no longer have the same visual appeal. The new, enlarged shapes of value often require a refinement of detail before the proper relationship of value and mood can be established.

Texture

THE VOCABULARY OF TEXTURE

INTRODUCTION TO TEXTURE

TEXTURE AND THE VISUAL ARTS

THE NATURE OF TEXTURE

TYPES OF TEXTURE

Actual Texture Simulated Texture Abstract Texture Invented Texture

TEXTURE AND PATTERN

TEXTURE AND COMPOSITION

Relative Dominance and Movement Psychological Factors

TEXTURE AND SPACE

TEXTURE AND ART MEDIA

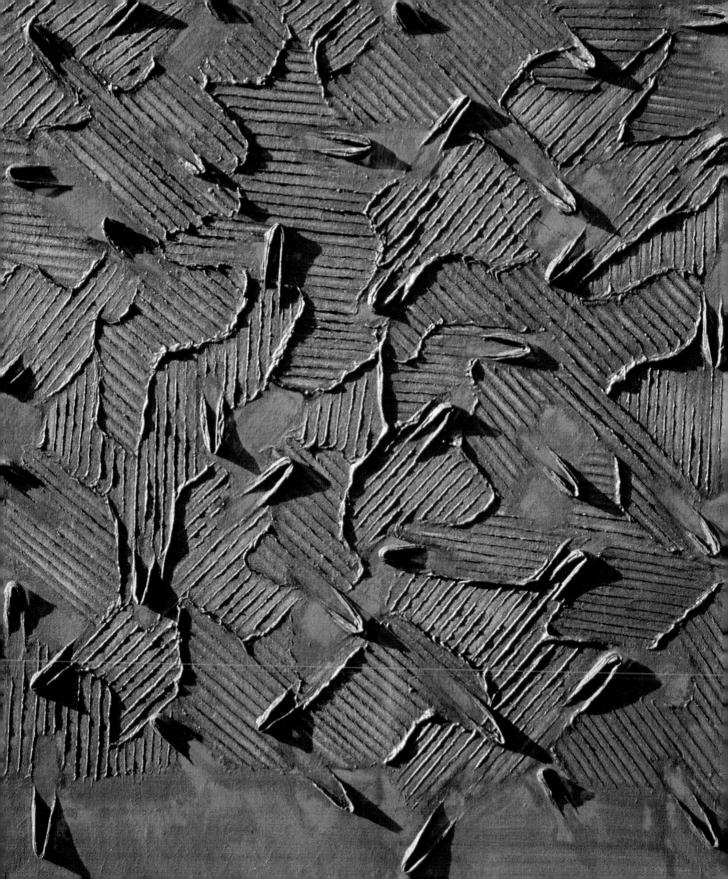

THE VOCABULARY OF TEXTURE

Texture. The surface character of a material that can be experienced through touch or the illusion of touch. Texture is produced by natural forces or through an artist's manipulation of the art elements.

abstract texture

A texture derived from the appearance of an actual surface but rearranged and/or simplified by the artist to satisfy the demands of the artwork.

actual texture

A surface that can be experienced through the sense of touch (as opposed to a surface visually simulated by the artist).

assemblage

A technique that brings together individual items of rather bulky three-dimensional nature that are displayed (in situ) in their original position rather than being limited to a wall.

atmospheric (aerial) perspective

The illusion of deep space produced in graphic works by lightening values, softening details and textures, reducing value contrasts, and neutralizing colors in objects as they recede.

collage

A pictorial technique where the artist creates the image, or a portion of it, by adhering real materials that possess actual textures to the picture plane surface,

often combining them with painted or drawn passages.

genre

Subject matter that concerns everyday life, domestic scenes, family relationships, etc.

illusionism

The imitation of visual reality created on the flat surface of the picture plane by the use of perspective, light-and-dark shading, etc.

invented texture

A created texture whose only source is in the imagination of the artist. It generally produces a decorative pattern and should not be confused with an abstract texture.

natural texture

Textures created as the result of nature's processes.

paint quality

The use of paint to enrich a surface through textural interest. Interest is created by the ingenuity in handling paint for its intrinsic character.

papier collé

A visual and tactile technique where

scraps of paper having various textures are pasted to the picture surface to enrich or embellish areas. In addition to the actual texture of the paper, the printing on adhered tickets, newspapers, etc., functions as visual richness or decorative pattern similar to an artist's invented texture.

pattern

I. Any artistic design (sometimes serving as a model for imitation). 2. Compositions with repeated elements and/or designs that are usually varied, and produce interconnections and obvious directional movements.

simulated texture

A convincing copy or translation of an object's texture in any medium.

tactile

A quality that refers to the sense of touch.

trompe l'oeil

Literally, "deceives the eye"; a technique that copies nature with such exactitude that the subject depicted can be mistaken for natural forms.

133

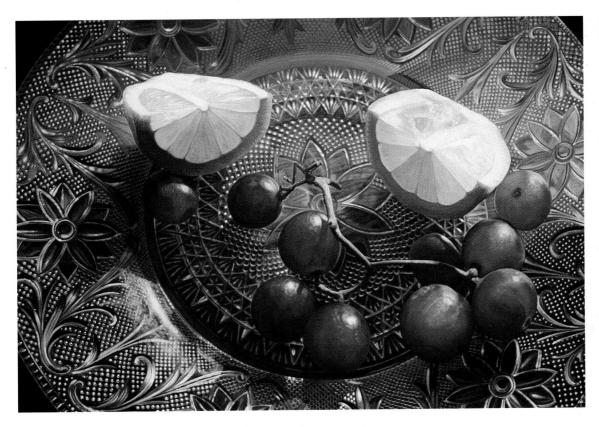

4 6 ⋅ 1

Dennis Wojtkiewicz, *Kaleidoscope*, 1996. Oil on canvas, 40×60 in $(101.6 \times 152.4 \text{ cm})$.

The convincing effect of naturalistic still-life paintings is due, in large part, to the artist's careful simulation of object surfaces.

Courtesy of the artist, collection Mr. and Mrs. Thomas Cody, Cincinnati, OH.

INTRODUCTION TO TEXTURE

Texture is an experience that is always with us. Whenever we touch something, we feel its texture. By concentrating on your hands and fingers holding this book you will realize that you are experiencing texture. If your fingers are against the open side, they will feel the ridged effect of the stacked pages; if on the surface of a page, its smoothness. By looking around the room where you sit, you will find many textures. In fact everything has a texture, from the hard glossiness of glass through the partial roughness of a lampshade to the soft fluffiness of a carpet. If your room happens to contain a painting or art reproduction, the work most likely illustrates textures that can be seen, not felt—but that are made to look as if they could be felt.

TEXTURE AND THE VISUAL ARTS

Texture is unique among the art elements because it activates two sensory processes. It is more intimately and dramatically known through the sense of touch, but we also can see texture and thus, indirectly, predict its feel. In viewing a picture, we may recognize objects through the artist's use of characteristic shapes, colors, and value patterns. But we may also react to the artist's rendering of the surface character of those objects. In such a case, we have both visual and **tactile** experiences (fig. 6.1).

Whether the artist is working in the two-dimensional or three-dimensional field, our tactile response to the work is always a concern (fig. 6.2). Sculptors become involved with the problem of texture by their choice of material and

6 . 2

Andrew Newell Wyeth, The Hunter, 1943. Tempera on masonite, $33 \times 33\%$ in (83.8 \times 86 cm).

Skillful manipulation of the medium can effectively simulate actual textures.

Toledo Museum of Art, Toledo, OH. Elizabeth C. Mau Bequest Fund. (1946.25)

the type and degree of finish they use. If they wish, sculptors can re-create the textures that are characteristic of the subject being interpreted. By cutting into the surface of the material, they can suggest the exterior qualities of hair, cloth, skin, and other textures (fig. 6.3).

THE NATURE OF TEXTURE

The sense of touch helps to inform us about our immediate surroundings. Our language, through such words as "smooth," "rough," "soft," and "hard," demonstrates that touch can tell us about

the nature of objects. Texture is really surface, and the feel of that surface depends on the degree to which it is broken up by its composition. This determines how we see it and feel it. Rough surfaces intercept light rays, producing lights and darks. Glossy surfaces reflect the light more evenly, giving a less broken appearance (figs. 6.4A and B).

TYPES OF TEXTURE

The artist can use four basic types of texture: actual, simulated, abstract, and invented.

A 6 · 3

Hiram Powers, Bust of Horatio Greenough, 1838. Marble, $26\frac{1}{2} \times 14 \times 9\frac{1}{4}$ in (67.3 \times 35.5 \times 23.5 cm).

This sculptor has polished portions of the bust in order to bring out the natural textural qualities of the marble. In addition, he has created actual and visual textures to simulate his subject's physical characteristics.

Bequest of Charlotte Gore Greenough Hervosches du Quilliou. Courtesy of Museum of Fine Arts, Boston, MA.

₩ 6 · 4A & B

(A) A cross section of three materials. On the left is a hard, smooth substance; in the middle is cinderblock; and on the right is weathered wood. The texture of the three upper surfaces can be clearly seen and could be felt if stroked. (B) The same cross section showing its upper plane. The arrow indicates the light source. The texture is defined by the highlights and shadows formed by this illumination. The material to the left, being smooth, produces no shadows (if glossy, it would show reflections). In the cinderblock shadows are cast among the small stones. The undulations in the weathered wood have shadows on the left side and highlights on the right. The nature of the texture in materials is defined by light and shadow patterns.

6.5

Robert Mazur, Floral (detail), 1990. Polymer acrylic medium and silica sand, 3 ft 6 in \times 4 ft 4 in (1.07 \times 1.32 m).

The aggregate, which is mixed into the paint, is supported by a careful selection of color to create a total effect similar to the surfaces found in nature.

Collection of Mr. and Mrs. John Martin.

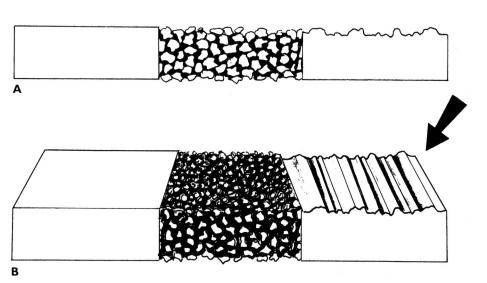

135

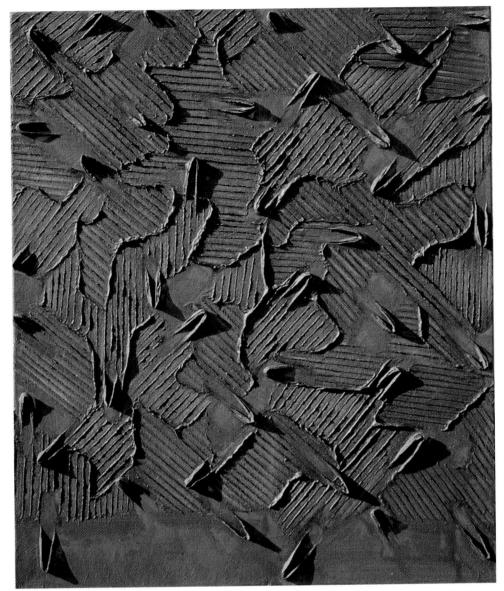

6 . 6

Seo-Bo Park, Ecriture No. 931215, 1993. Mixed media with korian paper, $20^{15}/_{16} \times 18^{1}/_{10}$ in (53.2 × 46 cm).

The massing of paint is clearly evident, particularly in the central portion. Some shapes seem to have been affected by a comb-like instrument.

Collection of Tokyo Gallery, Tokyo, Japan. Courtesy of the artist, President of the Seo-Bo Arts/Cultural Foundation, Seoul, Korea.

ACTUAL TEXTURE

Actual texture is the "real thing"; it is the way the surface of an object looks and feels. Generally, the emphasis is on the way it feels to the touch, but we can get a preliminary idea of the feel by viewing the object (fig. 6.5). Historically, **actual texture** has been a natural part of three-dimensional art, but it has rarely been present in the graphic arts. An exception might be the buildup of paint on Seo-Bo Parks' *Ecriture*, or van Gogh's *Starry Night*, in which the paint has been

applied in projecting mounds or furrows (fig. 6.6; see fig. 1.13). The usual artistic application of actual texture involves fixing a textured object to the working surface. When this is done, the texture simply represents itself, although a texture may sometimes be used out of context by displacing an expected texture. The adhering of textures in two-dimensional art probably began with Picasso and Braque in the early twentieth century. In 1908, Picasso pasted a piece of paper to a drawing. This is the first known example of

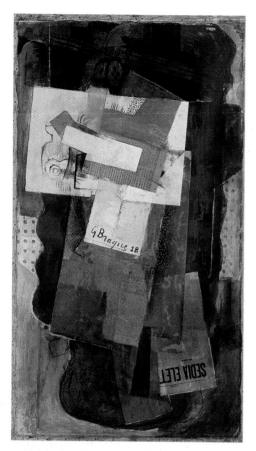

← 6 · 7

Georges Braque,

Still Life, c. 1917–18.

Pasted newspaper, paper,
gouache, oil, and charcoal
on canvas, 51½ × 29 in
(130.2 × 73.7 cm).

This Cubist painter helped to pioneer the papier collé and collage forms—art created by fastening actual materials with textural interest to a flat working surface. These art forms may be used to simulate natural textures but are usually created for decorative purposes.

Philadelphia Museum of Art, PA. Louise and Walter Arensberg Collection. © 1997 Artists Rights Society (ARS), New York/ADAGP, Paris.

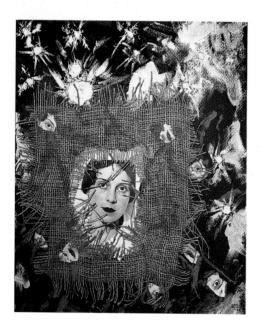

▲ 6 · 8 Ilse Bing, My World, 1985. Mixed media, $14 \times 17 \times 3^{3}$ /4 in (35.6 × 43.2 × 9.5 cm).

The inspiration behind the use of burlap in this artwork stems ultimately from the first collages of Picasso and Braque—then a revolutionary, but now a fairly commonplace technique.

© Ilse Bing, courtesy of Houk-Friedman, New York.

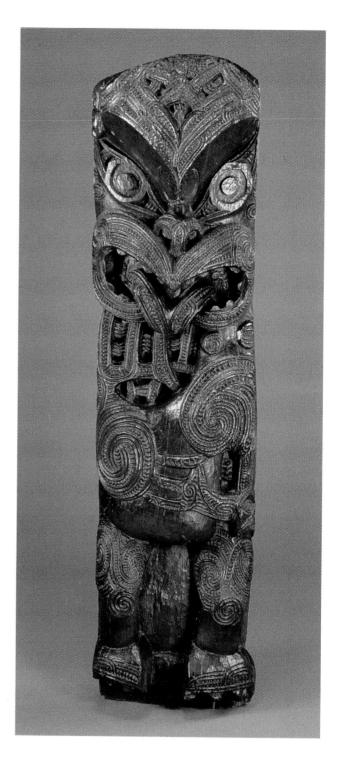

Ancestral Figure from House Post, Maori, New Zealand, c. 118–129. Wood, 43 in high (109.22 cm).

The Maori shallow relief figure from New Zealand, representing a tribal ancestor, has incorporated curving or spiral bands of invented textural pattern. The decorative treatment relates to the tattooing, which embellished the tribal members' bodies, including their faces. The carving functioned as one of the wall planks in their meeting house.

© Boltin Picture Library

137

papier collé. This practice was later expanded to include the use of tickets, portions of newspapers, menus, and the like.

Papier collé soon led to collage, an art form where actual textures, in the form of rope, chair caning, and other articles of greater substance than paper, were employed. Sometimes these were used in combination with simulated textures (fig. 6 .7). The use of papier collé and collage is not always accepted easily; it leads to an uncertainty that can be perplexing. The problem created by mixing objects and painting is: What is real—the objects or the artistic elements, or both? Do the painted objects have the same reality as the genuine objects? Whatever the answers, the early explorations of the Cubists (the style of Picasso and Braque, about 1907–12) stimulated other artists to explore new attitudes toward art and made them much more conscious of surface (fig. 6.8). A concern for pattern, arising out of interest in texture, can be found in the work of artists from every culture (fig. 6.9). In the art of today, we find many forms of surface applications. Aside from the more familiar texture of manipulated paint, we may find aggregate (sand, gravel, and so on) mixed into the paint to make the surface smoother or rougher, for whatever reason.

Actual textures contribute to a fairly recent development called **assemblage**. If there is any distinction to be made between collage and assemblage, it is that assemblages usually bring together rather bulky individual items that are displayed in different positions rather than on a wall. These objects, of course, possess actual texture in their own right (fig. 6.10; see figs. 10.83 and 10.85).

SIMULATED TEXTURE

A surface character that looks real but, in fact, is not, is said to be **simulated**. Every surface has characteristic light and dark features as well as reflections. When

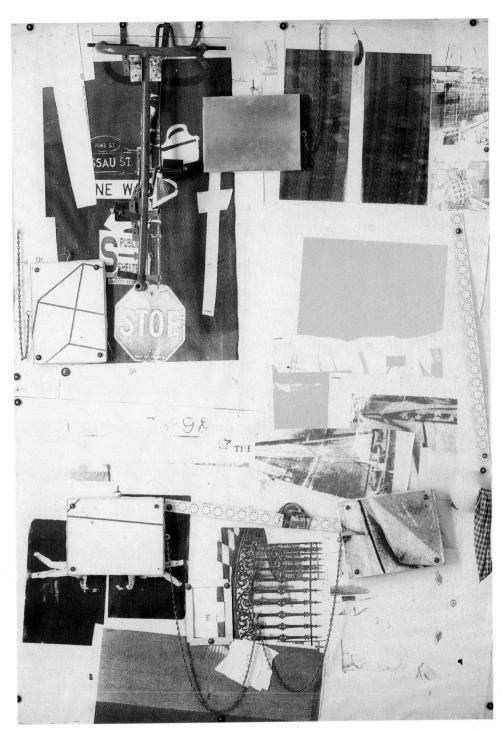

A 6 . 10

Robert Rauschenberg, Fossil for Bob Morris, New York, 1965. Paper, metal, plastic, rubber, and fabric on canvas, 84×60 in (213.4 \times 152.4 cm).

Perhaps the dividing line between collage and assemblage, as illustrated by this example, lies in the greater bulk and variety of the objects found in assemblages.

Hirshhorn Museum and Sculpture Garden, Smithsonian Institution, Washington, D.C. Gift of Joseph H. Hirshhorn, 1972. (Photograph by John Tennant.) © 1998 Robert Rauschenberg/Licensed by VAGA, New York.

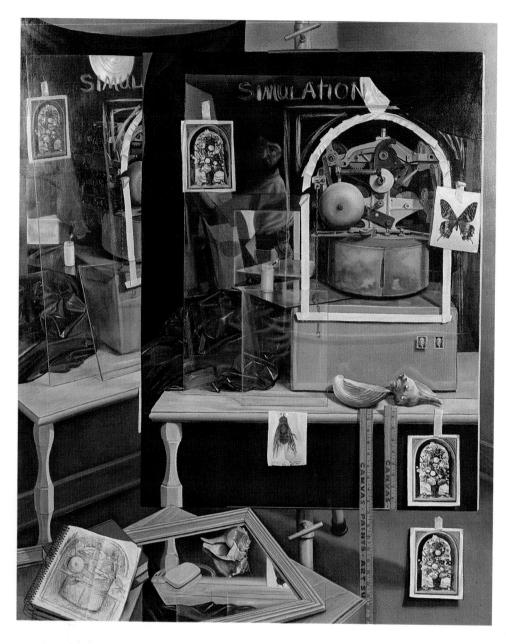

▲ 6 · 11 Gary Schumer, Simulation, 1979. Oil on canvas, 3 ft $6\frac{1}{2}$ in × 4 ft $4\frac{1}{2}$ in (1.08 × 1.33 m).

As the title implies, the artist is concerned with the simulation of natural textures.

Courtesy of Owens Corning Collection, Toledo, OH.

these are skillfully reproduced in the artist's medium (as in the case of the seventeenth-century Dutch painters), they can often be mistaken for the surfaces of "real" objects. Simulation is a copying technique, a skill that can be quite impressive in its own right; but it is far from being the sum total of art.

Simulated textures are useful for making things identifiable; moreover, we experience a rich tactile enjoyment when viewing them. The Dutch and Flemish artists produced amazing naturalistic effects in still-life and **genre** paintings. Their work shows the evident relish with which they moved from one textural detail to another. Interior designers employ this concept when painting "faux" (fake) surface treatments of imitation stone or marble-veined wall texture. Simulated textures are often associated with **trompe l'oeil** paintings, which attempt to "fool the eye" (fig. 6.11).

Simulated texture can serve to illustrate the dual character of texture. Imagine an artist painting a picture that includes a barn door. The door is so weathered and eroded that its wood grain stands out prominently; it would feel rough if stroked. The roughness results from the ridges and valleys, formed by exposure to the elements. These ridges and valleys can be felt but are visible only because they are defined by light and shadow. In rendering (or simulating) the door's texture the artist copies the highlights and shadows from a photograph (fig. 6.12) and, if performed with skill, it works like a feat of magic. The copied door appears to be rough, but is, in fact, smooth, as can be confirmed by stroking the surface of the work.

ABSTRACT TEXTURE

Very often artists may be interested in using texture, but instead of simulating textures, they **abstract** them. Abstract textures usually display some hint of the original texture but have been modified to suit the artist's particular needs. The result is often a simplified version of the original, emphasizing pattern. Abstract textures normally appear in works where the degree of abstraction is consistent throughout. In these works they function in a decorative way; obviously there is no attempt to "fool the eye" but they serve the role of enrichment in the same way that simulated textures do.

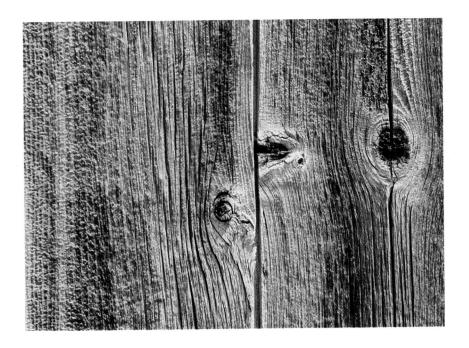

A 6 · 12

A closeup of a wooden barn door shows a detailed view of its grain. The wood has been so eroded by the weather that the grain and knots stand out. If you were to touch the actual surface of the door it would feel rough, but if you stroke the surface of the photographic reproduction on this page it feels perfectly smooth. The picture is, in fact, a simulation of the textured barn door. Courtesy of authors.

Besides helping the artist to simplify his or her material, abstract textures can be used to **accent** or diminish areas (relative dominance) and to control movement. They can be a potent compositional tool (fig. 6 .13).

INVENTED TEXTURE

Invented textures are textures without precedent; they neither simulate nor are they abstracted from reality; they are purely the creation of the artist's imagination. In some settings, invented textures may suggest that they function as another type of texture but such references are not generally intended by the artist. Invented textures usually appear in abstract works, as they are entirely nonobjective. It is sometimes difficult to distinguish abstracted from invented textures, because an artist with the same level of skill as the simulator (but probably with more imagination) can invent a texture and make it appear

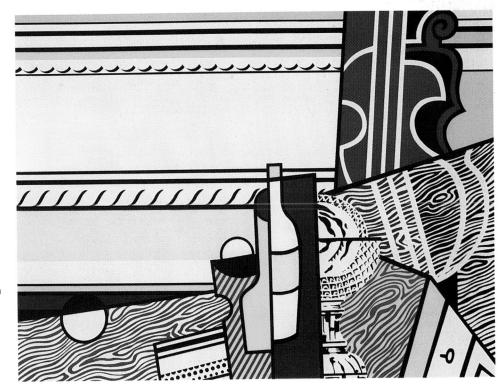

6 . 13

Roy Lichtenstein, Still Life with Crystal Bowl, 1976. Screenprint/lithograph (edition of forty-five), $32 \times 43^{1/2}$ in (81.3 \times 110.5 cm).

The wood grain in this work is not abstracted beyond recognition; it is clearly derived from wood, though simplified and stylized.

© Roy Lichtenstein.

A 6 · 14

Kenneth Knowlton and Leon Harmon, Computerized Nude, 1971. Computergenerated image.

This reproduction of a photograph by a specially programmed computer has not only a range of dark and light values, but also a variety of interesting textures. It illustrates the concept that invented textures can in themselves contribute an important aesthetic dimension to an ordinary subject.

Reproduced with permission of AT&T Archives.

B WHATHING WHATHING MANIMUM

▶ 6 · I5A, B, & C

This figure illustrates the differences and similarities between pattern and texture. (A) Piece of material with a light-and-dark allover pattern. (B) Cross section of material A, assuming it to be a piece of wallpaper. The dark spots are ink; the ink sits on the surface and penetrates the material. (C) Cross section of material A, assuming it to be a piece of carpet. The pattern comes from color changes and tufted areas (texture). Thus we have both pattern and texture in example C.

to have a precedent where none exists (fig. 6.14). In such a case it is difficult to know how, if necessary, to classify the texture; although the texture is created. and not re-created, it still seems to be derived from some source. When used in a realistic or semirealistic work it is probable that the invention would have some resemblance to a subject's texture. By contrast, there are invented textures in which such references to the objective world are not intended. These textures would most likely show up in abstract works in which one might not know whether they were invented or abstracted. Usually the uses of invented textures are much the same as those cited for abstract textures. And, in the hands of a Surrealistic artist, it is possible that they could be inserted in an unlikely context for a surprise or shock effect (see figures 4.5 and 10.59).

TEXTURE AND PATTERN

Because texture is interpreted by lights and darks, there is a very fine line between texture and pattern (which is created in a similar way). For example, a printed paisley pattern on a silk tie does not have an exaggerated texture; according to the dictionary, it is essentially a design (see fig. 2.9). This implies that it is not concerned with surface feel but with appearance. Pattern serves the artist mainly as ornament, independent from any tactile possibilities. But there is an overlap, because texture can create pattern (figs. 6.15A–C).

Pattern usually suggests a repetition; it is sometimes rather random or sometimes more controlled. A planter sows corn seeds at regular intervals in a field. As the corn grows, the stalks can produce the effect of both pattern and texture. An aerial view of the field would show the pattern primarily, but when closer, the texture would become more visible (figs. 6.16 and 6.17). Unless

€ 6 • 16

In this photograph of a corn field we have examples of both pattern and texture. The rows of corn and the gaps between them create a striped pattern, while the massed stalks produce a texture

© Craig Aurness/West Light.

₩ 6 • 17

The individual corn stalks, with their leaves and husks, can be clearly seen in this low-altitude view of a field. In the foreground, the corn, taken as a whole, appears as a huge three-dimensional texture. In the distant view over the top of the field, the corn forms patterned rows.

© Bob Coyle/Red Diamond Stock Photos.

it is smooth, like glass or steel, texture is normally identified with a threedimensional disruption of a surface. Pattern, by contrast, is generally thought of in two-dimensional (or flat) terms.

In most cases the distinction between texture and pattern is clearly defined, but in others it is not so apparent. In addition, the basis of the distinction is itself problematic and debatable. Some people argue that scale makes the difference—that pattern units are generally larger than textural units. By contrast some people assert that the difference lies in distance, in other words that generally the closer one gets to a surface the more it takes on the qualities of a texture. Your authors have debated both these points of view without coming to a firm conclusion, but we incline toward the latter position. In any event, there is little doubt that texture is the product of the nature of a surface. Consider the contrast between a pane of

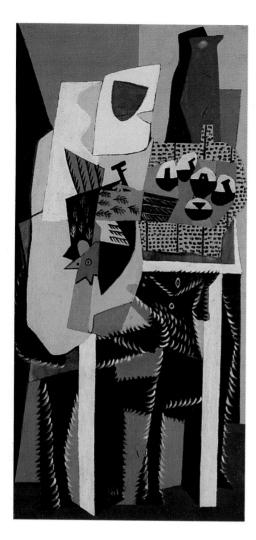

€ 6 • 18

Pablo Picasso, Dog and Cock, 1929. Oil on canvas, $60^{7/8} \times 30^{1/8}$ in (154.6 \times 76.5 cm).

Abstract texture can be a compositional tool that is important for capturing and directing attention. Clearly the abstracted white fur of the dog attracts us and creates movement.

Yale University Art Gallery, New Haven, CT. Gift of Stephen Carlton Clark, B.A. 1903. © 1997 Estate of Pablo Picasso /Artists Rights Society (ARS), New York.

glass and a shag carpet; the smoothness of glass might be regarded as a texture of sorts, but there is no doubt as to the carpet's texture.

TEXTURE AND COMPOSITION

RELATIVE DOMINANCE AND MOVEMENT

The sense of touch aside, texture is seen as variations of light and dark. These variations, apart from their ability to stimulate our sense of touch, are often exciting and attractive. In drawing our attention, these textural areas may create a problem because they are competing with other parts of the artwork. If the texture area is too strong in its hold on the spectator, other areas, possibly more important ones, may not get the attention they deserve; the texture must then be diminished. On the other hand, if an area is "dead," or not attractive, a texture can be added or emphasized to make it come to life.

Our attention is constantly being maneuvered about the surface of an artwork by (among other things) the degree of emphasis given to the various areas of that surface. The movement of our eyes is directed from one attractive area to another, passing over, or through, the "rests" (or deemphasized areas). The control of textures obviously can be a part of the directional thrusts that move through the work; it shares this role with the other art elements. The abstract

textures in Picasso's *Dog and Cock*, for example, draw our eyes to the more significant parts of the painting (fig. 6.18).

PSYCHOLOGICAL FACTORS

Textures can provoke psychological or emotional responses in us that may be either pleasant or unpleasant. In doing this, the textures are usually associated with environments, experiences, objects, or persons from our experience. Textures have symbolic or associative meanings. When we say a person is "slippery as a snake" or "a roughneck," tactile sensations are being linked to personality traits. Similarly, textures can be used as supplementary psychological devices in art. The artist can also use textures to stimulate our curiosity, shock us, or make us reevaluate our perceptions (fig. 6.19).

TEXTURE AND SPACE

Texture can also help to define space. The character of the texture of plantlife, for example, differs with distance (see fig. 8.14). When textures appear blurred and lack strong contrasts, they make objects seem distant, but if they are sharp and have strong contrasts, the objects appear to move forward. This is one of the principles of **atmospheric perspective**, a commonly used technique in representational painting. A less traditional artist might use textures from far to near and produce controlled variations or surprising contradictions (fig. 6.20).

TEXTURE AND ART MEDIA

Most of this discussion has dealt with the graphic arts, but textural possibilities are also considered in making other kinds of

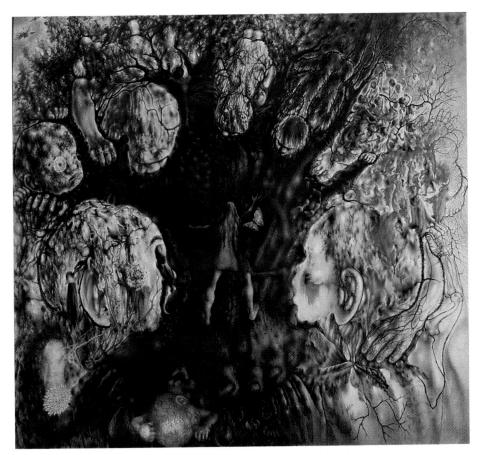

4 6 ⋅ 19

Pavel Tchelitchew, Hide-and-Seek {cache-chache}, 1940–42. Oil on canvas, 6 ft $6\frac{1}{2}$ in \times 7 ft $\frac{3}{4}$ in (1.99 \times 2.15 m).

A personal textural style is greatly responsible for much of the emotional quality in this painting. Here, instead of obvious invented patterns, we find a subtle textural treatment of organic matter that evokes a feeling of biological mystery.

The Museum of Modern Art, New York. Mrs. Simon Guggenheim Fund. Photo © 1998 Museum of Modern Art

₹ 6 • 20

Albert Bierstadt (1830–1902), Landscape, undated. Oil on canvas, $27^{3}/4 \times 38^{1}/2$ in (70.5 × 97.8 cm).

The foreground areas move forward because of their greater textural contrasts and clarity, while other areas are thrust into space by grayness and only the faint suggestion of details.

Columbus Museum of Art, Columbus, OH. Bequest of Rutherford H. Platt, 1929.

artworks. The architect balances the smoothness of steel and glass with the roughness of stone, concrete, and brick (see figs. 9.9 and 9.10). The ceramist works with glazes, aggregates in the clay, and various incised and impressed textures (see fig. 9.13). Jewelers, using different techniques, show concern for texture when making pins, rings, necklaces, brooches, and bracelets (see fig. 9.11). Printmakers use textures that are transferred onto paper after being etched into the printing plate (see fig. 5.2). Sculptors manipulate the textures of clay, wood, metal, and other natural and artificial materials (see fig. 9.4). From this we can see that texture is involved in all art forms, as it is in many life experiences—however unconscious of it we may be.

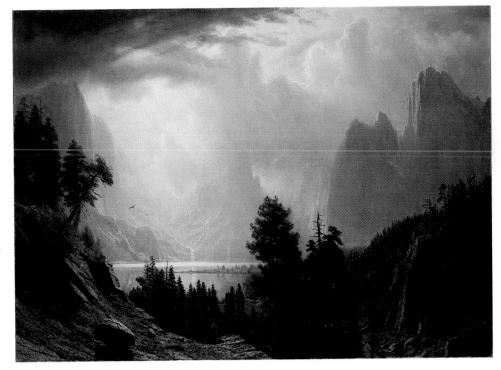

CHAPTER SEVEN

Color

THE VOCABULARY OF COLOR

THE CHARACTERISTICS OF COLOR

Light: The Source of Color

Additive color

Subtractive color

Artist's Color Mixing

The triadic color system

Neutrals

The Physical Properties of Color

Hue

Value

Intensity

Developing Aesthetic Color Relationships

Complements and split-complements

Triads

Tetrads

Analogous and monochromatic colors

Warm and cool colors

Plastic colors

Simultaneous contrast

Color and emotion

Psychological application of color

The Evolution of the Color Wheel

The origins of color systems

The discovery of pigment primaries

The first triadic color wheel

American educators

The Ostwald color system

The Munsell color system

The subtractive color mixing system

The discovery of light primaries

THE ROLE OF COLOR IN COMPOSITION

COLOR BALANCE

Color and Harmony Color and Variety

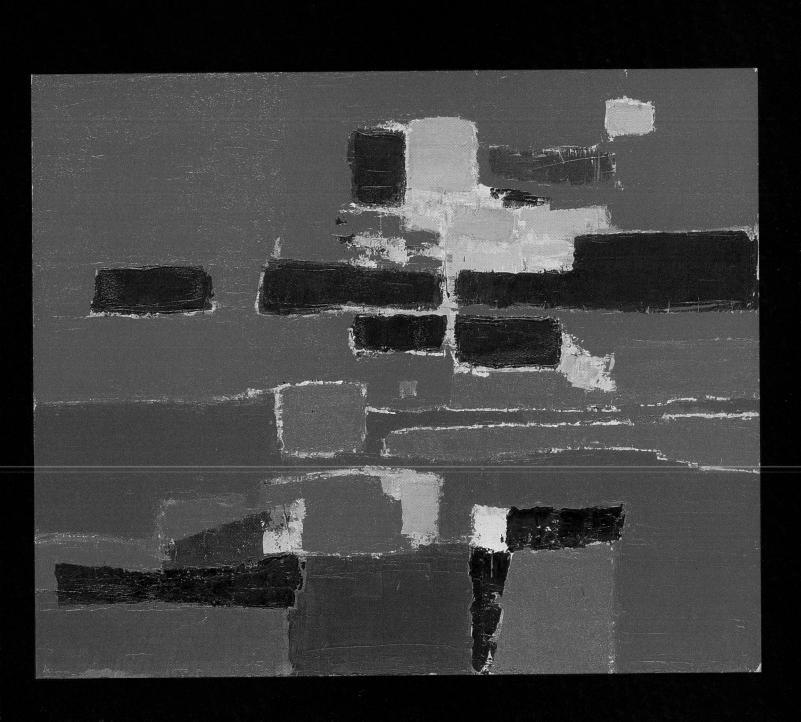

THE VOCABULARY OF COLOR

Color. The visual response to the wavelengths of sunlight identified as red, green, blue, etc.; having the physical properties of hue, intensity, and value.

additive color

Color created by superimposing light rays. Adding together (or superimposing) the three physical primaries (lights)—red, blue, and green—will produce white. The secondaries are cyan, yellow, and magenta.

analogous colors

Colors that are closely related in hue(s). They are usually adjacent to each other on the color wheel.

chroma

1. The purity of hue or its freedom from white, black, or gray. 2. The intensity of hue.

chromatic

Pertaining to the presence of color.

chromatic value

The value (relative degree of lightness or darkness) demonstrated by a given hue.

color tetrad

Four colors, equally spaced on the color wheel, containing a primary and its complement and a complementary pair of intermediates. This has also come to mean any organization of color on the wheel forming a rectangle that could include a double split-complement.

color triad

Three colors spaced an equal distance apart on the color wheel forming an equilateral triangle. The twelve-color wheel is made up of a primary triad, a secondary triad, and two intermediate triads.

complementary colors

Two colors directly opposite each other on the color wheel. A primary color is complementary to a secondary color, which is a mixture of the two remaining primaries.

high-key color

Any color that has a value level of middle gray or lighter.

hue

Designates the common name of a color and indicates its position in the spectrum or on the color wheel. Hue is determined by the specific wavelength of the color in a ray of light.

intensity

The saturation, strength, or purity of a hue. A vivid color is of high intensity; a dull color is of low intensity.

intermediate color

A color produced by a mixture of a primary color and a secondary color.

local (objective) color

The color as seen in the objective world (green grass, blue sky, red barn, etc.).

low-key color

Any color that has a value level of middle gray or darker.

monochromatic

Having only one hue; the complete range of value of one color from white to black.

neutralized color

A color that has been grayed or reduced in intensity by being mixed with any of the neutrals or with a complementary color.

neutrals

I. The inclusion of all color wavelengths will produce white, and the absence of any wavelengths will be perceived as black. With neutrals, no single color is noticed—only a sense of light and dark or the range from white through gray to black. 2. A color altered by the addition of its complement so that the original sensation of hue is lost or grayed.

pigments

Color substances that give their color property to another material by being mixed with it or covering it. Pigments, usually insoluble, are added to liquid vehicles to produce paint or ink. Colored substances dissolved in liquids, which give their coloring effects by being absorbed or staining, are referred to as dyes.

primary color

The preliminary hues that can't be broken down or reduced into component colors. The basic hues in any color system that in theory may be used to mix all other colors.

secondary color

A color produced by a mixture of two primary colors.

simultaneous contrast

When two different colors come into direct contact, the contrast intensifies the difference between them.

spectrum

The band of individual colors that results when a beam of white light is broken into its component wavelengths, identifiable as hues.

split-complement(s)

A color and the two colors on either side of its complement.

subjective (color)

I. That which is derived from the mind reflecting a personal viewpoint, bias, or emotion. 2. Art (color) that is subjective tends to be inventive or creative.

subtractive color

The sensation of color that is produced when wavelengths of light are reflected back to the viewer after all other

wavelengths have been subtracted and/or absorbed.

tertiary color

Color resulting from the mixture of all three primaries in differing amounts or

two secondary colors. Tertiary colors are characterized by the neutralization of intensity and hue. They are found on the color wheel on the inner rings of color leading to complete neutralization.

value (color)

Color

1. The relative degree of light or dark. 2. The characteristic of color determined by light or dark, or the quantity of light reflected by the color.

THE CHARACTERISTICS OF COLOR

Color is the element of form that arouses universal appreciation and the element to which we are most sensitive. **Color** appeals instantly to children as well as adults; even infants are more attracted to brightly colored objects. The average layperson, although frequently puzzled by what he or she calls "modern" art, usually finds its color exciting and attractive. This person may question the use of distorted shapes, but seldom objects to the use of color, provided that it is harmonious in character. In fact, a work of art can frequently be appreciated for its color style alone.

Color is one of the most expressive elements because its quality affects our emotions directly. When we view a work of art, we do not have to rationalize what we are supposed to feel about its color; we have an immediate emotional reaction to it. Pleasing rhythms and harmonies of color satisfy our aesthetic desires. We like certain combinations of color and reject others. In representational art, color identifies objects and creates the effect of illusionistic space. The study of color is based on scientific theory—principles that can be observed and easily systematized. We will examine these basic characteristics of color relationships to see how they help to give form and meaning to the subject of an artist's work.

LIGHT: THE SOURCE OF COLOR

Color begins with and is derived from light, either natural or artificial. Where there is little light, there is little color; where the light is strong, color is likely to be particularly intense. When the light is weak, such as at dusk or dawn, it is difficult to distinguish one color from another. Under bright, strong sunlight, as in tropical climates, colors seem to take on additional intensity.

Every ray of light coming from the sun is composed of waves that vibrate at different speeds. The sensation of color is aroused in the human mind by the way our sense of vision responds to the different wavelengths. This can be experimentally proven by observing a beam of white light that passes through a triangle-shaped piece of glass (a prism) and then reflects from a sheet of white paper. The rays of light bend, or refract, as they pass through the glass at different angles (according to their wavelength) and then reflect off the white paper as different colors. Our sense of vision interprets these colors as individual stripes in a narrow band called the **spectrum.** The major colors easily distinguishable in this band are red, orange, yellow, green, blue, blue-violet, and violet (scientists use the term "indigo" for the color artists call "blueviolet"). These colors, however, blend gradually so that we can see several intermediate colors between them (figs. 7.1 and 7.2).

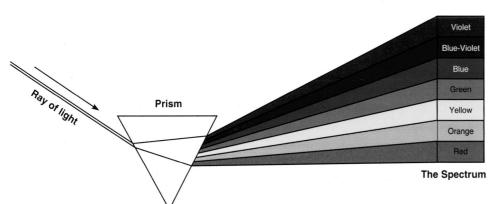

₹ 7 · I

The rays of red have the longest wavelength and those of violet the shortest. The angle at which the rays are bent, or refracted, is greatest at the violet end and least at the red end.

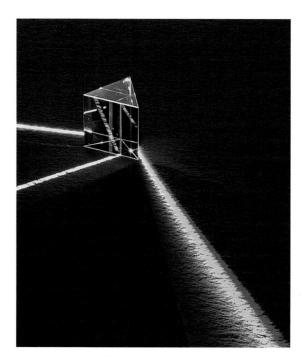

₹ 7 • 2

A beam of light passes through a triangular-shaped piece of glass (prism). The rays of light are bent, or refracted, as they pass through the glass at different angles (according to their wavelengths), producing a rainbow array of hues called the spectrum.

© David Parker, SPL/PhotoResearchers, Inc.

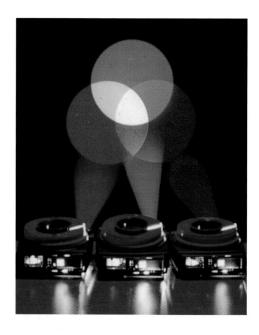

A 7·3

The projected additive primary colors—red, blue, and green—create the secondary colors of cyan, yellow, and magenta when two are overlapped. When all three primaries are combined, white light is produced.

© Eastman Kodak Company.

Additive color

The colors of the spectrum are pure, and they represent the greatest intensity (brightness) possible. If we could collect all these spectrum colors and mix them in a reverse process from the one described in the previous paragraph, we would again have white light. When artists or physicists work with rays of colored light they are using additive color. Some interesting things happen when rays of red, blue, and green (the additive primaries) are overlapped. Where red and blue light overlap, magenta is produced; where red and green light overlap, yellow is produced; where green and blue light overlap, cyan is produced. Where red, blue, and green light rays overlap, white light is produced —proving that white light may be created by the presence of all color wavelengths (fig. 7.3).

The television industry uses this additive color mixing process. The modern color monitor is made up of small triplet phosphor units of red, blue, and green. Seen in 525 horizontal lines, they are illuminated singly or in various

combinations to produce the sensation of every color possible. Each image is made up of two scans of alternate lines-oddnumbered lines, then even. This takes place at a rate of 60 scans per second. At viewing distance the lines and stripes of glowing colored phosphors cannot be distinguished as the eye merges them all together into a sharp image in full color. It is important for an artist to be familiar with the additive color system because it is used in video production, computer graphics, the neon sign industry, slide and multimedia presentations, laser light shows, and landscape and stage lighting. In each case, artists and technicians work with light and create color by mixing the light primaries—red, blue, and green.

Subtractive color

Because all the colors are present in a beam of daylight, how are we able to distinguish a single color as it is reflected from a natural object? Any colored object has certain physical properties called color quality or pigmentation that enable it to absorb some color waves and reflect others. A green leaf appears green to the eye because the leaf reflects only the green waves in the ray of light. An artist's pigment has this property, and when applied to the surface of an object, gives it the same characteristic. The artist may also alter the surface pigmentation of an object through the use of dyes, stains, and chemical washes or gases (as applied to sculpture).

Regardless of how the surface pigmentation is applied or altered, the sensation of color is created when the surface absorbs all the wavelengths except those of the color perceived. When the work is experienced through reflected light, we are dealing with subtractive color rather than actual light rays or additive color. With an area of white, all the light wavelengths of color are reflected back to the viewer—none is subtracted by the white. However, when a color covers the

Color 149

surface, only the wavelengths of that color are reflected back to the viewer—all others are subtracted or absorbed by the pigment. As a result, the sensation of that specific color is experienced. The total energy subtracted (not reflected) would equal the reflected color's opposite or complement (see fig. 7.21).

Therefore, in theory, when a color (which should reflect itself and absorb all wavelengths equal to its complement) is physically mixed on the palette with its complement (which should reflect itself and absorb all wavelengths equal to its complement—the other hue) they should cancel each other out, and the mixture should successfully absorb all wavelengths. In theory the area should appear black—no reflected light. The mixing of a color—blue—and its complement—orange (yellow and red)—involves the mixture of all three primaries. Notice that the result here is the opposite of additive color mixing, which produces white by mixing all the light primaries.

However, in actual practice on the palette, the mixture of all three primaries (a color and its complement) will not result in black but what often appears as a neutralized dark gray—hinting at some color presence but leaving the viewer uncertain and feeling it is rather "muddy." This occurs because of adulterants and imperfections in pigments, inks, and dye, and the fact that the surface may not perfectly absorb all wavelengths except for those being reflected. In addition, the pigment may reflect more than just one dominant color and/or a certain amount of white.

The theory of subtractive color, then, helps to explain how we perceive color, as an image reflects only the wavelength of the color seen, while absorbing all other wavelengths. We will see later that photographers, printers, and some artists have created a subtractive color system that uses primaries not usually known or practiced by the artist (see "The Subtractive Color Mixing")

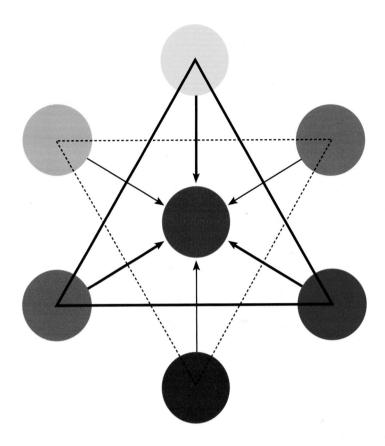

A 7·4

A primary triad is shown in solid line. When the yellow, red, and blue of the primary triad are properly mixed together, the resulting color is neutralized gray. A secondary triad is connected by dotted lines. When secondary colors are also properly mixed together, the resulting color is gray. Triadic color intervals are of medium contrast.

System" p. 168). But, for the following sections when we discuss color, we will be concerned with the artist's palette of pigments and the hue made visible by subtractive color (reflected light) rather than the sensation of mixed colored light or additive color.

ARTIST'S COLOR MIXING

As previously mentioned, the spectrum contains red, orange, yellow, green, blue, blue-violet, and violet, with hundreds of subtle color variations at their greatest intensity. This range of color is available in pigment as well. Children or beginners working with color are likely

to use only a few simple, pure colors. They do not realize that simple colors can be varied. Many colors can be created by mixing two other colors.

For artists working with traditional processes, there are three colors that cannot be created from mixtures; these are the hues red, yellow, and blue, known as the **primary colors** (fig. 7.4). When the three primaries are mixed in pairs, in equal or unequal amounts, they can produce all of the possible colors.

Mixing any *two* primaries in more or less "equal" proportions produces a **secondary color:** orange results from mixing red and yellow; green is created by mixing yellow and blue; and violet occurs when red and blue are mixed (see fig. 7.4).

7 . 5

Intermediate colors. When the colors of the intermediate triads are mixed together, the resulting color is gray.

₩ 7.6

This color wheel includes the primary, secondary, and intermediate hues, or the "standard" hues; of course, the number of possible hues is infinite. As one moves from a hue to its opposite on the color wheel, the smaller circles indicate the lessening of intensity due to the mixing of these opposites, or complementaries. The inner circles are the location of the tertiary hues—those hues result from the mixture or neutralization of one primary by its complement. This results in mixing three primaries. The features of tertiary colors are a loss of intensity and a neutralization of hue. Complete neutralization occurs in the center circle.

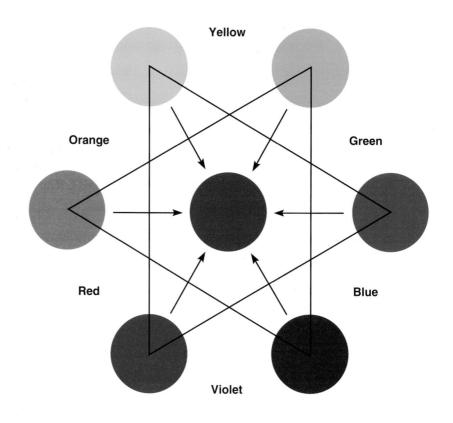

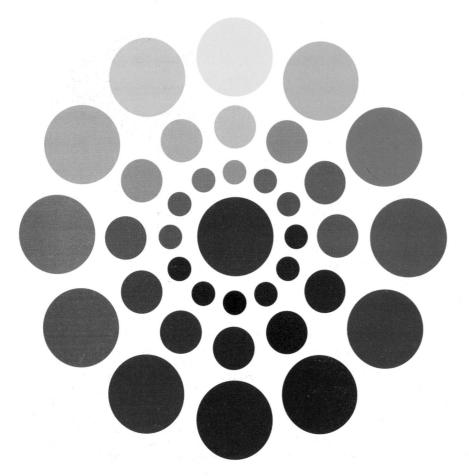

Intermediate colors are mixtures of a primary color with a neighboring secondary color. Because a change of proportion in the amount of primary or secondary color used will change the resultant hue, many subtle changes are possible. For example, between yellow, yellow green, and green, more yellow will move green toward yellow-green (fig. 7.5).

If we study the theoretical progression of mixed color from yellow to yellow-green to green, and so on, we discover a natural order that may be presented as a color wheel (fig. 7.6). Our ability to differentiate subtle variation allows us to see a new color at each position. Please note that the primaries, secondaries, and intermediates are found on the outer ring with the hues at spectrum intensity and the great range of tertiary colors—the browns, olives, maroons, etc.—found on the inner rings of the color wheel. Though we have

151

presented only two inner rings, we could have shown numerous rings as possible steps from a hue to complete neutralization in the center.

The triadic color system

This system is presented in theory as a way to organize color. The color illustrations presented are created by inks and should be used as guides rather than absolutes. The actual practice of mixing pigments will reveal that each manufacturer's "red" is different and that the color of your green may depend on what you use as primaries. Lemon yellow mixed with ultramarine blue will create a different green than one that uses cadmium yellow and cobalt blue. Color mixing experiments will disclose much about opacity, staining power, and the adulterants mixed in by the manufacturers.

With the triadic color system, the three primary colors are equally spaced apart on a wheel, with yellow usually on the top because it is closest to white in value. These colors form an equilateral triangle, called a primary triad (see fig. 7.4). The three secondary colors are placed between the primaries from which they are mixed; evenly spaced, they create a secondary triad composed of orange, green, and violet (see fig. 7.4). Intermediate colors placed between each primary and secondary color create equally spaced units known as intermediate triads (see fig. 7.5). The placement of all the colors results in a twelve-color wheel. The colors change as we move around the color wheel because the wavelengths of the light rays that produce these colors change. The closer together colors appear on the color wheel, the closer are their hue relationships; the farther apart, the more contrasting they are in character. The hues directly opposite each other afford the greatest contrast and are known as complementary colors (see fig. 7.13).

The complement of any color is based upon the triadic system. For example, the complement of red is green —a theoretical mixture of equal parts of the remaining points of the triad, yellow and blue. Thus, the color and its complement are made up of the three primary triadic colors; the complement of yellow is created by mixing blue and red, resulting in violet. If the color is a "mixed" secondary hue (orange, say), its complement may be found by knowing what primaries created the color (red and yellow); the remaining member of the triad (blue) will be the mixed color's complement.

Neutrals

Not all pigments contain a perceivable color. Some like black, white, or gray, do not look like any of the hues of the spectrum. No color quality is found in these examples; they are **achromatic**. They differ merely in the quantity of light they reflect. Because we do not distinguish any one color in black, white, and gray, they are also called **neutrals**. These neutrals actually reflect varying amounts of the color wavelengths in a ray of light.

One neutral, white, can be thought of as the presence of all color because it occurs when a surface reflects all of the color wavelengths to an equal degree.

Black, then, is usually called the absence of color because it results when a surface absorbs all of the color rays equally and reflects none of them.

Absolute black is rarely experienced except in deep caves, and so forth.

Therefore, most blacks will contain some trace of reflected color, however slight.

Any gray is an impure white because it is created by only partial reflection of all the color waves. If the amount of light reflected is great, the gray is light; if the amount reflected is little, the gray is dark. The neutrals are indicated by the quantity of light reflected, whereas color

is concerned with the quality of light reflected.

THE PHYSICAL PROPERTIES OF COLOR

Regardless of whether the artist works with paints, dyes, or inks, every color used must be described in terms of three physical properties: **hue**, **value**, and **intensity** (figs. 7.7 and 7.8).

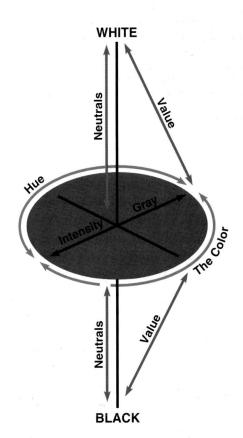

A 7·7

This diagram demonstrates the three physical properties of color. We can see all the color variations as existing on a three-dimensional solid (a double cone). As the colors move around this solid, they change in hue. When these hues move upward or downward on the solid, they change in value. As all of the colors on the outside move toward the center, they become closer to the neutral values, and there is a change in intensity (see also fig. 7.8).

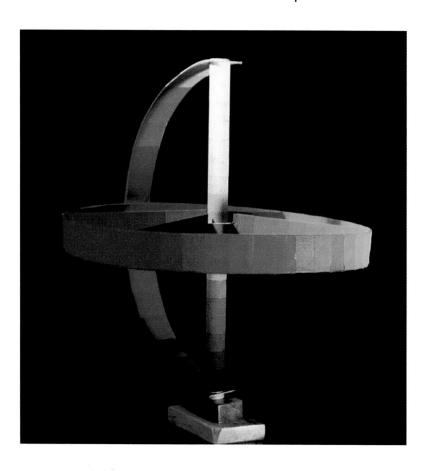

▶ 7 • 8
A three-dimensional model illustrating the three main characteristics of color (see also fig. 7.7).
Photograph courtesy of Ronald Coleman.

7.9

The electromagnetic spectrum. The sun, being the most efficient source of light, sends radiation to the earth in a series of waves known as electromagnetic energy. This may be likened to throwing a pebble into the middle of a pond. Waves radiate from that point and can be measured from the crest of one ripple to the crest of the next ripple. Similarly, waves from the sun range from mere atmospheric ripples—gamma rays, which measure no more than 6 quadrillionths of an inch (.000000000000000)—to the long, rolling radio waves, which stretch 18½ miles from crest to crest.

The wavelengths visible to the human eye are found in only a narrow range within this electromagnetic spectrum; their unit of measure is the "nanometer" (nm), which measures one billionth of a meter from crest to crest. The shortest wavelength visible to mankind measures 400nm—a light violet. The sensations of yellow, orange, and red are apparent as the waves lengthen to between 600 and 700nm. Contained in a ray of light but invisible to the human eye are infrareds (below reds) and ultraviolets (above violets): see figure 7.1.

Hue

Hue is the generic color name—red, blue, green, and so on—given to the visual response for each range of identifiable wavelengths in visible light (fig. 7.9; see fig. 7.1). Hue designates a color's position in the spectrum or on the color wheel. Every color actually exists in many subtle variations, although they all continue to bear the simple color names. Many reds, for example, differ in character from the theoretical red of the spectrum yet we recognize the redness of the hue in all of them. In addition, a color's hue can be changed by adding it to another hue; this actually changes the wavelength of light. There are an unlimited number of steps (variations) that may be created by mixing any two colors—between yellow and green, for example. Yet, for the sake of clarity, artists universally recognize the hues as positioned (identified or named) on the twelve-step color wheel.

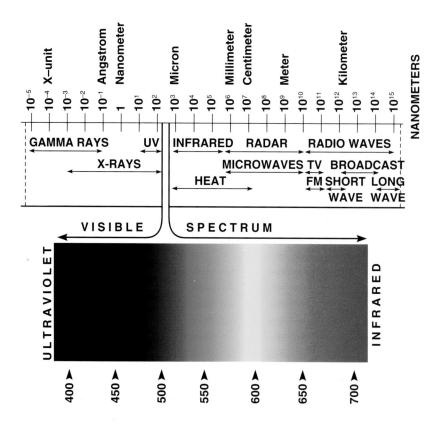

Value

A wide range of color value variations can be produced by adding black or white to a hue. This indicates that colors have characteristics other than hue. The property of color known as value distinguishes between the lightness and darkness of colors, or the quantity of light a color reflects. Many value steps can exist between the darkest and lightest appearance of any one hue. When a hue is mixed with varying amounts of white, the colors produced are known as tints. Shades are produced when a hue is mixed with black. Value changes may also be made when we mix the pigment of one hue with the pigment of another hue that is darker or lighter; this mixing will also alter the color's hue. The only dark or light pigments available that would not also change the hue are black and white or a gray.

Each of the colors reflects a different quantity of light as well as a different wavelength. A large amount of light is reflected from yellow, whereas a small amount of light is reflected from violet. Each color at its maximum intensity has a normal value that indicates the amount of light it reflects. It can, however, be made lighter or darker than normal by adding white or black, as previously noted. We should know the normal value of each of the colors in order to use them effectively. This normal value can be most easily seen when the colors of the wheel are placed next to a scale of neutral values from black to white (fig. 7.10). On this scale (and in the color wheel), all colors that are above middle gray are called **high-key** colors. All colors that are below middle gray are referred to as low-key colors. Whether a color remains low or high key is up to the artist. As noted, a low-key violet may be lightened with white. That adjustment may raise violet's value level until it corresponds to the value level of gray for any color along the neutral scale; violet could be made equal in value to

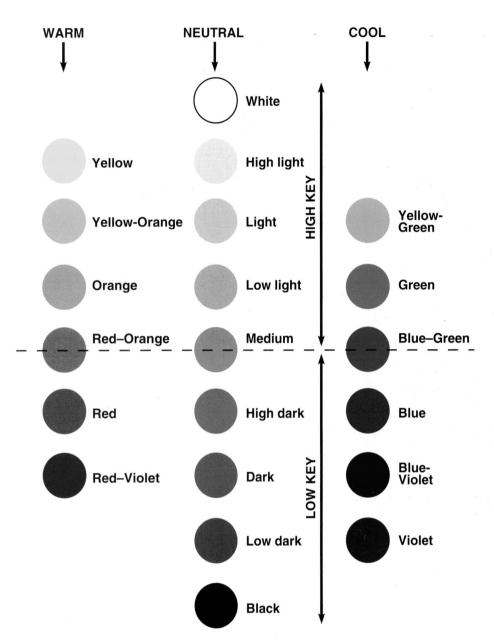

yellow-orange by checking the gray scale. Similarly, a high-key color like yellow may be adjusted with enough black until it has become a low-key color.

Intensity

The third property of color, intensity (sometimes called saturation or **chroma**), refers to the quality of light in a color. We use the term *intensity* to distinguish a brighter appearance from a duller one of the same hue; that is, to

A 7·10

Color values. This chart indicates the relative normal values of the hues at their maximum intensity (purity or brilliance). The broken line identifies those colors and neutrals at the middle (50 percent) gray position. All neutrals and colors above this line are high key and any below it are low key. Warm colors are found on the yellow and red side while cool colors are found with the greens and blues.

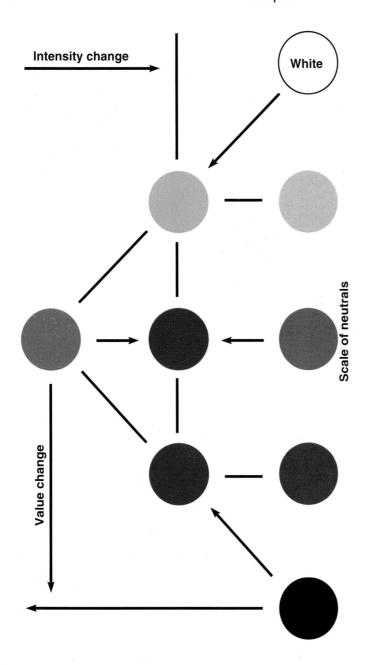

A 7·11

This diagram illustrates the way neutrals may be used to change the intensity of color. As white is added to bright red, the value gets lighter, but the resulting color is lowered in intensity. In the same way, the addition of black to bright red creates a dark red closer to the neutral scale because the intensity changes. When a neutral gray is added to the spectrum color, the intensity is lowered, but the value is neither raised nor lowered.

differentiate a color that has a high degree of saturation or strength from one that is grayed, neutralized, or less intense. The saturation point, or the purest color, is actually found in the spectrum produced by a beam of light passing through a prism. However, the artist's pigment that comes closest to resembling this color is said to be at maximum intensity. The purity of the light waves reflected from the pigment produces the variation in brightness or dullness of the color. For example, a pigment that

reflects only the red rays of light is an intense red, but if any of the complementary green rays are also reflected, the red's brightness is dulled or neutralized. If the green and red rays are equally absorbed by the reflecting surface, the resulting effect is a neutral gray. Consequently, as a color loses its intensity, it tends to approach gray.

There are several ways to change the intensity of a color. A common approach is to place one color next to its complement, which will appear to increase the color's intensity. Other methods of changing intensity require the mixing of pigments (fig. 7.11). This will automatically lower the intensity of the color being affected. The illustration shows the alteration of a hue (pigment) by adding a neutral (black, white, or gray). As white is added to any hue, the color becomes lighter in value, but it also loses its brightness or intensity. In the same way, when black is added to a hue, the intensity diminishes as the value darkens. We cannot change value without changing intensity, although these two properties are not the same. The illustration also shows an intensity change created by mixing the hue (pigment) with a neutral gray of the same value. The resulting mixture is a variation in intensity without a change in value. The color becomes less bright as more gray is added, but it will not become lighter or darker in value. The most efficient way to change the intensity of any hue is by adding the complementary hue. Mixing two hues that occur exactly opposite each other on the color wheel, such as red and green, blue and orange, or yellow and violet, actually results in the intermixing of all three primaries. In theory, when equal portions of the three primaries are used, a black should be created to absorb all wavelengths and not allow any colors to be reflected. However, because of impurities and an inability to absorb all the wavelengths, a neutral gray is actually

produced (see "The Subtractive Color Mixing System" p. 168–169). In the studio, some complements—blue to orange, for example—may give better grays than others. In addition, the gray ink in these diagrams may appear darker and characterless compared to your experiments.

When three primaries are mixed in various proportions, a tertiary color is produced and is characterized by a neutralization of intensity and hue. This occurs when complements are mixed. If the mixture has uneven proportions, the dominating hue creates the resulting color character. Though the hue's intensity has been neutralized to varying degrees relative to the amount of complement used, the resulting colors have a certain liveliness of character not present when a hue is neutralized with a gray pigment. The tertiary colors may be more fully explored by showing the neutralization of the hue's intensity. These show incremental steps of the change of one hue created by adding more and more of its complement until complete neutralization occurs. Tertiary colors may also be created by mixing two secondary colors (not analagous), which share a common color. For example, yellow orange and red violet share red as a common hue. They will have the same character and appearance as those colors created by the neutralization of a color by its complement. An uncountable number of tertiary colors are awaiting discovery—and for each, tints running to pure white and shades increasing to pure black may be developed. On the color wheel, the tertiary colors are located on the inner circles and appear as the browns (neutralized oranges), olives (neutralized greens), and so on. They are characterized by a loss of intensity and a neutralization of hue. They are not to be found on the outer circle with the secondary and intermediate colors (see fig. 7.6).

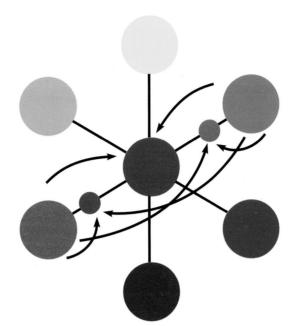

7 . 12

This diagram indicates change of intensity by adding to a color a little of its complement. For instance, by adding a small amount of green to red, a gray red is produced. In the same way, a small amount of red added to green results in a gray green. When the two colors are balanced (not necessarily in equal amounts), the resulting mixture is a neutral gray.

This neutralization also occurs when any combination of hues are mixed that contain the three primaries. For example, yellow orange (y+y,r) and yellow green (y+y,b) added to red violet (r+r,b) would actually mix 4 yellows with 3 reds and 2 blues—a reddish violet. Here, the resulting neutralization should have a reddish appearance.

In addition, it must be pointed out that it is difficult to change a color's intensity (by adding a little of its complement) without also changing its value level (fig. 7.12). A small amount of green (lighter value) was added to red (darker value), with the result being a loss of intensity and a lightening of value for the red. Conversely, when a small amount of red (darker value) was added to the green (lighter value) the green lost some of its intensity and became darker in value. This dual relationship, affecting the change of intensity and value, is perhaps more easily seen with yellow and violet. However, it occurs with every pair of complements except one—redorange and blue-green. They are the only pair of complements which may be used to lower each other's intensity

without changing the value level. This occurs because they begin in theory at the same value level—middle gray.

DEVELOPING AESTHETIC COLOR RELATIONSHIPS

When listening to music, we find a single note played for a long period of time rather boring. It is not until the composer begins to combine notes in chords that harmonic relationships of sound are created. All sounds work together differently; some are better than others at creating unique harmonic effects. The same is true for an artist working with color. No color is important in itself; each is always seen on the picture surface in a dynamic interaction with other colors. Combinations and arrangements of color express content or meaning. Consequently, any arrangement—objective or nonobjective—ought to evoke sensations of pleasure or discomfort because of its well-ordered presentation (see fig. 7.39). To develop a discerning eye, study

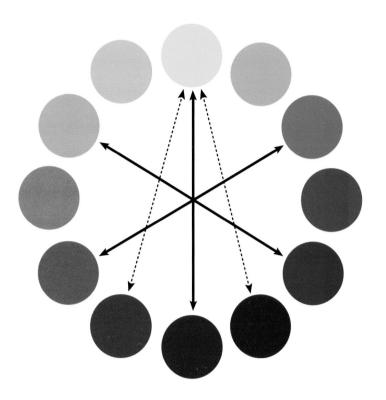

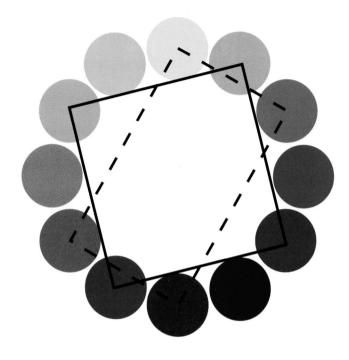

▲ 7 · 13

Complementary colors are shown connected by solid lines. They are of extreme contrast. An example of split-complementary colors (yellow, red violet, and blue violet) is shown by dotted lines. Though yellow is used, the idea may be applied to any color and would include the color on either side of the hue's complement. Split-complements are not quite as extreme in contrast as complements.

A 7·14

Color tetrad intervals (squares and rectangles). The color tetrad is composed of four colors equally spaced to form a square. A more casual relationship would have a rectangle formed out of two complements and their split complements. The rectangle or square may be rotated to any position on the color wheel to reveal other tetrad color intervals.

the wonderfully inexhaustible supply of exciting combinations from the extravagant color relationships of a peacock's feather to the soft muted tonality on the surface of a rock. This study should be followed by experiment and practice with these color schemes. It must be said that there are no exact rules for creating pleasing effects in color relationships, only some guiding principles.

The successful use of color depends upon an understanding of some basic color relationships. A single color by itself has a certain character, creates mood, or elicits an emotional response; but that character may be greatly changed when the color is seen with other colors in an harmonic relationship. Just as the musician can vary combined

tones to form different harmonies, so too can the artist create different relationships (harmonies) among colors that may be closely allied or contrasting.

Complements and splitcomplements

Color organizations that rely on the greatest contrast in hue occur when two colors that appear directly opposite each other on the color wheel (complementaries) are placed next to each other in the composition (fig. 7.13). When a color is seen, only that wavelength is being reflected, the wavelengths not reflected equal the color's complement. Therefore, when two complements are placed nearby, there is agitation because of the great contrast. Each color tends to

increase the apparent intensity of the other color, and when used in equal amounts, they are difficult to look at for any length of time (see "Simultaneous Contrast" p. 159–162). This can be overcome by reducing the size of one of the colors or introducing changes in the intensity or value level of one or both colors.

A subtle variation with slightly less contrast would be the **split-complement** system, which incorporates a color and two colors on either side of its complement (see fig. 7.13). This color scheme provides more variety than the straight complementary system, because the color is opposed by two colors closely related to the color's complement. Even greater variety or interest may be achieved by using an

157

intensity change or selecting variations from the complete value range of any or all of the colors in this color scheme.

Triads

A triadic color organization is based on an even shorter interval between colors, giving less contrast between the colors. Here, three equally spaced colors form an equilateral triangle on the color wheel; triads are used in many combinations. A primary triad, using only primary colors, creates striking contrasts (see fig. 7.4). With the secondary triad, composed of orange, green, and violet, the interval between hues is the same but the contrast is softer. This effect probably occurs because any two hues of the triad share a common color: orange and green both contain yellow; orange and violet both contain red; and green and violet both contain blue. Intermediate color schemes may be organized into two intermediate triads (see fig. 7.5). Here, too, as we move further away from the purity of the primaries, the contrast among the two triads is softer.

Tetrads

Another color relationship is based on a square rather than an equilateral triangle. Known as a **tetrad**, this system is formed when four colors are used in the organization. They are equally spaced around the color wheel and contain a primary, its complement, and a complementary pair of intermediates (fig. 7.14). A tetrad has also come to mean, in a less strict sense, any organization of color forming a "rectangular structure" that could include a double split-complement. This system of color harmony is potentially more varied than the triad because of the additional colors present. Try to avoid the temptation of using all the colors in equal volumes and the increased variety will be even more interesting.

7 · 15Analogous colors (close relationships).

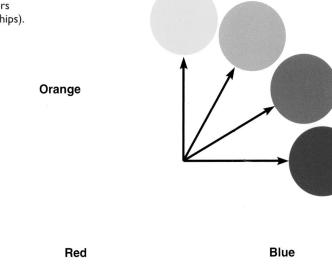

Analogous and monochromatic colors

Analogous colors are those that appear next to each other on the color wheel. They have the shortest interval and therefore the most harmonious relationship. This is because three or four neighboring hues always contain one common color that dominates the group (fig. 7.15). Analogous colors are not only found at the spectrum intensity levels (outer ring of the color wheel) but may also include colors made by neutralization (intensity changes) and value changes of any of these related hues (fig. 7.16). On the other hand, monochromatic color schemes use only one hue, but explore the complete range of tints (value levels of hue to white) and shades (value levels to black) for that color (see fig. 7.34). Even with thousands of variations of tints and shades of one color, this scheme is potentially the most monotonous. However, monochromatic studies are encouraged as a test of the artist's understanding of the value range of that hue.

Warm and cool colors

Violet

Color "temperature" may be considered as another way to organize color schemes. All of the colors can be classified into one of two groups: "warm" colors or "cool" colors. Red, orange, and vellow are associated with the sun or fire, and thus are considered warm. Any colors containing blue, such as green, violet, or blue-green, are associated with air, sky, earth, and water; these are called cool. This quality of warmth or coolness in a color may be affected or even changed by the hues around or near it. For example, the coolness of blue, like its intensity, may be heightened by locating it near a touch of its complement, orange.

Plastic colors

Colors may also be organized according to their ability to create compositional depth. Artists are able to create the illusion of an object's volume or flatten an area using color as an aid. This ability to model a shape comes from the advancing and receding characteristics of

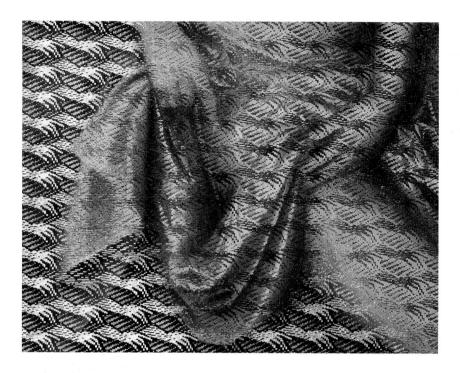

 \blacktriangle 7 · 16 Lia Cook, Point of Touch: Bathsheba, 1995. Linen, rayon, oil paint and dyes, 46 × 61 in (116.84 × 154.94 cm).

Lia Cook employs analogous colors, containing a common hue, to develop the illusion of hands holding folds of fabric on a pattern of changing hand images.

Collection of Oakland Museum of California. © Lia Cook.

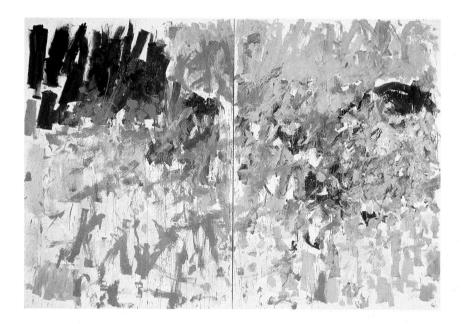

↑ • 17

Joan Mitchell, Quiet Please, 1980. Oil on canvas, 94½ × 142 in (240.03 × 360.68 cm).

Joan Mitchell has established a unity by painting broad areas of yellows and yellow oranges which seem to advance. Smaller areas of blues and blue violets provide contrasting accents and recede.

Courtesy of Manny Silverman Gallery, Los Angeles, CA © Succession Joan Mitchell.

certain colors. For example, a spot of red on a gray surface seems to be in front of that surface; a spot of blue, similarly placed, seems to sink back into the surface. In general, warm colors advance, and cool colors recede (fig. 7.17). The character of such effects, however, can be altered by differences in the value and/or intensity of the color.

These spatial characteristics of color were fully developed by the French artist Paul Cézanne in the latter part of the nineteenth century. He admired the sparkling brilliancy of the Impressionist artists of the period but thought their work had lost the solidity of earlier painting. Consequently, he began to experiment with expressing the bulk and weight of forms by modeling with color. Previous to Cézanne's experiments, the traditional academic artist had modeled form by changing values in monotone (one color). The artist then tinted these tones with a thin, dry local color that was characteristic of the object being painted. Cézanne discovered that a change of color on a form could serve the purpose of a change of value and not lose the effectiveness of the expression. He modeled the form by placing warm color on the part of the subject that was to advance and adding cool color where the surface receded (fig. 7.18). Cézanne felt that this rich color and its textural application expressed the actual structure of a solid object. Later, modern artists realized that Cézanne's advancing and receding colors could also create those backward and forward movements in space that give liveliness and interest to the picture surface. However, it is only a tool and there is no single correct way to employ it. For example, Paul Gauguin often applied the same principles to reverse the spatial qualities in a pictorial organization. By placing cool colors in the foreground that would normally seem to advance, he made it appear to recede. He painted the background that would recede in warm colors, causing it to advance. This combination flattened

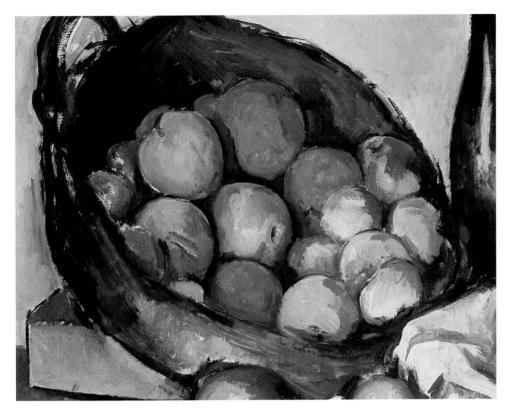

the pictorial space making it more decorative than plastic (fig. 7.19). Many abstract artists have used the relationships of balance and movement in space to give content to a painting, although no actual objects are represented (see fig. 10.80). Line, value, shape, and texture are greatly aided by the ability of color to create space and meaning.

Simultaneous contrast

While trying to match colors, an artist may mix a color on a palette only to find that it appears entirely different when juxtaposed with other colors on the canvas. Why does a red-violet appear to change color when placed beside a violet? During the early part of the 19th century, a French chemist, M. E. Chevreul, wanted to discover why the Gobelins tapestry works was having trouble with complaints about the color

A 7·18

Paul Cézanne, The Basket of Apples (detail), c. 1895. Oil on canvas, $25^{3}/4 \times 32$ in $(65.5 \times 81.3 \text{ cm})$.

Cézanne used changes of color as a means of modeling form. The use of warm and cool colors makes the fruit advance and recede rather than merely indicating a change in value.

Art Institute of Chicago. Helen Birch Bartlett Memorial Collection 1926.252. Photo © 1998, Art Institute of Chicago. All rights reserved.

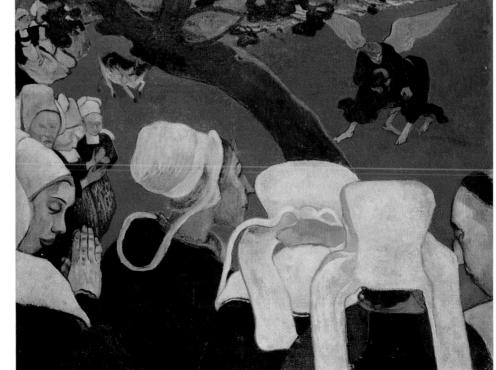

7 · 19

Paul Gauguin, The Vision After the Sermon (Jacob Wrestling with the Angel), 1888. Oil on canvas, $28^{3}/_{4}$ in \times 36 $^{1}/_{2}$ in (73 \times 92.7 cm).

Gauguin has used the nature of plastic color to reverse the spatial effect and make it shallow. The foreground that normally would advance has been painted in cool colors to make it recede. Instead, the background advances because of its warm reds.

National Gallery of Scotland, Edinburgh. Photo: SuperStock

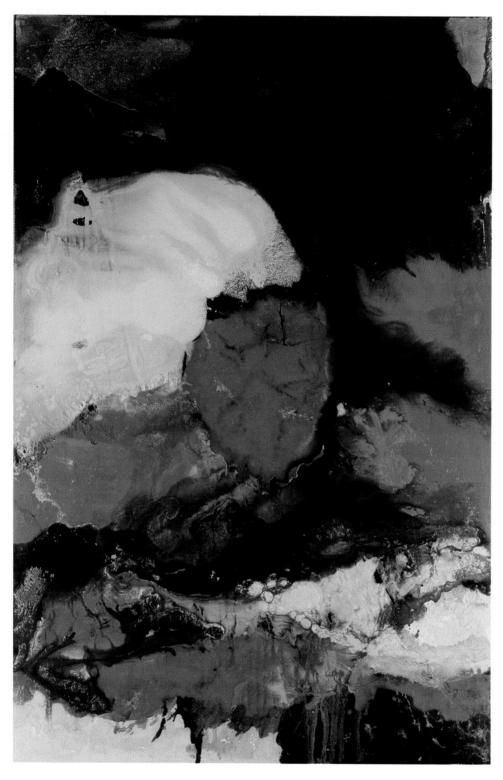

▲ $7 \cdot 20$ Noriyoshi Ishigooka, Spring in the Chateau du Repas, c. 1987. Oil on canvas, 6 ft $4\frac{3}{4}$ in× 4 ft $3\frac{1}{4}$ in (1.95 × 1.30 m).

Large areas of green and yellow dominate in this use of double complementary colors. Smaller areas of their complements, red and violet, balance the total color pattern.

Collection of the Pierre Gohill Corporation. Courtesy of the artist.

stability of certain blues, browns, light violets, and blacks. As Director of Tints and Dyes, Chevreul discovered that the problem was not a question of the dyestuffs but rather a phenomenon of color contrast. The color stability of these colors depended upon which color they were placed beside. These discoveries were the starting point for the Law of Simultaneous Contrast of Colors, published in 1839. With this publication, he became the "technical prophet" of two schools of painting that followed— Impressionism and Post-Impressionism. Both groups of painters often juxtaposed complements that increased the intensity of each through simultaneous contrast. Another early student of these principles, Eugène Delacroix, once said, "Give me mud and I will make the skin of a Venus out of it, if you will allow me to surround it as I please."

The effect of one color upon another is explained by the rule of simultaneous contrast. According to this rule, whenever two different colors come into direct contact, their similarities seem to decrease and the dissimilarities seem to be increased. In short, this contrast intensifies the difference between colors. This effect is most extreme, of course, when the colors are directly contrasting in hue, but it occurs even if the colors have some degree of relationship. For example, a yellow-green surrounded by green appears more yellow, but if surrounded by yellow, it seems more strongly green. The contrast can be in the characteristics of intensity and value as well as in hue. A grayed blue looks brighter if placed against a gray background and will tend to make the gray take on an orange cast; it looks grayer or more neutralized against a bright blue background. The most striking effect occurs when complementary hues are juxtaposed: blue is brightest when seen next to orange, and green is brightest when seen next to red. When a warm color is seen in simultaneous contrast with a cool color,

Color I61

the warm hue appears warmer and the cool color cooler. A color always tends to bring out its complement in a neighboring color. If a green rug is placed against a white wall, the eye may make the white take on a very light red or warm cast. A touch of green in the white may be necessary to counteract this. When a neutralized gray made up of two complementary colors is placed next to a strong intense color, it tends to take on a hue that is opposite to the intense color. When a person wears a certain color of clothing, the complementary color in that person's complexion is emphasized.

Some of these conditions of imposed "color" may be explained by the theory that the eye (and mind) seeks a state of balanced involvement with the three primaries. More than a psychological factor, this seems to be a physiological function of the eyes' receptors and their ability to receive the three light primaries—some combination of all three are involved in most mixed colors. And, as our eyes flash unceasingly about our field of vision, all the primaries and all receptors are repeatedly activated. The mind seems to function with less stress when all three receptor systems are involved concurrently. Within the area of vision, any combination of primaries may cause this without necessarily having to be of equal proportions (fig. 7.20).

However, if one or more primaries are missing, the eye seems to try to replace the missing color or colors because of receptor fatigue. If we stare at a spot of intense red for several seconds and then shift our eyes to a white area, we see an afterimage of the same spot in green, its complement. The phenomenon can be noted with any pair of complementary colors (fig. 7.21). Though we seem to desire the three primaries visually, our optic function may be over-stimulated (or less "peaceful") under certain conditions. Large volumes of clashing full intensity

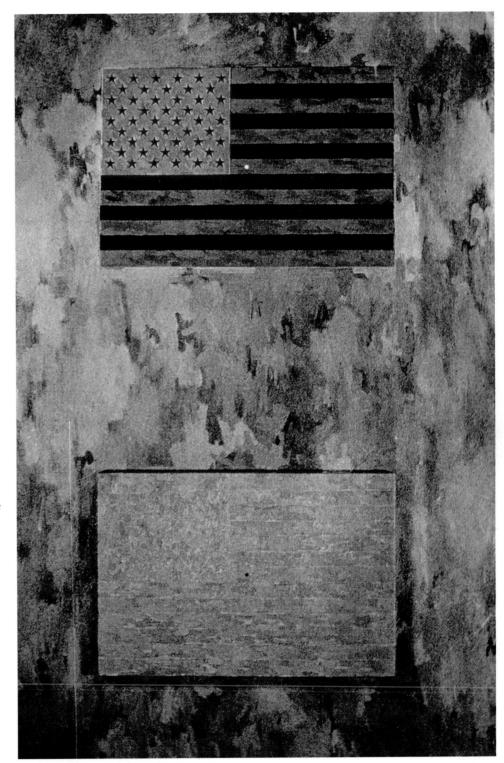

 $7 \cdot 21$ Jasper Johns, Flags, 1965. Oil on canvas with raised canvas, 6×4 ft (1.83 \times 1.22 m). With this painting, Johns wanted the viewer to experience an afterimage. This occurs when the

With this painting, Johns wanted the viewer to experience an afterimage. This occurs when the retina's receptors are overstimulated and are unable to accept additional signals. They then project the wavelengths of the complementary color. Stare at the white dot on the upper flag for forty seconds. Shift focus to the dark dot on the lower flag, and an afterimage will be seen in red, white, and blue.

© 1998 Jasper Johns/Licensed by VAGA, New York.

▲ $7 \cdot 22$ Richard Anuszkiewicz, *Injured by Green,* 1963. Acrylic on masonite, 36×36 in (91.4 × 91.4 cm).

This use of simultaneous contrast using a consistent pattern of two dot sizes, builds intensity toward the center by the juxtaposition of red's split complements. The central yellow green becomes so intense that it is almost blinding.

Collection of The Noyes Museum of Art, Oceanville, NJ. © 1998 Richard Anuszkiewicz/Licensed by VAGA, New York.

complements can make us uneasy. Museum guards at an Op Art show were said to have asked for reassignment complaining of visual problems ranging from headaches to blurred focus. In figure 7.22 Richard Anuszkiewicz refers in the title *Injured by Green* to the unsettling optical fatigue and pulsating colors created by simultaneous contrast.

The condition of balanced stimulation of the color receptors is much easier to experience when the three primaries are physically mixed together. The colors produced are less saturated or intense and seem easier to physically experience. This would explain why tertiary colors,

neutralized—sometimes nearly to the loss of hue—are often thought of as being more universally appealing or relaxing. Hues like blues and greens seem to be easier on the eye and mind when lightened with white; white would add more wavelengths to the reflected light and thus stimulate additional combinations of receptors. Muted, neutralized, or hues lightened in value will appear to recede compared to their most saturated or intense states. Intense blue walls will not make a room appear as large as a very light tint of the same blue.

In practice, it is recommended that the student try experiments that would

apply the principles of simultaneous contrast. See if the same color placed in the center of two related colors can be made to appear as two different hues, however subtle or different. Further, explore making two subtle variations in color appear to be the same by changing their surrounding colors. Investigate the eye's battle to focus or find edges when adjoining shapes or areas are closely related in value level or intensity and become difficult to see. Black lines will give greater clarity to the image but may also tend to flatten the areas. This may also work for "pulsating" edges that occur when the eye has the greatest struggle for edge definition—when complements are placed together. Greater contrast in value or intensity levels will also help with the visual problem of edge resolution or separation of image.

All these changes in appearance make us realize that no one color should be used for its character alone, but must be considered in relation to the other colors present. For this reason, many feel it is easier to develop a color composition all at once rather than trying to finish one area completely before going on to another.

Color and emotion

Color may also be organized or employed according to its ability to create mood, symbolize ideas, and express personal emotions. Color, as found upon the canvas, can express a mood or feeling in its own right, even though it may not be descriptive of the objects represented. Reds are often thought of as being cheerful and exciting whereas blue can impart a state of dignity, sadness, or serenity. Also, different values and intensities of the hues in a color range may affect their emotional impact. A wide value range (strongly contrasting light or dark hues) can give vitality and directness to a color scheme; closely related values and low intensities

163

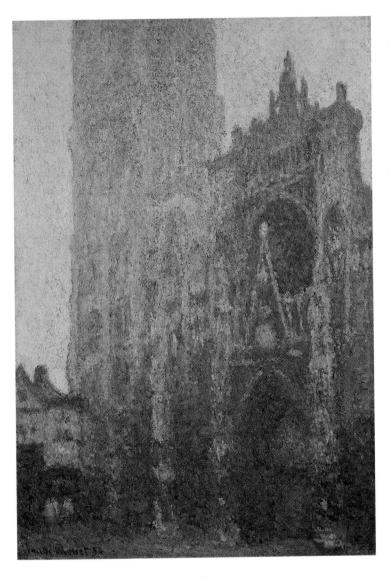

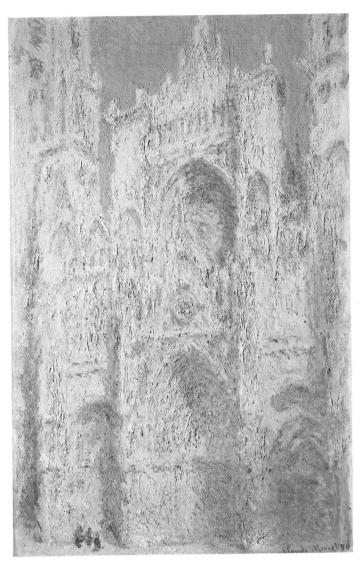

 \blacktriangle 7 · 23 Claude Monet, Rouen Cathedral; Morning, 1894. Oil on canvas, 42 × 29 in (106.7 × 73.5 cm).

The Impressionist Monet took a deep interest in the characteristics of light, and often painted the same subjects at different times of the day. As a result the hues, values, and intensities are markedly affected, as can be seen by comparing this painting with figure 7.24.

Beyeler Collection, Basel, Switzerland.

 $\,$ $\,$ 7 · 24 Claude Monet, Rouen Cathedral, West Façade, Sunlight, 1894. Oil on linen, 39½ \times 26 in (100.2 \times 66 cm).

In giving the impression of a passing moment the artist has deliberately sacrificed detailed architectural information for the effect of sunlight, color, and atmosphere playing on that form. This also applies to figure 7.23.

Chester Dale Collection. © 1998 Board of Trustees, National Gallery of Art, Washington.

help create the feeling of subtlety, calmness, and repose (figs. 7.23 and 7.24).

Some emotions evoked by color are personal and reinforced by everyday experiences. For example, some yellows are acidic and bitter almost forcing a pucker like a sour lemon. Other colors

carry with them associations given by the culture. Our speech is full of phrases that associate abstract qualities like virtue, loyalty, and evil with color: "true blue," "dirty yellow coward," "red with rage," "seeing red," "virgin white," "pea green with envy," and "gray gloom." In some cases, these feelings seem to be more universal because they are based on shared experiences. Every culture understands the danger of fire (reds) and the great vastness, mystery, and consistency of the heavens and the seas (blues). Blues can be used to imply

From 7 · 25

Gustavo Lopez

Armentia, El Eje de Todo, 1995. Oil on canvas, 76 × 76 in (193.04 × 193.04 cm).

The artist has achieved a very personal textural and color approach which supports this very stylized metaphor for man and his stormy environment.

Courtesy The Reece Galleries, Inc., New York, NY.

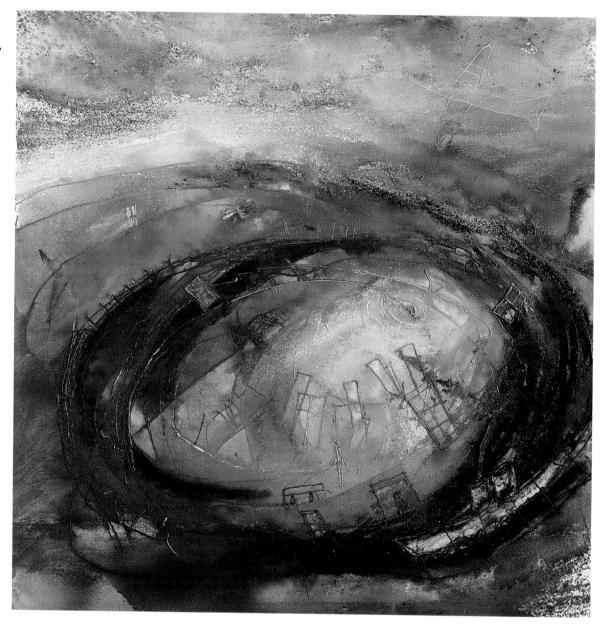

reliability, fidelity, loyalty, and honesty while reds also suggest danger, bravery, sin, passion, or violent death. However, not all color has the same application in each culture. On many pre-Columbian artifacts, priest-kings are shown in self bloodletting rituals and victims are sacrificed to the sun, with red symbolizing renewal and rebirth by allowing the life of the sun to continue. For many western cultures, green rather than red is the sign of regeneration, hope

and life. Many color associations can be traced back historically. For example, purple has signified royalty from the early Roman civilazation. Because of the rarity and expense of purple dye, only the Roman emperor could afford to wear it. However, even though dye became more affordable, the tradition (and the significance) has remained. In China, ancient potters created the technology of glazing ware with very unusual glazes. Among the glazes was a

very deep copper red that was so beautiful that the very best ware in every kilnload was immediately carried away to the emperor himself.

Psychological application of color

Research has shown that light, bright colors make us feel joyful and uplifted, warm colors are generally stimulating, cool colors are calming, while cool, dark,

or somber colors are generally depressing. Medical facilities, trauma centers, state correctional facilities are often painted in light blues or "institutional greens" because of the calming effect. Winter skiing lodges are adorned in warm yellows, knotty pine, oranges, and browns to welcome those coming in from sub-zero temperatures. Stories abound of the use of motivating color and sports programs. One visiting team was furious and refused to use the assigned locker room because the "powder puff pink" walls implied they were "sissies." In another incident, the home team's locker room was painted bright red to keep them keyed up and on edge during half time while light blue surroundings encouraged the opponent to let down and relax. It has been shown in some work situations that bright intense colors encourage worker productivity while neutralized or lighter hues slow down the work force.

We are continually exposed to the application of color's emotive power. In a supermarket, the meat section is

sparkling white to assure us and evoke feelings of cleanliness or purity. To encourage us to purchase the product, the best steaks are garnished lavishly with parsley or green plastic trim to make them appear "redder" and more irresistible. Bright yellow and orange cereal boxes use contrasting lettering (often complementary) to scream for our attention. Extremely small spaces are rarely painted dark or bright warm colors that would make them feel even smaller. Instead the space is made to appear larger by light cool colors.

With artists, an angry exchange, a love letter, a near miss in traffic may all subconsciously influence a choice of color. The power of color to symbolize ideas becomes a tool. It enriches the metaphor and makes the work stronger in content and meaning. Many artists have evolved a personal color style that comes primarily from their feelings about the subject rather than being purely descriptive. John Marin's color is essentially suggestive in character with little expression of form or solidity (see

fig. 8.48). It is frequently delicate and light in tone, in keeping with the medium in which he works (watercolor). The color in the paintings of Vincent van Gogh is usually vivid, hot, intense, and applied in snakelike ribbons of pigment (see fig. 1.13). His use of texture and color expresses the intensely personal style of his work. The image in Armentia's painting seems to feature an immense globule enveloping an earthly setting. The dominant blue suggests a cold setting while the touch of warm colors may indicate an explosive potential (fig. 7. 25). The emotional approach to color appealed particularly to the Expressionistic painters, who used it to create an entirely subjective treatment having nothing to do with objective reality (see fig. 10.29). Modern-day artists like Wolf Kahn continue to interpret their environment in terms of personal color selection (fig. 7.26). We cannot escape the emotional effects of color because it appeals directly to our senses and is a psychological and physiological function of sight itself.

7 . 26

Wolf Kahn, At Green Mountain Orchards, 1991. Oil on canvas, 3 ft 6 in \times 5 ft 6 in (1.07 \times 1.68 m).

Wolf Kahn is one contemporary painter who subordinates his subject—landscape—and all the other art elements to color. The hallmark of his later work is a vibrant, even risky use of color, making it instantly recognizable.

Collection of Dr. and Mrs. Brunno Manno, Courtesy of Thomas Segal Gallery, Baltimore. © 1998 Wolf Kahn/Licensed by VAGA, New York.

A 7 · 27

Munsell color tree, 1972. Clear plastic chart, $10^{1}/2 \times 12$ in (26.7 \times 30.5 cm); base size 12 in (30.5 cm) diameter; center pole size $12^{5}/8$ in (32.1 cm) high; chip size $3/4 \times 13/8$ in (1.9 \times 3.5 cm).

The Munsell system in three dimensions. The greatest intensity of each hue is found in the color vane farthest from the center trunk. The value of each vane changes as it moves up and down the tree. The center trunk changes only from light to dark. The colors change in hue as they move around the tree.

Courtesy of Macbeth, New Windsor, NY.

THE EVOLUTION OF THE COLOR WHEEL

In this book, the circular arrangement of the color wheel is based on a subtractive system of artist-pigmented colors using red, yellow, and blue as primaries. This triadic primary system has evolved over many centuries.

The origins of color systems

Sir Isaac Newton first discovered the true nature of color around 1660. Having separated color into the spectrum—red on top and violet on the bottom—he was the first to conceive of it as a color wheel. Ingeniously, he twisted what was a straight-lined spectrum, joined the ends, and inserted purple, a color leaning to red-violet and not found in the

spectrum. This red-violet he saw as a transition between violet and red. Newton's wheel contained seven colors, which he related to the seven known planets and the seven notes of the diatonic scale in music (the standard major scale without chromatic half-steps), red corresponding to note C, orange to D, yellow to E, green to F, blue to G, indigo to A, and violet to B.

The discovery of pigment primaries

Around 1731, J. C. Le Blon discovered the primary characteristic of the pigments of red, yellow, and blue and their ability to create orange, green and violet. To this day, his discovery remains the basis of much pigment color theory.

The first triadic color wheel

The first wheel in full color and based on the three primary system was published around 1766. It appeared in a book entitled *The Natural System of Colours* by Mr. Morris Harris, an English engraver. In the first decade of the nineteenth century, Johann Wolfgang von Goethe began placing the colors, with their triangular arrangements, around a circle. In addition, Philipp Otto Runge created the first color solid (a three-dimensional color organization) by exploring tints, tones, and shades of color.

American educators

In the United States, many educators advanced the red, yellow, and blue primary color wheels. Most noted among them was Louis Prang, who published *The Theory of Color* in 1876. Modern-day scholars like Johanness Itten and Faber Birren have done much to explore the relationship between color and expression. Their research has also clarified the historical development of the triadic color system.

The Ostwald color system

A distinguished German chemist and physicist, Wilhelm Ostwald, developed a color system around 1916 related to psychological harmony and order. Because the system was created from pigment hues technically available at the time, it uses red, yellow, sea green, and blue, with the secondaries orange, purple, turquoise, and leaf-green. The colors were placed in a circle and expanded by mixing neighboring colors into a 24hue—capable of further expansion. Complements were placed opposite each other—blue opposite yellow, for example. Strict rules for standardizing colors for industrial application were used. A three-dimensional model placed each color on the point of a triangle and

black and white on the other two points. The color harmonies were based upon mathematical relationships that doubled the tonal color change at each step from white to black, providing an even progression in the steps. This system concentrated on value changes, with intensity being controlled by and limited to the initial point of the triangle. The system was never fully adopted for industrial application.

The Munsell color system

Around 1936, the American artist Albert Munsell formulated a system to show the relationships between different color tints and shades based on hue, value, and intensity. This system was an attempt to give names to the many varieties of hues that result from mixing different colors with each other or with the neutrals. American industry adopted the Munsell system in 1943 as its material standard for naming different colors. The system was also adopted by the United States Bureau of Standards in Washington, D.C.

In the Munsell system, the five basic hues are red, yellow, green, blue, and purple (violet). The mixture of any two of these colors that are adjacent on the color wheel is called an intermediate color. For example, the mixture of red and yellow is intermediate color yellowred. The other intermediate hues are green-yellow, blue-green, purple-blue, and red-purple.

To clarify color relationships,
Munsell devised a three-dimensional
color system that classifies the different
shades or variations of colors according
to the qualities of hue, value, and
intensity (or chroma). His system is in
the form of a tree. The many different
color tones are adhered to transparent
plastic vanes that extend from a central
trunk like tree branches. The column
nearest the center trunk shows a scale of
neutral tones that begin with black at the
bottom and rise through grays to white
at the top. The color tone at the outer

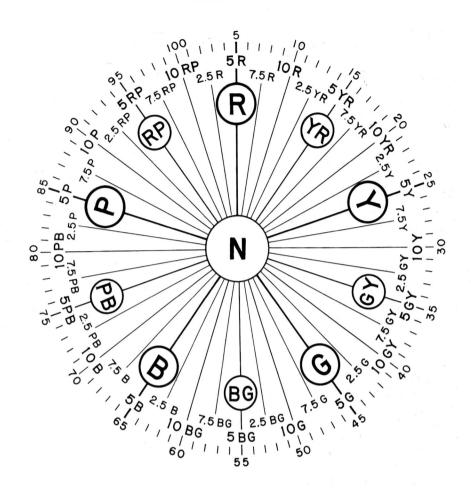

▶ 7 • 28
Munsell color wheel. This diagram shows the relationships of the hues on the wheel in terms of a specific type of notation (as explained in the text).
Courtesy of Macbeth, New Windsor, NY.

limit of each branch represents the most intense hue possible at each level of value (fig. 7.27).

The most important part of the Munsell color system is the color notation, which describes a color in terms of a letter and numeral formula. The hue is indicated by the notation found on the inner circle of the color wheel. The value of the colors is indicated by the numbers on the central trunk shown in figure 7.27. The intensity, or chroma, is shown by the numbers on the vanes that radiate from

the trunk. These value and intensity relationships are expressed by fractions, with the number on top representing the value and the number beneath indicating the intensity (chroma). For example, 5Y8–12 is the notation for a bright yellow.

It is interesting to compare the Munsell color wheel with the one used in this book (fig. 7.28; see fig. 7.6). Munsell places blue opposite yellow-red and red opposite blue-green, while we place blue opposite orange and red opposite green.

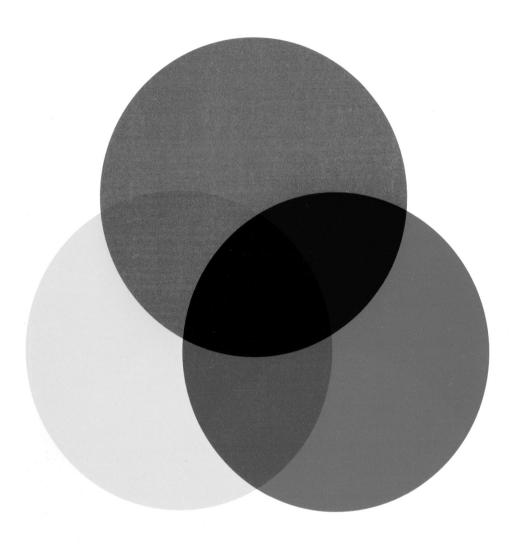

A 7 · 29

The primary colors of the subtractive color system include yellow, cyan, and magenta. Where they are mixed they produce red, blue, and green. When all three are combined, they produce black. Notice that the subtractive color primaries are the additive secondary colors and that the subtractive secondary colors are the additive primary colors.

The subtractive color mixing system

We have already discussed how we experience color by reflected light. A colored object reflects only the wavelengths of that color while absorbing all others (see "Subtractive Color," p. 148). By taking the reflected wavelengths and passing them through specific camera filters, photographers and printers have learned how to isolate specific wavelengths and photograph them. They discovered that when photographing on black and white film through a red filter—a light primary—

all the red wavelengths were absorbed (removed) and everything else (equaling red's complement cvan) was photographed at all its value levels. When this was done with a green filter. the value levels of magenta were revealed. Likewise, photographing through a filter named "blue" -actually on the violet side—recorded all the value ranges of yellow. They had created a special color organization with the primary colors of magenta, yellow and cyan (fig. 7.29). Notice that these primaries are the secondary colors in the additive (light) system (see fig. 7.3) and they aren't the primary colors of red, yellow, and blue familiar to the artist. In this system, red is a mixed color! Artists who work with dyes, color printing for photography, transparent inks, and the printing industry will need to become familiar with the subtractive primaries of magenta, yellow, and cyan.

The printing industry has applied these subtractive primaries to the fourcolor printing process and has made great advances in color reproduction. Several existing techniques came together to make this process possible. 1). Monochrome photography provided images in black, white, and a full value range of unbroken grays. 2). Halftoning was invented that allowed all the shades of gray to be printed by one shade of ink—black on white paper. This was done by translating all the grays into a network of tiny black-and-white dots of differing sizes for different values. 3). It was discovered that photographing a colored image through various colored filters and adding halftoning could create a printing plate with the proper range of value for each of the primariesmagenta, yellow, and cyan (fig. 7.30 A, B, and C).

When the printing plates for cyan, magenta, and yellow are printed together, all the colors and value ranges possible are created. Where the magenta and yellow overlap, red (a pigment primary for the artist's palette) is created

as a secondary color. Where the magenta is decreased and the yellow increased, the color swings more toward orange—and so on, depending on the adjustment of the two colors. Similarly, the other subtractive color mixing secondary colors are created by overprinting the remaining primaries: cyan plus magenta produces blue, and cyan plus yellow produces green. Overprinting cyan, magenta, and yellow creates something close to black but that is usually heightened by printing the fourth plate in black to add definition (fig. 7.30 D, E, and F).

Color photographers also use magenta, cyan and yellow. Instead of artists' pigment, they often develop color using dyes and gelatin emulsions. Colored film contains three layers of emulsion that respond to blue, red, and green light. When exposed to the image, a multilayered negative results. Lightsensitive silver halide compounds are converted to metallic compounds by the developer. In the process, they oxidize and combine with "coupler" compounds to produce dyes. Each layer forms one of the three dyes that are the subtractive primaries—yellow, magenta, and cyan. A yellow image is formed on the bluesensitive layer; a magenta image forms on the green-sensitive layer; and a cyan image is created in the red-sensitive layer. Next, the silver is bleached out of each layer, leaving only the appropriate colored dye on the correct layer. Color negatives, positive color transparencies (slides), and color printers all involve this same basic process (fig. 7.31).

The discovery of light primaries

Paralleling early developments with pigment was the discovery around 1790 of the red, green, and blue light primaries. These concepts were explored by scientists Hermann von Helmholtz of Germany and James Clerk Maxwell of Great Britain. Some additive-light

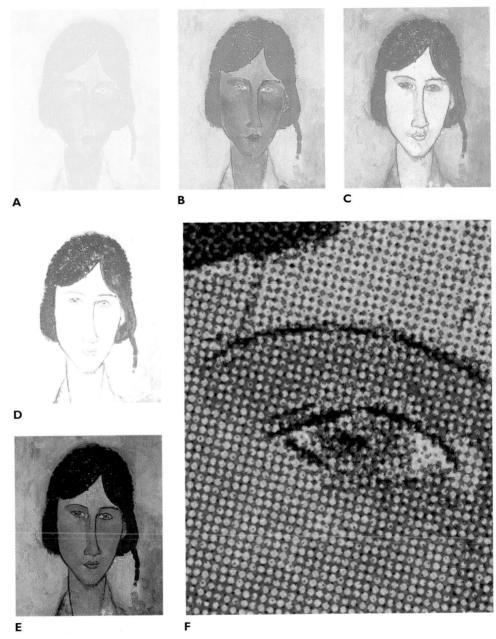

A 7 · 30

These illustrations show the yellow (A), magenta (B), cyan (C), and black (D) printing plates used in the four-color printing process. When printed together, they produce the full color image (E) a detail of Modigliani's Gypsy Woman with Baby (see fig. 10.27). An enlargement shows the dots printed from each plate and the colors created where the yellow, magenta, cyan, and black inks overlap (F).

© National Gallery of Art, Washington/SuperStock

primary systems have been represented as circles, but they should not be confused with color systems designed for artists' pigment. Space does not permit discussion of all the color systems that have evolved.

THE ROLE OF COLOR IN COMPOSITION

The function of describing superficial appearances was considered most

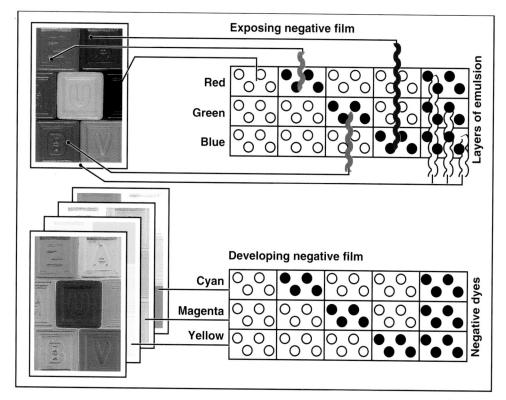

7.31

When color negative film is exposed, the blue, green, and red-sensitive layers of emulsion (color spots) record latent images (gray dots) that can be developed into black-and-white negatives. Colors that are mixtures of the primaries are recorded on several layers. Blacks do not expose any of the emulsion, while white light is recorded in all layers. Each color thus leaves a corresponding negative black-and-white impression.

When exposed color negative film is developed, a black-and-white negative image is produced in each emulsion layer (black dots). During this development, a colored dye is combined with each black-and-white negative image. The dyes are cyan, magenta, and yellow. Once the silver is bleached out, the three layers (colored dots) show the subject in superimposed negative dye images.

Photograph by Bob Coyle/© McGraw-Hill Higher Education.

important when painting was seen as a purely illustrative art. For a long period in the history of Western art, color was looked upon as something that came from the object being represented. In painting, color that is used to indicate the natural appearance of an object is known as local color (fig. 7.32). A more expressive quality is likely to be achieved when the artist is willing to disassociate the color surfaces in the painting from the object to which the color conventionally belongs. An entirely subjective color treatment can be substituted for local color. The colors used and their relationships are invented by the artist for purposes other than mere representation (fig. 7.33). This style of treatment may even deny color as an objective reality; that is, we may have purple cows, green faces, or red trees. Most of the functions of color are subjectively applied, making an understanding of their use very important to the understanding of contemporary art.

Regardless of which system is used, color serves several purposes in artistic composition. These purposes, however, are not always separate and distinct, but instead frequently overlap and interrelate. We have seen that color can be used in the following ways:

- 1. To give spatial quality to the pictorial field.
 - Color can supplement, or even substitute for, value differences to give plastic quality.
 - Color can create interest through the counterbalance of backward and forward movement in pictorial space.
- 2. To create mood and symbolize ideas.
- 3. To serve as a vehicle for expressing personal emotions and feelings.
- 4. To attract and direct attention as a means of giving organization to a composition.

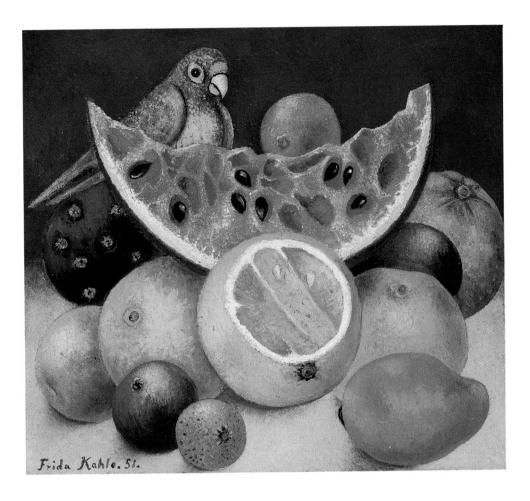

7 · 32
Frida Kahlo, Still Life with Parrot, 1951. Oil on masonite, 9½ × 10¼ in (24.1 × 26 cm). This still life is painted in local color—color that simulates the hues of the objects in nature. Art Collection, Harry Ransom Humanities Research Center, University of Texas at Austin. Reproduction authorized by National Institute of Fine Art and Literature of Mexico.

- To accomplish aesthetic appeal by a system of well-ordered color relationships.
- 6. To identify objects by describing the superficial facts of their appearance.

COLOR BALANCE

Any attempt to base the aesthetic appeal of color pattern on certain fixed

theoretical color harmonies will probably not be successful. The effect depends as much on how we distribute our color as on the relationships among the hues themselves. All good color combinations have some similarities and some contrasts. The basic problem is the same one present in all aspects of form organization: variety in unity. There must be harmonious relationships between the various hues, but these

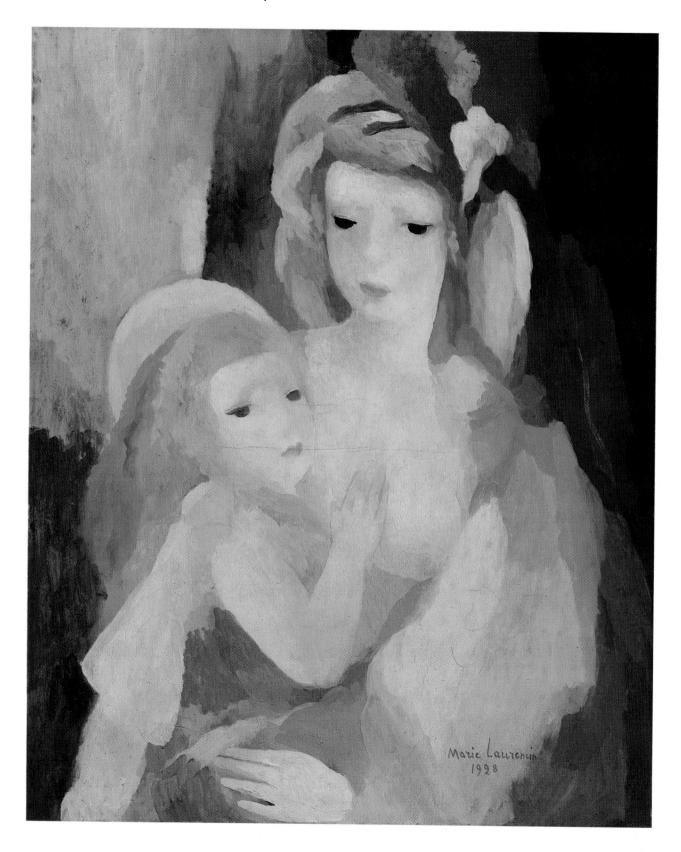

173

relationships must be made alive and interesting through variety.

COLOR AND HARMONY

Let us look first at the problem of harmonizing the color relationships. The pleasing quality of a color pattern frequently depends on the amount or proportion of color used. A simple way to create harmony and balance is by repeating similar color but in differing values and/or intensities (fig. 7.34) by controlling its placement in different parts of a composition. This one hue can also be a harmonizing factor if a little of it is mixed with every color used. A similar effect can be created by glazing over a varicolored pattern with a single transparent color, which becomes the unifying hue. In general, equal amounts of different colors are not as interesting as a color arrangement where one color, or one kind of color, predominates (see fig. 10.60). Such a unified pattern is found when all warm or all cool colors are used in combination. Again, however, a small amount of a complementary color or a contrasting neutral can add variety to the color pattern (see fig. 4.15). As a rule, where warm and cool colors are balanced against each other in a composition, it is better to allow one temperature to dominate. The dominance of any one color in a pattern can be because of its hue, value, or intensity (fig. 7.35); when the hue intervals are closely related, as in analogous colors, dominance can be affected by the character of the

7 • 33

Marie Laurencin, Mother and Child, 1928. Oil on canvas, $32 \times 25\frac{1}{2}$ in (81.3 \times 63.8 cm).

This French artist used color to construct a personal (or subjective) interpretation that creates the charming mood of the painting. Photo © 1998 The Detroit Institute of Arts, City of Detroit Purchase. © 1997 Artists Rights Society (ARS), New York/ADAGP, Paris.

A 7·34

Ellen Phelan, Umbrella Pine, 1991. Oil on canvas, 5 ft $4\frac{1}{2}$ in \times 3 ft 5 in (1.64 \times 1.04 m).

While concentrating on the orange color family, the artist has changed value and intensity to emphasize developing forms. The image was created using paint rollers to apply the medium in thin layers.

Courtesy of Dorsey Waxter Fine Art, Millbrook, NY.

A 7 · 35

Nicolas de Staël, Le ciel rouge (The Red Sky), 1952. Oil on canvas, $51\frac{1}{2} \times 64\frac{1}{8}$ in (130.81 \times 162.88 cm).

Although other colors appear in this painting, it is the predominant red hue that provides the overall unity.

Collection Walker Art Center, Minneapolis, MN. Gift of the T.B. Walker Foundation, 1954. © 1997 Artists Rights Society (ARS), New York/ADAGP, Paris. surrounding hues (fig. 7.36). A wide range of color may also be harmonized by bringing them all to a similar value level or making their intensity levels correspond. Where the basic unity of a color pattern has been established, strong contrasts of color hue, value, or intensity can be used in small accents; their size, then, prevents them from disturbing the basic unity of the color theme (see fig. 2.35). Low-key or high-key compositions benefit greatly from such contrasting accents, which add interest to

what might otherwise be a monotonous composition (see figs. 4.19 and 10.8).

COLOR AND VARIETY

In an attempt to become overly harmonious, we are often confused by color schemes where all of the tones become equally important, because we cannot find a dominant area on which to fix our attention. It is sometimes necessary to develop hue combinations that depend on strong contrast and/or a

175

variety of color (figs. 7.37 and 7.38). With this type of color scheme, the hue intervals are further apart, the greatest possible interval being that between two complementary colors. Color schemes based upon strong contrasts of hue, value, or intensity have great possibilities for expressive effect. In the contrasting color scheme, the basic problem is to unify the contrasts without destroying the general strength and intensity of expression. These contrasts can sometimes be controlled by the amount of opposing color used (see fig. 7.17). In this situation, a small, dark spot of color, through its lower value, can dominate a large, light area. At other times, a spot of intense color, though small, can balance a larger amount of a grayer, more neutralized color (see fig. 7.33). Also, a small amount of warm color usually dominates a larger amount of cool color, although both may be of the same intensity (see fig. 7.20).

Complementary colors, which of course, vie for our attention through simultaneous contrast, can be made more

► 7 · 36 Hughie Lee-Smith, Lost Dream, 1989. Oi

Lost Dream, 1989. Oil on canvas, 36 × 40 in (91.4 × 101.6 cm).

Blues are the dominant

hues in this painting by Lee-Smith. He achieves a dynamic balance by introducing smaller areas of contrasting color and a strong value pattern.

Collection of Mr. Warren Shaw, New York. Courtesy of June Kelly Gallery, New York. Photo: Manu Sassoonian.

© 1998 Hughie Lee-Smith/Licensed by VAGA,

₹ 7.37

New York.

Francine Matarazzo, East of Silverlake, 1994–95. Oil on canvas, 60×120 in (152.4 \times 304.8 cm).

Francine Matarazzo has personalized landscape with strong contrasts of color and value.

Courtesy of Track 16 Gallery, Santa Monica, CA.

7 . 38

Paul Jenkins, Phenomena Graced by Three, 1968. Polymer acrylic on canvas, 64×48 in (162.6 \times 121.9 cm).

Analogous (related) colors can produce harmony, while touches of complementary color contribute variety.

Archer M. Huntington Art Gallery, University of Texas at Austin. Gift of Mari and James A. Michener, 1991. Photo: George Holmes. © Paul Jenkins.

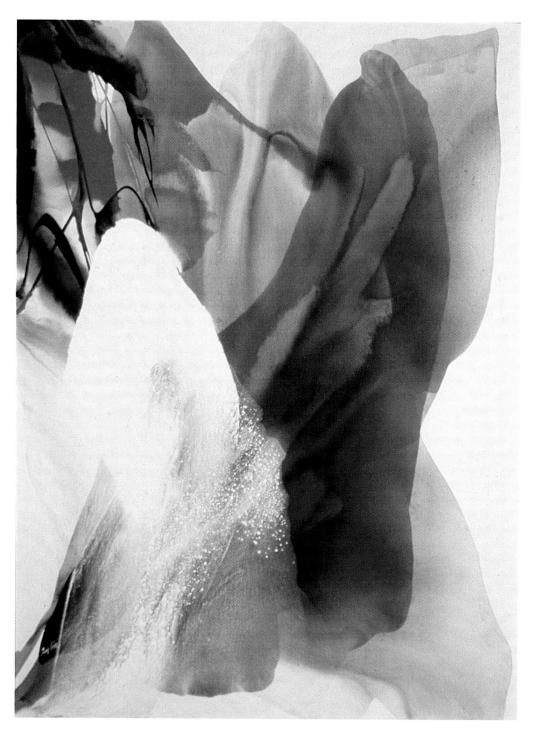

attractive if one of them is softened or neutralized. Another commonly used method of slightly softening exaggerated contrasts is to separate all or a part of the colors by a neutral line or area. Absolute black or white lines are the most effective neutrals for this purpose because they are so positive in character themselves. They not only tie together the contrasting hues, but also enhance their color character because of value contrast. The neutral black leading between the brilliant colors of stained-glass windows is an example of this unifying character. Such modern painters as Georges Rouault and Max Beckmann

found a black line effective in separating their highly contrasting colors (see figs. 10.28 and 10.33). A similar unifying effect can be brought about by using a large area of neutral gray or a **neutralized color** as a background for clashing contrasts of color (see figs. 2.11 and 7.25).

Color 177

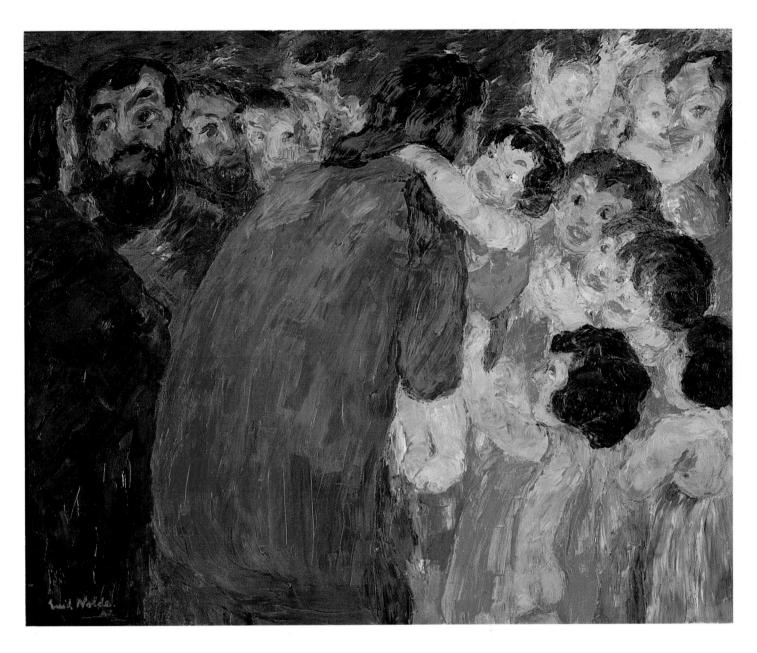

A 7 · 39

Emil Nolde, Christ Among the Children, 1910. Oil on canvas, $34\frac{1}{8} \times 41\frac{7}{8}$ in (86.8 \times 106.4 cm).

The Expressionists usually employed bold, clashing hues to emphasize their emotional identification with a subject. Intense feeling is created by the use of complementary and near-complementary hues.

The Museum of Modern Art, New York. Gift of Dr. W. R. Valentiner. Photo © 1998 Museum of Modern Art.

Finally, we should remember that artists frequently produce color combinations that defy these guiding principles but are still satisfying to the eye. Artists use color as they do the other elements of art structure—to give a highly personalized meaning to the subject of their work. We must realize that there can be brutal color combinations as well as refined ones. These brutal combinations are satisfying if they accomplish the artist's purpose of

exciting us rather than calming us. Some of the German Expressionist painters have proven that these brutal, clashing color schemes can have definite aesthetic value when used purposefully (fig. 7.39). There are no exact rules for arriving at pleasing effects in color relationships, but there are some guiding principles that we have discussed. With this foundation, every artist must build his or her own language of color as it is used in dynamic interaction in each work.

CHAPTER EIGHT

Space

THE VOCABULARY OF SPACE

INTRODUCTION TO SPACE

SPATIAL PERCEPTION

MAJOR TYPES OF SPACE

Decorative Space Plastic Space Divisions of Plastic Space Shallow space Deep and infinite space

SPATIAL INDICATORS

Size
Position
Overlapping
Transparency
Interpenetration
Fractional Representation
Sharp and Diminishing Detail

Converging Parallels
Linear Perspective
Major systems of linear perspective
Perspective concepts applied
The disadvantages of linear perspective
Other Projection Systems
Intuitive Space

THE SPATIAL PROPERTIES OF THE ELEMENTS

Line and Space Shape and Space Value and Space Texture and Space Color and Space

RECENT CONCEPTS OF SPACE

THE SEARCH FOR A NEW SPATIAL DIMENSION

Plastic Images
Pictorial Representations of Movement in Time

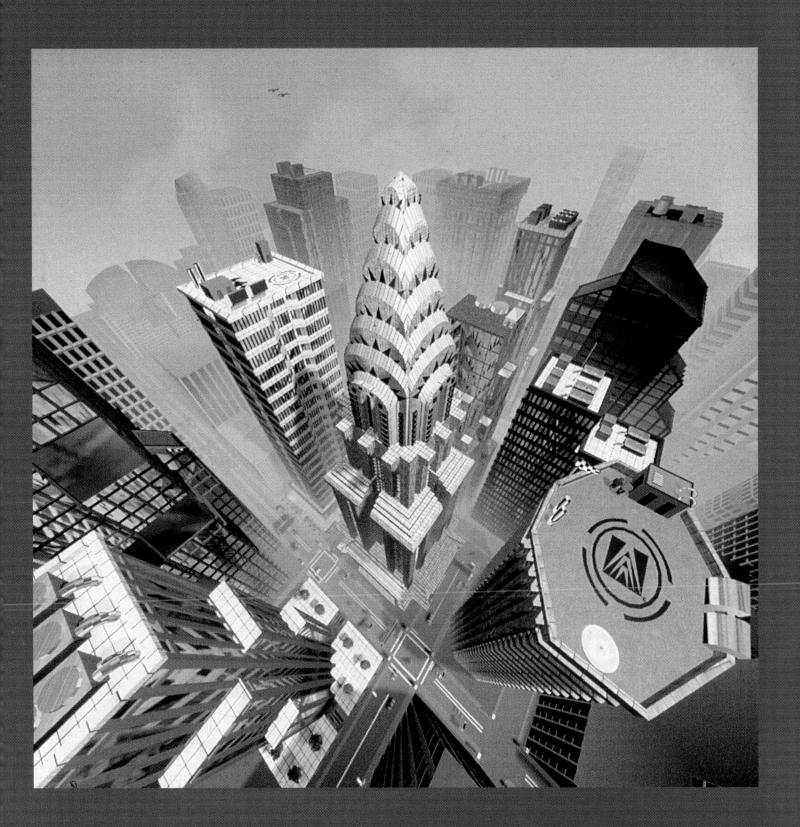

THE VOCABULARY OF SPACE

Space. The interval, or measurable distance, between points or images.

atmospheric (aerial) perspective

The illusion of deep space produced in graphic works by lightening values, softening details and textures, reducing value contrasts, and neutralizing colors in objects as they recede (see **perspective**).

decorative (space)

Ornamenting or enriching but, more importantly in art, stressing the two-dimensional nature of an artwork or any of its elements. Decorative art (space) emphasizes the essential flatness of a surface.

four-dimensional space

A highly imaginative treatment of forms that gives a sense of intervals of time or motion.

fractional representation

A device used by various cultures (notably the Egyptians) in which several spatial aspects of the same subject are combined in the same image.

infinite space

A concept in which the picture frame acts as a window through which objects can be seen receding endlessly.

interpenetration

The movement of planes, objects, or shapes through each other, locking them together within a specific area of space.

intuitive space

The illusion of space that the artist creates by instinctively manipulating

certain space-producing devices, including overlapping, transparency, interpenetration, inclined planes, disproportionate scale, fractional representation, and the inherent spatial properties of the art elements.

isometric projection (perspective)

A technical drawing system in which a three-dimensional object is presented two-dimensionally; starting with the nearest vertical edge, the horizontal edges of the object are drawn at a thirty-degree angle and all verticals are projected perpendicularly from a horizontal base.

linear perspective (geometric)

A system used to develop three-dimensional images on a two-dimensional surface; it develops the optical phenomenon of diminishing size by treating edges as converging parallel lines. They extend to a vanishing point or points on the horizon (eye-level) and recede from the viewer (see perspective).

oblique projection (perspective)

A technical drawing system in which a three-dimensional object is presented two-dimensionally; the front and back sides of the object are parallel to the horizontal base; and the other planes are drawn as parallels coming off the front plane at a forty-five degree angle.

orthographic drawing

Graphic representation of twodimensional views of an object, showing a plan, vertical elevations, and/or a section.

perspective

Any graphic system used in creating the illusion of three-dimensional images and/or spatial relationships on a two-dimensional surface. There are several types of perspective.

plastic (space)

1. The use of the elements to create the illusion of the third dimension on a two-dimensional surface. 2. Three-dimensional art forms such as architecture, sculpture, ceramics, etc.

shallow space

The illusion of limited depth. With shallow space, the imagery appears to move only a slight distance back from the picture plane.

three-dimensional (space)

To possess, or to create the illusion of possessing, the dimension of depth as well as the dimensions of height and width.

transparency

A visual quality in which a distant image or element can be seen through a nearer one.

two-dimensional (space)

To possess the dimensions of height and width, especially when considering the flat surface, or picture plane.

181

INTRODUCTION TO SPACE

Some people consider space an element of two-dimensional art, while others see it as a "product" of the elements. But however categorized, the presence of space is felt in every work of art, and it is something that must concern every artist. In this text, space is conceived of as a product rather than an element: it is created by the art elements. The importance of space lies in its function, and a basic knowledge of its implications and use is essential for every artist. Space, as discussed in this chapter, is limited to the graphic fields—that is, such twodimensional surface arts as drawing, painting, printmaking, and so forth. The space that exists as an illusion in the graphic fields is actually present in the plastic areas of sculpture, ceramics, jewelry, architecture, and so forth. Their three-dimensional space concepts are discussed in Chapter 9.

SPATIAL PERCEPTION

All spatial implications are mentally conditioned by the environment and experience of the viewer. Vision is experienced through the eyes but interpreted by the mind. Perception involves the whole pattern of nerve and brain response to a visual stimulus. We use our eyes to perceive objects in nature and continually shift our focus of attention. In so doing, two different types of vision are used: stereoscopic and kinesthetic. Having two eyes set slightly apart from each other, we see two different views of the object world at the same time. The term "stereoscopic" refers to our ability to overlap these two slightly different views into one image. This visual process enables us to see in three dimensions, making it possible to judge distances.

With kinesthetic vision we experience space in the movements of the eye from one part of a work of art to another. While viewing a two-dimensional surface, we unconsciously attempt to organize its separate parts so that they can be seen as a whole. In addition, we explore object surfaces with our eyes in order to recognize them. Objects close to the viewer requiremore ocular movement than those farther away, and this changing eye activity adds spatial illusion to our kinesthetic vision.

MAJOR TYPES OF SPACE

Two types of space can be suggested by the artist: **decorative space** and **plastic space**.

DECORATIVE SPACE

Decorative space is the absence of real depth as we know it and is confined to the flatness of the picture plane. As the artist adds art elements to that plane (or surface), the illusion created appears flat or limited. In fact, a truly decorative space is difficult to achieve; any art element when used in conjunction with others will seem to advance or recede. Decorative space, though sometimes useful in describing essentially flat pictorial effects, is not accurate. Thus, decorative space for the artist is quite limited in depth (fig. 8.1; see fig. 5.15).

PLASTIC SPACE

The term "plastic" is applied to all spatial imagery other than decorative. Artists base much of their work on their experiences in the objective world, and it is a natural conclusion that they should explore the spatial resources.

A 8 ⋅ I

Leonidas Maroulis, 68–388, 1988. Oil on canvas, 5 ft 3 in \times 5 ft (1.60 \times 1.52 m).

The planes in this work seem parallel to the picture surface. Spatial devices are missing except for the prominent white diagonal shape that fosters the illusion that the red shape where it rests is tilted back into space.

Photograph courtesy of the Vorpal Gallery, San Francisco and New York.

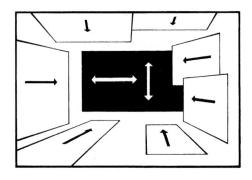

A 8 · 2

Shallow space. As a variation on the concept of shallow space, artists occasionally define the planes that make up the outer limits of a hollow boxlike space behind the picture plane. The diagram shows this concept, although in actual practice, a return to the picture plane would be made through objects occupying the space defined. The back plane acts as a curtain that prevents penetration into deep space.

DIVISIONS OF PLASTIC SPACE

Artists locate their images in plastic space according to their needs and feelings, because infinite degrees of depth are possible. As a result, the categorizations of depth locations cannot be specific or fixed but must be broadened to include general areas.

Shallow space

Concentration on the picture surface usually limits the depth of a composition. Varying degrees of limited space are possible. Limited space (or **shallow space**) can be compared to the

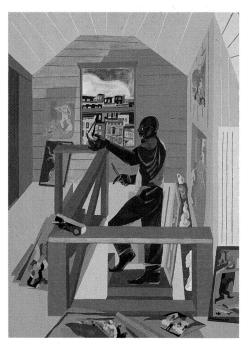

8 • 3

Jacob Lawrence, *The Studio*, 1977. Gouache on paper, 30×22 in $(76.2 \times 55.9 \text{ cm})$.

The use of shapes with solid colors and values, generally lacking in traditional shading, creates an overall feeling of flatness. In addition, a stagelike effect arises from the shallow space.

Seattle Art Museum. Partial gift of Gull Industries; John H. and Ann Hauberg; Links, Seattle; and gift by exchange from the estate of Mark Tobey. Courtesy of the artist and Francine Seders Gallery, Seattle, WA.

feelings one might experience if confined to a box or stage. The space is limited by the placement of the sides or walls. For consistency, any compositional objects or figures that might appear in the boxlike or stagelike confines should be narrowed in depth or flattened (fig. 8.2). In the modern painting *The Studio* by Jacob Lawrence, the single figure has been flattened and placed in a confined room (fig. 8.3).

Asian, Egyptian, and Medieval artists used comparatively shallow space in their art. Early Renaissance paintings were often based on shallow sculptures that were popular then. Many modern artists have elected to use shallow space because it allows more positive control and is more in keeping with the flatness of the working surface. Gauguin, Matisse, Modigliani, and Beckmann are typical advocates of the concepts of limited space (see figs. 5.16 and 10.27). For these artists, not having to create the illusion of deep plastic space allows more control of the placement of decorative shapes as purely compositional elements.

Deep and infinite space

An artwork that emphasizes deep space denies the picture plane except as a starting-point where the space begins. The viewer seems to be moving into the far distances of the picture field. This spatial feeling is similar to looking through an open window over a landscape that rolls on and on into infinity. This infinite quality is created using spatial indications that are produced by certain relationships of art form. Size, position, overlapping images, sharp and diminishing details, converging parallels, and perspective are the traditional methods of indicating deep spatial penetration (see fig. 6.20).

Infinite spatial concepts, allied with atmospheric perspective, dominated Western art from the beginning of the Renaissance (about 1350) to the middle of the nineteenth century. During this

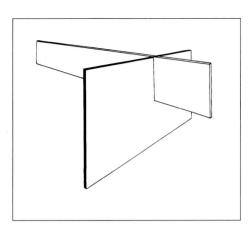

A 8 · 10

Interpenetrating planes. The passage of one plane or volume through another gives depth to a picture automatically.

Chapter 8

who are interested in exploring shallow space (see figs. 4.8 and 10.40).

INTERPENETRATION

Interpenetration occurs when planes or objects pass through each other, emerging on the other side. It provides a very clear statement of the spatial positioning of the planes and objects involved, and can create the illusion of either shallow or deep space (figs. 8.10 and 8.11).

FRACTIONAL REPRESENTATION

Fractional representation can best be illustrated by studying the treatment of the human body by Egyptian artists. Here we can find, in one figure, the profile of the head with one eye visible, the torso seen front-on, and a side view of the hips and legs. This is a combining of the most representative aspects of the different parts of the body (figs. 8.12 and 8.13). **Fractional representation** is a spatial device revived in the nineteenth

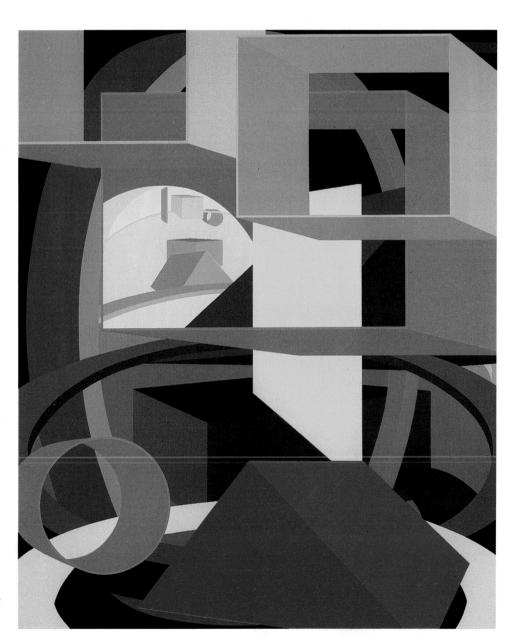

8 • 11

Al Held, Quattro Centric XIII, 1990. Acrylic on canvas, 5×6 ft (1.52 \times 1.83 m).

The effects in this work are quite subtle and do not follow any formal technique for generating space. Areas of overlapping and interpenetration contribute strongly to the overall sense of depth.

Courtesy of André Emmerich Gallery, a Division of Sotheby's, on behalf of Al Held.

viewing greatly abstracted and nonobjective work (fig. 8.7). The alternative, of course, is to see the picture plane as entirely devoid of spatial illusion and the distances of the visual elements as actually measurable across the flat surface. It is difficult to perceive in this way even when we discipline ourselves to do so, because it requires us to divorce ourselves entirely from ingrained environmental factors.

OVERLAPPING

Another way of suggesting space is by overlapping planes or volumes. If one object covers part of the visible surface of another, the first object is assumed to be nearer. Overlapping is a powerful indication of space, because once used, it takes precedence over other spatial signs. For instance, one ball placed in front of a larger ball appears closer than the larger ball, despite its smaller size (fig. 8.8).

TRANSPARENCY

The overlapped portion of an object is usually obscured from our view. If, however, that portion is continued and made visible through the overlapping plane or object, the effect of transparency is created. Transparency, which tends to produce a closer spatial relationship, is clearly evident in the upper triangle in the painting by Jack Brusca (fig. 8.9). It is most noticeable in the works of the Cubists and other artists

Jack Brusca, Untitled, 1969. Acrylic on canvas, 30×30 in $(76.2 \times 76.2 \text{ cm})$.

The precise, hard-edged geometric shapes in this work are a legacy of Cubism. However, notice that the implied triangular shapes overlap, remain transparent, and create a shallow space.

Courtesy of Owens Corning Collection, Toledo, OH.

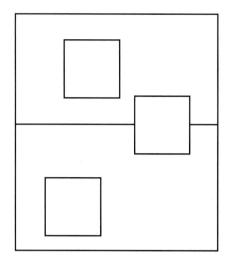

A 8 · 7

Placement of squares. A line across the picture plane reminds us of the horizon that divides ground plane from sky plane. Consequently, the lower shape seems close and the intermediate shape more distant, while the upper square is in a rather ambiguous position as it touches nothing and seems to float in the sky.

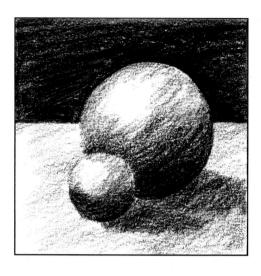

A 8 · 8

As an indicator of space, overlapping causes the object being covered to recede, regardless

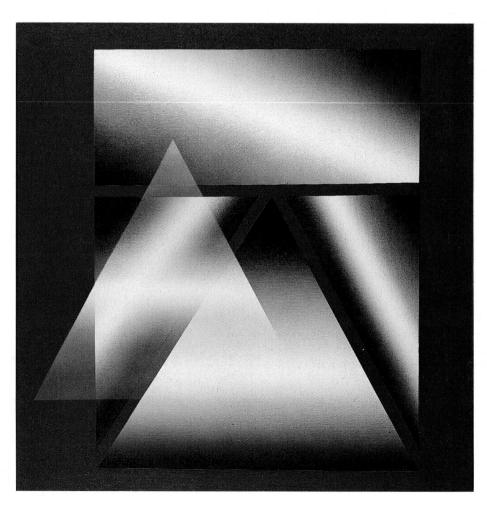

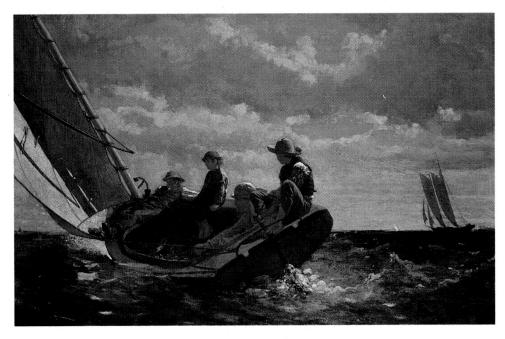

▲ $8 \cdot 5$ Winslow Homer, Breezing Up (A Fair Wind), 1873–1876. Oil on canvas, $24\frac{1}{8} \times 38\frac{1}{8}$ in (61.5 × 97 cm).

The horizon line in this painting separates the space into a ground plane below and sky plane above. The smaller size and higher position of the distant boats help to achieve the spatial effect.

Gift of the W. L. and May T. Mellon Foundation. © 1996 Board of Trustees, National Gallery of Art, Washington.

corresponds to its distance from us, regardless of all other factors (fig. 8.6; see fig. 10.18). This concept of space has not always been prevalent. In many broad periods and styles of art, and in the works of children, large scale is assigned according to importance, power, and strength, regardless of spatial location (see figs. 8.12 and 2.47).

POSITION

Many artists and observers automatically assume that the horizon line, which provides a point of reference, is always at eye level. The position of objects is judged in relation to that horizon line. The bottom of the picture plane is seen as the closest visual point, and the degree of rise of the visual units up to the horizon line indicates subsequently receding spatial positions (see fig. 8.5). Evidence suggests that this manner of seeing is instinctive (resulting from continued exposure to the objective world), for its influence persists even in

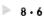

Antonio Canaletto (1697–1768), The Prato Della Valle at Padua (r. half) with the Church of the Misericordia, undated. Pen and watercolor with crayon outlines, $10\frac{5}{8} \times 14\frac{3}{4}$ in (27 × 37.5 cm).

In Canaletto's drawing, note how the figures gradually get smaller as they recede into the background areas. This, combined with the artist's command of linear perspective, gives the viewer a strong sense of depth.

© The Royal Collection, Her Majesty Queen Elizabeth II.

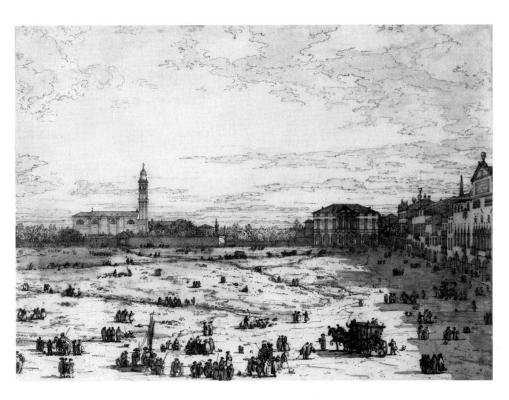

Space 183

period, generations of artists, such as Botticelli, Ruisdael, Rembrandt, and Poussin, to name only a few, developed and perfected the deep-space illusion because of its obvious accord with visual reality (fig. 8.4). Present-day art is largely dominated by the shallow-space concept, but many contemporary artists work with strongly recessed fields. Any space concept is valid if it demonstrates consistent control of the elements in relation to the spatial field chosen.

SPATIAL INDICATORS

Artistic methods of spatial representation are so interdependent that attempts to isolate and examine all of them here would be impractical and inconclusive, and might leave the reader with the feeling that art is based on a formula. Thus, we will confine this discussion to fairly basic spatial concepts.

Our comprehension of space, which comes to us through objective experiences, is enlarged, interpreted, and given meaning by the use of our intuitive faculties. Spatial order develops when the artist senses the right balance and the best placement, then selects vital forces to create completeness and unity. Obviously, then, this process is not a purely intellectual one but a matter of instinct or subconscious response (see fig. 5.9).

Because the subjective element plays a part in controlling space, we can readily see that emphasis on formula here, as elsewhere, can quell the creative spirit. Art is a product of human creativity and is always dependent on individual interpretations and responses. Space, like other qualities in art, may be either spontaneous or premeditated, but is always the product of the artist's will. If an artist has the impassioned will to make things so, they will usually be so, despite inconsistency and defiance of established principles. Therefore, the

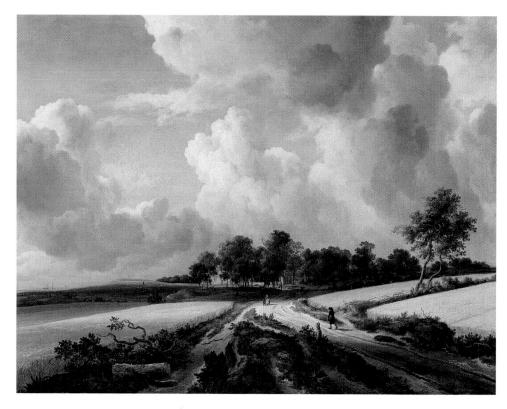

methods of spatial indication discussed in the following pages are those that have been used frequently and that guarantee one effect of space, though not necessarily one that is always exactly the same. These traditional methods are presented merely to give the student a conception of the more conventional spatial forces (see fig. 4.15).

SIZE

We usually interpret largeness of scale in terms of nearness. Conversely, a smaller scale suggests distance. If two sailboats were several hundred feet apart, the nearer boat would appear larger than the other. Ordinarily we would interpret this difference in scale not as one large and one small image (although this could play a part in our perception), but as two vessels of approximately the same size placed at varying distances from the viewer (fig. 8.5). Therefore, if we are to use depth-scale as our guide, an object or human figure assumes a scale that

A 8 · 4

Jacob van Ruisdael, Wheatfields, c. 1670. Oil on canvas, 4 ft $3\frac{1}{4} \times 3$ ft $3\frac{3}{8}$ in (1.30 × 1 m).

Early Dutch landscape painting, which aimed at the maximum illusion of visual reality, emphasized the concept of infinite space. Diminishing sizes of objects and hazy effects of atmospheric perspective give the viewer a sense of seeing far into the distance.

Metropolitan Museum of Art, New York. Bequest of Benjamin Altman, 1913 (14.40.623). Photo © Metropolitan Museum of Art, all rights reserved.

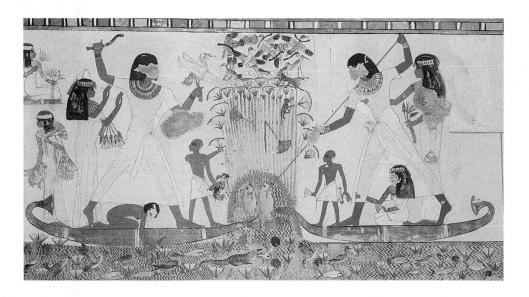

century by Cézanne, who used its principles in his still-life paintings (see "Plastic Images," p. 213). It was employed by many twentieth-century artists, most conspicuously Pablo Picasso. The effect is flattening in Egyptian work, but plastic in the paintings by Cézanne because it is used to move us "around" the subjects.

SHARP AND DIMINISHING DETAIL

Because we do not have the eyes of eagles and because we view things through the earth's atmosphere, we are not able to see near and distant planes with equal clarity at the same time. A glance out the window confirms that close objects appear sharp and clear in detail, whereas those at great distances seem blurred and lack definition. Artists have long known of this phenomenon and have used it widely in illusionistic work. In recent times they have used this method and other traditional methods of space indication in works that are otherwise quite abstract. Thus, in abstract and nonobjective conceptions, sharp lines, clearly defined shapes and values, complex textures, and intense colors are associated with foreground or near positions. Hazy lines, indistinct shapes,

A 8 · 12

Copy of Egyptian wall-painting (Thebes: tomb of Menna), Menna with family fishing and fowling, Dynasty 18, c. 1420 B.C. Copy in tempera, $39^{3}/4 \times 35$ in (101 \times 89 cm) (1:1 scale with original).

This work illustrates the Egyptian concept of pictorial plasticity: various representative views of the figure are combined into one image (fractional representation) and is kept compatible with the flatness of the picture plane. The arbitrary positioning of the figures and their disproportionate scale add to this effect.

Egyptian Expedition of the Metropolitan Museum of Art, New York. Rogers Fund, 1930 (30.4.48). Photo © Metropolitan Museum of Art, all rights reserved.

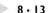

This drawing illustrates the Egyptian technique of fractional representation of the human figure. The head is in profile, but the eye full-face. The upper body is frontal, gradually turning until the lower body, from the hips down, is seen from the side. This drawing combines views of parts of the body in their most characteristic or easily seen positions. In order to see all these views, one would have to move around the body.

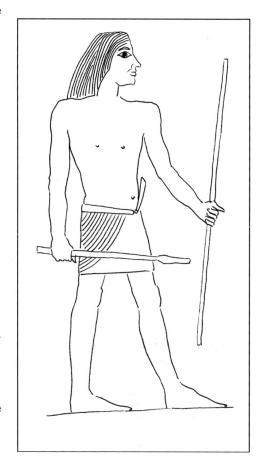

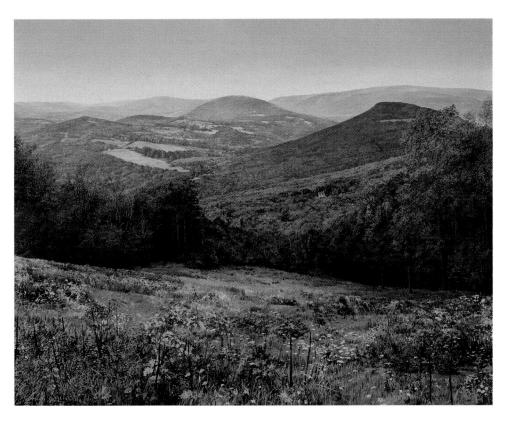

▲ $8 \cdot 14$ Doug Maguire, Sleeping Eye, 1987. Oil on linen, 4 ft $8\frac{1}{2} \times 6$ ft $\frac{1}{2}$ in (1.44 × 1.84 m).

The clarity of the weeds, grasses, and flowers in the foreground and the darkness of the trees in the middleground, contrasted with the haziness of the background, contribute to the spatial effect of the atmospheric perspective.

Courtesy of the Katharina Rich Perlow Gallery, New York.

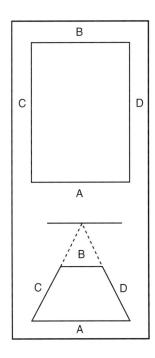

< 8 ⋅ 15

Converging parallels can make a shape appear to recede into the pictorial field.

grayed values, simple textures, and neutralized colors are identified with background locations. These characteristics are often included in the definition of **atmospheric perspective** (fig. 8.14).

CONVERGING PARALLELS

The space indicated by converging parallels can be illustrated using a

rectangular plane such as a sheet of paper or a tabletop. By actual measurement, a rectangle possesses one set of short parallel edges and one set of long parallel edges (fig. 8.15). If the plane is arranged so that one of the short edges (A) is viewed head-on, its corresponding parallel edge (B) will appear to be much shorter. Because these edges appear to be of different lengths, the other two edges (C and D) that connect them must seem to converge as they move back into space. Either set of lines, when separated from the other set, would continue to indicate space quite forcefully. The principle of converging parallels is found in many works of art that do not abide by the rules of **perspective**. It is closely related to perspective, but the amount of convergence is a matter of subjective or intuitive choice by the artist. It is not governed by fixed vanishing points and the rules governing the rate of convergence (fig. 8.16).

LINEAR PERSPECTIVE

Linear perspective is a system for converting sizes and distances of known objects into a unified spatial order. It is based on the artist's/viewer's optical perception and judgments of such specific concepts as scale, proportion, placement, and so on. Its use involves the application of such spatial indicators as size, position, and converging parallels. The general understanding of perspective occurred because of a renewal of interest in ancient Greco-Roman literature, philosophy, and art. This spirit swept many countries and sowed the seeds of the Italian Renaissance—the era that brought this spatial system to a point of high refinement. Artists focused their attention on one view, a selected portion of nature, seen from one position at a particular moment in time. The use of eye level, guidelines, and vanishing points gave this view mathematical exactitude (figs. 8.17A and 8.17B).

▶ 8 • 16

Anselm Kiefer, Nigredo, c. 1984. Oil, acrylic, emulsion, shellac, straw on photograph, mounted on canvas, with woodcut, 10 ft 10 in \times 18 ft $2^{1}/_{2}$ in (3.30 \times 5.55 m).

Kiefer uses perspective as an aid to help him draw the viewer into the heart of his enormous canvas.

Philadelphia Museum of Art, PA. Gift of Friends of the Philadelphia Museum of Art.

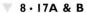

Masaccio, Trinity with the Virgin, St. John and Donors, 1427. Fresco at Santa Maria Novella, Florence, Italy, 21 ft 10 in \times 10 ft 5 in (6.65 \times 3.18 m).

According to some art history experts, Masaccio's fresco is the first painting created in correct geometric perspective. The single vanishing point lies at the foot of the cross, as indicated by the overlay in figure 8.17B.

Photo Scala/Art Resource, New York.

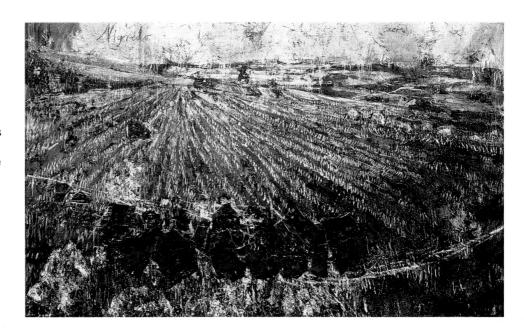

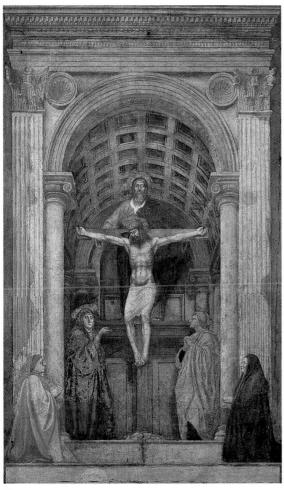

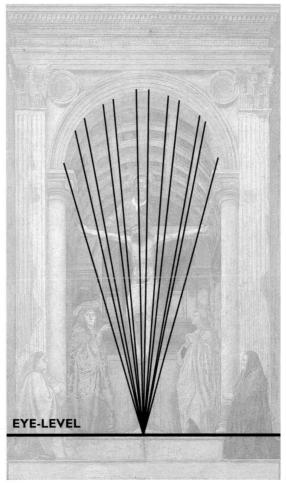

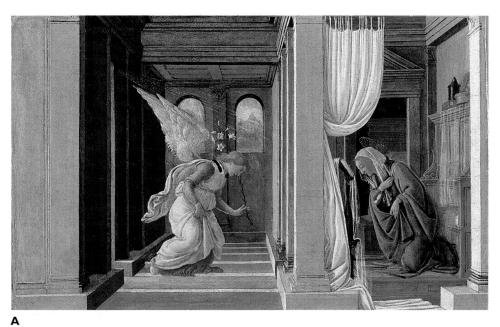

SKY PLANE
(ceiling)

GROUND PLANE (floor)

Vanishing point (VP)

GROUND PLANE (floor)

A 8 ⋅ 18A & B

В

Sandro Botticelli, Annunciation, c. 1490. Tempera and gold on panel, $7^{1}/_{2} \times 12^{3}/_{8}$ in (19.1 \times 31.4 cm) (painted surface).

In the tradition of much art of the Renaissance period, perspective in the form of receding planes creates space and directs our attention to the vanishing point (see fig. 8.18B). Metropolitan Museum of Art, New York. Robert Lehman Collection, 1975 (1975.1.74). Photo © Metropolitan Museum of Art, all rights reserved.

It has generally been agreed that perspective was developed by the Early Renaissance architect Filippo Brunelleschi (1377–1446), and was quickly adapted to painting by his contemporary, Masaccio (1401-28) (see fig. 8.17A). Employing their knowledge of geometry (then one of the most important elements in the classical education of every student), Renaissance artists conceived a method of depicting objects in space, whether animate or inanimate, that was more realistic than any other that had appeared in Western art since the Romans. In their concept, the perspective drawing of shapes (fig. 8.18A) makes the picture plane akin to a view through an entry window; picture framing or matting defines the window frame. In figure 8.18B imaginary sightlines or "orthogonals," called guidelines, are extended along the edges of the room's architectural planes to a point behind the angel's head.

The guidelines converge at a point on the eye level that is called the vanishing point (infinity). The eye level is synonymous with the horizon line (where the sky and ground meet) that is often seen in landscapes (see figs. 8.4 and 8.5). While the eye level reveals the relative height of the observer's/painter's eyes, it also demarcates upper and lower divisions called ground plane (floor) and sky plane (ceiling). A vertical axis that can be seen through the vanishing point, behind the angel's head, establishes the location of the artist or viewer. This is known as the viewer's location point. Changing the latter will drastically alter the view of the room (figs. 8.19A and B).

Major systems of linear perspective

There are three major systems of linear perspective: one-point, two-point, and three-point. All are relative to the way the artist views the subject or scene. Perspective is based on the assumption

that the artist maintains a fixed position and in theory views the subject with one eye (fig. 8.20). The Renaissance painter's approach had a ray of light come from one fixed point (the artist's eye) to every point on the object being drawn. They passed through a glass screen representing the artist's canvas—placed between the artist and the image or scene. The collection of points where the lines passed through the glass achieved the naturalistic view the artist wanted to recreate on the canvas. These devices were thought of as portable camera obscuras (see the "Beginning of Photography" section in Chapter 10, p. 249).

In reality, unless immobilized by a plaster cast and fitted with blinders, most viewers will casually move either their eyes or their head as their focus moves from object to object within the image. While this may extend the viewer's ability to understand the subject, changing the point of view to some extent works against the concepts of linear perspective.

Assuming a minimum of movement, the artist can view his subjects in one of three ways: 1. By taking a position directly in front of the image, the whole front plane of the subject is made to appear flat or parallel to the picture plane (one-point); 2. By moving so that an edge—instead of the whole flat plane is closest and centrally located, all planes will then appear to recede because the top and bottom edges converge to vanishing points on either side (twopoint); 3. Assuming a position very much above or below the subject that will make the sides as well as the top and bottom edges converge to distant points (three-point). In each of these examples, the subject was thought of as stationary and the artist changed position. But the same concepts can be applied to still-life material, which can be altered or repositioned; a small box could be placed in each of the three locations relative to the artist's viewpoint.

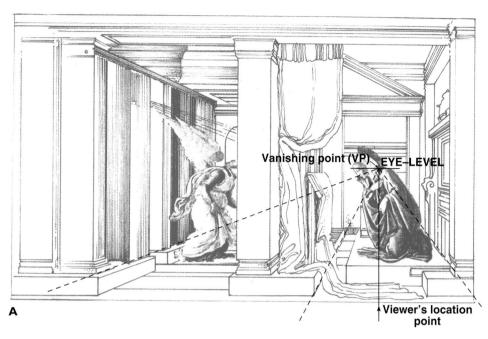

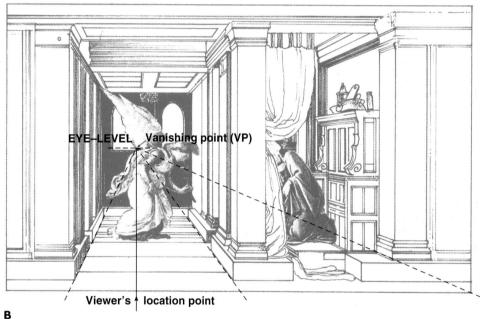

▲ 8 · I9A & B

These illustrations show how the interior might have changed if Botticelli had moved his location point left or right and up or down (see fig. 8.18A). Figure 8.19A indicates what Botticelli would have seen by moving to the right and standing directly in front of the Madonna. Figure 8.19B depicts the view he would have had by moving to the left, past the angel, and moving up a ladder one or two steps. Notice how the architectural elements change with each view, obscuring important parts of the image.

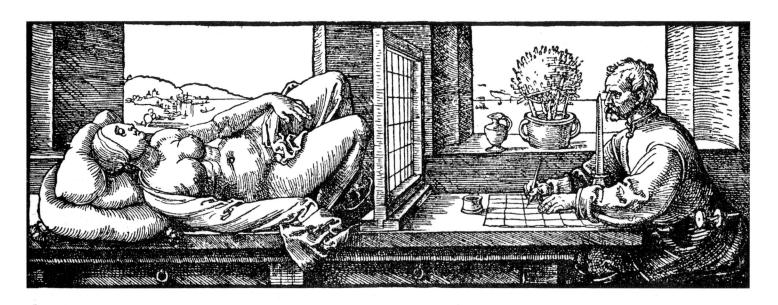

▲ 8 · 20
Albrecht Durer, *Draftsman Drawing a Nude*, c. 1525. Woodcut.

This woodcut illustrates an early approach to recording the effects of perspective from a fixed view. In "Underweysung der messing (Instruction in Proportion)," (Nurenberg, 1527) (appeared only 3rd ED., 1538). Private collection/Foto Marburg/Art Resource, New York.

₩ 8 • 21

With one-point perspective the whole front or back plane of the subject is made to appear flat or parallel to the picture plane.

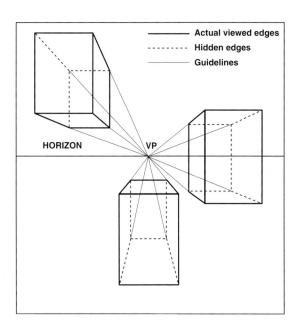

One-point perspective

One-point perspective is used when the artist views a flat surface or facing plane directly, or front-on. This flat plane will be drawn parallel to the picture plane and the horizon line. In this system, the artist first establishes the horizon line, which represents the eye level (fig. 8.21). It is placed low on the page if the artist is close to the ground, high on the page if the artist is on a ladder, or centered if the artist is standing. Next, the vanishing point is located. It is usually centered on the horizon line. To make the composition less monotonous it is sometimes placed slightly to the right or left of center, so that the picture is not divided too symmetrically. In either case, the vanishing point represents a position directly in front of the viewer and at eye level.

After the vanishing point on the horizon line is established, the artist begins with the frontal plane of the geometric solid—that portion closest to the viewer. Guidelines drawn from the four corners of the front plane to the vanishing point will establish the theoretical position of the solid's side planes. They will appear to diminish in size as they recede in depth toward the horizon. In one-point perspective, all lines return to the same vanishing point

except for those lines defining the original flat plane or any planes behind and parallel to it. Lines forming the front plane (horizontals or verticals) are at right angles to each other, remain constant, and are geometrically measurable. The lines forming these planes are parallel to the ground plane or perpendicular to it and establish their spatial location. Notice that the three geometric solids are located fairly close to the vanishing point. In reality, when viewing such solids, one sees the sides as foreshortened. The farther away from the (centrally located) vanishing point the solids are drawn, the more distorted their side planes seem to appear. These far right and left locations are no longer seen as frontal and would more correctly be seen as a two-point perspective view. However, artists often employ such distortions for compositional and/or conceptual advantage.

Any subject with a flat frontal view, like the end of a room, hallways, long frontal views of the interior and exterior of buildings, streets, and lines of trees, lend themselves well to one-point perspective pictures, as seen in Canaletto's *The Piazza of St. Mark, Venice* (fig. 8.22).

Two-point perspective

Two-point perspective is most often employed when the artist views a leading edge instead of a flat plane (fig. 8.23). This will cause the geometric solid to appear to be at an angle to the lines of sight; or, in other words, to appear to be at angular positions in depth on the surface of the picture plane. The artist begins by establishing the horizon line, as in one-point perspective, its placement in the drawing being relative to the height of the artist's viewing position. Next, vanishing points are located on the horizon line at the extreme left and right ends. In reality the vanishing points are near the edge of our field of view, and for the convenience of drawing, they are

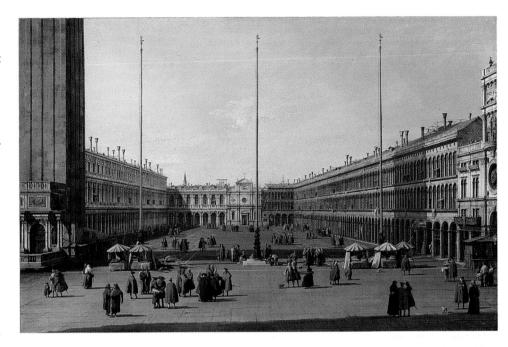

8 . 22

Antonio Canaletto, The Piazza of San Marco, Venice, c. 1735–45. Paint on canvas, $29^{7}/8 \times 46^{7}/8$ in (76 × 119 cm).

The appearance of planes and volumes in space determined by the systematic procedures of linear perspective is well illustrated in this painting by an eighteenth-century Venetian artist. It is basically in one-point perspective.

Detroit Institute of Arts. Founders' Society Purchase. General Membership Fund with a donation from Edsel B. Ford.

₹ 8 • 23

With two-point perspective, one vertical edge is closest and all top and bottom edges recede and converge at the left or right vanishing point.

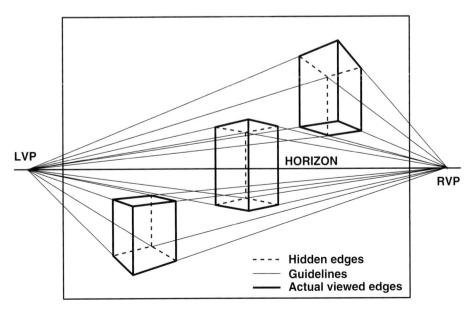

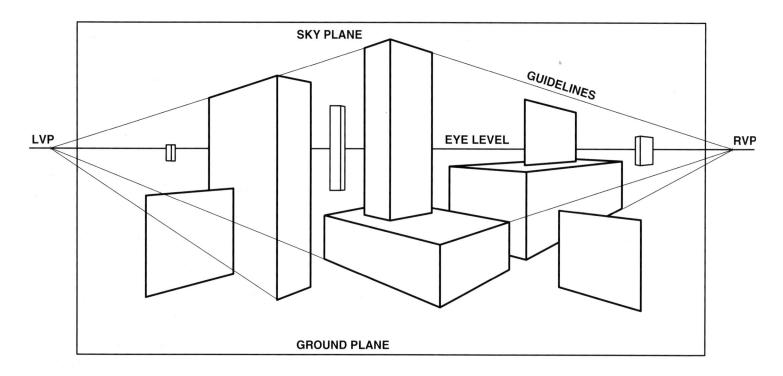

A 8 · 24

A drawing showing the essential difference between planes and three-dimensional shapes. Planes are shapes having only two dimensions (height and width), whereas three-dimensional shapes, which are made up of planes, have the effect of solidity (height, width, and depth). The component planes (sides) of three-dimensional shapes may be detached and inclined at any angle. The drawing is also an example of twopoint perspective. Object edges are shown as heavy lines, orthogonals (guidelines) as lighter lines. Vanishing points (LVP and RVP) show where object edges converge at the eye level or horizon line, which represents infinity. The eye level divides the picture plane into areas that stand for the ground and sky.

often located as far apart as possible. Now, the artist draws the closest portion of the box—the vertical edge—as a vertical line. From the top and bottom corners of this vertical, guidelines are extended back to both sets of vanishing points, tentatively establishing the side, top, and/or bottom planes of the geometric solid. These planes will appear to diminish as they recede toward the vanishing points. With two-point perspective, all lines except those that are vertical will return to the vanishing

points. The verticals indicate the height of the volumes, stay parallel, and are perpendicular to the ground plane. Only the verticals may be measured and never converge.

Notice in figure 8.24 that multiple solids and planes create a sense of deep space. In addition, the vanishing points are placed outside the picture plane. An artist has control over how much distortion of the objects is desired. Placing the vanishing points inside the edges of the picture frame will increase the exaggerated appearance of the shapes. Placing the vanishing points further apart eliminates the distortion of image that occurs when they are too close together. Unlike flies with multiple lens and 360-degree vision, our field of vision makes us specifically aware of objects in the central sixty degrees with some additional peripheral awareness of twenty to thirty degrees on either side. On the outer edges of our awareness we may only sense movement or images without color. With this in mind, the horizon line may be drawn on the paper representing the width of our visual field. The vanishing points may be

195

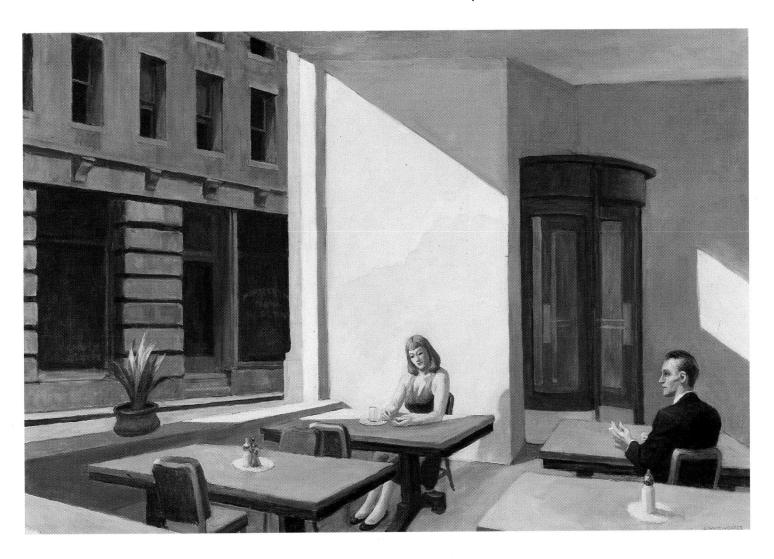

placed on either side of the drawn horizon line, a distance equal to approximately 1/4 of its width. The horizon line should be extended to the VPs. This will take them outside the pictorial area and possibly off the page. For compositional reasons, an artist may chose to work with only a portion of the complete field of view. If undistorted images are desired, the relative distance between vanishing points will remain unchanged and the section chosen will be located along that line relative to its location right or left and its width. In any case, the location of the VPs is only a tool and may be used to exaggerate (placed extremely close), present as observed (appropriately located), or distorted by nearly eliminating the receding quality of the image (spaced

extremely far apart). Each effect may be exactly what is needed at some point.

Two-point perspective is most often employed in graphic artworks when objects, usually set in architectural settings, appear to be at an angle to the lines of sight, or when the artist wishes them to appear at angular positions in depth on the picture plane, as can be seen in the Hopper painting and in Canaletto's drawing (fig. 8.25; see fig. 8.6).

Three-point perspective

Three-point perspective is used when an artist views an object from an exaggerated position—lying on the ground and looking up at a tree or looking down from a skyscraper into the center of the city. These are sometimes

A 8 · 25

Edward Hopper, Sunlight in a Cafeteria, 1958. Oil on canvas, 3 ft $4\frac{1}{4} \times 5$ ft $\frac{1}{8}$ in (1.02 \times 1.53 m).

This nostalgic interior with an outside view is painted in two-point perspective. The perspective has been altered to heighten the dramatic effect.

Yale University Art Gallery, New Haven, CT. Bequest of Stephen Carlton Clark, B. A. 1903.

€ 8 • 26

Charles Sheeler, Delmonico Building, 1926. Lithograph, $9\frac{3}{4} \times 6\frac{7}{8}$ in (24.7 × 17.4 cm).

This painting makes use of three-point perspective—a "frog's-eye view."

Fogg Art Museum, © President and Fellows, Harvard University Art Museums, Boston, MA. Gift of Paul J. Sachs.

8 . 27

Gene Bodio, New City, 1992. Computer graphic created using Autodesk 3D Studio-Release 2.

This is a bird's-eye view generated by a computer. Though not strictly in three-point perspective, the picture is an unusual variation in the depiction of three-dimensional objects in space.

Autodesk Inc., San Rafael, CA.

referred to as a "frog's-eye view" (fig. 8.26) and a "bird's-eye view" (fig. 8.27), respectively.

The artist begins by locating the horizon line that indicates the location of the viewer's eyes and fixing the left vanishing point (LVP) and the right vanishing point (RVP) at the appropriate location on the horizon line (fig. 8.28). Keep in mind that the closer together the vanishing points are placed, the greater will be the exaggeration or distortion of your image. Usually the horizon line will be relatively high or low on the picture plane. Next, a third point called the vertical vanishing point (VVP) is located along a vertical axis coming perpendicularly off the horizon line at a point representing the viewer's location point. The location of the

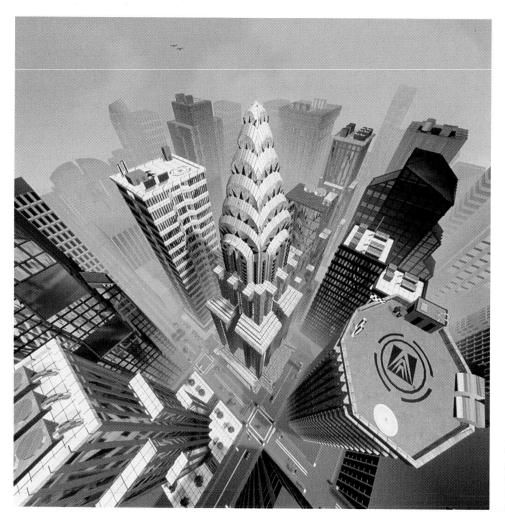

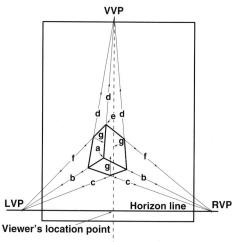

8 . 28

With three-point perspective a vantage point is assumed far above or below the subject. This will cause the sides, as well as the top and bottom edges, to converge to one of the three distant vanishing points.

197

(VVP) also controls the distortion of the object—the further away from the horizon line the third point is located, the less exaggerated the image will be. The image is started by fixing the nearest corner (a) of what will become a rectangular solid that seems to be floating overhead. From this point, guidelines (b) are extended to the RVP and to the LVP. This locates the leading front edges of the bottom plane. The width of both edges should be indicated and from those points new guidelines should be extended (c) again to the RVP and LVP. This completes the bottom plane and locates all four corners. The "verticals" (d) should now be drawn up and away from the three closest corners; but because there are no verticals in threepoint perspective, these lines will have to converge to the VVP. Once the "verticals" are drawn, it should be decided how long the rectangular solid must be by gauging its length on the closest or center "vertical" edge (a-e). After marking this point (e), guidelines (f) are extended from it to the RVP and to the LVP. In certain cases the hidden back edges (g) could be added. This completes the drawing of the edges and fully defines the geometric solid as seen from below in three-point perspective.

Only in three-point perspective are the vertical (height) lines, as well as those receding to the left and right vanishing points, spatially indicated. All three guideline systems converge at vanishing points. They are not perpendicular nor parallel to one another, but at oblique angles (see fig. 8.26).

Perspective concepts applied

Whether using one-, two-, or threepoint perspective, the artist is working with a system that allows the development of items of known size and their placing at various distances into the picture plane. A one-point cube, as illustrated in figure 8.29A, shows a whole flat frontal plane (the closest part) and a receding top plane. The center of any front plane-square or rectangularmay be found by mechanically measuring the horizontal and vertical lengths and dividing them in half. Lines (a) drawn from those points parallel to the verticals and horizontals will divide the plane into quarters. However, this type of measurement only works on flat, frontal planes found exclusively with one-point perspective. It will not work on any plane with converging sides one-, two-, or three-point—because the sides get smaller as they move away from the viewer and their changing ratio is not measurable on a ruler. Notice, on the front plane, that diagonals (b) drawn from corner to corner pass through the exact center found by mechanical measurement. The same type of diagonal lines drawn from corner to corner on the receding plane pass through the perspective center of the converging top plane. Lines drawn through this point parallel to the front edge (c) or to the

vanishing point (d) create the equal division of the four edges of the receding plane. This concept of corner-to-corner diagonals may be applied to cubes or rectangles in one-, two-, and three-point to locate the perspective centers on any receding plane.

Using the center point of a cube's front square, a circle can be drawn with a compass that should fit into the square perfectly (fig. 8.29B). Notice that when the diagonals are divided in thirds from the center, the circle crosses the diagonal lines on approximately the outer third mark. With a compass, try to draw a circle that fits into the top receding plane. It cannot be done, because even though we know that it is a circle, it will appear as an ellipse. The appropriate ellipse can be drawn on the top receding plane when it passes through the third marks on the diagonals and touches the square on the center points of each side. This system may be applied to any receding plane—vertical or horizontal in one-, two-, or three-point perspective (fig. 8.29C).

Figure 8.30A shows the changing ellipses that could be located in a very tall rectangle. Occasionally an artist must draw the appropriate ellipse for the top and bottom of anything cylindrical relative to its position above or below the horizon line. Notice that the ellipses further away from the horizon line are less distorted and that the ellipses flatten as they get closer to the horizon line. Ellipses do not always have to be

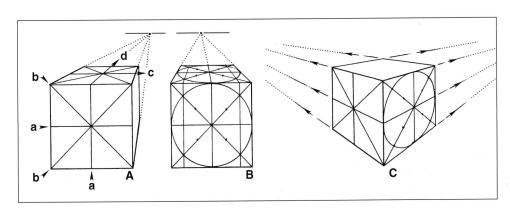

8 · 29A, B & C

Subdividing a plane. These diagrams illustrate how to find the perspective center of a plane by crossing diagonals from corner to corner (A). To draw a circle on the same plane, divide each half of the diagonals into thirds. Draw the circle so that it passes through the outside "third" marks (closest to the corners) on the diagonals. The circle should also touch the middle points on the sides of the square. This concept may be applied to one-and two-point perspective (B and C).

horizontal or vertical. Observe the ellipse drawn on the diagonal plane (fig. 8.30B). It is drawn using the same diagonal system for finding the center of the diagonal plane. In addition, the concept may be applied to drawing arches, bridges, and so on (fig. 8.30C). Although only the upper half of the

₩ 8 · 30A, B & C

When seen from the side, a perfect circle looks like an ellipse. The ellipse flattens as it moves closer to the horizon line (A). It may be applied to an inclined plane (B) or used to create arches, tunnels, and so on (C).

ellipses are shown in the arch, it will be necessary to know the basic cube or rectangle they were found in and the perspective centers of their shapes.

Once a square or rectangle is created it may be easily turned into a pyramid, cylinder, or cone by finding the perspective center for the top and bottom planes of the new shapes (figs. 8.31A-D). For a pyramid (A), simply draw lines from the top plane's perspective center to the four corners on the bottom plane. For the cylinder (B), it will be necessary to first draw the proper ellipse on the top and bottom planes—as described earlier. Then draw vertical lines from the outermost limits of both ellipses. Also note that a second pyramid (C) and cone (D) can be drawn with only the establishment of the bottom

plane. Find the perspective center of those planes and, from their points, draw lines perpendicular to the bottom planes at any desired length. Then from the end of this line draw the lines to the four corners for a pyramid and to the outeredge points on an ellipse for a cone.

The system for finding the perspective center of a receding plane can be used to project known distances back or sideways into space at the proper diminishing rate or ratio. If a telephone company plants seven poles equally spaced down the road, how does an artist know exactly where they should be drawn on the picture plane? Study figure 8.29A, covering up one-half of the illustration. Note that the diagonal lines (B) stop at the center point. In the portion covered up, they continue on

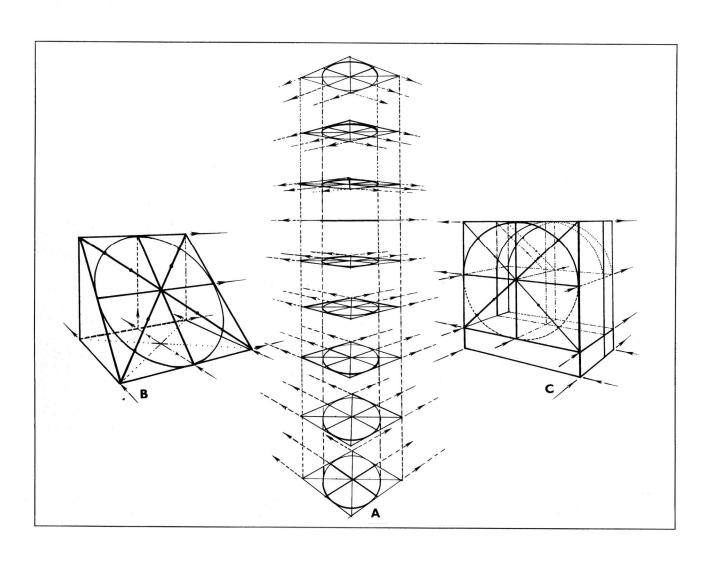

8 · 3 I A, B, C & D

The concept of locating a plane's perspective center and the correct ellipse to indicate a circle can be extended to create pyramids, cylinders, and cones.

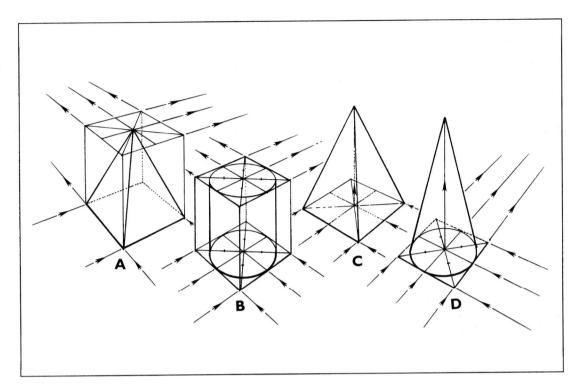

toward the upper and lower corners. Therefore, if the perspective center (vertical or horizontal plane) can be found, a known shape (half a unit) can be projected into a space on the opposite side of the center mark by continuing the diagonals until they cross an extension of the top or bottom edge.

To draw the telephone poles equally spaced in perspective, simply draw the first pole and then extend guidelines from the top and bottom to the vanishing point (fig. 8.32). Draw the second pole any distance you desire from the first and parallel to it touching the top and bottom guidelines. Next, find the center of the second pole by either measuring or by dividing the shape between the poles with diagonal lines. The point where the diagonals cross may be projected to the second pole by drawing a guideline from that point to the vanishing point. Now, remembering that diagonals cross on the midpoint, draw lines from the top and bottom of the first pole through the midpoint found on the second pole, extending them until they touch the guidelines.

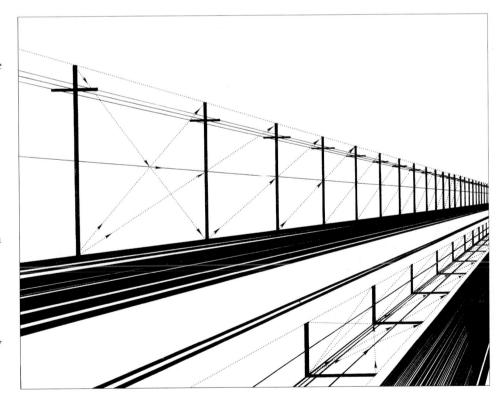

8 • 32

Telephone poles showing vertical projection systems. A given unit—the distance between two telephone poles—may be projected. Extending a diagonal guideline from a corner through the midpoint of the next pole to the appropriate top or bottom guideline reveals the location of the next pole. Units may be projected on a vertical or horizontal plane.

Where they do, extend another vertical and it will locate the next pole at a perspective unit equal to the one just projected. A single diagonal line may be used to project through the center point on the new pole to find the location of the next pole. This process may be repeated as often as necessary until the number of poles desired has been reached. Spacing may be projected horizontally as well as vertically. The same procedure has been applied to the guardrail poles in the lower right corner. In addition, horizontal projection may be applied to locate floor tiles, windows, and so on, or consistent spacing between architectural components (fig. 8.33).

A perspective drawing may also have several vanishing points other than those located on the horizon line (fig. 8.34). They are often used when it is desirable to show an angular or spatially receding plane within a perspective drawing, such as on a gable or truss-roofed house, or a

door opening at an angle. In this case the roof is located first and its edges are extended back to their new vanishing point. Then any additional images that would be drawn on that receding plane—for example shingles and skylight windows—must be extended to that new point. A point may also be located as a source of light with all cast shadows being indicated by guidelines projected from it to the ground plane. As a further complication, an artist may encounter situations where houses and other objects are not parallel to each other. One-, two-, and possibly three-point perspective systems may be used in the same drawing.

The disadvantages of linear perspective

Linear perspective has been a traditional drawing device used by artists for centuries. During that time the system

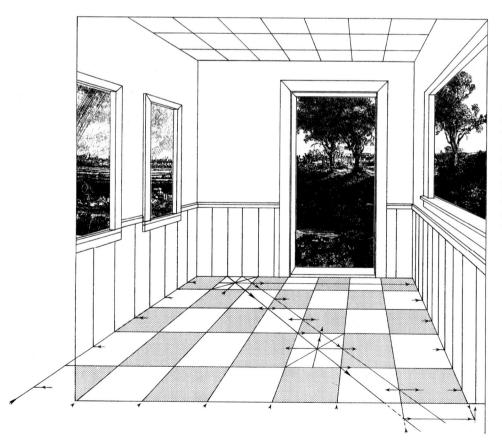

€ 8 • 33

A room interior. Because horizontals and verticals in one-point perspective may be measured, all tile spacing was marked on the back edge of the floor. From the vanishing point, floor lines were extended through each of these points toward the viewer. After establishing the first row of tiles, a diagonal line was extended from corner to corner of one tile and beyond. Where the diagonal crossed each floor line, a horizontal line was drawn, thereby defining a new row of tiles. A second line, passing through the center of the edge of each tile, located points that were projected on to both walls to identify wallboard spacing and window widths.

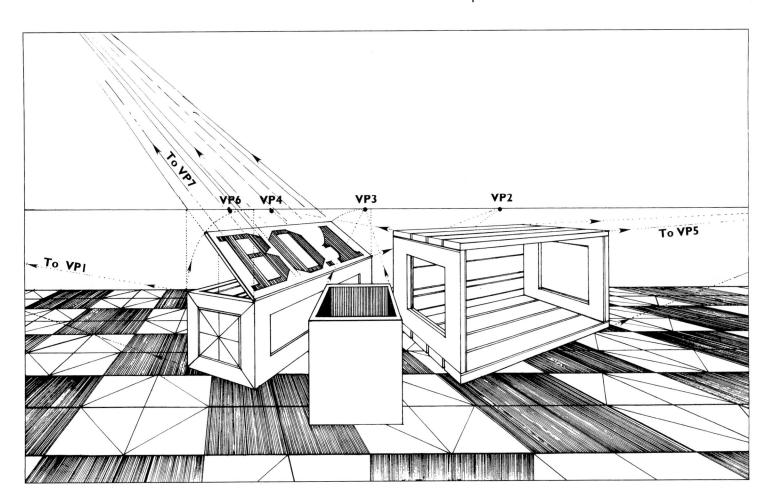

has evolved and undergone modifications in attempts to make it more flexible or more realistic in depicting natural appearances. Some of these include multiple perspectives, with more than three vanishing points, and, at other times, the use of multiple eye levels. Linear perspective has been most popular during periods of scientific inquiry and reached its culmination in the midnineteenth century. Despite its seeming virtue of accurately depicting natural appearances, the method has certain disadvantages that, in the opinion of some artists, outweigh its usefulness. Briefly, the liabilities of linear perspective are as follows:

- 1. It is never an actual statement of shape or mass as they are known to be.
- 2. The only appearances that can be legitimately portrayed are those that

- can be seen by the artist/observer from one position in space.
- 3. The necessary recession of parallel lines toward common points often leads to monotonous visual effects.
- 4. The extreme reduction of scale within a single object, resulting from the convergence of lines, is another type of perspective distortion (see fig. 8.15. This diagram indicates that a rectangular tabletop depicted in perspective becomes a trapezoid and leaves spatial vacuums left of C and right of D).

These disadvantages are mentioned only to suggest that familiar modes of vision are not necessarily those that function best in a work of art. At various periods of time an intuitive use of perspective has generally replaced systematic formulas for the indication of depth in pictorial forms of art (see fig. 8.39).

A 8 · 34

Seven in one. Seven vanishing points (VPs) were used to create this drawing. VPs I and 2 were used for the left box. VP 3 was used to create the center cube. VPs 4 and 5 were used for the open crate on the right. VP 6 was used for the floor tiles. VP 7 was used to define the inclined plane of the box lid and its lettering.

w 8 ⋅ 35

M. C. Escher, Belvedere, 1958. Lithograph, $18\frac{1}{8} \times 11\frac{5}{8}$ in (46 × 29.5 cm).

From his early youth, Escher practiced the graphic technique of perspective and for many years strived to master that skill. Later he found ideas he could communicate by extending his perspective technique, and he became fascinated with visually subverting our commonsense view of the three-dimensional world. In this print, Escher knew it was impossible to see the front and back of a building simultaneously, yet he managed to draw such an impossible building. Photo courtesy of the Vorpal Gallery, New York/ Photograph by D. James Dee. © 1997 Cordon Art — Baarn — Holland. All rights reserved.

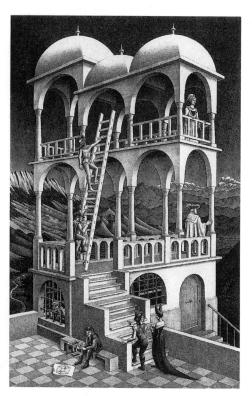

To a certain extent, artists could become prisoners of the system they have helped to produce. Because of its inflexible rules, perspective emphasizes accuracy of representation—an emphasis that tends to make the presentation more important than what is being represented. If, however, artists see perspective as an aid rather than an end in itself, as something to be used when and if the need arises in creating a picture, it can be very useful (see fig. 8.16). Many fine works of art ignore perspective or show "faults" in the use of the system. In such a case the type of spatial order created by traditional perspective is not compatible with the aims of the artist (fig. 8.35). Perspective, like any tool, should be learned by artists because it extends the range of conceptual expression.

OTHER PROJECTION SYSTEMS

Other systems that suggest objects spatially have been developed. These methods use parallel projecting lines (nonconverging). Because these systems present a stable and consistently measurable image that does not diminish as it recedes, designers, architects, and technical engineers use them for ease of drawing. They do, however, tend to "flatten" out objects when compared to traditional Western perspective systems that use vanishing points.

Oblique projection looks at first glance to be related to one-point perspective, for both present a flat frontal view, which is always parallel to the picture plane (fig. 8.36A). For engineering and architectural applications, the front plane is always drawn at full scale. However, with oblique perspective all left or right side edges that would have converged at a singular vanishing point are drawn parallel. They come off the front plane at a forty-five degree angle. This type of

nonconverging parallel edges on receding planes is often seen in Asian art.

Isometric projection may be compared to two-point perspective in appearance. Both begin with a vertical frontal edge. Like oblique perspective, isometric work does not have any converging receding edges (fig. 8.36B). All edges that intersect at the vertical move away at a thirty-degree angle, both to the left and to the right. For ease of drawing, all three dimensions of the object use the same measurement system (scale); there is no diminishing ratio on the receding planes. This system is often preferred to oblique perspective because all three faces are visible at the same time with less apparent distortion. No side of the image is drawn parallel to the viewer (picture plane). This system is used for technical illustration and drafting.

Orthographic drawing is perhaps less understood as a system for identifying objects in a spatial setting, but is used by engineers and architects to present blueprints and schematic layouts (see fig. 8.52). With this system all sides of the rectangular (geometric) object are drawn parallel or perpendicular to a base line and the measurements are scaled to an exact ratio. Artists, engineers, industrial designers, and architects employ this system.

The reverse perspective employed by traditional east Asian artists is a dramatic contrast to the linear perspective of the West. Ancient canons prescribed convergence of parallel lines as they approach the spectator. This type of presentation closes the space in depth so that the picture becomes a stage and the spectator an actor-participant in an active spatial panorama that rarely loses its identification with the picture plane (fig. 8.37A). Similar space concepts have been employed in the West during various historical periods. Ideas on pictorial space usually agree with the prevailing mental climate of the society that produces the art. In this sense, space is a form of human expression.

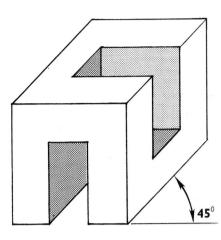

8 · 36A

Oblique projection. This system for showing spatial relationships makes use of a flat frontal shape with nonconverging side planes drawn at a forty-five degree angle from the front plane.

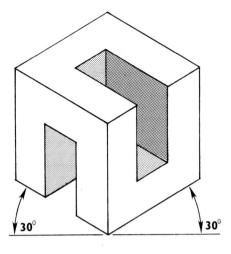

≥ 8 · 36B

Isometric projection features a vertical front edge and nonconverging side planes, which are drawn at a thirty-degree angle to the left and right.

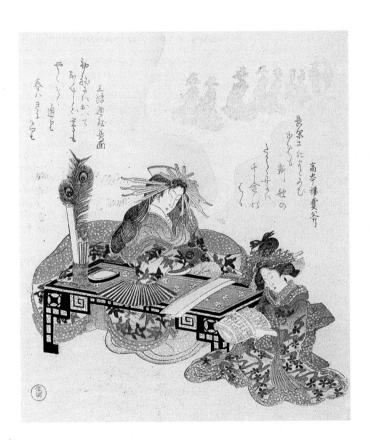

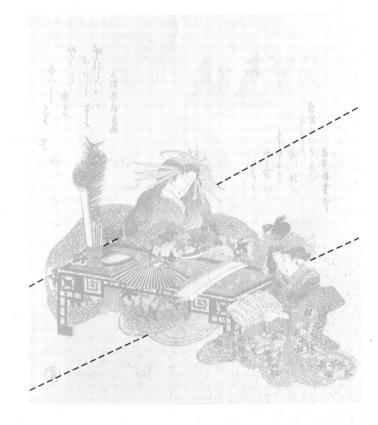

· 🛦 8 · 37A

Kubo Shunman, A courtesan dreaming of the New Year procession and her attendant, looking at a calendar, c. 1814. New Year's card, woodblock print, Surimono. $8^{1/4} \times 78^{1/4}$ in (20.95 \times 18.42 cm).

This Japanese artist, following his own (Asian) concept of space as moving forward toward the observer, employs—from a Western point of view—a kind of reverse perspective.

Metropolitan Museum of Art, New York. Bequest of Mrs. H. O. Havemeyer, 1929. The H. O. Havemeyer Collection. (JP 1971). Photo © Metropolitan Museum of Art, all rights reserved.

▲ 8·37B

A simple analysis of *Courtesans Dreaming* shows that if the lines defining the ends of the table are extended back toward the horizon line they will never meet as they would in the linear perspective of Western artists. However, if they are extended forward, following the Asian concept of space, they will converge. As a result, the near edge of the table is shorter than the back edge—which is characteristic of east Asian perspective.

INTUITIVE SPACE

Although planes and volumes play a strong part in creating illusions of space in linear perspective, they can also be used to produce intuitive space, which is independent of strict rules and formulae. Intuitive space is thus not a system, but a product of the artist's instinct for manipulating certain spaceproducing devices. The devices that help the artist to control space include overlap, transparency, interpenetration, inclined planes, disproportionate scale, and fractional representation. In addition, the artist may exploit the inherent spatial properties of the art elements. The physical properties of the art elements tend to thrust forward or backward; this can be used to define items spatially. By marshalling these spatial forces in any combination as needed, the artist can impart a sense of space to the pictorial image while adjusting relationships (fig. 8.38). The space derived from this

method is readily sensed by everyone, although judged by the standards of the more familiar linear perspective, it may seem strange, even distorted. Nevertheless, intuitive space has been the dominant procedure during most of the history of art; it rarely implies great depth, but makes for tightly knit imagery within a relatively shallow spatial field (fig. 8.39).

THE SPATIAL PROPERTIES OF THE ELEMENTS

The spatial effects that arise from using the elements of art structure must be recognized and controlled. Each of the elements possesses inherent spatial qualities, but the interrelationship between elements yields the greatest spatial feeling. Many types of spatial experiences can be achieved by manipulating the elements—that is, by varying their position, number, direction, value, texture, size, and color. The resultant spatial variations are endless (see fig. 3.22).

LINE AND SPACE

Line, by its physical structure, implies continued direction of movement. Thus line, whether moving across the picture plane or deep into it, helps to indicate spatial presence. Because, by definition, a line must be greater in length than in breadth (or else it would be indistinguishable from a dot or a shape), it tends to emphasize one direction. The extension of this dominant direction in a single line creates continuity, moving the eye of the observer from one unit or general area to another. Line can be a transition that unifies the front, middle, and background areas.

In addition to direction, line contains other spatial properties. Long or short, thick or thin lines, and straight, angular, or curved lines take on different spatial

₹ 8 • 38

Roger Brown, Land of Lincoln, 1978. Oil on canvas, 5 ft $11\frac{1}{2}$ in \times 7 ft $(1.82 \times 2.13 \text{ m})$.

Certain contemporary artists employ individualistic devices to create unusual spatial effects. This painting by Roger Brown shows multiple viewpoints that seem to project backward and forward in a scale of unusual proportions.

Courtesy of Phyllis Kind Gallery, Chicago, IL. \circledcirc Guy and Helen Barbier, Geneva, Switzerland.

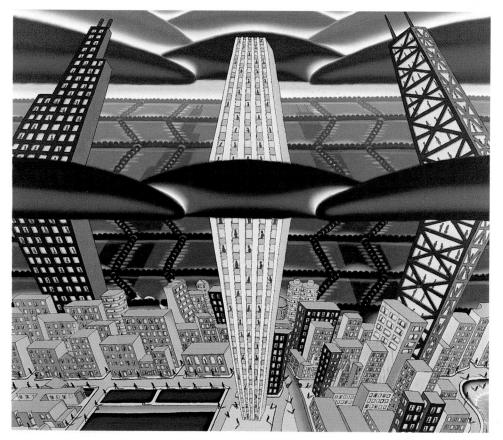

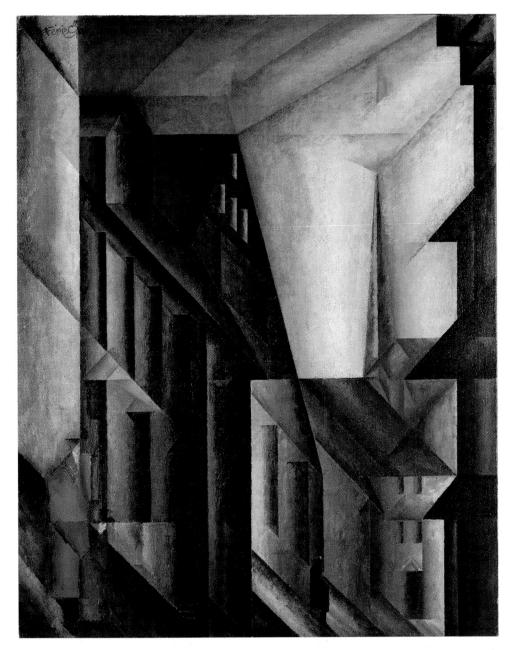

8 • 39

Lyonel Feininger, Street: Near the Palace, 1915. Oil on canvas, $39\frac{1}{2} \times 31\frac{1}{2}$ in (100.3 \times 80 cm).

In this painting the artist has used intuitive methods of space control, including overlapping planes and transparencies, as well as planes that interpenetrate one another and incline into space.

The Norton Simon Foundation, Pasadena, CA. © 1997 Artists Rights Society (ARS), New York/VG Bild-Kunst, Bonn.

positions and movements in contrast with one another. The indications of three-dimensional space mentioned earlier in this chapter are actively combined with the physical properties of line. A long thick line, for instance, appears larger (a spatial indication) and hence closer to the viewer than a short thin line. Overlapping lines establish differing spatial positions, especially when they are set in opposite directions (that is, vertical against horizontal). A

diagonal line seems to move from the picture plane into deep space, whereas a vertical or horizontal line generally appears comparatively static (fig. 8.40). In addition, the plastic qualities of overlapping lines can be increased by modulating their values. Lines can be lightened to the point that they disappear or become "lost" only to reappear (become "found") and grow darker across the compositon. This missing section or *implied* line can also help

8 • 40

Lines of various physical properties. Vertical, horizontal, and some diagonal lines often seem to occupy a fixed position in space. Wavy, spiral, serpentine, and zigzag lines appear to move back and forth in space. Alterations in line thickness also modify spatial position.

spatial suggestions arising out of this general principle are so infinitely varied that particular effects are usually the product of the artist's intuitive explorations. Wavy, spiral, serpentine, and zigzag line types adapt to all kinds of space through their unexpected deviations of direction and accent. They seem to move back and forth from one spatial plane to another. Unattached single lines define their own space and may have plastic qualities within themselves. Lines also clarify the spatial dimensions of solid shapes (fig. 8.41; see fig. 3.9).

8 • 41

Vivien Abrams, Changing Dynamics, 1984. Oil on masonite, $21^{3}/_{4} \times 21^{1}/_{2} \times 21^{1}/_{4}$ in (55.2 × 54.6 × 54 cm).

The overlapping and convergence as well as the physical properties of the lines in this work have been orchestrated to create a strong illusion of space.

Louise Ross Gallery, New York.

control compositional direction or movement. The modulated plastic illusion invariably suggests change of position in space.

The spatial indication of line convergence that occurs in linear perspective is always in evidence wherever a complex of lines occurs. The

SHAPE AND SPACE

Shape may refer to planes, solids, or volumes, all of which occupy space and are therefore entitled to consideration in this chapter. A plane, although physically two-dimensional, may create the illusion of three-dimensional space (fig. 8.42).

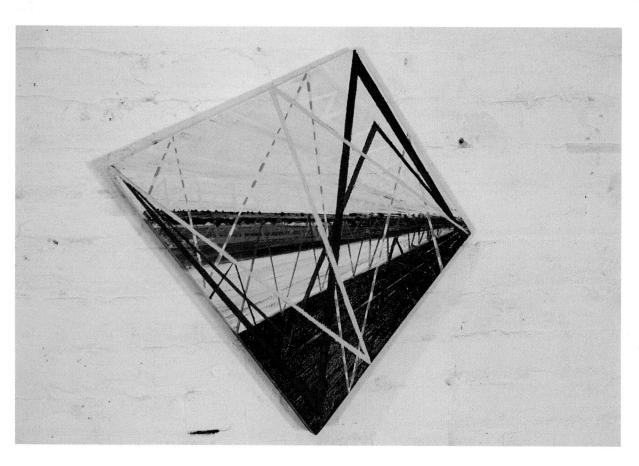

8 • 42

Planes in space. In this example, the outlines of the two-dimensional shapes (or planes) are varied in thickness and placement, while two edges converge toward the back to give the effect of three-dimensional space. The overlapping planes enhance the effect of depth behind the picture plane.

Solids, volumes, and masses automatically suggest three dimensions. Such shapes express the space in which they must exist and actually become a part of it. Planes, solids, and volumes can be made to take a distant position by diminishing their size in comparison to others in the frontal picture areas and by neutralizing their value, color, intensity, and detail (fig. 8.45). This treatment relates back to the indications of space outlined earlier in this chapter.

VALUE AND SPACE

The plastic effect of value can be used to control pictorial space. When a light

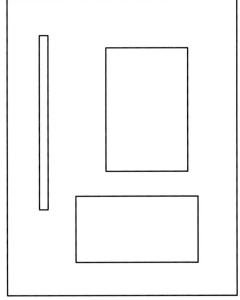

A 8 · 43

Flat planes. Because the shape outlines consist of horizontals and verticals repeating the essentially flat nature of the picture plane (as determined by the horizontals and verticals of the border), this diagram is an example of shape and space relationships that are two-dimensional.

source is assumed to be in front of a work, the objects in the foreground appear light. The middle and background objects become progressively dark as they move away from the picture plane (see fig. 10.1). When the light source is located at the back of the work, the order of values is reversed (see fig. 6.20). The order of value change is consistent in gradation from light to dark or dark to light.

In the natural world, foreground objects are seen with clarity and great contrast, while distant objects are ill-defined and gray. Therefore, neutral grays, when juxtaposed with blacks or whites, generally take a distant position (see fig. 8.14).

Cast shadows are sometimes helpful in describing plastic space, but they may be spatially confusing and even injurious

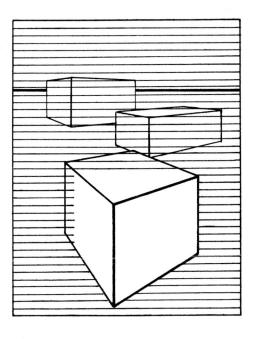

A 8 · 44

Planes and solids in space. The relationship of planes in this diagram describes an effect of solids or volumes that in turn seem to occupy space. The size, overlapping, and placement of these volumes further increase the effect of solidity. The horizontal shaded lines indicate an imaginary position for the picture plane, causing the near volume to project into the observer's space, or in front of the picture plane.

8 • 45

Al Held, B/WX, 1968. Acrylic on canvas, 9 ft 6 in \times 9 ft 6 in (2.90 \times 2.90 m).

Although the physical properties of the lines in this work are consistent throughout, their arrangement causes the enclosed shapes to be seen in different spatial positions. This is somewhat similar to the program of Op art.

Albright-Knox Art Gallery, Buffalo, NY. Gift of Seymour H. Knox, 1969. © 1998 Al Held/Licensed by VAGA, New York.

Tony King, Map: Spirit of '76, 1976. Acrylic and newspaper on canvas, 7×8 ft $(2.13 \times 2.44 \text{ m})$.

The format, with its papier collé surface, is perfectly flat, but the use of light-and-dark values creates a strongly three-dimensional illusion.

Courtesy of Owens Corning Collection, Toledo, OH.

to the design if not handled judiciously (see figs. 5.4A and 5.6).

Value-modeling can be abstract in the sense that it need not follow the objective natural order of light and dark. Many artists have totally ignored this natural order, using instead the inherent spatial position that results from the contrast of dark and light (fig. 8.46).

TEXTURE AND SPACE

Because of the surface enrichment that texture produces, it is tempting to think of this element purely in terms of decorative usefulness. Actually, texture can have the plastic function of describing the depth position of surfaces. Generally speaking, sharp, clear, and bold textures advance, while fuzzy, dull, and minuscule textures recede. When modified through varied use of value, color, and line, texture significantly contributes to the total pictorial unity.

8 • 47

Pablo Picasso, Seated Woman, 1927. Oil on canvas, $51\frac{1}{2} \times 38\frac{1}{2}$ in (130.8 \times 97.8 cm).

Because of their obviously decorative quality, abstract textures emphasize the flatness of the picture plane. Background and foreground forms become closely integrated so that little sense of receding space is felt by the observer.

Art Gallery of Ontario, Toronto. Purchase, 1964. Acc. no. 63/44. (Photograph by Carlo Catenazzi, AGO.) © 1997 Estate of Pablo Picasso/Artists Rights Society (ARS), New York.

Texture is one of the visual signs used to produce the decorative surface so valued in contemporary art. The physical character of texture is related to allover patterned design and, as such, operates effectively on decorative surfaces. When patterned surfaces are repeated and distributed over the entire pictorial area, the flatness of the picture plane becomes vitally important. Many works of Pablo

Picasso illustrate the modern use of surface textures to preserve the concept of the flat picture plane (fig. 8.47).

COLOR AND SPACE

One of the outstanding contributions of modern artists has been their reevaluation of the plastic potentialities of color. Color is now integrated directly into the form of the picture in a positive and direct manner in order to model the various spatial planes of surface areas (see the "Plastic Colors" section in Chapter 7, p. 157–58). Since the time of Cèzanne, there has been a new awareness of the spatial characteristics of color in art. Prior to then, deep space was considered as beginning with the picture plane and

A 8 · 48

John Marin, Sun Spots, 1920. Watercolor and charcoal on off-white wove paper, $16\frac{1}{2} \times 19\frac{3}{4}$ in (41.9 \times 50.2 cm).

Marin used the watercolor medium to exhibit a free, loose style of painting. His play of color—sea against sunspots—helps to create tremendous spatial interaction.

Metropolitan Museum of Art, New York. Alfred Stieglitz Collection, 1949 (49.70.121). Photo © Metropolitan Museum of Art, all rights reserved.

receding from it. Later, John Marin and others dealt with the spaces on or in front of the picture plane chiefly through the use of color (fig. 8.48). Hans Hofmann, the abstractionist, often used intense colors to seemingly advance shapes beyond the picture plane (fig. 8.49).

Analogous colors, because they are closely related, create limited spatial movement; contrasting colors enlarge the space and provide varied accents or focal points of interest. Both exploit the limitless dimensions of space.

RECENT CONCEPTS OF SPACE

Every great period in the history of art has espoused a particular concept of space. These spatial preferences reflect basic conditions within the civilization that produced them. Certain fundamental attitudes toward space seem to recur in varied forms throughout recorded history. When a new spatial approach is introduced, it is at first resisted by the public. Eventually, however, it becomes the standard filter through which people view things. During the period of their influence, these conventions become a norm of vision for people, gradually conditioning them to expect art to conform to certain general principles. The acceleration of change prompted by the cataclysmic revelations of modern science has now produced new concepts that are without precedent. Today, artists are groping for ways to understand and interpret these ever-widening horizons, and, as they do, their explorations are met by characteristic recalcitrance from the public (fig. 8.50).

THE SEARCH FOR A NEW SPATIAL DIMENSION

Artists of the Renaissance, conditioned by the outlook of the period, set as their goal the optical, scientific mastery of nature. They sought to accomplish this by reducing nature, part by part, to a static geometric system. By restricting their attention to one point of view, artists were able to develop perspective and represent some of the illusionary distortions of actual shapes as seen by the human eye.

Modern artists, equipped with new scientific and industrial materials and technology, have extended the search into nature initiated by the Renaissance. They have probed nature's inner and outer structure with microscope, camera, video, and telescope. The automobile, airplane, and spacecraft have given them the opportunity to see more of the world than their early predecessors knew existed. The radically changed environment of the artist has brought about a new awareness of space. It has become increasingly evident that space

€ 8 • 49

Hans Hofmann, The Golden Wall, 1961. Oil on canvas, 4 ft $11\frac{1}{2}$ in \times 5 ft $11\frac{5}{8}$ in $(1.51 \times 1.82 \text{ m})$.

The large areas of red in this painting unify the color scheme. A smaller area of green gives balance to the total color pattern. Complementary colors balance and enhance each other.

Art Institute of Chicago. Mr. and Mrs. Frank G. Logan Prize Fund, 1962.775. Photo © 1998 Art Institute of Chicago. All rights reserved.

cannot always be described from the one point of view characteristic of the Renaissance, and the search continues for a new graphic vocabulary to describe visual discoveries. Because one outstanding feature of the modern world is motion, contemporary artistic representation must move, at least illusionistically. Motion has become a part of space, and this space can be grasped only if a certain period of time is allotted to cover it. Hence, a new dimension is added to spatial conception—the fourth dimension, which combines space, time, and motion, and presents an important artistic challenge. This challenge is to discover a practical method for representing things in motion from every viewpoint on a flat surface. In searching for solutions to this problem, artists have turned to their own experiences as well as to the work of others.

■ 8 • 50

René Magritte, La lunette d'approche (The Telescope), 1963. Oil on canvas, 5 ft 9⁵/₁₆ in × 3 ft 9¹/₄ in (1.76 × 1.15 m).

On close inspection one can see that this work is deliberately inconsistent in its use of space. As a Surrealist, Magritte often created ambiguous and unexpected effects to titillate our senses.

Courtesy of the Menil Collection, Houston, TX. Photo: Hickey-Robertson, Houston. © 1997 C. Herscovici, Brussels/Artists Rights Society (ARS), New York.

A 8 · 51

Paul Cézanne, Still Life with Basket of Fruit (The Kitchen Table), c. 1888-90. Oil on canvas, $25\frac{5}{8} \times 31\frac{7}{8}$ in (65.1 × 81 cm).

Cézanne was concerned with the plastic reality of objects as well as with their organization into a unified design. Although the pitcher and sugar bowl are viewed from a direct frontal position, the rounded jar behind them is painted as if it were being seen from a higher location. The handle of the basket is shown as centered at the front, but it seems to become skewed into a right-sided view as it proceeds to the rear. The left and right front table-edges do not line up, and are thus viewed from different vantage points. Cézanne combined these multiple viewpoints in one painting in order to present each object with a more profound sense of three-dimensional reality.

Musée d' Orsay, Paris, France. Photo @ Erich Lessing/Art Resource, New York.

213

■ 8 · 52

Tom Haverfield, Kerosene Lamp, c. 1960. Pen and ink, 9×12 in (22.9 \times 30.5 cm).

In this work, objects are rendered in a type of orthographic drawing that divides them into essential views able to be drawn in two dimensions.

Courtesy of the artist.

PLASTIC IMAGES

Paul Cézanne, the nineteenth-century Post-Impressionist, was an early pioneer in the attempt to express the new dimension. His aim was to render objects in a manner more true to nature. This nature, it should be pointed out, was not the Renaissance world of optical appearances; instead, it was a world of forms in space, conceived in terms of a plastic image (fig. 8.51). In painting a still life, Cézanne selected the most characteristic viewpoint of all his objects; he then changed the eye levels, split the individual object planes, and combined all of these views in the same painting, creating a composite view of the group. Cézanne often shifted his viewpoint of a single object from the right side to the left side and from the top to the bottom, creating the illusion of looking around it. To see these multiple views of the actual object, we would have to move around it or revolve it in front of us; this act would involve motion, space, and time.

The Cubists adopted many of Cézanne's pictorial devices. They usually

showed an object from as many views as suited them. Objects were rendered in a type of orthographic drawing, divided into essential views that could be drawn in two dimensions, not unlike the Egyptian technique previously cited (see "Fractional Representation," p. 186-187, and figs. 8.12 and 8.13). The basic view (the top view) is called a plan. With the plan as a basis, the *elevations* (or profiles) were taken from the front and back, and the sections were taken from the right and left sides (Fig. 8.52). The juxtaposition of these views in a painting showed much more of the object than would normally be visible. The technique seems a distortion to the lay spectator conditioned to a static view, but within the limits of artistic selection, everything is present that we would ordinarily expect to see (fig. 8.53).

In the works of the Cubists, we find that a picture can have a life of its own, and that the creation of space is not essentially a matter of portrayal or rendering. The Cubists worked step by step to illustrate that the more a painted object departs from straightforward

8 • 53

Tom Haverfield, Kerosene Lamp II, c. 1960. Pencil on paper, 14×18 in $(35.6 \times 45.7 \text{ cm})$.

The juxtaposition of orthographic views illustrates all the physical attributes and different views of the object in one drawing. Such a composite drawing shows much more of an object than could normally be visible.

Courtesy of the artist.

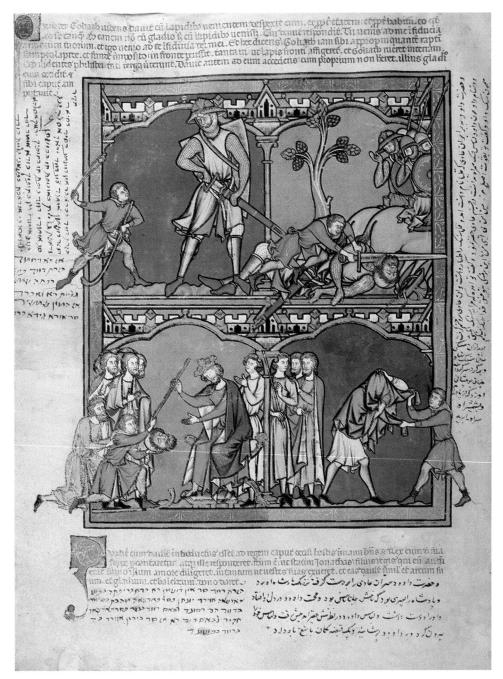

8 . 54

Unknown, David and Goliath, c. 1250. Manuscript dimensions: $15\frac{3}{8} \times 11\frac{3}{4}$ in (39 × 30 cm).

The element of time passing is present here, but in a conventional episodic manner. The order of events proceeds in a style similar to that of a comic strip.

Pierpont Morgan Library, New York, M.638 f.28v./Art Resource, New York.

optical resemblance, the more systematically could the full three-dimensional nature of the object be explored. Eventually, they developed the concept of the "synthetically" designed picture. Instead of analyzing a subject, they began by developing large, simple geometric shapes, divorced from a model. Subject matter suggested by the shapes was then imposed or synthesized into this spatial system (see fig. 4.8).

PICTORIAL REPRESENTATIONS OF MOVEMENT IN TIME

From time immemorial, artists have grappled with the problem of representing movement on the stationary picture surface. In the works of prehistoric and primitive humans, the efforts were not organized, but were isolated attempts to show a limited phase of observed movement.

In an early attempt to add movement to otherwise static figures, Greek sculptors organized the lines in the draperies of their figures to accent a continuous direction. By means of this device, the eye of the observer is directed along a constant edge or line.

The artists of the Medieval and early Renaissance periods illustrated biblical stories by repeating a series of still pictures. The representation of the different phases of the narrative (either in sequence or combined in a single work) created a visual synopsis of the subject's movement, the time period, and the space covered. These pictures were antecedents of modern comic-strip and motion-picture techniques whose individual frames, when projected at speed, provide the illusion of movement (figs. 8.54 and 8.55; see fig. 8.38).

Another representational device that suggests movement is the superimposition of many stationary views of the figure or its parts in a single picture. This technique catalogs the

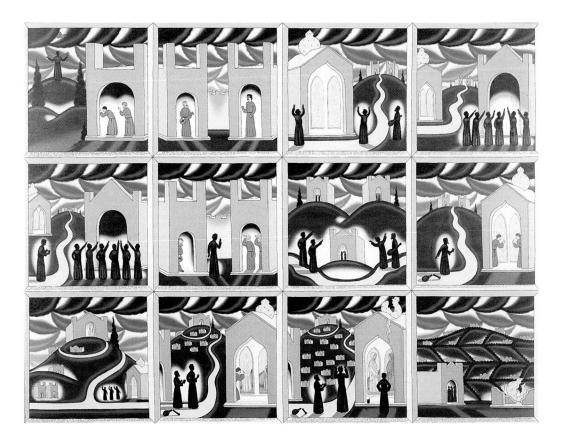

sequence of position of a moving body, indicating the visible changes.

Twentieth-century artists have attempted to fuse the different positions of the figure by filling out the pathway of its movement. Figures are not seen in fixed positions but as moving paths of action. The subject in Marcel Duchamp's *Nude Descending a Staircase* is not the human body, but the type and degree of energy the human body emits as it passes through space. This painting signified important progress in the pictorialization of motion, because the plastic forces are functionally integrated with the composition (fig. 8.56).

The Futurists (see the "Futurism" section in Chapter 10, p. 273) were devoted to motion for its own sake. They included not only the shapes of figures and objects and their pathways of movement, but also their backgrounds. These features were combined in a pattern of kinetic energy. Although this form of expression was not entirely new, it provided a new type of artistic

A 8 · 55

Roger Brown, Giotto and His Friends (Getting Even), 1981. Oil on canvas, 6 ft \times 8 ft 3 /8 in (1.83 \times 2.45 m).

Contemporary artist Roger Brown has used the historical technique of segmental narrative. Each segment of the work is a portion of an unfolding story.

Private collection. Photograph courtesy of the Phyllis Kind Galleries, Chicago and New York. (Photograph by William H. Bengtson.)

Marcel Duchamp, Nude Descending a Staircase, No. 2, 1912. Oil on canvas, 58×35 in (147.3 \times 88.9 cm).

The subject of Duchamp's painting is not the human body itself, but the type and degree of energy a body emits as it passes through space. Philadelphia Museum of Art, PA. Louise and Walter Arensberg Collection. Photo: Corbis Media. © 1997 Artist Rights Society (ARS), New York/ADAGP, Paris/Estate of Marcel Duchamp.

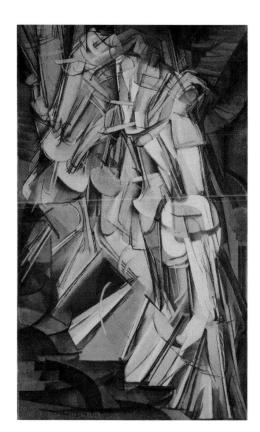

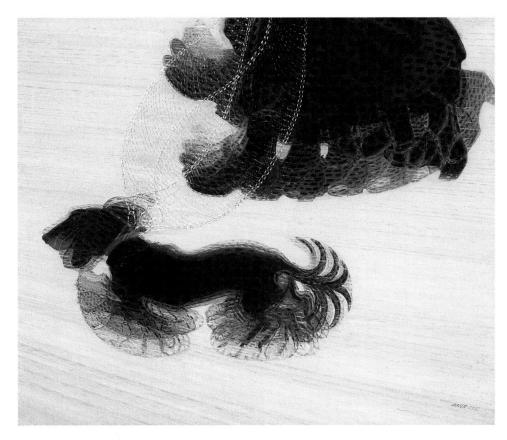

€ 8 • 57

Giacomo Balla, Dynamism of a Dog on a Leash, 1912. Oil on canvas, $35\frac{3}{8} \times 43\frac{1}{4}$ in (89.9 × 109.9 cm).

To suggest motion as it is involved in time and space, Balla invented the technique of repeated contours. This device soon became commonly imitated in newspaper comic strips, thereby becoming a mere convention.

Albright-Knox Art Gallery, Buffalo, NY. Bequest of A. Conger Goodyear and Gift of George F. Goodyear, 1964

adventure—simultaneity of figure, object, and environment (figs. 8.57 and 8.58).

The exploration of space in terms of the four-dimensional space—time continuum is in its infancy. As research reveals more of the mysteries of the natural world, artists will continue to absorb and interpret them according to their individual experiences. It is reasonable to assume that even more revolutionary concepts will emerge in time, producing great changes in art styles. The important point to remember is that distortions and unfamiliar forms of art expression do not occur in a vacuum; they usually represent earnest efforts to apprehend and interpret our world in terms of the latest frontiers of understanding.

Artists today may take advantage of the technological advances of our age. The hardware and software of computers can generate images that are preparatory, simulative, or final art products. By means of animation, the human form in motion may be studied. Video files make available a vast storehouse of information. The work of design agencies is greatly enhanced through the use of computer graphics. Many major motion pictures are now created by using the animation of computer graphics exclusively; Toy Story and Walt Disney films (such as The Beauty and the Beast and The Lion King) are a few of the very successful examples. Video, film, and computer-generated interactive environments only hint at the unlimited potential for visual arts in the future.

Space 217

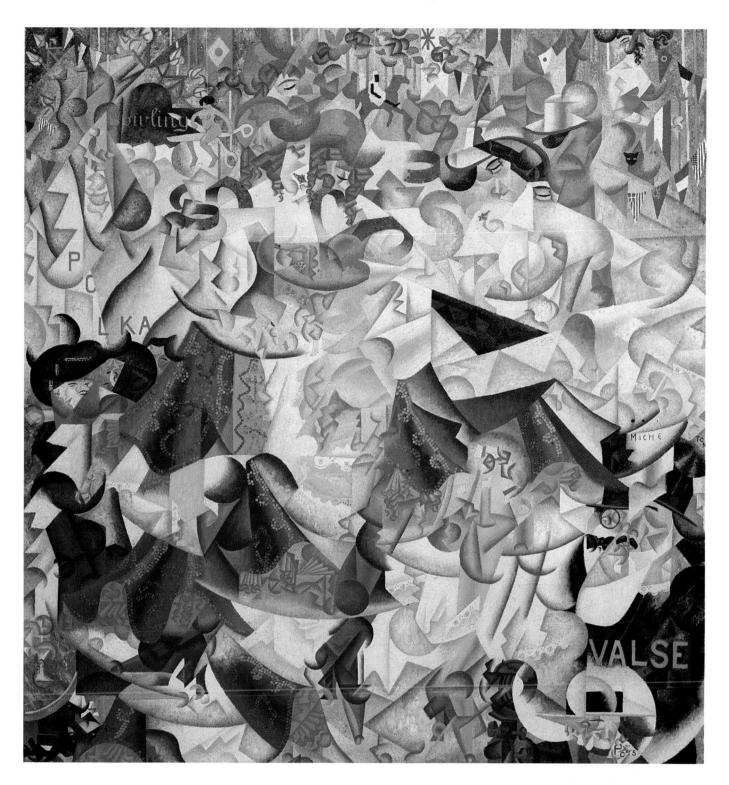

A 8 · 58

Gino Severini, Dynamic Hieroglyphic of the Bal Tabarin, 1912. Oil on canvas with sequins, $63^{5}/8 \times 61^{1}/2$ in (161.6 \times 156.2 cm).

The works of the Futurists were devoted to motion for its own sake. They included not only the shapes of figures and objects and their pathways of movement, but also their backgrounds. These features were combined in a pattern of kinetic energy.

The Museum of Modern Art, New York. Acquired through the Lillie P. Bliss Bequest. Photo © 1998 Museum of Modern Art. © 1997 Artists Rights Society (ARS), New York/ADAGP, Paris.

The Art of the Third Dimension

THE VOCABULARY OF THE THIRD DIMENSION

BASIC CONCEPTS OF THREE-DIMENSIONAL ART

Sculpture

Other Areas of Three-Dimensional Art

Architecture

Metalwork

Glass Design

Ceramics

Fiberwork

Product Design

THE COMPONENTS OF THREE-DIMENSIONAL ART

Materials and Techniques

Subtraction

Manipulation

Addition

Substitution

The Elements of Three-Dimensional Form

Shape

Value

Space

Texture

Line

Color

Time (the fourth dimension)

Principles of Three-Dimensional Order

Balance

Proportion

Economy

Movement

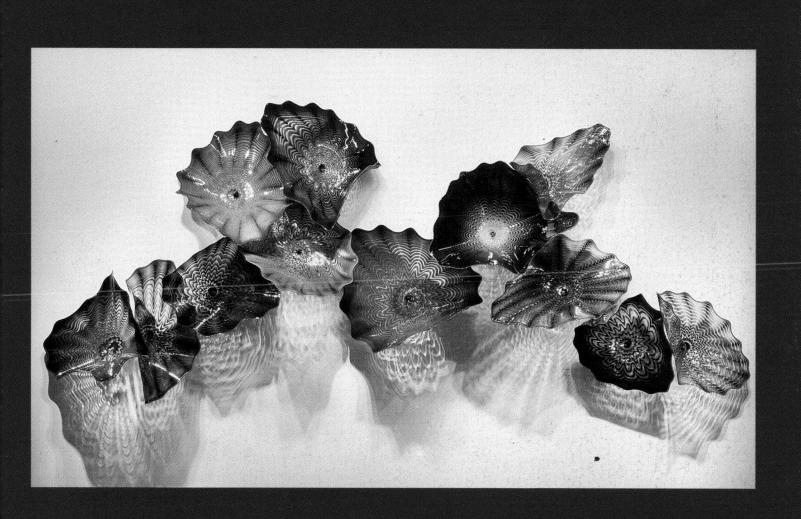

THE VOCABULARY OF THE THIRD DIMENSION

Three-dimensional To possess, or to create the illusion of possessing, the dimension of depth as well as the dimensions of height and width.

addition

A sculptural term that means building up, assembling, or putting on material.

atectonic

Characterized by considerable amounts of space; open, as opposed to massive (or tectonic), and often with extended appendages.

Bauhaus

Originally a German school of architecture that flourished between World War I and World War II. The Bauhaus attracted many leading experimental artists of both two- and three-dimensional fields.

casting

A sculptural technique in which liquid materials are shaped by being poured into a mold.

glyptic

I. The quality of an art material like stone, wood, or metal that can be carved or engraved. 2. An art form that retains the color, tensile, and tactile quality of the material from which it was created. 3. The quality of hardness, solidity, or resistance found in carved or engraved materials.

manipulation

The sculptural technique that refers to the shaping of pliable materials by hands or tools.

mass (third dimension)

I. In graphic art, a shape that appears to stand out three-dimensionally from the space surrounding it, or appears to create the illusion of a solid body of material.

In the plastic arts, the physical bulk of a

2. In the plastic arts, the physical bulk of a solid body of material.

mobile

A three-dimensional, moving sculpture.

modeling

A sculptural technique meaning to shape a pliable material.

patina

1. A natural film, usually greenish, that results from the oxidation of bronze or other metallic material. 2. Colored pigments and/or chemicals applied to a sculptural surface.

relief sculpture

An art work, graphic in concept, but sculptural in application, utilizing relatively shallow depth to establish images. The space development may range from very limited projection known as "low relief" to more exaggerated space development known as "high relief." Relief sculpture is meant to be viewed frontally not in the round.

sculpture

The art of expressive shaping of three-dimensional materials. "Man's expression

to man through three-dimensional form" (Jules Struppeck, see Bibliography).

shape (third dimension)

An area that stands out from the space next to or around it due to a defined or implied boundary, or because of differences of value, color, or texture.

silhouette

The area between or bounded by the contours, or edges, of an object; the total shape.

substitution

In sculpture, replacing one material or medium with another (see also **casting**).

subtraction

A sculptural term meaning to carve or cut away materials.

tectonic

The quality of simple massiveness; lacking any significant extrusions or intrusions.

biov

I. An area lacking positive substance; consisting of negative space. 2. A spatial area within an object that penetrates and passes through it.

volume (third dimension)

A measurable area of defined or occupied space.

BASIC CONCEPTS OF THREEDIMENSIONAL ART

In the preceding chapters, our examination of art fundamentals has been limited mostly to the graphic arts. These art disciplines (drawing, painting, photography, printmaking, graphic design, and so on) have two dimensions (height and width), exist on a flat surface, and generate sensations of space mainly through illusions created by the artist. This chapter deals with the unique properties of **three-dimensional** artwork and the creative concepts that evolve from these properties.

In three-dimensional art, the added dimension is that of actual depth. This depth results in a greater sense of reality and, as a consequence, increases the physical impact of the work. This is true because a graphic work is usually limited to one format plan, always bounded by a geometric shaped picture frame, while a three-dimensional work is limited only by the outer extremities of its multiple positions and/or views. The three-dimensional format, although more complicated, offers greater freedom to the artist and greater viewing interest to the spectator.

Because actual depth is fundamental to three-dimensional art, one must be in the presence of the artwork to fully appreciate it. Words and graphic representations of three-dimensional art are not substitutes for actual experience. Two-dimensional descriptions are flat, rigid, and representative of only one viewpoint; however, they do serve as a visual shorthand for actual sensory experiences. In this text, and particularly in this chapter, we use two-dimensional descriptions, by way of text and photographic reproductions, as the most convenient means of conveying the three-dimensional experience. But we emphatically encourage readers to put actual observation into practice.

9.

Isamu Noguchi, The Stone Within, 1982. Basalt, $75 \times 38 \times 27$ in (190.5 \times 96.5 \times 68.6 cm).

The sculptor Noguchi has subtracted just enough stone in this work to introduce his concept of minimal form while preserving the integrity of the material and its heavy, weighty mass.

Isamu Noguchi Foundation. (Photograph by Michio Noguchi.)

Practicing artists and art authorities designate the three-dimensional qualities of objects in space with such terms as form, shape, mass, and volume. The term form can be misleading here, because its meaning differs from the definition applied in early chapters—the inventive arrangement of all the visual elements according to principles that will produce unity. In a broad structural sense, form is the sum total of all the media and techniques used to organize the threedimensional elements within an artwork. In this respect, a church is a total form and its doors are contributing shapes; similarly, a human figure is a total form, while the head, arms, and legs are contributing shapes. However, in a more limited sense, form may just refer to the appearance of an object—to a contour, a shape, or a structure. Shape, when used in a three-dimensional sense, may refer to a positive or open negative area. By comparison, mass invariably denotes a solid physical object of relatively large weight or bulk. Mass may also refer to a coherent body of matter, like clay or metal, that is not yet shaped, or to a lump of raw material that could be modeled or cast. Stone carvers, accustomed to working with **glyptic** materials, tend to

think of a heavy, weighty mass (fig. 9.1); modelers, who manipulate clay or wax, favor a pliable mass. **Volume** is the amount of space the mass, or bulk, occupies, or the three-dimensional area of space that is totally or partially enclosed by planes, linear edges, or wires. Many authorities conceive of masses as positive solids and volumes as negative open spaces. For example, a potter who throws a bowl on a wheel adjusts the dimensions of the interior volume (negative interior space) by expanding or

9 · 2 John W. Goforth, Untitled, 1971. Cast aluminum, 15³/₄ in (40 cm) high with base.

The volume incorporates the space, both solid and empty, that is occupied by the work.

Collection of Otto Ocvirk. Courtesy of Carolyn Goforth.

 \P 9 • 3 Mark di Suvero, *Tom*, 1959. Wood, metal, rope, cable, and wire cable, 9 × 10 × 12 ft (2.74 × 3.05 × 3.66 m).

Modern sculpture exploits every conceivable material that suits the intentions of the artist. Photograph © 1997 Detroit Institute of Arts, Founders Society Purchase, Friends of Modern Art Fund, Mr. and Mrs. Walter Buhl Ford II Fund and contribution from Samuel J. Wagstaff, Jr.

compressing the clay planes (positive mass). The sculptor who assembles materials may also enclose negative volumes to form unique relationships (fig. 9.2).

Looking more widely, most objects in our environment have threedimensional qualities of height, width, and depth, and can be divided into natural and human-made forms. Although natural forms may stimulate the thought processes, they are not in themselves creative. Artists invent forms to satisfy their need for self-expression. In the distant past, most threedimensional objects were created for utilitarian purposes. They included such implements as stone axes, pottery, hammers and knives, and objects of worship. Nearly all these human-made forms possessed qualities of artistic expression; many depicted the animals their creators hunted. These historic objects are now considered an early expression of the sculptural impulse.

SCULPTURE

The term "sculpture" has had varied meanings throughout history. The word derives from the Latin verb sculpere, which refers to the process of carving, cutting, or engraving. The ancient Greeks' definition of sculpture also included the **modeling** of such pliable materials as clay or wax, to produce figures in relief or in-the-round. The Greeks developed an ideal standard for the sculptured human form that was considered the perfect physical organization—harmonious, balanced, and totally related in all parts. The concept of artistic organization was part of the definition of sculpture (see fig. 2.40).

Modern sculpture has taken on new qualities in response to the changing conditions of an industrialized age. Science and machinery have made sculptors more conscious of materials

and technology, and more aware of the underlying abstract structure in their art.

Sculpture is no longer limited to carving and modeling. It now refers to any means of giving intended form to all types of three-dimensional materials. These means include welding, bolting, riveting, gluing, sewing, machinehammering, and stamping. In turn, the three-dimensional artists have expanded their range of sculptural forms to include planar, solid, and linear constructions made of such materials as steel, plastic, wood, and fabric (fig. 9.3). The resulting sculptures are stronger (even though made of lighter materials) and more open. They also have expanded spatial relationships. Three-dimensional forms like wire constructions and mobiles have changed the definition of sculpture that, prior to the nineteenth century, would have included only solid, heavy, and sturdy glyptic forms. Michelangelo Buonarroti, an innovative sculptor within his Renaissance time-frame, thought only in terms of massive materials and heavy figures (fig. 9.4).

The diversity of newfound materials and techniques has led to greater individual expression and artistic freedom. Sculptors experiment with new theories and have found new audiences and new markets (fig. 9.5).

OTHER AREAS OF THREE-DIMENSIONAL ART

The bulk of this book has addressed works of pure or fine art that have no practical function. But sensitivity to the sculptural (and/or artistic) impulse is not confined to the fine arts; it permeates all three-dimensional structures. The same abstract quality of expressive beauty that is the foundation for a piece of sculpture can underlie such functional forms as automobiles, television receivers, telephones, industrial equipment, window and interior displays, furniture, and buildings (fig. 9.6). Artist-designers of these three-dimensional products organize elements, shapes, textures,

♠ 9 • 4
Michelangelo Buonarroti, The Bearded Captive,
c. 1516–1527. Marble, 8 ft 8½ in (2.65 m) high.

Michelangelo created heavy, massive sculpture and enlarged the sizes of human body parts for expressive purposes. The tectonic composition was in keeping with the intrinsic nature of the stone.

Accademia, Florence, Italy. © Arte Video Immagine Italia srl/Corbio Media.

9.5

Naum Gabo, Linear Construction in Space No. I (Variation), 1942–43 (enlargement 1957–58). Plexiglas with nylon monofilament, $24\frac{3}{4} \times 24\frac{3}{4} \times 9\frac{1}{2}$ in (62.9 × 62.9 × 24.1 cm).

Naum Gabo was an early pioneer in the Constructivist movement. He created sculptures free of traditional figures with such new materials as the sheet plastic seen here.

Patsy R. and Raymond D. Nasher Collection, Dallas, TX. (Photo: David Heald)

New concepts in automobile design are determined by advances in technology, engineering, economics, and visual appearance. One of the concept cars for General Motors' Pontiac was the Rageous, a futuristic performance coupé with realistic design and engineering features.

Courtesy of General Motors Design Center.

9.7

Armchair designed by Frank Lloyd Wright for the Ray W. Evans House, Chicago, IL, made by Neideken and Walbridge, c. 1908. Oak, $34\frac{1}{4} \times 23 \times 22\frac{1}{2}$ in (86.9 × 58.5 × 57.1 cm).

To Wright, form and function were inseparable, so a chair, which functions for sitting, should be considered along with the whole architectural environment.

Art Institute of Chicago. Gift of Mr. and Mrs. F. M. Fahrenwald, 1970.435. Photo © Art Institute of Chicago. All rights reserved. © 1998 Artists Rights Society (ARS), New York/Frank Lloyd Wright Foundation.

colors, and space according to the same principles of harmony, proportion, balance, and variety. Although form principles can be applied to such useful objects, the need for utility often restricts the creative latitude of the artist.

The famous architect Louis Sullivan made the oft-repeated remark that "form follows function." This concept has influenced several decades of design, changing the appearance of tools, telephones, silverware, chairs, and a vast array of other familiar and less familiar items. Sometimes this concept is misapplied. The idea of streamlining is practical when applied to the design of such moving objects as trains and cars, because it has the function of reducing wind resistance. However, streamlining has no logical application for the design of spoons and lamps. Although streamlining is helpful in eliminating irrelevancies from design, even simplification can be overdone. The Bauhaus notion of the house as a "machine for living" helped architects rethink architectural principles, but it also produced many cold and austere structures against which there was inevitable reaction.

Contemporary designers are very aware of the functional needs of the objects they plan. Consequently, they design forms that express and aid function. However, designers also know that these objects need to be aesthetically pleasing. All of this points out that the creator of functional objects must be able to apply the principles of fundamental order within the strictures of utilitarian need. Frank Lloyd Wright, the celebrated American architect, combined architecture, engineering, and art in shaping his materials and their environment. The unity of his ideas is expressed in the chair he designed for the Ray Evans House (fig. 9.7). The sophisticated design and formal balance that Wright incorporated into this ordinary object can be seen in his highly

selective repetitions, proportional relationships, and detail refinement.

The balance that exists between design, function, and expressive content within an object varies with each creator. For instance, when designing his rocking lounge chair, Michael Coffey placed strong emphasis on expressive form without totally sacrificing the function of reclining comfort (fig. 9.8). At first glance, we are drawn in by the chair's dominant outer contour and by its open shape. This unique piece of furniture resembles many freely expressed contemporary sculptures. Expressive form follows function in a new and creative way.

Tremendous developments have taken place in the general areas of threedimensional design where works usually serve some functional purpose.

Architecture

Recent technological innovations and new building materials have given architects greater artistic flexibility. Thanks to developments in the steel and concrete industries, buildings can now be large in scale without projecting massive, weighty forms. With the advent of electric lighting, vast interior spaces can be illuminated. Because of air conditioning, buildings can be completely enclosed or sheathed in glass. Cantilevered forms can be extended into space. Sophisticated free-formed shapes can be created with the use of pre-cast concrete. All of these structural improvements have allowed architects to think and plan more freely. Contemporary public buildings that demonstrate these developments include the Renaissance Center in Detroit (fig. 9.9), the Lincoln Center for the Performing Arts in New York, the Kennedy Center in Washington, D.C., the Jefferson Westward Expansion Memorial in St. Louis, and the Los Angeles City Hall and Civic Center. In

▲ 9 · 8

Michael Coffey, Aphrodite (a rocking lounge chair), 1978. Laminated mozambique, 4 ft 6 in × 7 ft 6 in × 28 in (137 × 229 × 71.1 cm).

A useful household article can be transformed by the style of contemporary sculpture.

Courtesy of the artist. (Photograph by Rich Baldinger, Schenectady, NY.)

▲ 9・9

John Portman, Renaissance Center, Detroit, Michigan, 1977.

Architect John Portman designed these high-level towers with steel, reinforced concrete, marble, and glass construction.

Photograph courtesy of the authors.

A 9·10

Louis I. Kahn, National Assembly Building at Sher-e-Bangla Nagar in Dhaka, Bangladesh, 1962–83. Poured concrete, wood, brick.

Louis Kahn, an American architect, shows his unique use of geometry in a simple, massive sculpture-like structure.

© Khaled Nowan/Architectural Association Slide Library, London.

4 9.11

Harold Hasselschwert, Cast Sterling Silver Pendent with Fumed Enamel (part of a series), 1977. Cast sterling silver with fumed enamel, $4\frac{1}{2}$ in (11.4 cm) height of pendant.

This article of metalwork, meant to be worn, is sculptural in concept.

Courtesy of Jean Hasselschwert, Bowling Green, Ohio.

many ways architects today are "building sculptors," and their designs require a thorough grounding in artistic principles as well as an understanding of engineering concepts (fig. 9.10).

Metalwork

Most of the changes in metalworking (jewelry, small bowls, and so on) have been in concept rather than technique. Although traditional techniques are still in use, modern equipment has made procedures simpler and more convenient. To a large degree, fashion determines the character of metalwork, but it is safe to say that contemporary work is larger and more oriented toward sculpture than most work of the past. Constant crossfertilization occurs among the art areas, and metalwork is not immune to these influences. The metalworker benefits from studying the principles of both two- and three-dimensional art (fig. 9.11).

Glass design

Glassworking is similar to metalworking now that modern equipment has simplified traditional techniques. Designing glass objects, however, is very much an artform of recent times. Many free-form and figurative pieces have the look of contemporary sculpture. Colors augment the designs in a decorative, as well as an expressive, sense. Thus, the principles of art structure are integrated with the craft of the medium (fig. 9.12).

Ceramics

In recent years the basic shape of the ceramic object has become more sculptural as ceramic work has become, in many cases, less functional. The ceramist must be equally aware of three-dimensional considerations and of the fundamentals of graphic art, because designs are often incised, drawn, or painted on the surface of the piece (fig. 9.13).

 \triangle 9 · 12 Dale Chihuly, GTE Installation, 1991, Dallas, TX. Blown glass, 9 × 20 × 2 ft (2.74 × 6.1 × .61 m).

These magnificent glass pieces are most unusual and creative in their scale, coloring, shape definition, and total environmental concept.

© Dale Chihuly. Photo: Lee Clockman/Courtesy of Hartenstein Communications, Inc.

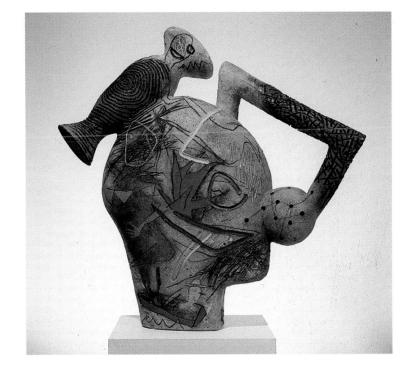

$9 \cdot 13$ Stan Welsh, A Question of Balance, 1987. Terracotta and clay glaze, $45 \times 47 \times 16$ in (114.3 \times 119.4 \times 40.6 cm).

The artist used low-temperature color glazes in conjunction with sandblasting to enhance the forms and strengthen the composition.

Courtesy of the artist. (Photo: Richard Sargent)

Fiberwork

Fiberwork has undergone a considerable revolution recently. Three-dimensional forms are becoming increasingly more common, particularly as the traditional making by hand of rugs and tapestries has diminished. Woven objects now include a vast array of materials incorporated into designs of considerable scale and bulk. Traditional as well as contemporary concepts of fiberwork require an understanding of both two-and three-dimensional principles (fig. 9.14).

Product design

A relative newcomer on the art scene, product design is usually concerned with commercial applications. The designer produces works that are based on function but geared to consumer appeal. To be contemporary in appearance and thus attractive to consumers, products must exploit all the design principles of the age. The designs of common objects in our daily environment are the products of the designer's training in these various principles.

9 · 14 Kathleen Hagan, Crocheted Series #5, 1979. Wool, linen, and cotton. Largest shape, 8 × 10 in (20.3 × 25.4 cm).

Contemporary textile design frequently goes beyond its largely two-dimensional traditions. Courtesy of the artist.

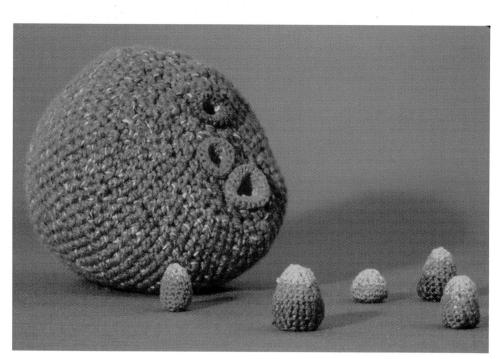

THE COMPONENTS OF THREEDIMENSIONAL ART

Subject, form, and content—the components of graphic art—function in much the same manner in the plastic arts. The emphasis placed on each of the components, however, may vary. For example, sculptors use the components for expressive purposes. Architects, ceramists, and metalsmiths, while expressive, may also interpret form for the sake of utility and ornamentation.

Formal organization is more complex in three-dimensional art than in the graphic arts. Materials developed in actual space through physical manipulation exist in a tactile, as well as in a visual, sense. The resulting complexities expand the content or meaning of the form.

MATERIALS AND TECHNIQUES

Materials and techniques also play larger roles in three-dimensional art than in graphic art. In the last one hundred years the range of three-dimensional materials has expanded from basic stone, wood, and bronze to steel, plastic, fabric, glass, laser beams (holography), fluorescent and incandescent lighting, and so on. Such materials have revealed new areas for free explorations within the components of subject, form, and content. But they have also increased our responsibilities for fully understanding three-dimensional materials and their accompanying technologies. The nature of the materials puts limitations on the structures that can be created and the techniques that can be used. For example, clay modelers adapt the characteristics of clay to their concept. They manipulate the material with their hands, a block, or a knife to produce a given expression or idea.

Modelers don't try to cut the clay with a saw. They understand the characteristics of their material and adapt the right tools and techniques to control it. They also know that materials, tools, and techniques are not ends in themselves but necessary means for developing a three-dimensional work (fig. 9.15).

The four primary technical methods for creating three-dimensional forms are: **subtraction, manipulation, addition,** and **substitution.** Although each of the technical methods is developed and discussed separately in the following sections, many three-dimensional works are produced using combinations of the four methods.

Subtraction

Artists cut away materials capable of being carved (glyptic materials), such as stone, wood, cement, plaster, clay, and some plastics. They may use chisels, hammers, torches, saws, grinders, and polishers to reduce their materials (fig. 9.16). It has often been said that when carvers take away material, they "free" the image frozen in the material and a sculpture emerges. The freeing of form by the subtraction method, although not simple, does produce unique qualities that are characteristic of the artist's material.

Manipulation

Widely known as modeling, manipulation relates to the way materials are handled. Clay, wax, and plaster are common media that are pliable or that can be made pliable during their working periods. Manipulation is a direct method for creating form. Artists can use their hands to model a material like clay into a form that, when completed, will be a finished product. For additional control, special tools, such as wedging boards, wires, pounding blocks, spatulas, and modeling tools

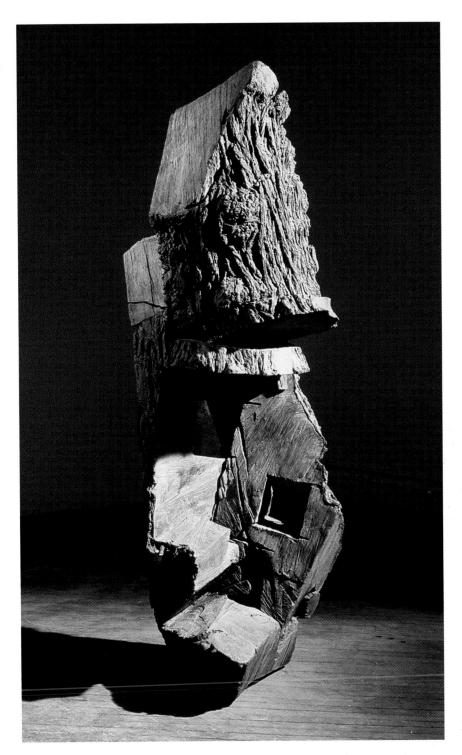

 \blacktriangle 9 · 15 Mel Kendrick, Bronze with Two Squares, 1989–90. Bronze (edition of three), 73 × 28 × 28 in (185.4 × 71.1 × 71.1 cm).

This piece appears to be made of wood, but it is actually bronze that has been colored chemically to resemble weathered wood. The sculptor has to know his materials well to create this kind of trompe l'oeil effect.

Courtesy of John Weber Gallery, New York.

4 9 - 16

Subtracting stone. In the subtractive process, the raw material is removed until the artist's conception of the form is revealed. Stone can be shaped manually or with an air hammer, as above. Photograph courtesy of Ronald Coleman.

9 • 17

In this example of the manipulation technique, clay is removed with a loop tool. Clay may be applied to the surface with fingers, hands, or other tools.

Photograph courtesy of Ronald Coleman.

Chapter 9

(wood and metal), are used to work manipulable materials (fig. 9.17).

Manipulable materials respond directly to human touch, leaving the artist's imprint, or are mechanically shaped to imitate other materials. Although many artists favor the honest autographic qualities of pliable materials, others—especially those in business and manufacturing—opt for the economics of quick results and fast change. Techniques and materials are important because both contribute their own special quality to the final form.

Because most common manipulable materials are not durable, they usually undergo further technical change. For instance, clay may be fired in a kiln (fig. 9.18) or cast in a more permanent material like bronze.

Addition

Methods of addition may involve greater technology and, in terms of (nonfunctional) sculpture, have brought about the most recent innovations. When using additive methods, artists add materials that may be pliable and/or fluid, such as plaster or cement (see figs. 9.22B and C). They assemble materials like metal, wood, and plastic with tools (a welding torch, soldering gun, or stapler, and so on) and fasteners (bolts, screws, nails, rivets, glue, rope, or even thread) (fig. 9.19; see fig. 9.3).

Because three-dimensional materials and techniques are held in high esteem today, the additive methods, with great range, freedom, and diversity, offer many challenging three-dimensional form solutions.

Substitution

Substitution, or **casting,** is almost always a technique for reproducing an original three-dimensional model. Sometimes an artist alters the substitution process to change the nature of the cast. Basically, in this technique, a model in one material is exchanged for a duplicate form in another material, called the cast, and this is done by means of a mold. The

9 • 18

David Cayton, One Dead Tern Deserves Another, 1990. Ceramics, primitive firing, 18 in (45.7 cm) high.

This is an example of clay that has been fired in a primitive kiln: the heavy reduction firing has caused the clay surfaces to turn black.

Courtesy of the artist.

9 • 27

Richard Lippold, Variation within a Sphere, No. 10, the Sun, 1953–56. 22-carat gold filled wire, 11 \times 22 \times 5½ ft (3.35 \times 6.70 \times 1.68 m).

Development of welding and soldering techniques for use in sculpture made the shaping and joining of thin linear metals possible, as in this work by Lippold.

Metropolitan Museum of Art, New York. Fletcher Fund, 1956. Photo © Metropolitan Museum of Art, all rights reserved.

values strengthen the shadows, while dark values weaken them. The lighter values work best on pieces that depend on secondary contours; darker values are most successful in emphasizing the major contours. Thin linear structures depend more on background contrast and appear as strong dark or light silhouette (fig. 9.27).

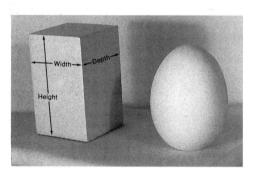

Space

Space may be characterized as a boundless or unlimited extension of

occupied areas. When artists use space, they tend to limit its vastness. They may mark off extensions in one, two, or three dimensions, or measurable distances between preestablished elements. Threedimensional artists use objects to displace space and to control spatial intervals and locations. Rectangular and ovoid shapes control space effectively, because their weight is felt and established by the flat or rounded dimensions of the planes (fig. 9.28). The two shapes seen together create a spatial interval. Although the two solids illustrated are threedimensional, their spatial indications are minimal. Greater interest and, in turn, greater spatial qualities could be added to the two shapes by manipulating their surfaces. If material were cut away, the space would move inward and if material were added, the space would move outward.

In figure 9.29A, the four bricks have been arranged in a very restricted

9 • 28

The rectangular and ovoidal solids are examples of two minimal objects that can be formed from displaced, boundless space. The flat and rounded planes in these positions define their special characteristics and spatial intervals.

9 • 29A, B, C, D, and E

The figures show four bricks that have been arranged and rearranged to illustrate an increasing level of visual complexity within the third dimension—this is achieved by interactions between the positive objects and negative sculptural spaces.

- A Stacked bricks
- **B** Separated bricks
- C Crooked bricks
- D Slanted bricks
- E Crossed bricks

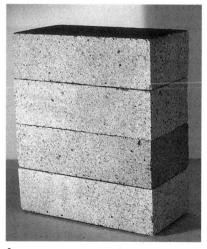

Α

В

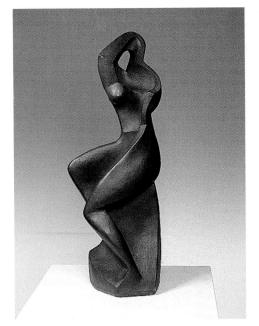

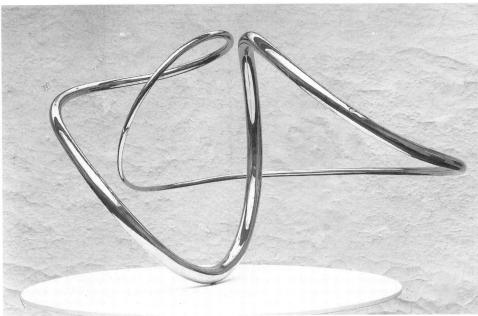

A 9 · 24

Alexander Archipenko, Woman Doing Her Hair, c. 1958. Bronze casting from plaster based on original terracotta of 1916, 215% in (55 cm) high.

This is a significant example of sculptural form where the shape creates negative space, or a void. Archipenko was one of the pioneers of this concept.

Courtesy of the Kunst Museum, Dusseldorf, Germany. (Photo: Walter Klein.)

often dominate the width, thickness, and weight of the materials that define them (fig. 9.25).

Value

As the artist physically manipulates three-dimensional shapes, contrasting values appear through the lights and shadows produced by the forms. Value is the quantity of light actually reflected by an object's surfaces. Surfaces that are high and facing a source of illumination are light, while surfaces that are low, penetrated to any degree, or facing away from the light source appear dark. Any angular change of two juxtaposed surfaces, however slight, results in changed value contrasts. The sharper the

A 9 · 25

José de Rivera, Brussels Construction, 1958. Stainless steel, 3 ft $10\frac{1}{2}$ in \times 6 ft $6\frac{3}{4}$ in (1.18 \times 2 m).

The concept of attracting observers to a continuous series of rewarding visual experiences as they move about a static three-dimensional work of art led to the principle of kinetic or mobile art, as with this sculpture set on a slowly turning motorized plinth.

Art Institute of Chicago. Gift of Mr. and Mrs. R. Howard Goldsmith, 1961.46. Photo © 1998, Art Institute of Chicago. All rights reserved.

angular change, the greater the contrast (fig. 9.26).

When any part of a three-dimensional work blocks the passage of light, shadows result. The shadows change as the position of the viewer, the work, or its source of illumination changes. If a work has a substantial high and low shape variation and/or penetration, the shadow patterns are more likely to define the work, regardless of the position of the light source. Sculptors who create mobiles typify artists interested in continuously changing light and shadow. The intensity of light markedly changes the shadow effect as the object moves.

Value changes can also be affected by painting a three-dimensional work. Light

₩ 9 • 26

Student work, *Untitled*, c. 1970. Plaster, approx. 18 in (45.7 cm) high.

A piece of sculpture "paints" itself with values. The greater the projections and the sharper the edges, the greater and more abrupt the contrasts.

Photograph courtesy of Ronald Coleman.

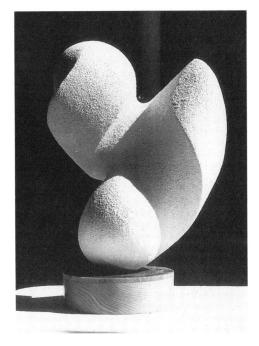

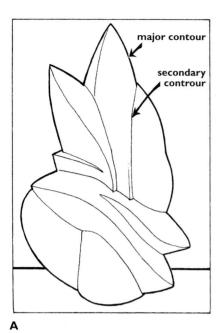

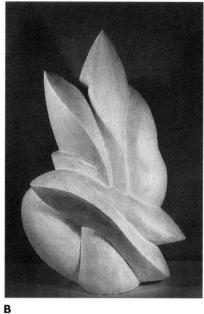

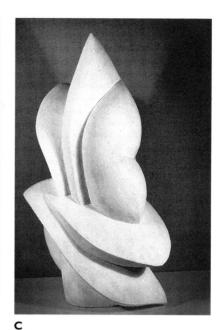

A 9 ⋅ 22A, B, & C

Major and secondary contours. In figure A, the major contour surrounds the silhouette, or the total visible area, of the work. Secondary contours enclose internal masses. In figures B and C, each change in position reveals new aspects of a sculpture in the round.

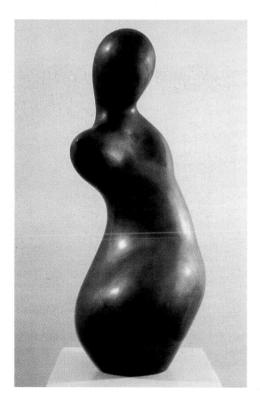

 \P 9 · 23 Jean Arp, Torsifruit, 1960. Bronze (edition of ten), $29 \times 12 \times 11 \frac{1}{2}$ in $(73.7 \times 30.5 \times 29.2 \text{ cm})$.

The major contour of *Torsifruit* is its outermost edge. Secondary contours are nonexistent or, at best, minimal.

© 1997 Artists Rights Society (ARS), New York/VG Bild–Kunst, Bonn.

edges guide the eye through, around, and over the three-dimensional surface.

In three-dimensional art the visible shape depends on the viewer's position. A slight change of position results in a change in shape. A major contour is the outer limit of the total three-dimensional work as seen from one position (figs. 9.22 A-C). Secondary contours are perceived edges of shapes or planes that move across and/or between the major contours. Some three-dimensional works are constructed so that the secondary contours are negligible (fig. 9.23).

A shape might be a negative space a three-dimensional open area that seems to penetrate through or be contained by solid material. Open shapes can be areas that surround or extend between solids. Such open shapes are often called voids. Alexander Archipenko and Henry Moore, prominent twentieth-century sculptural innovators, pioneered the use of void shapes (fig. 9.24, and see fig. 10.71). Voids provided new spatial extensions for these artists; they revealed interior surfaces, opened direct routes to back sides of the sculpture, and reduced excessive weight. Void shapes should be considered integral parts of the total form. In linear sculpture, enclosed void shapes become so important that they

9.19

Welding. In the additive process, pieces of material are attached to each other and the form is gradually built up. Welded pieces such as the one illustrated are often, though not always, more open than other sculptural techniques.

Photograph courtesy of Ronald Coleman.

9 . 20

Substitution technique. In the substitution process, molten metal is poured into a sand mold that was made from a model.

Photograph courtesy of Ronald Coleman.

purposes of substitution are first, to duplicate the model and second, to change the material of the model, generally to a permanent one. For example, clay or wax can be exchanged for bronze (fig. 9.20), fiberglass, or cement. A variety of processes (sand casting, plaster casting, lost-wax casting, and so on) and molds (flexible molds, waste molds, piece molds, and so on) are used in substitution. Substitution is the least creative or inventive of the technical methods because it is imitative; the creativity lies in the original, not in the casting process.

Besides acquiring a knowledge of three-dimensional materials and their respective techniques, artists must also be aware of the elements of form.

THE ELEMENTS OF THREE-DIMENSIONAL FORM

Three-dimensional form is composed of the visual elements: shape, value, space, texture, line, color, and time (the fourth dimension). The order of listing is different from that for two-dimensional art and is based on significance and usage.

Shape

The artist working in three dimensions instinctively begins with shape. Shape, a familiar element in the graphic arts, takes on expanded meaning in the plastic arts. It implies the totality of the mass or volume lying between its contours, including any projections and depressions. It may also include interior planes. We can speak of the overall space-displacing shape of a piece of sculpture or architecture, of the flat or curved shape that moves in space, or of a negative shape that is partially or totally enclosed. These shapes are generally measurable areas limited by and/or contrasted with other shapes, values, textures, and colors. The threedimensional artist should clearly define the actual edges of shape borders (fig. 9.21). Ill-defined edges often lead to viewers' confusion or monotony. Shape

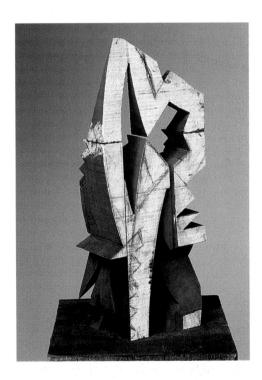

A 9·21

Mel Kendrick, White Wall, 1984. Basswood, Japan paint, $16 \times 5 \times 6^{1/2}$ in (40.6 \times 12.7 \times 16.5 cm).

The shape of this three-dimensional piece has edges that have been clearly defined.

Courtesy of John Weber Gallery, New York.

manner to form a large, minimal rectangular solid. The individual bricks are distinguished only by the line of crack-like edges visible in the front and side planes. These linear edges are reminiscent of graphic linear renderings.

The four bricks illustrated in figure 9.29B are separated by indentations similar to the mortar joints used by masons. These gaps, although relatively shallow, nevertheless produce distinctively clearer and darker edges than those shown in figure 9.29A. Although the darker edges indicate greater three-dimensional variation than the first stack of bricks shown, they still have decided spatial limitations. Many shallow-relief sculptures function in a similar way (fig. 9.30).

The bricks in figure 9.29C utilize even more space. They are positioned so that the planes moving in depth are contrasted with the front and side planes, moving toward and away from the viewer. The light that strikes the grouping produces stronger shadows and more interesting value patterns. This arrangement can be compared to the qualities of high-relief sculpture. The play of deep shadows against the lights on projecting parts of a high-relief sculpture can increase the work's expressive or emotional qualities (fig. 9.31).

9 · 30
Giacomo Manzu, Death by Violence, 1950. Bronze cast from clay model, 365/8 × 251/4 in (93.5 ×

64 cm).

This is a study for one of a series of panels for the doors of St. Peter's. The confining spatial limitations of relief sculpture are evident. To create a greater feeling of mass, Manzu used sharply incised modeling that is similar to the engraved lines of the printmaker's plate. The crisp incising creates sharp value contrasts that accentuate movement as well as depth.

© David Lees/Corbis Media

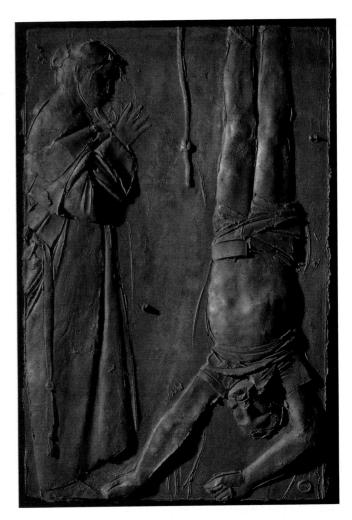

E

C

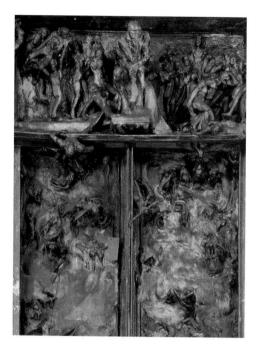

▲ 9 · 3 l Auguste Rodin, The Gates of Hell (detail), 1880–1917. Bronze, 20 ft 8 in × 13 ft 1 in (6.3 × 3.99 m).

In this high relief, the forms nearly break loose from the underlying surface.

Rodin Museum, Philadelphia, PA. Gift of Jules E. Mastbaum. Photo: Corbis Media.

Although still in a compact and closed arrangement, the rotation of the bricks in figure 9.29D makes possible new directions and spatial relationships. The work is becoming more spatially interesting as contrasts of movement, light, and shadow increase. In a way, this inward and outward play of bricks is similar to what the sculptor creates in a free-standing form. Such works are no longer concerned with simple front, side, and back views, but with multiple axes and multiple views. Although all the brick illustrations are actually freestanding, or in-the-round, the first two examples show surface characteristics closer in spirit to the condition of relief sculpture, as was previously indicated. Some authorities use the terms "freestanding" and "sculpture in-the-round" interchangeably when referring to any three-dimensional work of art not

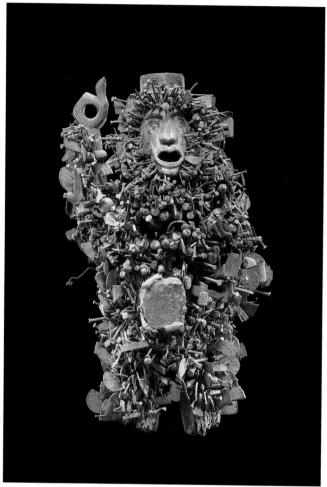

9 . 32

Fetish, Yombe tribe from Zaire, Africa. Wood and mixed media, $23\frac{1}{8}$ in (59.5 cm).

This African artist has created surface character (texture) in this sculpture that reflects the psychological and physical qualities of this Zaire subject.

Royal Museum of Central Africa, Tervuren, Belgium. (Photo: R. Asselberghs)

attached to a wall surface (see fig. 9.26).

The variety of brick positions in figure 9.29E, particularly the diagonally tipped brick, creates far greater exploitation of space than other groupings. The void, or open space, emphasizes the three-dimensional quality of the arrangement by producing a direct link between the space on each side.

Texture

Textures enrich a surface, complement the medium, and enhance expression and content. Textured surfaces range from the hard glossiness of glass or polished marble (fig. 9.33) to the contrasting rough media (fig. 9.32). Certain surfaces are inherent to certain media, and, traditionally, these intrinsic textures are respected. The artist usually employs texture to encapsulate the distinctive qualities of the subject. The sleek suppleness of a seal, for example, seems to call for a polished surface, while the character of a rugged, forceful person calls for a more rough-hewn treatment. However, artists sometimes surprise us

with a different kind of treatment. The actual, simulated, and invented textures of graphic artists are also available to plastic artists and are developed from the textures inherent in the materials that plastic artists use.

Line

Line is a phenomenon that does not actually exist in nature or in the third dimension. It is primarily a graphic device used to indicate the meeting of planes or the outer edges of shapes. Its definition might be broadened, however, to include the main direction or thrust (axis) of a three-dimensional shape whose length is greater than its width. Line, then, can be used to refer to the thin shapes of contemporary linear sculpture comprising wires and rods. Development of welding and soldering techniques made possible the shaping and joining of thin linear metals in sculpture. Such artists as José de Rivera and Richard Lippold have expanded the techniques of linear sculpture (see figs. 9.25 and 9.27).

Incising line in clay or in any other soft medium is similar to the graphic technique of drawing. In three-dimensional art, incised lines are used to accent surfaces for interest and movement. The Italian Giacomo Manzu employed such lines to add sparkle to relief sculpture (see fig. 9.30).

9 • 33

Isamu Noguchi, The Opening, 1970. French rose and Italian white marble, $30^{3}/4 \times 32 \times 8$ in (78.1 \times 81.3 \times 20.3 cm).

This sculpture is enriched by the artist's choice of materials in contrasting colors and variegated graining.

Courtesy of the Ishamu Noguchi Foundation, Inc.

Color

Color is also an inherent feature of sculptural materials. Sometimes it is pleasant, as in the variegated veining of wood or stone (fig. 9.33), but it can also be bland as in the flat chalkiness of plaster. Paint is often added when the material needs enrichment or when the surface requires color to bring out the form more effectively. Painted surfaces as with any color application can add expression and boost attractive qualities. The elements of value and color are so interwoven in sculpture that artists often use the two terms interchangeably. Thus, an artist may refer to value contrasts in terms of color, actually thinking of both

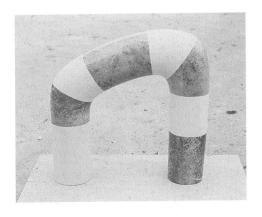

simultaneously. Many applications of color are an attempt to capture the richness and form-flattering qualities of the *patina* found on bronzes oxidized by exposure to the atmosphere. This approach stresses color that is subordinate to the structure of the piece. In certain historical periods (for example, early Greek art) application of bright color was commonplace. Some revival of this technique is evident in contemporary works. In every case the basic criterion for the use of color is compatibility with the form of the work (fig. 9.34).

Marisol, Women and Dog, 1964. Wood, plaster, synthetic polymer, taxidermed dog head and miscellaneous items, $72^{1}/4 \times 73 \times 30^{15}/16$ in (183.5 × 185.4 × 78.6 cm).

This example of Pop art reveals the willingness of some contemporary artists to use bright color to heighten the three-dimensional characteristics of form at the same time that it enriches surfaces. The form has its roots in previous twentieth-century styles (Cubism, Constructivism), while the use of combine-assemblage tends to fuse the media of sculpture and painting into one.

Collection of the Whitney Museum of American Art. Purchase, with funds from the Friends of the Whitney Museum of American Art, 64.17 a–g. © 1998 Marisol/Licensed by VAGA, New York.

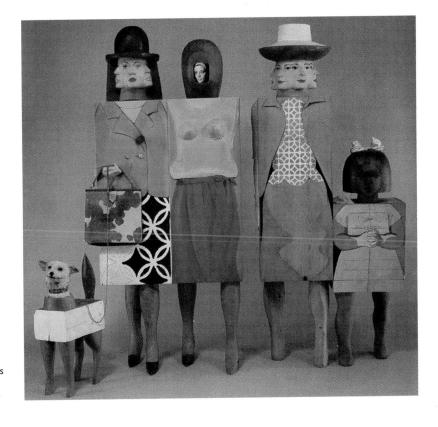

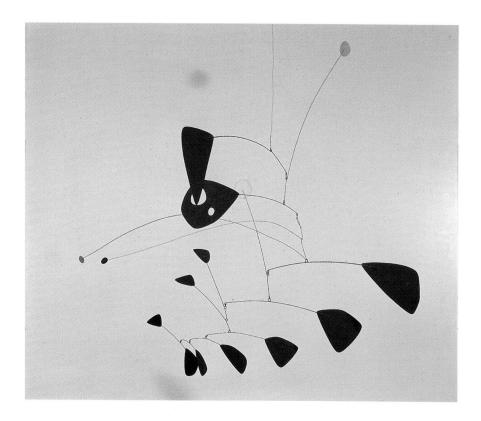

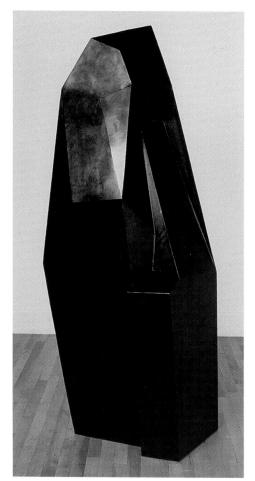

A 9 · 35

Alexander Calder, Antennae with Red and Blue Dots, 1960. Metal kinetic scuplture, 3 ft $7\frac{3}{4}$ in \times 4 ft $2\frac{1}{2}$ in \times 4 ft $2\frac{1}{2}$ in (1.11 \times 1.28 \times 1.28 m).

This noted artist introduced physically moving sculptures called mobiles. Movement requires time for observation of the movement, thereby introducing a new dimension to art in addition to height, width, and space. The result is a constantly changing, almost infinite series of views of parts of the mobile.

Tate Gallery, London/Art Resource, NY. © 1997 Artists Rights Society (ARS), New York/ADAGP, Paris.

9 • 36

James De Woody, Big Egypt, 1985. Black oxidized steel, $72 \times 30 \times 30$ in (182.9 \times 76.2 \times 76.2 cm).

In this example of a tectonic arrangement, James De Woody has cut planes that project in and out of his surfaces without penetrating voids or opening spaces. This is sometimes referred to as "closed" composition.

Courtesy of the Arthur Roger Gallery, New Orleans, LA.

Time (the fourth dimension)

Time is an element unique to the spatial arts. It is involved in graphic arts only insofar as contemplation and reflection on meaning are concerned. The physical act of viewing a graphic work as a totality requires only a moment. However, in a plastic work, the additional fourth dimension means that the work must turn or that we must move around it to see it completely.

The artist wants the time required to inspect the work to be a continuum of rewarding visual variation. Each sequence or interval of the viewing experience brings out relationships that will lure the observer around the work, all the while extending the time spent on it.

In the case of kinetic sculpture, the artwork itself, not the observer, moves. Such works require time for their movements. Mobiles, for example, present a constantly changing, almost infinite series of views (fig. 9.35; see fig. 10.88).

PRINCIPLES OF THREE-DIMENSIONAL ORDER

Organizing three-dimensional art is the same as organizing two-dimensional art. However, three-dimensional forms, with their unique spatial properties, call for somewhat different applications of the principles.

Three-dimensional artists deal with forms that have multiple views.
Composing is more complex. What might be a satisfactory solution for an arrangement with one view might be only a partial answer in the case of a work seen from many different positions. Adjustments are required in order to totally unify a piece. Compositionally, a three-dimensional work may be **tectonic** (closed, massive, and simple) with few and limited projections, as in figure 9.36, or **atectonic** (open, to a

9.37

Kenneth Snelson, Free Ride Home, 1974. Aluminum and stainless steel, $30 \times 60 \times 60$ ft (9.14 \times 18.28 \times 18.28 m).

Kenneth Snelson has developed sculptures that are "open" or atectonic.

Storm King Art Center, Mountainville, NY. Purchase 1975.64. (Photograph by Jerry L. Thompson.)

9 . 38

Nancy Graves, Unending Revolution of Venus, Plants, and Pendulum, 1992. Bronze, brass, enamel, stainless steel, and aluminum, $97 \times 71\frac{1}{2} \times 56\frac{1}{2}$ in (2.46 \times 1.82 \times 1.44 m).

In this sculpture, we see a variety of form parts. We also see an excellent example of an asymmetrically balanced sculpture.

Created at Saff Tech Art. © Saff Tech Arts/Nancy Graves 1992. (Photograph by Sam Kwong.)

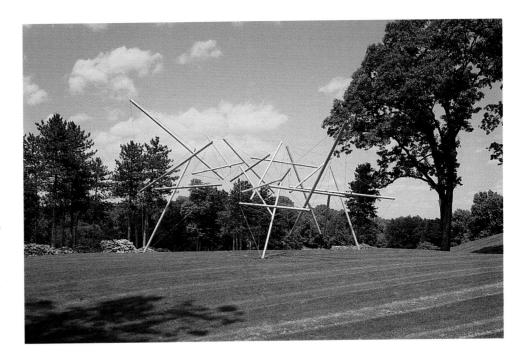

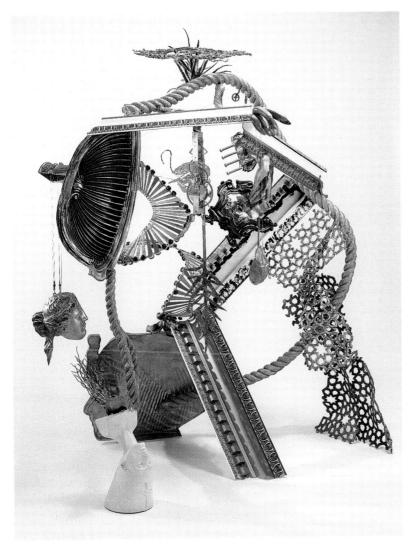

large degree), with frequent extensive penetrations and thin projections, as in figure 9.37. Both tectonic and atectonic arrangements can be found in nearly all three-dimensional art, and each of these arrangements can be used individually to achieve different expressive and spatial effects.

Balance

When considering balance and the extension of spatial effects in threedimensional art, some special conditions should be examined. For example, when balancing a three-dimensional piece of work symmetrically the added dimension of depth could change with its multiple views. While a sphere may appear symmetrical from any of its multiple views, a rectangular box could appear symmetrical only from its front and back views but not from its side or top views if seen in conjunction with other views. The views that are seen in depth could project other types of balance. Three types of balance are possible in actual space: symmetrical (see fig. 9.42), asymmetrical (fig. 9.38), and radial (fig. 9.39). Of the three, symmetrical and radial balance are more formal and

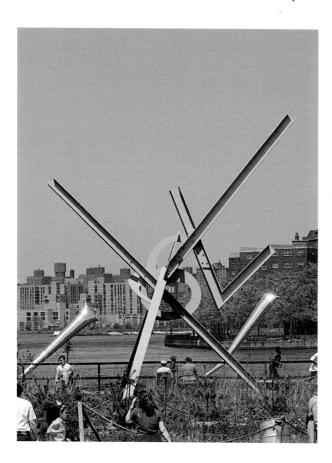

9.39

Mark di Suvero, For Veronica, 1987. Steel, 21 ft 9 in \times 35 ft 2 in \times 39 ft (6.63 \times 10.72 \times 11.89 m).

The center of this sculpture is the fulcrum identified by the contrasting rounded, curled parts. Most of the diagonal beams radiate in outwardly thrusting directions. The exception purposefully adds variety to an otherwise formal radial balance. The Rene and Veronica di Rosa Foundation, Napa, CA. Photograph: Oil & Steel Gallery, Long Island City, NY.

regular. Radial balance is spherical, with the fulcrum in the center. The parts that radiate from this point are usually similar in their formations. However, more artists make use of asymmetrical balance because it provides the greatest individual latitude and variety.

Proportion

When viewing a three-dimensional work, the effect of proportion (contemplating the relationship of the parts to the whole) is as crucial as it is in a two-dimensional work. Being in the presence of an actual three-dimensional work that can not only be seen, but can also be touched or caressed, stood on, walked on, or passed through, does put special emphasis on the parts and the whole. Proportion is more easily realized as it applies to three-dimensional art if

one actually grasps the nose or chin of a portrait sculpture while looking at it from multiple views. Similarly one could get much the same sensation by passing an arm through a void of an abstract sculpture while gripping a portion of that sculpture. Proportion is involved in determining the basic form: it sets the standard for relationships and permeates the other principles.

Scale is most dramatic when three-dimensional pieces are small enough to be held with the fingertips or when we are in the presence of gigantic architecture, landscapes, sculptures, and so forth (see fig. 9.10). The actual physical size of three-dimensional works when compared to the physical measurement of the human figure is here referred to as scale. Small jewelry and/or miniaturized models and maquettes of automobiles, architecture, landscapes, and sculpture are

representative of the smaller scaled pieces. Works designed for public places are usually of the largest scale. Religious temples, mosques, cathedrals, state houses, malls, parks, three-dimensional commercial displays, sculpture situs are examples of works on the largest scale possible. The spaces these pieces occupy are awe aspiring and, at the same time, mind boggling when one is in their presence (see figs. 9.10 and 9.37).

The one-on-one relationship of actually experiencing a three-dimensional work brings out a special feeling for tension, balance, and scale. Proportion is involved in determining the basic form; it sets the standard and permeates the other principles. Repetition and rhythm have relationships that include proportional similarities. Predictable rhythm incorporates proportional transitions that aid in giving flow to a work (fig. 9.40).

Economy

Included within the group known as Primary Structurists or Minimalists are three-dimensional artists who emphasize the principle of economy in their works, because they, like their fellow painters, want to create stark, simple, geometric shapes. These Minimalists strip their shapes of any emotional, psychological, or symbolic associations and eliminate physical irrelevancies. For further emphasis, they also tend to make a feature of large size. Tony Smith has reduced his shapes to simple geometric forms (fig. 9.41), while Donald Judd

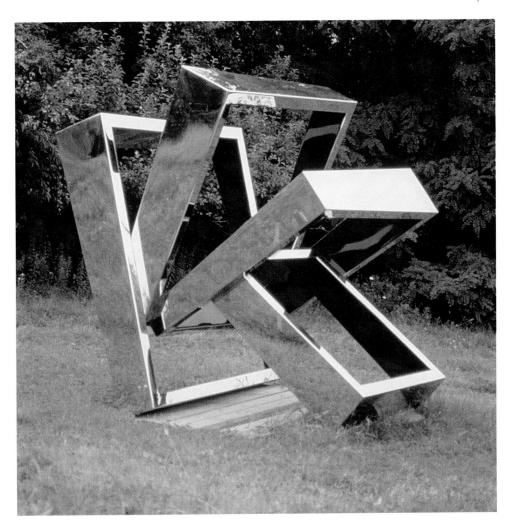

9 • 40

Beverly Pepper, Ventaglio, 1967. Stainless steel with blue enamel, $94\frac{1}{2} \times 78\frac{3}{4}$ in (240 × 200 cm).

The rhythmical repetition of the frames in Beverly Pepper's sculpture creates an exciting, flowing movement.

Courtesy of the André Emmerich Gallery, a division of Sotheby's, New York, on behalf of Beverly Pepper.

9 - 41

Tony Smith, Ten Elements, 1975-79 (fabricated 1980). Painted aluminum, ten pieces; tallest element 4 ft 2 in (1.27 m), shortest element 3 ft 6 in (1.07 m).

Tony Smith has created many artworks that represent nothing more than large-scale, starkly simple geometric shapes. In this backyard group, he has repeated ten different shapes that interact spatially. The economic means of Smith, a Minimalist, unify a complex arrangement.

Patsy R. and Raymond D. Nasher Collection, Dallas, TX. (Photo: David Heald)

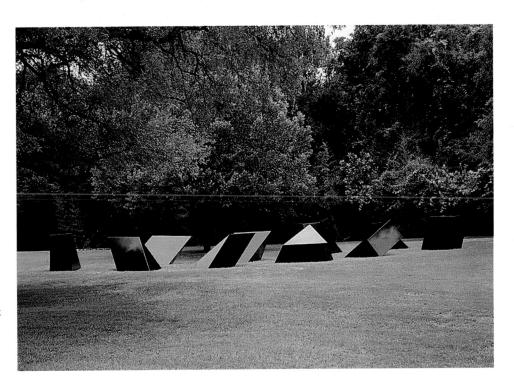

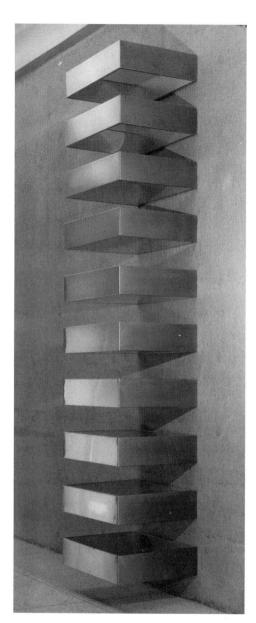

9 · 42

Donald Judd, Untitled, 1968. Brass, ten boxes, $6 \times 27 \times 24$ in (15.2 \times 68.6 \times 61 cm).

Judd is primarily interested in perceptually explicit shapes, reflective surfaces, and vertical interplay.

Photo: State of New York/Corbis Media. © 1998 Estate of Donald Judd/Licensed by VAGA, New York.

aligns his primary shapes in vertical and horizontal rows, thereby interrelating economy with repetition and rhythm (fig. 9.42).

Movement

Two types of movement are used by three-dimensional artists. Implied movement, the most common type (fig. 9.43; see fig. 9.40), is illusionary, but actual movement is special and involves the total work. Actual movements that take place in kinetic art are set into motion by air, water, or mechanical devices. Alexander Calder, the innovator of mobile sculptures, at first used motors to drive his pieces but later used air currents generated by human body

₹ 9 • 43

Ernst Barlach, The Avenger, 1914, later cast. Bronze, $17^{1}/_{4} \times 22^{3}/_{4} \times 8$ in (43.8 \times 57.8 \times 20.3 cm).

This figure is not actually moving, but it does depict a powerful forward thrust. Movement is implied by the long sweeping horizontal and diagonal directions made by the edges of the robe, the projection of the head and shoulders, and the base plane.

Tate Gallery, London/Art Resource, NY.

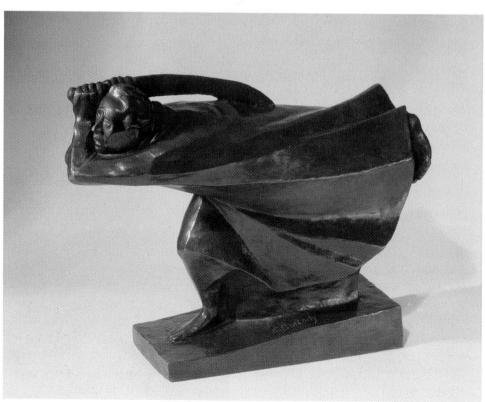

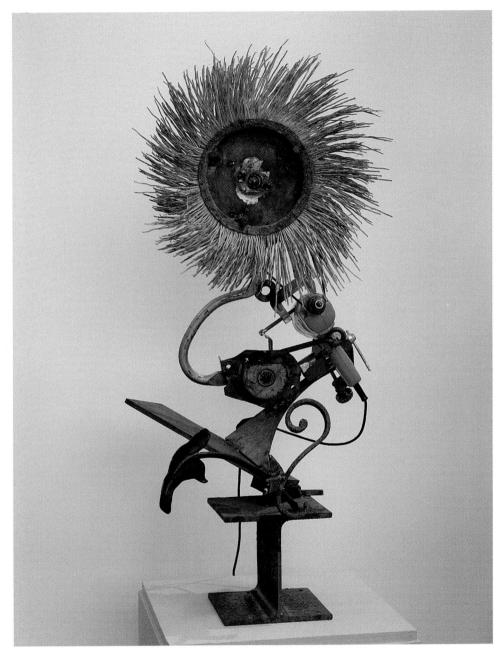

9 . 44

Jean Tinguely, O Sole Mio, 1982. Metal, steel, paint, plastic, drill, clamp; $40\frac{1}{8} \times 22 \times 20$ in (102 × 56 × 51 cm).

For Jean Tinguely, the machine was an instrument for the poet/artist. He produced machine-driven sculptures that involve kinetic anti-machine ironies, mechanical breakdowns, and appropriate rattling noises.

Photograph © 1997 Detroit Institute of Arts, Gift of the City of Montreux, Switzerland, Detroit Renaissance, and the artist. © 1997 Artists Rights Society (ARS), New York/ADAGP, Paris.

motion, wind, air conditioning, or heating (see figs. 9.35 and 10.73). George Rickey, a contemporary sculptor, works with wind and air propulsion (see fig. 10.88). Water has been used as a propellant in other three-dimensional works. Jean Tinguely, José de Rivera, and Pol Bury propel their sculptures with motor drives (fig. 9.44; see figs. 9.25 and 10.86). Computer-activated kinetics are now being marketed. The principle of

movement is inherently related to the art elements of time and space.

When properly combined, the principles of order produce vibrant forms. In the three-dimensional field, new conceptual uses of time, space, and movement have changed definitions and meanings that had endured for centuries. The prevailing thought of the past, that sculpture was a step-child of the graphic arts, needs no longer be true.

Content and Style

INTRODUCTION TO CONTENT AND STYLE

NINETEENTH-CENTURY ART

Neoclassicism
Romanticism
Beginning of Photography
Realism and Naturalism
Technological Developments in Photography
Impressionism
Post-Impressionism
Photographic Trends
Nineteenth-Century Sculpture

EARLY TWENTIETH-CENTURY ART

Expressionism
French Expressionism: The Fauves
German Expressionism
Expressionism in the United States and Mexico
Post-Impressionist and Expressionist Sculpture
Color Photography and Other New Trends
Cubism
Futurism
Abstract Art
Nonobjective Art
Abstract Art in the United States

Abstract Sculpture
Abstract and Realist Photography
Fantastic Art
Dadaism
Individual Fantasists
Surrealist Painting
Surrealist Sculpture
Surrealism and Photography

LATE TWENTIETH-CENTURY ART

Abstract-Expressionist Painting Abstract-Expressionist Sculpture Abstract-Expressionism and Photography **Post-Painterly Abstraction** Op Art **Assemblage Kinetics and Light Minimalism** Pop Art Happenings/Performance Art Site and Earth Art Postmodernism New Realism (Photorealism) **Process and Conceptual Art Neo-Expressionism Neo-Abstraction**

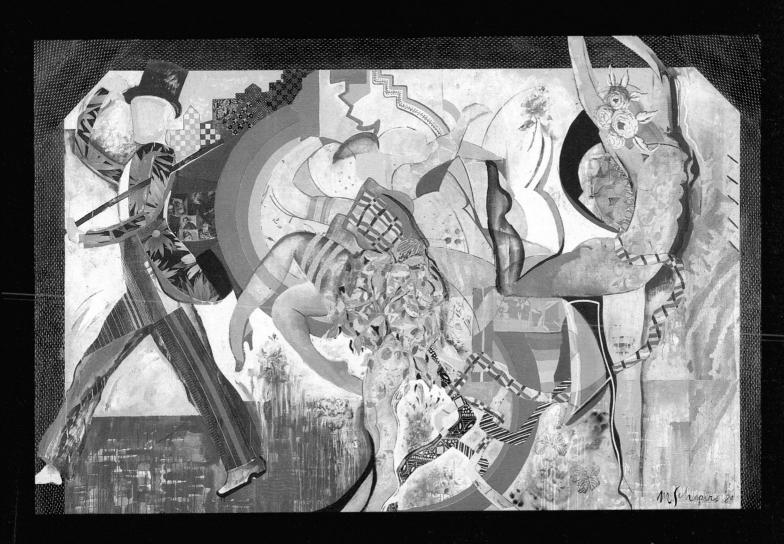

INTRODUCTION TO CONTENT AND STYLE

This chapter is concerned with the third component of a work of art called content; or, in other words, what the artist is trying to tell the audience. This chapter is also concerned with style, which may be defined in terms of the widespread practices of artists living in a particular area and period of history. Alternatively, style can refer to the ideas and techniques of an individual artist or group of artists—an increasingly valid definition for modern times. Because of the extremely subjective nature of content, there will be more discussion about the broad characteristics of style in this chapter than the meanings expressed. Nonetheless, the authors believe that the interpretation may help beginning students, in particular, become more knowledgeable about the visual arts. We also believe that it may serve as a stimulating guide and a source of ideas or groundwork for their own efforts. This discussion however, is limited so only a brief account of the last two centuries of art can be provided. For this reason, only the most important styles, or movements, are given; and there is a limited coverage of the artists who helped to create those styles. We have also made some effort to include the works of innovative photographers, as well as other activities in the arts.

A broad outline of developments in art from prehistory to recent times may be found in the timeline or Chronological Outline of Western Art following this chapter. The glossary should be consulted for unfamiliar terms used in the chapter text.

NINETEENTH-CENTURY ART

Most nineteenth-century styles contributed in some degree to the character of art in the present century. On the one hand, twentieth-century Western art can generally be considered a reaction to all art since the latter half of the eighteenth century; but on the other hand, recent art indeed owes a great deal to past traditions.

Until the middle of the last century, artists were still directly inspired by the appearance of the world around them: One of the significant events that helped to change this was the invention and development of the photographic camera and image. By the end of the century, partly through the impact of the photographic image, and partly from the growth of realism in the graphic arts from the Renaissance forward, the old problem of representing reality was so completely resolved that artists were compelled to search for new expressive directions. Some artists turned to ancient styles or to those of the Middle Ages, for example. The growth of photography also gave artists the opportunity to examine contemporary and past art in hitherto unknown, or little-known, places; this, combined with sociological and other matters, enhanced the search for new directions.

Economic conditions, which continue to be potent influences today, played a part in this search for new principles of expression. From about the time of the High Renaissance (the 1600s in Italy) until the 1850s, artists came to depend more frequently on the patronage of a wealthy middle-class clientele for their economic welfare. Some artists actually adopted the dubious aesthetic tastes of their patrons rather than learning to sell their art in the same milieu as the merchandise produced by the Industrial Revolution or asserting their own inventiveness. Such artists were happy to supply works of art

designed to satisfy and flatter the vanity of their patrons. The more daring and discerning artists dared to fight the tide of conventional popularity and prejudice, drawing their inspiration from their surroundings and society or from subjects that seemed to have more universality.

NEOCLASSICISM

The Neoclassical style, like so many others (until the middle of the twentieth century), originated in France. France had been the recognized epicenter of the arts in Europe since the seventeenth century. Neoclassicism began in the mid 1700s and lasted until about 1820. Perhaps the principal stimulus for the rise of Neoclassicism were the eighteenth century discoveries made at the sites of Herculanaeum and Pompeii, Roman cities buried by the eruption of the volcano Vesuvius in 79 A.D. Excavations made there led to a renewed interest in the classical past, as well as the romantic notion of remote places. By mid-century Neoclassicism became the approved manner of the governmentsupported École des Beaux-Arts (School of Fine Arts) and its Salons (exhibits). The founding of the French Royal Academy of Arts and Letters in 1648, which promoted rules for producing "correct" works of art, led to the strength of French art; but, by the 1900s, a stifling style dominated French art.

The principal artist of Neoclassicism was the painter Jacques-Louis David (1748–1825). David's classical style resulted from his winning the Royal Academy's Prix de Rome, permitting him to make a closer study of Roman Art and literature in Italy (which was significantly influenced by Greek culture). He also rebelled against Rococo, a style popular during his youth because it was artificial. Instead, he painted in a classical style because, according to him, it was "the imitation of nature in her most

beautiful and perfect form." David came to be identified with and was active in the revolution: he was a member of the national convention that voted for the death of the king. He also revamped the Academy and increased the holdings in the Louvre. David's The Oath of the Horatii (fig. 10.1), painted shortly before the revolution, sets a moral and political tone within a clearly readable horizontal composition that is set within a classical style. The shallow, porch-like setting and furniture are archaeologically correct. The severity of its mood, however, is more in keeping with the organization of the Napoleonic regime, for whom the artist also served, rather than the excesses of the French Revolution. The strength, firmness, and controlled compositions of David's works, often stressing a strong horizontality, were probably based in their relief-like effect on Roman relief sculptures and frescos, while the clarity and realistic details seem to anticipate the art of photography. It likewise strongly foreshadows the interest in the twodimensional nature or surface of paintings, which was to be so significant in the next century. With the restoration of the Bourbon monarchy in 1815, David was declared a regicide and forced into exile in Brussels.

Jean-Auguste-Dominique Ingres (1780-1867), a later Neoclassicist, was in essence a doctrinaire follower of Neoclassicism, but introduced a more ornamental, curvilinear style, owing much to the High Renaissance classicism of Raphael. He also had a romantic interest in exotic lands and people, which reflected a desire by society and artists to escape from the growing materialism of the time. This aspect of Ingres and his followers foreshadowed the replacement of Neoclassicism by a newer artistic style called Romanticism. As the long-serving head of the École des Beaux-Arts in Paris, however, Ingres had much to do with the domination of officially approved styles in art until past the middle of the century (fig. 10.2).

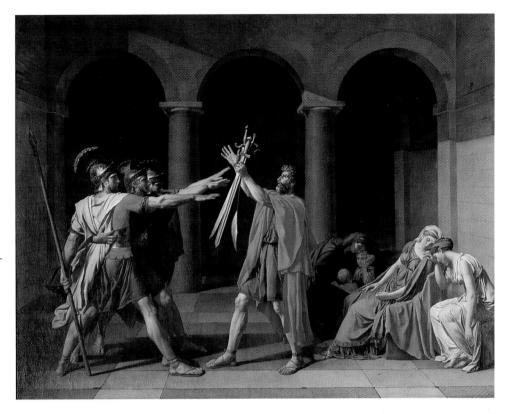

A 10 · I

Jacques-Louis David, The Oath of the Horatii, 1786. Oil on canvas, approx. 14×11 ft (4.27 \times 3.35 m).

A cold, formal ordering of shapes, with emphasis on the sharpness of drawing, characterized the Neoclassical form of expression. Both style and subject matter are strongly influenced by ancient Greek and Roman sculpture.

The Louvre, Paris, France. Photo: Lauros-Giraudon, Paris/SuperStock.

10 . 2

Jean-Auguste-Dominique Ingres, La Grande Odalisque, 1814. Oil, $35\frac{1}{4} \times 63\frac{3}{4}$ in (89.5 × 161.9 cm).

Neoclassicist Ingres, while being a doctrinaire follower of Classical expression, often tended toward romantic subjects with their attendant sensual expression of content. "Odalisque" was a term meaning harem girl, or concubine, in a Turkish seraglio.

The Louvre, Paris, France. Photo: Lauros-Giraudon, Paris/SuperStock.

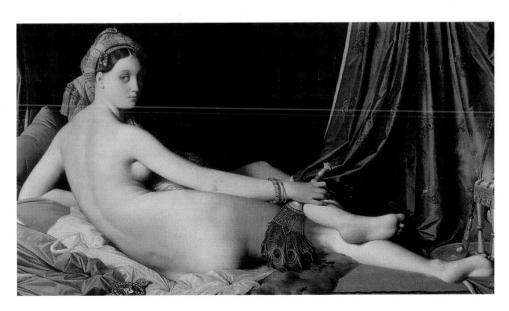

ROMANTICISM

The first group who rejected artistic servitude to the tastes of the middle class, or those aristocratic survivors of the Revolution, were the Romantics. With the restoration of the monarchy from 1815 to 1830, aristocrats dominated officialdom, and Romantic artists unfortunately had to find their clients among them. The Romantics became the first true revolutionaries of modern times, because they ceased to abide by their patrons' wishes and tastes, focusing, instead, on the intrinsic worth of the work of art itself. True revolutionaries realize that they do not always have to seek an audience. If there are values worth expressing, people will eventually be convinced by their views. This has become one of the fundamental principles underlying modern art. On the other hand, artists now had to market their art as a product because they could not suit all their potential clients' tastes, and they had to learn to sell their art to the general public. But the Romantic revolt did free creative artists to express their ideas, often in nontraditional ways. Some of the most important artists of the Romantic movement were: Eugéne Delacroix (1780–1867) of France, Francisco Goya (1746-1828) of Spain, and J. M. W. Turner (1775-1788) of England. Of course, there were several other artists that were on a par or near par with them. Goya is the earliest Romantic, emerging from the Spanish Rococo of the late 1700s, and preceding the movement, which was largely championed by the French. These artists' works share a feature common to most Romantic art: a frequent dependence on dramatic and exotic literary subjects, provided by novels, news sources, and history (figs. 10.3, 10.4, and 10.5).

Technically, the Romantics exploited the juicy and bold textures of oil paint, its ability to produce bright exciting hues and stirring value contrasts. These techniques shifted the emphasis away

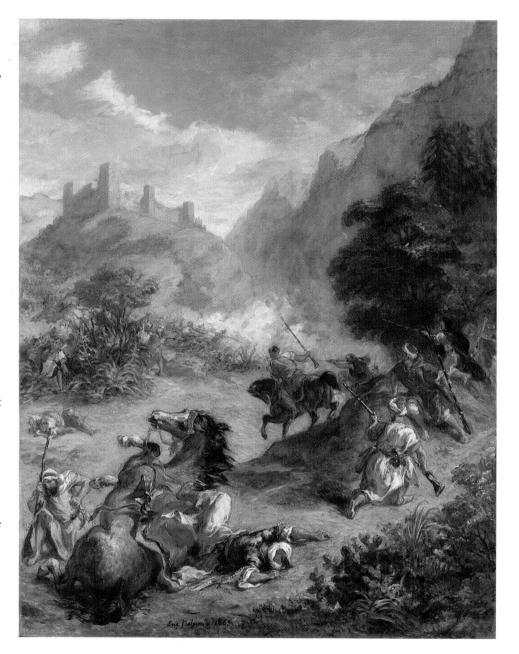

from choice of subjects toward an attention to form and the artist's materials—an emphasis that prevailed throughout much of the twentieth century. This Romantic approach to painting contrasts with that of the Neoclassicists, who used a smooth, glazed surface technique, surviving from the Renaissance. The Romantics tended to be more excited by the bold painting manner and asymmetrical compositions of seventeenth–century artists like Rubens or Rembrandt (see fig. 5.12).

A 10·3

Eugène Delacroix, Arabs Skirmishing in the Mountains, 1863. Oil on linen, $36^{3}/_{8} \times 29^{3}/_{8}$ in (92.4 × 74.6 cm).

Subject matter depicting violent action in exotic foreign settings was often found in paintings of the Romantic movement. Although relaxed in style, they were generally bold in technique, with an emphasis on bright colors.

Chester Dale Fund. © 1998 Board of Trustees, National Gallery of Art, Washington.

10.4

Francisco Goya, The Third of May, 1808. Oil on canvas, 8 ft 8 in \times 11 ft 8 in (2.64 \times 3.55 m).

The romanticism of Goya is displayed in both his choice of subject matter and his dramatic use of light and dark values.

Museo del Prado, Madrid, Spain. Photo: Erich Lessing/Art Resource.

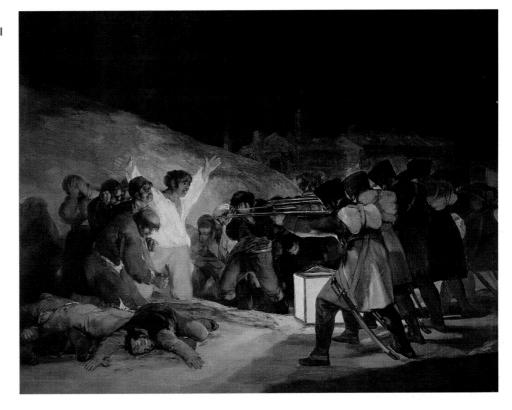

₩ 10 • 5

J. M. W. Turner, Keelmen Heaving in Coals by Moonlight, 1835. Oil on canvas, $36\frac{3}{8} \times 48\frac{3}{8}$ in (92.3 × 122.8 cm).

A historical theme and a seminarrative presentation of subject are qualities found in many works of the Romantic movement. By using color to produce atmospheric effects, Turner anticipated the techniques of later Impressionists. Like them, he placed less emphasis on formal organization.

 $\label{eq:Widener Collection.} \begin{tabular}{l} \begin{tabular}{l$

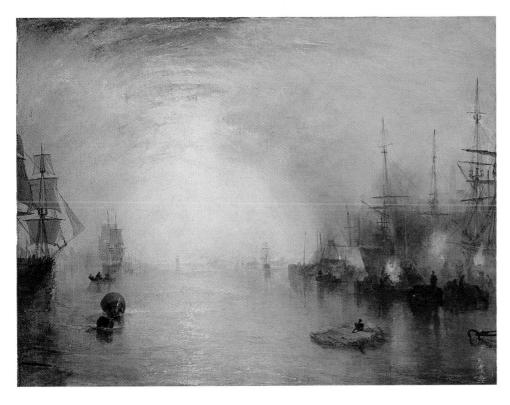

BEGINNING OF PHOTOGRAPHY

The development of the camera and the images produced by it had emerged over a number of centuries. However, it was not until the Industrial Revolution (usually dated in England around 1750-1850) had reached enough impetus that widespread use of the camera could occur. We can trace the origins of the camera back to the camera obscura (Latin for a "dark room") in the Renaissance (although it was already known in Ancient Greece). The camera obscura was a light proof room or box that had a small hole in one side and could produce an inverted image of an outside scene or object on the surface opposite the hole. The example by Dürer (see fig. 8.20), shows another derivation from the camera obscura in which artists drew directly from the model to establish perspective. The next step towards the picture-making camera was probably made by the artist Jacopo

Pontormo (1494-1556) who is believed to have added the first lenses to the camera obscura. The final step, the process of fixing an image on a light sensitized surface culminated between the 1830s and 1850s, made possible the imitation of natural appearances in a permanent image—the photograph. The efforts of, particularly, Louis J. M. Daguerre (1789–1851) and Joseph N. Niépce (1765–1833) (both of France), William H. Fox Talbot (1800-1877) (of England), and others were responsible for the first photographic images (fig 10.6). By mid-century the camera image had evolved far enough that a paintingconscious Romantic photographer like Oscar G. Rejlander (1813-1875) (fig. 10.7) could assemble a colossal, superficially Romantic work out of

many prints and exhibit it in the Salon des Beaux-Arts in 1857. This set in motion one aspect of photographical research called **Pictorialism**, which was opposed by those who believed that there should be no additional manipulation of the image, either in the taking or the developing process. These were designated *Straight*, or sometimes *Realist*, photographers.

REALISM AND NATURALISM

The art of the Romantics had been a reaction to the pseudoclassical and pedantic formulas of Neoclassicism. The Realist movement in its turn was a reaction against the exotic, escapist,

₩ 10 • 6

William Henry Fox Talbot, Nicole & Pullen sawing and cleaving, c. 1846. Salt paper print.

This is an example of a photograph by one of the medium's earliest pioneers, the English aristocrat Fox Talbot. His system, using sensitized paper negatives from which many prints could be made (calotype), was one of the key foundations of modern photography. Because of the long exposure time needed, "action" shots like this would have involved posing motionless for some minutes.

© The Royal Photographic Society of Great Britain, Bath, England.

literary tendencies of Romanticism. The Realists were stimulated by the prestige of science, particularly the technological revolution epitomized by photography, but opposed to the kind of superficial pictorial Romantic-Realism embraced by Rejlander. At the same time, they avoided mere surface appearances, such as the camera usually provided, and gave, instead, a philosophical or expressive quality to their art. Yet they also tried to impart a sense of the real-life immediacy they found missing in the idealistic content of Neoclassical and Romantic art. Because the Realists believed their clients shared their way of viewing the world, it might be thought that their art would have been immediately acceptable. Instead, because they often chose to depict working-class subjects, the Realists were more often seen by their upper-class clientele as subversive and thus were regarded with disfavor for a long time.

The most extreme form of Realist art is **Naturalism**, a term invented by the writer Emile Zola near the end of the nineteenth century. The naturalistic artist, according to Zola, closely accepted the optical veracity of the world, much of which was provided by the camera image. Artists of similar sensibilities, in turn, thought this kind of descriptive form was the way most people regarded reality. Thus they attempted to paint a visual copy of the objective world, without investing their art with the more universal meanings associated with Realism. The major difference between realistic and naturalistic art, therefore, lies in the degree of emphasis placed on natural detail and in the particularizing of specific times and conditions (of weather, for example) in the visual world. Among the more important Realist/Naturalist artists were the Frenchmen Honoré Daumier (1808-1879) and Gustave Courbet (1819-1877). Daumier, with his expressive renderings of poor city working-class people, refugees, and

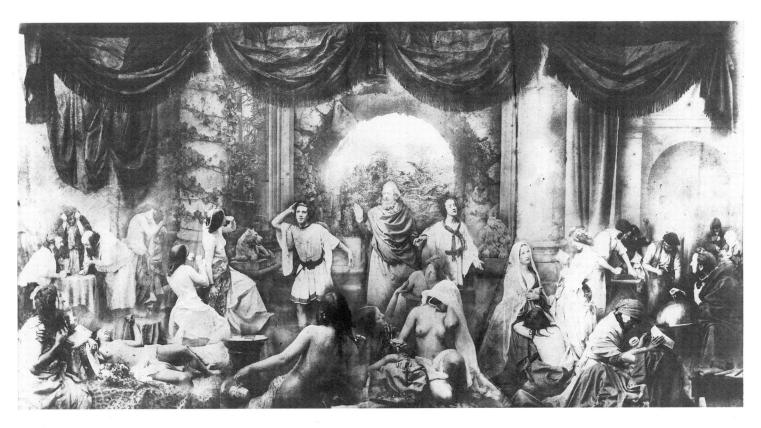

10 - 7

Oscar J. Rejlander, The Two Ways of Life, 1857. Gelatin silver print.

A photographer trained as a painter, Rejlander tried to create a great mural out of hundreds of photographs. His approach to image manipulation is a Romantic one that is called "Pictorialism" in photography.

Courtesy George Eastman House, Rochester, N.Y. © Royal Photographic Society of Great Britain, Bath, England.

others, tends to represent the Realist point of view. He managed to do this in hundreds of oils during his lifetime despite the fact that he labored for two Parisian journals producing thousands of caricatures to earn his living (fig 10.8).

Courbet has been credited with being a prime instigator of the Realist style. He was also a political activist and believed that the artist should only paint what he could see and touch. "Show me an angel and I will paint one" is his famous statement in this regard. He was a master both of the technique of oil painting and composition, creating many memorable works such as his *A Burial at Ornans* (fig.10.9). In some of his most detailed paintings, which look almost photographic, Courbet comes closest to Zola's dictum of naturalism.

▶ 10 ⋅ 8

Honoré Daumier, The Laundress, 1863(?). Oil on wood, $19\frac{1}{4} \times 13$ in (48.9 \times 33 cm).

Influenced by a climate of scientific positivism, the artists of the Realist movement tried to record the world as it appeared to the eye, but they also wished to interpret it so as to record timeless truths. This painting by Daumier shows his broadly realist renderings of working-class people.

The Metropolitan Museum of Art N.Y. Bequest of Lillie P. Bliss, 1931. Photo © 1997 Metropolitan Museum of Art.

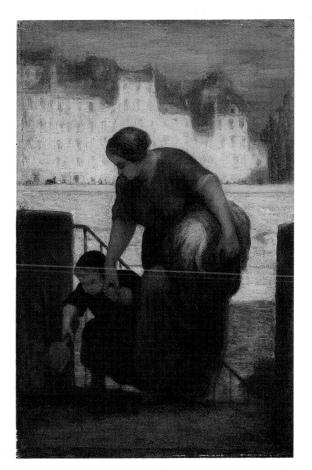

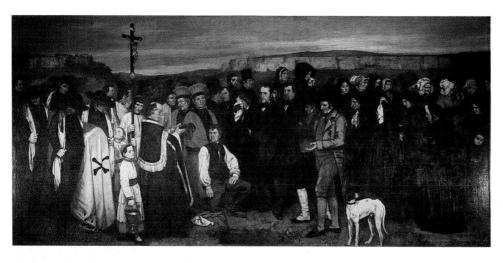

A 10·9

Gustave Courbet, Burial at Ornans, 1849. Oil, 10×22 ft $(3 \times 6.7 \text{ m})$.

Courbet was the leading early exponent of the Naturalist leanings of some Realist painters. Critics harshly condemned him for painting "ugly" pictures of average people at their mundane activities.

Collection the Louvre, Paris. Photo: AKG, Berlin/SuperStock.

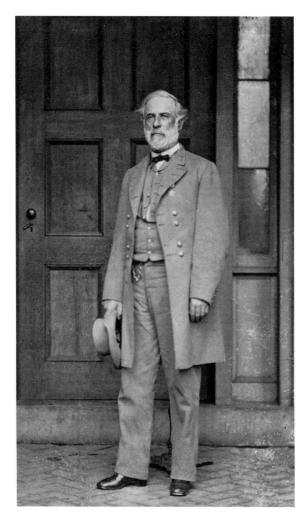

€ 10 - 10

Mathew Brady, General Robert E. Lee, 1865. Photograph.

Despite the bulky equipment needed in the "wet-plate" process, by the 1860s photographers were busily documenting wars, nature, and exotic locations all over the world. The portraitist Mathew Brady assembled such a troop of photographers and left us an amazing record of the American Civil War. Brady himself took this photograph, reluctantly posed for by the great Southern general, just a week after the surrender at Appomattox Court House.

Library of Congress/Corbis Media.

TECHNOLOGICAL DEVELOPMENTS IN PHOTOGRAPHY

At the same time, photographers were also developing their own kinds of artistic expression. Photographers could not escape the longer-standing traditions of painting and its sought-after qualities, so the Pictorialists often tried to imitate some of the outward effects of lighting and atmosphere. Technical experiments and research led to fairly rapid improvements in cameras, lenses, and in the quality of printing surfaces, which enabled photographers to experiment in new ways of creating pictures. Among some of the technical developments were the faster lenses invented in the 1840s; the "wet plate" (or collodion) process in 1851 and the "dry plate" process in 1871; and the development of films to replace glass and metal plates for the exposure process in the late 1890s/early 1900s. In 1888, George Eastman (1854-1932) invented the first camera that could be mass-produced (the "Kodak"); from then on, an amateur could take pictures economically without having to process the film or make prints. Thus the widespread popularity of the medium was assured.

Because of these technical improvements, photographic experimenters could more frequently create images of artistic quality, as well as exploit the medium's ability to record reality faithfully. This ability not only favored the honesty of straight photography but, despite the size and amount of the early equipment required, generated a notable record of human and natural phenomena everywhere in the world. For instance, by mid-century, cameras were recording the face of mass conflict, such as the Crimean War (1853-56) and the American Civil War (1861–65). Mathew Brady (c.1823–96), originally a New York portrait photographer, organized a team of photographers that left an outstanding

record of the Civil War (fig. 10.10). Others gave us fascinating views of the ruins of ancient cities, contemporary foreign cities, nature, and, particularly, the American "Wild West" (fig. 10.11). From such images, many graphic artists, even when they could not actually travel themselves, became familiar with exotic places, and cultures past and present, which they often sought as subjects. Out of both the technical improvements and the photographic record cited came the first illustrations leading to photogravure (printing from an etched plate made from a photograph), which in its turn hastened the development of photojournalism. The rapid expansion of photographic images in newspapers, magazines, and journals was devoted to all kinds of specific topics, among which was photography itself. Photojournals, like the documents issued by the other graphic media in the late nineteenth and early twentieth centuries, helped to gain acceptance of, and appreciation for, the formal qualities of the medium.

Among other important discoveries were those in color photography. Daguerre had experimented with color, but very little progress was made in recording colored images until James Clerk Maxwell demonstrated in 1860 that all color could be reduced to three primary colors. This was followed a decade later by Dr. Hermann Vogel's discovery that dye colors could be made sensitive to light and thus the sensitivity of silver emulsions could be extended into both panchromatic and orthochromatic areas of the spectrum.

IMPRESSIONISM

In the 1860s, younger Realist painters such as Edouard Manet (1832–83), Edgar Degas (1834–1917), and Pierre Auguste Renoir (1841–1919) were often painting outdoor subjects like picnics, café groups, and boaters. These subjects formed the transition to the new movement of

Impressionism. Manet was fascinated particulary by the effect of color and light on subjects. He set in motion the theories that became fascinating to the Impressionist painters. Claude Monet (1840–1926), Camille Pissarro, and Renoir-took the lead in the Impressionist movement (fig. 10.12; and see figs. 4.3 and 10.13).

10 • 11

William Henry Jackson, Devil's Gate, High Bridge, Central Span, c. 1889. Collodion print.

Jackson was one of the earliest photographers of Western scenery in the United States. This is one of the many superb studies he made as the West was being opened up after the Civil War. His work foreshadows the great landscape photography of, for example, Edward Weston and Ansel Adams.

Courtesy Colorado State Historial Society. WH J#7007.

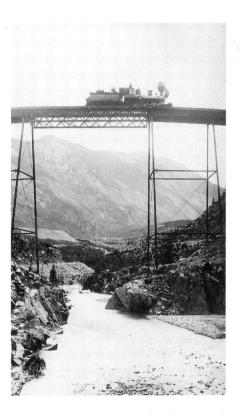

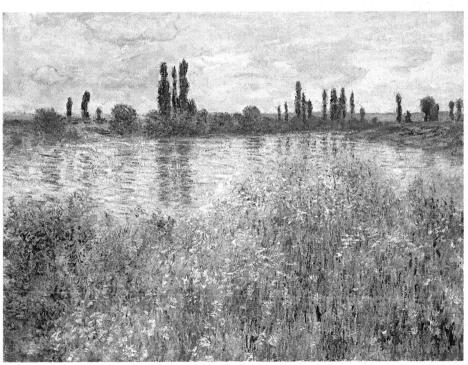

▲ $10 \cdot 12$ Claude Monet, Banks of the Seine, Vetheuil, 1880. Oil on canvas, $28^{7/8} \times 39^{5/8}$ in (73.3 × 100.6 cm).

The selection of subject in this painting is typical of the Impressionist movement. The bright weather and the shimmering water offered an opportunity to express light and atmosphere through a scientific approach to the use of color.

Chester Dale Collection. © 1998, Board of Trustees, National Gallery of Art, Washington.

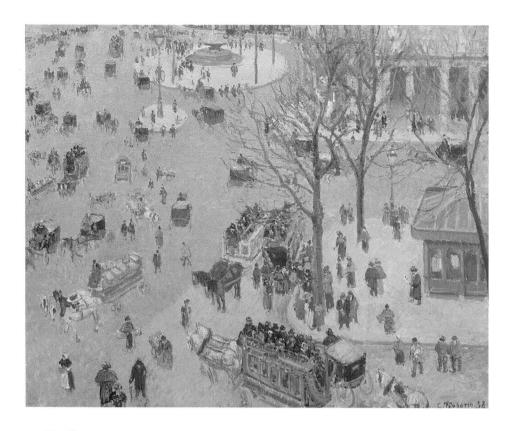

▲ 10 · 13 Camille Pissarro, La Place du Théatre Français, 1898. Oil on canvas, $28\frac{1}{2} \times 36\frac{1}{4}$ in (72.4 × 92.1 cm).

In this painting, the Impressionist Pissarro shows a high-angle view of the Parisian street, a technique that was influenced by both Japanese prints and photography.

Los Angeles County Museum of Art, CA. Mr. and Mrs. George Gard De Sylva Collection, M.46.3.2. Photo: Lauros-Giraudon, Paris/SuperStock.

It is interesting to note, and significant for its relationship to photography, that the first independently arranged Impressionist exhibit was held in the studio of the eminent Realist portrait photographer Felix Nadar (Gaspard-Felix Tournachon, 1824–1910) in 1874. However, despite the Impressionists' concern with recording reality, they wanted to do it in a new way. Impressionism indicates a strong shift toward the modern view that the form of a work (materials and methods) is more important than the subject matter. Where previous movements had developed the trend towards freedom of choice in subject, the Impressionists contributed a new technical approach to painting, which underlined the importance of the art object itself, as well as achieving a new way of conveying the

appearance of natural phenomena. It is in this respect that the Impressionists represented the transition between tradition and revolution in art. While still wishing to represent the essential appearance of a subject, they developed revolutionary and controversial techniques for doing so.

The Impressionists' interest in light and atmosphere required them to make a fairly intensive scientific study of light theory, particularly, the effect of light on the color of objects. The technique of juxtaposing complementary hues in large areas for greater brilliance, and the interpretation of shadows as being composed of hues opposite those of the object(s) casting shadows, was of tremendous significance. To achieve the vibrating character of light, they revived the old technique of *tachiste* painting

(from the French "la tache" meaning "spot"), where pigment is put on the canvas in thick spots or dabs that catch actual light and reflect it from the surface. The tachiste method of painting can be seen in the work of earlier exponents, from Titian (c.1490-1576) (see fig. 5.10) to that of Goya and Delacroix in later times. The Impressionists' use of complementary hues in the dabs of pigment, however, was the important breakthrough. When seen from a distance, these spots or dabs tend to form tones fused from the separate hues. Local color was very important to secure the effects of sunlight, shade, and shadows, and all kinds of weather conditions. Thus landscape, actually painted outdoors (plein air), directly from the subject to the canvas "wet-on-wet" (alla prima), became the Impressionists' favorite method of recording it.

Traditional methods of composition were challenged when the Impressionists discovered the fascinating possibilities of high or unexpected angles of composition. The new photographic views of the natural scene were often different from the conventional eve-level arrangements that had been used by artists for many years. Japanese block prints, imported into France for the first time, also encouraged new views. These prints often placed a dramatic decorative emphasis on high-angle views or on views looking down on landscape subjects and people. Compare, for instance, Camille Pissarro's La Place du Théatre Français (see fig.10.13) to Hiroshige's The Kintai-Kyō Bridge at Iwakuni print (fig. 10.14). Often used merely to wrap up goods being shipped to Europe, these prints were frequently cropped, resulting in curious truncated compositions. These odd-angled views had also appeared in landscape photography, inspiring those that typified Impressionist painting. The camera was now also able to capture human and animal figures stopped in action, in the midst of walking or running.

Some of the coloristic effects of

weather were not yet reproducible by the camera, because only black-and-white photography was possible. But this was soon to begin changing with the invention in 1906 of the first commercially feasible color process; the color was not dependable, however, until the 1930s.

Edgar Degas (1834-1917) is sometimes included as an Impressionist of movement, or of "stop-action" painting (fig. 10.15). Degas, in fact, was well acquainted with photography, sometimes using photographs to achieve his high-angle views and the sense of motion in his ballet dancers and other subjects. He preferred working in his studio to painting out-of-doors. However, Edouard Manet (1832-83) also shows the impact of the photograph in his depiction of the impression of movement, but he is usually regarded as a representative of the transition from Realism to Impressionism. His technique of an even, but painterly application of paint once again accentuated the growing interest in the painting surface; but it also pointed up a startling difference from the textural use of paint by such contemporaries as the now aging Courbet and the Impressionists. It is also oddly fascinating to compare Manet's Race Track Near Paris, painted in 1864, with the photographs of horses in motion ("scientifically considered") taken by the Anglo-American photographer Eadweard Muybridge (1830-1904) in 1878-79 (figs. 10.16 and 10.17).

By 1888, some of the Impressionists were beginning to realize that there were certain deficiencies in the movement's theory and innovations, causing some to pursue individual directions. The key innovation of the 1860s and 1870s, as we have seen, was the perceptual recording of light, color, and atmospheric effects. But some artists, for example Cézanne and van Gogh, felt that these effects were now being executed superficially, in an automatic manner. The principal flaw, which irritated most of them, was the

loss of shape and design resulting from an acceptance of surface illusion alone. The effect of light and atmosphere in Impressionist painting appeared to make objects evaporate or become indistinct. The Post-Impressionists, as they were to be called, also objected to the way that outdoor lighting affected the way they saw color. In strong sunlight, it was difficult to avoid making greens too raw, and there was a tendency to overload the canvas with yellows.

≥ 10 • 14

Utagawa Hiroshige, Suö Province: Kintaikyō Bridge at Iwakuni (No. 52), mid-19th century. Color woodblock print.

The high angle view of this bridge from the artist's series, Landscapes at Celebrated Places in the Sixty-Odd Provinces of Japan, shows one aspect of Japanese art that influenced French Impressionist and Post-Impressionism in the 1800s.

Courtesy Hiraki Ukiyo-E Foundation, Tokyo, and Hiraki Ukiyo-E Museum, Yokohama, Japan.

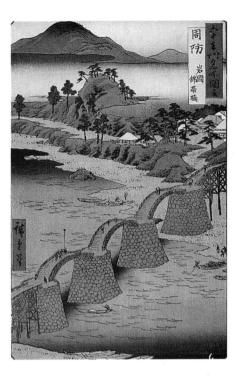

10 - 15

Edgar Degas, Four Dancers, c. 1899. Oil on canvas, 4 ft 11½ in \times 5 ft 11 in (1.51 \times 1.80 m).

Two aspects of the Impressionist artist's recording of natural form can be found in this painting. First, it demonstrates the customary interest in the effects of light. Second, the painting shows a high-angle viewpoint of composition derived either from Japanese prints or from the accidental effects characteristic of photography.

Chester Dale Collection. © 1998, Board of Trustees, National Gallery of Art, Washington.

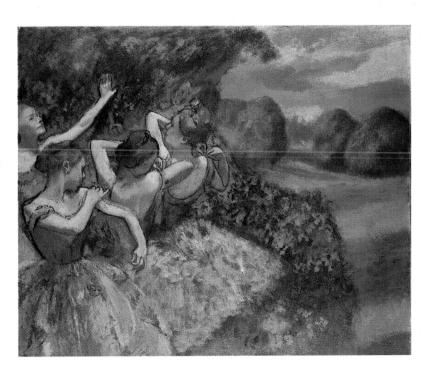

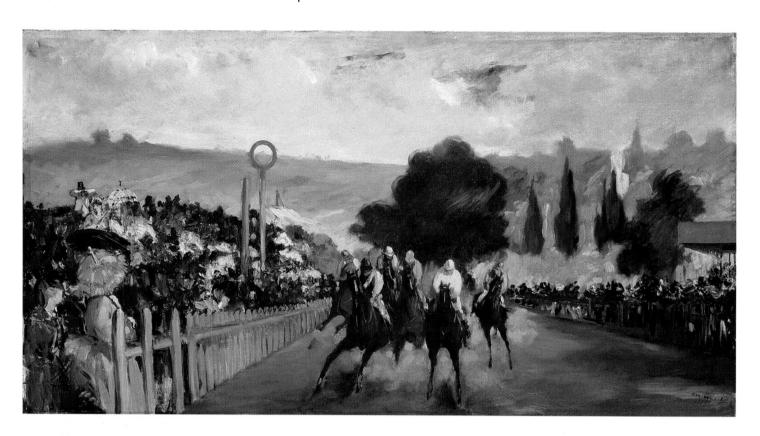

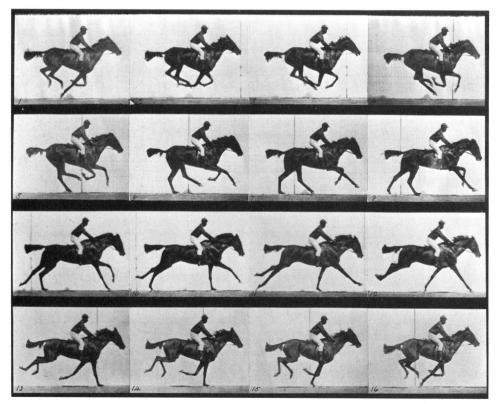

A 10 · 16

Edouard Manet, The Races at Longchamp, 1866. Oil on canvas, $17\frac{1}{4} \times 33\frac{1}{4}$ in (43.9 \times 84.5 cm).

The artist Manet reveals the Impressionists' concern to capture movement realistically, as part of their desire to render perceptual reality in a new way. Photographic studies like those of Muybridge (see fig. 10.17) may have benefited Manet.

Art Institute of Chicago, Mr. and Mrs. Potter Palmer Collection 1922.424. Photo © 1998 Art Institute of Chicago. All rights reserved.

■ 10・17

Eadweard Muybridge, A Horse's Motion Scientifically Considered. Engravings after photographs, c. 1875.

An American rancher friend and supporter of Muybridge encouraged his studies of horses in motion, which proved that at some point in midgallop all four hooves leave the ground (note the top row, numbers 2, 3, and 4). The photographer took the series with some of the earliest fast-action cameras and went on to influence Manet (see fig. 10.16), Degas, and later artistic students of motion.

Hulton Deutsch Collection/Corbis Media

POST-IMPRESSIONISM

The most important artists near the end of the nineteenth century had once been inspired by Impressionist theories, but now they began to abandon them. These artists were Georges Seurat (1859–91), Paul Cézanne (1839-1906), Paul Gauguin (1848-1903), and Vincent van Gogh (1853–90). From these pioneers stem the major directions and styles of twentieth-century art. At the same time, their styles were all individualistic and completely different from each other's. The ambiguous title given to these artists—Post-Impressionists—does not indicate this, nor does it point to their significance for the future of art.

These artists had some common objectives because they all sought: (1) a return to the structural organization of pictorial form; (2) an increased emphasis on the picture surface for the sake of pictorial unity and the unique patterns that might result; and (3) a more or less conscious exaggeration of natural appearances for emotionally suggestive effects, which is popularly called distortion (see fig. 8.51). Stylistically, Seurat and Cézanne on the whole illustrate the first of these aims; Gauguin, the second; and van Gogh, the third. Each, however, incorporated some aspect of the others' objectives in his stylistic form. It is these similarities that, despite the artists' individuality, caused the Post-

10 • 18

Georges Seurat, Sunday Afternoon on the Island of La Grande Jatte, 1884–86. Oil on canvas, 6 ft 9 in \times 10 ft 6 in (2.06 \times 3.2 m).

Seurat is classified as a Post-Impressionist, but his technique set him apart from all other artists. He applied his color in a manner that he considered scientific, using dots of broken color that are resolved and harmonized by the eye of the observer. Though a remarkable achievement, "Pointillism" had only a brief stylistic life.

Art Institute of Chicago. Helen Birch Bartlett Memorial Collection 1926.224. Photo © 1998 Art Institute of Chicago. All rights reserved.

Impressionists to be grouped in the same stylistic movement.

In 1886, at the last Impressionist exhibit, Georges Seurat's masterpiece A Sunday on La Grande Jatte-1884 (fig. 10.18) appeared. This painting, with its methodically dotted canvas, in many ways defines the moment when Impressionism began to be supplanted by Post-Impressionism. Seurat had been trained in the academic manner of the École des Beaux-Arts. He admired the Classical modes of the Early Renaissance, eighteenth-century painters like Nicolas Poussin (1594-1665) (see fig. 1.16), and, from his own century, Ingres (see fig. 10.2). Yet in the 1880s, he became associated with, and influenced by, the Impressionists, particularly Camille Pissarro (see fig. 10.13). From these influences he developed his own style, which he called Divisionism, but which others came to call Pointillism or Neo-Impressionism. Seurat's achievement came from his merging of the earlier academic/classical influences with the newer techniques and theories of the Impressionists, as seen, for instance, in the Grande Jatte. In its interrelationship

between people and object shapes, it is Classical, while in its textured pigment and use of precisely arranged complementary colors, it is Impressionist. Seurat's sense of classical monumentality and reserve also contrasted with the lighter-hearted mood or content of Impressionism. This combination foretells much about the abstract art of the following century.

Like Seurat, Paul Cézanne—by general agreement, the paramount artist of the Post-Impressionist movementremains close in spirit to Classicism. He, too, sought a way out of the patently haphazard organization and ephemeral forms of the Impressionists, seeing a work of art in terms of the interrelationship of all its parts. In this, he foreshadowed the Gestalt psychologists' theories a short time later (see Chapter 4, p. 95). While retaining the individual dabs of color of the Impressionists, Cézanne used them more as building blocks in the total physical structure of his paintings, while not becoming as rigidly precise as Seurat (see figs. 2.44A and 7.18). Although Cézanne might be called an analyst rather than a recorder of

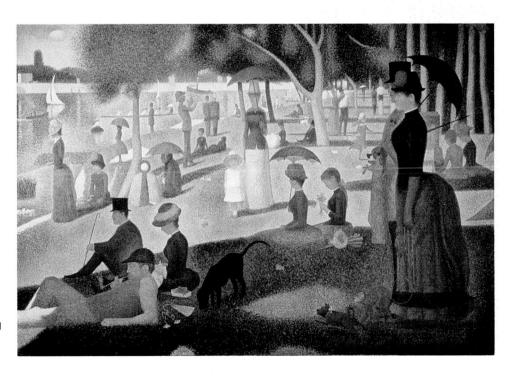

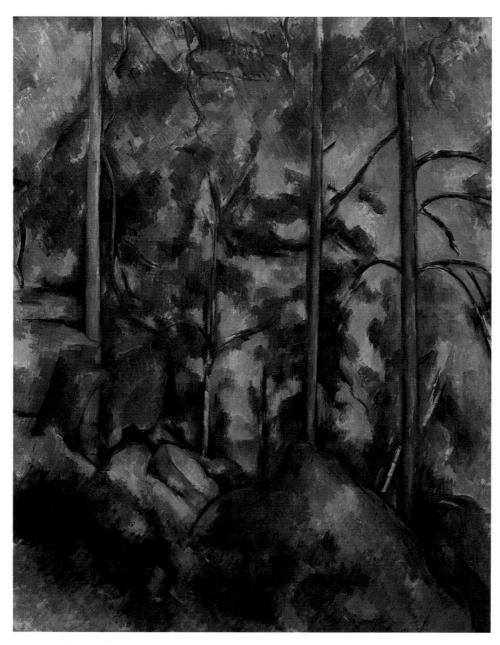

■ 10 · 19

Paul Cézanne, Pines and Rocks
(Fontainebleau?), 1896–99. Oil on canvas,
32 × 25³/₄ in (81.3 × 65.4 cm).

Cézanne tried to show the essence of natural forms rather than mere surface description. In this painting, he simplified the tree and rock shapes to produce a solid compositional unity. The Museum of Modern Art, New York. Lillie P. Bliss Collection. © 1998 Museum of Modern Art.

reality (as both the Realists and Impressionists had been), he went beyond mere analysis. Reality for him was not the object in nature where he drew his inspiration, but all of the artistic interpretations of the object, brought to fruition in the completed work. He conceived of reality as the totality of expression derived from the appearance of nature as it was transformed by the artist's mind and hand. Therefore, although Cézanne found his startingpoint in nature, as was traditional, he

became the first artist of modern times to consider the appearance of his pictorial form more important than the "realistic" representation of the subject.

In searching for his own kind of reality, Cézanne looked beneath the surface matter of the world for universal changeless form. He once wrote to a friend that he found that all nature was reducible to such simple geometric shapes as cones, spheres, and cubes. The essential character of such forms seemed more permanent to Cézanne than the transient effects of nature (fig. 10.19). Because of the intellectual processes involved in his realizations of form, he is considered a Classicist in spirit. Nevertheless, he was the forerunner of modern Cubism as well as other intellectualized abstraction in the twentieth century.

In comparison to the Classical, architectural character of Cézanne and Seurat, the works of Paul Gauguin show the invention of a vivid, symbolic world of decorative patterns (see figs. 1.26 and 7.19). The patterns owe part of their particular character to the types of expression Gauguin gleaned from Medieval carvings, mosaics, and manuscripts. He saw some of these carvings on roadside chapels while living in Brittany, France, in the 1880s. While many of his later themes (during the 1890s) were inspired by more exotic places, particularly Tahiti in the Pacific, Gauguin's work always demonstrates a sophistication typical of French art. An underlying suavity tempers Gauguin's work and gives to it a quality reminiscent of an old master's painting, in spite of his brilliant color and free patterns. The decorative style of the early twentiethcentury French Fauves stems primarily from the work of Paul Gauguin.

The work of Vincent van Gogh, the fourth pioneer, represents the beginning of a new, highly charged, subjective expression that we find in many forms of modern art. The character of Expressionism in the early 1900s owes a

great deal to the impetuous brushstrokes and dramatic distortions of color and objects first used by Vincent van Gogh. He was mostly self-taught as an artist, having turned to art after failures at other careers. It was van Gogh's failures, however, that were the root of his impassioned style, now marked by history as one of the greatest and most distinctive. His way of vibrantly meshing his emotions with his subjects, be they portraits, landscapes, or still-life paintings, goes far beyond the perceptual startingpoint and final forms of the Impressionists (see figs. 1.13 and 3.1).

PHOTOGRAPHIC TRENDS

In the meantime, certain Pictorialist photographers were working in an Impressionist or Post-Impressionist vein, while others were following the Symbolists (see Glossary), whose style sought to achieve ultimate reality by intuitive or inward spiritual experiences of the world. Many of these artists, like their counterparts in painting, always worked directly from nature and yet, increasingly, were making perception a way of learning about composition and an evocative expression. They also seem to have had an awareness that there was something beyond the mere recording of a moment. Some of these Pictorialists did not approve of the fuzzy focus and film manipulation that their colleagues used to attain their effects. They began to experiment instead with the natural effects of light and atmospheric effects, as had the Impressionist painters. The fusing of experimental Pictorialism with a Realist point of view, then, seems to have been influenced by the theories of both Post-Impressionism and, to some extent, Symbolism. Many of these modernist photographers grouped together, leading to the foundation in London in 1892 of the so-called Linked Ring. From this early group, the Royal

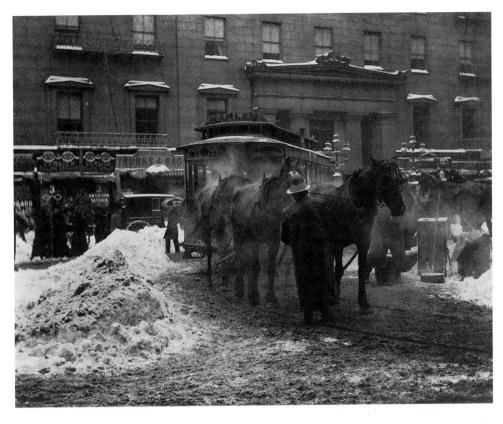

Photographic Society of England branched off shortly after, while various "Linked-Ring" groups spread to the major cities of Europe. By the end of the nineteenth century, many of these photographers were scrupulously promoting the artistic worth of the camera image through exhibits and documents. They were also calling themselves Photo-Secessionists, and by likening themselves to those painters who had held "secessionist" exhibits of their rejected works in defiance of the École des Beaux-Arts, the photographers deliberately declared their affinity to them and the similarity of their aims.

It was in great part due to the photographer Alfred Stieglitz (1864–1946) that progressive modernist directions in art came to America. Born in New Jersey, Stieglitz originally went to Germany to study engineering, but he became interested in photography and immediately adopted it as his career. His early work in that medium had an affinity with late nineteenth-century

A 10 · 20

Alfred Stieglitz, The Terminal, c. 1892. Photogravure, $10 \times 13^{1/4}$ in (25.4 \times 33.7 cm).

Stieglitz was probably the most influential photographer of the late 1800s and early 1900s, and had a very important role in introducing avant-garde European and American art to the public in the United States. He was an artist with Pictorialist leanings at first who became one of the best Straight photographers. Here he recorded the atmospheric conditions of a cold morning in a memorable image.

Art Institute of Chicago. The Alfred Stieglitz Collection, 1949.706. Photo © 1998 Art Institute of Chicago. All rights reserved.

painting, but through his affiliation with Edward Steichen (1879–1973) (fig. 10.23), Stieglitz was to become a connoisseur of avant-garde painting and sculpture in Europe, even after his return to New York in 1890. While his picture *The Terminal* (c. 1892) (fig. 10.20), photographed shortly after his return, shows Stieglitz's awareness of Impressionist "slices-of-life" under atmospheric conditions, it also indicates

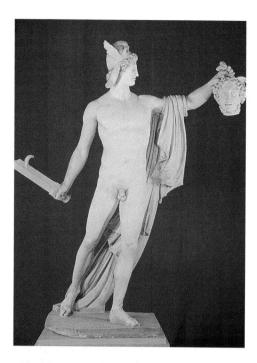

■ 10・21

Antonio Canova, Perseus with the Head of Medusa, c. 1808. Marble, 7 ft 2^{5} /8 in (2.20 m) high.

Although he was the best of the Neoclassical sculptors, Canova's great technical facility lacked the streak of individualistic meaning that would have made his art truly outstanding. He repeated themes that were centuries old and hackneyed. Metropolitan Museum of Art, New York, Fletcher Fund, 1967 (67.110). Photo: SuperStock.

that he was a Pictorialist experimenting in a Straight manner. But, despite his working in a Realist manner, Stieglitz strongly believed in the autonomous value of the camera image. Moreover, in articles written for the New York Camera Club, and in his later magazine, Camera Work, established in 1903, Stieglitz joined all the Pictorialists in maintaining that their works should be displayed and regarded for their intrinsic artistic qualities, like other nonphotographic media. In 1905, Stieglitz established the Little Galleries of the Photo-Secession at 291 Fifth Avenue in order to exhibit the work of his group and to promote photography as a unique form of art.

NINETEENTH-CENTURY SCULPTURE

At this point we turn to nineteenthcentury sculpture to trace the way that twentieth-century sculpture developed from preceding times. Just as the direction of painting changed course in the second half of the nineteenth century, so too did the sculptural values; a change that resounded into the twentieth century. But first we should reiterate at least two of the differences between the media. These differences have been treated more extensively in Chapter 9, "The Art of the Third Dimension" so here we only need to point out that the major differences are in the kinds of materials used and in the differing concepts of space.

Painters work with flexible materials in an additive manner. They invent not only their own illusion of space, but also the kinds of three-dimensional shapes that occupy that space. By contrast, sculptors work with tangible materials that are usually more resistant, creating objects with actual mass and/or volume in real space.

Obviously, the thinking of sculptors would normally be dominated by the weight and mass of the materials they employ. Yet, paradoxically, the spirit of nineteenth-century sculpture was primarily painterly, or additive. This was partly because clay modeling, an additive rather than a subtractive process, was dominant during that time. During the early 1900s, a key development that occurred in sculpture, as well as in

painting, was the gradual overcoming of the conservative reluctance towards change. The continued authoritarianism of the European academies was a primary cause for this lack of change, in all the arts. The lingering preference in sculpture for allegorical ideals, which use the human figure to symbolize spiritual values, whether from Classical mythology and/or religion, was largely responsible. Another reason was that in the preceding century, more so than in painting, commissions to sculptors were awarded on the basis of fidelity to nature. This attitude was influenced mostly by the actual three-dimensionality of sculpture, but was partly nurtured by the popularizing of the photographic image. Is it any wonder that the best sculptural talent was submerged by such strictures, or that sculptors, more than contemporary painters, lost sight of the older values so fundamental to their craft?

For these reasons, there tended to be a void in innovative sculpture during the nineteenth century. True, there were gifted sculptors who were skilled in the tools of sculpture, handling with virtuoso dexterity resistant materials like marble, and creating some memorable works. Such a sculptor was Antonio Canova (1757-1822), an Italian Neoclassicist (fig. 10.21), who was almost as closely connected to the post-Revolutionary Napoleonic regime as the painter, David. Others, like the Romantic sculptor Antoine Louis Barye (1796–1875) employed, more imaginatively than Canova, malleable materials such as clay and plaster (from which bronzes are usually cast) (fig. 10.22). Yet while Barye seems more original in his grasp of the essentially dynamic, monumental, and ferocious character of animal life, his allegorical subjects conform to the recommendations of the academies. Barye was reworking an old romantic tradition of evoking human emotions by parallels with animal nature or the vagaries of the weather. It had originally been expounded in the 1600s by the

great Dutch philosopher Baruch Spinoza, thus, Barye was repeating old values and ways of thinking. However, Edgar Degas, the painter, escaped eclecticism by creating a group of dance figures notable for their sense of mobility and poise, reminiscent of his paintings and pastels.

Of all nineteenth-century sculptors, Auguste Rodin (1840–1917) can be adjudged the most important. He looked to the future as well as to the past, and, he was the link to exploiting form, materials, and expressive content for their own inherent sake. Rodin was basically a Realist who, by embracing Romanticism, Realism, and Impressionist effects in his art, predicted the early Twentieth-Century Expressionists. In his search to suggest emotional states directly through sculptural form, he was a Romantic. In his attack on the medium

of clay and plaster (from which his many bronzes were to be cast), the gouged, irregular surface effects are similar to the Impressionists, particularly because of the way light falls on them. It is also partly from these effects that an emotional quality, something like those of the expressive Post-Impressionists van Gogh, or Tolouse-Lautrec (1864-1901) result (see figs. 1.13 and 3.4). Rodin began his career apprenticed to Antoine Louis Barve but was more influenced by Renaissance sculptors Donatello (c. 1386-1466) and Michelangelo (1475-1564). He also admired the carvers of Gothic cathedrals in the Middle Ages. While he was repelled by most of the academic sculpture of his time, he did not hesitate to make use of literary, heroic, and allegorical themes. Employing such a theme is the Gates of Hell, which was unfinished at Rodin's death in 1917

(see fig. 9.31). Rodin also paid a great deal of attention to movement, trying to express drama and emotive effect in static sculptures. He often sketched from moving or walking models in his studio, and probably was influenced by the photographer Muybridge and painter Degas (see figs. 10.17 and 10.15). He may have also been influenced by the great seventeenth-century sculptor Giovanni Lorenzo Bernini (1598–1680), whom he

₩ 10 • 22

Antoine Louis Barye, Tiger Devouring an Antelope, 1851. Bronze, $13 \times 22^{1/2} \times 11^{5/8}$ in (33 × 57.1 × 29.5 cm).

Barye's emotionalized romantic form is similar in dynamism to the intense coloristic qualities of Romantic painters such as Delacroix and Turner. Philadelphia Museum of Art, PA. W. P. Wilstach Collection Purchase.

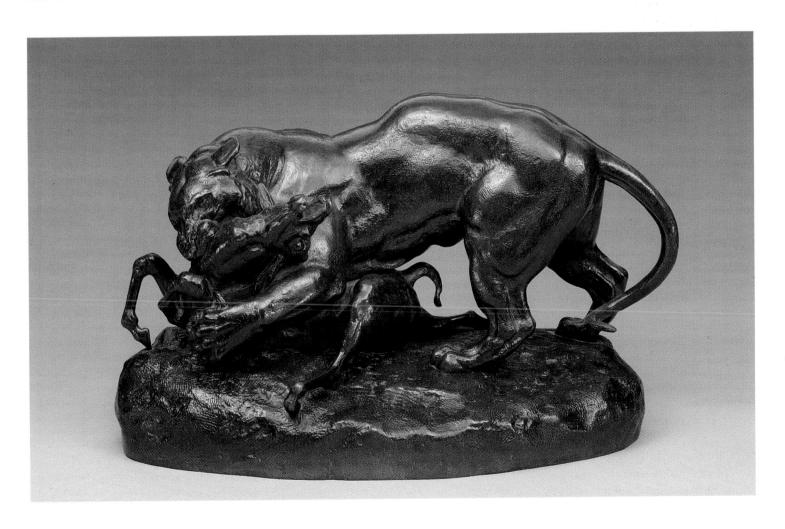

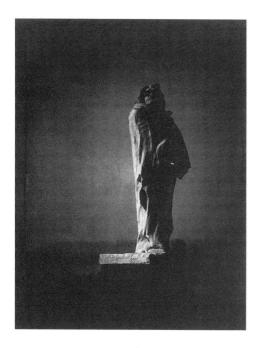

▲ 10 · 23 Edward Steichen, Balz

Edward Steichen, Balzac-the Open Sky, 1908. Photogravure from Camera Work, No. 34–35.1911, $8\times6^{1}/8$ in (20.3 \times 15.6 cm).

A close friend and long-time associate of Alfred Stieglitz, Steichen began his career by capturing on film the sculpture of the great Auguste Rodin. This example of Rodin's *Balzac* catches the author in the throes of the creative act. In order to better express this romantic idea, Rodin suggested that the young photographer take the picture by moonlight.

The Museum of Modern Art, New York. Copy print © 1998 Museum of Modern Art.

regarded highly. Although he claimed to detest attempts at capturing movement on camera, because he said it produced distortions of reality, he was not adverse to photography as a document or record of his work. See Edward Steichen's youthful photograph of Rodin's *Balzac* in figure 10.23.

But it was mostly in admiration of Michelangelo that Rodin tried to restore sculptural values that he felt had been lost since the Renaissance. Among those values, as seen in the Danaide (1885) (fig. 10.24), were the heft and texture of stone, and the contrast between highly polished surfaces and unfinished roughness. Here Rodin also reintroduced the technique of having a figure, or its parts, emerging from blocks of stone. In other sketches and finished works, he created fragmentary human forms, producing an effect of humanity striving against fateful forces (see fig. 9.4). Moreover, it was in the unusual effects of torsion, dimension, fractional

₩ 10 • 24

Auguste Rodin, Danaïde, 1885. Marble, $14\frac{1}{4} \times 28 \times 20\frac{7}{8}$ in $(36 \times 71 \times 53$ cm).

This example of the sculptor's later work reflects Michelangelo's influence in its partially revealed form emerging from the roughly finished stone (see fig. 9.4).

Collection Musée Rodin, Paris #S.1155. Photograph © Musée Rodin and Bruno Jarret / © 1997 ADAGP, Paris/Artists Rights Society (ARS), New York.

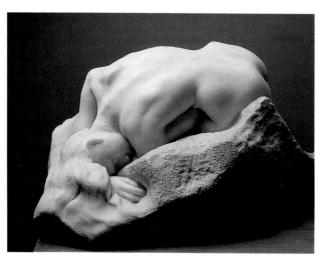

presentation, and the potency expressed in his figures that he predicted the future. These effects paved the way for twentieth-century sculptors to escape the inhibitions imposed by official dictates on so much nineteenth-century art.

Rodin's career also confirms once more that individual genius most often leads the way to new ideas and forms. Most artists, substantive though they may be, usually profit mainly from only one or two of the directions foreseen by the genius. This statement brings up the question of whether or not Rodin was a lone genius because in the last few years various critics have rediscovered one of Rodin's most important assistants, Camille Claudel (1864-1943). She apparently came to him as a student, soon becoming his model and mistress. She had the ability as a great artist in her own right and may have inspired and, most importantly, aided Rodin in creating some of his works, such as the Gates of Hell and Burghers of Calais. A few of her own works on display at the Rodin Museum and other works in private collections show that she created more fluid movement in her work than Rodin and became equally technically adept at handling the harder stuff like marble and onyx. Although many of her works show Rodin's influence, she did break away and create some rather horrifying, naturalistic studies of old people. Claudel worked on a much smaller scale than Rodin's monumental pieces because her favorite medium was clay. Claudel has had only one bronze cast of her work (fig. 10.25), in contrast to the many and repeated duplications, of Rodin's work. She also was a fine painter, adept particularly at portraits. She broke up with Rodin before the turn of the century and gradually became severely mentally ill. She finally was incarcerated in a mental institution by her brother, the poet, Paul Claudel. The epic tragedy of her life was compounded by having her work forgotten for so many years.

EARLY TWENTIETH-CENTURY ART

EXPRESSIONISM

French and German Expressionism, perhaps the most significant phase in the evolution of newer art forms, came into being around 1910. The young artists of this movement were the first to declare so forcefully their rightful freedom to paint a subject in accord with their feelings. *Expressionism* is a form of art that tries to arrive at the emotional essence of a subject rather than to show its external appearance. As previously mentioned, similar ideas were being put forward by the Photo–Secessionist groups (see p. 259).

In a sense, these artists were merely more liberal Romantics. However, it was possible to be more liberal only after the intervening period of change, driven by Post-Impressionism—a period that had introduced new ways of seeing and feeling.

But it was the early 1900s that saw the greatest growth of a new awareness in art. Cézanne, Seurat, Gauguin, and van Gogh had opened the door through which hosts of young artists were eager to pass, anxious to explore a new world of artistic sensations, diversions, and mysteries. The shape of this new artistic world was signaled by an explosion of color and an exciting style of drawing that ranged from the graceful curves of Henri Matisse to the bold slashings of Oskar Kokoschka.

FRENCH EXPRESSIONISM: THE FAUVES

The members of the earliest Expressionist group were called *Les* Fauves (The Wild Beasts) because of the wild appearance of their paintings due to the unnatural, bold coloring and

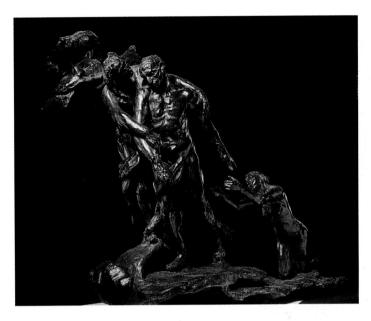

▲ 10 · 25 Camille Claudel, *Maturity (L'Age Mûr)*, 1907. Bronze, 47⁵/₈ × 70⁷/₈ × 28³/₄ in (121 × 180 × 73 cm).

Sadly neglected for a half a century, this sculptress was student, assistant, model, and mistress to Auguste Rodin. Her work had a more fluid style than Rodin's.

Collection Musée Rodin, Paris. © Musée Rodin/DR (Photo: Erik & Petra Hesmerg).

exaggerated figures. This was the name applied to the new artists by the French critic, Louis Vauxcelles, when he saw their first exhibit at the Salon d'Automne in 1905. He was later to name the Cubists in disparaging the work of Georges Braque as mere cubes. Of course, the Institute of France and the general public were still expecting a more conservative traditional style. The public had been only dimly aware of Cézanne and van Gogh as revolutionaries, but they could not ignore this host of new young painters, who threw Paris into a turmoil with group exhibitions, pamphleteering, and other forms of personal publicity. At first the Fauves seemed to be trying to live up to their name. However, within a period of only seven years they had lost their original vigor and were considered rather sedate compared to the newer movements that were evolving. While it sought to evoke the emotional essence of a subject, rather than its appearance, the

Fauve manner was decorative, colorful, spontaneous, and intuitive. When an Expressionist artist's emotional excitement was communicated to the spectator, the work of art could be called successful.

The color, brilliance, and winning sophistication found in the work of Henri Matisse (1869-1954), nominal leader of the Fauvist group, was largely influenced by Persian and Middle Eastern art (fig. 10.26; see figs. 4.7 and 5.16). The group as a whole registered similar influences, often searching for patterns in museums of ancient artifacts. The Fauves were inspired by the work of the Byzantines, the Coptic Christians, and archaic Greek artists, as well as by the tribal art of Africa, Oceania, and Native Americans. The influence of African masks and sculpture can be detected in the stylized, impersonal human faces found in Matisse's paintings, as well as those of numerous other early twentieth-century artists. Behind this

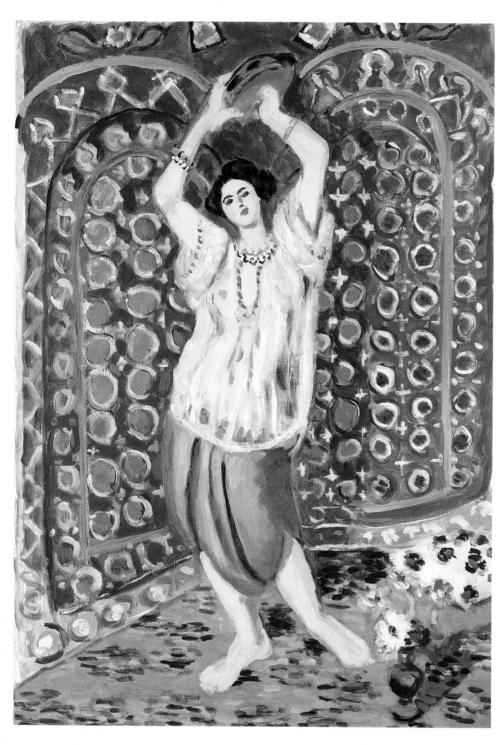

A 10 · 26

Henri Matisse, Odalisque with Tambourine (Harmony in Blue), 1926. Oil on canvas, $36\frac{1}{4} \times 25\frac{5}{8}$ in (92.1 × 65.1 cm).

The Fauves, led by Matisse, tried to show the emotional essence of a subject rather than its external appearance. Matisse also exhibits the characteristically decorative, colorful, spontaneous, and intuitive qualities of this French Expressionist style.

Norton Simon Art Foundation, Pasadena, CA. © 1997 Succession H. Matisse/Artists Rights Society (ARS), New York.

impersonal but enigmatic effect lies a sense of mystery or threat (see fig. 10.39).

The Expressionists Matisse and Modigliani (1884–1920), despite their general preference for strong, vibrant color, painted charming, decorative structures that continued the long tradition of Classical restraint found in French and Italian art (fig. 10.27). Georges Rouault (1871-1958), on the other hand, was an exception among the French Fauve Expressionists; his work was as harsh and dramatic as that of his German counterparts. His paintings express a violent reaction to the hypocrisy and materialism of his time through characteristic use of thick, crumbling reds and blacks. His images of Christ are symbols of man's inhumanity to man, as his Christ Mocked by Soldiers reveals (fig. 10.28); his paintings of judges are comments on the crime and corruption of his time. Rouault's artistic comments on the French political and legislative leaders of the day were anything but complimentary.

GERMAN EXPRESSIONISM

German artists of the early twentieth century felt that they, as prophets of new, unknown artistic values, must destroy the conventions that bound the art of their time. The foundation of painting in Europe for the next fifty years was provided by three groups of German artists: Die Brücke (The Bridge), Der Blaue Reiter (The Blue Rider), and Die Neue Sachlichkeit (The New Objectivity). The Expressionism of these artists, drawn from an environment that seemed complacent toward social and political injustices, was ultimately an art of protest, but it was also an attempt to assert as directly as possible their basic urge for expression. The resulting art forms had a vehemence, drama, gruesomeness, and fanaticism never

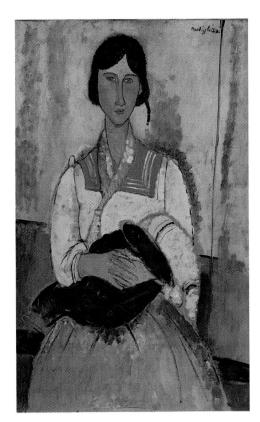

completely captured by the rationality of French art. The German Expressionists often identified with the religious mysticism of the Middle Ages, with the tribal arts of primitive peoples, and with the psychotic expression of the mentally ill. Others followed the manner of children, with a naive, but direct emotional identification with the environment. For example, the art of Emil Nolde (1867–1956) is similar in

feeling to the mystic art of the Middle Ages (see fig. 7.39). The Norwegian Edvard Munch (1863–1944), a pioneer of Expressionism living in Germany, was introducing a style of emotional instability based on his own tragic childhood (fig. 10.29). Munch was also partly influenced by folk art, tales from the Middle Ages, and by African tribal art. The Austrian Oskar Kokoschka (1886–1980) revealed that even in

▲ 10 · 27 Amedeo Modigliani, Gypsy Woman with Baby, 1919. Oil on canvas, $45\frac{5}{8} \times 28\frac{3}{4}$ in (115.9 × 73 cm).

The artist's painting stresses sensitive shape arrangement and subtle modeling of form within a shallow space. His interpretation of the figure reminds us of the influence of Gothic and African sculpture.

 $\label{lem:charge_constraint} \mbox{Chester Dale Collection.} \ \ \mbox{\mathbb{Q} National Gallery of Art,} \\ \mbox{$Washington/SuperStock.}$

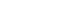

10 . 28

Georges Rouault, Christ Mocked by Soldiers, 1932. Oil on canvas, $36\frac{1}{4} \times 28\frac{1}{2}$ in (92.1 \times 72.4 cm).

In this Expressionist contrast of clashing complements, the pattern is stabilized by heavy neutralizing lines of black reminiscent of Medieval stained glass.

The Museum of Modern Art, New York. Given anonymously. Photo © 1998 Museum of Modern Art. © 1997 Artists Rights Society (ARS), New York/ ADAGP, Paris.

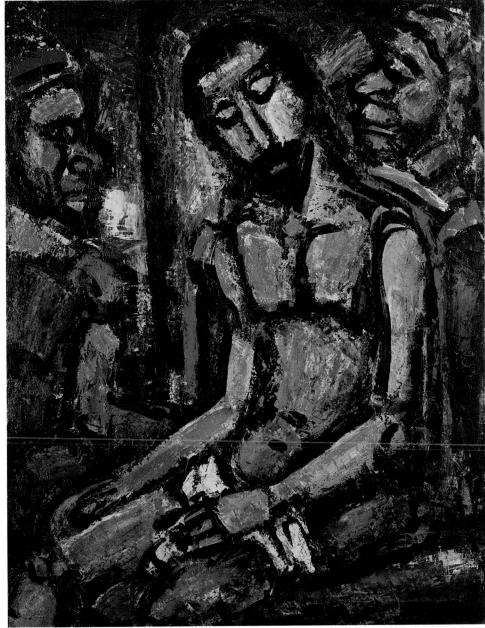

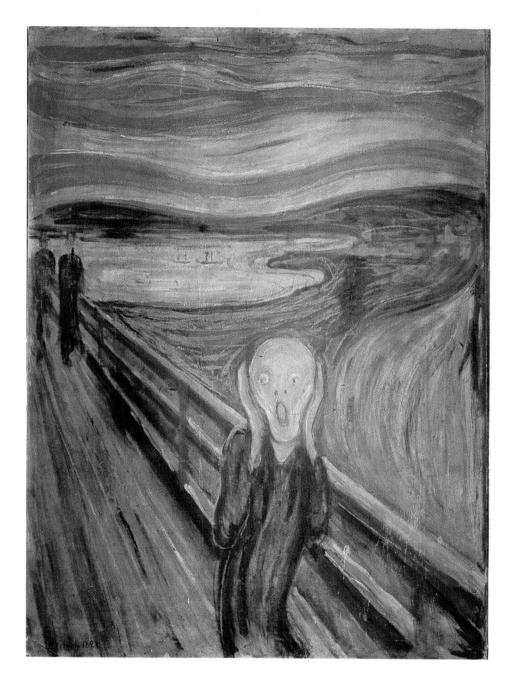

portraiture it was not the external likeness that counted, but the emotional significance and mood of the artist and model (fig. 10.30). Kokoschka in his later years turned to an increasingly romantic kind of Impressionist-Abstraction in which he tried to infuse cities in different parts of the world with an emotional, personal character.

Following World War I, protests

Following World War I, protests against Prussian jingoism and the failures of the Weimar Republic (which led to the rise of the Nazis) became the subject matter of the New Objectivity painters, such as George Grosz (1893-1959) and Otto Dix (1891-1969) (figs. 10.31 and 10.32). Max Beckmann (1884–1950), although not a part of any organized Expressionist group, followed a path close in spirit to the work of the New Objectivity. While his work similarly satirized the swampy, degraded underworld of political society, he modified Expressionism's emotional bite by way of a calming, geometric order, learned from Cubism. This quality gives a certainty of execution to his manner of painting that is reminiscent of the work of the old masters (fig. 10.33).

 \triangle 10 · 29 Edvard Munch, The Scream or Cry, 1893. Oil and tempera on board, $35\frac{1}{4} \times 29$ in (89.5 × 73.7 cm).

The angst-ridden life of this artist is reflected in his emotional and distorted pictures. Childish terrors and medieval superstitions are interwoven in a form of frightful conditions.

National Gallery, Oslo, Norway. Photo: Bridgeman Art Library, London/SuperStock.

▶ 10 • 30

Oskar Kokoschka, Self-Portrait, 1917. Oil on canvas, $31\frac{1}{8} \times 24\frac{3}{4}$ in $(79 \times 63 \text{ cm})$.

The Expressionism of Kokoschka is manifested by his tortured forms and violent ribbons of paint.

Von der Heydt Museum, Wuppertal, Germany. Photo: Giraudon/Art Resource. © Artists Rights Society (ARS), New York/Pro Litteris, Zurich.

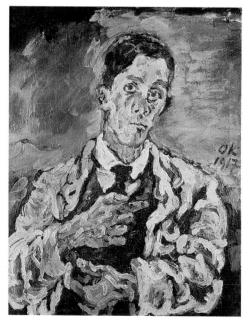

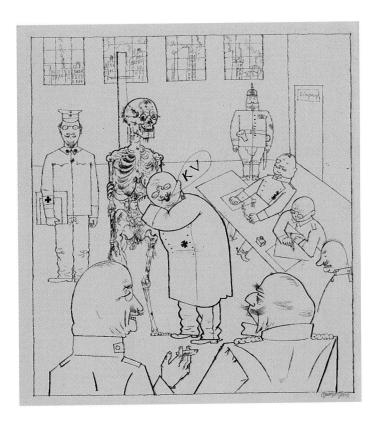

▲ 10·31 George Grosz, Fit for Active Service, 1916–17. Pen, brush, and ink, $20 \times 14\frac{3}{8}$ in (50.8 × 36.5 cm).

In this work, characteristic German emotionalism is pressed into the service of satire. Expressionism, which shows moral indignation at its peak, now becomes an instrument of social protest, as the artist comments bitterly on his experiences of World War I. Niceties of color are ignored in favor of harsh, biting black lines.

The Museum of Modern Art, New York. A Conger Goodyear Fund. Photo © 1998 Museum of Modern Art. © 1998 Estate of George Grosz/licensed by VAGA, New York.

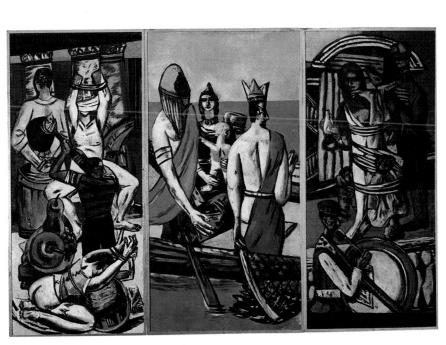

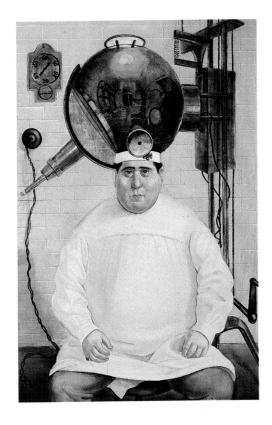

 \land 10 · 32 Otto Dix, Dr. Mayer-Hermann, 1926. Oil and tempera on wood, $58^{3}/_{4} \times 39$ in (149.2 × 99.1 cm).

The German Expressionists, with whom Dix is grouped, were highly critical of German society after World War I. Their paintings of people of that period were either tinged with satire or savage with invective.

The Museum of Modern Art, New York. Gift of Philip Johnson. Photo © 1998 Museum of Modern Art. © 1997 Artists Rights Society (ARS), New York/VG Bild-Kunst, Bonn.

4 10⋅33

Max Beckmann, Departure, 1932–33. Oil on canvas, triptych: center panel 7 ft 3 /₄ in \times 3 ft 9 /₈ in (2.15 \times 1.15 m); both side panels 7 ft 3 /₄ in \times 3 ft 3 /₄ in (2.15 \times .997 m).

Here style is emotionally intensified through strong contrasts of value and the impasto with which the artist has applied his pigment. However, the intensity of expression is partially modified by the cool, orderly arrangement derived from Cubism.

The Museum of Modern Art, New York. Given anonymously (by exchange). Photo © 1998 Museum of Modern Art. © 1997 Artists Rights Society (ARS), New York/VG Bild-Kunst, Bonn.

EXPRESSIONISM IN THE UNITED STATES AND MEXICO

The expressionistic style had adherents in the Americas as well as in European countries. The Great Depression of the 1930s influenced artists such as John Marin (1879-1953), Max Weber (1881-1961), and Ben Shahn (1898–1969), all of whom spent time in Paris either during the war or later. There they were affected by Fauvism and Cubism. Shahn returned home to face the depression and make mournful and sometimes mildly satirical comments on the American society of that time (see figs. 2.28 and 8.48). It was also in this milieu that young, experimental artists like Edward Hopper (1882-1967) and Charles Burchfield (1893–1967), among the best of the so-called Regionalists, or Scene Painters, had to find their way (see figs. 8.25 and 4.24).

Mexico, during the 1920s and 1930s, underwent an artistic renaissance. Many artists there found fruitful ground in an expressionistic style that identified with the problems of the Indian and mestizo (mixed) classes. José Clemente Orozco (1883–1949), whose art evolved during this period, became the greatest exponent of Expressionism in the Western hemisphere. Inspired by the rapidly changing social order in Mexico, he produced work similar in its dark, tragic vision to that of Rouault in Europe (see fig. 2.13A).

POST-IMPRESSIONIST AND EXPRESSIONIST SCULPTURE

New concepts in painting remained ahead of those in sculpture until about the 1950s, but a continuous interchange of ideas guaranteed that lines of development were parallel in the two groups.

By 1900, revolutionary changes were discernible as sculptors began to react to contemporary thought and experience rather than to ancient myth and legend. Sculpture then took three general directions: (1) the human figure was retained but simplified to express only the essential structure and material used; (2) forms were abstracted from nature or new forms of a highly structural character were invented; and (3) experimentation with new materials produced new shapes and techniques.

No Post-Impressionist movement took place in sculpture, but the works of such artists as Aristide Maillol (1861–1944) and Wilhelm Lehmbruck (1880–1919) suggest a new interest in the totality of form and an accent on the intrinsic beauty of materials—trends that are similar to the new synthesis of form from nature in Post-Impressionist painting.

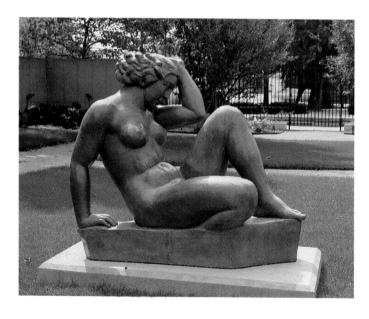

A 10·34

sense of modern monumentality.

Aristide Maillol, La Montagne, 1937. Original plaster, posthumously cast in lead, 1979, 66½ in (168.9 cm) high. Aristide Maillol combined classical serenity and repose with a

Columbus Museum of Art, Ohio. Museum Purchase: Schumacher Fund and the Battelle Memorial Institute Foundation. © 1997 Artists Rights Society (ARS), New York/ADAGP, Paris.

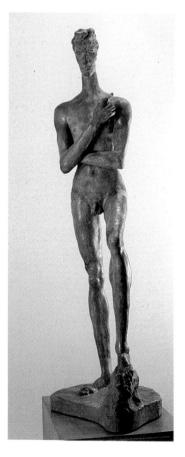

4 10⋅35

Wilhelm Lehmbruck, Standing Youth, 1913. Cast stone, 7 ft 8 in \times 33½ in \times 26¾ in (233.7 \times 85.1 \times 68 cm), including base.

This work is a good example of the mildly expressionistic style that dominated the pioneering phase of contemporary sculpture in the early twentieth century.

The Museum of Modern Art, New York. Gift of Abby Aldrich Rockefeller. Photo © 1998 Museum of Modern Art. Maillol, while maintaining a classical sense of serenity indicative of the paintings of Cézanne and Seurat, pioneered a simplification of figurative form. He wanted to recover a sense of sculptural monumentality that would reassert the essential blockiness of stone and the agelessness suggested by bronze and lead. He also generated a trend away from academic representation of the human figure by using slightly exaggerated proportions (fig. 10. 34).

Lehmbruck worked in a manner reminiscent of the more emotional aspects of Post-Impressionism, comparable in some ways to Gauguin or van Gogh. Lehmbruck evolved a style of elongated figures that was suavely charming or nostalgic and melancholic. He distributed the masses of his figural forms rhythmically, using a strong vertical axis (fig. 10.35).

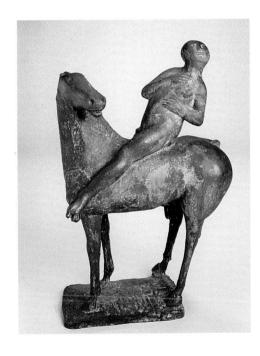

Marino Marini, Horse and Rider, c. 1947.

Bronze, 39 × 27 in (99 × 68.6 cm).

In this work, a formal tension is created by allying the time-honored tradition of equestrian sculpture with twentieth-century abstraction.

Art Institute of Chicago. Gift of Mrs. Wolfgang Schoenborn, 1971.881. (Photograph by Robert Hashimoto/Art Institute of Chicago.) © 1998 Estate of Marino Marini/licensed by VAGA, New York. Just as there was no clearly defined Post-Impressionist movement in sculpture, neither was there a clearly perceivable Expressionist school. Several sculptors worked in a manner similar to that expressed by the "Blaue-Reiters" in Germany—stripping away surface reality to arrive at underlying truths. Generally speaking, however, such sculptors were less disposed than Expressionist painters toward violent distortion of form to reveal the psyche. Lehmbruck is sometimes called an Expressionist, for example, because of his moderate distortion of human form.

In the 1940s and 1950s sculptors like the Italian artist Marino Marini (1901–1980) continued to work in this mildly expressionistic idiom reminiscent of early twentieth-century sculpture. A slight distortion characterizes his best-known works—the equestrian figures. The subtly abstract shapes of horse and rider may be related to Wassily Kandinsky's rider series of 1909–10 and seem to convey Marini's concern with the impersonality of modern life (fig. 10.36). Marini's sculpture became increasingly abstract in later years.

COLOR PHOTOGRAPHY AND OTHER NEW TRENDS

In 1907, when the Lumière brothers made it commercially possible to create color images with the *autochrome*, photographers began to experiment. Although the process used in the autochromes—coating a plate with tiny grains of starch loaded with light spectrum colors—gave images with good color fidelity, some found the coarseness of these grains objectionable. Yet interestingly this graininess, in conjunction with the Pointillism of Seurat, was a major influence on the Fauve painters' method of working.

Another drawback to early experiments with color photography was

the instability of the color dyes, which had a tendency to bleed into the layers of emulsion. In 1935, with Kodak's development of Kodachrome film, which left the dyes to the color process, more dependable color images, with less graininess, could be made. This film also made it possible for anyone who could successfully expose black-and-white film to make colored photographs, and it was soon being employed not only by photographers, but also by amateur movie makers. Then the 35-millimeter camera was developed and became the favorite means for shooting both blackand-white and color photographs. Eventually, newer color films increased the speed with which exposures could be made in weaker light and cameras could stop fast action in color. All these technological advancements naturally led to a growth of experimentation in photography, paralleling similar efforts in painting and sculpture to express a freedom from past ideas. Most professional photographers, however, continued to explore monochromatic photography, rather than color, and this has been the case until recent times. This was because of the more abstract quality of black-and-white images and the departure from simulated reality that they provided, not to mention the ephemeral quality of color dyes used in color films and printing papers.

The two graphic media of painting and photography have had a long history of mutual influence. This has been almost continuous, from Daguerre's first discovery in 1839 to the present day. We also noted how the grainy texture of early autochromes influenced the Fauves. The German Expressionists were also indebted to photographers' experiments and contributed to them, too. The work of German photographers may have affected the New Objective portraits of certain compatriots like Otto Dix, for example. By contrast, photographer Heinrich Kuehn (1866-1944) was apparently influenced by the

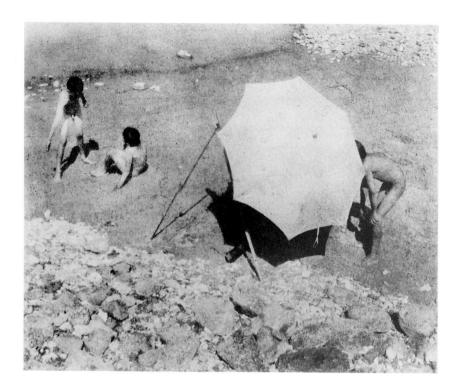

▲ 10 · 37 Heinrich Kuehn, Der Malschirm (The Artist's Umbrella), 1910. Hand-printed photogravure on heavy wove paper, $9\frac{1}{2} \times 11\frac{5}{8}$ in (23 × 28.9 cm).

As late as 1910, the photographing of nudes in unusual settings was a rebellion against the vestiges of Victorian prudery. This, in itself, marks out Kuehn as a modernist, but so does the use of a high-angled shot, which has the effect of flattening space.

© Metropolitan Museum of Art, New York. The Alfred Stieglitz Collection, 1949. (49.55.193)

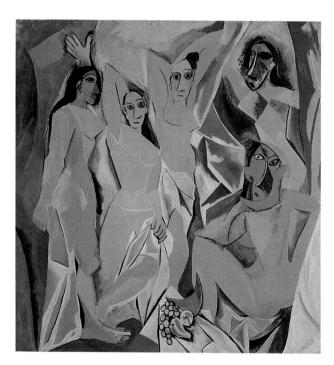

■ 10 · 38

Pablo Picasso, Les

Demoiselles d'Avignon,

June–July, 1907.

Oil on canvas, 8 ft × 7 ft 8 in

(2.43 × 2.33 m).

In this landmark painting Picasso swept away practically all previous concepts of painting. This resulted, in part, from his exposure to African tribal sculpture.

The Museum of Modern Art, New York. Acquired through the Lillie P. Bliss bequest. Photo © 1998 Museum of Modern Art. © 1997 Estate of Pablo Picasso/Artists Rights Society (ARS), New York.

Expressionist painters to take candid, unidealized shots of his nude models in bright natural light, which are reminiscent of the Brücke artists (fig. 10.37).

CUBISM

Around 1906 in Paris, a new attitude toward the world was observed in the work of certain artists. Before Cézanne. European artists tended to see nature and objects in terms of material surfaces. Cézanne began the trend toward the search for a reality (the universal unvariables) that lay beneath these material things. He observed and emphasized the basic structure of the world around him. This new way of seeing developed gradually over a period of about twenty-five years, paralleling the changing concepts of reality in science and photography. Cézanne had stated, for instance, that the artist should seek the universal forms of nature in the cube, the cone, and the sphere. Artistic exploration founded directly on this concept evolved in the styles of certain Fauve Expressionists and finally resulted in a new approach to art, termed Cubism.

Among the most active of the young artists in the Fauve movement from 1903 to 1906 was the Spaniard Pablo Picasso (1881-1973) (see fig. 2.36). Because of his admiration for the work of Paul Cézanne and his desire to challenge Henri Matisse's leadership of the Fauves, Picasso had begun to look for new possibilities of form expression. He based his explorations on volumetric illusions and an analysis of spatial structure. Like Cézanne, Picasso had become dissatisfied with the contemporary emphasis on the external characteristics of objects and sought a method whereby he could express their internal structure. By 1907, in his painting Les Demoiselles d'Avignon, Picasso had begun to develop a formal style that showed the structure of objects in space by portraying many facets of them at the same time—a principle

called *simultaneity* (fig. 10.38). Many of his ideas for this type of pictorial expression are traceable not only to the influence of Cézanne, but to the style characteristics of such **primitive art** as archaic Greek sculpture or traditional African tribal sculpture. Compare the Fang tribal mask from Gabon, Africa, (fig. 10.39) to the women's faces in Picasso's painting (see fig. 10.38), for example. By 1910–11, the sophistication of this style—called *Analytical Cubism*—culminated in such works as *Man with Violin* (fig. 10.40; see fig. 8.47 for Picasso's art after his Cubist period).

One of the most noticeable aspects of Analytical Cubist paintings by Picasso and his collaborator, Georges Braque (1882–1963), is the cubelike rendering or geometric faceting of the people and objects they painted. Another feature of these works is that different views from different positions in space—say, a back, front, and high-angle view-are all superimposed simultaneously, thereby preserving a sense of the twodimensional picture plane. By these methods, the Cubist artists, as well as their chief followers, tried to arrive at a more permanent order than that found in a standard representation of natural forms—an idea certainly stimulated by Cézanne. At the same time, Cubists set about reordering the traditional illusion of space in order to create a more stable form of spatial relationships, independent of the vagaries of light and the distorting effects of linear perspective.

In his concern with arriving at a new aesthetic view of the structure of matter, Picasso often stripped away many aids to expression—richness of color, for example. Moreover, in this process of reduction, he formulated an artistic language that put an end to the adherence to surface appearance that had been dominant in most art since the time of the Renaissance. Paintings began to emphasize image-making devices for their own sake rather than as a means for imitating nature. Traditional renderings

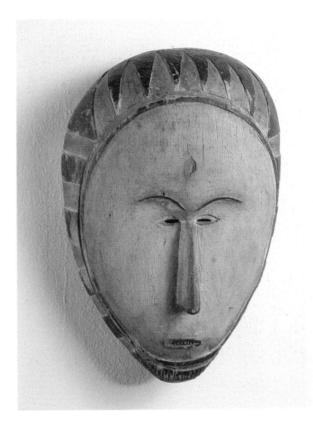

< 10 ⋅ 39

Fang tribal mask from Gabon, Africa. Painted wood, 187/8 in (48 cm) high.

This mask is a typical example of African tribal arts that influenced so many of the early twentieth-century artists such as Matisse, Modigliani, and Picasso.

Musée National dÁrte Moderne/Centre de Création Industrielle, Centre Georges Pompidou, Paris.

10 • 40

Pablo Picasso, Man with a Violin, 1911–12. Oil on canvas, $39\frac{3}{8} \times 29\frac{7}{8}$ in $(10 \times 7.59 \text{ m})$.

The shapes in Picasso's facet-Cubist style are component planes coaxed forth from subject forms and freely rearranged to suit the artist's design concept. Some facets are retained in their original position, and certain elements of the figure are only fleetingly recognizable.

Philadelphia Museum of Art, PA. Louise and Walter Arensberg Collection.

© 1997 Estate of Pablo Picasso/Artists Rights Society (ARS), New York.

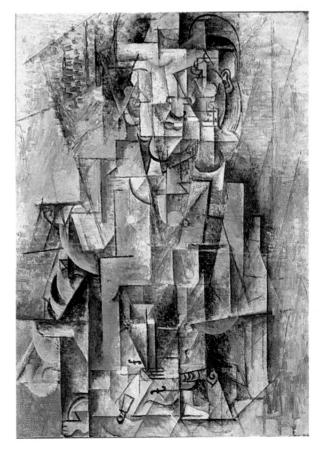

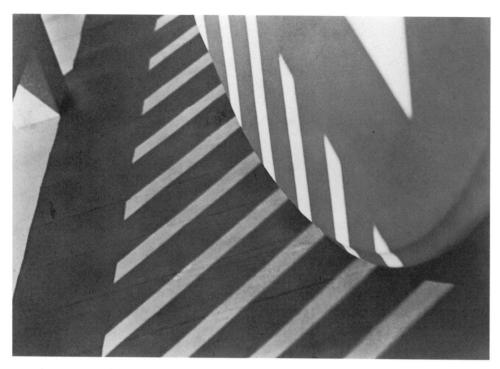

■ 10 · 41

Paul Strand, Abstraction, Porch Shadows,
Twin Lakes, Conn., 1916. Satista print,
13 × 9 in (33.2 × 23 cm).

In this high-angle close-up, Paul Strand has created a handsome abstract shadow photograph with rich darks and brilliant whites. Art Institute of Chicago. The Alfred Stieglitz Collection, 1949.885. Photo © 1997 Art Institute of Chicago, all rights reserved. © 1971 Aperature Foundation, Inc./Paul Strand Archive.

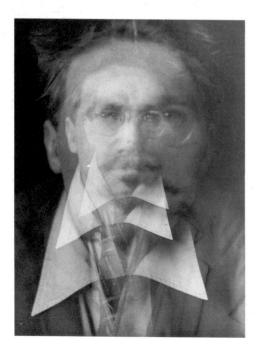

of natural appearances began to give way to expressions of pure artistic form. This new value placed on the art elements as builders of artistic form and expression in their own right led to a new set of terms to explain what the artist was trying to achieve as the goal of art. Abstract Art was the major term that was used and applied to these new forms. Cubism, a semi-representational art form, was the forerunner of all the later forms of abstraction, whether they were still partly representing (or symbolic of nature) or totally abstract. A gradual transformation from the Post-Impressionists through the Cubists, and the Futurists to the abstractions of Wassily Kandinsky and Piet Mondrian occurred.

Cubism, therefore, as the beginning of what became Abstract Art, was of

■ 10 · 42 Alvin Langdon Coburn, Portrait of Ezra Pound, 1916. Photograph.

Strongly influenced by Cubism, the diversely talented photographer Coburn produced this multiple image of the poet Ezra Pound.

Courtesy George Eastman House, Rochester, NY.

major importance. It was introduced to the world not only in the works of Picasso, but also in those of Georges Braque, a French artist who shared a studio with Picasso between 1910 and 1912. Braque added a uniquely expressive quality to the Cubist approach of Picasso by attaching non-painted, textured materials to the surface of his canvases—a technique called papier collé or, more generally, collage (see fig. 6.7). But it is worth noting that it was Louis Vauxcelles, in critiquing Braques' landscape exhibit of 1908, that launched the name Cubism. However, despite his use of the new Cubist forms, Braque remained true to the tradition in French art of reason and charm in content. This contrasted with the more forceful, even explosive quality seen in some of Picasso's work. The sense of relaxed beauty in those of Braque's works executed during the peak of Cubist expression (1911–18) was engendered by his restrained manipulation of tasteful color and value patterns. The patterns were developed in terms of the finite volume of space, one of the chief Cubist idioms (see fig. 4.17A for Braque's painting after Cubism).

Two other Cubists of note were Fernand Léger (1881–1955), another French artist, and Juan Gris (1887–1927), a countryman of Picasso. These two preferred the rather austere expression of Picasso to his more violent side. Léger and Gris developed individual form qualities within the Cubist idiom that set them apart as important creators in their own right. Inspired by the impact of industry on society, Léger took the machine as his central motif (see fig. 4.28). Gris, on the other hand, stayed close to nature, treating material masses as decorative shape patterns suggestive of recognizable objects (see fig. 4.8). But Gris developed these patterns without aiming to merely imitate appearances.

There were also some photographers who worked within the Cubist idiom, such as Paul Strand (1890–1976) and the Englishman, Alvin Langdon Coburn

(1882–1966), who were members of Stieglitz's Photo-Secession group in New York (figs. 10.41 and 10.42). They worked either with close-up camera shots from above a subject, or used overlapping multiple effects to produce decoratively formal photographic images. These photographers later explored more Abstract imagery with Coburn going through a Futurist phase as well.

FUTURISM

Futurism, like Cubism, remained a "submovement" within the overall field of abstraction. Futurism is a form of Cubism remodeled by certain Italian artists who had been in Paris during the excitement caused by the new artistic ventures of Picasso and Braque. Among these was Gino Severini (1883–1966), who was instrumental in getting a French journal to publish the poet/critic Filippo Marinetti's Futurist Manifesto. The most important artists in this movement, besides Severini (see fig. 8.58), were Giacomo Balla (1871–1958) and Umberto Boccioni (1882-1916) (fig. 10.43). Balla was the oldest adherent and seems to have led the way for the others in his paintings (fig. 10.44; see fig. 8.57). These artists either studied in France or were very much influenced by its visual arts. Marinetti's manifesto belligerently denounced the old classical tradition in the fine arts (Italy's chief source of tourism), while extolling the virtues of the new age of machinery, physical well-being, and aggressive force. Under the sway of Marinetti's arguments the above mentioned artists soon wrote their own manifesto, forming a union of ideas with Marinetti. Their expression was inspired by the ceaseless activity of modern machinery, the speed and violence of contemporary life, and the psychological effects of this ferment on human life. The artists tried to show both the activity and what they perceived as the beauty of modern machinery at work. Using sheaves of

▶ 10 • 43

Umberto Boccioni, Unique Forms of Continuity in Space, 1913. Bronze (cast 1931), $43^{7}/8 \times 34^{7}/8 \times 15^{3}/4$ in (111.4 × 88.6 × 40 cm).

Boccioni was a leading founder and member of the Futurist group. An accomplished painter and sculptor, he was preoccupied for much of his career with the dynamics of movement. The Museum of Modern Art, New York. Acquired through the Lillie P. Bliss Bequest. Photo © 1998

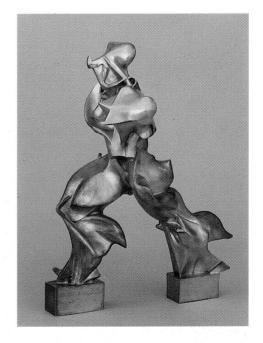

₩ 10・44

Museum of Modern Art.

Giacomo Balla, Speeding Automobile, 1912. Oil on wood, $21\frac{7}{8} \times 27\frac{1}{8}$ in (55.6 \times 68.9 cm).

This artist's handling of the image of a speeding machine is characteristic of the Futurist idiom. Incorporated into the dynamic form is a sense of the hysteria, violence, and sheer tension in modern life.

The Museum of Modern Art, New York. Purchase. Photo © 1998 Museum of Modern Art.

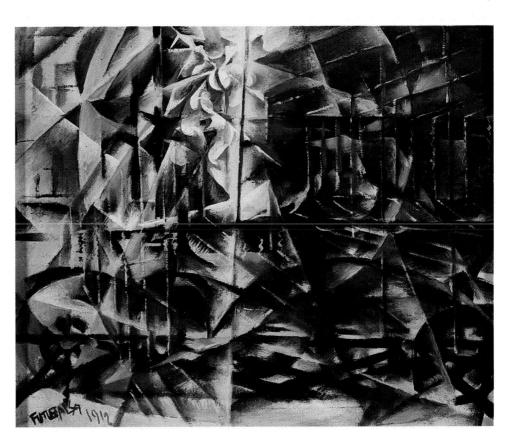

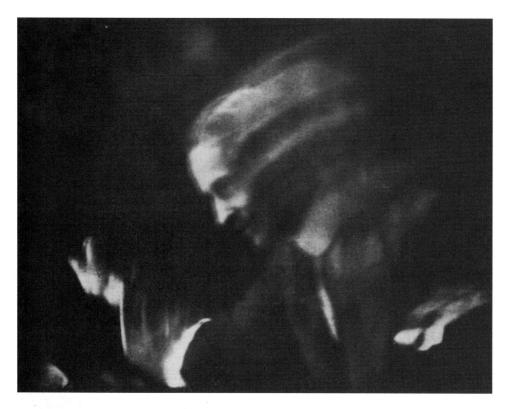

lines and planes, they created an effect of dynamic movement and tension within the canvas. The Futurists were preoccupied with attempts to interpret contemporary incidents of violence—such as riots, strikes, and wars—and their effects for the future.

Arguably, however, the fervor of the Futurists does not really match up to their artistic contributions. They merely energized the somewhat static geometry of Cubism and brought back richer coloring. Perhaps the group's attention to the machine was its most important contribution, because other artists and the public became more aware of the mechanized nature of their society.

Again it appears that photography and the other graphic arts had a mutual impact on one another. In Italian Futurism, for example, the influence of early photographers such as the Englishman Eadweard Muybridge is implicit, not only on painters such as the Frenchman Marcel Duchamp (1887–1968) (see fig. 8.56) and the Italian Giacomo Balla, but on Italian

photographers like Antonio Julio Bragaglia (1889–1963) (fig. 10.45) .

ABSTRACT ART

During the period from 1910 to 1918, the chief motivation of many artists throughout Europe was to completely eliminate nature from art. When Abstract Art began, however, the starting point was still in reference to visible matter and was inspired primarily by the experiments of Picasso. As artists explored total abstraction, they took two main directions. Some, like the Russian Wassily Kandinsky (1866–1944), preferred an emotional, sensuous, expressionist abstraction, which later influenced American abstract painting. Others, such as the Dutch artist Piet Mondrian (1872–1944), preferred the cold precision of geometric abstraction, which also later inspired Hard-Edge Abstraction in the United States.

Kandinsky's earliest, and perhaps best work featured powerful rhythms and loose biomorphic shapes that had a sense

10 · 45

Anton Giulio Bragaglia, Salutando (Greeting), 1911. Fotodinamica. From Fotodinamismo Futurista Sedici Tavole, 1911.

Within the milieu of Italian Futurist painting, Bragaglia made this time exposure of a man in the midst of greeting someone with a broad gesture. He coined the term "photo-dynamic" to describe pictures of this kind.

Centro Studi Bragaglia, Rome. Collection of Antonella Vigliani Bragaglia.

of great spontaneity (fig. 10.46). Although it was rarely evident, Kandinsky's paintings usually originated from specific conditions or circumstances. He was painting in a more Expressionist manner as a Blaue Reiter when he began to interpret his responses to nature in terms of a bold visual language without much reference to outward appearances. His loose, direct manner remained essentially as that of a romantic. After his experiments with biomorphic abstraction, Kandinsky underwent another conspicuous style change in 1919 after joining the German Bauhaus as a faculty member. At that time, influenced by other teachers there, Kandinsky's style became more geometrically abstract.

The most representative exponent of Geometric abstraction was Piet Mondrian. Like Kandinsky, Mondrian also eventually dealt with the most basic elements of form but, unlike Kandinsky, purged them of any perceivable emotional qualities. Although Mondrian came only gradually to total abstraction, once he did, he pushed the unemotional qualities of shape, value, and color to a state of total nonrepresentation (see fig. 1.3). In such work, meaning or content is inherent in the precise relationships established between the horizontal and vertical lines creating rectilinear shapes and the sole use of primary colors. This direction seemed sterile and shallow to both artists and critics when it first appeared. That it was, instead, momentous and rich in possibilities is proven by its tremendous impact on

hundreds of artists. Believers were soon finding metaphysical and mystical content in the purely optical harmonies of geometric abstraction, and the critics who were ridiculing his art were soon in the minority.

NONOBJECTIVE ART

The abstract art discussed so far in this chapter originated from nature. The next development was so-called Nonobjective art, where artists divorced themselves from nature altogether, originating the forms for their art entirely (insofar as this can be determined) within their minds. The differences between abstraction and nonobjective works of art are not readily apparent and, perhaps, an attempt to differentiate between them is of theoretical interest only. Both concepts opened up a new realm of aesthetic endeavor, and exploration in this area continues to this day. The term Abstract is the most popular today, sufficing for all nonrepresentational art. The term Nonobjective, however, never meant that the artist had no objective or purpose, even though it seems to imply it. This confusion is probably the reason why Abstract has generally become the accepted term for all nonrepresentational art. Ideas about the use of the elements of form, unencumbered by recognizable objects, became subjects for hundreds of artists. A certain amount of nonrepresentational art lacks originality, of course, because, although it is easy to produce synthetic (or academic) abstract art that is an end in itself, this art may truly have no meaning. However, where abstraction is genuinely a part of the creative process, great powers of thought and expression are required of the artist.

Many elements of the human-made world today derive their personality from the continuing influence of abstraction. Modern designers readily assimilated abstract theories of form in buildings (the *International Style* of architecture), furniture, textiles, advertising, and

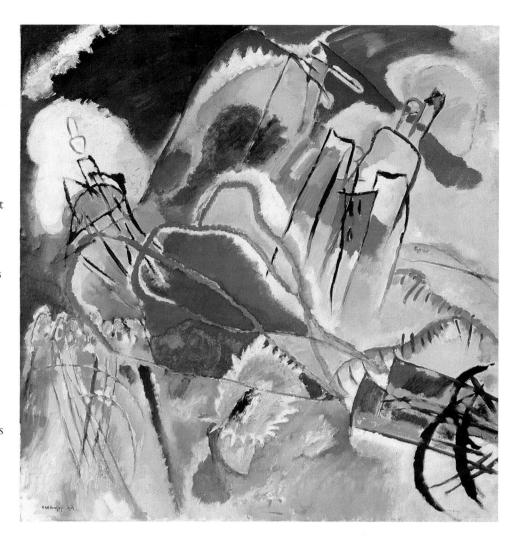

machines, to name only a few areas. The gap between fine art and art of a commercial or industrial nature has gradually narrowed. This may be because abstract art developed out of an environment where the practical function of the machine had become both an implicit and a conscious part of life. In a sense, the abstract artist created a machine-age aesthetic.

ABSTRACT ART IN THE UNITED STATES

Abstract art was slow in coming to America. The New York Armory Show in 1913 revealed to American audiences for the first time many of the important avante garde artists of Europe. Some of the Americans who were to proceed in ▲ 10 · 46

Wassily Kandinsky, Improvisation 30 (Cannons), 1913. Oil on canvas, 3 ft 7 in \times 3 ft $7\frac{1}{4}$ in (1.09 \times 1.10 m).

About 1910, the Russian Wassily Kandinsky began to paint freely moving biomorphic shapes in rich combinations of hues. His characteristic early style can be seen in this illustration. Such an abstract form of expression was an attempt to show the artist's feelings about object surfaces rather than to describe their outward appearances.

Art Institute of Chicago. Arthur Jerome Eddy Memorial Collection, 1931.511. Photo © 1998 Art Institute of Chicago. All rights reserved.

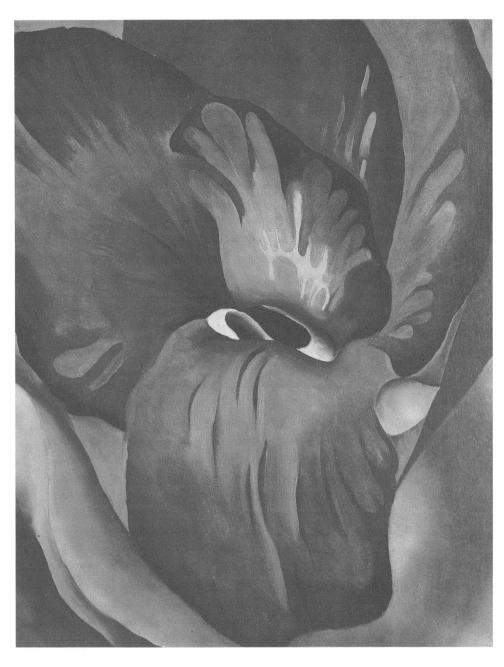

▲ 10 · 47 Georgia O'Keeffe, Canna Red and Orange, 1922. Oil on canvas, 20 × 16 in (50.8 × 40.6 cm).

Inspired by light, this "Precisionist" artist stripped away most features of reality to create her colorful, semi-abstract images.

Private Foundation.

creating an American abstract movement, out of which others would sprout, were also exhibited. Meanwhile, between 1905 and 1917, under the aegis of Alfred Stieglitz and Edward Steichen (pp. 259–260, and 262), the New York-based 291 gallery (as it was known) became a meeting place for American and international pioneers of avant-garde photography, painting, and sculpture. Among the painters and sculptors introduced by the gallery were Cézanne, Rodin, Matisse, Toulouse-Lautrec,

Constantin Brancusi, Picasso, Marcel Duchamp, along with American artists such as John Marin and Georgia O'Keeffe (whom Stieglitz married). These events encouraged the earliest experiments of Americans with abstraction. Shortly after World War I, a coterie of pioneer abstractionists appeared. Some like Marin, Weber, and Burchfield remained close to Expressionism (see figs. 8.48 and 4.24); others called the *Precisionists*, similarly kept a basically representational form while stripping away so much detail that their forms impact as nearly abstract. The founders and principal artists in the group were probably Georgia O'Keeffe (1887-1986) and Charles Sheeler (1883-1965). O'Keeffe and Sheeler both felt the influence of photography. While O'Keeffe painted buildings, flowers, and cow skulls in a semi-abstract manner that were notable for their clarity, poise, and harmony, Sheeler concentrated mainly on different kinds of buildings in a somewhat similar style (fig. 10.47; see figs. 4.26 and 8.26).

It took awhile longer before total abstraction gathered momentum in the United States. It was evolving in the 1930s but didn't mature until the 1940s. The influence of European emigré artists was an important factor in this development. Most outstanding among these artists were Hans Hofmann (1880-1966) and Joseph Albers (1888-1976) of Germany. Hofmann taught in his own school in Germany before coming to the United States in the 1930s. His teaching in this country and his loose, abstract, brilliantly colorful style helped establish the Abstract Expressionist style. Albers was a student and teacher at the Bauhaus before he came to America and the earliest immigrant artist to import Bauhaus ideas. He was also a Constructivist. His forte was to experiment with the related phenomenon of color next to color within shapes (usually squares) (see figs. 8.49 and 4.25).

ABSTRACT SCULPTURE

Picasso's Cubist collages and constructions of 1912–14 opened the way for a wide range of abstract sculptural forms. Perhaps the most important early abstract sculptor was the Franco-Romanian Constantin Brancusi (1867-1957). As early as 1913, he chose to free sculpture from mere representation. Such works as the Bird in Space of 1928 reveal an effective and sensuous charm through their flowing, geometrical poise and emphasis on beautifully finished materials. Brancusi usually preferred to work in a semiabstract mode, but always considered the shape, texture, and handling of materials to be more significant than the representation of subject (fig. 10.48).

Another pioneer abstract sculptor, the Russian-born Alexander Archipenko (1887–1964), belonged to the so-called School of Paris during the Cubist period of Picasso and Braque. His significant contribution was the use of negative space (the void) in sculpture, as in *Woman Doing Her Hair* (in which a hollow replaces the face). Archipenko also explored the use of new materials and technology, occasionally incorporating machine-made parts into his work (see fig. 9.24).

The same Cubist intellectual and artistic ferment that led Archipenko to explore human-made materials and Brancusi to pioneer the use of power tools also led the Russian brothers Naum Gabo (1890-1977) and Antoine Pevsner (1882-1962) to develop their important Constructivist concepts. This movement was founded in pre-Communist Russia by Vladimir Tatlin (1885-1956), but it is mostly associated with Gabo and Pevsner because they issued the definitive manifesto in 1920, proclaiming total abstraction as the new realism in art. Gabo was the more exciting of the two, inventing both nonobjective and nonvolumetric forms (three-dimensional forms that do not enclose space but

interact with it) (see fig. 9.5). Pevsner worked more with solid masses, nearer to sculpture of a traditional kind. The common denominator in the work of all abstract sculptors during the period of 1900–30 was an approach that emphasized materials and blurred the division between the fine arts and the functional arts. This was essentially the point of view held by both the Constructivists and the Bauhaus movement.

ABSTRACT AND REALIST PHOTOGRAPHY

Abstract art was also making its influence felt in the experimental work of photographers. So photography, too, began to be freed from its former role as a recorder of reality and to explore a whole new language of patterned design. We saw this process beginning to some extent with photographers inspired or stimulated by Cubist and Futurist painting, such as Paul Strand (see fig. 10.41) and Alvin Langdon Coburn (see fig. 10.42). These artist-photographers had been determined to work in the Realist or Straight tradition without manipulating focus, negatives, or the process of development. Coburn's image in figure 10.49 illustrates how he achieved his more abstract manner by inventing a system of multiple, three mirror image reflections of his subjects. Under the backing of Steiglitz and Steichen, we have also seen how European and American artists were often first exhibited in this country at Gallery 291 (pp. 260 and 276). Among the earliest group of photographers exhibited at 291 were Edward Steichen, A.L. Coburn, and Stieglitz's protégé Paul Strand. In the early 1930s, Edward Weston, Imogene Cunningham, Ansel Adams and others were added to these early exhibitors (see page 279). The exhibits of these photographers were significant in giving photography a

credibility that meant the art form itself could not be dismissed without at least an artistic evaluation. It is also interesting to note that photographers from the United States were far more respected in Europe than artists in other media. They seemed to be more inventive than their European counterparts and often took the prizes in photographic exhibits during the first two decades of the twentieth century.

₩ 10 • 48

Constantin Brancusi, Bird in Space, 1928. Bronze (unique cast), $54 \times 8\frac{1}{2} \times 6\frac{1}{2}$ in (137.2 × 21.6 × 16.5 cm).

Brancusi abstracted down to essential forms and showed great concern for the properties of his medium.

The Museum of Modern Art, New York. Given anonymously. Photo © 1998 Museum of Modern Art. © 1997 Artists Rights Society (ARS), New York/ADAGP, Paris.

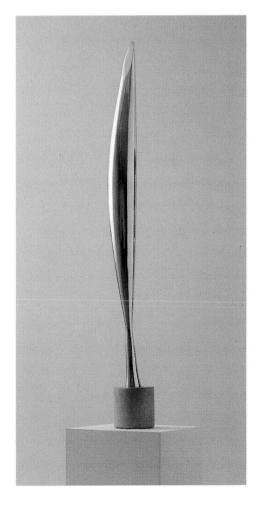

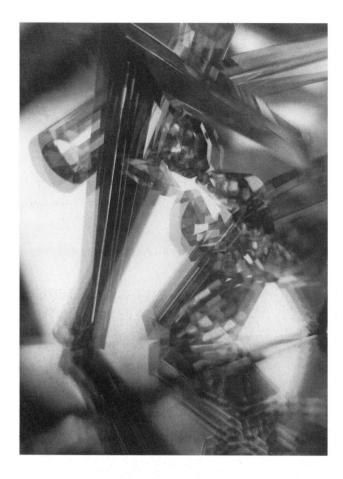

▲ 10 · 49 Alvin Langdon Coburn, Vortograph #1, 1917. Gelatin silver print, $7\frac{7}{8} \times 5\frac{3}{4}$ in (20 × 14.6 cm).

As was already evident in the portrait of Ezra Pound, (fig. 10.42), before coming to his pure-abstract "vortographs" Coburn had invented a method of recording multiple images of people. In the vortographs, the image was recorded from the manifold refractions of objects from three mirrors, which were arranged in an open triangle around the objects.

The Museum of Modern Art, New York. Gift of the photographer. Copy Print © 1998 Museum of Modern Art, New York.

10.51

Edward Steichen, Wind Fire (Thérèse Duncan), 1921. Gelatin silver print, $16\%_{16} \times 13\%_{8}$ in (42 \times 34.6 cm).

This magnificent portrait of the dancer Thérèse Duncan, daughter of Isadora Duncan, is one artist's tribute to another. Steichen, in Athens to photograph Isadora's dance troupe, wrote about the garments flickering like flames in the wind when he took this photograph.

Photo courtesy of George Eastman House. Reprinted with permission of Joanna T. Steichen.

▲ 10 · 50 Alfred Stieglitz, Equivalent, 1929. Chloride print, $3\frac{5}{6} \times 4\frac{5}{6}$ in $(9.2 \times 11.6$ cm).

Stieglitz reacted to the criticism that he could only create powerful portraits by producing completely straight abstract images of cloud patterns, anticipating Abstract-Expressionist painting of the forties.

Art Institute of Chicago. The Alfred Stieglitz Collection, 1949.791. Photo © Art Institute of Chicago. All rights reserved.

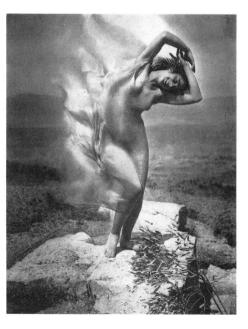

As an exponent of straight photography, despite some Pictorialist leanings that lingered, Stieglitz in his later years created some daring photographs (probably under the influence of his wife, the painter Georgia O'Keeffe; see fig. 10.47) of cloud patterns that were very abstract and evocative, predicting American Abstract–Expressionist painting in the 1940s. They were titled *Songs of the Sky*, but Stieglitz said they were *Equivalents* (fig. 10.50), intended to be seen not merely as clouds alone, but gateways to more profound emotional experiences.

Edward Steichen, Stieglitz's ingenious compatriot, was born in Luxembourg, but came to the United

States in 1880. Some of his early work in Europe was for Auguste Rodin, as we have seen (see fig. 10.23). A Pictorialist by persuasion, Steichen became a straight (or Realist) photographer after his experiences as an aerial photographer during World War I and his association with the 291 gallery. With the closing of 291 and the dissolution of the magazine Camera Work in 1917, Steichen turned to fashion photography, becoming chief photographer for Vogue and Vanity Fair. From about 1923 to 1938, his outstanding portraits of luminaries and fashion models frequently appeared in the two magazines (fig. 10.51). Steichen also served with the U.S. Navy in World War II as director of its Photographic Institute. In 1947, Steichen was put in charge of photography at the Museum of Modern Art in New York. In 1955, he mounted a famous exhibit of photographs from all over the world, known as The Family of Man. Steichen was also an accomplished painter.

Paul Strand, the young protégé of Stieglitz, was also a practitioner of Straight (or Realist) photography. By using sharp focus and close-ups, his photographs of natural objects fill the picture format and in so doing he achieved almost abstract effects (see fig. 10.41). Also noted for his studies of ordinary New Yorkers, he worked as an X-ray technician with a medical team during World War I and made movies for a time afterwards. Eventually, Strand returned to photography and traveled, created an album of photographs taken in Mexico, and wrote several books on the subject with other authors. He died

10.52

Edward Weston, Juniper, Lake Tenaya, 1937 (Yosemite National Park). Gelatin silver print.

The hypnotic play of dark and light values and the contrast between the textures of bark, stone, and clouds are indicative of Weston's artistic accomplishments.

© 1981 Center for Creative Photography, Arizona Board of Regents.

in France, where he had gone to live toward the end of his life.

In 1932 a photographic group calling themselves *F*–64, because they used the smallest aperture (the f–64) to provide good depth of field, was established in the western United States. Charter members of the group were: Edward Weston, (1884–1958), Imogen Cunningham, (1883–1945) and Ansel Adams (1902–1984). Edward Weston was born in Illinois, but he moved to California where he opened a studio and achieved international fame for his soft-

focused, Pictorialist portraits of Hollywood personalities. Later, after meeting Stieglitz and winning a Guggenheim fellowship, Weston became noted for his beautifully detailed studies of nudes, nature, and structures typical of "the American scene" (fig. 10.52). In this respect, he shared the preoccupations of Regionalist painters like Grant Wood and others. Imogen Cunningham, after soft-focused beginnings, also changed to Realist photography. She produced enlarged studies of plants with precisionist lighting and details that are

the counterpart in photography of Georgia O'Keeffe's floral studies in painting (fig.10.53 and see fig. 10.47).

Another photographer carrying on the Stieglitz credo after World War II was Ansel Adams, Adams, like the other members of F-64, changed from earlier Pictorialist imagery to Straight and was influenced by Paul Strand. By 1936, Adams had become so well known for his scenes of the West with their dramatic dawn or sunset lighting that Stieglitz exhibited his work at the American Place, a new gallery opened to replace the earlier 291 (see fig. 1.18). Adams was also very important as a teacher, as a publisher of technical books (particularly for his "zonal system," used to translate the values of nature to those of the photographic image) and for starting college photography departments. Adams also worked for periods as a commercial photographer and served as an advisor to the Polaroid Company.

FANTASTIC ART

Fantasy—the third major direction for twentieth-century art first became apparent about 1914, the first year of World War I. The war had evidently begun to raise questions about human alienation in a mechanized society, and it was suggested that individual freedoms might actually be destroyed in an age of technology. As a kind of antidote to the machine cult in abstract art, certain writers, poets, and artists began to extol artistic forms that reemphasized the emotional, intuitive side of creativity. During the period of World War I, which marked the end of early twentieth-century experiments, Picasso moved away from the monumental style of early Cubism and began to make new experiments that were to become the basis for Dadaism's destructive, cynical, and absurd parodies on the cult of materialism in society. Then, in the mid 1920s, he became an exponent of art

forms that suggest a Surrealist bent (there is even a suggestion of this direction six years earlier in the example from 1914). Picasso continued to lead many of those artists he influenced (fig. 10.54 and see fig. 8.47).

Artists had devoted their energies to fantastic art in the past. The centaurs of the ancient Greeks; the beast symbols of human sin in Medieval manuscripts and sculpture; the superstitions and alchemical nightmares of Hieronymous Bosch (c.1450–1516) in the early sixteenth; and the fantasies of Goya in the late eighteenth and early nineteenth —these are a few of the prototypes of twentieth-century fantasy.

Inogen Cunningham, Two Callas, c. 1929. Photograph.
As a member of the F-64 group of western photographers,
Cunningham created precisionist flowers in photography similar to the way that O'Keeffe crafted them in paintings.

© 1970, 1998 Imogen Cunningham

A 10 · 54

Pablo Picasso, Glass of Absinth, spring 1914. Painted bronze with absinth spoon, $8\frac{1}{2} \times 6\frac{1}{2} \times 3\frac{3}{8}$ in (21.6 × 16.4 × 8.5 cm); diameter at base, $2\frac{1}{2}$ in (6.4 cm).

In constructions such as this, which were produced during the same period as his Cubist paintings, Picasso opened the door for many developments in the plastic arts, such as assemblage and "found" art.

The Museum of Modern Art, New York. Gift of Mrs. Bertram Smith. Photo © 1998 Museum of Modern Art. © 1997 Estate of Pablo Picasso/Artists Rights Society (ARS), New York.

DADAISM

Dadaism—the first style to appear of a fantastic kind was nurtured by the terrible blood shedding and destructiveness of World War I. It was the outgrowth of an art that emphasized the irrational side of human behavior and promoted by the savagery of the war, which fostered disillusionment with the role of reason in all aspects of society. Neutral Switzerland had become the mecca for poets, writers, artists, liberals, and political exiles who sought refuge there from persecution and the terrors of modern warfare. Out of this intellectual milieu arose Dada, the anti-art form, that was characterized largely by the attempt to undermine traditional civilized mores by cynically deriding all of society's most firmly held beliefs. Its proponents believed that so-called civilized society had degenerated and brought the world to war. The Dadaists promoted the idea that a complete destruction of accepted institutions and conventions was needed because only on completely virgin soil could humanity rebuild a more desirable society. The Dadaists, therefore, embarked on a programmatic visual and auditory destruction of all that had formerly been thought to be important, noble, or beautiful in the visual and literary arts. Marcel Duchamp (1887-1968), Max Ernst (1891-1953), and others began to fashion machinelike forms that depicted humans as unthinking robots. Later, they created biomorphic images that discredited Kandinsky's romanticized abstract art (fig. 10.55; see fig. 2.11). These inventions were meant to show disrespect toward the new experimental art forms and shock a public already disturbed by a visual revolution. One of the most complex and intelligent of the Dadaists, Marcel Duchamp, the French painter, was already well known for his Futurist Nude Descending a Staircase (see fig. 8.56); however, in 1916, he helped found Dada and established a form of

A 10 · 55

Max Ernst, The Horse, He's Sick, 1920. Pasted photoengraving and pencil on paper, $5^{3}/4 \times 8^{1}/2$ in (14.6 \times 21.6 cm).

As part of the Dadaists' debunking of all twentieth-century art forms, a natural organism is here turned into a mechanical absurdity. At the same time, the use of pasted photoengravings is a nonsensical twist of the collage technique first invented by Braque.

The Museum of Modern Art, New York. Abby Aldrich Rockefeller Fund. Photo © 1998 Museum of Modern Art. © 1997 Artists Rights Society (ARS), New York/ADAGP, Paris.

Dada that was to have an impact on the rest of the century. Duchamp pioneered "Ready-mades" or "Found art" illustrated by the *Bicycle Wheel* (fig. 10.56). In this form of Dadaism, commonplace items were given an "artistic" value when they began to be exhibited and bought by museums and collectors, even though they were intended to satirize all conventional aesthetic values.

Dada thus provided its adherents with an intellectual license to attack the old social and artistic order. In principle, there was no limit to the disorder that might be unleashed on painting, poetry, and general social behavior.

Consequently, Dadaism created a backlash against modern art among much of the public. For many years people tended to classify all twentieth-

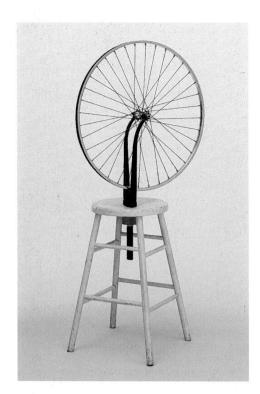

10.56

Marcel Duchamp, Bicycle Wheel, 1951 (third version, after lost original of 1913). Assemblage, metal wheel, $25\frac{1}{2}$ in (63.8 cm) in diameter, mounted on painted wood stool $23\frac{3}{4}$ in (60.2 cm) high; overall, $50\frac{1}{2}$ in \times $25\frac{1}{2}$ in \times $16\frac{5}{8}$ in (128.3 \times 63.8 \times 42 cm).

Duchamp was one of the most complex and inventive of the Dadaists. After having become disillusioned with Cubism and Futurism, he was forever questioning the aesthetic viability of art. With this piece he gave birth in 1913 to the concept of "ready-made" art, which was to be a profound influence.

The Museum of Modern Art, New York. Sidney and Harriet Janis Collection. Photo © Museum of Modern Art. © 1997 Artists Rights Society (ARS) New York/ADAGP, Paris/Estate of Marcel Duchamp.

outlandish forms created by the Dadaists. Actually, the disorder of the movement eventually led to its demise. Dada was pure nihilism, an exhibitionism of the absurd. Being against art, its only medium was a kind of outrage, publicly displayed to discredit all forms of sense. Its main value today is historical, because it was the principal source of Surrealism and a new liberator of expressive freedom. But, it was also a precursor of much absurdity found in modern art to the present.

INDIVIDUAL FANTASISTS

century works of art in terms of the

Fantasy in art seemed to be a general tendency in Western Europe during the period of Dada satire. This fantasy followed individual, but quite influential, directions in the hands of certain artists who were not part of the Dada movement. The Italian Giorgio de Chirico (1888–1978) painted incongruous modern machines in ancient shadowed plazas (see fig. 5.6). Using the vaguely Classical image of silent city squares inhabited by statuesque remnants of an unknown people, he seemed to be commenting on the decadence of the modern world. The frozen, trancelike effect of his images evokes a wistful desire to recover the past.

The Swiss artist Paul Klee (1879–1940), who was strongly influenced by children's art, created an idiom using witty, abstract imagery based on Expressionism and Cubism. His work pokes gentle but penetrating fun at the cult of the machine and smiles shyly at human pretensions. The implication is that there is more to extrasensory perception than modern humanity's addiction to practicality allows us to believe (fig. 10.57). Marc Chagall (1889–1985) was born in Russia but became a resident of France and the

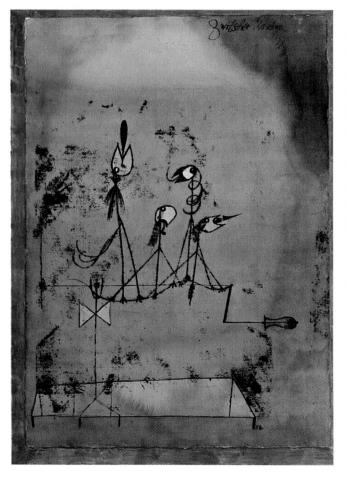

■ 10 · 57 Paul Klee, Twittering Machine, 1922. Watercolor, and pen and ink on oil transfer drawing on paper, mounted on cardboard. $25\frac{1}{4} \times 19$ in $(63.8 \times 48.1 \text{ cm}).$ Many artists developed fusions of twentieth-century concepts that defy ready classification. This reproduction is a refined synthesis of relaxed Cubist forms allied to the naïve charm of children's art. The Museum of Modern Art. NY. Purchase. Photo © 1998 Museum

of Modern Art.

United States later in his life, originally worked in an Expressionist manner. His stay in France brought him within the sphere of Cubism. Eventually, he joined fantasy and Cubism, creating a brand of romanticized poetic art that has an Alice-in-Wonderland quality. Chagall showed people's interior organs and let them float on air in a gravity-free world. The first contact with Chagall usually brings a chuckle to the spectator. On better acquaintance, his underlying warmth and humanity are revealed (fig. 10.58).

SURREALIST PAINTING

Surrealism evolved about 1924 from the art of the individual fantasists and Dadaists and became a way of life for its members. With the end of World War I, there came a semblance of stability, and the public became complacent about the ills of modern society. The Surrealists reacted to this by following a Dadaist program designed to preserve the life of the imagination against the pressures and tensions of the contemporary world.

Whereas the Dadaists had tried to debunk meaning in what they saw as a stale art tradition propped up by a corrupt society, the Surrealists tried to build a new art out of works that fused the conscious and unconscious levels of human awareness. Generally speaking, both Dadaism and Surrealism were a continuation of the counterattack (first instigated by the Romantics in the nineteenth century) against an increasingly mechanized and materialistic society. The Romantics had often created the same kind of hallucinatory images in which the Surrealists delighted. In so doing, they gave evidence of the growing belief that humanity could not solve every problem by means of science, and that littleknown, seemingly insoluble problems existed within the human mind. Sigmund Freud's theories of dreams and their meanings lent strong credence to

this belief. Operating on this thesis, Surrealist artists created a new pantheon of subconscious imagery that was claimed to be more real than that generated by activities and behavior on the conscious level. The Surrealists believed that only in dreams, which arise in the mind from below the conscious level, could humans retain their personal liberties. In their art, the Surrealists cultivated images that arose unbidden from the mind. These images were recorded through automatic techniques of drawing and painting. Such images bring to attention the arbitrary way that our senses construct reality, by exploring incongruous relationships of normal objects in abnormal settings and vice versa. The Surrealists juxtaposed commonsense notions of space, time, and scale in unfamiliar ways.

Max Ernst (1891-1976), a German painter associated with Dada and a founder of Surrealism, invented several devices in exploring his fantastic concepts. His Frottages (invented about 1925) employed the Surrealist technique of shutting off the conscious mind. Frottages were rubbings made on rough surfaces with crayon, pencil, or similar media. In the resulting impressions, the artist would search for a variety of images while in a state of feverish mental intoxication. A process bordering on self-hypnosis was embraced to arrive at this heightened state. No doubt some artists used drugs and alcohol. Salvador Dali (1904-89), a Spanish painter, affected a similar creative fever but used a meticulous, naturalistic technique to give authenticity to his improbable, weird, and shocking images (fig. 10.59).

Yves Tanguy (1900–1955), a French merchant seaman who took up painting surrealistically after seeing a painting by Georgio de Chirico, the Italian fantasist, employed a method similar to that of Ernst. Allowing his hand to wander in free and unconscious doodlings, he created strange landscapes consisting of nonfigurative objects that suggested life.

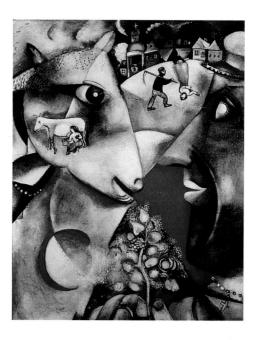

 \blacktriangle 10 · 58 Marc Chagall, I and the Village, 1911. Oil on canvas, 6 ft 3^{5} /8 in \times 4 ft 11^{5} /8 in (1.92 \times 1.51 m).

The fairy-tale world of the imagination is found in this example by an artist who evades fixed classification. Recent technological concepts (X-rays and flight) are reflected in the freely interpreted transparent objects and in the disregard for gravity.

The Museum of Modern Art, New York. Mrs. Simon Guggenheim Fund. Photo © 1998 Museum of Modern Art. © 1997 Artists Rights Society (ARS), New York/ADAGP, Paris.

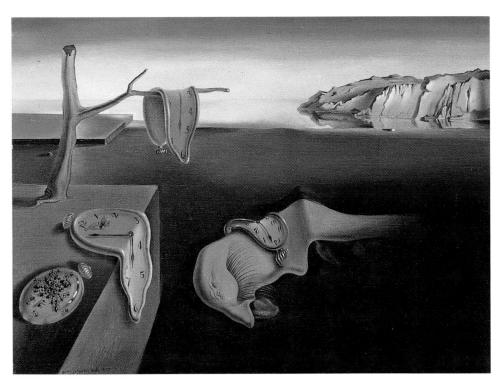

▲ 10 · 59 Salvador Dali, Persistence of Memory, 1931. Oil on canvas $9\frac{1}{2} \times 13$ in (24.1 × 33 cm).

A naturalistic technique combined with strange abstractions gives a nightmarish mood to this painting. The limp watches may be a commentary on the unreliability of our sense of time.

Museum of Modern Art, New York. Given anonymously. Photo © 1998 Museum of Modern Art. © 1997 Demart Pro Arte (R), Geneva/Artists Rights Society (ARS), New York.

Tanguy's pictorial shapes have the appearance of perceptive, alien organisms living in a mystical twilight land (fig. 10.60; see fig. 4.6). There were many Surrealists, but Ernst, Dali, and Tanguy were the most influential, thanks to their unflagging invention of arresting images. Even when other painters did not hold with the strictures of the Surrealist Manifesto by André Breton (1896-1966), a French writer and founder of Surrealism, of 1924, they fell under the sway of these outstanding Surrealist artists. Some of those influenced followed the ideas of the group, while planning and designing in a traditional manner, an approach disdained by orthodox Surrealists.

SURREALIST SCULPTURE

The effect of Surrealism on the work of many artists was variable. Certainly, not many twentieth-century sculptors were pure Surrealists when we consider the character of their work. Generally,

however, the trends of the first two decades merged to such an extent that classification into specific categories is rarely possible. This tendency increased after the middle of the century and led to the complex, interwoven movements of the second half of the twentieth century.

Alberto Giacometti (1901–1966), a Swiss sculptor/painter who spent much of his career in France, was perhaps one of the greatest Surrealist artists of this century. The evolvement of his personal style was affected by such diverse influences as Lehmbruck's mild Expressionism, and by Cubism, and Constructivism. Like other twentiethcentury sculptors, Giacometti was fascinated not only by the effects of new materials, but also by the effect of light and space on form. By 1934 he had reached his mature style of elongated, slender figures pared away until almost nothing remained of substantial form. In their arrested movement, these figures suggest poignant sadness and isolation (fig. 10.61). Giacometti's indirect method of approaching content stemmed from Surrealism and was related to the stream-of-consciousness theory supported by early twentieth-century psychologists. The first sculptor to explore direct metal sculpture (welding) was the Spanish artist Julio González (1876-1942). In the late 1920s, under the influence of Picasso, González began to substitute outlines for masses and planes and even allowed the tendrils of metal to stop short so that they were completed by implication alone. His sense of the dematerialization of form is similar to Giacometti's but is more often infected with a humor that teeters on the edge of the subconscious. The influence of González's work could be seen in Picasso's sculptural experiments of the 1930s, but the influence worked both ways (fig. 10.62).

The Alsatian artist Jean Hans Arp (1887–1966) also explored the Surrealist preoccupation with preconscious

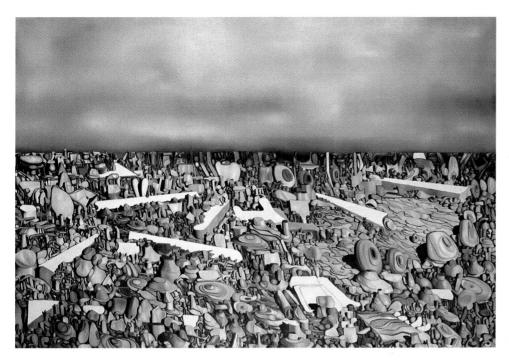

₩ 10 • 62

Julio González, Cactus Man No. 1, 1939-40. Bronze, $30^{3}/_{4} \times 10^{5}/_{8} \times 7^{7}/_{8}$ in (78 × 27 × 20 cm).

Expressively textured surfaces appealed greatly to this Spanish artist, who was the earliest modern sculptor to introduce welding as part of his repertoire.

Collection of the Montreal Museum of Fine Arts. Purchase, Horsley and Annie Townsend Bequest. Photo: Montreal Museum of Fine Art. © 1997 Artists Rights Society (ARS), New York/ADAGP, Paris.

A 10 · 60

Yves Tanguy, Multiplication of the Arcs, 1954. Oil on canvas, 3 ft 4 in \times 5 ft (1.02 \times 1.52 m).

Working with nonfigurative objects in a polished technique, the Surrealist Tanguy invents a world that appears to be peopled by lifelike gems.

The Museum of Modern Art, New York. Mrs. Simon Guggenheim Fund. Photo © 1998 Museum of Modern Art. © 1997 Estate of Yves Tanguy/Artists Rights Society (ARS), New York/ADAGP, Paris.

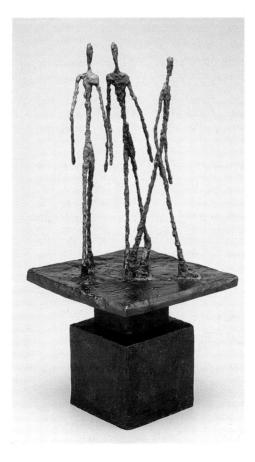

10.61

Alberto Giacometti, Three Walking Men 1948/49. Bronze, 291/2 in (74.9 cm) high. Giacometti emphasizes the lonely vulnerability

of humanity by reducing his figures to nearinvisibility and by emphasizing the spaces between them.

Art Institute of Chicago. Edward E. Ayer Endowment in memory of Charles L. Hutchinson, 1951.256. Photo © Art Institute of Chicago. All rights reserved. © 1997 Artists Rights Society (ARS), New York/ADAGP, Paris.

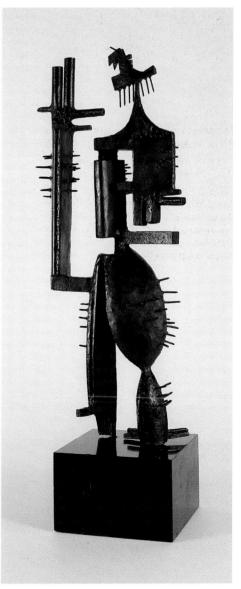

suggestion and the effect of the unexpected, or surprising, form. Before this shift of direction, Arp had explored most of the avant-garde movements of the early twentieth century: Cubism, The Blaue Reiter, Dada (he was a cofounder of the Zurich Dada branch with Marcel Duchamp in 1916), and Constructivism. He was well known for his abstract collages and reliefs, arranged according to the laws of chance, such as Mountain Table Anchor Navel of 1925, before turning to ovoidal sculptural forms in the 1930s. These later works reveal the influence of Brancusi and the prehistoric sculpture of the Cycladic Islands. In fact, Arp's ovoidal shapes became so famous that almost all kinds of rounded, organic shapes were called "Arp shapes" for a time (see fig. 9.23).

► 10 · 63 Man Ray, Rayograph, 1924

This photograph involves

the technique, developed by Man Ray, of placing objects on sensitized paper that is then exposed to light. Courtesy of the International Museum of Photography at George Eastman House, Rochester, NY. © 1997 Artists Rights Society (ARS), New York/Man Ray Trust, Paris.

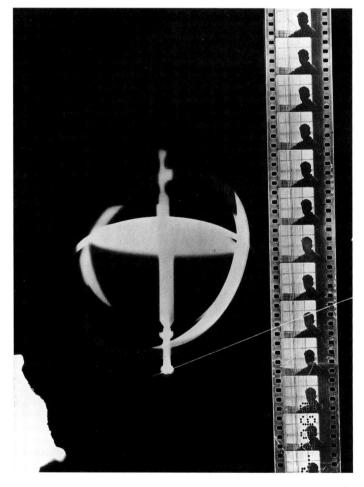

SURREALISM AND PHOTOGRAPHY

While only a few Dadaists and Surrealists seemed to use photography as a source for their images, the medium's power to distort reality proved a way for some to free themselves from traditional imagemaking. Arp, for example, may have used the cut-and-paste method of creating accidental arrangements of shapes in his reliefs, known as photomontage. This technique, arguably invented by George Grosz, was directly descended from the Cubist papier collé or collage techniques. Although we know Dali profoundly admired Jan Vermeer (1632-75), the Dutch Baroque painter, and the nineteenth-century Romantic-Naturalist Jean Louis Ernest Meissonier (1815–91), he did call his weirdly delineated paintings "hand-painted dream photographs," hinting that he was as much influenced by that medium. Along with Spanish director Luis Buñuel (1900-83), he created two Surrealist art movies, Un Chien Andalou and L'Age d'Or, using the distinctive advantages of the medium to create unusual Surrealist effects.

Two photographers liberated by Surrealism were the American Man Ray (1890-1976) and the Frenchman Henri Cartier-Bresson (b. 1908). Duchamp and Man Ray were invited to exhibit at Gallery 291 by Stieglitz and were important for introducing Dada and later Surrealism to New York. Man Ray took up photography at Stieglitz's instigation and had a long, successful career. He is credited with inventing a photographic technique, independent of cameras, which he called the Rayograph. This consisted of placing objects on or near sensitized paper and exposing it to light, thereby creating "chance" or "automatic" photographic images (fig. 10.63). These have been popular ever since. Man Ray was also a painter; in 1922, his Aerographs saw the introduction of the first spray

techniques used in the medium. Similarly, he was able to create an unearthly halo effect in his photographic *Solarizations*, which were made by exposing the film to light halfway through the development time to fog it. About 1920, Man Ray went to Paris where he lived most of the time, photographing artists, art, and fashions until he died.

Henri Cartier-Bresson, the French photographer partly influenced by Surrealism, was famous for his "chance" photographs of people engaged in their day-to-day activities. His pictures attempted to seize the moment, and his aim was "to 'trap' life . . . as it unrolled itself before his eyes." Although he was basically a photojournalist, his images have a character that goes far beyond the mere record of an incident and are creative in terms of their organization and dramatic lighting. He was also among the first to use the recently introduced 35-millimeter Leica, a format that became the most popular among professionals and amateurs alike. Recently, Cartier-Bresson has become a painter (fig. 10.64).

ABSTRACT-EXPRESSIONIST PAINTING

A host of artists mixed certain aspects of the major movements of the early twentieth century. Generally speaking, these artists found pure abstraction too impersonal, mechanical, and dehumanizing. On the other hand, they felt that Surrealism disregarded the desire for order that was traditionally fundamental to most art.

Abstract Expressionism was the next significant style that combined early

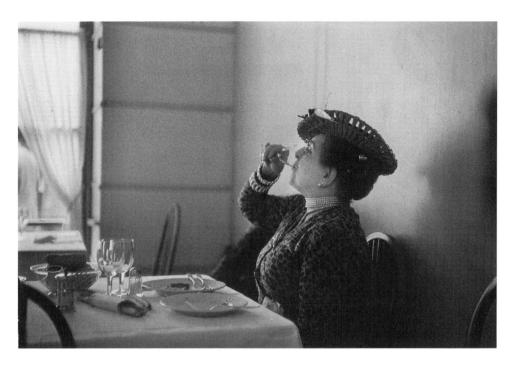

▲ 10 · 64 Henri Cartier-Bresson, An Old Customer, San Remo, Italy, 1953. Photograph.

This "chance" photograph of a genteel woman, caught at the moment of downing the last of her drink, was typical of this great photographer's semisurreal "accidental" images. © Henri Cartier-Bresson/Magnum.

twentieth-century approaches. Its significant leaders managed to combine the harmonious relationships of Abstraction with the unbidden imagery of Surrealism. Many of these leaders were Europeans, some of whom (Albers, Hoffmann, and Mondrian) we met under Abstract Art. Others, such as Willem de Kooning (1904–1997) of Holland, Arshile Gorky (1904-1948) of Turkish Armenia, Joan Miró (1893-1983) of Spain, Rufino Tamayo (1899-1991) of Mexico, and Roberto Matta Echaurren (Roberto Sebastian; b. 1912) of Chile, had a more surrealist inclination. These artists, along with the European Abstract artists, helped to pioneer this first wholly American art movement (it seemed

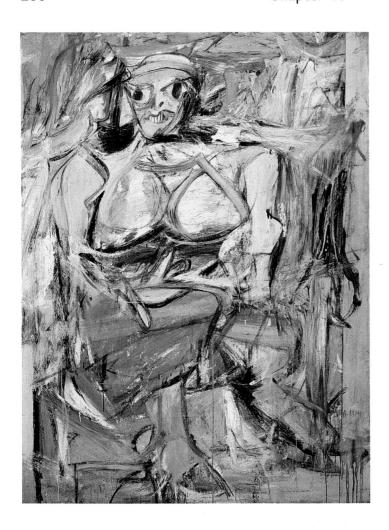

10.65

Willem de Kooning, Woman, I, 1950-52. Oil on canvas, 6 ft $2^{7}/8$ in \times 4 ft 10 in (1.90 \times 1.47 m).

This artist summarized most aspects of the romantic, or Action, group of Abstract Expressionism: revelation of the ego through the act of painting; neglect of academic or formal organization in favor of bold, direct, free gestures that are instinctively organized; and willingness to explore unknown and indescribable effects and experiences. Even though de Kooning's subject was ostensibly the figure, its representational value was subordinated to the motivating activity of pure painting.

The Museum of Modern Art, New York. Purchase. Photo: AKG, Berlin/SuperStock. © 1997 Willem de Kooning Revocable Trust/Artist Rights Society (ARS), New York.

■ 10 · 66 Arshile Gorky, Agony, 1947. Oil on canvas, 3 ft 4 in \times 4 ft 2½ in (1.02 \times 1.28 m).

A combined engineering and artistic background in his student days, plus the stimulation of Surrealism's unconscious imagery, led this artist into the emotionalized phase of Abstract Expressionism. Gorky's career followed a downward spiral of bad luck and tragedy, which seems to be mapped out in his work. His early paintings are precise and stable, gradually becoming more unsettled and unsettling in the later work. Gorky was an important influence on the younger generation of American Abstract Expressionists.

The Museum of Modern Art, New York. A. Conger Goodyear Fund. Photo: Museum of Modern Art/SuperStock.

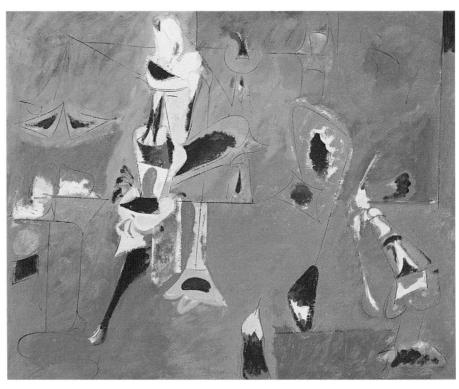

289

"wholly" so at first, but is now interpreted by some critics as an alien movement derived from Europe) (figs. 10.65, 10.66, and 10.67; see figs. 4.1, 4.5).

We also have to take into consideration the Expressionists, because Abstract Expressionism was actually a coalescence of the three major movements that had peaked in the 1930s: Expressionism, Abstraction, and Surrealism. Some deeper roots can be traced similarly to the influence of Post-Impressionism. Essentially the Abstract Expressionists wanted to state their individual emotional and spiritual state of being without necessarily referring to representational form. But one should stress that Abstract Expressionism was a movement without a common style: each artist expressed his or her experiences independently.

Works of art that would be loosely gathered under the banner of Abstract Expressionism began to coalesce in the early 1940s. By 1951, the exhibit in New York's Museum of Modern Art "Abstract Painting and Sculpture in America" made the arrival of the new style official. The artistic founders of the group were primarily painters concentrated in New York toward the end of World War II. However, by the mid 1950s, there were artists working in various media in this manner all over the United States, as well as in Western Europe, Japan, and Latin America. As the movement developed, it had a generally romantic aspect, often called "Action" or "Gestural" painting. The Action painters found their origins in the "automatic" works of such artists as Matta, Gorky, and De Kooning, and in the biomorphic abstractions of Wassily Kandinsky (see fig. 10.46). There was originally a second group more closely allied to the branch of pre-World War II Geometric Abstraction, whose overriding influence in the United States was Piet Mondrian (see fig. 1.3) and Hans Hofmann (see fig. 8.49). This group, who is now seen as in opposition

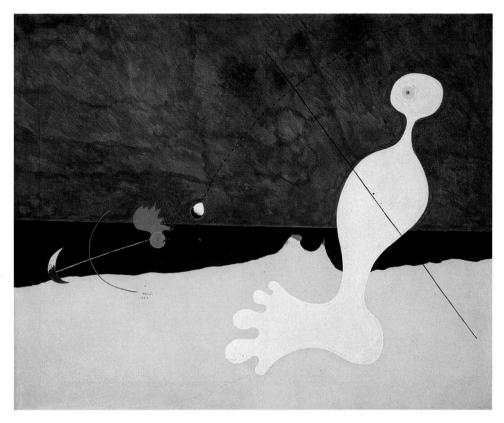

 \blacktriangle 10 · 67 Joan Miró, Person Throwing a Stone at a Bird, 1926. Oil on canvas, 29 × 36½ in (73.7 × 92.1 cm).

Miró here combines sophisticated color and biomorphic shapes with simple childlike images. The Abstract Surrealism of Miró is, in general, semirepresentational in character.

The Museum of Modern Art, New York. Purchase. Photo © 1998 Museum of Modern Art. © 1997 Artists Rights Society (ARS), New York/ADAGP, Paris.

to the impromptu looseness or "painterliness" of Abstract Expressionism, is labeled *Post-Painterly Abstractionists*. They are discussed later in this chapter.

Jackson Pollock and Franz Kline may be considered among the outstanding artists of Abstract Expressionism. They worked in a way that was reminiscent not only of Surrealism and Kandinsky's prewar biomorphic expressionism, but their brush technique also reminds people of Impressionism. Confusion, fear, and uncertainty about humanity's place in a world threatened by thermonuclear holocaust may have led such painters to reject most previous forms of twentieth-century art and, as a kind of personal catharsis, to express their belief in the "value of doing" at the expense of disciplined design. For example, Jackson Pollock (1912–56) is frequently cited as the sole originator of the "gesture," on which Action Painting was founded (although Navajo sand painting is said to have been a strong influence on him, because it also requires the use of the gesture to apply the colored sand). Pollock's swirling, nonrepresentational images created out of linear skeins of fast-drying paint

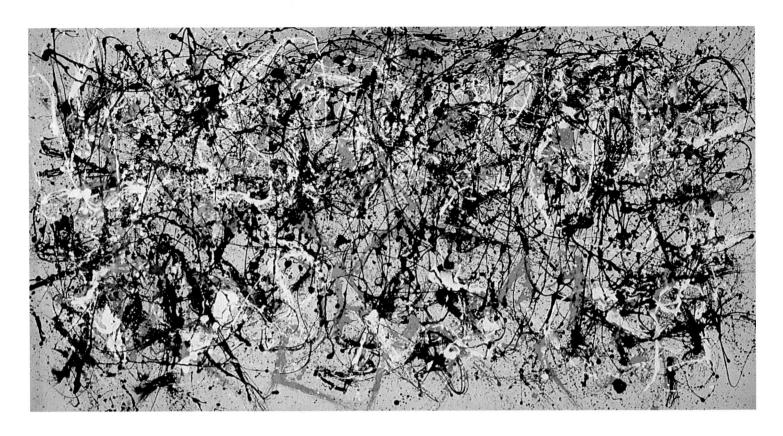

 \blacktriangle 10 · 68 Jackson Pollock, Autumn Rhythm, 1957. Oil on canvas, 8 ft 9 in \times 17 ft 3 in (2.67 \times 5.26 m).

This artist is considered the prime example of youthful Abstract-Expressionist Action painters in the late 1940s. He is noted primarily for creating swirling nonrepresentational images in linear skeins of fast-drying paint that are dripped directly onto canvases through controlled gestures of his tools.

Metropolitan Museum of Art, New York. George A. Hearn Fund, 1957. © 1997 The Pollock-Krasner Foundation/Artists Rights Society (ARS), New York.

dripped directly onto large canvases, expressed through the direct act of creation the reality of self (figs. 10.68 and 10.69).

Franz Kline (1910–62) followed a slightly different course but with a similar intention of expressing self through direct contact with the forms created. His drawings were made with gestures of a brush on newsprint, then cut up and reassembled to provide a sense of power, movement, and an intensified personal rapport. Kline used these "sketches" as guides and enlarged them with loaded brushes on large canvases without directly copying them. Applied with a house painter's brush, his

savage slashings in black and white, or sometimes color, became monumental projections of inward experiences (fig. 10.70).

The daring and willingness to explore the unknown self that such artists displayed were also expected of the viewer. This conscious attempt to involve the spectator in art is, perhaps, the leitmotif of the second half of the twentieth century, going far beyond a similar endeavor in much previous art. Perhaps one of the reasons for recent efforts among artists to involve the viewer is the increased awareness of the pressures and aberration caused by urban life. Art serves as a tonic for helping

people to escape, if only momentarily, their sordid surroundings. We must remember that the early careers of many of these New York artists had been marked by neglect and deprivation.

ABSTRACT-EXPRESSIONIST SCULPTURE

Many sculptors worked in forms allied to Surrealism, but with a greater degree of formality. These ranged from the organically sleek figures of the Englishman Henry Moore (1898–1986) to the built-up, open-wire, and welded sculptures prefigured by the forms of González and Picasso in the 1930s. Among those influenced by wire or linear sculpture was the maker of mobiles, Alexander Calder (1898–1976). González, as the pioneer of welded sculpture, must also be credited with influencing a younger generation of sculptors, most important of whom was David Smith (1906-1965).

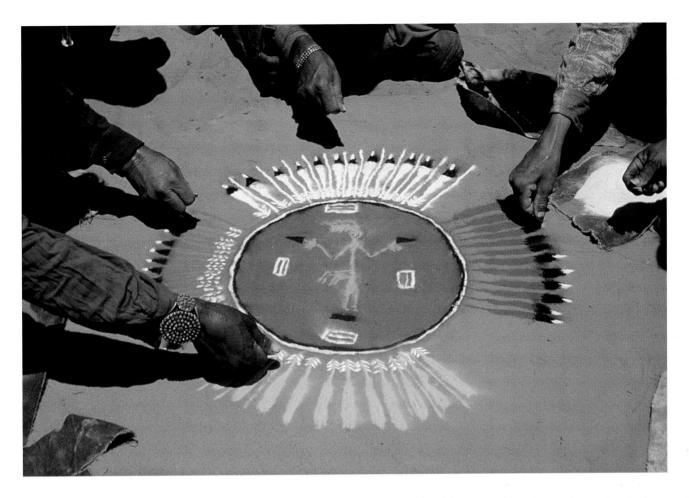

A 10 · 69

Navajo dry or sand painting. Photograph.

This kind of painting used by the Navajo for religious and symbolic healing powers is said to have influenced the gestural style of Jackson Pollock. Medicine men and their helpers crushed sandstone, pollen, and charcoal. The works are temporary, needing to be destroyed by sunset to avoid evil spirits. This example depicts the sun god and the sacred eagle.

© Charles W. Herbert/National Geographic Image Collection.

▶ 10 • 70

Franz Kline, Mahoning, 1956. Oil and paper collage on canvas, 6 ft 8 in \times 8 ft 4 in (2.03 \times 2.54 m).

The artist was more interested in the actual physical action involved in this type of expression than in the character of the resulting painting.

Collection of the Whitney Museum of American Art, New York. Purchase, with funds from the Friends of the Whitney Museum of American Art, 57.10.

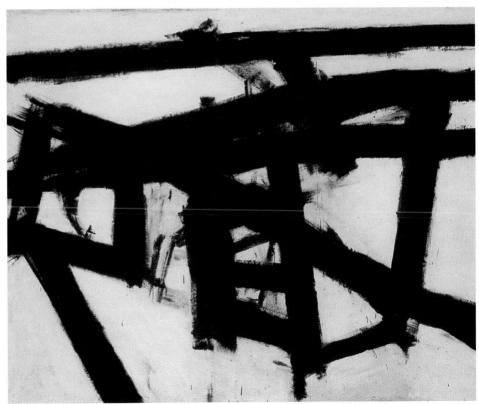

Henry Moore merged the vitality and expressive potential of González and Arp with such older traditions as Egyptian, African, and pre-Columbian sculpture, which he had discovered as a student. Moore's objective over the years was to create lively, though not lifelike, forms. His sculptures emphasize the natural qualities of the selected materials; only secondarily do they resemble human forms. In this respect, his frequently repeated theme of the reclining nude seems to retain in stone a geologically inspired character, and in wood a sense of organic growth and an emphasis on the natural grain. Moore was primarily responsible for

reestablishing British art on the international scene and laid the basis for the great vitality British art has shown in the twentieth century (fig. 10.71).

The Latvian sculptor Jacques Lipchitz (1891–1973), who worked in France before World War I and was strongly influenced by Cubism at the time, began to be concerned with the Surrealist idiom in the 1930s. He developed a highly robust configuration of freely flowing, knotted, and twisted masses that evoke at times the agonies of birth, death, and psychic torment; and, at other times, he depicted nameless new species of mythological monsters. The horrors of the Jewish holocaust in World

War II were in the minds of many of these artists. From Surrealism, Lipchitz had also gleaned the semiautomatic principle, kneading his favorite sketching medium of clay into shapeless blobs without forethought. Then, through the accident of suggested form, he would construct the finished piece (fig. 10.72). Lipchitz, whose fame became international, came to the United States in 1941 and strongly influenced a younger generation of American Abstract-Surrealist sculptors.

Certainly one of the most significant American pioneers of Surreal-Abstract sculpture was the Philadelphia-born Alexander Calder. Calder's father was a sculptor working in a conservative nineteenth-century Realist style. At first, Calder reacted to this academic conservatism by training as an engineer. However, he was soon ensconced at the Art Students League in New York from where, in 1926, he left for Paris. There he began to create the wire sculptures of animals that won him almost immediate recognition. In the late 1920s, he was mingling in Dada, Surrealist, and abstract circles, meeting people like Miró, Duchamp, Mondrian, Arp, and González. These new associations led him to drop figurative work for free-form abstract

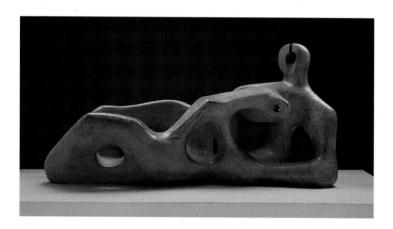

A 10 · 71

Henry Moore, Reclining Figure, 1939. Carved elm wood, 37 \times 79 \times 30 in (94 \times 201 \times 76 cm).

Moore's work is a synthesis of influences from primitive sculpture, Surrealism, and a lifelong study of the forms of nature.

Detroit Institute of Arts. Founders Society Purchase with funds from the Dexter M. Ferry, Jr., Trustee Corporation. Reproduced by permission of the Henry Moore Foundation.

▶ 10 • 72

Jacques Lipchitz, Rape of Europa, 1938. Bronze, 16×23 in $(40.6 \times 58.4 \text{ cm})$.

After an early exposure to Cubism, Lipchitz developed his unique sculptural shapes and personal symbolism, but his Cubist background always served as a disciplinary force.

Art Institute of Chicago. Gift of an anonymous donor, 1943.594. Photo: Robert Hashimoto/Art Institute of Chicago. © 1998 Estate Jacques Lipchitz, licensed by VAGA, New York/Courtesy Marlborough Gallery, NY.

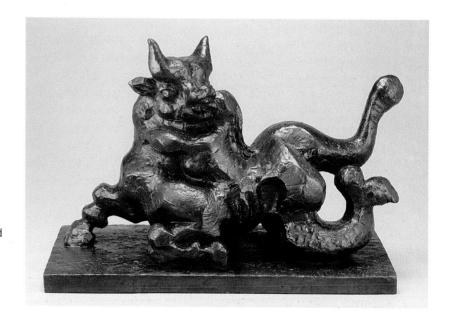

shapes of sheet metal and wire, and by 1930, he had created the first of his mobiles. His earlier kinetic assemblages (see pages 298 and 301) had been powered by motors and pulleys; but, the delicate balance and perfect engineering of the mobiles needed only air currents to create rhythmic, varied motion, producing ever new compositions and relationships of shapes in space (see fig. 9.35). Thus, Calder was able to express the fourth dimension of time and movement in space, for which artists, with their implied kinetics, had been trying to accomplish since the beginnings of Impressionism.

Calder evolved three basic types of assemblage (a term invented by Marcel Duchamp in 1950):

- 1. The *stabile* is usually attached to a base, can rest on the ground, and does not move. However, some later ones were made with moving parts.
- 2. The *mobile* hangs in the air, usually from a ceiling.
- 3. The *constellation* is a form of mobile that is usually suspended on one or more arms from a wall.

Mobiles are probably one of the most popular forms of modern art, and Calder is thus considered by many as among the most important American artists of the twentieth century. From 1933 until his death in 1976, Calder divided his time between farms in Connecticut and France, where he created, toward the end of his career, monumental stabiles and stabile/mobiles of welded iron, some of which were architectural in scale (fig. 10.73).

The promising career of David Smith, (1906–65), an Ohio native who studied at the Art Students League in New York during the late 1920s and early 1930s, was cut short by a fatal automobile accident in 1965. In the thirties, pictures of González's and Picasso's Surrealist sculptures awoke his interest in creating similar Surreal-Abstract forms. Their influence helped

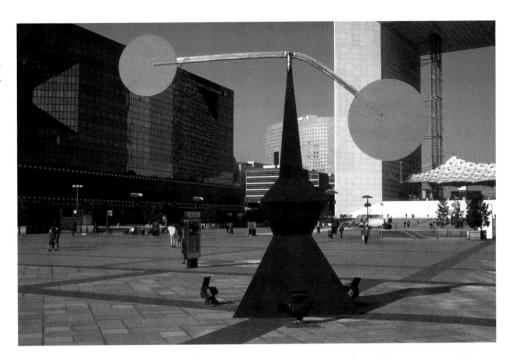

him to originate welded sculpture, and he was reportedly the earliest American artist to employ this technique. Smith usually investigated linear sculptures and volumetric shape systems at the same time. Smith's use of such materials as welded sheets of wrought iron and steel give his sculptures an undeniable power, reminiscent of both Cubism and Constructivism and the Action painting of Franz Kline. The slashing diagonals of his linear forms and metal cubes, in particular, remind one of Kline's black diagonals against their flat white-canvas surfaces. Smith's last cubic style before his death influenced the next generation of sculptors, who, like their counterparts in painting, broke away from the metaphysical subjectivism of Abstract Expressionism (fig. 10.74).

Another distinguished international sculptor is the Japanese-American, Isamu Noguchi (1904–88), who started his career studying with the academic sculptor Gutson Borglum (1867–1941) before studying further in New York, Japan, and France. He was in Paris on a Guggenheim fellowship at the height of Cubist and Surrealist domination. Noguchi's study with Brancusi was

A 10 · 73

Alexander Calder, Totem, on the Parvis de la Defense, Paris, 1974. Painted steel.

A late work by the famous inventor of movable sculpture combines portions of moving (mobile) and static (stabile) forms. Photo © Art on File/Corbis Media. © 1997 Artists Rights Society (ARS), New York/ADAGP, Paris.

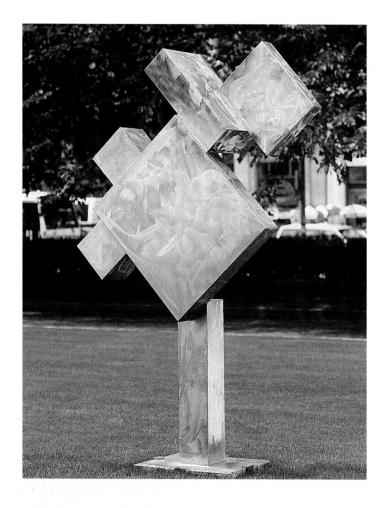

A 10 · 74

David Smith, Cubi VII, 1963. Stainless steel, 9 ft 3\% in (2.83 m) high.

Smith was rarely concerned with likeness to natural objects. Instead, he used nonobjective forms and tried to give them a life of their own through his animated arrangement.

Art Institute of Chicago. Grant J. Pick Purchase Fund, 1964.1141. Photo © Art Institute of Chicago. All rights reserved. © 1998 Estate of David Smith/licensed by VAGA, New York.

A 10 · 75

Isamu Noguchi (and Shoji Sadao), California Scenario, located at Two Town Center, Costa Mesa, California, 1981–82.

The work of the great Japanese-American sculptor Isamu Noguchi ranged from pure abstract through Surreal-Abstract and Minimalist styles, but he is equally well-known for his architecturally oriented plazas in various parts of the world.

Courtesy of the Isamu Noguchi Foundation Inc., Long Island City, NY. (Photograph © Gary McKinnis.)

particularly important; he also became acquainted with Calder while in France. His first exhibit of Constructivist-like sculpture took place in New York in 1929. Noguchi was soon widely recognized as an important sculptor; but, throughout his career, he also pursued interests in architectural landscape, furniture, and theatrical design. Always aware of both his Asian heritage and Western origins, his sculpture, with a sense of grace and elegance, makes use of a kind of Surreal-Abstract biomorphics.

Noguchi's style ranged from near Surrealism to something approaching Minimalism (see figs. 9.1 and 9.33). One of Noguchi's distinguished landscape designs and sculptures can be seen in the *Plaza at Costa Mesa*, California (fig. 10.75). Perhaps through his association with Brancusi, Noguchi has always shown an inclination for a complete mastery of craft, which entails the use of beautiful materials. His preferred taste was for stone, which shows how Noguchi cherished color. Color adds an

inestimable charm to his works, whether the works are small or very large.

ABSTRACT-EXPRESSIONISM AND PHOTOGRAPHY

In the years after World War II, there were at least two photographers whose work continued to show the Straight photographic influence of Stieglitz and his group while bearing a resemblance to

the Abstract-Expressionist painting then developing. The most important of these photographers was Minor White (1908-1976). His background of psychology and religious studies provided a basis for the expressive sensitivity seen at work in his photography. White also wrote poetry and sometimes used it in conjunction with photographs to enhance their meaning. Although he generally created Straight images of a Realist kind (see fig. 1.15), White often favored two forms tending towards abstraction—the Equivalents, based on those of Stieglitz (fig. 10.76), and the Sequences, which he invented. The Sequences appear to draw upon organic natural forms and, while often obscure in form and meaning, generally seem to concern White's own feelings, as do the Equivalents. His photographs were often metaphysical, expressive of the fears and tensions of his time, and were probably a form of personal catharsis. White's imagery was masterly and beautiful in its use of detail, texture, and value relationships, or luminosity. The reasons for his importance as a force in creative photography are multiple: the frequent exhibits of his work; his association as a staff member of the George Eastman House; his editing of the influential Aperture journal; his teaching and workshops, held at technological institutes across the country—all contributed to his respected position.

A second post-World War II photographer whose work sometimes seems similar to Abstract-Expressionist painting was Harry Callahan (b. 1912). Early in his career, he became interested in pattern and design, creating images reminiscent of Paul Strand and Edward Steichen. Callahan's main source of inspiration was the second generation of Stieglitz-influenced photographers—Ansel Adams and Edward Weston. To some degree, he also emerged from the Bauhaus tradition of Moholy-Nagy (1895–1946) at the Chicago Institute of

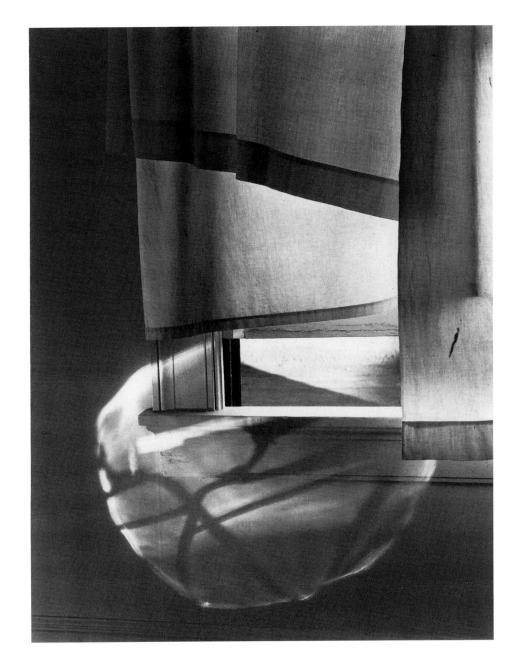

Design (sometimes called the American Bauhaus). From the 1940s forward, he worked in a multitude of styles that always showed his interests in form; his subjects ranged from nudes and street photographs to multiple-exposure abstractions. Callahan's more abstract works are often akin to those of the Color Field painters; even the realistic trees of *Chicago*, 1950, can conjure up the stark lines of a Newman or Noland against a single color ground. It is this range from dark to light, this sparse

▲ 10 · 76 Minor White, Windowsill Daydreaming, 1958. Photograph.

A follower of Stieglitz's Straight photography, White applied his knowledge of religion and psychology to his photography. His study of early morning sunlight pouring through a window has an almost mystical sensitivity. Reproduction coursesy of the Minor White Archive, Princeton University, NJ. © 1982 by the Trustees of Princeton University. All rights reserved.

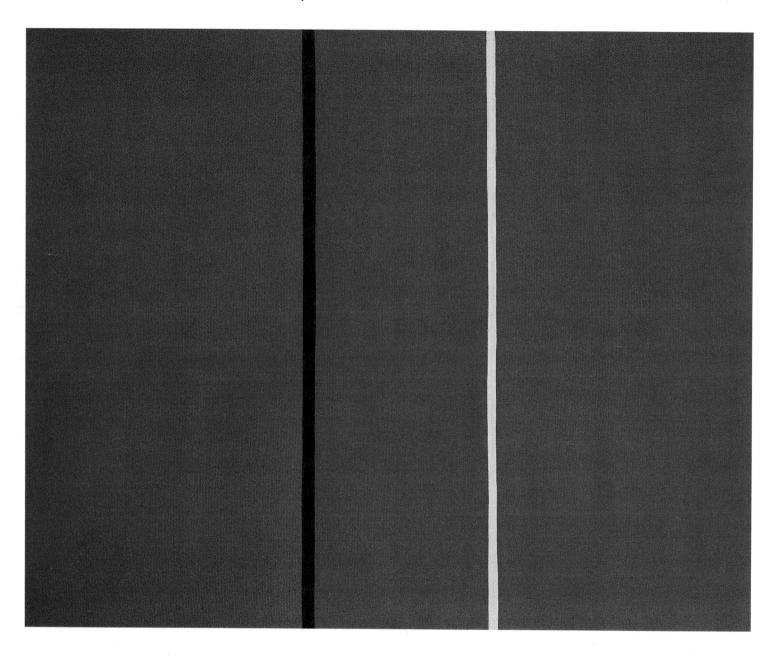

A 10 · 77

Barnett Newman, Covenant, 1949. Oil on canvas, 3 ft $11\frac{3}{4}$ in \times 4 ft $11\frac{5}{8}$ in $(1.21 \times 1.51 \text{ m})$.

This example is characteristic of Newman, an early Color Field painter. Such works generally feature carefully placed stripes superimposed on a flat color.

Hirshhorn Museum and Sculpture Garden, Smithsonian Institution, Washington D.C. Gift of Joseph H. Hirshhorn, 1972. Photo: Lee Stalsworth. © 1997 Barnett Newman Foundation/Artists Rights Society (ARS), New York. realism and lyrical simplicity, that make Callahan's work notable. Like White, Callahan was a teacher, organizing the highly admired and popular program at the Chicago Institute of Design.

POST-PAINTERLY ABSTRACTION

The first serious challenge to the dominance of Abstract Expressionism after World War II was among a group of painters known as the *Post-Painterly*

Abstractionists. This category of painting has also been called Hard-Edge and Color Field painting. The painters in this group all owe a debt to early twentieth-century Geometric Abstract works, particularly that of Josef Albers. His series called Homage to the Square (see fig. 4.25) had a particularly strong influence. In this series, Albers' interest in Gestalt psychology is expressed through the effects of optical illusion. He created passive, free-floating square shapes that had just enough contrast of value, hue, and intensity with surrounding colors to

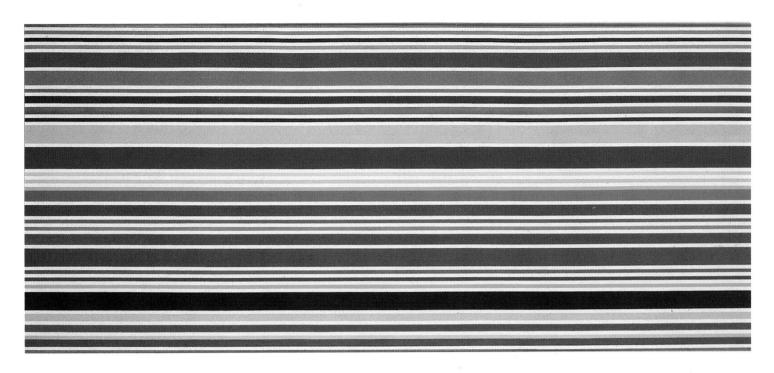

be able to emerge slightly from the background. Albers' successors, Color Field painters like Barnett Newman (1905-70) and Ellsworth Kelly (b. 1923), stress definition of edges or shapes that are set off more explicitly than others in the Color Field (fig. 10.77 and see fig. 1.25). These painters generally were a more classical or restrained group than the Abstract Expressionists who were their contemporaries. They explored extremely large scale, unified color fields of personally conceived shapes or signs concerned primarily with provoking sensations of ritual, human tragedy, mythology and the like.

Other artists in Color Field painting of note were Kenneth Noland (b. 1924), and Frank Stella (b. 1936) (fig. 10.78 and see fig. 2.3). Most of them use stripes or bands of color moving in different directions, or spots and shapes of various kinds—specific combinations of these are trademarks of their individual styles. Others typical of this group who used less sharply defined shapes were Mark Rothko (1903–70), Morris Louis (1912–1962), and Helen Frankenthaler (b. 1928). Frankenthaler, younger than

A 10 · 78

Kenneth Noland, Wild Indigo, 1967. Acrylic on canvas, 7 ft 5 in \times 17 ft 3 in (2.26 \times 5.26 m).

Noland's Hard-Edge, nonobjective painting is descended from Cubist works like Léger's. Without the benefit of any representation, the meanings we intuit in such a work are less obvious and appeal to the intellect. Compared to a biomorphic work such as Matta's *Listen to Living* (see fig. 4.5) with its soft edges and emotional implications, we must seek meaning in Noland through a more cerebral approach.

Albright-Knox Art Gallery, Buffalo, NY. Charles Clifton Fund, 1972. © 1998 Kenneth Noland/licensed by VAGA, New York.

the others, is still actively at work and often appears closer to the gestural group in Abstract Expressionism.

Because Abstract Expressionism and Post-Painterly Abstraction were contemporary movements they sometimes influenced or overlapped one another somewhat. It is not surprising that paintings by each, therefore, were meant to enwrap the spectator and make him or her a part of the painting through shared sensation. One of the most interesting of the Color Field painters, Mark Rothko (1903–1970), is said to have been inspired by the emotional and spiritual qualities of expression he found in primitive and archaic art. He also

believed in the flatness of the picture plane and large rectangular shapes to express "complex ideas simply" (fig. 10.79). Helen Frankenthaler is considered another important Color Field painter because of her novel method of staining canvases by pouring handsome tones of color on unprimed canvases that soak up the brilliant colors. She is said to have been influenced by witnessing Jackson Pollock pour thinned black paint on raw canvas. She used oil paint in this technique until acrylics became popular (see fig. 4.27).

Morris Louis also explored this technique of the direct application of color in thin washes so they become one

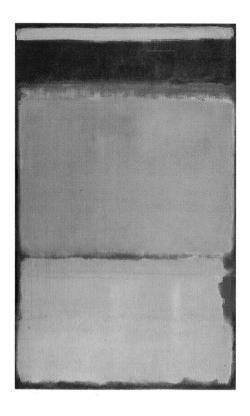

Mark Rothko, Number 10, 1950. Oil on canvas, 7 ft 6^{3} /8 in \times 4 ft 9^{1} /8 in (2.30 \times 1.45 m).

Using apparently simple masses of color on a large scale, the artist is able to evoke emotional sensations in the observer. Rothko was one of the American artists who worked in the pure abstract idiom.

The Museum of Modern Art, New York. Gift of Philip Johnson. Photo © 1998 Museum of Modern Art. © 1997 Kate Rothko Prizel & Christopher Rothko/Artists Rights Society (ARS), New York.

with the surface (fig. 10.80). Frank Stella is of interest because of the excitement evoked by his tremendously enlarged, shaped canvases (see fig. 2.3).

OP ART

The "Op" in *Op Art* is an abbreviation for "optical." This form of art is primarily graphic, although it merges into three-dimensionality when the colors used in paintings provide the illusion of relief. Op Art is, once more, an extension and modification of earlier twentieth-century Geometric Abstraction. Even while some artists were opposing the relative obscurity of meaning in modern abstraction, others chose to send abstract art in yet another direction. Among the artists who chose to do this were the *Kinetic* and *Light*

₹ 10 - 80

Morris Louis, Number 99, 1959. Acrylic on canvas, 8 ft 3 in \times 11 ft 10 in (2.51 \times 3.61 m).

The Color Field painter Morris Louis pioneered the technique of flooding the canvas with liquid pigments, which rendered his stripes and shapes soft-edged and almost intangible. Louis was also one of the earliest painters to explore spray-painting.

Contemporary Collection of the Cleveland Museum of Art, 68.110, Cleveland, OH. © 1993 Marcella Louis Brenner.

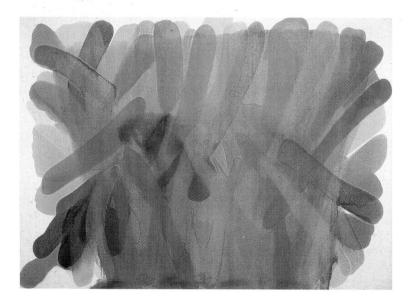

sculptors, the *Minimalist* sculptors, and the *Op* artists: Victor Vasarely (b. 1908), Richard Anuszkiewicz (b. 1930), and Bridget Riley (fig. 10.81; see figs. 2.23, 2.33, and 7.22). These artists employed precise shapes, sometimes wiggly lines or concentric patterns that have a direct impact on the physiology and psychology of vision. They explored wavy patterns that seem dedicated more to the scientific investigation of vision than to its evocative expression in art.

ASSEMBLAGE

Drawn by technological innovations, artists have often met the desire for change by refusing to observe the separate categories of painting and sculpture, instead merging the two in assemblages. This mixture of hitherto separate disciplines has its closest parallel in Baroque art of the seventeenth century, in which a similar intermingling of traditionally separate media and disciplines took place. Some artists have explored film, video, dance, and theater, and computer-generated art. A fusion of computer technology with video, particularly, has been of great significance recently.

Robert Rauschenberg (b. 1925) was one of the first to drift away from pure Abstract Expressionism. He combined pure, fluid brushwork in pigments with foreign materials like old mattresses, wireless sets, photographic images, and stuffed animals attached to the canvas. He called his new forms *Combines*. From Rauschenberg's combine-paintings came much of the new art of *Assemblage* (fig. 10.82; see fig. 6.10), a term used before in relation to Calder's distinctive works.

The popularity of assemblage and the enhancement of the Dada idea of the "found object" led to a revival of what has been referred to as "junk" sculpture. The Dadaists—as well as Picasso—can be said to have pioneered the use of "found objects" as works of art—see Marcel Duchamp's *Bicycle Wheel* (see fig.

▶ 10 • 81

Bridget Riley, Drift No. 2, 1966. Acrylic on canvas, 7 ft $7\frac{1}{2}$ in \times 7 ft $5\frac{1}{2}$ in (2.32 \times 2.27 m).

Op artists generally use geometric shapes, organizing them into patterns that produce fluctuating, ambiguous, and tantalizing visual effects very similar to those observed in moiré patterns, such as in door or window screens. Albright-Knox Art Gallery, Buffalo, NY. Gift of Seymour H. Knox. 1967.

10.56) and Picasso's work from about 1914 on (see fig. 10.54). Ultimately, all similar forms of art stem from Picasso's and Braque's experiments with collage in the early part of the century. It is not too surprising to find, therefore, that the "junk" later twentieth-century artists used, was based on these earlier experiments. They often included scrapped fragments of such industrial forms as automobiles, farm machinery, factory parts, airplanes, tubes, and pipes. The satire here was implicit: many of these items were the cast-offs of an overly affluent and wasteful society. John Chamberlain's (b. 1927) sculptures, made from the parts of wrecked automobiles, and those of Richard Stankiewicz (b. 1922), created by welding together old boilers, sinks, and the like, are a kind of comment on consumer culture that can also be found in Pop art (fig. 10.83). The artists just mentioned are American, but Europeans like César (Baldaccini) (b. 1921) work along similar lines.

Edward Kienholz's (1927–94) works, which he called *Tableaux*, also fall into

▶ 10 • 82

Robert Rauschenberg, Monogram, 1955–59. Construction (free-standing combine), 3 ft 6 in \times 5 ft $3\frac{1}{4}$ in \times 5 ft $4\frac{1}{2}$ in (1.07 \times 1.61 \times 1.64 m).

In this combine-painting that merges into three-dimensional assemblage, one can witness the drift away from the pure painting of the 1950s. Such work provided a platform for the Pop art movement that followed shortly.

Moderna Museet, Stockholm, Sweden. Photo: Per Anders Allsten. © 1998 Robert Rauschenberg/licensed by VAGA, New York.

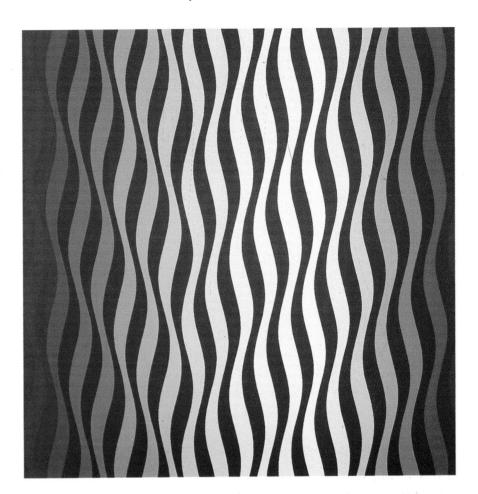

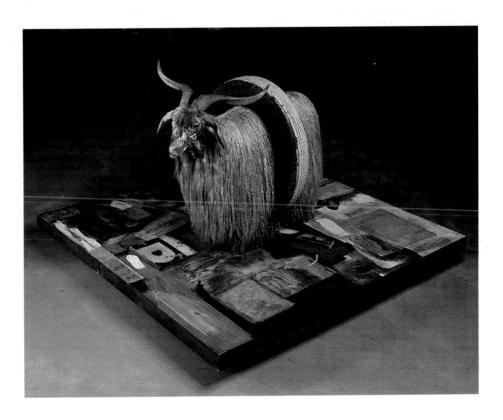

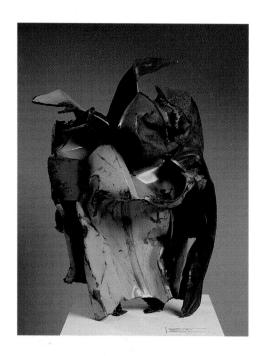

4 10 ⋅ 83

John Angus Chamberlain, Untitled, 1958–1959. Painted and welded metal, $32\frac{1}{2} \times 26\frac{1}{2} \times 24$ in (82.6 × 67.3 × 61 cm).

The popularity of assemblage, enhanced by the Dadaist idea of the "found object," led to the junk ethos of metal and other material form combinations. During the 1950s and 1960s, artist of this persuasion, like Chamberlain, who worked with bent and crushed metal from old automobiles, were dubbed Neo-Dadaists.

Cleveland Museum of Art, Cleveland, OH. Andrew R. and Martha Holden Jennings Fund, 73.27. © 1997 John Chamberlain/Artists Rights Society (ARS), New York.

the category of assemblages. His varied combinations of materials have something of the shock value of Dada, making pungent comment on the sickness, tawdriness, and melancholy of modern society (fig. 10.84).

Early in her career, Louise Nevelson (1899–1988) was using smooth abstract shapes in a way comparable to Henry Moore. Later, when she moved toward assemblage, she developed her own

₩ 10 • 84

Edward Kienholz, *The Wait*, 1964–65. Tableau: wood, fabric, polyester resin, flock, metal, bones, glass, paper, leather, varnish, B/W photos, taxidermed cat, live parakeet, wicker, and plastic; I3 units, overall: $80 \times 160 \times 84$ in (203.2 \times 406.4 \times 213.4 cm).

This artist belongs to a branch of assemblage art sometimes known as environments. His tableaux of the old, the derelict, and the mentally handicapped are comments on the sickness, tawdriness, and melancholy of modern society.

Collection of Whitney Museum of American Art, Gift of the Howard and Jean Lipman Foundation, Inc. 66.49a-m.

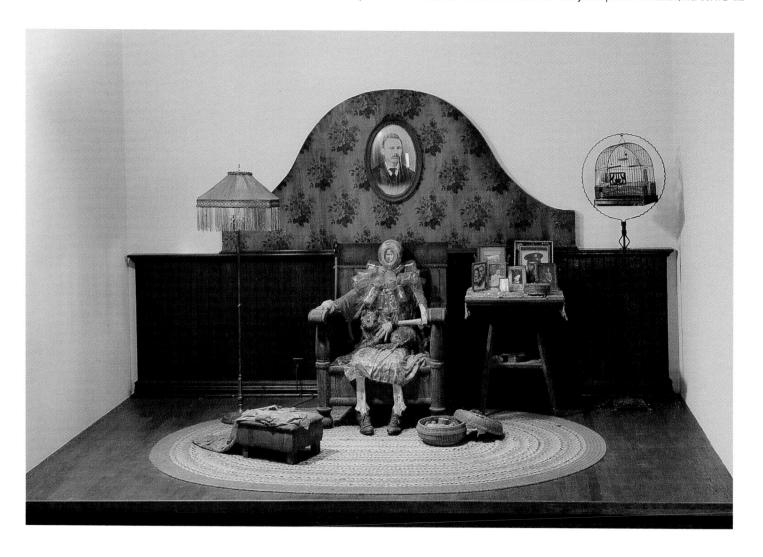

distinct style by fitting together readymade wooden shapes, such as knobs, bannisters, moldings, and posts gleaned from demolished houses and old furniture. These fragments were articulated into boxlike compartments various-sized rectangles and squares that became large screens or freestanding walls. These complex pieces were usually painted a uniform color, which stressed the unified relationship between the parts. The relationships and complexities of Nevelson's forms seem in keeping with a recent trend toward Process Art, but her final results are often more exciting than those of artists like the Minimalists, who often emphasized process over content (fig. 10.85).

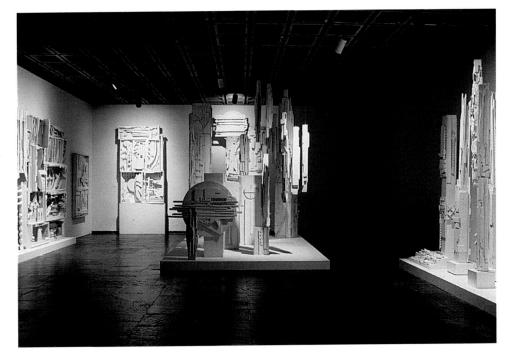

KINETICS AND LIGHT

Kinetic forms of art are those that create movement, while those that create *Light* may take various forms—from incandescence and fluorescence to reflectiveness. Light sculptures often combine materials similar to "assemblages."

Obviously kinetics are partly derived from Calder's motor-driven, wire and wood circus of the 1920s and later mobiles, but they also owe their origins to Dadaism and Op Art. Dadaists, under the aegis of their antitraditional and destructive credo, created the first examples of actual movement or kinetics in art. The earliest examples can be found in the work of Marcel Duchamp. For a short period in the twenties, he became fascinated by the swirling designs produced by phonograph turntables or disks driven by other rotating means. Duchamp, however, soon lost interest in movement, but Calder did not.

Many kinetic artworks use a mechanical means to make the art object move, as in the example by Pol Bury (b. 1922) (fig. 10.86). Other pieces, such as those by George Rickey (b. 1907), use wind to produce motion, as did those of

A 10 · 85

Louise Nevelson, American Dawn, 1962. Painted wood, $18 \times 14 \times 10$ ft (5.49 \times 4.27 \times 3.05 m) in situ.

This example of the assemblage concept in today's art is by a well-known sculptress. She utilizes separate, columnar shapes that build up in a unified but dynamic overall form. The shapes are a change from the more frequently used boxlike screens that enclose smaller sculptural units in other works.

Art Institute of Chicago. Grant J. Pick Purchase Fund, 1967.387. Photo: Jerry L. Thompson, Art Institute of Chicago. All rights reserved. © Estate of Louise Nevelson.

Pol Bury, The Staircase, 1965. Wood with motor, $78^{5}/8 \times 27 \times 16^{1}/4$ in (200 \times 68.6 \times 41.3 cm).

Here is an example of an art form where the components (the ball shapes) actually move. Today a growing number of technologically oriented artists exploit the possibilities of such kinetic art.

Collection, the Solomon R. Guggenheim Museum, New York. Photograph by Robert E. Mates; © The Solomon R. Guggenheim Foundation, New York; 65.1765. © 1997 Artists Rights Society (ARS), New York/ADAGP, Paris.

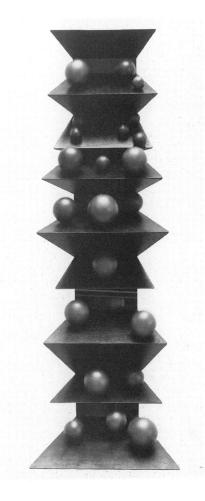

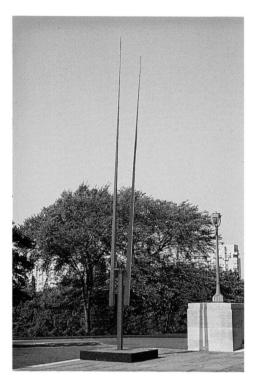

Calder. Nonetheless, Rickey's style is imaginatively distinct from Calder's and is a distinguished accomplishment in its own right (fig. 10.87). While kinetics owes something of its origins to Op Art, the latter remains primarily a static form, using various realistic devices to suggest movement. Kinetic Art is thus another form deriving from a concern with space and time that began with elements of Impressionism in the late nineteenth century and continued with Futurism, Dadaism, and Calder's Surreal-Abstract mobiles in the early twentieth century.

Present-day kineticists use mechanical or electronic means, as well as random movement, to achieve their ends. Jean Tinguely (b. 1925) created large, slack, junky contrivances that outdid the imaginary cartoons of Rube Goldberg in the 1920s and 1930s.

▲ 10 • 87
George Rickey, Two Red Lines II, 1967. Painted

steel, 37 ft \times 30 in \times 8 in (11.28 m \times 76.2 cm \times 20.3 cm).

Many of Rickey's works are kinetic, having been constructed to make use of the wind and so to provide constantly changing views of the parts.

Collection of the Oakland Art Museum, CA. © 1998

George Rickey/licensed by VAGA, New York.

₩ 10・88

Dan Flavin, *Untitled* (in memory of my father, D. Nicholas Flavin), 1974. Daylight flourescent light (edition of three), 8×48 ft (2.44 \times 14.63 m).

One of the artists who has devoted much of his career to light sculptures or assemblages, Dan Flavin represents a branch of artists working with static assemblies of fluorescent lights, as opposed to the moving, or kinetic, forms of others.

Courtesy Leo Castelli Gallery, New York. © 1997 Estate of Dan Flavin/Artists Rights Society (ARS), New York.

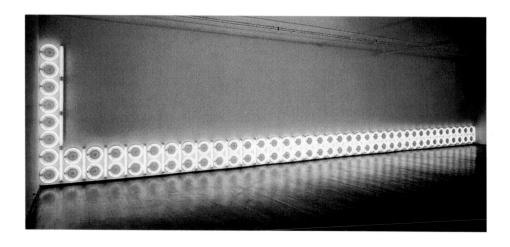

Tinguely's pieces usually move about, but more often merely stood and shook, as if they were about to scatter the gears and cogs that ran them. In fact, Tinguely's most famous kinetic construction of this kind, called Homage to New York, did just that, destroying itself in 1960 in the garden of the Museum of Modern Art in New York (see fig. 9.44 for an existing example of a Tinguely). The sculptors or assemblers of light forms, such as Dan Flavin (b. 1933), explore lighted objects, sometimes combining them with movement and electronically produced sounds to create kinetic fantasies. Artists who create light sculptures mainly use neon light in their assemblages (fig. 10.88).

Another artist producing a slightly different kind of lighted sculptural form is Richard Lippold (b. 1915). Primarily seen as a pioneer of welded sculpture, he did not actually light his sculptures, but constructed them from such bright materials that they take on a mystic luminescence when lit up by external sources. He created some distinctive linear forms of this kind that are compatible with such monumental architectural settings as churches and commercial buildings (see fig. 9.27).

MINIMALISM

Minimalists, of whom the nonconformist New Yorker Ad Reinhardt (1913-67) was a key figure in the late 1950s, painted pictures in such close values that only after intense concentration could the spectator determine that any shapes or lines or other elements of form were present at all (fig. 10.89). In sculpture the Post-Painterly Hard-Edge Abstractionists are paralleled by a group of artists that includes Donald Judd, Anthony Caro (b. 1924; a British artist who worked for a time with Henry Moore) (see figs. 9.42 and 4.4), and others. They have transformed the late mechanomorphic cubes of David Smith into blunt

sculptures of simplified geometric volumes that seem stripped of all psychological or symbolic content. These artists have been variously labeled, but Minimalists seems to be the popular word today. Quite often they rejected metal and welding for materials hitherto uncommon in sculpture, such as cardboard, masonite, plywood, plastics, and glass. Some, like Larry Bell (b. 1939), use hard sheet plastic (plexiglas) or tinted glass to create transparent volumes that enclose space (fig. 10.90). While a few artists still preferred the abstract mass or solid, most of the Minimalists apparently wanted to obliterate the core, creating simple volumes of enclosed space, or opening up numerous voids. Some of these pieces are merely boxes of gigantic size. (Large size is a characteristic of much twentieth-century sculpture and painting.) Donald Judd (1928-94), another proponent of Minimalism, constructed a repeated sequence of loafshaped boxes hung on a wall, relief fashion (see fig. 9.42). Later he turned to making sculptures of identical large, open-centered concrete boxes. Whether repeated either in the same or different materials, Judd's and others' sculptures were often laid out in rows or stacked up vertically. In the 1970s, when a considerable number of such "repeats" were laid out on the floor of galleries, museums, warehouses, or other open spaces (they had to be large enough areas to contain some of them); they were labeled siteworks or Site Art. This subject will be discussed later in the chapter.

There is, however, another branch of Minimalist Art that preferred open spatial forms to the simplified volumes of the first group considered. Their main distinction from the enclosed-shape or volumetric Minimalists was their liking for large, spatially opened, rectilinear, and curvilinear forms. Sometimes these sculptures featured beam-like arms or girder-like extensions into space, and at other times curving planes, or flat planes with curving edges that are interrelated.

10 . 89

Ad Reinhardt, Abstract Painting, Blue 1953, 1953. Oil on canvas, 50×28 in (127 \times 71.1 cm).

This Reinhardt work is an example of Minimalist painting, in which the values are so close that only intense scrutiny can reveal differences of shape within.

Collection of the Whitney Museum of American Art, New York. Gift of Susan Morse Hilles 74.22. © 1997 Estate of Ad Reinhardt/Artists Rights Society (ARS), New York.

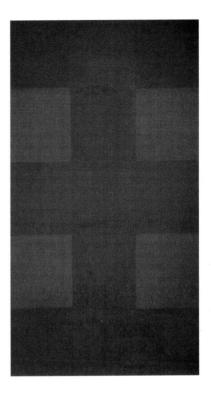

₩ 10 • 90

Larry Bell, First and Last, 1989. Two glass rectangles, 6×8 ft, eight glass triangles, 6×6 ft, coated: nickel-chrome.

The Primary Structurists make use of simple monumental forms exploiting a wide variety of materials.

Musée d'Art Contemporain, Lyon, France. © Larry Bell. Photograph courtesy of the artist.

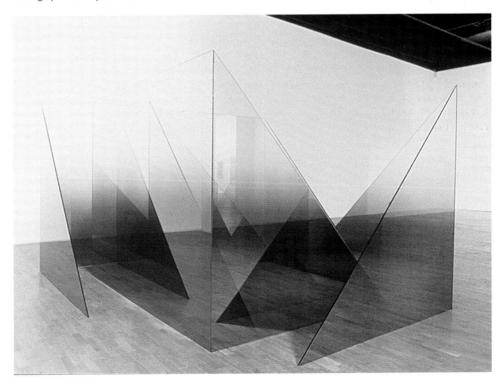

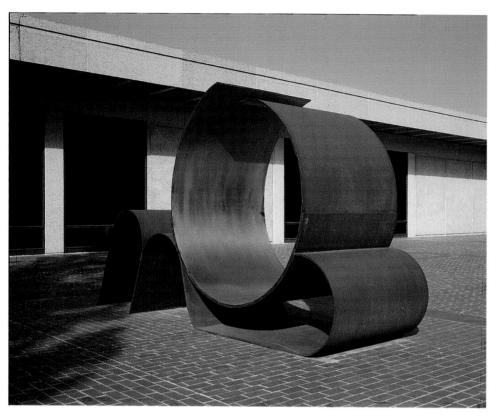

A 10 · 91

Lila Katzen, *Oracle*, 1974. Corten and stainless steel, $11 \times 17 \times 5$ ft (3.35 \times 5.18 \times 1.52 m).

These flowing sheet-metal forms, set in outdoor space, are typical of the works of Katzen.

University of Iowa Museum of Art. Purchased with funds from National Endowment for the Arts and matching funds contributed by Mr. and Mrs. William O. Aydelotte, Edwin Green, Sylvia and Clement Hanson, Mr. and Mrs. Melvin R. Novick, and William and Lucile Jones Paff, 1976.88. © 1988 Lila Katzen/licensed by VAGA, New York.

These sculptures were often related to the walls, floor, or ceiling of a room just like those of the simpler volumes of the other Minimalists. They were also often made on a scale appropriate for an outdoor environment, becoming public monuments in parks, or in conjunction with architecture (especially in the 1970s). Examples of this trend can be found in Lila Katzen's (b. 1932) large, open-rolled, sheet-metal forms (fig. 10.91).

A few of the open boxes, and occasionally some of the enclosed rectilinear sculptures, stress brightly colored surfaces, while others are neutral or devoid of color. Without doubt, many such pieces make a powerful impact as we come on them in public places; however, some of these Minimalist forms often transmit a feeling of sameness or monotony and, to younger artists growing to maturity in the sixties and seventies, often seemed without perceivable content. In addition, the creative process of constructing such objects seemed more important at times than its form or final effect on the response of the observer. In their stress on totally simplistic forms, the Minimalists rejected the belief that humans count for much in the work of art. This is a reminder of antecedents from the 1930s to 1950s—purists like Mondrian and the painters of the Nonobjective Movement (see "Abstract Art" and "Nonobjective Art", pp. 274-75). The lack of content in Minimalist art was most likely a reaction to the psychological suggestivity found in welded sculpture, particularly the Abstract-Expressionist kind.

POP ART

Pop Art continued to "stir the pot" and the growing revolt against all forms of Abstract Art that began to be manifest in the early 1960s. This revolt was predicted not only in the work of Robert Rauschenberg, whom we met under Assemblage (see fig. 10.82), but also in Jasper Johns' (b. 1930) work, an American artist more satirical in his approach than Rauschenberg. Johns was equally important in pointing the new direction away from all formalist styles. He chose as his chief motif single images of commonplace objects that had lost their effectiveness, such as the flag of the United States, targets, and the like (see fig. 7.21).

The term "Pop" stands for "popular art" or even for "pop bottle art," judging by the frequency with which such mundane objects appeared. The movement as a whole originated in England in the fifties and then naturally filtered through to the United States. In this movement, images made popular by mass-media advertising and comic strips, and other everyday objects (such as pop bottles, beer cans, and supermarket products) are presented in bizarre combinations, distortions, or exaggerations of size. The original human-made object is always rendered faithfully, however. Works such as Andy Warhol's (1925-87) Campbell's soup cans or Roy Lichtenstein's (b. 1923) grotesquely magnified comic-strip heroes and villains were capable of startling viewers by shocking them with images of the familiar in a new context (figs. 10.92 and 10.93). As with Abstract Expressionism, the observer is involved directly in the work of art, if only because of the frequency with which the observer sees these commonplace items; the realist style application, however, is entirely the opposite of abstraction. Because similar experiences were promoted by the Dadaists in 1916, the Pop artists were called Neo-Dadaists when they first began to appear. But whereas Dada was nihilistic, selfexterminating, and satirical, Pop art had little of this purpose. Instead, it encouraged an awareness and acceptance of the fact that mass media communications have a tremendous impact on our daily lives. There was a kind of joyful enthusiasm for exploring the possibilities thrown up by the daily images and objects of a metropolitan culture. From billboards to bar interiors, from grocerystore cans and boxes to the bathtubs and sinks of the average house interior came the realist subjects of Pop art—certainly a reaction, in part, to the inwardly directed and cerebral art of Abstract Expressionism and Post-Painterly Abstraction.

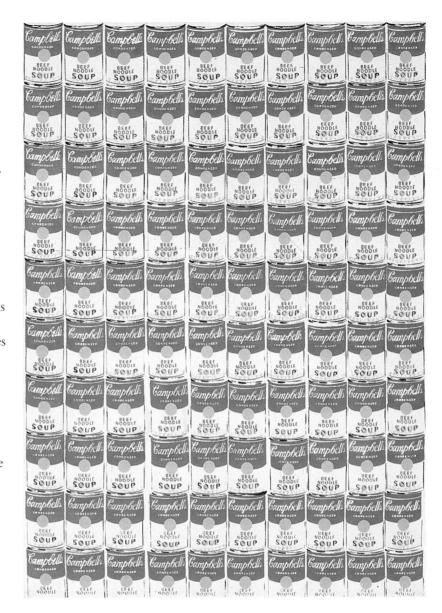

A 10·92

Andy Warhol, 100 Cans, 1962. Oil on canvas, 6 ft \times 4 ft 4 in (1.83 \times 1.32 m).

Warhol's 100 Cans beats a repetitive visual tattoo whose power derives from the insistence of similar commercial imagery in our daily lives. Repetition of a more or less monotonous kind was one of the principles of form exploited first by the Pop artists.

Albright-Knox Art Gallery, Buffalo, NY. Gift of Seymour

Albright-Knox Art Gallery, Buffalo, NY. Gift of Seymour H. Knox, 1963. © 1997 Andy Warhol Foundation for the Visual Arts/Artists Rights Society (ARS), New York.

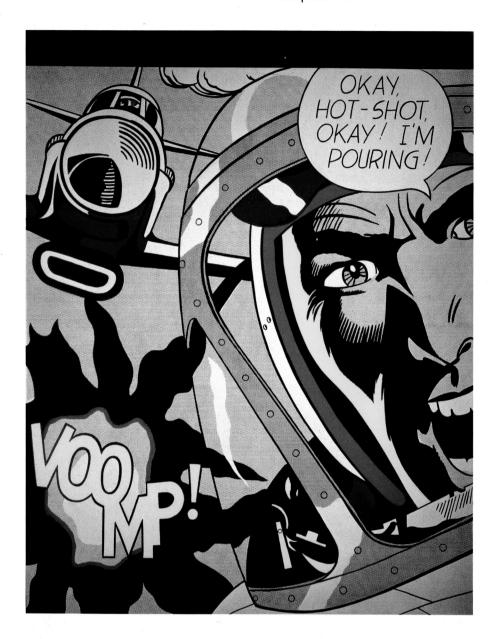

▲ 10.93 Roy Lichtenstein, Okay, Hot Shot, Okay, 1963. Oil and magna on canvas, 80×68 in (203.2 \times 172.7 cm).

Lichtenstein's use of magnified comic-strip heroes and heroines is typical of Pop art's playful treatment of popular culture.

© Roy Lichtenstein

Significant artists of the Pop persuasion, besides Warhol and Lichtenstein, are Claes Oldenburg (b. 1925) and George Segal (b. 1924). These artists are sculptors or assemblers, fields in which Pop Art made as much progress as it did in painting (figs. 10.94 and 10.95). Oldenberg, one of the most imaginative of the Pop artists, through playing on the contradiction of scale and commonly accepted reality (like the Dadaists and Surrealists) has gone through various phases of good humored work featuring edibles in painted plaster to others in soft materials. Later, he also treated telephones and toilets in a similar way. Finally, he made colossal lipstick tubes, clothes pins, and the like, out of metal. These invade the environment monumentally and are featured in public places (see fig. 2.45). The environmental concept was an important development in the 1960s. We shall see it continued into the 1970s and 1980s with renewed vigor.

In the late fifties and sixties, at about the same time as the tongue-in-cheek irony and humor of Pop Art's new look at rampant consumerism in the United States, came another unique way of looking at American life through photography. It was introduced by a Swiss-born American, Robert Frank (b. 1924), in his photographic journal entitled "The Americans" (1959). Created in a style reminiscent of the candid social commentary of the Farm Security Administration photographers during the Depression, the journal is a photographic record of Frank's travels throughout the country in an old car (1955) on a Guggenheim fellowship. Frank apparently took candid shots of people engaged in mundane tasks. They seem to say "this is life" . . . sometimes rough, sometimes sad, often suggesting through almost empty rooms, and vast uninhabited landscapes the isolation of individuals from one another. There are people from all walks of life with "good

▶ 10 • 94

Claes Oldenburg, Shoestring Potatoes Spilling from a Bag, 1966. Canvas, kapok, glue, acrylic, 9 ft \times 3 ft 10 in \times 3 ft 6 in (2.74 \times 1.17 \times 106.7 m).

Pop artists generally disregard all form considerations, which they believe create a barrier between the observer and the everyday objects that serve as subjects. Pop Art is an art rooted in the present.

Collection of the Walker Art Center, Minneapolis, MN. Gift of the T. B. Walker Foundation, 1966.

₩ 10 • 95

George Segal, Walk, Don't Walk, 1976. Plaster, cement, metal, painted wood, and electric light, 8 ft 8 in \times 6 ft \times 6 ft (2.64 \times 1.83 \times 1.83 m).

In 1961, this artist began to win fame for his plaster-casts of living people. Dressing them in ordinary clothing and placing them in everyday situations, Segal was able to break down the barriers between life and art—a familiar preoccupation with Pop artists.

Collection of the Whitney Museum of American Art, New York. Purchased with funds from the Louis and Bessie Adler Foundation, Inc., Seymour M. Klein, President, the Gilman Foundation, Inc., the Howard and Jean Lipman Foundation, Inc., and the National Endowment for the Arts. 79.4. © 1998 George Segal/licensed by VAGA, New York.

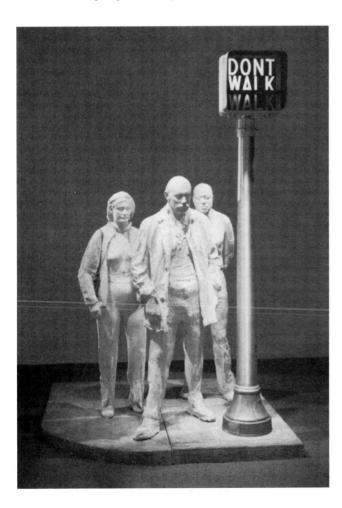

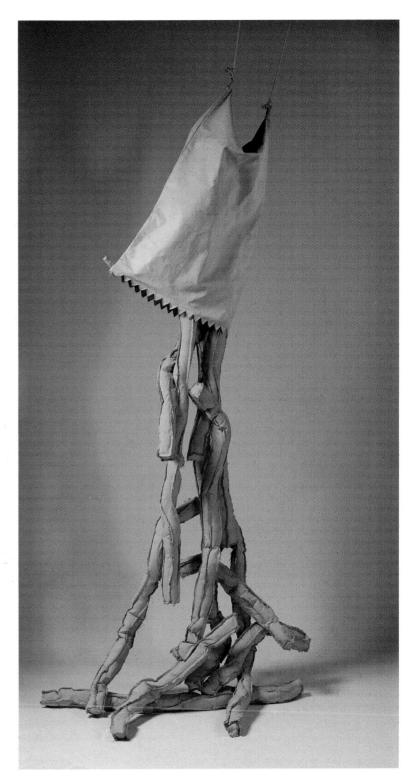

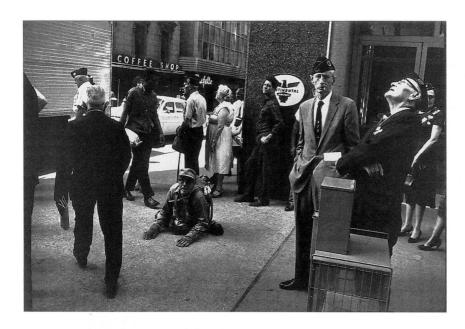

▲ 10.96

Garry Winogrand, American Legion Convention; Dallas, Texas, 1964. Gelatin silver print.

In the 1960s, Garry Winogrand chose to photograph the moment glimpsed before or after an important event. An earlier generation of photographers, in the tradition of Henri Cartier-Bresson (see fig. 10.64), would have searched for a scene showing the precise moment of an occurrence of apparently deeper significance.

Courtesy Fraenkel Gallery, San Francisco and © The Estate of Garry Winogrand.

buddy" politicians and movie stars or starlets with somewhat vacant expressions on their faces. Frank influenced a new generation of social realist photography, later epitomized by the work of Gary Winogrand (1928– 1984) (fig. 10.96), Lee Friedlander (b. 1934) (fig. 10.97), and others.

HAPPENINGS/ PERFORMANCE ART

The blurring between art and real life in Pop Art is more pronounced in the Poporiginated **Happenings**. Happenings were a form of participatory art in which spectators, as well as artists, were engaged. They have been defined as an

"assemblage on the move," bringing in concepts of motion, time, and space. More recently this type of art has been called **Performance Art**, expanding its approach to include theater, dance, music, cinema, video, and computer art. Both Happenings and Performances are based on the ancient concept of drawing spectators into the heart of a work of art so that they can experience the work more directly. This concept reached a climax in Baroque Art of the seventeenth century when the disciplines overseen by the Medieval guilds had finally lost their technical control over the artist. From the Renaissance on, the religious iconography and media used by artists were intermingled in an artistic fabric

(the church building) that was unified within itself. However, the completion of this unifying process was dependent on the spectator's participation in the artistic experience.

Happenings were identified and developed by Allan Kaprow (b. 1927), who gave his first happenings in John Cage's classes for experimental music at the New School for Social Research in New York in 1957. These performances were usually initiated by one person, the artist, nourished by some environmental setting. Kaprow's new art exploited human or group activities which were involved in spatial settings. His art materials were everyday materials, often junk found on the street, as well as sounds, lights, and odors (fig. 10.98). These performances inspired other artists and soon Happenings became popular events that spread from the United States to Europe. Kaprow, however, chose to avoid such publicity, and has carried out his experiments more or less among friends to date.

Joseph Beuys (1921-1986) a German artist who was a fighter pilot in World War II, also was associated with Performance Art. After the war in his school in Dusseldorf he put on performances that had a ritualistic, or spiritual quality. At that time he believed that such art performances were the direct means for affecting his audiences.

The Korean artist, Nam June Paik, who began his career in Germany as an electronic musician and composer, realized the possibilities of expressing himself through video or TV assemblages. Video gave him the ability to exert his domination over the mass media field. He thus became famous as the first artist to display video ensembles, which are examples of both Performance and Process Art (fig. 10.99). He now has several followers, although it is difficult to be original after Paik's example.

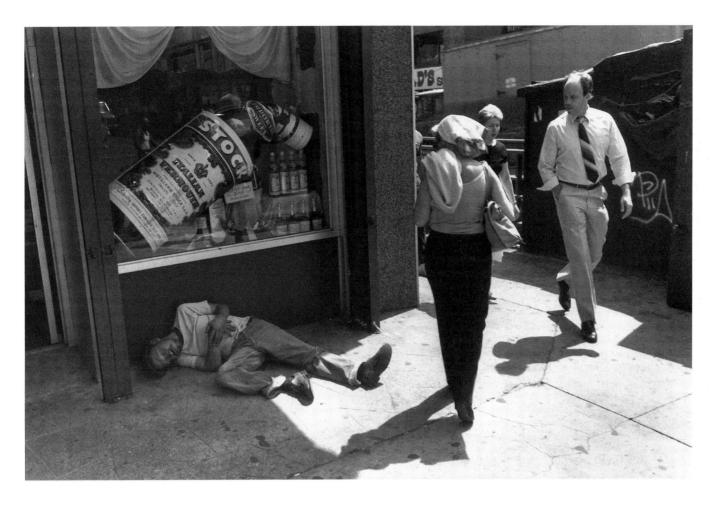

▲ 10 · 97 Lee Friedlander, New York City, 1983. Photograph.

Running a gamut from street photography to nature and nudes, this photographer is another of the innovative "social landscapists" that appeared in the 1950s–1960s. Friedlander, like the others in this group, captures unusual aspects of life events caught in a happened-upon moment.

Courtesy of Fraenkel Gallery, San Francisco, on behalf of the artist

▶ 10 • 98

Allen Kaprow, Household, May 1964. One photograph of a series taken of A Happening commissioned by Cornell University, Ithaca, NY.

There were no spectators at the event. Those taking part in it attended a preliminary meeting where the Happening was discussed and parts distributed. In Scene V shown, women go to the car and lick jam.

Courtesy of the artist, Allen Kaprow. Photograph © Sol Goldberg.

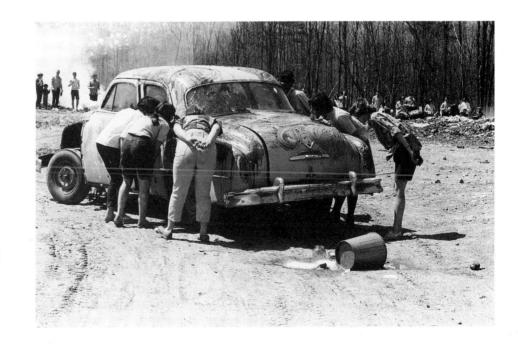

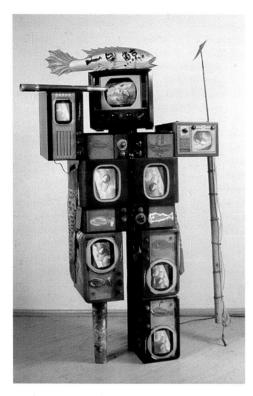

A 10·99

Nam June Paik, Captain Ahab, 1990. Antiques, televisions, and videos, $89 \times 58 \times 27$ in (226.1 \times 147.3 \times 68.6 cm).

Process, Conceptual, and Performance Art are closely related, often overlapping, art forms. The Korean-American artist Nam June Paik, who mostly produces video installations—which he pioneered—bridges the slight differences between the forms. He has several followers who also explore the impact of technology on modern society.

Courtesy of the Holly Solomon Gallery, New York.

▶ 10 • 100

Lucas Samaris, Mirrored Room, 1966. Mirrors on wooden frame, $8\times8\times10$ ft (2.44 \times 2.44 \times 3.05 m).

This is an example of environmental art, which, by its size and structure, may actually enclose the observer within the form of the work.

Albright-Knox Art Gallery, Buffalo, NY. Gift of Seymour H. Knox, 1966.

SITE AND EARTH ART

This form of art was at first called *Environmental Art*, taking its name from the fact that the environment, like its art, surrounds the spectator. The artwork became an artificial slice of life, which is completed by spectators because of the stress placed on the details of the created forms around them. Environmental

artists came out of Assemblage, Pop, and Minimalism. Its artists believe that not only should the spectators' vision be engaged in works of art, but their whole bodies, including the senses of touch, smell, and hearing. Dadaists like Kurt Schwitters (1887–1948) (an important German artist who created his own version of Dadaist works called "Merz") and Marcel Duchamp created the first

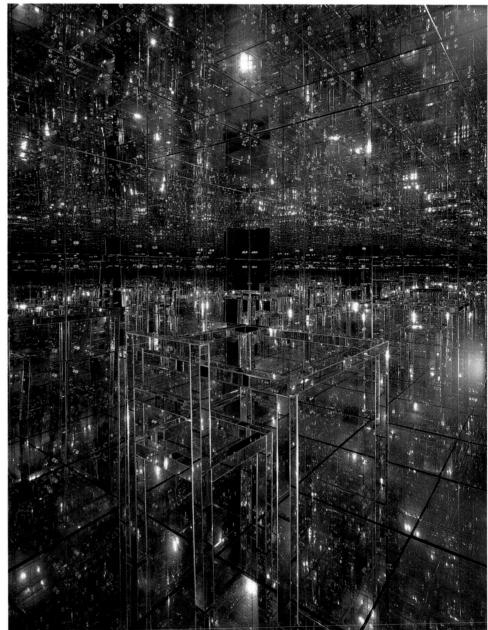

twentieth-century Environments. The Pop artists must be credited with renewing this form of art in the 1960s and 1970s. While Lucas Samaris (b. 1936) was primarily a Pop artist, his *Mirrored Room* is also a good example of that particular form of an Environment called a Site work or Site Art (fig. 10.100).

When such forms of art were first being exhibited, such as being arranged on the floors, walls or from the ceilings of a gallery, they were named Scatterworks, Floorworks, or Siteworks. Now the term Site Art is simply designated for indoor or outdoor art of varied types.

Earth Art has to do with a branch of Site Art in which the artist transforms the environment, or some part of it, on a gigantic scale. The Pop Art concept of bombarding the spectator with mundane images from the everyday world by taking the most commonplace items in our culture out of their normal context and giving them the legitimacy of fine art was of considerable importance in the evolvement of this kind of art. Like Minimalism, these artists' creations also seem to reject any connotations of human expression other than the look of human intervention. With Site and Earth Art, spectators became involved in the principle of space/time—the action involved in either creating or looking at works of art—that involves the fourth dimension. This has been a continuous concern for many generations and remains so in recent work.

Christo (b. 1935) and Jeanne-Claude are among the artists who currently produce Earth Art or Site Art (although the term Environmental Art seems more appropriate in this case) while they create other kinds of art. They are probably the best known because of their international activity. But Oldenburg, whom we have already encountered as a Pop artist, is also well known. Christo and Jeanne-Claude have continuously explored the environment, from the great air packages (balloons of 280 ft. height

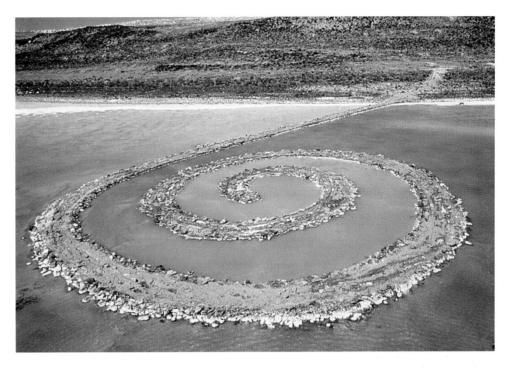

suspended by cables) featured in New York City (Whitney Museum) and Germany in 1968 to the surrounding of islands off the coast of Florida with pink sheets of plastic in the early 1980s. In our last edition (the seventh) we featured their Umbrellas (1984-91), which was then a recent work. In this present volume, we are illustrating the Wrapped Reichstag, or former German assembly house, that Christo and Jeanne-Claude encapsulated in polypropylene fabric (see fig. 1.14). Like the Umbrellas, it was probably preceded by drawings and paintings that they used as working models for the final projects. These are sold to raise money for the supplies and helpers required to execute their monumentally scaled art. In a sense, the accomplishment of an Environmental form also takes on the character of a Happening or Performance. A leading pioneer of Earth Art is the sculptor Robert Smithson (1938-73), whose Spiral Jetty, created at Great Salt Lake, Utah, in 1970, played an important part in such large-scale Environments (fig. 10.101). The Minimalist emphasis on the large scale of their art forms also helped lead to those branches of Environmental

A 10 · 101

Robert Smithson, Spiral Jetty, Great Salt Lake, Utah, 1970. Rock, salt crystals, earth, algae, coil, 1,500 ft (457 m).

Students of art must be willing to concede the possible validity of many unfamiliar forms of individual expression.

Estate of Robert Smithson, courtesy of the John Weber Gallery, New York. (Photograph by Gianfranco Gorgoni.)

Art called Site and Earth Art. The displacement of the natural and/or prepared land and space necessary for the setting or exhibiting of large-scale public sculptures drew attention to the places where they would be situated. Some artists soon conceived that the manipulation of the setting, or natural environment itself, was a significant artwork in its own right.

The exact birth of Earth Art is difficult to pinpoint, although its roots have existed in landscape painting, sculptural monuments, and landscape or park design for at least three centuries. As a movement in modern times it appears to have developed in the late 1960s. In 1967, for example, Claes Oldenburg dug holes in New York's Central Park and called them "invisible"

▲ 10 · 102

Michael Heizer, Double Negative, Mormon Mesa, Overton, Black Rock Desert, Nevada, 1969–70. 240,000-ton displacement in rhyolite and sandstone, 1,500 \times 50 \times 30 ft (457 \times 15 \times 9 m).

Some of the artists producing Environments—in this case, an earthwork—were looking to escape the high-pressure commercial world of galleries and museums. Antecedents for Environments are found in landscape architecture and painting, while the modern desire for works on a monumental scale also played a part.

© Michael Heizer. Photograph courtesy of the artist.

sculptures." Michael Heizer (b. 1944) dug five twelve-foot trenches that he lined with wood in the Black Rock Desert of Nevada in 1969 (fig. 10.102). The concept of "bigger is better" has also taken hold in earthworks, because cranes and power shovels have been used by the artists/directors to produce their works.

Part of the reason artists took their work outdoors in the first place was to escape from the dominance, the hyperbole, and reverential attitude displayed by galleries marketing artists' works. Ironically, in spite of the desire to escape institutional domination on the part of Site and Earth artists, Site Art examples are possessed by art museums today. It is impossible to miss these collections of wood, rope, cloth, metal, and so forth, that, because of their size, monopolize large parts of a museum's

space. On the other hand, the practice of making Earth Art seems to have ended, probably because of the works' isolation, its short life, lack of public attendance, and tremendous cost. The exception is the work of Christo and Jeanne-Claude that could be considered Environmental Art.

POSTMODERNISM

Throughout history, new generations of artists have become dissatisfied with the route taken by their elders and, therefore, struck out in new directions. The feeling that inherited methods and media have reached a state of perfection or have exhausted their possibilities has been especially keen among artists of the twentieth century and increasingly so since mid-century. Among the strong motivations for change have been the

development of motion pictures and other technological advances in photography, machinery, electronics, and space flight. The growing desire to "clean the slate and start over again" was not the only factor governing changes in the arts since mid-century. The feelings that society seems to have become exhausted and bled of new ideas, and/or society appears unable to solve its problems have also influenced the arts. Two World Wars and several major wars during the century, accompanied by the breaking up of cultures through forced migration, attempts at genocide, and the consequent political upheavals attest to the depth of the turmoil. The trials caused by racial prejudice, uneven distribution of income, and the desire to solve such issues is still with us at the end of the century. As a reflection of our world, all the arts have been affected.

Postmodernism is the term applied to the new mode of art created mostly by a younger generation of artists, although there are some older artists identified with it. The term is given to the variety of styles that have arisen since the late 1960s and 1970s. All art of the last thirty plus years that appears to be looking either for a new means of expression, or for near-realistic figurative form, can be said to lie within the Postmodern sphere. Most figurative art had been cast in the shadows by the dominance of formal abstraction. Many artists therefore returned to art that had for long been considered out of the mainstream. A new kind of eclecticism that expressed itself through copying of previous art, or referring to it, from recent to ancient times, came into play. Artists who took this course modified the older works by changes in scale or relationships, however, so they were viewed in a new way. New materials or media continued to be introduced. Some critics see that what we call Postmodernism is not a radically new phase of art (or history), but the normal result of the kind of pedantic, or haughty "control" of the arts and life that has always accompanied

changes within the visual arts at various times in the past.

Most of this art is the expression of individuals. Yet some of them reject the notion of individualism and want to return art to the anonymity that dominated most historical styles before the Renaissance. In the context of art today, this is most likely an impossibility.

Other notable characteristics of Postmodernism were the reintroduction of decoration, such as can be found in Islamic manuscripts (perhaps an influence from Matisse); a diversity of novel techniques as required by new media; and even a return to literary sources, a procedure adopted before by the nineteenth-century Romantics. From early modernism there has been a constant switching back and forth between styles and media, so that it is difficult today to coin specific names for groups or categories of artists. Because of this, it would make no sense to say that Postmodernism means that all the practices of early modernism were abandoned; thus, the term is loosely used to encompass all the styles that have come into being as reactions to some of the early modern (particularly, Abstract) "dogmas." In the case where there has been a decided return to abstraction, Postmodernism also takes on a new or different meaning. The artists try to present their forms in such a way that a reference to content beyond, or in back of the work, seems apparent. Therefore, Postmodernism no longer depends on a "worship" of total form "for its own sake" as it did before.

NEW REALISM (PHOTOREALISM)

New Realism was the first art to use the human figure and portrait to any extent since the early part of the century. A general trend from the 1960s through the 1970s, it was, in a sense, a new kind of Pop Art that dealt for its style in verisimilitude, but of a more matter-of-

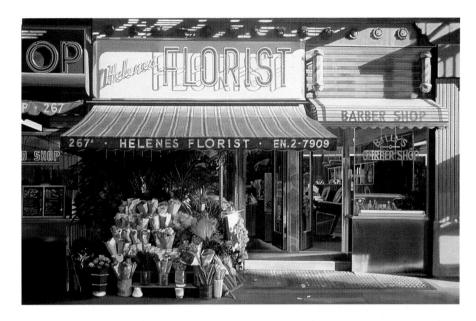

A 10 · 103

Richard Estes, Helene's Florist, 1971. Oil on canvas, 4×6 ft $(1.22 \times 1.83 \text{ m})$.

The meticulously rendered images of Richard Estes attempt to reach the degree of reality found in photography.

Toledo Museum of Art, Toledo, OH. © 1998 Richard Estes/licensed by VAGA, New York/Courtesy Marlborough Gallery, NV.

fact kind, having little of the wit, humor, and sly jibes of Pop. For most of the century, representation was anathema to abstract artists. Their values had been based on the rejection of anything suggesting an objective mapping of reality. Now representation, or realism, had returned "with a vengeance." Important to the movement were Richard Estes (b. 1936), Chuck Close (b. 1940), and Philip Pearlstein (b. 1924) (figs. 10.103 and 10.104; see fig. 2.49). The example by Duane Hanson (1925-96) (fig. 10.105) indicates that, like Pop Art, New Realism extended into sculpture.

The New Realists are also referred to as New Illusionists, Photorealists, and Superrealists. They depended on both photography and images taken from commercial advertising to gain their meticulous artistic ends; although some, like Pearlstein, maintain that they do not paint from projected images, or

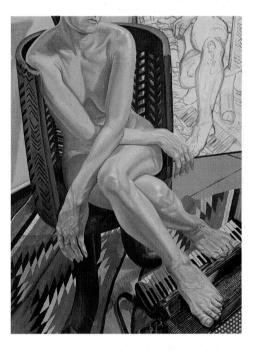

■ 10 · 104

Philip Pearlstein, Chevrons #2, 1996. Oil on canvas, 48 × 36 in (121.9 × 91.4 cm).

This New Realist painter uses a kind of descriptive lighting to represent human figures.

Courtesy of Robert Miller Gallery, New York.

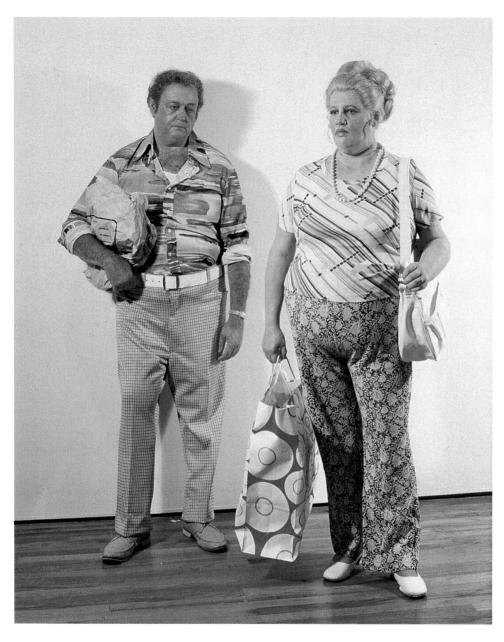

▲ 10 · 105

Duane Hanson, Couple with Shopping Bags, 1976. Polyvinyl/polychromed in oil, life size.

This work belongs in the context of photorealist painting, but it incorporates more illusions than any painting could. Duane Hanson's three-dimensional, likelike, life-sized figures are cast in colored polyester resin and fiberglass to look like real skin and are clothed in real garments. His human reproductions are so meticulously detailed that one reacts to them first as real people, and only later as sculpture.

Courtesy of Mrs. Duane Hanson.

photographs, but rely upon painstaking observation of their model(s). By and large, however, all the New Realists show average people involved in everyday activities; there is little or no evocative content. Many feature photo-like renditions of city streets, store fronts, and the like.

The New Realists were preceded, clearly, by the continuing high level of interest in realistic art throughout the twentieth century, particularly in the United States. This can be witnessed not only in the unabated popularity of

Andrew Newell Wyeth (b. 1917), but the recurring interest in artists like (Edward Hopper (1882-1967) and Ben Shahn (1898-1969) from the earlier part of the century (see figs. 6.2, 8.25, and 2.28). On occasion, nineteenth-century Realism, from the Pre-Raphaelites (an English nineteenth-century Realist movement based on Proto-Renaissance and Early Renaissance "primitives" before Raphael) to the Impressionists, has also returned to favor. Even Picasso, that towering genius of the century, in the midst of all his Expressionist, Abstract, and Surrealist explorations, continually returned to realistic idioms.

The New Realist sculptors refined the styles of Segal and Oldenburg and made even more lifelike images in fiberglass and resins. *Trompe l'oeil* verisimilitude reached a new level of virtuosity in such three-dimensional illusions.

PROCESS AND CONCEPTUAL ART

As we have found, the Minimalists of the 1960s and 1970s emphasized purity of form in simple volumes with obscure content (although faithful believers saw it as transcendental in meaning). Earlier, the Abstract Expressionists had promoted this lack of content—as the Postmoderns saw it—by raising the creative act in importance over the form of the finished artwork. In these movements, a great deal of artistic energy had been expended toward exploring the creative process and the conception of ideas. The forms called Process and Conceptual Art are the results of this kind of thinking carried to its logical conclusion, where the "process" or "idea" become ends in themselves. To Postmoderns at least, both seemed to somewhat conceal the importance of artistic personality, or expression, which even in early modern art had served as the goal in art. The Process artists believed that art is

experienced primarily in the act of producing. The interpretations given to the final form do not seem important to them, as is suggested by, for example, the exposure of their art works to the natural effects of the weather. Process and Conceptual Art are, therefore, transitional between earlier forms and full-blown Postmodernism. As has been indicated, Postmodernism was foreshadowed in Pop Art as early as the late 1950s and expanded into all kinds of new art alongside the older avant-garde.

The German artist Joseph Beuys, in his Rescue Sled (fig. 10.106), whom we saw previously as a Performance artist, may here be taken as a Process/ Conceptual artist. He obviously uses clearly recognizable objects as subjects, but states that the ideas behind the work and its production are more important than the medium or form. He claimed that every act of society is a work of art. The blanket rolls, pieces of animal fat, and flashlights that appear in this work, while not the ordinary media of traditional artists, are meant to express complex, deep-seated personal, and symbolic meanings. These objects are symbols of Beuys' survival during World War II, when his airplane was shot down and he was saved by nomadic Crimean Tartars on just such a sled. His art is moreover a continuing reference to the catastrophic brinkmanship of our times—times afflicted by many major and minor wars, nuclear weapons, the resulting Cold War, and the destruction of our environment.

The most significant concern of Conceptual Art is the "idea" that creates it. With the New York show called *Information* exhibited at the Museum of Modern Art in 1970, the gradual decline of the aesthetic of formalism seems to have been completed for many artists. Conceptual artists believed that neither the act of making nor completing an art object was as important as the idea, or concept, that lay behind it. The most extreme representatives of this point of

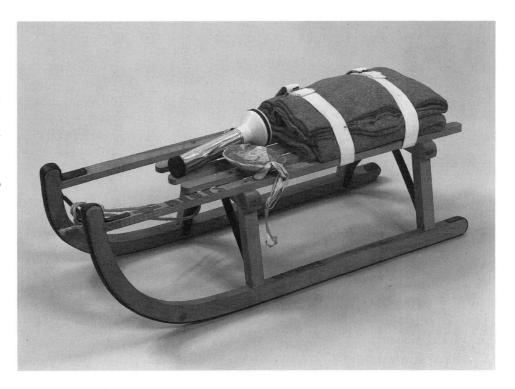

view, and an early indicator of how the "idea" would dominate over form eventually, were the artists who conceived of filling the air with oxygen or steam vapor in the early 1960s. They called it "universal art," because the vapors would expand endlessly into the universe. Today this form of art, like Process Art, often involves action by the artist alone, but more often involves helpers and/or an audience. In one sense, Christo's site works can be considered Conceptual forms of art since they require a "director," who has conceived of the work, and those who assist or participate in the recording of the idea in whatever form it may take. However, most Concept Art was on a smaller scale and began to take on the respectable veneer of "fine art" once it was exhibited in galleries.

An early example of Conceptual Art is found in Joseph Kosuth's (b. 1945) *One and Three Chairs* of 1965 (fig. 10.107). Kosuth took a "ready-made" or "found object," in this case a chair, added a photograph of the chair, and next to that a dictionary definition of a chair. Rapidly, during the late 1960s and early

10 - 106

Joseph Beuys, Rescue Sled, 1969. Wood, metal, rope, blanket, flashlight, wax, 13³/₄ in (35 cm).

Process artists, such as Joseph Beuys, believe that the ideas behind and production of an artwork are more important than its medium or form. His commonplace objects often entail a complex symbolism springing from personal experiences.

Art Institute of Chicago. Twentieth Century Purchase Fund, 1973.56. Photo © Art Institute of Chicago. All rights reserved. © 1997 Artists Rights Society (ARS), New York/VG Bild-Kunst, Bonn.

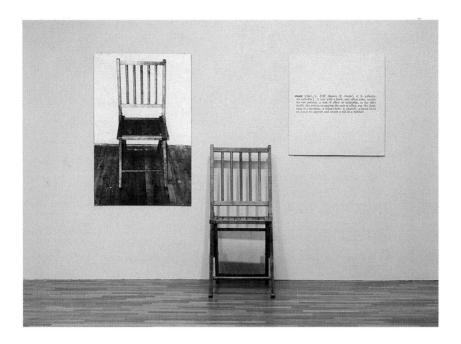

A 10 · 107

Joseph Kosuth, One and Three Chairs, 1965. Wooden folding chair, photographic copy of a chair, and photographic enlargement of dictionary definition of a chair; chair, $32^3/8 \times 14^7/8 \times 20^7/8$ in $(82 \times 37.8 \times 53$ cm); photo panel, $36 \times 24^1/8$ in $(91.5 \times 61.1$ cm); text panel, $24 \times 24^1/8$ (61×61.3 cm). In this example of Conceptual Art, the idea of one actual or "ready-made" chair is triplicated by a photograph of a chair and a dictionary definition of a chair. The Museum of Modern Art, New York. Larry Aldrich Foundation Fund. Photo © 1998 Museum of Modern Art. © 1997 Joseph Kosuth/Artists Rights Society (ARS), New York.

1970s, similar items were being exhibited and given the status of aesthetic objects. When they were put on display, it was much to the discomfiture of the artists involved, because such ideas were intended to squash the idea of art-asprecious-object and the control exerted over artists by galleries, museum officials, and private owners. Many Conceptual works were just displays of typed or handwritten words, explaining theories of art, the sciences, topology, or anything else that might make the "idea" positive. Their keenness to get the idea across was probably an influence from commercial advertising. Photographs, plus cinematic and video images, were often used to record these concepts, or to get them across in the same way.

The Minimalist sculptor, Sol Lewitt (b. 1928), who may have coined the term "Conceptualism," once wrote to

the effect that conceptual works were only as good as the idea behind them.

One common denominator detectable in many works of art from the 1970s forward is the strong desire to bring back recognizable content or meaning to works of art. There have been attempts to give a name to some of the different ways in which this new concern for a more representational approach has manifested itself; but the attempt flounders because of the diversity of manners prevalent today. A good example of this diversity can be found in the work of a single artist because, quite often, the artist shifts styles.

Miriam Schapiro (b. 1923), a New York-based Hard-Edge abstractionist before she moved for a number of years to Los Angeles in the late 1960s, can possibly be classified as a decorator or conceptual artist. In LA, she became cofounder of the Feminist Art Movement along with Judy Cohen (b. 1939). While helping students restructure an old house into a completely feminine environment, her interest was aroused by the long history of women's beautiful and often intricate designs or patterns for domestic applications. Wanting to bring attention to this long neglected domestic art tradition, Schapiro began to make abstract and semi-representational collages of women's craft and needlework materials. She called these femmages (fig. 10.108). These works, beyond their qualities as art, may be interpreted as analogies or symbols of the equally long devalued role of women's arts in general. Schapiro has continued through the 1980s to create lively, colorful images usually with discernible but sometimes ambiguous content.

Perhaps another indicator of differences between the eighties and sixties in the arts is the use of a wide variety of media and techniques. Some of the media are new, requiring new techniques, and very often a single format might display a wide diversity of media. For example, where acrylic painting dominated the pictorial arts in the 1960s, we now often see a return to the use of conté crayon, pastels and graphite, while oil paint sticks and pens, cloth, ceramics, powdered metallics, and other materials like straw seem relatively new. Oils and acrylics are still being used, however, and sometimes many combinations of these media appear in the same work of art. This juxtaposition of media is mirrored by a combining of techniques in the realm of printmaking. Lithography, silk-screen, etching, and engraving are often employed in the same image along with India ink, graphite, and other materials. Some of these "combo-techniques" are descended from history, of course, but not as great a variety of techniques were put together in the past for lack of scientific development.

Although it was difficult to predict the exact form much of the newer art of representation would take, by the late 1980s one direction was becoming clearer: A great deal of the new art reflects the momentous social and political changes that have taken place in the last decade. The arts have reacted dramatically to those changes. Many of the artists born in the last forty years tend to reject not only the works of their predecessors, but also the philosophical beliefs that accompanied them. Sometimes their work responds to what they think is the disinformation or the lies fed to them by all forms of mass communication and/or advertising. They question not only the originality of art and what is presented as authentic, but also the concept of originality as a worthwhile goal. Thus, these artists must question their own individuality. They react to the violence being shownsexual, political, social, and environmental. Much of what they see in these forms of information seems, at least, largely untruthful; or it conveys a partial and deeply conservative view of the world. Yet the sources for these artists' work are often found in the visual media; the artists parody or satirize it, often by laying bare the structures through which our entertainment and information are disseminated.

Reality is also in question again! What is real? The film or television portrayals of "ordinary" people in their beautiful apartments and designer clothes, or those people found in tenements, or "everyday" working women or men? Are the handsomely staged street scenes of Hollywood as real as those decaying inner-city streets all over America?

NEO-EXPRESSIONISM

So far, the longest-lasting and seemingly strongest movement of the new figurative approach to art during the

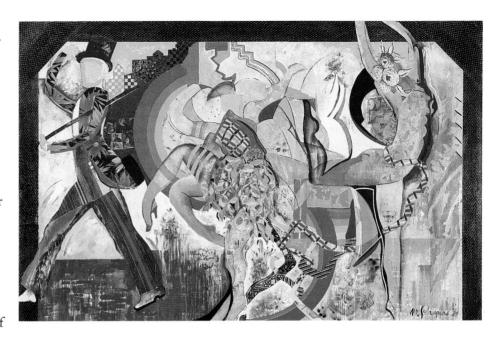

▲ 10 · 108

Miriam Schapiro, I'm Dancin' as Fast as I Can, 1985. Acrylic and fabric on canvas, 7 ft 6 in \times 12 ft (2.29 \times 3.66 m).

This artist became well-known in the late 1960s for her *Femmages*, which incorporate collage, sewing and quilting materials and techniques. Using the same basic techniques, she has recently propelled her work in a figurative direction, though the content remains disturbing and ambiguous. Her work is a good example of recent Postmodernist directions in art.

Collection of Dr. and Mrs. Harold Steinbaum. Courtesy of the Steinbaum Krauss Gallery, New York.

1980s and beyond has been that of the Neo-Expressionists. There was such a widespread desire among the general populace for a return to figurative art and for a more personalized expression that it seemed for a time in the early eighties that these artists were being deliberately forced on the public for commercial purposes. In hindsight, however, it has become evident that Neo-Expressionism had deeper roots and the values it expressed were those genuinely being sought by a new generation of artists. One method conceived to satisfy the growing appetite for recognizable images and an art with newly meaningful content was a return to monumentally dramatic figures with broad gestures, painted in broad brushstrokes.

Some of the conditions and the questions they have raised in the preamble to this section above have been

responsible for the work of artists representing Neo-Expressionism, such as Cindy Sherman, Enzo Cuchi, Julian Schnabel, and Anselm Kiefer among others. This renewed art of social expression has been strongly influenced by the feminist movement. Women have long been relatively neglected in the arts; historically, it has been a male-dominated discipline, as with other aspects of life. Women are working to change that situation, not only in society generally, but in the arts, as well.

Chief among European Neo-Expressionists is the Italian Enzo Cucchi and the German Anselm Kiefer. The common denominator of style, of course, was a reawakening of the emotional fervor of early twentieth-century Expressionism, but often updated with modern techniques and themes. Late Renaissance Mannerism, the later phases of Giorgio de Chirico's classicizing style,

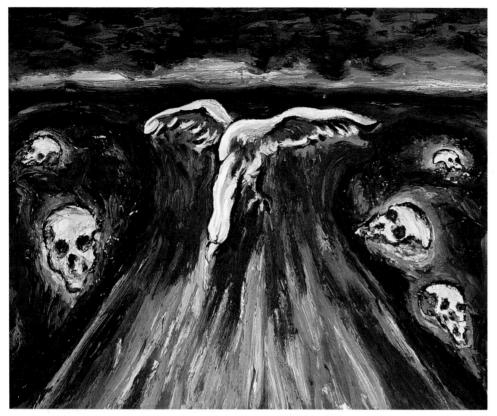

10 · 109

Enzo Cucchi, Paesaggio Barbaro, 1983. Oil on canvas, 4 ft 3 in \times 5 ft $2^{3}/_{4}$ in (1.30 \times 1.59 m).

The Italian Neo-Expressionist Enzo Cucchi paints heavily pigmented canvases contrasting living creatures with symbols of death, abandonment, and decay.

Private Collection. Photograph courtesy of the Sperone Westwater Gallery, New York. Courtesy Gallery Bruno Bischofherger, Zurich.

which had been declared as decadent after his earlier near Surrealist fantasies and the more representational styles of Picasso—all were sources for the Neo-Expressionists.

Enzo Cucchi (b. 1950) (fig. 10.109) has remained on his native soil near the seaport, Ancona, on the East coast of Italy. It is a land of sudden cataclysms caused by landslides. The animal and human life on his family farm and the abruptness with which tragedy can appear, have fed his art. Cuchi's heavily pigmented canvases, sometimes mixed with powdery materials like earth and coal dust express through their contrasts of living creatures and bony skulls his sense of death, abandonment, and decay.

Anselm Kiefer (b. 1945) was born amidst the expiration of Hitler's regime at the end of World War II; this German artist has given that country a new, monumental, dramatically mythic style. He expresses, by symbolic means, an apology for Germany's past sins against humanity, while providing more hopeful signs for the future by recalling the country's more noble, courageous, and/or heroic moments. Like Cuchi, Kiefer uses many materials formerly considered inappropriate for painting. Some of these are old photographs,

■ 10・110

Julian Schnabel, Affection for Surfing, 1983. Oil, plates, wood, and bondo on wood, 108 \times 228 \times 24 in (274.3 \times 579.1 \times 61 cm).

Julian Schnabel, one of the Neo-Expressionists of the early 1980s, uses size and bulky collage to symbolize the discarded materials of a dying civilization.

Courtesy of the Pace Gallery, New York.

metal, and straw. The far-reaching symbolic meanings in this artist's works are difficult to completely explore in so few words. He is well worth further study. In his *Nigredo* (see fig. 8.16) for instance, he takes the significant moment when the alchemist transforms matter, such as the earth, into gold. It becomes symbolically, a sign not only of the perfection of matter, but of that for the world—a redemptive force.

One of the first Americans to paint in a Neo-Expressionist manner was Texas-born Julian Schnabel (b. 1951) (fig. 10.110). Though he is a commentator on modern life, many of Schnabel's themes are gleaned from the Old and New Testaments. A notable feature of his work, like that of the other Neo-Expressionists, is the use of unusual materials, ranging from canvases made of velvet and other fabrics, to broken bits of china adhered to the picture plane. By and large, these Neo-Expressionists were rejecting what the mainstream avantgarde establishment had dictated as "acceptable" subjects for art in the modern age.

Cindy Sherman (b. 1954), originally a photographer working in a Neo-Expressionist idiom, became well known for her self-portraits. These showed her dressed in all kinds of costumes, modern and historical, and served as metaphysical scrutiny of her own person and reminder that all photographic reality is in some way a staged fable. They were also commentaries on the visual clichés that the motion picture film industry, in particular, uses to promote stereotypes of women. In the late 1980s, Sherman's work became more abstract; her images were sometimes very grotesque and sinister and were probably meant to make statements about the power men have held over women through their physical and sexual vulnerability (fig. 10.111). This has become even more obvious in recent work where she uses plastic manequin body parts of women to suggest rape and other horrors

forcefully imposed.

Susan Rothenberg (b. 1934), a painter, became known for her heavily impastoed, monochromatic horse paintings in the 1970s. These retained a sense of the flat painting surface through the use of a slashing diagonal or vertical across the canvas which split the shallow space and horse into two uneven, but visually balanced, parts. By the mid 1980s she was painting other subjects, including the human figure, that are partially blurred into the deeper space provided. Her images of this kind became increasingly Expressionist and Abstract (fig. 10.112; see fig. 3.16).

NEO-ABSTRACTION

At the same time as the Neo-Expressionists were making themselves known in the 1980s and beyond, other young artists were returning to more abstract styles again. Even some Neo-Expressionists were showing this tendency in the late eighties. None of these artists is exactly alike, so again *Neo-Abstraction* must be seen as a loose affiliation made up of many individuals with distinct styles.

A noticeable trend in the late eighties and early nineties has been the tendency of certain artists to borrow from the work of others. This tendency has appeared in all forms of Postmodernist work, and Neo-Abstraction is no exception. In appropriating the work of others, Neo-Abstract artists have usually modified or transformed the original by changing the scale, media, or colors to show the older work in a new frame of reference and, as a result, with a new meaning. Sometimes the meanings are satirical or scathing, or are intended as comments on the decadence of modern society. Their styles range from the near abstract to non-objective as in earlier modern art. They are sometimes referred to as Post-Minimalists in order to distinguish them from the Minimalists who were not

inclined to suggest meanings beyond the object as the present day Neo-Abstract artists are.

Lynda Benglis (b. 1941) was trained as a painter but began to be fascinated by sculpture in the early 1970s when she was considered a Process artist. She developed a method of adding beautiful colors to different plastics in their molten state. After allowing the plastics to flow freely onto the floor, she shaped them into large insectlike creatures, which were then usually mounted on a wall. She has also created mock videos and advertisements of herself, aiming to

₩ 10 • 111

Cindy Sherman, *Untitled*, 1989. Color photograph, 7 ft 6 in \times 5 ft (2.29 \times 1.52 m).

Sherman, like other Postmodernist artists, focuses her creative energies on many of the environmental and social problems of our times. She deals, in particular, with the various trite ways in which women are viewed by society and through the visual media. Her photographs generally take the form of theatrical self-portraits that parody female stereotypes. Recent images, as found here, are often more abstract and sometimes grotesque. Courtesy of the artist and Metro Pictures.

▲ 10 · 112 Susan Rothenberg, Reflections, 1981. Oil on canvas, 3 ft 8 in \times 3 ft 4 in (1.12 \times 1.02 m).

The Postconceptual work of this artist has run the gamut from simple, heavily pigmented canvases of horses to expressionistic and abstract seascapes, such as this.

Collection of Mr. and Mrs. Robert Lehrman, Washington, D.C. Photograph courtesy of the Greenberg Gallery, St. Louis, MO, courtesy of Sperone Westwater, New York on behalf of the artist.

▲ 10 · 113 Lynda Benglis, *Tossana*, 1995–96. Stainless steel, wire mesh, zinc, aluminum, and silicone bronze, $49 \times 63 \times 14$ in (1.24 × 1.6 × .36 m).

This artist began as a painter, then moved over to Process Art using heated, free-flowing plastics that were shaped before the material had set. Recently she has switched to working in shiny metals, forming knots, bows, and insectlike pleated sculptures.

© 1998 Lynda Benglis/licensed by VAGA, New York.

satirize normally hackneyed representations of women in these media and in society. In recent work, Benglis has turned to shaping knots, bows, and more insectlike, pleated sculptures in shiny metal (fig. 10.113) that suggest a connection with the feminine world beyond them.

Another example of Neo-Abstraction is found in the art of the African-American Martin Puryear (b. 1941). Born in Washington, D.C., Puryear began as a realist, but discovered the "magic" or "sense of life" evoked by primitive African forms while serving with the peace corps in Sierra Leone during the mid sixties. He became particularly fond of woodworking techniques applied to sculpture, which he studied in Scandinavia and Japan in addition to Africa. From this background, Puryear developed an

organic abstract style that goes beyond some Minimalist leanings in the animistic sensitivity to woodcraft and meanings inferred beyond the object itself. Some works hint at nature-based sources and content in their flowing stretching effect. They also have tension between parts that want to project into space while they remain rooted to the ground. Some volumes remain more closed, but suggest, through their refined craftsmanship and attention to handsome surface detail, Puryear's study of cabinetry, joining, boat building and traditional Japanese architecture. These latter works especially make the observer search for an implicit utilitarian use beyond their actual presence (fig. 10.114).

Finally, in concluding our survey of the Neo-Abstract style, we will look at two painters who represent their own kind of geometric abstraction: Sean Scully and Dorothea Rockburne. The Irish-American Sean Scully (fig. 10.115) paints mostly in vertical and horizontal stripes, which are related to the work of geometric abstractionists, as well as to that of the Hard-Edge Post-Painterly Abstractionists. Dorothea Rockburne (b. 1934) was born near Montreal. Canada. She attended Black Mountain College in North Carolina and became acquainted with, or was taught by, modern artists like Rauschenberg, Kline, Guston, and others. She also studied dance with Merce Cunningham and knew the highly inventive American composer John Cage. She began to find her style, a vibrant color palette dominated by reds, yellows, blues, and greens translucently filling overlapping geometric shapes, in the late 1960s. Rockburne's abstractions have always had a similarity, or continuity, in terms of the shapes from her earliest large sheets of paper folded in near Minimalist abstract monochromes to the present time diagonals used in large murals. Another continuous quality is her lack of overt emotional expression in her forms. But unlike the emphasis on the object such as in Minimal art, Rockburne's paintings have a metaphysical quality that links past and present in a way that makes her audience search for meaning beyond their presence. The technical control in her shapes, colors, and linear, looping arabesques cannot be doubted either. The lines especially add a feeling of lightness, almost joyfulness, to the otherwise hard edge geometry of shapes (see fig. 4.29).

This brings us to the conclusion of our survey of modern art. There are very many, very good artists working today, more than we could ever hope to cover, or do full justice to, but we have not seen any change from the last edition that warrants a different conclusion. So we continue to say that in the authors' estimations, no truly major figures have emerged, as they did in the late nineteenth and earlier twentieth centuries. Perhaps the "natural selection" of a few more decades is needed to reveal the most durable artists and styles of the late modern era. It also remains clear that the sheer diversity of styles, techniques, and media employed are still with us, raising continual questions about their quality to last or be preserved. Such questions may only be answered in the years ahead.

▶ 10 · 115

Sean Scully, A Bedroom in Venice, 1988. Oil on canvas, 8×10 ft 10 in (243.8 \times 304.8 cm).

This Neo-Abstract painter works in a manner reminiscent of early twentieth-century geometric abstraction, as well as Hard-Edge Post-Abstract-Expressionist painters like Kenneth Noland.

The Museum of Modern Art, New York. Fractional gift of Agnes Gund. Photo © 1998 Museum of Modern Art.

Martin Puryear, *Thicket*, 1990. Basswood and cypress, 67 × 62 × 17 in (170.1 × 157.5 ×

43.1 cm).

This African-American artist demonstrates the influences that African tribal art and his worldwide study of woodcraft techniques had in the development of his mature work.

The Seattle Art Museum, gift of Agnes Gund. Photo: Paul Macapia. © Martin Puryear/McKee Gallery.

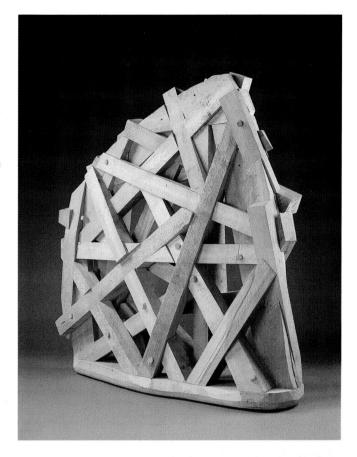

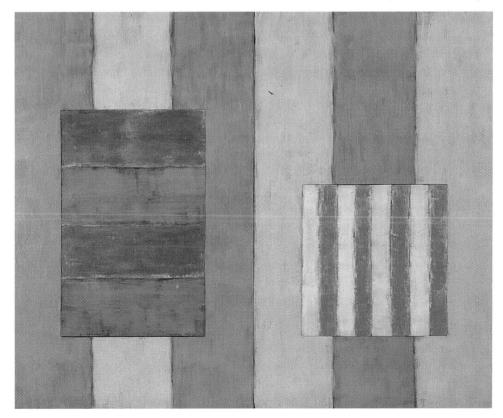

Chronological Outline of Western Art

PREHISTORIC ART (c. 35,000-3000 B.C.)

35,000 B.C. Upper Paleolithic: Late Old Stone Age. Stone Tool Industries.
Art begins: Cave painting and fertility gooddesses (Europe).

10,000 Mesolithic: Middle Stone Age. End of last Ice Age.

6000 Neolithic: New Stone Age. Begins Middle East; spreads to

3000 Europe. Settled agricultural communities; pottery, architecture begins.

ANCIENT ART (c. 4000 B.C.-A.D. 146)

4000 B.C.	Egyptian Art: Old Kingdom.
3000	Sumerian Art: Iraq. Invention of writing.
2800	Aegean Art: Isle of Crete. Minoan I & II.
2300	Akkadian Art: Syria and Iraq.
2000	Aegean Art: Mycenaean Age; Greece. Minoan III; Crete.
1700	Babylonian Art: Syria and Iraq.
1600	Egyptian Art: New Empire.
1500	Neolithic: Ends in Europe.
1100	Aegean Art: Homeric Age, Greece-Turkey.
	Etruscan Art: Italy.
1000	Egyptian Art: Decadence.
900	Assyrian Art: Middle East.
750	Greek Art: Archaic Age; Greece and South Italy.
	Etruscan Art: North Italy.
600	Neo-Babylonian Art: Middle East.
550	Achaemenid Persian Art: Iran / Middle East
470	Greek Art: Classical Age; Greece.
330	Greek Art: Ptolemaic Age, Egypt.
320	Greek Art: Hellenistic Age, Greece and Middle East (Seleucid Empire).
280	Roman Art: Roman Republic, Italy.
140	Graeco-Roman Art: Italy to Greece and Middle East.
30 B.CA.D. 146	Imperial Roman Art: Italy, parts of Europe and Middle East.
30 B.C.?	Jesus Christ born?

EARLY CHRISTIAN AND MEDIEVAL ART	(c. 200-1300 A.D.)	
EARLI CHRISTIAN AND FILDIEVAL ANT	(C. LOU ISOU AID)	

500 B.CA.D. 400	Migratory Period Art in Europe: Celts, Goths, Slavs, Scandinavians.
200	Iranian (Persian) Art: Sassanid Empire.
	Late Imperial Roman Art and Early Christian Art: Italy and Europe.
330	Early Byzantine Art: Centers at Constantinople (Istanbul), Turkey and parts of Middle East.
	Coptic Christian Art: Egypt.
	Early Christian Art: Western Europe and Italy.
476	Roman Art ends.
493	Early Byzantine Art: Introduced at Ravenna and Venice.
570-632	Mohammed founds Islamic religion.
650	Islamic Art: Beginning in Syria, Palestine, and Iraq.
760	Carolingian Art: France, Germany, and North Italy.
800	Developed Byzantine Art: Middle East, Greece, Balkans, and parts of Italy.
950	Ottonian Art: Mostly in Germany.
1000	Romanesque Art: France, England, Northern Spain (Moslems in South), Italy, and Germany.
1150	Gothic Art: France, Italy, Northern Spain, Germany, and England.

RENAISSANCE ART (c. 1300-1600)

From here on, indicated artists are painters unless otherwise stated in parenthesis.

1300	Proto-Renaissance Italy: Duccio, Giotto, Pisano (sculptor).
1400	Early Renaissance Italy: Donatello (sculptor), Masaccio,
	Francesca, Fra Angelico, Fra Filippo Lippi, Brunelleschi (architect), da Vinci.
	Early Northern Renaissance: (modified by vestiges of Medievalism):
	Netherlands: van Eyck, van der Goes, van der Weyden; France: Limbourg
	brothers, Fouquet; Germany: Lochner, Moser, Witz, Pacher, Schongauer (printmaker).
1500	High Renaissance Italy: Giorgione, Titian, Raphael, Michelangelo (sculptor, painter), Tintoretto.
	High Renaissance in Western Europe: (affected by Italy): Netherlands: Bosch, Breughel. Germany: Dürer (printmaker, painter), Grünewald. France: Master of Moulins. Spain: El Greco,
1520	Mannerism and Early Baroque Italy: Caravaggio, Bernini (sculptor).

BAROQUE AND ROCOCO ART (c. 1600-1800)

Baroque Art in Europe: Netherlands (Belgium, Holland): Rubens, van Dyck, Hals.
France: Poussin, Claude. Spain: Ribera, Velasquez.

Early Colonial Art in the Americas: Primarily limners (or primitive portraitists) in
English colonies. Church or cathedral art in Latin Americas.

Rococo Art: Primarily French but spreads to other European countries: France:
Watteau, Boucher, Chardin, Fragonard. Italy: Canaletto, Guardi, Tiepolo.
England: Gainsborough, Hogarth, Reynolds. Colonial Arts and Early
Federal Art in U.S.: Copley, Stuart, West.

NINETEENTH-CENTURY ART (c. 1780-1900)

c. 1780	Neoclassicism: France: David, Ingres; Italy: Canova (sculptor).
1820	Romanticism: France: Barye (sculptor), Delacroix, Géricault,
1826	Niepce (first permanent camera image); Daguerre (photographic process),
	Rejlander (painter & photographer); Spain: Goya; England: Turner, Fox Talbot
	(photographic process); U.S.: Ryder.
1850	Realism (and Naturalism): France: Daumier, Courbet, Rodin and Camille
	Claudel (Romantic Realist Sculptors); England: Constable; U.S.: Eakins, Homer,
	Brady & O'Sullivan (photographers).
1870	Impressionism: France: Monet, Pissarro, Renoir, Degas (some sculpture);
	England: Sisley; U.S.: Hassam, Twachtman, Muybridge (Anglo-American
	photographer); Italy: Medardo-Rosso (sculptor).
1880	Post-Impressionism: France: Cézanne, Gauguin, Seurat, Toulouse-Lautrec;
	Holland: van Gogh; Symbolism: France: Bonnard.

EARLY TWENTIETH-CENTURY ART (1900-c. 1955)

1930-40

	under more than	one of these categories	Note Pablo Picasso particularly
†Artists often change styles and media so some names appear	under more than	Tone of these categories.	Troce rubic ricuser pursuant,

Post-Impressionist sculpture: France: Maillol; U.S.: Lachaise; Germany: 1900 Lehmbruck, Kolbe. Stieglitz and Steichen found 291 Gallery in New York City to advance acceptance of 1902-1907 photography and avant-garde art. Expressionism: France: Les Fauves (Wild Beasts) Dufy, Matisse, Vlaminck, Rouault, Utrillo; Modigliani (Italian). Pablo Picasso.† (Spanish: Blue, Rose, and Negro periods). German Expressionism: Die Brücke (The Bridge): Kirchner, Kokoschka†, 1902-1907 Munch (Norwegian), Nolde, Schmidt-Rotluff; Der Blaue Reiter (The Blue Rider): Jawlensky, Kandinsky†, Macke, Marc, Kuehn (photography); Die Neue Sachlichkeit (The New Objectivity): Dix, Grosz, Heckel, Sander (photographer); Independent German Expressionists: Beckmann, Kokoschka†. Expressionist Sculpture: England: Epstein; Italy: Marini; U.S.: Zorach. Cubism: France: Picasso (Spanish painter, sculptor, potter)†, Braque, Leger, 1906 Gris (Spanish). Futurism: Italy: Balla, Severini, Carra, Boccioni (painter & sculptor), Bragaglia (photographer); France: Marcel Duchamp.† Abstract Art: Germany: Albers†, Hofmann†, Kandinsky (Russian)†, 1910-1920 Archipenko (Russian sculptor); Feininger (American); Russia: Constructivism: Tatlin, Malevitch, Larionov, Gabo and Pevsner (sculptors); Holland: Piet Mondrian; de Stijl architecture: Rietveldt. France: Delaunay, Brancusi (Romanian sculptor), Arp (French sculptor)†; England: Nicholson; U.S: Dove, Marin, O'Keeffe, Sheeler, Davis. Stieglitz (photographer), Steichen (German photographer), Strand (photographer), Coburn (English photographer). Fantasy in Art-Individual Fantasists: France: Chagall (Russian), Henry Rousseau (primitive painter); Italy: de Chirico; Germany: Schwitters, Klee (Swiss). Armory Show, New York: Helps introduce avant-garde art to United States. 1913 Dadaism: France: Arp†, M. Duchamp†, Picabia; Germany: Schwitters†, Ernst†; 1914 U.S.: Man Ray (photographer, painter). Later Expressionism: France: Soutine, Buffet, Balthus, Dubuffet; U.S: Avery, c. 1920-1930 Baskin, Broderson, Levine, Shahn, Weber; Mexico: Orozco, Siqueirios†. Surrealism: France: Arp (sculptor)†, Tanguy, Picasso (Spanish)†, Delvaux, Masson, 1924 Cartier-Bresson (photographer), Gonzáles (Spanish sculptor); Switzerland: Giacometti (sculptor, painter); Belgium: Magritte; England: Bacon; Germany: Ernst†; U.S.: Dali (Spanish; painter; Surrealist cinemas with Luis Buñuel), Man Ray (photographer, painter).

Realist painting and Photography (Straight) in U.S.: Wyeth, Wood, Benton,

Burchfield; F-64 Group of photographers: Weston, Adams, Cunningham.

LATE TWENTIETH-CENTURY ART

c. 1945-1951

Abstract Expressionist Painting (Action or Gestural): Holland: de Kooning; Spain: Mirò; Turkey: Gorky; Chile: Matta; Mexico: Tamayo; U. S.: Hoffmann (German), Pollock, Kline, White (photographer).

Surreal Abstract or Abstract Expressionist Sculpture: England: Moore, Hepworth, Chadwick; France: Richier; Latvia: Lipchitz; U.S.: Calder†, Smith, Noguchi.

1960s

Post-Painterly Abstraction (Hard-Edge or Color-Field Painting): U.S.: Albers† (from Germany); Mondrian† (from Holland), Kelly, Newman, Noland, Stella, Frankenthaler, Rothko, Louis, Callahan (photographer); France: Mathieu, Manessier, Soulages; Portugal: Vieira da Silva; Spain: Tapies; Japan: Okidata.

Op Art: France: Vasarely; U.S.: Anuskiewicz; England: Riley.

Assemblage: U.S.: Rauschenberg†, Oldenburg†, Chamberlain, Stankiewicz, Kienholz; Nevelson.

1960s-1970s

Kinetics and Light Sculpture: France: M. Duchamp† (1920s); U.S.: Wolfert (color organ: 1930–1963), Calder†, Rickey, Bury (Polish); Chryssa, Takis, and Samaris (Greek); Flavin, Lippold (English); Tinguely (Swiss).

Minimalism: U.S.: Reinhardt† (painter), Judd, Bell, Katzen, di Suvero, Caro and Tony Smith (English).

Pop Art: England: Hamilton, Hockney, Kitaj (American); U.S.: Johns, Rauschenbergt, Indiana, Lichtenstein, Warhol, Wesselman, Dine, Oldenburgt (sculptor or assembler), Segal (sculptor); Marisol (Venezeualen sculptor); Samarist (Greek).

Happenings/Performance Art: U.S.: Kaprow (earliest Happening—1958), Nam June Paik (Korean); Germany: Beuys.

Site and Earth Art (Environmental Art): (Earliest examples: Kurt Schwitters†

Germany and Marcel Duchamp† France); U.S.: Christo and Jeanne Claudel;

Oldenburg†, Smithson, Heizer, Samaris† (Greek).

c. 1965-1990s

Postmodernism: Reactions to Abstact Art and dogma, the increasing disparity of income, cynicism about politics and society (some of which resulted from the Vietnam War), etc. Resulted in the reintroduction of the human figure, decoration, literary subjects, eclecticism, and the reuse of older media and mixed techniques along with newer methods. Introduction of Computer Art in the 1980s.

New Realism (Photorealism): U.S.: Estes, Pearlstein, Close, Hanson (sculptor), Frank (Swiss), Winogrand, Friedlander (photographers).

Process and Conceptual Art: Germany: Beuys†; U.S.: Kosuth (early example—1965), Christo and Jeanne Claudel†, Schapiro.

Neo-Expressionism: Germany: Kiefer, Baselitz, Fetting; Italy: Cuchi, Chia; U.S.: Schnabel, Rothenberg, Sherman (photographer-painter).

Neo-Abstraction: U.S.: Benglis (sculptor-painter), Graves (sculptor), Puryear (sculptor), Jensen, Scully (Irish), Rockburne (Canadian).

Glossary

abstraction

Abstraction is a relative term for it is present in varying degrees in all works of art from full representation to complete nonobjectivity. (A term given to the visual effects derived by the simplification and/or rearrangement of the appearance of natural objects or nonrepresentational work arranged simply to satisfy artists' needs for organization or expression.)

Abstract art

The term given to one of the major forms of nonrepresentational and semi-representational art of the twentieth century. It began with Cubism in the second decade of the twentieth century and reached a peak about the middle of the century.

Abstract Expressionism

An American style of painting that developed in the late 1940s sometimes called "Action or Gestural painting." It was characterized by a nonrepresentational style that stressed psychological or emotional meaning.

abstract texture

A texture derived from the appearance of an actual surface but rearranged and/or simplified by the artist to satisfy the demands of the artwork.

academic

Art that conforms to established traditions and approved conventions as practiced in Art Academies. An art that stresses standards and set procedures and rules.

accent

Any stress or emphasis given to elements of a composition that makes them attract more attention than other features that surround or are close to them. Accent can be created by a brighter color, darker tone, greater size, or any other means by which a difference is expressed (see dominance).

achromatic (value)

Relating to differences of light and dark; the absence of hue and its intensity.

Action/Gestural Painting

An Abstract-Expressionist style that involves dripping, spraying, and brushing techniques in the application of pigment to the painting surface. Dribbled lines, roughly textured surfaces, and interwoven shards of color were meant to carry the emotional message to the spectator without reference to anything in the objective world.

actual shape

Clearly defined or positive areas (as opposed to an implied shape).

actual texture

A surface that can be experienced through the sense of touch (as opposed to a surface visually simulated by the artist).

addition

A sculptural term that means building up, assembling, or putting on material.

additive color

Color created by superimposing light rays. Adding together (or superimposing) the three physical primaries (lights)—red, blue, and green—will produce white. The secondaries are cyan, yellow, and magenta.

aesthetic, aesthetics

The theory of the artistic or the "beautiful"—traditionally a branch of philosophy, but now a compound of the philosophy, psychology, and sociology of art. As such, aesthetics is no longer solely confined to determining what is beautiful in art, but attempts to discover the origins of sensitivity to art forms and the relationships of art to other phases of culture (such as science, industry, morality, philosophy, and religion). Frequently, aesthetics is used in this book to mean concern with artistic qualities of form as opposed to descriptive form or the mere recording of facts in visual form. (See **objective**.)

allover pattern

Refers to the repetition of designed units in a readily recognizable systematic organization covering the entire surface.

amorphous shape

A shape without clarity or definition: formless, indistinct, and of uncertain dimension.

analogous colors

Colors that are closely related in hue(s). They are usually adjacent to each other on the color wheel.

approximate symmetry

The use of similar imagery on either side of a central axis. The visual material on one side may resemble that on the other, but is varied to prevent visual monotony.

art

The formal expression of a conceived image or imagined conception in terms of a given medium. (Sheldon Cheney)

assemblage, Assemblage (art style)

A technique that brings together individual items of rather bulky three-dimensional nature that are displayed *in situ* in their original position rather than being limited to a wall. As a style it is associated with artists like Rauschenberg and Kienholz.

asymmetry

Having unlike, or non-corresponding, appearances
— "without symmetry." An example: a twodimensional artwork that, without any necessarily
visible or implied axis, displays an uneven
distribution of parts throughout.

atectonic

Characterized by considerable amounts of space; open, as opposed to massive (or tectonic), and often with extended appendages.

atmospheric (aerial) perspective

The illusion of deep space produced in graphic works by lightening values, softening details and textures, reducing value contrasts, and neutralizing colors in objects as they recede (see **perspective**).

balance

A sense of equilibrium achieved through implied weight, attention, or attraction, by manipulating the visual elements within an artwork in order to accomplish unity.

Bauhaus

Originally a German school of architecture that flourished between World War I and World War II. The Bauhaus attracted many leading experimental artists of both two- and three-dimensional fields.

biomorphic shape

Irregular shape that resembles the freely developed curves found in live organisms.

calligraphy

Elegant, decorative writing. Lines used in artworks that possess the qualities found in this kind of writing may be called "calligraphic" and are generally flowing and rhythmical.

casting

A sculptural technique in which liquid materials are shaped by being poured into a mold.

cast shadow

The dark area that occurs on a surface as a result

of something being placed between that surface and a light source.

chiaroscuro

1. Distribution of light and dark in a picture. 2. A technique of representation that blends light and shade gradually to create the illusion of three-dimensional objects in space or atmosphere.

chroma

1. The purity of hue or its freedom from white, black, or gray. 2. The intensity of hue.

chromatic

Pertaining to the presence of color.

chromatic (value)

The value (relative degree of lightness or darkness) demonstrated by a given color.

classical

Art forms that are characterized by a rational, controlled, clear, and intellectual approach. The term derives from the ancient art of Greece in the fourth and fifth centuries B.C. The term "classical" has an even more general connotation, meaning an example or model of first rank or highest class in any kind of form, literary, artistic, natural, or otherwise. Classicism is the application of, or adherence to, the principles of Greek culture by such later cultural systems as the Roman and Renaissance civilizations, and the art of the Neoclassical movement in the early nineteenth century.

closed-value composition

Values are limited by the edges or boundaries of shapes.

closure

A Gestalt concept where the development of groupings or patterned relationships occurs when incomplete information is seen as a complete-unified whole—the artist provides minimum visual clues and the observer brings them to final recognition.

collage

A pictorial technique where the artist creates the image, or a portion of it, by adhering real materials that possess actual textures to the picture plane surface, often combining them with painted or drawn passages.

color

The visual response to the wavelengths of sunlight identified as red, green, blue, etc.; having the physical properties of hue, intensity, and value.

Color Field Painting

A branch of Post Painterly Abstraction. A style closely related to Geometric Abstraction. It is also called Hard Edge Painting. The artists filled extremely large canvases with bright color meant to involve the viewer psychologically. They created unified shapes, fields, and/or symbols of the artists' personal feelings. The fields of color

Glossary

were flat in technique and bonded or integral to the surface.

color tetrad

Four colors, equally spaced on the color wheel, containing a primary and its complement and a complementary pair of intermediates. This has also come to mean any organization of color on the wheel forming a rectangle that could include a double split-complement.

color triad

Three colors spaced an equal distance apart on the color wheel forming an equilateral triangle. The twelve-color wheel is made up of a primary triad, a secondary triad, and two intermediate triads.

complementary colors

Two colors directly opposite each other on the color wheel. A primary color is complementary to a secondary color, which is a mixture of the two remaining primaries.

composition

An arrangement and/or structure of all the elements, as organized by the principles, that achieves a unified whole. Often used interchangeably with the term "design."

concept

1. A comprehensive idea or generalization. 2. An idea that brings diverse elements into a basic relationship.

Conceptual Art

The most significant concern of Conceptual Art is the "idea." Though often denying the use of art materials and form in preference to conveying a message or analyzing an idea through photography, words and "found" objects of human construction. At the extreme, all that is needed is an idea or concept. It first appeared in the 1960s.

conceptual perception

Creative vision derived from the imagination.

Constructivism

Pre-communist movement founded in Russia by Vladimir Tatlin that proclaimed total abstraction as the new realism in art in 1920. It had much to do with the assembly and new use of contemporary materials and application of traditional materials in both painting and sculpture.

content

The expression, essential meaning, significance, or aesthetic value of a work of art. Content refers to the sensory, subjective, psychological, or emotional properties we feel in a work of art, as opposed to our perception of its descriptive aspects alone.

contour

In art, the line that defines the outermost limits of an object or a drawn or painted shape. It is sometimes considered to be synonymous with "outline"; as such, it indicates an edge that also may be defined by the extremities of values, textures, or colors.

craftsmanship

Aptitude, skill, or quality workmanship in use of tools and materials.

cross-contour

A line that crosses and defines the surface undulations between, or up to, the outermost edges of shapes or objects.

Cubism

The name given to the painting style invented by Pablo Picasso and Georges Braque between 1907 and 1912, which used multiple views of objects to create the effect of their three-dimensionality, while acknowledging the two-dimensional surface of the picture plane. Signaling the beginning of abstract art, it is a semi-abstract style that continued the strong trend away from representational art initiated primarily by Cézanne in the late 1800s.

curvilinear

Stressing the use of curved lines; as opposed to "rectilinear," which stresses straight lines.

Dada

A nihilistic, anti-art, anti-everything movement resulting from the social, political, and psychological dislocations of World War I. The movement, which literally means "hobbyhorse," is important historically as a generating force for Surrealism. The Dada movement began in Zurich, Switzerland, in 1916.

decorative (art, line, shape, color, space, and so forth)

Ornamenting or enriching but, more importantly in art, emphasizing the two-dimensional nature of an artwork or any of its elements. Decorative art emphasizes the essential flatness of a surface.

descriptive (art)

A type of art that is based upon adherence to actual appearances.

design

The underlying plan on which artists base their total work. In a broader sense, design may be considered synonymous with the term **form**.

de Stiil

A Dutch form of art featuring primary colors within a balanced structure of lines and rectangles. It was a style meant to perfectly express the higher mystical unity between humankind and the universe. Translated as "the Style," it was the form of abstraction developed by Piet Mondrian and Theo van Doesburg about 1914–17.

dominance

The principle of visual organization where certain elements assume more importance than others in the same composition or design. Some features are emphasized and others are subordinated.

Glossary 329

economy

Distilling the image to the basic essentials for clarity of presentation.

elements of art

Line, shape, value, texture, and color—the basic ingredients the artist uses separately or in combination to produce artistic imagery. Their use produces the visual language of art.

Environmental Art

A form of art taking its name from the fact that it surrounds and affects the spectator like the environment. Derived primarily from Assemblage and Pop Art, it is now generally called Site and Earth Art.

equivocal space

A condition, usually intentional on the artist's part, when the viewer may, at different times, see more than one set of relationships between art elements or depicted objects. This may be compared to the familiar "optical illusion."

expression

1. The manifestation through artistic form of a thought, emotion, or quality of meaning. 2. In art, expression is synonymous with the word **content.**

Expressionism

A form of art in which there is a desire to express what is felt rather than perceived or reasoned. Expressionistic form is defined by an obvious exaggeration of natural objects for the purpose of emphasizing an emotion, mood, or concept. It can be better understood as a more vehement kind of Romanticism. The term is best applied to a movement in art of the early twentieth century, encompassing the Fauves and German groups, although it can be used to describe all art of this character.

Fantastic Art

Not a particular style or movement, but a term used to describe the kind of art that arose as a reaction to the machine cult in Abstract Art and the bloodshed in World War I. It extolled artistic freedom to reemphasize the emotional and intuitive side of creativity.

Fauves (Fauvism)

A name (meaning "wild beasts") for an art movement that began in Paris, France, about 1905. It was expressionistic art in a general sense, but more decorative, orderly, and charming than German Expressionism.

form

1. The organization or inventive arrangement of all the visual elements according to the principles that will develop unity in the artwork. 2. The total appearance or organization.

four-dimensional space

A highly imaginative treatment of forms that gives a sense of intervals of time or motion.

fractional representation

A device used by various cultures (notably the Egyptians) in which several spatial aspects of the same subject are combined in the same image.

Futurism

A sub-movement within the overall framework of abstraction adopted by many twentieth-century artists. The imagery of Futurist artists was based on an interest in time, motion, and rhythm, which they felt were manifested in the machinery and human activities of modern times and their extension into the future.

genre

Subject matter that concerns everyday life, domestic scenes, family relationships, etc.

geometric shape

Ā shape that appears related to geometry. Geometric shapes are usually simple, such as triangles, rectangles, and circles.

Gestalt, Gestalt psychology

A German word for "form." Defined as an organized whole in experience. Around 1912, the Gestalt psychologists promoted the theory that explains psychological phenomena by their relationships to total forms, or Gestalten, rather than their parts.

glyptic

1. The quality of an art material like stone, wood, or metal that can be carved or engraved. 2. An art form that retains the color, tensile, and tactile quality of the material from which it was created. 3. The quality of hardness, solidity, or resistance found in carved or engraved materials.

golden mean/golden section

1. Golden mean—"perfect" harmonious proportions that avoid extremes; the moderation between extremes. 2. Golden section—a traditional proportional system for visual harmony expressed when a line or area is divided into two sections so that the smaller part is to the larger as the larger is to the whole. The ratio developed is 1:1.6180. . . . or, roughly, 8:13.

graphic art

1. Two-dimensional art forms such as drawing, painting, making prints, etc. 2. The two-dimensional use of the elements. 3. May also refer to the techniques of printing as used in newspapers, books, magazines, etc.

Happenings

A form of participatory art in which artists and spectators were engaged. Sometimes called "assemblages on the move." It stemmed from Dada and came into being with Pop Art in the mid to late 1950s. Being ephemeral, Happenings are recorded by photographers and cinemamakers. Now, Performance Art is the more popular term (see **Performance Art**).

harmony

The quality of relating the visual elements of a composition. Harmony is achieved by repetition of characteristics that are the same or similar. These cohesive factors create pleasing interaction.

hatching

Repeated strokes of an art tool producing clustered lines (usually parallel) that create values. In "cross"-hatching similar lines pass over the hatched lines in a different direction, usually resulting in darker values.

high-key color

Any color that has a value level of middle gray or lighter.

high-key value

A value which has a level of middle gray or lighter.

highlight

The portion of an object that, from the observer's position, receives the greatest amount of direct light.

hue

Designates the common name of a color and indicates its position in the spectrum or on the color wheel. Hue is determined by the specific wavelength of the color in a ray of light.

illusionism

The imitation of visual reality created on the flat surface of the picture plane by the use of perspective, light-and-dark shading, etc.

illustration(al)

An art practice that stresses anecdotes or story situations.

implied line

Implied lines (subjective lines) are those that dim, fade, stop and/or disappear where the missing part is implied to continue and is visually completed by the observer as the line reappears.

implied shape

A shape suggested or created by the psychological connection of dots, lines, areas, or their edges, creating the visual appearance of a shape that does not physically exist. (See **Gestalt.**)

Impressionism

A movement of the late nineteenth century primarily connected with such painters as Claude Monet and Camille Pissarro. A form of realistic painting based on the way in which changing aspects of light affect human vision, it challenged older modes of such representation.

infinite space

A concept in which the picture frame acts as a window through which objects can be seen receding endlessly.

intensity

The saturation, strength, or purity of a hue. A vivid color is of high intensity; a dull color is of low intensity.

intermediate color

A color produced by a mixture of a primary color and a secondary color.

interpenetration

The movement of planes, objects, or shapes through each other, locking them together within a specific area of space.

intuitive space

The illusion of space that the artist creates by instinctively manipulating certain space-producing devices, including overlapping, transparency, interpenetration, inclined planes, disproportionate scale, fractional representation, and the inherent spatial properties of the art elements.

invented texture

A created texture whose only source is in the imagination of the artist. It generally produces a decorative pattern and should not be confused with an abstract texture.

isometric projection (perspective)

A technical drawing system in which a threedimensional object is presented twodimensionally; starting with the nearest vertical edge, the horizontal edges of the object are drawn at a thirty-degree angle and all verticals are projected perpendicularly from a horizontal base.

Kinetic Art

A form of art named after a Greek word (kinesis) meaning "motion." Art that involves an element of random or mechanical movement.

kinetic assemblage

An assemblage that moves, a mobile, for example (see **assemblage**).

line (actual)

The path of a moving point that is made by a tool, instrument, or material as it moves across an area. A line is usually made visible because it contrasts in value with its surroundings. Three-dimensional lines may be made using string, wire, tubes, solid rods, etc.

linear perspective (geometric)

A system used to develop three-dimensional images on a two-dimensional surface; it develops the optical phenomenon of diminishing size by treating edges as converging parallel lines. They extend to a vanishing point or points on the horizon (eye-level) and recede from the viewer (see **perspective**).

local (objective) color

The color as seen in the objective world (green grass, blue sky, red barn, etc.).

Glossary

local value

The relative light and dark of a surface, seen in the objective world, that is independent of any effect created by the degree of light falling on it.

low-key color

Any color that has a value level of middle gray or darker.

low-key value

Any value which has a level of middle gray or darker

manipulation

The sculptural technique that refers to the shaping of pliable materials by hands or tools.

mass

1. In graphic art, a shape that appears to stand out three-dimensionally from the space surrounding it or appears to create the illusion of a solid body of material. 2. In the plastic arts, the physical bulk of a solid body of material.

medium, media (pl.)

The material(s) and tool(s) used by the artist to create the visual elements perceived by the viewer.

Minimalism

Abstract art forms reduced to the barest essentials that reveal very little variation in the use of elements.

mobile

A three-dimensional, moving sculpture.

modeling

A sculptural technique meaning to shape a pliable material.

modern art, modernism

The term "modern art" is applied to almost all progressive or avant-garde phases of art from the time of the Impressionists in the late 1880s to the growth of Postmodernism in the 1960s. Modernism is usually associated with the nonrepresentational, formally organized kinds of modern art, as opposed to its organic and/or fantastic branches.

moments of force

Direction and degree of energy implied by the art elements in specific compositional situations; amounts of visual thrust produced by such matters as dimension, placement, and accent.

monochromatic

Having only one hue; the complete range of value of one color from white to black.

motif

A designed unit or pattern that is repeated often enough in the total composition to make it a significant or dominant feature. Motif is similar to "theme" or "melody" in a musical composition.

movement

Eye travel directed by visual pathways in a work of art.

naturalism, Naturalism (art style)

The approach to art that is essentially a description of things visually experienced. Pure naturalism would contain no personal interpretation introduced by the artist; this is a physical impossibility. As a style Naturalism is associated with artists like Courbet and Meissonier.

natural texture

Textures created as the result of nature's processes.

negative area(s)

The unoccupied or empty space left after the positive elements have been created by the artist. However, when these areas have boundaries, they also function as design shapes in the total structure.

Neo-Abstraction

Within the umbrella of Postmodern art there exists a hard core of artists who have chosen to remain within the abstract manner. Most of them are influenced by the rich color work of such artists as Frank Stella or Al Held.

Neoclassicism

A style, initiated in the late 1700s in France, which centered upon a reintroduction of Classical Greek and Roman forms of art, as then understood. It became the basis for the "approved" or official art of the French government until about the middle of the nineteenth century. The main exponents were Jacques-Louis David and Jean-Auguste-Dominique Ingres.

Neo-Expressionism

Dating from the early 1980s, this style reaffirmed the psychic emotionalism of early twentiethcentury Expressionism. It became perhaps the most distinctive direction in Postmodernism.

neutralized color

A color that has been grayed or reduced in intensity by being mixed with any of the neutrals or with a complementary color.

neutrals

1. The inclusion of all color wavelengths will produce white, and the absence of any wavelengths will be perceived as black. With neutrals, no single color is noticed—only a sense of light and dark or the range from white through gray to black. 2. A color altered by the addition of its complement so that the original sensation of hue is lost or grayed.

Nonobjective, nonrepresentational (art)

A type of art that is entirely imaginative and not derived from anything visually perceived by the artist. The elements, their organization, and their treatment by the artist are entirely personalized and, consequently, not associated by the observer with any previously experienced natural objects.

objective (art) and (shape)

A type of art that is based, as near as possible, on physical actuality or optical perception. Such art tends to appear natural or real.

oblique projection (perspective)

A technical drawing system in which a threedimensional object is presented two-dimensionally; the front and back sides of the object are parallel to the horizontal base; and the other planes are drawn as parallels coming off the front plane at a forty-five degree angle.

Op Art

A form of abstract art that has a direct impact on the physiology and psychology of vision or sight; began in the late 1950s.

open-value composition

Values cross over shape boundaries into adjoining areas.

optical perception

A way of seeing in which the mind has no other function than the natural one of providing the visual sensation of object recognition.

organic unity

A condition in which the components of art, that is, subject, form, and content, are so vital and interdependent that they may be likened to a living organism. A work having "organic unity" is not guaranteed to have "greatness" or unusual merit.

orthographic drawing

Graphic representation of two-dimensional views of an object, showing a plan, vertical elevations, and/or a section.

paint quality

The use of paint to enrich a surface through textural interest. Interest is created by the ingenuity in handling paint for its intrinsic character.

papier collé

A visual and tactile technique where scraps of paper having various textures are pasted to the picture surface to enrich or embellish areas. In addition to the actual texture of the paper, the printing on adhered tickets, newspapers, etc., functions as visual richness or decorative pattern similar to an artist's invented texture.

patina

1. A natural film, usually greenish, that results from the oxidation of bronze or other metallic materials. 2. Colored pigments and/or chemicals applied to a sculptural surface.

pattern

1. Any artistic design (sometimes serving as a model for imitation). 2. Compositions with repeated elements and/or designs that are usually varied, and produce interconnections and obvious directional movements.

Performance Art

A type of art derived from Happenings in which the action is performed by a single artist. It consists of mixed-media performances of painting, music, theatrics, kinetics (see **Happenings**).

perspective

Any graphic system used to create the illusion of three-dimensional images and/or spatial relationships on a two-dimensional surface. There are several types of perspective—atmospheric, linear, and projection systems.

photogravure

The process of printing a photographic image from an etched plate.

Pictorialism

A branch of photography dating from the early nineteenth century. Pictorialist photographers were opposed to the dreary predictability of Realist (or Straight) photography and to the academic, artificial Pictorialism of Rejlander. They believed in the possibility of a personal expression of order and beauty in which science and art would combine in photographic imagery. Many Pictorialists turned to manipulating focus and film development in an attempt to arrive at this result. Pictorialism has become one of the favored forms of photography.

picture frame

The outermost limits or boundary of the picture plane.

picture plane

The actual flat surface on which the artist executes a pictorial image. In some cases, the picture plane acts merely as a transparent plane of reference to establish the illusion of forms existing in a three-dimensional space.

pigments

Color substances that give their color property to another material by being mixed with it or covering it. Pigments, usually insoluble, are added to liquid vehicles to produce paint or ink. Colored substances dissolved in liquids, which give their coloring effects by being absorbed or staining, are referred to as dyes.

planar (shape)

Having to do with planes.

Plane

 An area that is essentially two-dimensional, having height and width.
 A flat or level surface.
 A two-dimensional surface that extends in a three-dimensional spatial direction.

plastic (art, line, shape, color, space, value, and so forth)

1. The use of the elements to create the illusion of the third dimension on a two-dimensional surface.
2. Three-dimensional art forms such as architecture, sculpture, ceramics, etc.

Pop Art

The name given to the form of art that uses, often satirically, the mundane products of mass popular culture, such as magazine, newspaper, billboard, television advertising, comic strips and books, supermarket shelves, and so on, as its subject matter. It derived from certain early modern art forms and ideas, especially from Marcel Duchamp's "ready-made" and "found" objects of the 1920s through 1950s. It began to take shape in England in the late 1950s and spread quickly during the 1960s in the United States, where it was most widely accepted.

positive area(s)

The state in the artwork in which the art elements (shape, line, etc.), or their combination, produce the subject—nonrepresentational or recognizable objects. (See **negative area.**)

Post-Impressionism

The name applied to a few artists at the end of the nineteenth century who sought to restore formal organization, decorative unity, and expressive meaning to art. The most important were Paul Cézanne, Georges Seurat, Paul Gauguin, and Vincent van Gogh. These artists believed that the qualities cited above had been lost in Contemporary Art, particularly by the Impressionists. Post-Impressionism began the strong divergence from Representational Art that was to occupy such a strong place in twentieth-century Abstract Art.

Postmodernism

It began to seem in the 1970s that the dominant styles of art-Minimalism and Conceptualismno longer fitted a world struggling with such rising social problems as drugs, crime, divorce, and commercial greed. As a result, a plurality of styles developed as a reaction to these worsening circumstances. Other Postmodernists, however, more forcefully expressed a desire to do away with art that seemed to have no meaningful content, and began to turn back to figurative art and the establishment of meaning. Still other forms of Postmodernism extend modern art in new ways by appropriating earlier styles, with minor or major modifications, and pastiching them. Due to the sheer variety of sources and styles in Postmodernism, it has been difficult to categorize such artists with the same ease as those of earlier styles or movements.

Post-Painterly Abstraction

This category of painting has also been called "Hard-Edge" and "Color Field." Painters were closely related to early twentieth-century Geometric Abstraction.

Glossary

principles of organization

There are seven principles that guide the employment of the elements in achieving unity. They are harmony, variety, balance, proportion, dominance, movement, and economy.

primary color

The preliminary hues that can't be broken down or reduced into component colors. The basic hues in any color system that in theory may be used to mix all other colors.

Primitive Art

The art of a people with a tribal social order or an early (though complex) stage of culture. The art of such people is often characterized by a heightened emphasis on form and a mysterious or vehement expressive content. Modern Primitive Art, like that of Henri Rousseau in France and Grandma Moses in the United States, is mostly the work of untrained or slightly trained artists. This kind of recent Primitive Art shows a naivetæ of form and expression closely related to the untrained, but often sensitive imagery of Folk Art. Early twentieth-century artist, such as the Expressionists and the Cubists, were influenced by Primitive Art.

proportion

The comparative relationship between parts of a whole or units as to size. For example, the size of the Statue of Liberty's hand relates to the size of her head (see **scale**).

radial

Compositions that have the major images or design parts emanating from a central location.

realism, Realism (art movement)

A style of art that retains the basic impression of visual actuality without going to extremes of detail. In addition, realism attempts to relate and interpret the universal meanings that lie beneath surface appearances. As a movement, it relates to painters like Honoré Daumier in nineteenth-century France and Winslow Homer in the United States in the 1850s.

Realist (or Straight) photography

The branch of photography opposed to the "false" imagery of the Pictorialists who believed primarily in the honest use of available materials and technology to provide a photographic image, as opposed to the blurry, altered images of the Pictorialists, which amounted to an attempt to "enhance" content.

rectilinear shape

A shape whose boundaries usually consist entirely of straight lines.

relief sculpture

An art work, graphic in concept, but sculptural in application, utilizing relatively shallow depth to establish images. The space development may

range from very limited projection known as "low relief" to more exaggerated space development known as "high relief." Relief sculpture is meant to be viewed frontally not in the round.

repetition

The use of the same visual effect a number of times in the same composition. Repetition may produce the dominance of one visual idea, a feeling of harmonious relationship, an obviously planned pattern, or a rhythmic movement.

representation(al) art

A type of art in when the subject is presented through the visual art elements so that the observer is reminded of actual objects (see **naturalism** and **realism**).

rhythm

A continuance, a flow, or a sense of movement achieved by repetition of regulated visual units; the use of measured accents.

Romanticism

In the visual arts, the romantic spirit is characterized by an experimental point of view and extols spontaneity of expression, intuitive imagination, and the picturesque rather than a carefully organized, rational approach.

Romanticism, a movement of nineteenth-century artists, such as Delacroix, Géricault, Turner, and others, is characterized by just such an approach to form. (See classical.)

scale

Scale is established when associations of size are created relative to some constant standard or specific unit of measure relative to human dimensions. For example, the Statue of Liberty's scale is apparent when she is seen next to an automobile (see **proportion**).

sculpture

The art of expressive shaping of three-dimensional materials. "Man's expression to man through three-dimensional form" (Jules Struppeck, see Bibliography).

secondary color

A color produced by a mixture of two primary colors.

shadow, shade, shading

The darker value on the surface of an object that gives the illusion that a portion of it is turned away from or obscured by the source of light.

shallow space

The illusion of limited depth. With shallow space, the imagery moves only a slight distance back from the picture plane.

shape

An area that stands out from the space next to or around it because of a defined or implied

boundary, or because of differences of value, color, or texture.

silhouette

The area between or bounded by the contours, or edges, of an object; the total shape.

simulated texture

A convincing copy or translation of an object's texture in any medium.

simultaneity

In art the use of separate views, representing different points in time and space, that are brought together and sometimes superimposed to create one integrated image.

simultaneous contrast

When two different colors come into direct contact, the contrast intensifies the difference between them.

space

The interval, or measurable distance, between points or images.

spectrum

The band of individual colors that results when a beam of white light is broken into its component wavelengths, identifiable as hues.

split-complement(s)

A color and the two colors on either side of its complement.

style

The specific artistic character and dominant trends of form noted during periods of history and art movements. Style may also refer to artists' expressive use of media to give their works individual character.

subject

1. In a descriptive approach to art, subject refers to the persons or things represented, as well as the artists' experiences, that serve as inspiration. 2. In abstract or nonobjective forms of art, subject refers merely to the visual signs employed by the artist. In this case, the subject has little to do with anything experienced in the natural environment.

subjective (art, shapes, color, etc.)

- 1. That which is derived from the mind reflecting a personal viewpoint, bias, or emotion.
- 2. Subjective art tends to be inventive or creative.

substitution

In sculpture, replacing one material or medium with another (see **casting**).

subtraction

A sculptural term meaning to carve or cut away materials.

subtractive color

The sensation of color that is produced when wavelengths of light are reflected back to the

Glossary 333

viewer after all other wavelengths have been subtracted and/or absorbed.

Surrealism

A style of artistic expression, influenced by Freudian psychology, that emphasizes fantasy and whose subjects are usually experiences revealed by the subconscious mind through the use of automatic techniques (rubbings, doodles, blots, cloud patterns, etc.). Originally a literary movement and an outgrowth of Dadaism, Surrealism was established by a literary manifesto written in 1924.

Symbolism/Symbolists

A literary movement that spread to painting in the 1880s. Symbolists tried to grapple with the notion of subjective ideas, stating that the senses are inseparable from human emotions and that people and objects are, therefore, merely symbols of a deeper existence beyond the everyday. It was not a style as such, and merely set a goal for artists to reach in a number of ways. The painters Odilon Redon and Pierre Bonnard, among others, are associated with the movement, and Paul Gauguin is considered a father figure.

symmetry

The exact duplication of appearances in mirrorlike repetition on either side of a (usually imaginary) straight-lined central axis.

tactile

A quality that refers to the sense of touch.

technique

The manner and skill with which artists employ their tools and materials to achieve an expressive effect. The ways of using media can have a strong effect on the aesthetic quality of an artist's total concept.

tectonic

The quality of simple massiveness; lacking any significant extrusions or intrusions.

tenebrism

A technique of painting that exaggerates or emphasizes the effects of chiaroscuro. Larger amounts of dark value are placed close to smaller areas of highly contrasting lights—which change suddenly—in order to concentrate attention on important features.

tension

The manifested energies and forces of the art elements as they pull or push in affecting balance or counterbalance.

tertiary color

Color resulting from the mixture of all *three* primaries in differing amounts or two secondary colors. Tertiary colors are characterized by the neutralization of intensity and hue. They are found on the color wheel on the inner rings of color leading to complete neutralization.

texture

The surface character of a material that can be experienced through touch or the illusion of touch. Texture is produced by natural forces or through an artist's manipulation of the art elements.

three-dimensional

To possess, or to create the illusion of possessing, the dimension of depth, as well as the dimensions of height and width.

transparency

A visual quality in which a distant image or element can be seen through a nearer one.

trompe l'oeil

Literally, "deceives the eye"; a technique that copies nature with such exactitude that the subject depicted can be mistaken for natural forms.

two-dimensional

To possess the dimensions of height and width.

unity

The result of bringing the elements of art into the appropriate ratio between harmony and variety to give a sense of oneness.

value

1. The relative degree of light or dark. 2. The characteristic of color determined by light or dark, or the quantity of light reflected by the color.

value pattern

The arrangement or organization of values that control compositional movement and create a unifying effect throughout a work of art.

variety

Differences achieved by opposing, contrasting, changing, elaborating, or diversifying elements in a composition to add individualism and interest; the counterweight of **harmony** in art.

void

1. Areas lacking positive substances and consisting of negative space. 2. A spatial area within an object that penetrates and passes through it.

volume

A measurable area of defined or occupied space.

Bibliography

- ADAM, MICHAEL, Womankind. New York: Harper and Row, 1979.
- AGOSTON, GEORGE A., Color Theory and its Application in Art and Design. Berlin, Heidelberg, New York: Springer Verlag, 1987.
- ALBERS, JOSEF, Interaction of Color. New Haven, Conn.: Yale University Press, 1963.
- ARMSTRONG, TOM, 200 Years of American Sculpture, catalog for Whitney Museum of American Art. Boston, Mass.: The Godine Press, 1976.
- ARNASON, H. H., History of Modern Art. Englewood Cliffs, N.J.: Prentice-Hall, 1986.
- ARNHEIM, RUDOLPH, Art and Visual Perception. Berkeley, Calif.: University of California Press, 1966.
- BATES, KENNETH F., Basic Design: Principle and Practice. New York: Funk & Wagnalls, 1975.
- BETHERS, RAY, Composition in Pictures. New York: Pitman Corporation, 1956.
- BETTI, CLAUDIA and SELE, TEEL, A Contemporary Approach: Drawing. New York: Holt, Rinehart & Winston, 1980.
- BEVLIN, MARJORIE E., Design Through Discovery. New York: Holt, Rinehart & Winston, 1980.
- BINDMAN, DAVID, William Blake. Thames and Hudson, 1982.
- BIRREN, FABER, Creative Color. New York: Van Nostrand Reinhold, 1961.
- ———, *Principles of Color.* New York: Van Nostrand Reinhold, 1969.
- ———, Color Perception in Art. New York: Van Nostrand Reinhold, 1976.
- BLOCK, JONATHAN, et al., *Understanding Three Dimensions*. Englewood Cliffs, N.J.: Prentice-Hall, 1987.
- BLOOMER, CAROLYN M., Principles of Visual Perception. New York: Van Nostrand Reinhold, 1976.
- BRO, L. V., Drawing: A Studio Guide. New York: W. W. Norton, 1978.
- CANADAY, JOHN, What Is Art? New York: Alfred Knopf, 1980.
- CARPENTER, JAMES M., Visual Art: An Introduction. New York: Harcourt Brace Jovanovich, 1982.
- CHAET, BERNHARD, *The Art of Drawing*. New York: Holt, Rinehart & Winston, 1970.

- CHEATHAN, FRANK R.; CHEATHAN, JANE HART; and OWENS, SHERYL HATER, Design Concepts and Applications. Englewood Cliffs, N.J.: Prentice-Hall, 1983.
- CHEVREUL, M. E., The Principles of Harmony and Contrasts of Colors and Applications to the Arts. New York: Van Nostrand Reinhold, 1981.
- CHILVERS, IAN; OSBORNE, HAROLD; and FARR, DENNIS, *The Oxford Dictionary of Art.* New York: Oxford University Press, 1988.
- CLEAVER, DALE G., Art: An Introduction. New York: Harcourt Brace Jovanovich, 1972.
- COLEMAN, RONALD, Sculpture: A Handbook for Students. Madison, Wisc.: Brown & Benchmark Publishers, 1990.
- COLLIER, GRAHAM, Form, Space and Vision. Englewood Cliffs, N.J.: Prentice-Hall, 1972.
- COMPTON, MICHAEL, *Pop Art.* London: Hamlyn, 1970.
- CRAWFORD, WILLIAM, The Keepers of the Light: A History and Working Guide to Early Photographic Processes. New York: Dobbs Ferry, 1979.
- DANTZIC, CYNTHIA MARIS, *Design Dimensions*. Englewood Cliffs, N.J.: Prentice-Hall, 1990.
- DAVIS, PHIL, *Photography.* Madison, Wisc.: Brown & Benchmark Publishers, 1995.
- DIAMOND, DAVID G., Art Terms. Boston, Mass.: A Bulfinch Press Book; Little, Brown, 1992.
- EDWARDS, BETTY, Drawing on the Right Side of the Brain. Los Angeles: Tarcher, 1979.
- ELIOT, ALEXANDER, *Myths.* New York, McGraw Hill, 1976.
- ELSEN, ALBERT E., Origins of Modern Sculpture. New York: George Braziller, 1974.
- ENSTICE, W., and PETERS, M., *Drawing*. Englewood Cliffs, N.J.: Prentice-Hall, 1996.
- FAINE, BRAD, The Complete Guide to Screen Printing. Cincinnati: Quartu Publishing, 1989.
- FAULKNER, RAY; SMAGULA, HOWARD; and ZIEGFELD, EDWIN, Today: An Introduction to the Visual Arts. New York: Holt, Rinehart & Winston, 1987.
- GARDNER, HELEN, revised by Tansey, Richard G. and Kleiner, Fred S., Art Through the Ages. (VOLUME II, Renaissance and Modern Art). New York: Harcourt Brace, 1996.

- GILBERT, RITA, and McCARTER, WILLIAM, *Living with Art.* New York: Alfred Knopf, 1988.
- GOLDSTEIN, NATHAN, *The Art of Responsive Drawing.* Englewood Cliffs, N.J.: Prentice-Hall, 1977.
- HARLAN, CALVIN, Vision and Invention: A Course in Art Fundamentals. Englewood Cliffs, N.J.: Prentice-Hall, 1970.
- HELLER, NANCY, Women Artists: An Illustrated History. New York: Abbeyville Press, 1981.
- HIBBARD, HOWARD, The Metropolitan

 Museum of Art. New York: Harper & Row,
 1980.
- HUNTER, SAMUEL, American Art of the 20th Century. New York: Harry N. Abrams, 1972.
- ITTEN, JOHANNES, *The Art of Color.* New York: Van Nostrand Reinhold, 1970.
- ——, Design and Form. New York: Van Nostrand Reinhold, 1975.
- JENKINS, DONALD, *Images of a Changing World*. Portland, Oregon: Portland Art Association, 1983.
- KISSICK, J., Art Context & Criticism. Madison, Wisconsin: Brown & Benchmark Publishers, 1993.
- KNAPPE, KARL-ADOLF, *Dürer.* New York: Harry N. Abrams, 1965.
- KNOBLER, NATHAN, *The Visual Dialogue*. New York: Holt, Rinehart & Winston, 1980.
- KUEPPERS, HARALD, *The Basic Law of Color Theory.* New York: Barron's Educational Series, 1982.
- ——, Color Atlas. New York: Barron's Educational Series, 1982.
- LANE, R., *Images from the Floating World*. Secaucas, N.J.: Cartwell Books, Inc., 1978.
- LAUER, DAVID, Design Basics. New York: Holt, Rinehart & Winston, 1989.
- LERNER, ABRAM, et al. *The Hirshhorn Museum and Sculpture Garden*. New York:
 Harry N. Abrams, 1974.
- LEWIS, R. L., and LEWIS, S. I., *The Power of Art.* Orlando, Florida: Harcourt Brace, 1994.
- LOCKER, J. L., *The World of M. C. Escher.* New York: Harry Abrams, 1971.
- LOWE, SARAH M., Frida Kahlo. New York: University Publishing, 1991.

- LUCIE-SMITH, EDWARD, Late Modern: The Visual Arts Since 1945. New Praeger, 1969.
- ——, The Thames and Hudson Dictionary of Art Terms. New York: Thames and Hudson, 1984.
- MACAULAY, DAVID, *The Way Things Work*. Boston, Mass.: Miffen, 1988.
- MEISEL, L. K., *Photorealism Since 1980.* New York: Harry Abrams, 1993.
- MYERS, JACK FREDRICK, The Language of Visual Art. Orlando, Fla.: Holt, Rinehart & Winston, 1989.
- NATIONAL GALLERY OF ART, Johannes Vermeer. Washington, D.C., 1995.
- POIGNANT, R., Oceanic Mythology. London: Paul Hamlyn,. 1967.
- PREBLE, DUANE, We Create, Art Creates Us. New York: Harper & Row, 1976.
- ——, Art Forms. New York: Harper & Row, 1989.
- RICHARDSON, JOHN ADKINS, et al., Basic Design. Englewood Cliffs, N.J.: Prentice-Hall, 1984.
- RICHARDSON, J. A., Art: The Way It Is. Englewood Cliffs, N.J., Prentice-Hall/Harry Abrams, 1986.

- RUBIN, W., *Primitivism in 20th Century "Art."* New York: Museum of Modern Art, 1984. (2 vols.)
- RUSSELL, STELLA PANDELL, Art in the World. Orlando, Fla.: Holt, Rinehart & Winston, 1989.
- SAFF, DONALD and SACILOTTO, DELI, Printmaking. New York: Holt, Rinehart & Winston, 1978.
- SIMMONS, SEYMOUR, III, and WINER, MARC S. A., *Drawing: The Creative Process*. Englewood Cliffs, N.J.: Prentice-Hall, 1977.
- SMITH, BRADLEY, *Mexico–A History in Art.* New York: Doubleday, 1968.
- SMITH, B., and WENG, W., China–A History in Art. New York: Harper & Row, 1972.
- SPARKE, PENNY; HODGES, FELICE; DENT, EMMA; and STONE, ANNE, *Design Source Book*. Secaucus, N.J.: Chartwell, 1982.
- STRUPPECK, JULES, *The Creation of Sculpture*. New York: Henry Holt, 1952.
- SUTTON, P., Dreamings: The Art of Aboriginal Australia. New York: George Braziller, 1988.
- TERUKAZU, AKIYAMA, Japanese Painting. New York: Rizzoli International Publications, 1977.

- THORP, R. L., Son of Heaven; Imperial Arts of China. Seattle: Son of Heaven Press, Printed by Nissha Printing Co., Ltd., 1988.
- VERITY, ENID, Color Observed. New York: Van Nostrand Reinhold, 1980.
- WAX, CAROL, *The Mezzotint*. New York: Harry Abrams, 1996.
- WEISS, HILLARY, *The American Bandanna*. San Francisco, Calif.: Chronicle, 1990.
- WILLIAMS, RICHARD L., series editor, *Life Library of Photography.* New York: Time-Life,
 1971.
- WINGLER, HANS M., *The Bauhaus*. Cambridge, Mass.: The M.I.T. Press, 1986.
- WONG, WUCIUS, Principles of Color Design. New York: Van Nostrand Reinhold, 1987.
- ——, Principles of Form and Design. New York: Van Nostrand Reinhold, 1993.
- ———, Principles of Three-Dimensional Design. New York: Van Nostrand Reinhold, 1977.
- YENAWINE, PHILIP, How to Look at Modern Art. New York: Harry N. Abrams, 1991.
- ZELANSKI, PAUL, et al., Shaping Space. New York: Holt, Rinehart & Winston, 1987.

Abrams, Vivien	Aesthetics, 4 Affection for Surfing (Schnabel), 318	developing works, 19–21, 20–21 elements of, 4, 19, 26	Barbara and Baby (Wesselmann), 24 Barlach, Ernst
Changing Dynamics, 206	Agony (Gorky), 288	ingredients of, 9–10	Avenger, The, 242
Abstract art, 272	Albers, Josef, 110, 276, 296–97	media and techniques, 21,	Barye, Antoine Louis, 260–61
subject in, 10	Homage to the Square: Star Blue,	21–23, 23	Tiger Devouring an Antelope, 261
in United States, 275–76, 276	111, 296	need and search for, $6-7$, $6-9$, 9	Basket of Apples, The (Cézanne), 159
See also Nonobjective art	"Alla prima" landscapes, 254	Assemblage, 132, 137, 137, 280,	Baudelaire (Villon), 86
Abstract Painting, Blue	Allover pattern, 30, 35, 37, 37	282, 293, 298–301,	Bauhaus, 220, 224
(Reinhardt), 303	American Legion Convention; Dallas,	299–301	Bearded Captive, The (Buonarroti), 223
Abstract texture, 132, 138–39, <i>139</i>	Texas (Winogrand), 308	Asymmetrical (occult) balance,	Beckmann, 182
Abstract-Expressionism	Amorphous shape, 94, 96, 96	56–58, 58, 59	Beckmann, Max, 266
painting, 276, 287, 288–91,	An Old Customer, San Remo, Italy	Asymmetrically balanced sculpture,	Departure, 267
289–90	(Cartier-Bresson), 287	239, 239	Bedroom in Venice, A (Scully), 321
photography, 294–96, 295	Analogous colors, 146, 157, <i>157</i> ,	Asymmetry, 30	Bell, Larry, 303
sculpture, 290, 292–94, <i>292–94</i>	158, 210	At Green Mountain Orchards (Kahn),	First and Last, 303
Abstraction, 4, 12, 13, 20, 20–21	Analytical Cubism, 271, 271	165, <i>165</i>	Belvedere (Escher), 202
economy and, 68–69, <i>69</i> , 70	Ancestors of Tehamana (Gaugin), 27	Atectonic composition, 220,	Benglis, Lynda, 319–20
Academic art, 30	Ancestral Figure from House Post	238–39, 239	Tossana, 320
Academic artists, 158	(Maori wood	Atmospheric (aerial) perspective,	Bernini, Giovanni Lorenzo, 261–62
Accents, texture as, 139, 139	sculpture), 136	132, 180	Beuys, Joseph, 308, 315
Achromatic pigments, 151	And the Home of the Brave	Atmospheric perspective, 142, 143,	Rescue Sled, 315
Achromatic value, 116, 117	(Demuth), 11	188, 188	Bicycle Wheel (Duchamp), 281, 282,
"Action" painting, 289	Andreas, George	Autochrome process	298-99
Actual shape, 94	Energy, 69	(photography), 269	Bierstadt, Albert
Actual texture, 132, <i>134–37</i> , 135, 137	Angular line, 79–80, 80	Autumn Rhythm (Pollock), 290	Landscape, 143
Adams, Ansel, 21, 277, 279, 280, 295	Annunciation (Botticelli), 190, 191	Avenger, The (Barlach), 242	Big Egypt (De Woody), 238
Moonrise, 21	Antennae with Red and Blue Dots		Bing, Ilse
Addition, 220, 222, 230, 230, 231,	(Calder), 238	В	My World, 136
232, 229–30	Anuszkiewicz, Richard, 298		Biomorphic shape, 94, 97,
Additive color, 146, 148, 148	Injured by Green, 162, 162	Balance, 30, 31, 50, 52-54, 52-58	97–98, 112
Adoration of the Magi, The (Fra	Iridescence, 57	approximate symmetry, 30, 55, 56	Bird in Hand (Giloth), 34
Angelico and Fra Filippo	Aphrodite (Coffey), 225	asymmetrical (occult) balance,	Bird's-eye view, 195–96, 196
Lippi), 25	Apple Face (Haskins), 44, 45	56–58, 58, 59	Birren, Faber, 166
Adoration of the Shepherds, The	Apples (Kelly), 76	radial, 55–56, <i>57</i>	Blanket, Tlingit tribe, 55
(Giorgione), 122	Approximate symmetry, 30, 55, 56	shape and, 104-5	Blue Window, The (Matisse), 98
Aerographs (Ray), 286	Arabs Skirmishing in the Mountains	symmetry, 31, 54–55, <i>55</i>	Boccioni, Umberto, 273
Aesthetic color relationships,	(Delacroix), 248	in three-dimensional art, 239,	Unique Forms of Continuity in
155–65, 177	Archipenko, Alexander, 232, 277	239–40, 240, 242	Space, 273
analogous and monochromatic	Woman Doing Her Hair, 233, 277	Balancing Act with Stone II	Bochner, Mel
colors, 157, 157, 158, 173	Architectural Cadences (Sheeler), 111	(Yasami), 56	Vertigo, 80
complements and split-	Architecture, 225, 225-26, 226	Baldaccini, César. See César	Bodio, Gene
complements, <i>156</i> , 156–57	radial balance in, 56	(Baldaccini)	New City, 196
emotion and color, 162–64, <i>163</i>	Areogun Nigerian mask, Yoruba	Balla, Giacomo, 273, 274	Borglum, Gutson, 293
plastic colors, 157–59, <i>158</i> , <i>159</i>	tribe, 12	Dynamism of a Dog on a	Bosch, Hieronymous, 280
psychological application of	Armchair (Wright), 224	Leash, 216	Botticelli, Sandro, 183
color, 164, 164–65, 165	Arp, Jean Hans, 284, 286	Speeding Automobile, 273	Annunciation, 190, 191
simultaneous contrast, 159–62,	Mountain Table Anchor Navel, 286	Balzac—The Open Sky (Steichen),	Brady, Mathew, 252, 252
160–62	Torsifruit, 232	262, 262	Bragaglia, Antonio Julio, 274
tetrads, 146, <i>156</i> , 157	Art	Bamboo in the Wind (Wu), 79	Greeting, 274
triads, 149, 150, 157	appreciation of, 16, 17–19, 18–19	Banks of the Seine, Vetheuil	Brancusi, Constantin, 276, 277, 286
	components of, 10–16	(Manat) 253	Bird in Space, 277, 277

(Monet), 253

warm and cool colors, 157

Prato Della Valle at Padua, Christ Mocked by Soldiers (Rouault), neutrals, 151 Braque, Georges, 135, 137, 263, physical properties of, 151, 184, 195 264, 265 271, 272 Still Life, 136 Canna-Red and Orange Christ Presented to the People 151-55, 152 Still Life: The Table, 105 (O'Keeffe), 276 (Rembrandt), 20-21role in composition, 170-71, Canova, Antonio, 260 Breakfast (Gris), 98 Christensen, Daniel 171, 172 space and, 209-10, 210, 211 Perseus with the Head of GRUS, 88 Breezing Up (A Fair Wind) Christo, 311 subtractive, 148-49, 161 Medusa, 260 (Homer), 184 Captain Ahab (Paik), 310 German Reichstag, 311 in three-dimensional art, 237, 237 Breton, André Surrealist Manifesto, 284 Caravaggio, Michelangelo Merisi da Umbrellas, 311 triadic color system, 149, 150, Wrapped Reichstag, Berlin, 17 151, 156 St. John the Baptist, 123 Broderson, Morris Chroma, 146, 153 See also Aesthetic color Carnival (Stevovich), 128, 129 Picador with Horse, 109 relationships; Color wheel Broken line, 77, 77 Caro, Anthony, 302 Chromatic value, 116, 118, 146 Bronze with Two Squares Odalisque, 97 ciel rouge, Le (de Staël), 174 Color balance, 171, 173-77 Circus Sideshow (La Parade) (Seurat), harmony and, 173-74, 173-75 (Kendrick), 229 Cartier-Bresson, Henri, 286, 287 variety and, 158, 160, 164, 172, An Old Customer, San Remo, 62, 63 Brown, Roger City, The (Viera da Silva), 89 174-77, 175-77 Giotto and His Friends, 215 Italy, 287 Brunelleschi, Filippo, 190 Cast shadows, 116, 118, 119, 207-8 Claudel, Camille, 262, 263 Color Field painting. See Post-Painterly Abstraction Cast Sterling Silver Pendant with Maturity (L'Age Mûr), 263 Brusca, Jack Color photography, 169 Untitled, 185, 185 Fumed Enamel Close, Chuck, 65, 313 Color tetrad, 146, 156, 157 Brussels Construction (de Rivera), 233 (Hasselschwert), 226 Jud. 66 Closed-value composition, 116, 127, Color triad, 146 Buñuel, Luis, 286 Casting, 220 128, 129 Color value, 147, 151, 151-53, 153 Casting (substitution), 220, Buonarroti, Michelangelo, 223, 261 Closure tendency, 40-41, 41 changing intensity and, 155, 155 230-31, 231 Bearded Captive, The, 223 Color wheel, 166-71 Burchfield, Charles, 268, 276 Cayton, David Closure (visual grouping), 30, light primaries, 169-70 One Dead Tern Deserves 40-43, 41, 68 Night Wind, The, 110, 112 shapes in, 46, 48 Munsell color system, 150, Bury, Pol, 243, 301 Another, 230 Ceramics, 226, 227 Cobblestone House, Avon, New York 165-67, 167Staircase, The, 301 (White), 18 origins of color systems, 166 Bust of Horatio Greenough César (Baldaccini), 299 Coburn, Alvin Langdon, 272, Ostwald color system, 166-67 (Powers), 134 Cézanne, Paul, 158, 187, 212, 213, 272-73, 277 pigment primaries, 166 B/WX (Held), 103, 208 257-58, 258, 263, 270, Portrait of Ezra Pound, 272 subtractive color mixing system, 271, 276 Basket of Apples, The, 159 Vortograph #1, 278 148, 168-69, 168-70 Pines and Rocks, 258 Cock Fight (student work), 80 triadic color wheel, 166 Still Life with Basket of Fruit, 212 Coffey, Michael, 225 Combines (assemblage), 298, 299 Cabinet Makers (Lawrence), 66 Chagall, Marc, 282-83 Aphrodite, 225 Complementary colors, 146, 151, Cactus Man No. 1 (González), 285 156, 156 I and the Village, 283 Cohen, Judy, 316 Calder, Alexander, 40, 77, 238, Composition, 20, 30, 32 Pont de Passy et la Tour Eiffel, Le, 57 Cold Mountain 3 (Marden), 82 242-43, 290, 292-93 Chamberlain, John, 299-300 Coleman, Ronald role of color in, 170-71, 171, 172 Antennae with Red and Blue Supervisory Wife II, 108, 108 Composition, 1916 (Mondrian), 7 Untitled, 300 Dots, 238 Changing Dynamics (Abrams), 206 Collage, 132, 137 Composition with Red, Blue, Yellow, Totem, 293 Collodion prints (photography), 252, Black and Gray Character of line, 81, 81 Callahan, Harry, 295-96 (Mondrian), 7 Chevreul, M.E., 159-60 252, 253 Calligraphic lines, 77, 78, 79, 79, Color, 19, 144-77 Computerized Nude (Knowlton and Chevrons #2 (Pearlstein), 313 85, 87 Chiaroscuro, 116, 121, 121, 122 additive, 148, 148 Harmon), 140 Calligraphy, 74, 78, 79, 79 hue, 147, 152, 152 Computers, use of, 216, 243 Chihuly, Dale Camera obscura, 249 intensity of, 150, 153-55, Concept of space, importance of, 70 GTE Installation, 227 Canal, Giovanni Antonio. See Chirico, Giorgio de, 282, 283, 154, 155 Conceptual art, 14, 15, 314-17, Canaletto 317 - 18light as source of, 147, 315 - 17Canaletto (Giovanni Antonio Canal) Conceptual perception, 4, 16 Christ Among the Children 147-49, 148 Imaginary View of Venice, 117 (Nolde), 177 line and, 88-89, 89 Cone, 198, 199 Piazza of San Marco, Venice, The, mixing, 149, 149-51, 150 Constellation, 293 193, 193

David and Goliath (unknown), 214

Constructivism, 286

Daguerre, Louis J. M., 250

Danaïde (Rodin), 262, 262

Laundress, The, 251

Two Barristers, 90

Persistence of Memory, 284

Daumier, Honoré, 5, 13, 250-51

David, Jacques-Louis, 246-47, 247

Oath of the Horatii, The, 247, 247

Dali, Salvador, 283, 286

extremes of scale and, 64, Content, 4, 9-10, 12, 13-15, 14-16 Davis, Ron Dr. Mayer-Hermann, 267 Dog and Cock (Picasso), 142, 142 64-65 shape and, 97, 109-10, Parallelepiped Vents #545, Dominance, 30, 31, 65-67, 66-68 repetition and, 34 109-13, 112103, 103 Energy (Andreas), 69 style and, 244-321 Day and Night (Escher), 44 extremes of scale and, 64, 64-65 shape and, 107, 107-8, 108 Entombment of Christ, The de Chirico, Giorgio Continuous Ship Curves, Yellow Ochre Nostalgia of the Infinite, The, 120 through contrast, 49 (Titian), 122 (Rockburne), 80 Donatello, 261 Environmental art. See Earth art Contour, 74, 95, 95 de Kooning, Willem, 287 Woman, I, 288 Doryphoros (Polyclitus of Argos), 60 Equivalent (Stieglitz), 278 Contour Drawing (Tovish), 84 Dos Personajes Atacados por perros de Staël, Nicolas Equivalents, 278, 295 Contour lines, 83 (Tamayo), 95 Contours, 232, 232 ciel rouge, Le, 174 Equivocal space, 94, 102, 103 Double Negative (Heizer), 312 Ernst, Max, 281, 283 Converging parallels, 188, 188, 189 De Woody, James Hat Makes the Man, The, 38, 38 Big Egypt, 238 Dr. Mayer-Hermann (Dix), 267 Cook, Lia Point of Touch; Bathsheba, 158 Draftsman Drawing a Nude Horse, He's Sick, The, 281 Dead Toreador, The (Manet), 126 Cool colors, 157 Death by Violence (Manzu), 236 (Dürer), 192 Erté Corner of a Park at Arles (Tree in a Decorative art, 4, 19-20 Drawing media, 22 Twin Sisters, 55 Meadow) (van Gogh), 99 shape in, 94, 99-100, 100 Drift No. 2 (Riley), 299 Escher, M.C., 49 Couple with Shopping Bags Decorative space, 180, 181, 181 "Dry-plate" photographic Belvedere, 202 (Hanson), 314 Decorative value, 116 process, 252 Day and Night, 44 Estes, Richard, 118 Deep and infinite space, 180, Dubuffet, Jean Courbet, Gustave, 250, 251 Helene's Florist, 313 182-83, 183, 194, 194 Urgence, 87 Burial at Ornans, A, 251, 252 Deerskin jacket, 9 Duchamp, Marcel, 274, 276, 281, Expression, 4, 10, 74 Courtesan Dreaming, A line and, 82, 82-83 (Shunman), 203 Degas, Edgar, 253, 255, 261 286, 293, 301, 310 Bicycle Wheel, 281, 282, 298-99 value and, 120, 120 Four Dancers, 255 Covenant (Newman), 296 Expressionism, 263 Delacroix, Eugène, 160 Nude Descending a Staircase, Craftsmanship, 4 Arabs Skirmishing in the 215, 215 German, 264-66, 266, 267 Creativity, 15-16 Duration, shape and, 106, 106, 107 sculpture, 268, 268-69, 269 Crocheted Series #5 (Hagan), 228 Mountains, 248 Dürer, Albrecht, 249 in United States and Mexico, 268 Cross-contours, 74, 83, 83, 84, 85 della Francesca, Piero Draftsman Drawing a Nude, 192 Extended edges, 45, 46, 47 Madonna of Mercy, 65, 65 Cubi VII (Smith), 294 Dykmans, Anne, 118 Extensions, in visual linking, 41, Cubism, 94, 98, 98, 105, 113, 213, Delmonico Building (Sheeler), 196 Demoiselles d'Avignon, Les (Picasso), Trois Fois, 119 45-46, 47, 48, 48-49 263, 270-72, 270-73 Cuchi, Enzo, 317, 318 Pablo, 270, 270 Dynamic Hieroglyphic of the Bal Eye level, 183, 184, 190 Paesaggio Barbaro, 318 Demuth, Charles Tabarin (Severini), 217 in one-point perspective, Cunningham, Imogen, 277, 279-80 ...And the Home of the Brave, 11 Dynamism of a Dog on a Leash 192, 192 Two Callas, 280 Departure (Beckmann), 267 (Balla), 216 Currin, John Der Blaue Reiter (The Blue Rider), F 264 Moved Over Lady, The, 26 Der Malschirm (The Artist's Umbrella) Curved line, 75, 79 F-64 group, 279 Curvilinear planes, 100, 100, (Kuehn), 270 Earth art, 310-12, 310-12 Family of Saltimbanques (Picasso), 59 101, 102 Descent from the Cross (Rembrandt), East of Silverlake (Matarazzo), 175 Fang tribal mask (Gabon, Africa), 271 Cylinder, 198, 199 124, 125 Fantastic art, 280, 280, 282, Eastman, George, 252 Descriptive art, 4, 18, 19 Economy, 30, 31, 68-69, 69, 70 282-83, 283 Design, 4, 32, 103-9 in three-dimensional art, 240, Fauves, Les, 263-64, 264, 265, 271 D Devil's Gate, High Bridge, Central Span Feininger, Lyonel 241, 242, 242 (Jackson), 253 da Vinci, Leonardo, 16, 120 Ecriture (Park), 135, 135 Street: Near the Palace, 205 di Suvero, Mark Effect of Light on Objects Feminist Art Movement, 316 Proportions of the Human Figure, Tom, 222 (McKnight), 126 Femmages, 316, 317 60,61 For Veronica, 240 Eiso (Manes), 35 Fetish, Yombe tribe (Zaire), 236 Treatise on Painting, 16 Diana and the Nymphs (Vermeer), 47 Virgin of the Rocks, 121 Eje de Todo, El (Lopez Armentia), 164 Fiberwork, 228, 228 Die Brücke (The Bridge), 264 Dadaism, 281, 281-82, 282 El Greco Fibonacci Series (numbers), 59-60, Die Neue Sachlichkeit (The New

Objectivity), 264, 266

shape and, 100, 104, 105, 105

Disproportionate scale, 62, 64, 64

(Lasker), 81

Direction

of line, 80, 80

Division of Happiness, The

Distortion, 257

Divisionism, 257

Madonna and Child with

Electromagnetic spectrum, 152

Elements of art, 4, 19, 26

Elevation view, 213, 213

Elements of form, 231-38

Saint Martina and

Saint Agnes, 24

Ellipse, in perspective, 197-98, 198

Emotion, color and, 162-64, 163

61

First and Last (Bell), 303

Fit for Active Service (Grosz), 267

For Veronica (di Suvero), 240

Field, 25-26

Figure, 25, 27

Flavin, Dan

Flags (Johns), 161

Untitled, 302

Floral (Mazur), 134

Dix, Otto, 266, 269

Emphasis

Form, 4, 9, 12, 12, 14, 28–71	Giloth, Copper	Hanson, Duane, 313	Hopper, Edward, 268, 314
form unity, 71	Bird in Hand, 34	Couple with Shopping Bags, 314	Sunlight in a Cafeteria, 195, 195
principles of organization and,	Giorgione, 120	Happenings, 308, 309, 310	Horizon line, 193, 193, 194–95
32–69, 33	Adoration of the Shepherds, The, 122	Hard-Edge painting. See Post-	Horizontal balance, 53, 53
space, concept of, 31, 70-71	Giotto, 121	Painterly Abstraction	Horse, He's Sick, The (Ernst), 281
in three-dimensional art, 221	Kiss of Judas, The, 121	Harmon, Leon	Horse and Rider (Marini), 269
visual ordering and, 31,	Giotto and His Friends (Brown), 215	Computerized Nude, 140	Horse's Motion Scientifically Considered,
31–32, <i>32</i>	Girten, Elmer	Harmony, 30, 31, 33-49	A (Muybridge), 256
Fossil for Bob Morris	calligraphy, 78	closure (visual grouping).	Household, May 1964 (Kaprow), 309
(Rauschenberg), 137	Glass design, 226, 227	See Closure	How to Understand and Use Grids
"Found art," 281, 282, 315, 316	Glass of Absinth (Picasso), 280	color balance and, 173-74,	(Swann), 48
Four Dancers (Degas), 255	Glyptic materials, 220, 221, 221	173-75	Hue, 146, 147, 147, 151, 151, 152
Four-color printing process,	Goforth, John	repetition and, 30, 33, 34,	Hugo, Victor, 16
168–69, 169	Untitled, 222	34–38, 35	Hunt, Richard
Four-dimensional space, 180	Golden mean, 30, 58, 59, 60	rhythm and, 30, 33, 38-40,	Untitled, 10
Fourth dimension, 210–11	Golden rectangles, 59, 60, 62, 63	39, 40	Hunter, The (A. Wyeth), 133
Fra Angelico, 121	Golden section, 30, 58, <i>59</i> , <i>61</i> , 62, <i>63</i>	shape and, 108	Timilei, The (II. Wyelli), 133
Adoration of the Magi, The, 25	Golden Wall, The (Hofmann),	visual linking and. See Visual	•
Fra Filippo Lippi, 121	210, 211	linking	
Adoration of the Magi, The, 25	Gonzales, José Victoriano.	Harris, Morris	
Fractional representation, 180,	-		I and the Village (Chagall), 283
186–87, <i>187</i>	See Gris, Juan González, Julio, 284, 290	Natural System of Colours,	Illusion of spatial movement, 68
		The, 166	Illusionary effect of shape, 101, 102,
Frank, Robert, 306, 308	Cactus Man No. 1, 285	Haskins, Sam	103, 103, 206–7, 207
Frankenthaler, Helen, 297	Gorky, Arshile, 287	Apple Face, 44, 45	Illusionism, 69, 132
Storm Center, 112	Agony, 288	Hasselschwert, Harold	I'm Dancin' as Fast as I Can
Free Ride Home (Snelson), 239	Goya, Francisco, 248	Cast Sterling Silver Pendant with	(Schapiro), 317
"Free-standing" art, 233, 236	Third of May, The, 249	Fumed Enamel, 226	Imagery, effect of media and tools
Friedlander, Lee, 308	Grande Odalisque, La (Ingres), 247	Hat Makes the Man, The (Ernst),	on, 22, 23
New York City, 309	Graphic art, 4	38, 38	Imaginary View of Venice
Frog's-eye view, 195–96, 196	Graves, Nancy	Hatching, 74, 85–86, 86	(Canaletto), 117
Frontal plane, 192–93	Perfect Syntax of Stone and Air, 51	Haverfield, Tom	Implied line, 74, 205–6
Frottages, 283	Unending Revolution of Venus,	Kerosene Lamp, 213	Implied shape, 94, 96
Futurists, 215-16, 216, 217	Planets, and Pendulum, 239	Kerosene Lamp II, 213	Impressionism, 253–55, 253–56
	Gravity	Heizer, Michael, 312	Improvisation 30 (Cannons)
C	balance and, 50, 52	Double Negative, 312	(Kandinsky), 275
G	Greatest Homosexual, The	Held, Al	Infinite space, 180, 182–83, <i>183</i>
Gabo, Naum, 277	(Rivers), 129	B/WX, 103, 208	-
Linear Construction in Space No. 1	Greeting (Bragaglia), 274	Quattro Centric XIII, 186	Ingres, Jean-Auguste-Dominique, 247, 257
(Variation), 223	Grid system for layout, 48	Helene's Florist (Estes), 313	
	Gris, Juan (José Victoriano	Hesse, Eva	Grande Odalisque, La, 247
Gates of Hell, The (Rodin), 236	Gonzales), 272	Repetition 19 III, 34	Injured by Green (Anuszkiewicz),
Gates of Hell (Rodin), 261	Breakfast, 98	Hide-and-Seek (Tchelitchew), 143	162, 162
Gauguin, Paul, 158–59, 182, 257,	Portrait of Max Jacob, 90	Hierarchical scaling, 65, 65	Inscape (Sugarman), 49
258, 263	Grosz, George, 266	High key values, 117, 117	Instruments. See Tools
Ancestors of Tehamana, 27	Fit for Active Service, 267	High-key colors, 146, 153, <i>153</i>	Intaglio printing, 120
Vision After the Sermon, 159	Ground, 25–26	Highlights, 116, 118	Intensity, 146
Genre paintings, 132, 138	Group lines, 85, 85	Hilty, Thomas	of color, 150, 151, 151, 152,
Geometric shape, 94, 96		Meditation, 22	153–55, <i>154, 155</i>
German Expressionism, 264-66,	Grove of Cypresses (van Gogh), 75	100000000000000000000000000000000000000	Intermediate colors, 146, 150, 150
266, 267	GRUS (Christensen), 88	Hiroshige, Utagawa	Intermediate triad, 150, 151
German Reichstag (Christo and	GTE Installation (Chihuly), 227	Kintai-Kyo Bridge at Iwakuni,	International style of
Jeanne-Claude), 311	Guernica (Picasso), 104	254, 255	architecture, 275
Gerzo, Gunther, 43	Gypsy Woman with Baby	Hofmann, Hans, 276, 289	Interpenetration, 180, 186, 186
Dorganization Dad and Plus 12	(Modigliani), 169, 265	Golden Wall, The, 210, 211	Interition 190 204 204 205

Under the Wave off Kanagawa, 39

(Albers), 111, 296

Breezing Up (A Fair Wind), 184

Homage to New York (Tinguely), 302

Homage to the Square: Star Blue

Hokusai, Katsushika

Homer, Winslow, 5

H

Personage in Red and Blue, 42

Gestalt, 30, 95-96, 101

Gestural painting, 289

Giacometti, Alberto, 284

Gibson, Kathleen Ellen

Owls, 88

Gestural drawing, 90, 91, 91

Three Walking Men, 285

Hagan, Kathleen Crocheted Series #5, 228 Halftoning, 168 Handball (Shahn), 54, 54

09)2, Interpenetration, 180, 186, 186 Intuitive space, 180, 204, 204, 205 shape and, 100, 104 Invented texture, 132, 139-40, 140 Iridescence (Anuszkiewicz), 57 Ishigooka, Noriyoshi Spring in the Chateau du

Repas, 160

М Kinesthetic vision, 181 Light and Dark (McKnight), 119 Isometric projection, 202, 203 Kinetic art, 94, 99 Light primaries, 169-70 Isometric projection (perspective), 180 McKnight, Russell F. Kinetic sculpture, 68, 238, 238, 301, Line, 19, 46, 48, 72-91 Itten, Johanness, 166 Effect of Light on Objects, 126 301-2,302art elements and, 83-88 Light and Dark, 119 King, Tony color and, 88-89, 89 Shadows, 119 Map: Spirit of '76, 208 direction of, 80, 80 Madonna and Child with Saint Kintai-Kyo Bridge at Iwakuni effect of media and tools on, 81, Jackson, William Henry Martina and Saint Agnes (Hiroshige), 254, 255 81, 86, 87, 88, 88 Devil's Gate, High Bridge, Central (El Greco), 24 Kiss of Judas, The (Giotto), 121 expressive properties of, 82, Span, 253 Madonna of Mercy (della Francesca), 82 - 83Kitaj, Ronald Jane Avril (Toulouse-Lautrec), 77 65, 65 location of, 80-81 Walter Lippmann, 58 Jeanne-Claude, 311 Madonna of Mt. Carmel and the Souls Klee, Paul, 282 as means of communication, German Reichstag, 311 in Purgatory (Tiepolo), 68 Twittering Machine, 282 74-75, 75-79, 77, 79, Umbrellas, 311 Magada, Steve Kline, Franz, 289, 290, 293 85, 87 Wrapped Reichstag, Berlin, 17 Trio. 91 measure of, 79 Knowlton, Kenneth Jeff Davies (Witkin), 64, 64-65 Magritte, René physical characteristics of, 79-81 Computerized Nude, 140 Jenkins, Paul lunette d'approche, La, 211 Kodachrome film, 269 representation and, 89-91, 89-91 Phenomena Graced by Three, 176 Maguire, Doug Kokoschka, Oskar, 263, 265-66 shape and, 83, 83-85, 85 Jewelry, radial balance in, 56 Sleeping Eye, 188 Self-Portrait, 266 space and, 88, 88-89, 89, Johns, Jasper, 304 Maillol, Aristide, 268-69 Kosuth, Joseph, 315-16 204-6,206Flags, 161 Montagne, La, 268 One and Three Chairs, 315, 316 spatial characteristics of, 88, Jud (Close), 66 Mama, Pap is Wounded (Tanguy), 98 Kuehn, Heinrich, 269 88-89,89 Judd, Donald, 69, 240, 242, 302, 303 Man with a Violin (Picasso), 271, 271 Der Malschirm (The Artist's texture and, 86, 87, 88, 88 Untitled, 242 Manes, Paul Umbrella), 270 in three-dimensional art, 77, Juniper, Lake Tenaya (Weston), 279 Eiso, 35 233-35, 237Manet, Edouard, 125, 253, 255 value and, 85, 85-86, 86, 88, 88 Dead Toreador, The, 126 K Linear Construction in Space No. 1 Race Track Near Paris, 255 (Variation) (Gabo), 223 Lac Laronge IV (Stella), 33 Races at Longchamp, The, 256 Kahlo, Frida Linear (geometric) perspective, Land of Lincoln (Brown), 204 Manipulation, 220, 229-30, 230 Still Life with Parrot, 171 103, 180 Landscape (Bierstadt), 143 Manzu, Giacomo, 237 Kahn, Louis I. concepts applied, 197-200, Lasker, Jonathan Death by Violence, 235 National Assembly Building, 197-201 Division of Happiness, The, 81 Map: Spirit of '76 (King), 208 Bangladesh, 226 disadvantages of, 188, 189, Laundress, The (Daumier), 251 Marca-Relli, Conrad Kahn, Wolf 200-202, 202 Laurencin, Marie Picador, The, 109 At Green Mountain Orchards, major systems of, 190-97, 192 Mother and Child, 172, 173 Marden, Brice 165, 165 one-point, 192, 192-93, 193 Law of Simultaneous Contrast of Colors Cold Mountain 3, 82 Kaleidoscope (Wojtkiewicz), 133 three-point, 195-97, 196 (Chevreul), 160 Marin, John, 165, 210, 268, 276 Kandinsky, Wassily, 269, 272, 274, two-point, 184, 193-95, 193-95 Lawrence, Jacob Sun Spots, 210 275, 289 Lipchitz, Jacques, 292 Cabinet Makers, 66 Improvisation 30 (Cannons), 275 Marinetti, Filippo, 273 Rape of Europa, 292 Studio, The, 182, 182 Marini, Marino, 269 Kaprow, Alan, 308 Lippold, Richard, 77, 237, 302 Layout, grid system for, 48 Horse and Rider, 269 Household, May 1964, 309 Variation within a Sphere, No. 10, Le Blon, J.C., 166 Marisol Karan, Khem the Sun, 234 Lee-Smith, Hughie Women and Dog, 237 Prince Riding an Elephant, 125 Listen to Living (Matta Echaurren), Lost Dream, 175 Maroulis, Leonidas Katzen, Lila, 304 97, 112 Left vanishing point (LVP), 196, 196 68-388, 181 Oracle, 304 Lithography, 120 Léger, Fernand, 272 Mars and Venus (Poussin), 19 Keelmen Heaving in Coals by Local (objective) color, 146, 170, 171 Three Women, 113 Masaccio, 121, 190 Moonlight (Turner), 249 Local value, 116 Lehmbruck, Wilhelm, 268, 269 Trinity with the Virgin, St. John and Kelly, Ellsworth, 68-69, 297 Location, of line, 80-81 Standing Youth, 268 Donors, 189 Apples, 76 Log cabin quilt, 37 Lewitt, Sol, 316 Mass, 4, 20, 74, 94, 96, 99 Red and White, 27 Lopez Armentia, Gustavo Liberation of the Peon, The Mass (third dimension), 220 Kendrick, Mel Eje de Todo, El, 164 (Rivera), 32 Matarazzo, Francine Bronze with Two Squares, 229 Lost Dream (Lee-Smith), 175

Louis, Morris, 69, 297-98

Number 99, 298

Lovers, The (Picasso), 70

Low key values, 117, 117

Low-key colors, 146, 153, 153

lunette d'approche, La (Magritte), 211

LVP (left vanishing point), 196, 196

East of Silverlake, 175

Mathematics, role in proportion,

Matisse, Henri, 68, 182, 263-64,

Blue Window, The, 98

Nuit de Noël, 127

58-60, 59-63, 62

264, 270, 271, 276

Lichtenstein, Roy, 305

Okay, Hot Shot, Okay, 306

as source of color, 147,

147-49, 148

tenebrism and, 123, 123, 124

Still Life with Crystal Bowl, 139

White Wall, 231

Kerosene Lamp (Haverfield), 213

Kiefer, Anselm, 317, 318-19

Nigredo, 189, 319

Kienholz, Edward

Wait, The, 300

Kerosene Lamp II (Haverfield), 213

Odalisque with Tambourine	Montagne, La (Maillol), 268	Nevelson, Louise, 300–301	Shoestring Potatoes Spilling from a
(Harmony in Blue), 264	Moonrise (Adams), 21	American Dawn, 301	Bag, 307
Mats, achieving balance with, 52	Moore, Henry, 232, 290, 292,	New City (Bodio), 196	Spoonbridge and Cherry, 64
Matta Echaurren, Roberto, 287	300, 302	New Realism (photorealism), 313,	One and Three Chairs (Kosuth),
Listen to Living, 97, 112	Reclining Figure, 292	313–14, <i>314</i>	315, 316
Maxwell, James Clerk, 169, 253	Sheep Study, 118	New York City (Friedlander), 309	One Dead Tern Deserves Another
Mazur, Robert	Mother and Child (Laurencin),	Newman, Barnett, 69, 297	(Cayton), 230
Floral, 134	172, 173	Covenant, 296	100 Cans (Warhol), 305
Measure, of line, 79	Motif, 30, 36–38, 36–38	Newton, Isaac, 166	One-point cube, 197, 197
Media, 4, 20	Motion, as part of space, 211	Nicole & Pullen sawing and cleaving	One-point perspective, 191, 192,
effect on line, 81, 81, 86, 87,	Motion pictures, animation in, 216	(Talbot), 250	192–93, 193
88, 88	Mountain Table Anchor Navel	Niepce, Joseph N., 250	Op art, 89, 298, 299
materials of three-dimensional	(Arp), 286	Night Wind, The (Burchfield),	Opening, The (Noguchi), 237
art, 228-29, 229	Moved Over Lady, The (Currin), 26	110, 112	Open-value composition, 116,
new techniques and, 21,	Movement, 30, 31, 67–68, 69	Nigredo (Kiefer), 189, 319	129, 129
21–23, 23	texture and, 142, 142	Noguchi, Isamu, 293–94	Optical perception, 4–5, 16
texture and, 142–43	in three-dimensional art, 233,	California Scenario, 294	balanced stimulation of color
value and, 117, <i>117</i>	238, 241–43, 242–43	Opening, The, 237	receptors, 160,
Meditation (Hilty), 22	Movement in time, 204, 214–16,	Stone Within, The, 221	160–62, 161
Meeting of Saint Anthony and Saint	214–17	Noland, Kenneth, 297	Oracle (Katzen), 304
Paul, The (Sassetta), 106	Mozart and Mozart Upside Down and	Wild Indigo, 297	Organic unity, 5, 14, 14, 20–21
Meissonier, Jean Louis Ernest, 286	Backward	Nolde, Emil, 265	Organization, 30, 32–69, 33
Menna with family fishing and fowling	(Rockburne), 113	Christ Among the Children, 177	balance. See Balance
(fresco), 187	Multiple viewpoints, 212		
		Nonobjective art, 4, 74, 275	dominance, 30, 31, 49, 65–67, 66–68
Merisi, Michaelangelo. See	Multiplication of the Arcs	subject in, 10, 10	
Caravaggio	(Tanguy), 285	See also Abstract art	economy, 30, 31, 68–69, 69, 70
"Merz," 310	Munch, Edvard, 265, 266	Nonobjective shape, 97	expression and, 83
Metalwork, 226, 226	Scream, The (Cry), 266	Nonrepresentational art. See	harmony. See Harmony
Minimalism, 301, 302–4, 303, 304	Munsell, Albert, 167	Nonobjective art	movement, 30, 31, 67–68, 69
Minimalist style, 69	Munsell color system, 150,	Nonrepresentational shape, 97	proportion. See Proportion
Minimalists, 240, 241, 242, 242	165–67, 167	Nontraditional media, 22	in three-dimensional art, 238,
Miró, Joan, 287	Music, 11	Nostalgia of the Infinite, The (de	238–43, 239
Mirrored Room (Samaris), 310	Muybridge, Edweard, 255, 261, 274	Chirico), 120	variety. See Variety
Mitchell, Joan	Horse's Motion Scientifically	Nude Descending a Staircase	Orion (Vasarely), 50, 50
Quiet Please, 158	Considered, A, 256	(Duchamp), 215, 215	Orozco, José Clemente, 39, 268
Mobile, 293	My World (Bing), 136	Nuit de Noël (Matisse), 127	Zapatistas, 40
Mobiles, 99, 220, 223, 238, 238		Number 99 (Louis), 298	Orthogonals, 190, 190
Modeling, 220, 222. See also Manipulation	N	Number 10 (Rothko), 298	Orthographic drawing, 180, 202, 203, 213, 213
Modernists, 68–69, 70	Nadar, Felix (Gaspard-Felix		Ostwald, Wilhelm, 166
Modigliani, Amedeo, 182, 264, 265	Tournachon), 254	0	Ostwald color system, 166–67
Gypsy Woman with Baby, 169, 265	Nathan Admonishing David	O Sole Mio (Tinguely), 243	Overlapping space, 185, 185
Moments of force, 53-54	(Rembrandt), 81, 81	Oath of the Horatii, The (David),	Owls (Gibson), 88
Mona Lisa, 68	National Assembly Building, Bangladesh	247, 247	
Mondrian, Piet, 6–9, 7, 272,	(Kahn), 226	Objective art, 4	D
274, 289		Objective shape, 94, 96	P
Composition, 1916, 7	Natural System of Colours, The		D
Composition with Red, Blue, Yellow,	(Harris), 166	Objects from nature, 13	Paesaggio Barbaro (Cuchi), 318
Black and Gray, 7	Natural texture, 132	Oblique projection, 180, 202, 203	Paik, Nam June, 308
Tree, 6	Naturalism, 4, 13, 250–51, 251, 252	Occult (asymmetrical) balance,	Captain Ahab, 310
Monet, Claude, 253	Navajo dry or sand painting, 291	56–58, 58, 59	Paint quality, 132
Banks of the Seine, Vetheuil, 253	Negative areas, 4, 25–26, 26, 27, 41,	Odalisque (Caro), 97	Painting
Rouen Cathedral; Morning, 163	42–43 Na Alamatian 210, 21, 220, 221	Odalisque with Tambourine (Harmony	Abstract-Expressionist, 276, 287,
Rouen Cathedral, West Façade,	Neo-Abstraction, 319–21, 320, 321	in Blue) (Matisse), 264	288-91, 289-90
Sunlight, 163	Neoclassicism, 246–47, 247	Okay, Hot Shot, Okay	Surrealist, 283–84, 284, 285, 286
Rouen Cathedral paintings, 38	Neo-Expressionism, 317–19, 318–20	(Lichtenstein), 306	tachiste, 254
Water Lilies, 96	Neo-Impressionism, 257	O'Keeffe, Georgia, 276, 278	Painting media, 21–22
Monochromatic, 146	Neutral colors, 146, 151	Canna-Red and Orange, 276	Papier collé, 132, 135, 137, 272
Monochromatic colors, 157, 173	Neutralized color, 146, 164, 176	Songs of the Sky, 278	Parallelepiped Vents #545 (Davis),
Managhaman alata analas 160	Neutrals, 154, <i>154</i>	Oldenburg, Claes, 306, 311–12	103, 103

Monochrome photography, 168

Park, Seo-Bo

Glass of Absinth, 280

Estimate, 135, 135	Moore), 292 , 94, 98, 98, 98, 91, 100 elly), 27 Rietveld), 8 mberg), 320 o), 302 ng, Blue, 303 G., 250 ife, The, 251 nee 7, 107–8, 108 42, 142 20 220, 235, 235 menszoon van Rijn, 3 d to the People, he Cross, 124, 125 nishing David, 81, r (Portman), 225 nguste, 253 3, 34, 34–38, 35 36–38 6, 36 Hesse), 34 ine and, 89–91, art, 5, 74 likeness, 14 s), 315 ive, 202–3, 203 38–40, 39, 40 5, 105–6 243, 301–2 II, 302 ir, 8 her House, 8
Patting, 220, 237 Pattern, 30, 35–36, 36, 132 texture and, 137, 140, Pettor pattern, 30, 35–36, 36, 132 Pettor, 31, 140, 141, 143 Pettor, 110, 110, 113, 133 Pettor, 31, 140, 141, 143 Pettor, 31, 140, 141	94, 98, 98, 98, 9, 100 elly), 27 Rietveld), 8 mberg), 320 9, 302 19, Blue, 303 G., 250 19, The, 251 1000 1000 1000 1000 1000 1000 1000 1
Pattern, 30, 35 – 36, 36, 132 texture and, 137, 140, 140 – 42, 141 Pictor islim, 250 Picture frame, 5, 23, 23 – 25, 25 Picture frame, 5, 23, 23 – 25 Picture fra	o, 100 elly), 27 Rietveld), 8 enberg), 320 o, 302 og, Blue, 303 G., 250 oife, The, 251 ence 7, 107–8, 108 42, 142 20 220, 235, 235 enenszoon van Rijn, 3 d to the People, see Cross, 124, 125 enishing David, 81, e. (Portman), 225 enguste, 253 a, 34, 34–38, 35 a6–38 a, 36 Hesse), 34 ane and, 89–91, art, 5, 74 likeness, 14 s), 315 ive, 202–3, 203 a8–40, 39, 40 art, 5, 105–6 a43, 301–2 II, 302 ir, 8 der House, 8
texture and, 137, 140,	elly), 27 Rietveld), 8 mberg), 320 2, 302 ng, Blue, 303 G., 250 ife, The, 251 nee 7, 107–8, 108 42, 142 20 220, 235, 235 nenszoon van Rijn, 3 d to the People, ne Cross, 124, 125 nishing David, 81, r (Portman), 225 nguste, 253 3, 34, 34–38, 35 36–38 6, 36 Hesse), 34 ine and, 89–91, art, 5, 74 likeness, 14 s), 315 ive, 202–3, 203 38–40, 39, 40 5, 105–6 243, 301–2 II, 302 ir, 8 der House, 8
140-42, 141 Picture frame, 5, 23, 23-25, 25 Precisionism, 276 Red/Bluc Chair (Riem Pearlstein, Philip, 118, 313 Picture-stories," 18, 19 Primary triad, 149, 151 Reflections (Rotenber Pearlstein, Philip, 118, 313 Pigenturp strainers, 166 Primary triad, 149, 151 Reflections (Rotenber Pearlstein, Philip, 118, 313 Pigenturp strainers, 166 Primary triad, 149, 151 Reflections (Rotenber Pearlstein, Philip, 118, 313 Pigenturp strainers, 166 Primary triad, 149, 151 Reflections (Rotenber Pearlstein, Philip, 118, 313 Pigenturp strainers, 166 Primary triad, 149, 151 Reflections (Rotenber Pearlstein, Philip, 118, 313 Pigenturp strainers, 166 Primary triad, 149, 151 Reflect from the Reflections (Rotenber Pearlstein, Philip, 118, 313 Pigenturp strainers, 166 Primary triad, 149, 151 Primitwe art, 271 Primary triad, 149, 151 Primary triad, 149, 151 Primary triad, 149, 151 Primary triad, 149, 151 Primitwe art, 271 Primary triad, 149, 151 Primitwe art, 271 Primary triad, 149, 151 Primitwe art, 271 Primary triad, 149,	Rietveld), 8 mberg), 320 0, 302 ng, Blue, 303 G., 250 ife, The, 251 nce 7, 107–8, 108 42, 142 20 220, 235, 235 nenszoon van Rijn, 3 d to the People, le Cross, 124, 125 nishing David, 81, r (Portman), 225 nguste, 253 3, 34, 34–38, 35 36–38 6, 36 Hesse), 34 ine and, 89–91, art, 5, 74 likeness, 14 s), 315 ive, 202–3, 203 38–40, 39, 40 5, 105–6 243, 301–2 II, 302 ir, 8 ler House, 8
Patterns: These (student work), 36 Picture plane, 5, 19, 23, 23, 96 Primary triad, 149, 151 Reflexions (Rothenber Vinder), 46, 69, 30 Cherons #2, 313 Pigment primaries, 166 Primary triad, 149, 151 Reinhardt, Ad, 69, 30 Pelton, Agnes Pigments, 146, 148 Primary triad, 149, 151 Reinhardt, Ad, 69, 30 Pepper, Beverly mixing to affect intensity, Vintaglio, 241 154, 154 Primary triad, 149, 151 Relative dominance (Raran), 125 Perception, 16 Pines and Rooks (Cesame), 258 Print Room and Air (Garcos), 51 Print Room and Air (Garcos), 51 Product edsign, 224, 228 Product edsign, 224, 228 Product edsign, 224, 228 Relative dominance shape and, 107, 110 texture and, 12, 117 Proces art, 301, 314-17, 315-17 Product edsign, 224, 228 Product edsign, 224, 224	nnberg), 320 0, 302 ng, Blue, 303 G., 250 ife, The, 251 nce 7, 107–8, 108 42, 142 20 220, 235, 235 nenszoon van Rijn, 3 d to the People, see Cross, 124, 125 nishing David, 81, r (Portman), 225 nguste, 253 3, 34, 34–38, 35 36–38 6, 36 Hesse), 34 ine and, 89–91, art, 5, 74 likeness, 14 s), 315 ive, 202–3, 203 38–40, 39, 40 5, 105–6 243, 301–2 II, 302 ir, 8 der House, 8
Pearlstein, Philip, 118, 313	20, 302 20, 302 20, 810e, 303 31 32 32 35 36, 250 36 36 37, 107-8, 108 42, 142 20 220, 235, 235 31 31 32 31 32 31 33 34 34 35 36 38 36 38 31 31 31 31 31 31 31 31 31 31 31 31 31
Pigment primaries, 166 Primitive art, 271 Abstract Painting, B Pelton, Agnes Pigment, 146, 148 Pigment, 146, 148 Pigment, 146, 148 Percepter Wide, Fig. 67 achromatic, 151 mixing to affect intensity, brinaglio, 241 154, 154 Pines and Rocks (Cézanne), 258 Pines, 164, 154 Pines and Rocks (Cézanne), 258 Pines, 164, 154 Pines and Rocks (Cézanne), 258 Pines, 164, 164 Pines and Rocks (Cézanne), 258 Pines and Rocks (Cézanne), 259 Pines and Rocks (Céz	Ig, Blue, 303 G., 250 ife, The, 251 nce 7, 107–8, 108 42, 142 20 220, 235, 235 nenszoon van Rijn, 3 d to the People, see Cross, 124, 125 nishing David, 81, r (Portman), 225 niguste, 253 3, 34, 34–38, 35 36–38 6, 36 Hesse), 34 ine and, 89–91, art, 5, 74 likeness, 14 s), 315 ive, 202–3, 203 38–40, 39, 40 5, 105–6 243, 301–2 II, 302 ir, 8 der House, 8
Pelton, Agnes Voice, The, 67 Voice, Voice, St. 19 Voi	G., 250 ife, The, 251 nee 7, 107–8, 108 42, 142 20 220, 235, 235 nenszoon van Rijn, 3 d to the People, see Cross, 124, 125 nishing David, 81, r (Portman), 225 niguste, 253 3, 34, 34–38, 35 36–38 6, 36 Hesse), 34 ine and, 89–91, art, 5, 74 likeness, 14 s), 315 ive, 202–3, 203 38–40, 39, 40 5, 105–6 243, 301–2 II, 302 ir, 8 der House, 8
Verticage Vert	ife, The, 251 nece 7, 107–8, 108 42, 142 20 220, 235, 235 nenszoon van Rijn, 3 d to the People, see Cross, 124, 125 nishing David, 81, r (Portman), 225 nguste, 253 3, 34, 34–38, 35 36–38 6, 36 Hesse), 34 ine and, 89–91, art, 5, 74 likeness, 14 s), 315 ive, 202–3, 203 38–40, 39, 40 5, 105–6 243, 301–2 II, 302 ir, 8 der House, 8
Pepper, Beverly mixing to affect intensity, Printmaking techniques of, 120 Shape and, 107, 107 Perception, 16 Pines and Racks (Cézanne), 258 Pinas in, 14-15 Piranesi, Giovanni Battista Process art, 301, 314-17, 315-17 Relifer Syntax of Stone and Air (Graves), 51 Pissarro, Camille, 253, 257 Product design, 224, 228 Relief sculpture, 220, 200 Persistence of Memory (Dali), 284 Place du Théatre Français, La (Gerzo), 260 Place du Théatre Français, La (Gerzo), 42 Plan view, 213, 213 Planar shape, 94, 99, 99 Planes, 5, 19, 94, 99, 206-7, 207 Perspective distortion, 188, 201 Perspective distortion, 188, 201 Perspective distortion, 188, 201 Perspective distortion, 188, 201 Pullar shape, 94, 99, 99 Planes, 5, 19, 94, 99, 206-7, 207 Photography, 16, 18, 18 Plani ari "landscapes, 254 Point of Touki, Bathsheba (Cook), 158 Pointilism, 60, 257 Pointar Rageous concept car, 224 Pointormo, Jacopo, 249-50 Popphones, 60, 237 Pontiar of Rageous concept car, 224 Pontormonotage, 286 Photorealism (New Realism), 313, 313-14, 314 Position, space and, 184, 184-85, 185 Position, space and, 184, 184-85, 185 Proportions of, 120 Shape in, 125 Product design, 224, 228 Relief sculpture, 220, value and, 117, 117 Relefit sculpture, 220, valu	rice 7, 107–8, 108 42, 142 20 220, 235, 235 rienszoon van Rijn, 3 d to the People, see Cross, 124, 125 rishing David, 81, r (Portman), 225 riguste, 253 3, 34, 34–38, 35 36–38 6, 36 Hesse), 34 rine and, 89–91, art, 5, 74 likeness, 14 s), 315 rive, 202–3, 203 38–40, 39, 40 5, 105–6 243, 301–2 II, 302 ir, 8 der House, 8
Perception 154, 154 Perception 154, 154 Perception 154, 154 Perception 16 Pines and Rocks (Cézanne), 258 Perceptual art, 14-15 Piranesi, Giovanni Battista Process art, 301, 314-17, 315-17 Relief printing, 120 Relief sculpture, 220, Persistence of Memory (Dali), 284 Personage in Red and Blue (Gerzo), 42 Plane view, 213, 213 Planar shape, 94, 99, 99 Perspective, 94, 180, 188, 188, 189 Planes, 5, 199, 499, 906-7, 207 Plestic art, 5, 20 Plastic colors, 157-59, 158, 159 Plastic colors, 157-59, 158, 159 Plastic value, 116, 120 Plastic value, 116, 120 Plastic value, 116, 120 Poperations of the Human Figure (da Value and, 117, 117 texture and, 142, 4 Relief printing, 120 Relief sculpture, 220, Product design, 224, 228 Relief printing, 120 R	7, 107–8, 108 42, 142 20 220, 235, 235 menszoon van Rijn, 3 d to the People, see Cross, 124, 125 mishing David, 81, r (Portman), 225 misuste, 253 misuste, 253 misuste, 34 mine and, 89–91, art, 5, 74 likeness, 14 s), 315 ive, 202–3, 203 misuste,
Perception 16	42, 142 20 220, 235, 235 nenszoon van Rijn, 3 d to the People, see Cross, 124, 125 nishing David, 81, r (Portman), 225 nguste, 253 3, 34, 34–38, 35 36–38 6, 36 Hesse), 34 ine and, 89–91, art, 5, 74 likeness, 14 s), 315 ive, 202–3, 203 38–40, 39, 40 5, 105–6 243, 301–2 II, 302 ir, 8 der House, 8
Perception, 16 Perceptial art, 14–15 Perceptial art, 14–15 Perceptial art, 14–15 Perceptial art, 14–15 Perfect Syntax of Stone and Air (Graves), 51 Personage art, 308, 309, 310 Personage in Red and Blue (Canova), 260 Perspective, 94, 180, 188, 188, 189 Perspective, 94, 180, 188, 188, 189 Perspective, 94, 180, 188, 188, 189 Pelean, Ellen Umbrella Pine, 173 Phenomena Graced by Timee (Jenkins), 176 Photography, 16, 18, 18 abstract and realists, 262, 272, 276, 277–79, 278 Abstract-Expressionist, 294–96, 295 beginnings of, 249–50, 250, 251 color photography, 269–70, 270 development of, 21 subtractive color in, 169, 170 surrealist, 286, 286–87 technological developments, 252, 252–33, 253 trends in, 259, 259–60, 262 Photogravure, 253 Photogravure, 253 Photogravure, 253 Photogravure, 253 Photogravure, 253 Photomomatage, 286 Photorealism (New Realism), 313, 313–14, 314 Personage and Air Will, The, 76 Pissarro, Camille, 253, 257 Piroduct design, 224, 228 Proportion, 24, 25, 25, 30, 31 In three-dimensional art, 226, 26, 62, 64–65 in three-dimensional art, 226, 239, 240, 241 Proportions of the Human Figure (da Vinci), 60, 61 Proportions of the Human Figure (da Vinci), 60, 61 Psychological application of color, 164, 164–65, 165 Psychological application of color, 164, 164–65, 165 Puryear, Martin, 320 Priside, 249–50 Pastic value, 116, 120 Planar shape, 94, 99, 99 Plastic cart, 5, 20 shape in, 94, 96, 97, 99 Plastic color, 157–59, 158, 159 Plastic color, 157–59, 158, 159 Plastic value, 116, 120 Plastic value, 116, 120 Plein air landscapes, 254 Point of Touris, Badisheba (Cook), 158 Quattro Centric XIII (Held), 186 Question of Balance, A (Welsh), 227 Quiet Please (Mitchell), 186 Question of Realance, A (Welsh), 227 Quiet Please (Mitchell), 187 Representational like, 186 Representational like, 186 Representational like, 186 Representational like, 186 Reveal and Planar shape, 94, 99, 99 Pontiar, 94, 95, 90, 99 Pontiar English, 262, 272, 277 Popy 3, 33, 34–4 Pound (Cook), 158 Quilts, pattern in, 37, 37 Reverse perspective, 29, 2	20 220, 235, 235 nenszoon van Rijn, 3 d to the People, se Cross, 124, 125 nishing David, 81, r (Portman), 225 nguste, 253 3, 34, 34–38, 35 36–38 6, 36 Hesse), 34 ine and, 89–91, art, 5, 74 likeness, 14 s), 315 ive, 202–3, 203 38–40, 39, 40 5, 105–6 243, 301–2 II, 302 ir, 8 der House, 8
Perceptual art, 14-15	220, 235, 235 nenszoon van Rijn, 3 d to the People, le Cross, 124, 125 nishing David, 81, r (Portman), 225 nguste, 253 3, 34, 34–38, 35 36–38 6, 36 Hesse), 34 ine and, 89–91, likeness, 14 s), 315 live, 202–3, 203 38–40, 39, 40 5, 105–6 243, 301–2 II, 302 lir, 8 ler House, 8
Perfect Syntax of Stone and Air (Graves), 51	220, 235, 235 nenszoon van Rijn, 3 d to the People, le Cross, 124, 125 nishing David, 81, r (Portman), 225 nguste, 253 3, 34, 34–38, 35 36–38 6, 36 Hesse), 34 ine and, 89–91, likeness, 14 s), 315 live, 202–3, 203 38–40, 39, 40 5, 105–6 243, 301–2 II, 302 lir, 8 ler House, 8
Graves), 51	nenszoon van Rijn, 3 d to the People, le Cross, 124, 125 nishing David, 81, r (Portman), 225 nguste, 253 3, 34, 34–38, 35 36–38 6, 36 Hesse), 34 ine and, 89–91, art, 5, 74 likeness, 14 s), 315 ive, 202–3, 203 38–40, 39, 40 5, 105–6 243, 301–2 II, 302 ir, 8 der House, 8
Performance art, 308, 309, 310 Place du Théatre Français, La 253, 254 62, 64-65 Christ Presented to (Canova), 260 Place du Théatre Français, La (Pissarno), 254 Place du Théatre Français, La (Pissarno), 254 Place du Théatre Français, La (Pissarno), 254 Personage in Red and Blue (Gerzo), 42 Plan shape, 94, 99, 99 Planes, 5, 19, 94, 99, 206-7, 207 Planar shape, 94, 99, 99 Planes, 5, 19, 94, 99, 206-7, 207 Plastic art, 5, 20 Planes, 5, 19, 94, 99, 206-7, 207 Plastic colors, 157-59, 158, 159 Plastic value, 116, 120 Pl	3 d to the People, le Cross, 124, 125 hishing David, 81, r (Portman), 225 higuste, 253 3, 34, 34–38, 35 36–38 6, 36 Hesse), 34 hine and, 89–91, likeness, 14 s), 315 ive, 202–3, 203 38–40, 39, 40 5, 105–6 243, 301–2 II, 302 lir, 8 ler House, 8
Perseus with the Head of Medusa (Canova), 260 253, 254 62, 64-65 Christ Presented to in three-dimensional art, 226, 20-21 Christ Presented to in three-dimensional art, 226, 239, 240, 241 Description the Criman Figure (da Vinci), 60, 61 239, 240, 241 Description the Criman Figure (da Vinci), 60, 61 Nathan Admonishin Vinci), 60, 61 81 Perspective, 94, 180, 188, 188, 188, 189 Planar shape, 94, 99, 99 Planes, 5, 19, 94, 99, 206-7, 207 Plastic and shape, 94, 99, 99 Plastic integes, 187, 212, 212-32 Psychological application of color, 164, 164-65, 165 Renaissance Center (Poportions of the Human Figure (da Vinci), 60, 61 81 Perspective distortion, 188, 201 Plastic intages, 187, 212, 212-31, 213 Psychological application of color, 164, 164-65, 165 Renoir, Pierre August 164, 164-65, 165 Repotition, 30, 33, 34 Phenomena Graced by Three (lenkins), 176 Plastic images, 187, 212, 212-312, 213 Pyramid, 198, 199 Pyramid, 198, 199 Puryear, Martin, 320 Repetition, 30, 33, 34 Photography, 16, 18, 18 Plastic value, 116, 120 Plastic value, 116, 120 Pyramid, 198, 199 Pyramid, 198, 199 Representation, line a Representation, line a Representation, line a Sep-91 Representation, line a Representation, line a Representation, line a Pyramid of Agents	the Cross, 124, 125 mishing David, 81, or (Portman), 225 miguste, 253 miguste, 263 miguste, 263 miguste, 263 miguste, 263 miguste, 263 miguste, 263 miguste, 34 miguste, 36 miguste, 36 miguste, 36 miguste, 36 miguste, 36 miguste, 36 miguste, 37 migust
Canova), 260 Place du Théatre Français, La (Pissarro), 254 (Pissarro), 255 (Photorgalism, 253 Photoromitage, 286 Photorealism (New Realism), 313, 31–14, 314 (Pissarro), 254 Point of Touch; pace and, 184, 184–85, 185 (Pissarro), 254 (Pissarro),	the Cross, 124, 125 mishing David, 81, or (Portman), 225 miguste, 253 miguste, 263 miguste, 263 miguste, 263 miguste, 263 miguste, 263 miguste, 263 miguste, 34 miguste, 36 miguste, 36 miguste, 36 miguste, 36 miguste, 36 miguste, 36 miguste, 37 migust
Persistence of Memory (Dali), 284 (Pissarro), 254 239, 240, 241 Descent from the Cr Personage in Red and Blue (Gerzo), 42 Plan view, 213, 213 Proportions of the Human Figure (a Nathan Admonishin (and the Human Figure) Nathan Admonishin (All (an	rishing David, 81, r (Portman), 225 riguste, 253 3, 34, 34–38, 35 36–38 6, 36 Hesse), 34 rine and, 89–91, art, 5, 74 likeness, 14 s), 315 rive, 202–3, 203 38–40, 39, 40 5, 105–6 243, 301–2 II, 302 rir, 8 der House, 8
Personage in Red and Blue	rishing David, 81, r (Portman), 225 riguste, 253 3, 34, 34–38, 35 36–38 6, 36 Hesse), 34 rine and, 89–91, art, 5, 74 likeness, 14 s), 315 rive, 202–3, 203 38–40, 39, 40 5, 105–6 243, 301–2 II, 302 rir, 8 der House, 8
Perspective, 94, 180, 188, 188, 189	r (Portman), 225 nguste, 253 3, 34, 34–38, 35 36–38 6, 36 Hesse), 34 ine and, 89–91, art, 5, 74 likeness, 14 s), 315 ive, 202–3, 203 38–40, 39, 40 5, 105–6 243, 301–2 II, 302 ir, 8 der House, 8
Perspective, 94, 180, 188, 189, 189, 189, 201 Perspective distortion, 188, 201 Phelan, Ellen Umbrella Pine, 173 Plastic colors, 157–59, 158, 159 Umbrella Pine, 173 Plastic colors, 157–59, 158, 159 Plastic space, 180, 181–83 Plastic value, 116, 120 Plastic orbor, 169, 189, 199 Plastic orbor, 169, 189, 189 Plastic value, 116, 120 Plastic valu	aguste, 253 3, 34, 34–38, 35 36–38 6, 36 Hesse), 34 ine and, 89–91, art, 5, 74 likeness, 14 s), 315 ive, 202–3, 203 38–40, 39, 40 5, 105–6 243, 301–2 II, 302 ir, 8 der House, 8
Perspective distortion, 188, 201 Plastic art, 5, 20 Perspective distortion, 188, 201 Plastic pace, 180, 187, 99 Plastic colors, 157–59, 158, 159 Umbrella Pine, 173 Plastic images, 187, 212, 212–13, 213 Phenomena Graced by Three (lenkins), 176 Plastic value, 116, 120 Photography, 16, 18, 18 abstract and realist, 262, 272, 276, 277–79, 278 Point of Touch; Bathsheba (Cook), 158 Abstract-Expressionist, 294–96, 295 beginnings of, 249–50, 250, 251 color photography, 269–70, 270 development of, 21 subtractive color in, 169, 170 surrealist, 286, 286–87 technological developments, 252, 252–53, 253 trends in, 259, 259–60, 262 Photograwire, 253 Photograwire, 253 Photograwire, 253 Photograwire, 253 Photograwire, 253 Photograwire, 253 Photograwire, 256 Photorealism (New Realism), 313, 313–14, 314 Plastic art, 5, 20 164, 164–65, 165 Purylarit, 320 Purylarit, 321 Purylar, Martin, 320 Purylarit, 321 Purylar, Martin, 320 Purylarit, 321 Purylar, Martin, 320 Purylarit, 321 Purylarit, 321 Purylar, Martin, 320 Purylarit, 321 Purylarit, 321 Purylarit, 321 Purylarit, 321 Purylarit, 321 Purylarit, 320 Purylarit, 321 Purylarit, 320 Purylarit, 321 Purylarit, 320 Purylarit, 321 Purylarit, 321 Purylarit, 321 Purylarit, 320 Purylarit, 321 Purylariti, 320 Purylariti, 321 Purylariti, 321 Purylariti, 321 Purylariti, 320 Purylariti, 321 Purylariti, 321 Purylariti, 321 Purylariti, 3	aguste, 253 3, 34, 34–38, 35 36–38 6, 36 Hesse), 34 ine and, 89–91, art, 5, 74 likeness, 14 s), 315 ive, 202–3, 203 38–40, 39, 40 5, 105–6 243, 301–2 II, 302 ir, 8 der House, 8
Pevsner, Antoine, 277 shape in, 94, 96, 97, 99 Puryear, Martin, 320 Repetition, 30, 33, 34 Phelan, Ellen Plastic colors, 157-59, 158, 159 Puryear, Martin, 320 Repetition, 30, 33, 34 Phenomen Graced by Three Plastic value, 116, 120 Plastic value, 116, 120 Pyramid, 198, 199 Representation, line a Photography, 16, 18, 18 "Plein air" landscapes, 254 Quattro Centric XIII (Held), 186 Representational like Abstract-Expressionist, 294-96, 295 Pollock, Jackson, 289-90, 297 Question of Balance, A (Welsh), 227 Rescue Sled (Beuys), 3 Deginnings of, 249-50, 250, 251 Polyclitus of Argos, 58-59 Obeyiditus of Argos, 58-59 Quilts, pattern in, 37, 37 Rhythm, 30, 33, 38-4 surrealist, 286, 286-87 Tetchnological developments, 252, 252-53, 253 Pontiac Rageous concept car, 224 Pontormo, Jacopo, 249-50 Radial balance, 53, 53, 55-56, 57 Radially balanced sculpture, 239, 240 Rietveld-Schröder Hous Photogravure, 253 Photogravure, 253 Portrait of Exra Pound (Coburn), 272 Renaissance Center, 225 Radially balanced sculpture, 239, 240 Rejetiveld-Schröder Hous Photogravire, 253 Portrait of Exra Pound (Coburn), 272 Portrait of Exra Pound (Coburn), 272 Rage of the Sabines	3, 34, 34–38, 35 36–38 5, 36 Hesse), 34 ine and, 89–91, art, 5, 74 likeness, 14 s), 315 ive, 202–3, 203 38–40, 39, 40 5, 105–6 243, 301–2 II, 302 ir, 8 der House, 8
Phelan, Ellen	36–38 5, 36 Hesse), 34 ine and, 89–91, art, 5, 74 likeness, 14 s), 315 ive, 202–3, 203 38–40, 39, 40 5, 105–6 243, 301–2 II, 302 ir, 8 der House, 8
Umbrella Pine, 173 Plastic images, 187, 212, 212–13, 213 Pyramid, 198, 199 pattern, 35–36, 36 Phenomena Graced by Three (Jenkins), 176 Plastic space, 180, 181–83 Plastic value, 116, 120 Repetition 19 III (Hess Representation, line at Representation, lin	6, 36 Hesse), 34 ine and, 89–91, art, 5, 74 likeness, 14 s), 315 ive, 202–3, 203 38–40, 39, 40 5, 105–6 243, 301–2 II, 302 ir, 8 der House, 8
Phenomena Graced by Three (Jenkins), 176 Photography, 16, 18, 18 abstract and realist, 262, 272, 276, 277-79, 278 Abstract-Expressionist, 294-96, 295 beginnings of, 249-50, 250, 251 color photography, 269-70, 270 development of, 21 subtractive color in, 169, 170 surrealist, 286, 286-87 technological developments, 252, 252-53, 253 Photogravure, 253 Photogravure, 253 Photogravure, 253 Photogravure, 253 Photogravure, 253 Photoromotage, 286 Photorealism (New Realism), 313, 313-14, 314 Particular of Max Jacob (Gris), 90 Position, space and, 184, 184-85, 185 Plastic space, 180, 181-83 Representation, line a 89-91 Representation, line a 89-91 Representational art, in Re	Hesse), 34 ine and, 89–91, art, 5, 74 likeness, 14 s), 315 ive, 202–3, 203 38–40, 39, 40 5, 105–6 243, 301–2 II, 302 ir, 8 der House, 8
Plastic value, 116, 120 Photography, 16, 18, 18 Plein air" landscapes, 254 Point of Touch; Bathsheba (Cook), 158 276, 277-79, 278 Point of Touch; Bathsheba (Cook), 158 274, 277-79, 278 Point of Touch; Bathsheba (Cook), 158 Point of Touch; Point of Touch; Point of Touch; Point of Balance, A (Welsh), 227 Regresentational art, 162 Point of Balance, A (Welsh), 227 Point of Balance, A (Welsh), 227 Point of Balance, A (Welsh), 227 Point of Poi	art, 5, 74 likeness, 14 s), 315 ive, 202–3, 203 38–40, 39, 40 5, 105–6 243, 301–2 II, 302 ir, 8 der House, 8
Photography, 16, 18, 18 abstract and realist, 262, 272, Point of Touch; Bathsheba (Cook), 158 276, 277–79, 278 Pointillism, 60, 257 Pollock, Jackson, 289–90, 297 294–96, 295 Autumn Rhythm, 290 Polyclitus of Argos, 58–59 color photography, 269–70, 270 development of, 21 subtractive color in, 169, 170 surrealist, 286, 286–87 technological developments, 252, 252–53, 253 Photogravure, 253 Photogravure, 253 Photogravure, 253 Photomontage, 286 Photorealism (New Realism), 313, 313–14, 314 Piein air "landscapes, 254 Point of Touch; Bathsheba (Cook), 158 Quattro Centric XIII (Held), 186 Question of Balance, A (Welsh), 227 Quiet Please (Mitchell), 158 Reverse perspective, 2 Quiet Please (Mitchell), 158 Quiet Please (Mitchell), 158 Reverse perspective, 2 Rescue Sled (Beuys), 3 Reverse perspective, 2 Rescue Sled (Beuys), 3 Reverse perspective, 2 Rescue Sled (Beuys), 3 Reverse perspective, 2 Ricky, George, 243, Tiwo Red Lines II, Rickey, George, 243, Tiwo Red Lines II, Races at Longchamp, The (Manet), 256 Radial, 30 Radial balance, 53, 53, 55–56, 57 Radially balanced sculpture, 239, 240 Ragamala Salangi Raga, 56 Rape of Europa (Lipchitz), 292 Rape of the Sabines (Poussin), 127 Portrait of Max Jacob (Gris), 90 Position, space and, 184, 184–85, 185 Porifi No. 2, 299 Drift No. 2, 299 Prift No. 2, 299	art, 5, 74 likeness, 14 s), 315 ive, 202–3, 203 38–40, 39, 40 5, 105–6 243, 301–2 II, 302 ir, 8 der House, 8
abstract and realist, 262, 272, 276, 277–79, 278 Point of Touch; Bathsheba (Cook), 158 276, 277–79, 278 Pointillism, 60, 257 Quattro Centric XIII (Held), 186 Representational like of Regions of Results of Representational art, and Representational like of Representational art, and Results and Results and Results and Results and Representational art, and Results and Results and Results and Results and Representational art, and Results	likeness, 14 s), 315 ive, 202–3, 203 38–40, 39, 40 5, 105–6 243, 301–2 II, 302 ir, 8 der House, 8
276, 277–79, 278 Abstract-Expressionist, 294–96, 295 Beginnings of, 249–50, 250, 251 color photography, 269–70, 270 development of, 21 subtractive color in, 169, 170 surrealist, 286, 286–87 technological developments, 252, 252–53, 253 Photogravure, 253 Photogravure, 253 Photogravure, 253 Photogravure, 253 Photomontage, 286 Photorealism (New Realism), 313, 313–14, 314 Point in fight and the properties of the Sabines (Poussin), 127 Point in fight and the properties of the Sabines (Poussin), 127 Portfin in fight and the properties of the Sabines (Poussin), 127 Portfin in fight and the properties of the Sabines (Poussin), 127 Portfin in fight and the properties of the Sabines (Poussin), 127 Portfin in fight and the properties of the Sabines (Poussin), 127 Portfin in fight and the properties of the Sabines (Poussin), 127 Portfin in fight and the properties of the Sabines (Poussin), 127 Portfin in fight and the properties of the Sabines (Poussin), 127 Portfin in fight and the properties of the Sabines (Poussin), 127 Portfin in fight and the properties of the Sabines (Poussin), 127 Portfin in fight and the properties of the Sabines (Poussin), 127 Portfin in fight and the properties of the Sabines (Poussin), 127 Portfin in fight and the properties of the Sabines (Poussin), 127 Portfin in fight and the properties of the Sabines (Poussin), 127 Portfin in fight and the properties (Belusys), 3 Reverse perspective, 2 Quilts Please (Mitchell), 158 Reverse perspective, 2 Rulling, pattern in, 37, 37 Rhythm, 30, 33, 38–4 Rickey, George, 243, 37 Rickey, Geor	likeness, 14 s), 315 ive, 202–3, 203 38–40, 39, 40 5, 105–6 243, 301–2 II, 302 ir, 8 der House, 8
Abstract-Expressionist, 294–96, 295	s), 315 tve, 202–3, 203 38–40, 39, 40 5, 105–6 243, 301–2 II, 302 ir, 8 der House, 8
294–96, 295 beginnings of, 249–50, 250, 251 color photography, 269–70, 270 development of, 21 subtractive color in, 169, 170 surrealist, 286, 286–87 trends in, 259, 259–60, 262 Photogravure, 253 Photogravure, 253 Photogravure, 253 Photogravure, 253 Photogravure, 253 Photogravure, 253 Photomontage, 286 Photorealism (New Realism), 313, 313–14, 314 Partial of Max Jacob (Gris), 90 Position, space and, 184, 184–85, 185 Polyclitus of Argos, 58–59 Polyclitus of Argos, 58–59 Polyclitus of Argos, 58–59 Quilts, pattern in, 37, 37 Rhythm, 30, 33, 38–4 Squilts, pattern in, 37, 37 Rhythm, 30, 33, 38–4 Shape and, 105, 10 Rickey, George, 243, 3 Two Red Lines II, 2 Races at Longchamp, The (Manet), 256 Radial balance, 53, 53, 55–56, 57 Radially balanced sculpture, 239, 240 Ragamala Salangi Raga, 56 Reverse perspective, 2 Rhythm, 30, 33, 38–4 Shape and, 105, 10 Rickey, George, 243, 3 Two Red Lines II, 2 Reietveld, Gerrit Red/Blue Chair, 8 Reverse perspective, 2 Rhythm, 30, 33, 38–4 Shape and, 105, 10 Rickey, George, 243, 3 Two Red Lines II, 2 Reietveld, Serric Red/Blue Chair, 8 Reverse perspective, 2 Rhythm, 30, 33, 38–4 Shape and, 105, 10 Rickey, George, 243, 3 Two Red Lines II, 2 Reietveld, Serric Red/Blue Chair, 8 Reverse perspective, 2 Rhythm, 30, 33, 38–4 Shape and, 105, 10 Rickey, George, 243, 3 Two Red Lines II, 2 Reietveld, Serric Red/Blue Chair, 8 Reverse perspective, 2	ive, 202–3, 203 38–40, 39, 40 5, 105–6 243, 301–2 II, 302 ir, 8 der House, 8
beginnings of, 249–50, 250, 251 color photography, 269–70, 270 development of, 21 subtractive color in, 169, 170 surrealist, 286, 286–87 technological developments, 252, 252–53, 253 trends in, 259, 259–60, 262 Photogravure, 253 Photogravure, 253 Photomontage, 286 Photomontage, 286 Photorealism (New Realism), 313, 313–14, 314 Postion, space and, 184, 184–85, 185 Polyclitus of Argos, 58–59 Quilts, pattern in, 37, 37 Rhythm, 30, 33, 38–2 shape and, 105, 10 Rickey, George, 243, 3 Tiwo Red Lines II, 3 Rickey, George, 243, 3 Rickeyld, Gerrit Races at Longchamp, The (Manet), 256 Radial, 30 Radial balance, 53, 53, 55–56, 57 Radially balanced sculpture, 239, 240 Ragamala Salangi Raga, 56 Rape of Europa (Lipchitz), 292 Rape of the Sabines (Poussin), 127 Races at Longchamp, The (Manet), 256 Radial balance, 53, 53, 55–56, 57 Radially balanced sculpture, 239, 240 Rape of Europa (Lipchitz), 292 Rape of the Sabines (Poussin), 127 Rape of the Sabines (Poussin), 127 Races at Longchamp, The (Manet), 256 Races at Longchamp, The (Manet), 256 Radial balance, 53, 53, 55–56, 57 Radially balanced sculpture, 239, 240 Rickey, George, 243, 3 Rictveld, Gerrit Races at Longchamp, The (Manet), 256 Radial balance, 53, 53, 55–56, 57 Radially balanced sculpture, 239, 240 Rape of Europa (Lipchitz), 292 Rape of the Sabines (Poussin), 127 Rape of the Sabines (Poussin), 127 Rape of the Sabines (Poussin), 127 Races at Longchamp, The (Manet), 256 Races at L	38–40, 39, 40 5, 105–6 243, 301–2 II, 302 ir, 8 der House, 8
color photography, 269–70, 270 development of, 21 subtractive color in, 169, 170 surrealist, 286, 286–87 technological developments, 252, 252–53, 253 trends in, 259, 259–60, 262 Photogravure, 253 Photogravure, 253 Photogravure, 253 Photomontage, 286 Photorealism (New Realism), 313, 313–14, 314 Doryphoros, 60 Pont de Passy et la Tour Eiffel, Le (Chagall), 57 (Chag	5, 105–6 443, 301–2 II, 302 ir, 8 der House, 8
development of, 21 subtractive color in, 169, 170 surrealist, 286, 286–87 pontiac Rageous concept car, 224 technological developments, 252, 252–53, 253 trends in, 259, 259–60, 262 Photogravure, 253 Photogravure, 253 Photomontage, 286 Photorealism (New Realism), 313, 313–14, 314 Pontial Rageous concept car, 224 Pontormo, Jacopo, 249–50 Races at Longchamp, The (Manet), 256 Radial, 30 Races at Longchamp, The (Manet), 256 Radial balance, 53, 53, 55–56, 57 Radially balanced sculpture, 239, 240 Ragamala Rage of Europa (Lipchitz), 292 Rape of the Sabines (Poussin), 127 Races at Longchamp, The (Manet), 256 Radial balance, 53, 53, 55–56, 57 Radially balanced sculpture, 239, 240 Rage of Europa (Lipchitz), 292 Rape of the Sabines (Poussin), 127 Rape of the Sabines (Poussin), 127 Rape of the Sabines (Poussin), 127 Races at Longchamp, The (Manet), 256 Radial balance, 53, 53, 55–56, 57 Radially balanced sculpture, 239, 240 Rage of Europa (Lipchitz), 292 Rape of the Sabines (Poussin), 127 Races at Longchamp, The (Manet), 256 Radial balance, 53, 53, 55–56, 57 Radially balanced sculpture, 239, 240 Rage of Europa (Lipchitz), 292 Rape of the Sabines (Poussin), 127 Races at Longchamp, The (Manet), 256 Radial, 30 Rickey, George, 243, 17 Rickey, George, 243, 17 Rickey, George, 243, 17 Rickey, George, 243, 17 Rictveld, Gerrit Radial, 30 Radial balance, 53, 53, 55–56, 57 Radially balanced sculpture, 239, 240 Rage of Europa (Lipchitz), 292 Rape of the Sabines (Poussin), 127 Races at Longchamp, The (Manet), 256 Radial, 30 Rictveld, Gerrit Red/Blue Chair, 8 Red/Blue Chair, 8 Rietveld, Schröder Hous Races at Longchamp, The (Manet), 256 Radial, 30 Radial balance, 53, 53, 55–56, 57 Radially balanced sculpture, 239, 240 Ragamala Rictveld, Schröder Hous Races at Longchamp, The (Manet), 256 Radial, 30 Reitveld-Schröder Hous Races at Longchamp, The (Manet), 256 Radial, 30 Reitveld-Schröder Hous Races at Longchamp, The (Manet), 256 Radial balance, 53, 53, 55–56, 57 Radially balanced sculpture, 239, 240 Ragamala Rictveld-Schröder Hous Races at Lo	243, 301–2 II, 302 ir, 8 der House, 8
subtractive color in, 169, 170 surrealist, 286, 286–87 pontiac Rageous concept car, 224 technological developments, 252, 252–53, 253 trends in, 259, 259–60, 262 Photogravure, 253 Photogravure, 253 Photomontage, 286 Photorealism (New Realism), 313, 313–14, 314 Position, space and, 184, 184–85, 185 Radiall, 57 Races at Longchamp, The (Manet), 256 Radial, 30 Races at Longchamp, The (Manet), 256 Radial balance, 53, 53, 55–56, 57 Radially balanced sculpture, 239, 240 Ragamala Salangi Raga, 56 Rape of Europa (Lipchitz), 292 Rape of the Sabines (Poussin), 127 Races at Longchamp, The (Manet), 256 Radial, 30 Reitveld, Schröder Hous	II, 302 ir, 8 ler House, 8
surrealist, 286, 286–87 Pontiac Rageous concept car, 224 technological developments, 252, Pontormo, Jacopo, 249–50	ir, 8 ler House, 8
technological developments, 252, Pontormo, Jacopo, 249–50 252–53, 253 Pop art, 237, 299, 304–6, Radial, 30 Photogravure, 253 Photogravure, 253 Photomontage, 286 Photorealism (New Realism), 313, 313–14, 314 Position, space and, 184, 184–85, 185 Pontormo, Jacopo, 249–50 Radial, 30 Radial, 30 Radial balance, 53, 53, 55–56, 57 Radially balanced sculpture, 239, 240 Ragamala Salangi Raga, 56 Radial balance, 53, 53, 55–56, 57 Radially balanced sculpture, 239, 240 Ragamala Salangi Raga, 56 Rape of Europa (Lipchitz), 292 Rape of the Sabines (Poussin), 127 Radially balanced sculpture, 239, 240 Right vanishing point 196, 196 Radial, 30 Radial, 30 Radial balance, 53, 53, 55–56, 57 Radially balanced sculpture, 239, 240 Ragemala Salangi Raga, 56 Radial, 30 Rateveld-Schröder House Schröder), 50 Rage of Europa (Lipchitz), 292 Rape of the Sabines (Poussin), 127 Radially balance, 53, 53, 55–56, 57 Radially balanced sculpture, 239, 240 Rape of Europa (Lipchitz), 292 Rape of the Sabines (Poussin), 127	ler House, 8
252–53, 253 Pop art, 237, 299, 304–6, trends in, 259, 259–60, 262 Photogravure, 253 Photogravure, 253 Photogravinalism, 253 Photomontage, 286 Photorealism (New Realism), 313, 313–14, 314 Pop art, 237, 299, 304–6, Radial, 30 Radial, 30 Radial balance, 53, 53, 55–56, 57 Radially balanced sculpture, 239, 240 Ragamala Salangi Raga, 56 Rape of Europa (Lipchitz), 292 Rape of the Sabines (Poussin), 127 Rape of the Sabines (Poussin), 127 Position, space and, 184, 184–85, 185 Radial, 30 Rietveld-Schröder Hous Schröder Hous Schröder Hous Schröder, 8 Rietveld-Schröder Hous Schröder, 8 Radial, 30 Ra	ler House, 8
trends in, 259, 259–60, 262 Photogravure, 253 Photojournalism, 253 Photomontage, 286 Photorealism (New Realism), 313, 313–14, 314 Prosition, space and, 184, 184–85, 185 Radial balance, 53, 53, 55–56, 57 Radially balanced sculpture, 239, 240 Schröder Hous Schröder Hous Schröder Hous Schröder, 6 Ragamala Salangi Raga, 56 Rape of Europa (Lipchitz), 292 Rape of the Sabines (Poussin), 127 Position, space and, 184, 184–85, 185 Radial balance, 53, 53, 55–56, 57 Radial balance, 53, 53, 55–66, 57 Radially balanced sculpture, 239, 240 Schröder), 6 Right vanishing point of Europa (Lipchitz), 292 Radial balance, 53, 53, 55–66, 57 Radially balanced sculpture, 239, 240 Schröder), 6 Ragamala Salangi Raga, 56 Rape of Europa (Lipchitz), 292 Rape of the Sabines (Poussin), 127 Prift No. 2, 299	
Photogravure, 253 Photojournalism, 253 Photomontage, 286 Photorealism (New Realism), 313, 313–14, 314 Position, space and, 184, 184–85, 185 Portman, John Radially balanced sculpture, 239, 240 Ragamala Ragamala Right vanishing point Salangi Raga, 56 Rape of Europa (Lipchitz), 292 Rape of the Sabines (Poussin), 127 Rape of the Sabines (Poussin), 127 Drift No. 2, 299 Riley, Bridget, 298 Drift No. 2, 299	
Photojournalism, 253 Renaissance Center, 225 Ragamala Right vanishing point Salangi Raga, 56 Rape of Europa (Lipchitz), 292 Riley, Bridget, 298 Rape of the Sabines (Poussin), 127	
Photomontage, 286 Portrait of Ezra Pound (Coburn), 272 Salangi Raga, 56 Photorealism (New Realism), 313, Portrait of Max Jacob (Gris), 90 Rape of Europa (Lipchitz), 292 313–14, 314 Position, space and, 184, 184–85, 185 Rape of the Sabines (Poussin), 127 Photomontage, 286 Portrait of Ezra Pound (Coburn), 272 Salangi Raga, 56 Rape of Europa (Lipchitz), 292 Rape of the Sabines (Poussin), 127 Prift No. 2, 299	
Photorealism (New Realism), 313, Portrait of Max Jacob (Gris), 90 Rape of Europa (Lipchitz), 292 Riley, Bridget, 298 313–14, 314 Position, space and, 184, 184–85, 185 Rape of the Sabines (Poussin), 127 Drift No. 2, 299	
313–14, 314 Position, space and, 184, 184–85, 185 Rape of the Sabines (Poussin), 127 Drift No. 2, 299	
District 200 204	
Dhyllotavy 60 61 Pacitive areas 5 75-76 76 77	
Phyllotaxy, 60, 61 Positive areas, 5, 25–26, 26, 27 Rauschenberg, Robert, 298, 304 Rivera, Diego Piazza of San Marco, Venice, The Post-Impressionism, 213, 247, 253, Post-Impressionism, 213, 247, 253, Liberation of the Pec	e Peon The 32
(Canaletto), 193, 193 255, 257, 257–59, 258 Monogram, 299 Rivera, José de, 237, 2	
Picador, The (Marca-Relli), 109 sculpture, 268, 268–69, 269 Ray, Man, 286–87 Brussels Construction	
Picador with Horse (Broderson), 109 Post-Minimalists, 319–21, 320, 321 Aerographs, 286 Rivers, Larry	minon, 255
Picasso, Pablo, 68, 135, 137, 209, Postmodernism, 312–13 Rayographs, 286 Greatest Homosexu.	sexual The 129
Descended the stronger of the	
270–71, 276, 280, 299 Post-Painterly Abstraction, 289, Demoiselles d'Avignon, Les, 296–98, 296–98 Rayograph (Photography), 260 Rayographs (Ray), 286 Continuous Ship C	
270, 270 Poussin, Nicolas, 127, 183, 257 "Ready-mades," 281, 315, 316 Ochre, 80	W VALLEY, TEHOW
Decline 5 43 250 51 252	•
V_{100} and V_{200}	80
Dog and Cock, 142, 142 Mars and Venus, 19 Realism, 3, 13, 250–51, 251, 252 Mozart and Mozart Family of Saltimbanques, 59 Rape of the Sabines, 127 Realist (straight) photographers, 250 and Backwa	80 ozart Upside Down

Powers, Hiram

Realistic art, content of, 12

Rodin, Auguste, 261, 262, 276, 279 expressionist, 268, 268-69, 269 Shared edges, 42-44, 43-44 Burghers of Calais, 262 form in, 12, 12 Shared space. See Visual linking Sharp and diminishing detail, Danaïde, 262, 262 kinetic, 301, 301-2, 302 187-88, 188 Gates of Hell, 261 linear-type materials in, 77 Sheeler, Charles, 110, 276 Gates of Hell, The, 236 media for, 22 nineteenth-century, 255, 256, Architectural Cadences, 111 Rodríguez Rueda, Ismael 260-62, 260-62 Delmonico Building, 196 Sueño de Erasmo, El, 107, 107-8 Sheep Study (Moore), 118 Romanticism, 248, 248, 249 Post-Impressionist, 268, Sherman, Cindy, 317, 319 268-69, 269 Rothenberg, Susan, 319 Untitled, 319 surrealist, 284, 285, 286 Reflections, 320 Shoestring Potatoes Spilling from a Bag United States, 84 texture in, 133-34, 134 "Sculpture-in-the-round," 233, 236 (Oldenburg), 307 Rothko, Mark, 297 Seated Woman (Picasso), 209 Shunman, Kubo Number 10, 298 Secondary color, 146, 149, 149 Courtesan Dreaming, A, 203 Rouault, Georges, 264 Christ Mocked by Soldiers, Secondary triad, 149, 151 Silhouette, 220 264, 265 Section view, 213, 213 Simulated texture, 132, 137-38, 138, Rouen Cathedral; Morning 139 Seely, J. Stripe Song, 89 Simulation (Schumer), 138 (Monet), 163 Rouen Cathedral, West Façade, Sunlight Segal, George, 306 Simultaneity, 270, 270-71 Walk, Don't Walk, 307 Simultaneous contrast, 146, 159-62, (Monet), 163 160 - 62Ruisdael, Jacob van Self-Portrait (Kokoschka), 266 Siteworks, 310-12, 310-12 Wheatfields, 183 Semi-abstract art, 13 Siteworks (Site Art), 303 Rule of proximity, 41, 41 Semifantasy, 95, 95 68-388 (Maroulis), 181 Runge, Philipp Otto, 166 Sequences, 295 Size, space and, 183-84, 184, 187 RVP (right vanishing point), Seurat, Georges, 60, 62, 257, 263 196, 196 Circus Sideshow (La Parade), 62, 63 Sleeping Eye (Maguire), 188 Sunday Afternoon on the Island of Smith, David, 290, 293, 302 Cubi VII, 294 La Grande Jatte, 257 Smith, Tony, 69, 240 Severini, Gino, 273 Ten Elements, 241 Dynamic Hieroglyphic of the Bal St. John the Baptist (Caravaggio), 123 Tabarin, 217 Smith, W. Eugene, 12 Salangi Raga (Ragamala), 56 Spanish Wake, 13 Shades, 153 Samaris, Lucas, 311 Shadow, 116, 233 Smithson, Robert, 311 Mirrored Room, 310, 311 Shadows (McKnight), 119 Spiral Jetty, 311 Sassetta Shahn, Ben, 268, 314 Snelson, Kenneth, 77 Meeting of Saint Anthony and Saint Handball, 54, 54 Free Ride Home, 239 Paul, The, 106 Shallow space, 116, 180, 182, 182

Shallow-space concept, 125

balance and, 104-5

Shape, 19, 46, 48, 92-113, 220

content and, 97, 109-10,

109-13, 112

design principles and, 103-9

harmony and variety in, 108

intuitive space and, 100, 104

shape-edge development, 102,

in three-dimensional art, 94, 99,

100-101, 101-3, 103,

221, 231-33, 231-33

space and, 206-7, 207, 208

space concept and, 108-9

dimensions of, 99-103

line and, 83, 83-85, 85

semifantasy and, 95, 95

103, 103

uses of, 98-109

rhythm and, 105, 105-6

configuration of, 110, 111-13, 112

definition of, 95-98, 95-98, 105

direction and, 100, 104, 105, 105

Scale, 31

extremes of scale, 62, 64, 64

in three-dimensional art, 226, 240

I'm Dancin' as Fast as I Can, 317

hierarchical scaling, 65, 65

Study after Poussin, 128

Affection for Surfing, 318

Rietveld-Schröder House, 8

Scream, The (Cry) (Munch), 266

Bedroom in Venice, A, 321

Sculpture, 20, 220, 222, 222-23, 223

292-94, 292-94

Abstract-Expressionist, 290,

Schactman, Barry, 127

Schapiro, Miriam, 316

Schröder, Truus

Schumer, Gary

Simulation, 138

Schwitters, Kurt, 310

Screen printing, 120

abstract, 277, 277

Scully, Sean, 320

Schnabel, Julian, 317, 319

Solarizations (photography), 287 Songs of the Sky (O'Keeffe), 278 Space, 5, 178-216 color and, 209-10, 210, 211 as concept, 31, 70-71 converging parallels and, 188, 188, 189 decorative, 181, 181 deep and infinite, 180, 182-83, 183 fourth dimension, 210-11 fractional representation and, 186-87, 187 interpenetration and, 186, 186 intuitive, 204, 204, 205 isometric projection, 202, 203 line and, 88, 88-89, 89, 204-6,206linear perspective and. See Linear (geometric) perspective movement in time and, 204, 214-16, 214-17 oblique projection, 202, 203

orthographic drawing, 202, 203, 213 overlapping, 185, 185 plastic, 181-83 plastic images and, 187, 212, 212-13, 213 position and, 184, 184-85, 185 recent concepts of, 210-16 shallow, 182, 182 shape and, 108-9, 206-7, 207, 208 sharp and diminishing detail, 187-88, 188 size and, 183-84, 184, 187 spatial indicators, 183-204 spatial perception, 181 texture and, 142, 143, 208-9, 209 in three-dimensional art, 233-36, 234-36 transparency and, 185, 185-86 value and, 188, 207-8, 208 Spanish Wake (Smith), 13 Spatial characteristics of color, 157-59, 158, 159 Spatial indicators, 183-204 Spatial perception, 181 Spectrum, 146, 147, 147, 148 Speeding Automobile (Balla), 273 Spiral Jetty (Smithson), 311 Split-complements, 146, 156, 156-57 Spoonbridge and Cherry (Oldenburg and van Bruggen), 64 Spring in the Chateau du Repas (Ishigooka), 160 St. Francis Receiving the Stigmata (van Evck), 65, 65 Stabile, 293 Staircase, The (Bury), 301 Standing Youth (Lehmbruck), 268 Stankiewicz, Richard, 299 Starry Night, The (van Gogh), 15, 135 Steichen, Edward, 21, 259, 262, 276, 277, 278, 278-79, 295 Balzac-the Open Sky, 262, 262 Wind Fire: Thérèse Duncan, 278 Stella, Frank, 297 Lac Laronge IV, 33 Stepovich, Andrew Carnival, 40 Stereoscopic vision, 181 Stevovich, Andrew Carnival, 128, 129 Stieglitz, Alfred, 21, 259, 276, 278 Equivalent, 278 Terminal, The, 259, 259 Still Life: The Table (Braque), 105 Still Life (Braque), 136 Still Life with Basket of Fruit (Cézanne), 212

344

Index

T Still Life with Crystal Bowl sculpture. See Sculpture Turner, J.M.W., 248 (Lichtenstein), 139 shape in, 94, 99, 100-101, 101-3, Keelmen Heaving in Coals by Tachiste painting, 254 Still Life with Parrot (Kahlo), 171 103, 231-33, 231-33 Moonlight, 249 Tactile experience, 132, 133, 133 space in, 233-36, 234-36 Stone Within, The (Noguchi), 221 Twin Sisters (Erté), 55 Talbot, William Henry Fox, 250 Storm Center (Frankenthaler), 112 texture in, 222, 236-37 Twittering Machine (Klee), 282 Nicole & Pullen sawing and Straight line, 79 time (fourth dimension) in, Two Barristers (Daumier), 90 cleaving, 250 Two Callas (Cunningham), 280 Straight (realist) photographers, 250 238, 238 Tamayo, Rufino, 287 Strand, Paul, 272, 272, 277, 279, value in, 233, 233-34, 234 Two Red Lines II (Rickey), 302 Dos Personajes Atacados por 280, 295 Three-dimensional space, 180 Two Ways of Life, The perros, 95 Shadows (Porch Abstraction), 272 Three-point perspective, 191, (Rejlander), 251 Tanguy, Yves, 283-84 Street: Near the Palace (Feininger), 205 195-97, 196 Two-dimensional art, 5, 19, 181 Mama, Papa is Wounded, 98 Stripe Song (Seely), 89 Tiepolo, Giambattista shape in, 94, 99, 99-100, 100, Multiplication of the Arcs, 285 Madonna of Mt. Carmel and the Studio, The (Lawrence), 182, 182 108 - 9Tchelitchew, Pavel Study after Poussin (Schactman), 128 Souls in Purgatory, 68 Two-dimensional space, 180 Hide-and-Seek, 143 Study for Figure of Falsehood on the Tiepolo, Giovanni Battista Two-point perspective, 184, 191. Technique, 5 Ceiling of the Palazzo Study for Figure of Falsehood on the 193-95, 193-95 Tectonic composition, 220, 238, 238 Trento-Valmarana, Ceiling of the Palazzo Ten Elements (Smith), 241 Vicenza (Tiepolo), 90 Trento-Valmarana, U Tenebrism, 116, 123, 123, 124 Study for First Illuminated Nude Vicenza, 90 Tension, in balance, 50, 52, 54, 54 (Wesselmann), 69 Tiger Devouring an Antelope Umbrella Pine (Phelan), 173 Terminal, The (Stieglitz), 259, 259 Style, 5, 244-321 (Barye), 261 Umbrellas (Christo and Jeanne-Tertiary color, 147, 150, 155 Subject, 5, 910, 10-11, 11, 14 Time (fourth dimension), in three-Claude), 311 Texture, 19, 130-43 Subjective, 5, 16 dimensional art, 238, 238 Under the Wave off Kanagawa abstract, 138-39, 139 Subjective color, 146, 170, 172 Tinguely, Jean, 243, 302 (Hokusai), 39 actual, 134-37, 135, 137 Subjective edges, 45-46 Homage to New York, 302 Unending Revolution of Venus, Planets, art media and, 142-43 Subjective line, 46, 48, 74 O Sole Mio, 243 and Pendulum invented, 139-40, 140 Tints, 153 Subjective shape, 94, 96 (Graves), 239 line and, 86, 87, 88, 88 Substitution (casting), 220, Titian Unique Forms of Continuity in Space nature of, 134, 134 230-31, 231 Entombment of Christ, The, 122 (Boccioni), 273 pattern and, 140, 140-42, 141 Subtraction, 220, 229, 230 Tom (di Suvero), 222 United States (Rothenberg), 84 psychological factors, 142, 143 Subtractive color, 146–47, Tools, effect on line, 81, 81, 86, 87, Unity, 5, 32 relative dominance and 148-49, 161 88.88 "Universal art," 315 movement, 142, 142 Subtractive color mixing system, Topographical map, 83, 83 Untitled (Brusca), 185, 185 simulated, 137-38, 138, 139 148, 168-69, 168-70 Torsifruit (Arp), 232 Untitled (Chamberlain), 300 space and, 142, 143, 208-9, 209 Sueño de Erasmo, El (Rodríguez Tossana (Benglis), 320 Untitled (Flavin), 302 in three-dimensional art, 222, Total abstraction, 277 Rueda), 107, 107-8 Untitled (Goforth), 222 236 - 37Sugarman, George Totem (Calder), 293 Untitled (Hunt), 10 visual arts and, 133, 133-34, 134 Toulouse-Lautrec, Henri de, Inscape, 49 Untitled (Judd), 242 Theory of Color, The (Prang), 166 261, 276 Sullivan, Louis, 224 Untitled (Sherman), 319 Thicket (Puryear), 321 Sun Spots (Marin), 210 Jane Avril, 77, 77 Untitled (student work), 233 Third of May, The (Goya), 249 Sunday Afternoon on the Island of La Tournachon, Gaspard-Felix Urgence (Dubuffet), 87 Three Men in a Circle (Trova), 110 Grande Jatte (Seurat), 257 (Felix Nadar), 254 Three Walking Men (Giacometti), 285 Sunlight in a Cafeteria (Hopper), Tovish, Harold Three Women (Léger), 113 195, 195 Contour Drawing, 84 Three-dimensional art, 5, 19, 218-43 Supervisory Wife II (Coleman), Transparency, 180, 185, 185-86 balance in, 239, 239-40, Value, 19, 114-29 108, 108 Treatise on Painting (da Vinci), 16 240, 242 chiaroscuro, 116, 121, 121, 122 Surrealism, 94, 97, 98, 98, 105, 112 Tree in a Meadow (Corner of a Park at basic concepts, 221, 221-28, 222 of color, 147, 151, 151-53 painting, 283-84, 284, 285, 286 Arles) (van Gogh), 99 color in, 237, 237 compositional functions of, 125, photography, 286, 286-87 Tree (Mondrian), 6 economy in, 240, 241, 242, 242 127, 127 sculpture, 284, 285, 286 Triadic color system, 149, 150, elements of form, 231-38 decorative value, 123, 125, Surrealist Manifesto (Breton), 284 151, 156 forms of, 223-28, 224, 225 125, 126 Swann, Alan Triadic color wheel, 166 line in, 77, 233-35, 237 descriptive uses of, 118, 118, How to Understand and Use Trinity with the Virgin, St. John and materials and techniques of, 119, 120 Grids, 48 Donors (Masaccio), 189 228 - 31, 229expressive uses of, 120, 120 Trio (Magada), 91 Symbolists, 259 movement in, 233, 238, 241-43, line and, 85, 85-86, 86, 88, 88 Symmetrically balanced sculpture, Trois Fois (Dykmans), 119 242 - 43open and closed compositions, 239, 242 Trompe l'oeil, 132, 138, 138, 229 principles of organization, 238, 120, 127-29, 129 Symmetry, 31, 54-55, 55 Trova, Ernest 238-43, 239 space and, 188, 207-8, 208 Synthetically designed pictures, 214 Three Men in a Circle, 110 proportion in, 226, 239, 240, 241 tenebrism, 116, 123, 123, 124

in three-dimensional art, 233, 233-34, 234 value relationships, 117, 117-18 Value patterns, 116, 127, 127, 128, 129 Value-modeling, 208, 208 van Bruggen, Coosje Spoonbridge and Cherry, 64 van Eyck, Jan St. Francis Receiving the Stigmata, 65, 65 van Gogh, Vincent, 257, 258-59, 261, 263 Corner of a Park at Arles (Tree in a Meadow), 99 Grove of Cypresses, 75 Starry Night, The, 15, 135 van Renesse, Constantijn Descent from the Cross, 124, 125 van Rijn, Rembrandt Harmenszoon. See Rembrandt Harmenszoon van Rijn Vanishing point(s), 190, 190 multiple, 200, 200, 201 in one-point perspective, 192, 192 in two-point perspective, 193-94, 194-95 Variation within a Sphere, No. 10, the Sun (Lippold), 234 Variety, 31, 49-50 color balance and, 158, 160, 164, 172, 174-77, 175-77 contrast and, 49, 49 elaboration and, 44, 49-50, 50, 51

shape and, 108

Vasarely, Victor, 298 Orion, 50, 50 Vauxcelles, Louis, 263, 272 Vecellio, Tiziano. See Titian Ventaglio (Pepper), 241 Vermeer, Jan, 286 Vermeer, Johannes Diana and the Nymphs, 47 Vertical balance, 53, 53 Vertical projection systems, 199, 199 Vertical vanishing point (VVP), 196 - 97Vertigo (Bochner), 80 Viera da Silva, Maria Helena City, The, 89 Villon, Jacques Baudelaire, 86 Virgin of the Rocks (da Vinci), 121 Vision After the Sermon (Gauguin), 159 Visual arts, texture in, 133, 133-34, 134 Visual grouping. See Closure Visual interest, variety and, 49 Visual linking, 43-49 connections (shared edges), 42-44, 43-44 extensions, 41, 45-46, 47, 48, 48 - 49interpenetration, 45, 46 overlapping, 43, 44, 45 transparency, 43, 44-45 Vogel, Hermann, 253 Voice, The (Pelton), 67 Void, 220 Voids, 232-33, 233

Volume, 5, 20, 94, 99, 220 in three-dimensional art, 221–22 von Goethe, Johann Wolfgang, 166 von Helmholtz, Hermann, 169 Vortograph #1 (Coburn), 278 VVP (vertical vanishing point), 196–97

Wait, The (Kienholz), 300 Walk, Don't Walk (Segal), 307 Walter Lippmann (Kitaj), 58 Wang Hsi-chih Passages of Calligraphy, 78 Warhol, Andy, 305 100 Cans, 305 Warm colors, 157 Water Lilies (Monet), 96 Weber, Max, 268, 276 Welding, 231 Well, The (Piranesi), 76 Welsh, Stan Question of Balance, A, 227 Wesselmann, Tom Barbara and Baby, 24 Study for First Illuminated Nude, 69 Weston, Edward, 277, 279, 295 Juniper, Lake Tenaya, 279 "Wet-plate" photographic process, 252, 252, 253 Wheatfields (Ruisdael), 183 White, Minor, 295 Cobblestone House, Avon, New York, 18 Windowsill Daydreaming, 295

White Wall (Kendrick), 231 Wild Indigo (Noland), 297 Wind Fire: Thérèse Duncan (Steichen), 278 Windowsill Daydreaming (White), 295 Winogrand, Garry, 308 American Legion Convention; Dallas, Texas, 308 Witkin, Jerome Paul Jeff Davies, 64, 64-65 Wojtkiewicz, Dennis Kaleidoscope, 133 Woman, I (de Kooning), 288 Woman Doing Her Hair (Archipenko), 233, 277 Women and Dog (Marisol), 237 Wrapped Reichstag, Berlin (Christo and Jeanne-Claude), 17 Wright, Frank Lloyd, 224-25 armchair, 224 Wu Chen Bamboo in the Wind, 79 Wyeth, Andrew Newell, 314 Hunter, The, 133

Yasami, Masoud

Balancing Act with Stone II, 56

Zapatistas (Orozco), 40 Zola, Emile, 250 Zonal system (photography), 280

Media Index

A

Architecture, 8, 225, 226 Assemblage, 137, 282, 299

C

Calligraphy, 78
Ceramics, 227
Collage, 38, 42, 66, 87, 109, 136
Commercial products, 224
Computer-aided art, 34, 108, 140, 196
Constructions and assemblages, 34, 49
environments, 17

D

Drawings, 36, 62, 80, 81, 128, 267 mixed media, 80, 99 pen and ink, 75, 79, 90, 118, 127, 213 pencil, 76, 84, 90

E

Earth art, 311, 312 Engravings, 256

F

Fabric art, 158, 228 blankets, 55 quilts, 37 Fashion, 9 Fresco, 32, 121, 187, 189 Furniture, 8, 224, 225

G

Glass design, 227

Н

Happenings/performance art, 309, 310

J

Jewelry, 226

L

Landscape design, 294 Lithography, 10, 77, 139, 169, 196

M

Manuscripts, 214 Metalwork, 226 Mixed media, 22, 51, 56 Mobiles, 238, 293

P

Paintings, 95 acrylic, 33, 69, 84, 87, 103, 112, 134, 162, 176, 185, 186, 208, 297, 298, 317 gouache, 66, 182 oil, 6, 7, 11, 15, 19, 24, 26, 27, 35, 40, 42, 47, 57, 58, 59, 63, 64, 65, 67, 68, 69, 70, 81, 82, 89, 96, 97, 98, 104, 105, 107, 110, 111, 113, 120, 121, 122, 123, 124, 126, 128, 133, 138, 142, 143, 158, 159, 160, 161, 171, 173, 174, 175, 181, 183, 184, 188, 193, 195, 204, 205, 206, 209, 212, 215, 216, 217, 247, 248, 252, 253, 254, 255, 256, 257, 258, 264, 265, 267, 271, 273, 276, 283, 284, 285, 288, 290, 291, 296, 298, 303, 305, 306, 307, 313, 318, 320, 321 tempera, 25, 54, 106, 133, 190 watercolor, 110, 125, 184, 209, 282

Photography, 13, 18, 21, 45, 47, 89, 101, 119, 126, 139, 141, 170, 250, 251, 252, 253, 259, 262, 274, 278, 279, 280, 281, 287, 291, 295, 308, 309, 316, 319

Prints

etchings, 20—21, 76, 86, 117 intaglio, 119 lithographs. *See* Lithography serigraphs, 55 silkscreen, 89, 139 woodblock prints, 39, 44, 192, 203, 255

S

Sand painting, 291
Sculpture, 64, 221, 222, 223, 233, 237, 243, 268, 302, 303, 307, 310, 314, 315
marble, 60, 134, 223, 237, 260, 262
metal, 97, 222, 223, 229, 232, 233, 234, 235, 236, 238, 239, 240, 241, 242, 261, 263, 269, 273, 277, 280, 285, 292, 293, 294, 300, 302, 304, 320
wood, 12, 136, 231, 236, 271, 292, 301, 321
Stained glass window, 127

T

Tableaux, 300

W

Wallcoverings, 36